SUNS

OF

GOD

KRISHNA, BUDDHA and CHRIST UNVEILED

ACHARYA S

In *Suns of God*, Acharya S achieves a rarely attained level of scholarship that essentially proves the non-historicity of popular religious figures such as Krishna, Buddha and Christ. While tackling an extremely important, difficult and contentious subject, Acharya manages to render it both accessible and fascinating. The world could seriously benefit from the widespread dissemination of such information.

—Tim Leedom, author of
The Book Your Church Doesn't Want You to Read

Amidst the global chaos of George Bush's "War on Terror," largely founded on religious intolerance and simplistic notions of good and evil, Acharya S is the voice of reason. Weaving an incredible tale that begins in the dawn of time—with the personification of the sun and the replication of the born-again sun-god meme the world over—Acharya S shows us that the "Christian way of life" we are dying to protect is actually a fable of ancient propagandists. If you want to understand how humanity has been doomed to a cycle of war, division and chaos, read Acharya S's *Suns of God*. There will be no escape from the conclusion that we're now living in an Armageddon of our own making. We have become part of the machine.

—Joan d'Arc
Paranoia Magazine
www.paranoiamagazine.com

Skeptic and believer alike will find *Suns of God* enormously rewarding. This astonishing book not only returns the study of religion to its astrotheological origins, but it also abundantly explores mythologies of ancient resonance and provides a welcome critique of the parapolitics that warped them into the psycho-social nightmares of the major mainstream religions of today. *Suns of God* supplies vital knowledge for anyone claiming to be an authority on world religions.

—Kenn Thomas
Steamshovel Press
www.steamshovelpress.com

This dramatic new work by Acharya S, *Suns of God*, continues, expands, and enhances her drive to reveal the truth and expose the lies behind so-called organized Christian religions that began with her myth-shattering work, *The Christ Conspiracy*. This book too is a must-read for any sincere human being who has the courage to search for literal truth as opposed to the soft-soap salves offered by priests, preachers and ministers alike whose actual interests have nothing to do with "saving souls." Instead,

they use blatant myths, silky lies, and psychological threats and suggestion to gain unlimited power to govern, control, and bilk the needy and the gullible. *Suns of God* offers compelling arguments that the *story* of "Jesus the Christ" existed long before the myth of Jesus of Nazareth was methodically created around that story. Every thinking person who wishes to truly understand the nature of this world should not only read both *The Christ Conspiracy* and *Suns of God*, but they also should study and challenge her findings...if they can.

<div align="right">

—Robert W. Morgan, author, filmmaker, founder of
American Anthropological Research Foundation

</div>

Wow, Acharya! *Suns of God* is a remarkable book that everyone should have, with its amazing research raising the torchlight of truth in a time of darkness, hatred and destruction. May this enlightening book open the path to oneness globally, uniting us in a vast celebration of peace.

<div align="right">

—Hehpsehboah, author of
The Etherean Travellers and the Magical Child
www.trafford.com

</div>

SUNS OF GOD
Krishna, Buddha and Christ Unveiled

Copyright 2004 by Acharya S

ISBN: 1-931882-31-2

Printed in the United States of America

Published by
Adventures Unlimited Press
One Adventure Place
Kempton, Illinois 60946

www.adventuresunlimitedpress.com

SUNS
OF
GOD

KRISHNA, BUDDHA and
CHRIST UNVEILED

Adventures Unlimited Press

TABLE OF CONTENTS

Foreword

Shortly after completing my theological history education, I came upon the book *The Christ Conspiracy*, a sort of prequel to this book, *Suns of God*. By my last year in graduate school, I had come to the uncomfortable conclusion that much of what I had been taught as fact was really tradition. The ideas considered as reality were hardly more than a long list of elaborate and chaotic beliefs about the world around us. These ideas and beliefs of modern religions were borrowed thousands of years ago from a host of sources, who themselves borrowed from even older sources. It was clear that there truly was nothing new under the sun. In this regard, it is imperative to ask how something so archaic and easily shown to be erroneous still exists in a time of space shuttles, ten-dimensional universes, and light-speed computer chips. Perhaps there are many reasons, the first and most obvious being humanity's desire to understand.

I have a little friend who believes in ghosts. His father died when he was only two years old, and this belief is the only way he can maintain a connection to his father. Of course, he is only five years old now, but I can see how these beliefs, once instilled, are not easy to overcome. He explained that his father was a ghost who lived underground, as he had been to his father's grave and had seen this place for himself. Despite assurances that, in my educated experience, such things as ghosts were most certainly not real, my young friend simply nodded his head and told me I was wrong. He truly believed in ghosts, although he did comment that vampires were unlikely, as were swamp monsters. Did someone tell him his father was now a ghost? Or, did the combination of television, ghost stories and the knowledge of his father's death simply add up to his belief? This type of circumstance is perhaps how many religious people come to profess their beliefs in gods and spirits. Some part of them needs to believe, and their limited knowledge of history and of older cultures, especially the earliest cultures, adds up to a belief in some great and powerful unseen forces.

Today we live, for the most part, in an age of modern accomplishment. Disease is no longer the purvey of demons or bad astrology but viruses or bad genetics. Yet, despite all our advancements as a species—or, perhaps because of them—the need for the control of our minds seems to have reached a fever pitch. Even in this modern age, we are still faced with those who argue names and semantics at the "point of a sword." Wars are fought daily around the globe because of religious ideas—ideas based on nothing more, as Acharya's books show, than the mistranslated words or another culture, as well as the desperate

need to raise "our" gods over those of our neighbors. In addition to presenting this troubling history in an easily followed narrative, Acharya goes a step further, explaining as only she can how a once-simplistic idea has been carried into our modern world with terrible and nearly unimaginable results. Unending horrors are committed as certain individuals, believing—and I cannot stress the word strongly enough, *believing*—that they are best able to ascertain an otherwise unknowable knowledge, hidden from all but the truest followers, depending on which deity they follow, aggressively demand to show the rest of us, atheist, agnostic and infidel alike, how to live. In the book you now hold in your hands, you will find a great many answers to the most fundamental questions of organized religion, how it has maintained its vice-like grip on both the uneducated and educated, as well as how those people who profess "love" and "kindness" the most vociferously are often among the most dangerous.

Just as my young friend needs to believe in ghosts to understand his world, so too do many otherwise intelligent citizens of our world need some mythology to give meaning to their lives. We must never underestimate the stakes the modern myth-spinners have in keeping their myths alive. Whether tied to a cultural identity, a matter of social and political control, or simply an ignorance of the natural world, some people who profess to know our hearts' desires in reality wish only for the chaos and oppression created by "their" history. Although we ourselves may be satisfied to live in this modern age, these individuals seem to prefer, in many instances, the age of our ancestors, when unreachable gods controlled the puppet strings of humanity. Alternatively, perhaps, like my little friend, the more innocent among us have a psychological need, a desire unmet by other facets of life, that these myths fulfill. Naturally, this need does not usually include vampires, although judging from the "religious" fixation on blood, as depicted most graphically in the recent horror flick "The Passion of the Christ," perhaps it does.

W. Sumner Davis, BA, MS, M.Div, Th.D
Ecology Affiliate, New York Academy of Sciences
Author, *Heretics*
New York City
May 2004

Introduction

The reproaching cry of heretic, infidel, atheist, etc., will be raised against the author of these lectures, by every fiery intolerant bigot into whose hand they may fall. But he alone is the true infidel who forsakes the laws of his nature, and gives up his mind to a belief in fabulous and demoralizing legends, which contradict all experience, and stand in opposition to the testimony of his own sense and reason.

Christian Mythology Unveiled, 1842

The orthodox teachings are so false that they have made the utterance of truth a blasphemy, and all the proclaimers of truth blasphemers! Oppose their savage theology, and you are denounced as an Atheist. Expose the folly of their faith, and you are an Infidel all around. Deny their miracles, and they damn your morals.

Gerald Massey, *Gerald Massey's Lectures*

While the Western world begins its new millennium, little has changed in terms of religious understanding, and the world in general continues to be divided largely along the lines of faith. The proselytizers, proponents and propagandists of these various faiths persist in fighting over bodies and souls, in an endless religious tug-of-war that has ruined culture, wrecked minds and wreaked havoc. It also invades privacy and stomps all over individual rights. Religion is motivated by fear and insecurity: People want to believe, in God, Jesus, Krishna, Buddha— something, anything, so as not to feel so alone, helpless and forgotten. Life is a cruel, sadistic torment in countless places around the globe. This fact should create more questions than it does about whether or not there is any good god in charge of everything and whether or not religion has any value in the first place. Yet, in the face of tragedy, rationality and logic fail to win out over powerlessness that desperately needs to believe in the Other, somewhere "out there." What this insight reveals is that God is a popular concept not because people have reasoned it through and proved it true, but because humans are terrified of the opposite notion: If God is not, all is for naught.

The concepts of God and religion have varied greatly over the millennia, in the sense that they have been developed within cultural contexts, with odd details and interpretations based chiefly on race, gender, language and environment. Thus, goddess worship rather than god worship dominated in a variety of places globally for thousands of years, and gods and goddesses often have been of the same color and mentality, as well as speaking the same language, as the culture in which they have been developed. These variances have led to a horrendous amount of

suffering and terror, as fanatics of sundry religions, sects, cults, etc., have believed themselves superior to all the rest, and have attempted to force themselves upon everyone else. This aggressive behavior also is out of insecurity, as beliefs are flimsy things, and it is imagined that the more people who believe, the more these beliefs will be real. Not so, unless as a phantasmagoria, a nightmare.

Concerning the fluidity of religion, famed scholar Max Müller remarked:

> ...Religion floats in the air, and each man takes as much or as little of it as he likes.

> We shall thus understand why accounts given by different missionaries and travelers of the religion of one and the same tribe should sometimes differ from each other like black and white. There may be in the same tribe an angel of light and a vulgar ruffian, yet both would be considered by European travelers as unimpeachable authorities with regard to their religion.[1]

Although it is often useless to attempt to argue logic in the religious arena, which frequently bases itself on illogic and blind faith, one must ask how an "omnipresent" god—that is, *everywhere present*—can be contained in one religion or another. If "God" is omnipresent, then "he" is in all ideologies and texts, whether sacred or secular. Even atheist writings would be "of God," if the omnipresence of "monotheism" were correct in its premise. In reality, the line between monotheism and pantheism is very slight and exists only in the mind of the believer. The difference between theism and atheism is also very slight. Indeed, it is evident that the human mind has the capacity to be monotheistic, polytheistic, pantheistic and atheistic all at the same time.

Between the zealous believer and the hardcore atheist, the latter is frequently more savvy, having considered the subject of God and come to conclude, through rationality and integrity, that no such being as portrayed in the monotheist religions could possibly exist. When confronted with the paradox of why, if there is some omnipotent god person in charge of everything, there could be such pain and atrocity in this world, the blind believer can only make excuses for this purported creator. For example, the devil somehow got the better of him, even though God is supposedly all knowing and all powerful. And if all pervasive, i.e., everywhere present, he must also be in the devil! In fact, God must *be* the devil. In some cultures, he is: For instance, the Old Testament god Yahweh was logically the orchestrator of evil as well as of good, since he was all powerful.

A more sophisticated argument—leaving out the devil, a concept that tends to provoke giggles these days from the more sensible segment of society—is that God is "testing" us with all this horror and trauma. This concept of a horrible god who would constantly be tormenting and torturing his puny little creatures is exactly what creates atheists. It is very difficult for the thinking and feeling person to consider the atrocities that have plagued life on this planet to be the product of a "good" god. In other words, the paradoxical concept of an all-powerful "good" god who would nonetheless be either helpless to stop atrocity, or is actually the architect of evil, cannot but create dishonesty and a lack of integrity. Furthermore, much of this brutality is actually *because of* the belief in God in the first place.

The Intolerance of Religion

In this day and age, as the world becomes smaller than ever before, there is an increasing need for investigation and education in religion, as it is one of the most important and volatile of all human issues. Save for the few enlightened periods and places, throughout history people of faiths different from the ruling religion have been persecuted mercilessly. Oddly enough, the Roman Empire, which was notorious for hardship and horror, nevertheless exercised religious tolerance to an extreme degree; yet, cultures with the pretense of being more civilized than Rome terrorize and kill those who do not follow the prescribed path and preferred god. Thankfully, some nations have achieved a standard of not persecuting and prosecuting members of minority religions and non-religious freethinkers for "blasphemy" and "heresy." However, in many countries freethinkers, secularists, agnostics and atheists remain pariahs and outcastes, even though many of the world's greatest thinkers have been of this inclination.

Even today, when man pretends to be civilized, terrible evils are regularly committed in the name of religion. Besides the ongoing slaughter over whose god is bigger and better than everybody else's—a popularity contest generally dependent on "might being right"—there is tremendous destruction of culture globally. For example, in India Christian converts are taught to hate their ancient culture, and in South Korea Protestant evangelists engage in vandalism and destruction of their ancestors' culture, burning Buddhist temples and statues, and defacing monuments. Missionaries overrun Thailand and teach the youth to despise their own culture and its elders. The destruction and terror do not begin or end with Christianity, as one look at the situations in Israel, Indonesia, Afghanistan, Saudi Arabia, Pakistan and other places will prove. Religious strife may

lead to a nuclear exchange between India and Pakistan. Were such a battle to occur, the entire world might be threatened.

Today's religious strife is as barbaric as that of the past, the atrocities and warfare essentially the same, although it is claimed that there is less "human sacrifice." Yet, it is often believed by zealots that the mere presence of an infidel in their midst brings about God's wrath in the form of natural disasters and other suffering; hence, according to these fanatics, the unbeliever should be put to death, and often is. Is this not human sacrifice to appease a god? And what is religious warfare, which leads to the deaths of thousands, but human sacrifice on a large scale? As French scholar and *abbé* Charles Dupuis observes, in *The Origin of All Religious Worship*:

> I am perfectly aware that our modern religions are not so horrid in their sacrifices, but what is the difference whether it is on the altar of the Druids, or in the fields of the Vendée, that men are murdered in honor of the Deity, when instigated thereto by religion? Whether they are burnt in the statue of Moloch or on the funeral piles of the Inquisition? The crime is always the same, and the religions which lead to it are nonetheless fatal institutions to society: it would be an outrage to God to suppose him jealous of such homage. But if he abhors a worship costing so much blood to humanity, can it be believed that he should like one which degrades our reason, and which makes himself descend as by enchantment into a piece of wafer at the will of the impostor who invokes him? He, who gave man Reason as the most beautiful gift he could bestow on him, does he require him to disgrace it by the most stupid credulity and by a blind confidence in the absurd fables which are dealt out to him in the name of the Deity?...
>
> But it is by no means the Deity which has ordered man to establish a worship: it is man himself, who has conceived the idea for his own benefit; and Desire and Fear, more than Respect and Gratitude, have given birth to all religions. If the Gods, or the priests in their name, would not promise anything, the temples would soon be empty.[2]

Among the countless atrocities committed in the name of God and religion over the millennia looms large the practice of human sacrifice. This bloody and common ritual allowed for marauding Christian armies to justify the cultural destruction and genocide perpetrated in so many nations globally, including in the Americas, as a prime example. In other words, in order to stop human sacrifice, Christian armies sacrificed millions of humans. Moreover, the god of the Old Testament was hardly a paragon of peace and love, and the list of atrocities gleefully boasted about in the Bible is long indeed. As British royal physician Dr. Thomas Inman states in *Ancient Faiths and Modern*:

...Is there any human king who ever promulgated a more bloody order than did Jehovah Sabaoth, the God which, amongst the Hebrews, corresponded to the Mexican god of war, when he commissioned Samuel to say to Saul (1 Sam. 15:3), "Now go and smite Amalek, and utterly destroy all that they have; slay both man and woman, infant and suckling, ox and sheep, camel and ass!" After such a destruction of the Midianites as is narrated in Numb. 31, the fearful slaughter, effected by Crusaders, of Jews, Turks, and heretics, is scarcely worth mentioning.

...and surely, when our Bible, which is treasured by so many as the only rule of faith amongst us, details such horrible religious slaughters as are to be found in its pages, and abounds with persecuting precepts, we had better not talk too much about Mexican sacrifice. Was there any Aztec minister so brutal in his religious fury as Samuel was (1 Sam. 15:33), who hewed Agag into pieces? The Mexican was merciful to his victim; the Hebrew was like a modern Chinese executioner, who kills the criminal by degrees....

Surely the Christians have too much sin amongst themselves to cast a stone at the inhabitants of Mexico.

We find a very strong offset to the horror of Aztec cruelty in the very Bible, which we regard as the mainstay of our religious world. What, for example, is the essential difference between a Mexican monarch sacrificing one or ten thousand men taken in battle, and Moses commanding the extermination of the inhabitants of Canaan, and only saving, out of Midian, thirty-two thousand virgins, that they might minister to the lust of Hebrew followers? What, again, are we to say of David's God, who would not turn away from his anger from Judah until seven sons of the preceding king had been offered up as victims? And lastly— thought still more awful! what must we say of the fundamental doctrines of Christianity, that Jehovah Himself sacrificed His own Son by a cruel death; and not only so, but that He had intercourse with an earthly woman, and had thus a son by her, for the sole purpose of bringing about his murder?[3]

Furthermore, while there certainly was a tremendous amount of barbarity perpetrated by Mexicans, the Spanish propagandists have been accused of exaggerating the brutality in order to justify committing atrocities of their own, at which they were well skilled, per their own chroniclers.

Concerning biblical supremacy, Dr. Inman continues:

How can any reasonable man hold the opinion that the Devil instigated all the atrocities of the Syrians, Chaldees, Assyrians, Romans, Turks, Tartars, Saracens, Afghans, Mahometans, and Hindoos, and believe that the good God drowned the whole world, and nearly every single thing that had life; that He ordered the extermination, not only of Midianites and Amalekites, but slaughtered in one way or another, all the people

whom he led out of Egypt—except two—merely because they had a natural fear of war. What was the massacre at Cawnpore compared to that in Jericho and other Canaanite cities?[4]

The intolerance and supremacy based on religion were perfected in Judaism and, subsequently, Christianity, which has proved to be a deliberately bigoted ideology. For example, in its definition of "Paganism," the Catholic Encyclopedia ("CE") states that it is "all religions other than the true one":

> Paganism, in the broadest sense includes all religions other than the true one revealed by God, and, in a narrower sense, all except Christianity, Judaism, and Mohammedanism.[5]

This list of Pagan and "untrue" religions, according to CE, includes "Brahminism, Buddhism and Mithraism." After outlining the more sublime features of Roman religion and the "high abstractions" of the Persian, CE further says:

> Exactly opposite, and disastrous, were the tendencies of the idealistic Hindu, losing himself in dreams of Pantheism, self-annihilation, and divine union. Especially the worship of Vishnu (god of divine grace and devotion), of Krishna (the god so strangely assimilated by modern tendency to Christ)...[6]

CE thus states that Eastern religion is "disastrous," with its pantheism (i.e., *omnipresent divine*) and union with the divine. In other words, that which separates out the divine and keeps humans from being united with it is good! In actuality, such a separating and deluding force would have to be considered "satanic," as "satan" represents the adversary or opposite of the divine. Also, is an ideology superior which dictates that a giant anthropomorphic male god, absolutely separate and apart from the rest of creation—although paradoxically considered "omnipresent"—came to this earth, to be scourged and brutally killed?

Moreover, while subtly acknowledging the similarities between the Hindu god Krishna and the Jewish Christ, the CE asserts that the Indian deity is "strangely assimilated by *modern* tendency to Christ," a subterfuge to thwart charges of plagiarism by Christianity from older "Pagan" religions. In reality, Christianity is Paganism rehashed, and, as W.R. Halliday says in *The Pagan Background of Early Christianity*, "no one who is devoid of any sympathetic understanding of pagan thought and literature can have anything of essential value to tell us about the contemporary Christians."[7]

The intolerance and hatred taught by religions that dominate the world represent the antithesis of religiosity and spirituality. In *Christian Mythology*, George Every describes the typical reactions upon discovery of another's faith:

One is to insist on the sacred truth of one's own myth and divine law, pouring scorn on everything else, and the other is to allow that all are imperfect, symbolic representation of a mysterious reality, although some are more distorted than others. The first approach is characteristic of the Jews, and to a lesser extent of the Greeks and the Chinese, who regarded other nations [as] barbarians....

It is broadly true to say that the West has advanced on the first path and the East on the second.[8]

The East, with its "strange assimilation," is more tolerant and inclusive than the West. Whether Eastern or Western, however, so-called religious people are often egotistical, arrogant and conceited. The priesthood was in large part created not to "serve God," who, being omnipotent, would need no such help in the first place, but to free certain privileged men from manual labor and drudgery. With their free time, the priests could educate themselves and keep their mumbo-jumbo over the heads of the masses in order to exploit them. As Dupuis remarked, "The credulity of the people is a rich mine, which everybody is contending for."[9]

In another specious argument, it is claimed that a religion is determined to be "superior" and "genuine" based on "miracles" and the number of people who have been willing to die for it. Concerning the "martyrdom" argument, often used by Christians, Walter Cassels comments:

Every religion has had its martyrs, every error its devoted victims. Does the marvellous endurance of the Hindoo, whose limbs wither after years of painful persistence in vows to his Deity, prove the truth of Brahmanism? Or do the fanatical believers who cast themselves under the wheels of the car of Jagganath establish the soundness of their creed? Do the Jews, who for centuries bore the fiercest contumelies [insults] of the world, and were persecuted, hunted and done to death by every conceivable torture for persisting in their denial of the truth of the Incarnation, Resurrection and Ascension, and in their rejection of Jesus Christ, do they thus furnish a convincing argument for the truth of their belief and the falsity of Christianity?... History is full of the records of men who have honestly believed every kind of error and heresy, and have been steadfast to the death, through persecution and torture, in their mistaken belief. There is nothing so inflexible as superstitious fanaticism, and persecution, instead of extinguishing it, has invariably been the most certain means of its propagation. The sufferings of the Apostles, therefore, cannot prove anything beyond their own belief, and the question of what it was they really did believe and suffered for is by no means as simple as it sounds.[10]

Even in ancient times rational critics found the idea of martyrdom appalling. Famed "Pagan" writer of the third century CE, Porphyry, remarked that "it is not befitting the will of God—nor even the wishes of a good man—that thousands should be tortured for their beliefs..."[11]

Muslims have regularly martyred themselves—would a Christian then agree that Islam is the "truth faith?" Since millions of so-called Pagans have been willing to die for *their* faith, by this faulty martyrdom logic *Paganism* must be the "true faith!" In the final analysis, martyrdom proves nothing, except the fervor of the believer. Also, it should be kept in mind that, for many of us, those "Pagan" people who were tortured, killed and had their property stolen and cultures destroyed in the name of God, by whatever religious mania, were *our ancestors*. When Christians, for example, rant about "heathens" and "pagans," they are talking about *our ancestors* and, in many cases, *their own*. This "ancestor-hatred" is in exact opposition to practices found in many places around the world, dating back thousands of years, and has led to a tremendous amount of disrespect for ancient traditions, as well as for our own family members.

It is further claimed that there are "good things" in religion. Of course, there are: Nothing can be so encompassing and be all bad—or all good. The good within religion is in accordance with human nature, inherent in the human conscience, such that it is not a product of religion but a nucleus. In other words, what is good in religion is already innately good and does not need religion to make it so. Many human beings are innately good; they would behave in a decent and empathetic manner, no matter what religion they believed or disbelieved. Moreover, the goodness and morality found within any given religion generally exists within other religions—thousands of them—and in secular ideologies as well.

Despite the divisiveness, insanity and carnage, the fact remains that virtually all religions have similar roots and that the differences may be traced to cultural development over a period of centuries and millennia. To wit, these differences in dogma and ritual were *not* handed down by some omnipotent, omniscient and omnipresent god who happened to favor some individual or individuals within a particular culture, to the exclusion of the rest.

The Past Destroyed

When it comes to religion, alternative perspectives are considered highly suspect and are subject to intense scrutiny, held up to impossible standards of proof, while the accepted

paradigm is lightly handled and can pass with little or no evidence at all. Those who step outside the box are dunned with requests for credentials and bibliographies, while believers in the mainstream ideology require no credentials except belief and seem not to need to read much at all, including the very "sacred scriptures" they defend. Moreover, when doing investigative research into religion, dating back thousands of years, one must use a variety of sources, ancient and modern. If one uses works too modern, the hue and cry is for "primary sources!" If one uses material "too old," the criticism is that it is "outdated." Hence, the religious scholar is put in a double bind, while the critical fanatic is never satisfied. In such a picky environment, it is a wonder anything important is ever written or read.

The "outdated" argument becomes specious when it is understood that the work of more "modern" authors is nonetheless based on those who proceeded. To become a *scholar* one must study as much as is possible; obviously, whatever one is studying must have come *before*. The current studies are *based on* the past studies. No modern writer can possibly be called a scholar if he or she has not studied the works of the past; hence, he or she is using what detractors would call "outdated" material. Since true scholarship is founded upon the studies of the centuries and millennia past, it could *all* be deemed "outdated" by these illogical and impossible standards. It should not be necessary to point out this fact, but it often seems as if sense were not common at all, and every little detail, every meaning between the lines, must be clearly spelled out or else misrepresentation and misunderstanding will follow. In any case, the date of a book is frequently irrelevant, as truth is timeless.

Furthermore, the so-called outdated scholarship on the origins of religion in general, and Christianity in particular, that arose in the past few centuries is actually *superior* not only in depth but also in perspective to what is often produced today. One invaluable aspect of the older scholarship is that it preserved information regarding literature, iconography and other artifacts since destroyed—and there has been a great deal of destruction during the past three centuries, including two World Wars. Indeed, the reconstruction of the ancient world and its religion has been difficult because of the passage of time and the vast desolation of cultures worldwide. The eradication of evidence has been so rampant and thorough that it is remarkable anything can be said with any certainty at all. However, enough does survive, in bits and pieces, that we can gain a good idea of what has occurred in at least the past few thousand years. When critics clamor for "primary sources," the din actually serves to raise the

fact of this criminal and shameful cultural destruction, the purpose of which frequently was to cover the tracks of conspirators gleefully plagiarizing others' religions and falsely presenting their products as "divine revelation." Also, the "primary source" argument can be used in response by asking, where are the primary sources that prove Christianity and the existence of Jesus Christ? Where are the precious originals of the gospels, written by the very hands of the apostles and other witnesses to Jesus's alleged advent? The earliest New Testament manuscripts in existence date only to the third or fourth century. Not only are there no primary sources proving Christian claims, but what texts do exist have been altered thousands of times.

Much of what has survived the ages literarily is due to the practice of quoting. Hence, as was the case with *The Christ Conspiracy*, this book, *Suns of God*, is "quote heavy" for a number of significant reasons. Possibly most important of these reasons is that, since this subject matter is highly contentious, it is necessary to provide opinions from a wide variety of authorities, in their original words, because, as they say, seeing is believing. Also, providing originals leaves no room for "interpretation," and many of these writers are so concise and pithy as to be nearly impossible to paraphrase. Still further, many books are not readily available to the majority of people; hence, germane sections are reproduced here for easy access. In addition, as time passes the number of these important texts dwindles, so it is crucial to preserve them as best as is possible. To repeat, a significant portion of lost literature fortunately has been preserved to some degree over the centuries and millennia *through quotes*. Were it not for the practice of quoting, we would not possess the invaluable arguments of the opponents of the early Church, for example, whose works were deliberately destroyed. Some of the early Church fathers, especially Catholic historian Eusebius, quoted heavily from ancient authors and thankfully preserved these significant words for posterity.

Also, a number of salient books have been mutilated even in more recent times; had not other authors reproduced their material, we would have lost some very valuable knowledge. In the Western world, the blatant mutilation of texts that were for centuries in the hands of the vested interests, i.e., clergy, should have been a clue that these writings contained information injurious to the supernatural claims of Christianity. This mutilation did not cease with the end of the Inquisition but has continued, with such examples as what happened to the pious Christian missionary Edward Moor's *Hindu Pantheon*, an influential work first published in 1810 and later "edited" by other Christians long after Moor's death. Fortunately, Moor's original

tome survived both World Wars and has now been reproduced in India. We can only wonder at the contents of the millions of books that have been destroyed globally. We can also attempt to theorize what they contained, in an effort to reconstruct the ancient world to as accurate a degree as is possible, instead of relying on the propaganda promulgated since.

This "deep archaeology," or detailed reconstruction of the past, is difficult and time-consuming, requiring painstaking investigative and detective work, as well as innovative thinking. It is not the plopping of a spade into the ground and finding a magnificent, intact building with a plaque identifying it, the year in which it was built, and the builders, as well as the era's politics, religions, mores, etc. The restoration of the past is nitty-gritty, down-in-the-dirt, up-to-the-elbows, under-the-microscope, hard labor, not cursory or casual scanning. The reconstruction of literary evidence likewise requires extensive digging, brushing and piecing together. It is not a simple process of miraculously discovering a "primary document" in pristine shape that spells out everything. This reconstruction is not found neatly laid out in a single volume in a central library, on a CD, compiled in an orderly, organized fashion. If it were, it would already be known, and there would be no point to digging. And, if the truth had not been deliberately hidden, suppressed or destroyed, there could be no suspicion of conspiracy.

Moreover, no document exists that contains all the *secrets* of the world's most powerful people, groups and civilizations. Without a doubt, the most secretive organization or group has been the priesthood, the brotherhood or other factions "supernaturally" inclined or believed to be "inspired." Indeed, what becomes clear as one delves deeply into the subject of the origins of religion is that much of this information constitutes what are called "the mysteries," which are in fact enigmatic and represent *secrets* not readily available to the public and untrained eye. Many of these mysteries were passed along orally, and in foreign or mystical languages, all of which makes them difficult to reconstruct—until we realize that much religion revolved around natural phenomena, i.e., was frequently astrotheological, which is to say it reflects the worship of the sun, moon, stars and planets.

In excavating the truth, then, many sources must be used, many sciences consulted. In the case of the world's religions—products of the most secretive and cunning group—symbolism and allegory, the understanding of myths and rituals, are the principal keys to unlocking the past. Before writing was commonplace, much knowledge was transmitted verbally, as well as in myths, in statuary, on pottery, and in and on masonry.

Around the world are strange artifacts, icons, idols and edifices that require our scrutiny and decipherment, as they do not possess identification tags and instruction manuals. And where there is writing, it must be translated, with a mind to capturing nuances and idioms of the time, place and people. Such an extraordinary ability to think "like a native" of hundreds and thousands of years ago cannot be fully grasped, especially if the data is fragmentary, if the entire culture is not well understood, from the language spoken, the food eaten, the clothes worn, and the gods worshipped, to the books read, the type of government and so on. The difficulty of the process lies in the fact that the culture is buried, destroyed, suppressed, hidden or lost, often in a cataclysmic manner. Whole cultures have vanished for hundreds, thousands, perhaps even tens of thousands of years or more. Many are gone for eternity, while others will always remain very sketchy.

Ancient Cultural Commonality

One significant example of how cultural destruction has prevented the modern world from gaining ancient knowledge and obtaining "primary sources" can be found in Central America, where the invading Spaniards were astonished to discover a religious/governing system nearly identical to both Judaism and Christianity. This fact of similarity led crazed Christian authorities to destroy thousands of Mexican books or codices containing much evidence that Christianity was not "unique" or "original." Since this discovery, the subject has been ignored, especially in the past century, during which time scholarship on religion and mythology has taken a nosedive after a backlash by those vested in the Christ myth.

Fortunately, despite the massive destruction enough remains to reconstruct a picture of the pre-Christian Mexican life. In 1831, the eminent Lord Kingsborough published a multi-volume series called *Antiquities of Mexico*, in which he outlined the numerous correspondences between the Christian religion and that of the pre-Columbian Central Americans. The Mexican mythology included an omniscient, omnipresent god, who was, like the typical monotheistic god, "invisible, incorporeal, a being of absolute perfection and perfect purity," as Dr. Inman puts it. In the same manner as the "polytheistic monotheism" of other cultures, including the Judeo-Christian, this "one god" was divided into angels and devils. Regarding the Mexican religion, Lewis Spence remarks:

> The various classes of the priesthood were in the habit of addressing the several gods to whom they ministered as

"omnipotent," "endless," "invisible," "the one god complete in perfection and unity," and "the Maker and Moulder of All."[12]

Concerning the Mesoamerican system, Inman also says:

> This great Mexican divinity was essentially the same as the *Jehovah Tsebaoth* of the Hebrew Scriptures... His portrait is identical, apparently, with the commonly received likeness of Jesus....[13]

Other similarities between the Mexican and Christian religions include baptism and the end-of-October festival of "All Souls" or "All Saints Day." The Mexican fast for 40 days as a tribute to the god was essentially the same as the fasting of Jesus "forty days upon a mountain." Also, like Jesus (Rev. 22:16) and Lucifer (Is. 14:12: "Helel, son of the dawn"), the Mexican god Quetzalcoatl was the "morning star." Furthermore, the Mexicans revered the cross, upon which their god was nailed. Likewise, the Mexican Mother and Child were adored, and many Mexican sayings find their equivalents in the Judeo-Christian bible. Moreover, the Mexican priesthood was startlingly similar to that of Catholicism, with "fathers" who acted as confessors listening to penitents' sin and who prescribed prayers, penance and fasting.[14] Like that of Catholicism, the Mexican priesthood exacted tithes in order to support itself, and priests and nuns constituted the populace's teachers.[15] In addition, the human sacrifice ritual in Mexico was very similar to that of the biblical Jews and what is recorded in the gospel story. As Dr. Inman relates:

> The necessity of sacrifice, as atonement for sin, forms an essential, though bloody, part of both the Hebrew and the Christian faiths, and history has long taught us that the slaughter of a man, woman, or child, formed, in the estimation of the Ancient Greeks, and other nations, one of the most acceptable of the forms of homage paid by a human being to the Creator. This idea is at the very basis of the Christian theology.... In Hebrews 10:12, we find this doctrine very distinctly enunciated, in the words, "this man, after he had offered one sacrifice of sins for ever, sat down on the right hand of God"... Again, in Heb. 9:26, "once in the end of the world hath he appeared to put away sin by the sacrifice of himself;" and in Heb. 10:10, "we are sanctified through the offering of the body of Jesus Christ;" and in 9:28, "Christ once offered to bear the sins of many."[16]

This fact is sadly ironic considering the excuse used for centuries in destroying these cultures in the first place: to wit, because they practiced human sacrifice. In reality, the destruction was motivated in large part because of the correspondences between the Mexican and Catholic cultures, as well as the quest for booty.

Over the centuries, one popular explanation for the appearance of the "Christian" mythos and ritual in distant countries long before Christians arrived there has been that "the devil" anticipated Christ and spread his doctrine; hence, all these other stories and cultures are diabolical. Besides the "devil got there first" ruse, researchers have also surmised that all these stunning similarities in the Americas are the result of Jews and Christians arriving on the continent before Columbus. In this scenario, the handy "Lost Tribes of Israel" are paraded out and loudly trumpeted. Some have even gone so far as to insist that either Christ himself or an apostle preached in America, having flown there through the air. However, close scrutiny reveals that the Mexican culture could not have come from either Jews or Christians, and represents an earlier, pre-Christian and pre-Judaic tradition. For one thing, although the languages of Hebrew and Mexican possess many similarities, there is no evidence in Central America of any example of Hebrew *writing*, which indicates that these cultures emerged from the same root, separated before the development of the alphabet. Also, the Mexicans appear to have had no knowledge of iron, a metal widely used in the "Old World," and easily made from raw materials abundant in Central America. It is difficult to believe that "Jews" who supposedly established culture in the "New World" would not have used iron, which they knew about at an early period (Job 28:2). There simply is no trace of any specific "Jewish" influence; nor is there anything precisely traceable to European Christian culture. Furthermore, the so-called Lost Tribes would have been composed of those who were *not* Judeans, or Jews, and in some cases were anti-Judeans. They would not, therefore, be spreaders of Judaism and Judean culture but of the distinctive Hebrew and Israelite religion and culture. In reality, there were no "Lost Tribes," as these cultures were indigenous in Canaan/Israel *before and after* the formation of the Yahwistic Judeans. As Michael Bradley says, "Having invented this great Israelite kingdom in Palestine, the [biblical] scribes and rabbis had to explain what had happened to its population, so they then had to invent the 'Lost Tribes.'"

As distressing to the Catholic Church as was the discovery of their mythos and ritual in Mexico was finding it in Asia, from the Near to Far East. In the 19th century, Catholic missionary Abbé Huc traveled to Asia, where he encountered rites and rituals startlingly similar to those of Catholicism. In his book *Christianity in China, Tartary, and Thibet*, Huc makes the following surprising statements:

The Gospel of the Christian religion, when preached successively to all the nations of the earth, excited no astonishment, for it had been everywhere prophesied, and was universally expected. A Divine Incarnation, the birth of a Man-God, was the common faith of humanity—the great dogma that under forms, more or less mysterious, appears in the oldest modes of worship, and may be traced in the most ancient religions. The Messiah, the Redeemer, promised to fallen man in the terrestrial Paradise, had been announced uninterruptedly from age to age; and the nation specially chosen to be the depository of this promise had spread hope abroad among men for centuries before its fulfillment; such was, under Providence, the result of the great revolutions which agitated the Jews, and dispersed them over all Asia and the world at large.[17]

Abbé Huc thus admitted that the basic gospel story was found "everywhere," ages ago, in the "most ancient religions." Fortunately, Huc was honest enough to acknowledge the profound correspondences between Christianity and this pre-Christian worship he discovered, which proved the unoriginality of Christianity. In order to explain these similarities, which were profound and not casual, Huc asserted that "agitated Jews" spread the fables, and he then put forth the claim made repeatedly by apologists over the ages, i.e., that these tales constituted prophecy fulfilled in Christ:

When the Christ appeared, it was not only in Judea, among the Hebrews, that he was looked for; he was expected also at Rome, among the Goths and Scandinavians, in India, in China, in High Asia especially, where almost all religious systems are founded on the dogma of a Divine Incarnation. Long before the coming of the Messiah, a reconciliation of man with a Saviour, a King of righteousness and peace, had been announced throughout the world. This expectation is often mentioned in the Puranas, the mythological books of India.[18]

This paragraph is extremely revealing; yet, what is not disclosed is that in "High Asia," this Divine Incarnation *had already arrived*, several times in fact, as the many Buddhas and incarnations of Indian gods, such as Krishna. Moreover, a Christian missionary pronouncing the sacred scriptures of another culture's "mythological books," while evidently maintaining his own to be the "historical Word of God," represents propaganda and the puerile game of "my god is bigger and better than yours."

Concerning the resemblances between Buddhism and Christianity, Huc remarks:

Those who have studied the system of Buddhism in Upper Asia, have been often struck with the analogy, in many points, between its doctrines, moral precepts, and liturgy, and those of

Christian Churches. Unbelievers have exulted at these resemblances, and have inferred immediately that Christianity was copied from the religious systems of India and China.[19]

Again, basic biblical stories and doctrines were found widespread in these vast and isolated regions, established long prior to the arrival of Christian missionaries. The missionary Huc, a pious man no doubt terrified of what would and eventually did happen to him—excommunication—could not admit to Christian plagiarism, and thus sought to establish the opposite reason for why "Christianity" or the basic mythos and ritual was discovered in Asian countries, before missionaries had arrived there. Hence, he claimed that the "descendants of Noah," having spread out from Judea centuries before the Christian era, were accountable for the correspondences.

Thus, in order to explain Christianity's status as a johnny-come-lately Redeemer religion, its advocates hid behind the pretense that it was "prophesied," a clever way of avoiding the charge of plagiarism that would hound it for almost two millennia. In the final analysis, the idea that a particular people was "chosen" to bring "the hope" of this Redeemer religion to the ignorant masses represents cultural bigotry and supremacy. The fact is that the most salient concepts within Christianity have existed in numerous other cultures; they have been, in reality, the reigning religious ideas, such that they were already well known to a large percentage of people, long before the Judeo-Christian creators decided to "fulfill prophecy" by pretending that the Redeemer had arrived in their country as one of their own people.

In any event, after providing details of the Indian "Kali Yuga" or "Age of Iron," Missionary Huc further relates the following fascinating and germane prophecy from an Indian poem called "Barta-Sastra," in which a sage addresses the "Darma Raja," one of the India's greatest kings:

> "Then shall be born a Brahmin, in the city of Sambhala. This shall be the Vishnu Yesu; he shall possess the Divine Scriptures and all the sciences, without having employed to learn them as much time as it takes to pronounce a single word. That is why he shall be called the *Sarva Buddha*—he who knows in perfection all things. Then this Vishnu Yesu, conversing with the race of man, shall purge the earth of sinners (which would be impossible to any other than him), and shall cause truth and justice to reign upon it; and shall offer the sacrifice of the horse, and shall subject the universe to Buddha. Nevertheless, when he shall have attained old age, he shall withdraw into the Desert to do penance; and this is the order that the Vishnu Yesu shall establish among men. He shall establish virtue and truth in the

midst of the Brahmins, and restore the four Castes within the limits of their law. Then the first age will be restored. The Supreme King will render the sacrifice so common to all nations, that even the wilderness shall not be deprived of it. The Brahmins, established in virtue, shall employ themselves only in the ceremonies of religion and sacrifice; they shall cause penitence, and other virtues, which follow in the train of truth, to flourish; and they shall spread abroad the splendour of the Holy Scriptures. The seasons shall succeed each other in an invariable order; the rain in due time shall inundate the fields, the harvest in due time shall pour forth abundance. Milk shall flow at the pleasure of those who desire it; the earth, as in the first age, shall be intoxicated with joy and prosperity, and all the nations shall taste of ineffable delights." (*Kaly-Younga* and *Krita-Younga* of the Hindoos.)

Whilst the Indian poet Maricandeya sung thus on the banks of the Ganges, Virgil [70-19 BCE] was making the shores of Tiber resound with nearly the same strain.[20]

These assertions by the pious Huc are more than intriguing: Especially astonishing is the name of the divine incarnation as "Vishnu *Yesu*," prior to the alleged advent of Jesus or *Yeshua*. Yet, this Indian "prophecy" shows no sign of influence by Judaic thought; indeed, it is purely Indian. Born to a Brahmin in Shambala, "Yesu" shall be called "Sarva Buddha" and will offer the sacrifice of the horse, as well as subject the universe to Buddha? Ages and castes? These concepts are neither Jewish nor Christian. Moreover, Christ certainly did not "attain to an old age," unless we accept the contentions of certain early Christians, against the received gospel story, or unless 30-33 years old is to be considered "old age." Also, it is enlightening that Vishnu (Krishna), Yesu (Jesus) and Buddha are identified with each other in this pre-Christian "prophecy."

In addition to the "devil" and "Noah" excuses, to explain these various startling discoveries of not only Huc but also many other travelers, beginning just centuries into the Christian era, the Church further claimed they were the result of the proselytizing efforts of apostles, a "monstrous assumption," as Inman calls it. Inman also says, "But it seems more probable that the Romanists, who are known to have adopted almost every ceremony, symbol, doctrine, and the like, have unknowingly copied from travelled Orientals..." One tale claims that "St. Thomas" had gone to India, where he preached the gospel. Concerning the Thomas tale, Huc writes, "They ground this belief on the Chaldean books that have been found in India." The abbé then cites the "Breviary of the church of Malabar," which relates the deeds of "St. Thomas" in preaching about the "Father, Son, and Holy Ghost." What was dismaying to the Christians who

discovered these Indian followers of "St. Thomas" was the absence of worship and mention of Christ, as well as the reverence for Thomas, in his stead. As Huc also relates:

> In the same Chaldean service for St. Thomas's day, is found the following anthem:

> "The Indians, the Chinese, the Persians, and the other *insular people*...offer their adorations to your holy name in commemoration of St. Thomas."[21]

In the respected British studies of the 18th and 19th centuries, *Asiatic Researches*, Christian scholar Col. Wilford observes that "the *Christians* of St. THOMAS are considered as *Baudd'hists* [Buddhists] in the *Dekhi* [Deccan], and either their divine legislator, or his apostle THOMAS, is asserted to be a form of BUDDHA."[22] This story is very slippery, in that it is apparent the "divine legislator" was *not* Jesus Christ but "Thomas" himself, who is equivalent to Buddha and is not an "apostle." The indication that the "St. Thomas Christians" had never heard of Christ and did not worship him but *Thomas* is further verified by Wilford:

> It is...very possible that [the Hindus] should have considered the Apostle and disciple, who first preached the Gospel in *India*, as a form of Christ, or as Christ himself, after several centuries had elapsed...[23]

This justification, i.e., apostles spreading the word, has been used abundantly by those who cannot explain why the basic gospel story appears in the mythologies of other nations. The fact is, however, that Thomas, "like all the rest of the heroes of the gospel," is a character not found in history;[24] hence, he could not be responsible for these tales.

The coast of Malabar, where these "St. Thomas Christians" purportedly thrived, was reported by Arabian travelers to have been governed by the most powerful race of Hindu kings in all of India.[25] It is impossible to believe that a sole, wandering and impoverished zealot from the West, such as "St. Thomas," could have any impact upon such a kingdom, particularly in light of the fact that much of India already possessed similar beliefs and quite a bit more knowledge and wisdom than any "apostle" could bring with him. In reality, even so long as 2500 years ago, by conservative estimates, Western seekers were traveling *to* India to gain knowledge and wisdom.

It appears that the "St. Thomas Christian congregation" at Malabar and elsewhere was *pre-Christian*, revolving around a *god* named Tamus or Tamas, centuries or millennia before the common era. In fact, the sun was worshipped for hundreds to thousands of years as Dumuzi, Tammuz, Tem,[26] Tum, Tmu, etc.

The Syrian Tammuz, whose name means "abstruse" or "concealed,"[27] was a dying and resurrecting savior god—the same entity "prophesied," i.e., extant in many areas around the globe, centuries prior to the Christian era, including the very area where Christianity is said to have sprung up. As the pious Christian Jacob Bryant relates:

> The Canaanites, as they were a sister tribe of the Mizraim [Egyptians], so were they extremely like them in their rites and religion. They held a heifer, or cow, in high veneration, agreeably to the customs of Egypt. Their chief Deity was the Sun, whom they worshipped together with the Baalim, under the titles of Ourchol, Adonis, Thammuz...who was the same as Thamas, and Osiris of Egypt.[28]

In his *Hindu Pantheon* the missionary Major Moor, in discussing the mystical Indian male principle *Narayana*, declares that it was "wholly surrounded in the beginning by *Tamas*, or *darkness*." This darkness, evidently personified as "Tamas," was comparable to the Greek chaos or "primordial night," possibly also the same as "*Thaumaz*, or *Thamas*, of the ancient *Egyptians*."[29]

According to Strong's Concordance, the biblical word "Thomas" is derived from the Aramaic, which in turn is from the Semitic root *ta'am*, meaning "twin" or, as in Parkhurst's Lexicon, "dark." In the Sanskrit dictionary, "tamas," "tamasa" or "taamasa" means "darkness, inertia, ignorance."[30] Another word for "dark" in Sanskrit is "krsna" or *krishna*, which is also the name of "a kind of demon or spirit of darkness."[31]

Concerning Thomas/Tamas, in his *Anacalypsis* Godfrey Higgins shows that ancient India was at some point and place called the "Promontory of Tamus," and that Tamus/Tamas or other variant of "Tam" was an epithet of the sun (as well as of "Buddha") during the equinoctial Age of Gemini. The Indian "Thomas" followers with the Chaldean texts are most certainly related to the Syriac-Hebrew Tammuz worshippers, and were not "Christians" until the Portuguese discovered them and through persecution forced Christianity upon them.

In another instance of pre-Christian "prophecy" needing to be explained away, the popular Roman poet Virgil (70 BCE-19 CE) described the future Messiah and Savior in his *Eclogues*, years before the appearance of the Christian savior. Hence, a large percentage of the inhabitants of the Roman Empire were already aware of the concept that would later be falsely affixed into history.

In any case, the charge is laid in the opposite direction that Christianity "borrowed" or, rather, *plagiarized* its rites and then falsely presented them as "divine revelation," utterly different

from, and far superior to, those of Paganism. This charge of "borrowing" by Christianity from Paganism is not new and was raised by non-Christians from the beginning of the true era of Christian germination, i.e., the second and third centuries. One of the early critics of Christianity was Celsus (fl. 180), the witty philosopher who observed that Christianity was a "degraded kind of Platonism, and that what is reasonable in it is filched from the Greek philosopher." Naturally, the Christians retaliated that Paganism had "borrowed or stolen its doctrines from the Scriptures." Hence, the "alleged borrowing of rites, a familiar weapon of modern rationalism, was bandied to and fro, and the Fathers explained similarities by the supposition that the Devil had inspired parodies of the sacraments."[32]

The evidence of this charge can be found abundantly enough in the writings of the Church fathers, who merely denied it, unconvincingly but with the same vitriol and fervor of modern apologists. Such fervent attempts have worked thus far in keeping the masses unaware of the debate, as has the destruction and non-translation of texts. Fortunately, although his original works were destroyed, Celsus had his arguments preserved in the work of his main detractor, zealous Church father Origen, who, oddly enough, eventually abandoned orthodox Christianity in disgust. Originally written about 178 CE and recently restored by R. Joseph Hoffman, Celsus's *True Doctrine* employs every argument conceivable to demonstrate the unoriginality and irrationality of the Christian founder and doctrine. It is very evident that Celsus's incisive and surprisingly modernistic work was highly damaging to the fledging Christian organization, such that tremendous efforts were required to suppress it and remove its reason from the human mind. In addition to viewing Judaism as a "plagiarizing religion," Celsus tore into its offspring, which he called a "monstrous fiction." Celsus's beef with the gospel story included its depiction of an omnipotent and perfect god needing to lower himself to such a beggarly and revolting state in order to "fix" (in some grotesque and nonsensical manner) a creation he had made badly in the first place.

"The cult of Christianity is a secret society whose members huddle together in corners," begins Celsus. He then continues with the arguments mentioned above, including that nearly everything of Christianity can be found within Paganism. These correspondences he lists in detail, mentioning Pagan god after god who came before the Christian miracleworker but who were essentially identical in germane characteristics or who were more powerful overall. Says Celsus, "Clearly the Christians have used the myths of the Danae and the Melanippe, or of the Auge and the Antiope in fabricating the story of Jesus' virgin birth."[33]

After thus critiquing Christianity in a thorough manner, Celsus also says, "Nor is it really likely that the Jews are God's chosen people and are loved more than other folk, or that the angels are sent only to them—as though they had been given some land set aside just for themselves. We can see what sort of land it is that God thought worthy of them! And we see what sort of people inhabit it!"[34] As can be seen, so-called modern criticisms of Judeo-Christianity have existed from the beginning of the Christian era.

The Bible As History—Not!

The reality is that the basic gospel tale and numerous other major biblical stories are found in a variety of cultures, before the Christian and Jewish eras. The reason for this scenario is not because the same "history" played out over and over again in various ages and places, like some bizarre and bloody film loop, but because these stories are myths that reflect natural, recurrent phenomena perceivable worldwide. Modern science and scholarship, based on numerous archaeological discoveries, biblical criticism and comparative mythology, have shown that the Bible is in large part myth. Included in the most recent developments is the work of Israeli archaeologists Ze'ev Herzog and Israel Finkelstein, both of Tel Aviv University, the latter co-author with Neil Asher Silberman of *The Bible Unearthed*. Also holding down the fort of biblical criticism formerly occupied by the German and English is the Danish school, including Thomas Thompson, author of *The Mythic Past: Biblical Archaeology and the Myth of Israel*. This fact of biblical non-historicity has been known for centuries, however, and was particularly revealed in the 19th century. One of these 19th-century scholars was Dr. Inman, who wrote:

> We have demonstrated, as far as such a matter is capable of demonstration, that the Old Testament, which has descended to us from the Jews, is not the mine of truth which it has been supposed by so many to be: that not only it is not a revelation given by God to man, but that it is founded upon ideas of the Almighty which are contradicted by the whole of animate and inanimate nature. We showed that its composition was wholly of human origin, and that its authors had a very mean and degrading notion of the Lord of Heaven and Earth. We proved, what indeed [Bishop] Colenso [1814-1883] and a host of German critics have demonstrated in another fashion, that its historical portions are not to be depended upon; that its stories are of no more real value than so many fairy tales or national legends; that its myths can now be readily traced to Grecian, Babylonian, and Persian sources; that its miracles are as apocryphal as those told of Vishnu and Siva; and its prophecies absolutely worthless. We

proved, moreover, that the remote antiquity of its authorship has
been greatly exaggerated; that the stories of the creation, of the
flood, of Abraham, of Jacob, of the descent into, and the exodus
from, Egypt, of the career of Moses and the Jews in the desert, of
Joshua and his soldiers, of the judges and their clients, are all
apocryphal, and were fabricated at a late period of Jewish
history...; that the so-called Mosaic laws were not known until
long after the time of David... We showed that the Jewish
conception of the Almighty, and of His heavenly host, did not
materially differ from the Greek idea of Jupiter and his inferior
deities... We called attention to the apparently utter ignorance of
the Jews that certain laws of nature existed, and of their
consequent belief that defeat, disease, famine, slaughter,
pestilence, and the like, were direct punishments of ceremonial
or other guilt; while victory, wealth, virility, and old age were
special and decided proofs of Divine favour. We showed that the
Jews were, in general, an abject but very boastful race, and their
spiritual guides—the so-called prophets—were constantly
promising, but always vainly, a striking manifestation of the
Almighty's power in favour of the Hebrews...that histories were
fabricated to give colour to these statements... we showed,
moreover, that the race was imitative and readily adopted the
religious ideas and practices of those who conquered them.... In
fine, we showed that the Hebrews could not sustain the claim
they made to be the especial people of God, and that their
writings are of no more value, as records of absolute truth, or of
Divine revelation, than the books of the Greeks, Persians,
Egyptians, Hindoos, Chinese or the more modern Mahometans.[35]

As we can see, over a century ago what is just being exposed
to the public was already known, in detail, and was accurately
summarized, even without the benefit of modern archaeological
discoveries. Concerning biblical imposture, Inman further
observes:

...according to what is known as Mosaic law, it was a crime
punishable by a lingering death to gather sticks on a Sabbath
day (Num. 15:32-36); but it was no crime to kill all the males
and women of a whole nation, and retain the maidens for private
prostitution and for the use of the priest (Num. 31: 17, 18, 40,
41). In such a nation it was no crime to commit forgery—and of
all the bearers of false witness, none exceeded in ancient times
the Jewish writers in the Bible—but in mercantile England, the
former has been at one time punished with death, and the latter
by ignominious penalties.[36]

The sentiments expressed by Inman and so many others
during the 19th century came on the heels of the higher biblical
criticism that so handily exposed the mythical nature of biblical
texts. Indeed, the cacophony concerning the Bible, a book
violently compelled upon Europeans for centuries, was loud and

nearly universal at that time. It is clear that these critics, who included freethinkers, Christians and Jews alike, upon discovering that they had been duped, understandably became angry. Instead of junking the old, cruel, bogus and bigoted system, and creating a new and improved ethic, however, the vested interests regrouped and fired back, with the result that critics were stifled and the scholarship subsequent to WWII did not approach that of the previous two centuries. The ridicule, by those who believed the ridiculous, and the economic pressure, by those who held the purse strings, won out. It is also apparent that the educational system was intentionally dumbed down.

The Importance of Myth

Part of this "dumbing down" has included the disparagement of myth, a derogation that explains the intense resistance to the facts presented by mythicists, due to the term "myth" being widely misunderstood as dismissive. Regarding the meaning of myth and its current derision, Gerald Massey states:

> In modern phraseology a statement is sometimes said to be mythical in proportion to its being untrue; but the ancient mythology was not a system or mode of falsifying in that sense. Its fables were the means of conveying facts; they were neither forgeries nor fictions. Nor did mythology originate in any intentional double-dealing whatever, although it did assume an aspect of duality when direct expression had succeeded the primitive mode of representation by means of things as signs and symbols.[37]

This misconception has been part of an evidently deliberate attempt to belittle the ancient gods as nothing but "mere" myths, while raising up the Judeo-Christian god, savior, etc., as the "real thing." Myths are not, however, mere meaningless mumbo-jumbo. Myths have meaning and purpose, so much so as to contribute copiously to cultural development worldwide for thousands of years: "Every myth is the product of reality, but this reality is not a historical event, it is a cultural reality."[38]

In "The Great Myth of the Sun-Gods," Dr. Alvin Boyd Kuhn remarked that myth was a special means by which spiritual truth could be conveyed, making it more memorable because of its dramatic presentation:

> The myth would enhance spiritual truth as a drama reinforces moral presentation. It was all the more powerful in its message precisely because it was known not to be outwardly a true story. No one was caught by the literal falsity of the construction.[39]

In *The Jesus Mysteries*, Freke and Gandy describe myth thus:

> In antiquity the word *mythos* did not mean something "untrue,"
> as it does for us today. Superficially a myth was an entertaining
> story, but to the initiated it was a sacred code that contained a
> profound spiritual teaching.[40]

As we shall see, myth is highly profound and has played an
enormous role in human culture, forming the basis of its most
cherished religions. In particular, these religions have been
founded upon astromythology or astrotheology and nature
worship.

As can also be seen, and as is the case with *The Christ
Conspiracy*, which is necessarily forceful in order to dislodge
unhealthy and obdurate memes or mental programmings from
the mass human psyche, there is some editorializing in this book.
Some people find such editorializing disturbing; others feel it is a
refreshing tonic. These books are not only scholarly but also
visionary, in that they are attempting both to provide vital
information and to produce a broadening of human thought and
a greater joy in human experience.

Before the reader enters into a brave new world, she or he
may wish to ask her or himself: Do you truly want to continue to
have religious "enemies?" Do you wish to think of your friends,
family members and neighbors, who may not believe as you do,
as being "lost," "infidel" or "evil," and to live in suspicion and fear
of them? Or feeling superior to them? Would it not be more
pleasant and refreshing to know that, behind mythological and
fantastical accretions, your beliefs and morals are essentially the
same as those of your so-called adversaries? That most of us are
human beings trying to manage and make sense of the world the
best we can? That we are, in fact, one family sharing one home?
In reality, the study of the origin of religion demonstrates that,
despite the obvious divisiveness of modern religions, many
cultures worldwide share a common heritage, one more
fascinating and wondrous than has been perceived or depicted
over the past few millennia. It is to this engrossing and shared
inheritance that we shall now turn, with a mind to understanding
our past and progressing into our future.

[1] Müller, *LOGR*, 90.
[2] Dupuis, 305-306.
[3] Inman, *AFM*, 44-46.
[4] Inman, *AFM*, xii.
[5] www.newadvent.org/cathen/11388a.htm
[6] www.newadvent.org/cathen/11388a.htm
[7] Halliday, 3.
[8] Every, 15-16.

9 Dupuis, 309.
10 Cassels, 189.
11 Hoffmann, *PAC*, 72.
12 Spence, *MMP*, 59.
13 Inman, *AFM*, 31-32.
14 Spence, *MMP*, 107-108.
15 Spence, *MMP*, 115.
16 Inman, *AFM*, 37-39.
17 Huc, I, 1-2.
18 Huc, I, 3-4.
19 Huc, I, 32.
20 Huc, I, 4-5.
21 Huc, I, 29.
22 Jones, *AR*, X, 92.
23 Jones, *AR*, X, 121.
24 Taylor, *DP*, 183.
25 Jones, *AR*, I, 146.
26 Spence, *AEML*, 17
27 Taylor, *DP*, 185fn.
28 Bryant, I, 371-372.
29 Moor (1810), 385.
30 sanskrit.gde.to/dict/
31 www.uni-koeln.de/phil-fak/indologie/tamil/mwd_search.html
32 Halliday, 9.
33 Hoffmann, *CTD*, 57.
34 Hoffmann, *CTD*, 89.
35 Inman, *AFM*, 4-6.
36 Inman, *AFM*, 416.
37 Massey, *GML*, 166.
38 Dujardin, 11.
39 tridaho.com/kuhn/abksungods.htm
40 Freke and Gandy, 21.

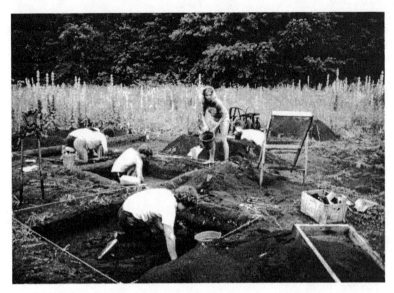

The author excavating a Paleo-Indian site c. 3,000 years old,
Connecticut

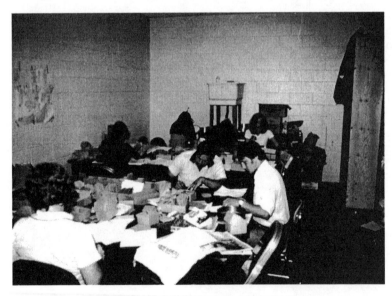

The author in the lab processing the finds from the
excavation in Connecticut

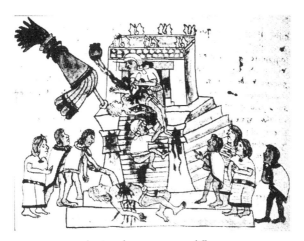

Aztec human sacrifice

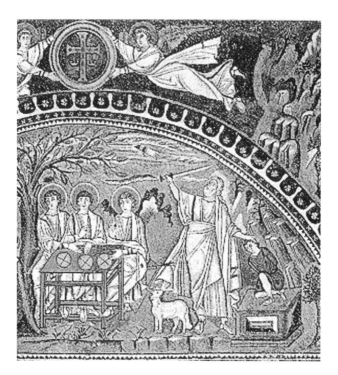

Christian depiction of Abraham about to sacrifice
the boy Isaac, 6th century, Ravenna, Italy.

Astrotheology of the Ancients

At Stonehenge in England and Carnac in France, in Egypt and Yucatán, across the whole face of the earth are found mysterious ruins of ancient monuments, monuments with astronomical significance. These relics of other times are as accessible as the American Midwest and as remote as the jungles of Guatemala. Some of them were built according to celestial alignments; others were actually precision astronomical observatories... Careful observation of the celestial rhythms was compellingly important to early peoples, and their expertise, in some respects, was not equaled in Europe until three thousand years later.

Dr. Edwin C. Krupp, *In Search of Ancient Astronomies*

From these stories of the stars originated the angels of the Jews, the genii of the Arabs, the heroes of the Greeks, and the saints of the Romish Church.

W. Winword Reade, *The Veil of Isis; Or, Mysteries of the Druids*

The further one regresses in time, the more obvious it becomes that the principal and singular religious worship found around the globe has revolved around nature. This nature worship has included reverence not only for the earth, its creatures and their fecundity, but also for the sun, moon, planets and stars. For many thousands of years, man has looked to the skies and become awestruck by what he has observed. This awe has led to the reverence and worship both of the night and day skies, an adoration called "astrotheology." While fertility worship has constituted an important and prevalent part of the human religion, little has astonished humankind more than the sky, with its enormous, blazing, white day orb in the azure expanse, and with its infinite, twinkling, black night dome. So fascinated by the sky, or heavens, has been man that he has created entire religions, with organized priesthoods, complex rituals and massive edifices, in order to tell its story.

The story begins, as far back as the current evidence reveals, with the night sky as the primary focus of pre-agricultural, nomadic peoples. The night sky held particular importance in the lives of desert nomads, because the fiery sun was a hindrance to them, while the cool night allowed them to travel. In traveling by night, these desert nomads became keenly aware of the night sky's various landmarks, including the stars, planets and moon. The nomads noticed regularity and began to chart the skies, hoping to divine omens, portents and signs. Others who developed this astronomical science included ancient mariners who journeyed thousands of miles through the open seas, such as the Polynesians, whose long, Pacific voyages have been estimated to have begun at least 30,000 years ago. The

astronomical science allowed the ancients to predict weather patterns, the turn of seasons and attendant climate changes, as well as comets, asteroids and meteors menacing the earth. This *archaeoastronomy* was an accurate prognosticator for daily, weekly, monthly and yearly events. Indeed, it was an augur for the changes of entire ages, some of which, as in the chronologies of the Maya, Babylonians and Hindus, extend back hundreds of thousands or millions of years.

Determining the archaeoastronomy requires the use of astronomy, archaeology, ethnography and other sciences to study legends, texts, artifacts and architectural remains. Such fascinating relics include rock paintings, megalithic structures, calendars and medicine wheels. Cultural remains and ruins globally demonstrate the ancients' interest in and knowledge of "the complex regularity of the motions of the sun, moon, and stars and...unusual occurrences such as the appearance of a nova or comet in the sky."[1]

In recent years, a great number of such ruins on all inhabited continents have been discovered that possess astronomical alignments, whether to the sun, moon, planets or constellations. For example, in 1998 it was reported that the "oldest astronomical megalith alignment" was discovered in Southern Egypt:

> An assembly of huge stone slabs found in Egypt's Sahara Desert that date from about 6,500 years to 6,000 years ago has been confirmed by scientists to be the oldest known astronomical alignment of megaliths in the world.[2]

Interestingly, buried around this structure were cattle, while the date of the "temple" corresponds to the precessional Age of Taurus the Bull, some 6500 to 4300 years ago. Part of the structure is aligned with the summer solstice, a common occurrence with megaliths by mainly sun-worshipping cultures. Belonging to the "Nabta" culture, this ruin raises questions about whether or not the high Egyptian culture was developed elsewhere, such as Mesopotamia and Syria, or was derived from the "indigenous" Nabta or others. As concerns the antiquity of these ruins, renegade researchers and archaeologists have consistently placed other astronomical megaliths such as those at the Andean site of Tiahuanaco thousands of years earlier than the mainstream perspective.

Moreover, in an article dated April 5, 2004, entitled "Ancient Tombs and Shrines Face Sun and Stars," Tariq Malik reports: "The orientation of Neolithic tombs erected across Europe and Africa around 10,000 B.C. were apparently built to face the rising sun, securing the sun's importance in various human cultures across three countries, two continents and the Mediterranean

islands," according to Michael Hoskin, an English historian of astronomy. Hoskin has also catalogued numerous Bronze Age sanctuaries also astronomically oriented.

That ancient peoples, including those thought to be "primitive," possessed this impressive knowledge, which required precise geometrical capacity as well as astronomical expertise, is a fact. That they went to extraordinary lengths to encapsulate and memorialize it is also a fact. Another fact is that the depth of inspiration and passion reflected by these remains is indicative of the ancients' astrotheological *religious* tendencies.

The astronomical science of the ancients is the same used today to determine full moons, eclipses, conjunctions and other cosmic events both past and future. It is because of the ancient study that we have this capability today, although our abilities are just beginning to catch up to the archaeoastronomy of such peoples as the Maya and their forebears. This regression and loss of knowledge is due to cataclysm and destruction of human culture. Yet, the basics of this important knowledge were preserved because the ancients used myths as mnemonic devices passed along from generation to generation. This tradition was especially important during the thousands of years when writing was either non-existent or limited. Unfortunately, the *key* to this knowledge was nevertheless often lost, as the myths became believed as "historical fact."

In order to create this mythology, the ancients animated the celestial luminaries and natural forces, identifying them with animals and other mundane objects, eventually personifying them as "gods." These gods, as creators, preservers and destroyers of the cosmos, needed to be appeased, it was believed, so they would not wreak havoc upon Earth. Thus was born the religion of *astrotheology.*

In *Prehistoric Lunar Astronomy*, Indian scholar S.B. Roy describes and contrasts with today's "cold astronomy" the ancient astrotheology in all its splendor, in particular pertaining to its development in India, where some of the oldest known culture may be found:

> Astronomy is a cold concept today—a cold science which means the knowledge of the movement of the inert (lifeless) masses moving in a lifeless sky. In the ancient prehistoric days, it was otherwise.
>
> To the ancients...heaven was the land of gods and mystery. The sky—the Dyaus of the Rig Veda—was itself living. The stars were the abode of the gods. The shining stars were indeed themselves luminous gods. Astronomy was the knowledge not of heavenly bodies, but of heavenly *beings*: It was the heavenly, celestial,

cosmic or divine knowledge—knowledge of *devas*—the bright luminous gods.[3]

Astronomical or astrotheological knowledge reaches back to the dawn of humanity, appearing widespread and becoming highly developed over a period of millennia. In its entry on "Astrology," the Catholic Encyclopedia describes the development of this archaic science in the ancient world:

> The history of astrology is an important part of the history of the development of civilization, it goes back to the early days of the human race.... Astrology was...the foster-sister of astronomy, the science of the investigation of the heavens.... According to the belief of the early civilized races of the East, the stars were the source and at the same time the heralds of everything that happened, and the right to study the "godlike science" of astrology was a privilege of the priesthood. This was the case in Mesopotamia and Egypt, the oldest centres of civilization known to us in the East. The most ancient dwellers on the Euphrates, the Akkado-Sumerians, were believers in judicial astrology, which was closely interwoven with their worship of the stars. The same is true of their successors, the Babylonians and Assyrians, who were the chief exponents of astrology in antiquity.... The Assyro-Babylonian priests (Chaldeans) were the professional astrologers of classical antiquity. In its origin Chaldaic astrology also goes back to the worship of stars; this is proved by the religious symbolism of the most ancient cuneiform texts of the zodiac. The oldest astrological document extant is the work called "Namar-Beli" (Illumination of Bel) composed for King Sargon I (end of the third millennium B.C.) and contained in the cuneiform library of King Asurbanipal (668-626 B.C.).... Even in the time of Chaldean, which should be called Assyrian, astrology, the five planets, together with the sun and moon, were divided according to their character and their position in the zodiac as well as according to their position in the twelve houses. As star of the sun, Saturn was the great planet and ruler of the heavens.... The Egyptians and Hindus were as zealous astrologers as the nations on the Euphrates and Tigris. The dependence of the early Egyptian star (sun) worship (the basis of the worship of Osiris) upon early Chaldaic influences belongs to the still unsettled question of the origin of early Egyptian civilization.[4]

Thus, astrology—a "godlike science"—dates back thousands of years and has been an important part of human civilization. According to mainstream archaeology, the oldest extant text specifically addressing "astrology" dates from the 3rd millennium BCE; yet, the astrological religion or astrotheology is recorded abundantly in Indian, Egyptian and Sumerian sacred literature as well, some of which represents traditions much older than the third millennium. Also, as noted, megalithic ruins push

astronomical knowledge back at least 6,000 to 6,500 years ago, while ancient mariners reveal such knowledge dating to 30,000 or more years ago.

In *The Roots of Civilization,* archaeologist Alexander Marshack discusses "calendar sticks," or ancient bones with markings that Marshack determined represented lunar calendars, dating to at least 25,000 or 35,000 years ago. One of these artifacts is the "Ishango bone" discovered at Lake Edward in Zaire, and possibly dating to 18,000-23,000 BCE. Marshack found other such bones, from the Upper Paleolithic (30,000-10,000 BCE) or Aurignacian culture. Marshack's contention that they are lunar calendars is not "set in stone," but there is more than good reason to assume it to be accurate. In his book *In Search of Ancient Astronomies,* astronomer and past-director of Los Angeles's Griffith Observatory, Dr. Edwin Krupp, relates:

> The Blanchard bone, a small piece of bone found in the Dordogne region of France inscribed by some Cro-Magnon individual about twenty thousand years ago, has a complicated pattern of marks. The shapes of the marks vary, and the sequence curves around in a serpentine pattern. In Marshack's view the turns in the sequence represent, on one side, the times of dark, new moon, and on the other, bright full moon. Statistical analyses may not support Marshack's interpretations, but similar batons and sticks are carved for the same purpose by the Nicobar Islanders in the Bay of Bengal.[5]

At the very least, these bones demonstrate that the ancients knew how to count, to a certain point. The thesis that these bone markings also reflect the "moons" or menstrual periods of women is likewise sound; hence, it has been suggested, women were the "first mathematicians." One of these women is represented on an 18-inch bas-relief called the "Venus of Laussel," an image dating to the Aurignacian era, some 21,000 years ago. Originally painted in red ochre, suggesting menstrual blood, the Venus holds a curved bison horn with 13 notches, which represent the crescent moon and, apparently, the "Universal Vulva," along with the annual lunar months and women's menses.[6] Significantly, the average menstrual cycle is 29.5 days, the same as the lunar month; hence, the two are intimately connected. In all probability, it was women's observations of their menses that led to timekeeping.[7] Another factor in the development of astronomy was the need for hunters to know the lunar cycle, so they could plan their hunt, based on the waxing or waning of the moon.

In the famous caves of Lascaux in France have been discovered star maps that date to 16,500 years ago and, according to Dr. Michael Rappenglueck of the University of Munich, record the Pleiades, or "Seven Sisters," as well as the

"Summer Triangle," composed of the three stars Vega, Deneb and Altair. A 14,000-year-old star map recording the Northern Constellation was also found in the Cueva di El Castillo in Spain. The art of the ancients in such places as Lascaux and Alta Mira, Spain, dating to the Paleolithic (17,000+ Before Present), or Adduara, Sicily (15,000-10,000 BCE), shows a high degree of intelligence, comparable to that of humans today. In discussing the ancients it should be kept in mind that, despite the impression given by strict, linear-evolutionary thinking, humans at least 100,000 years ago (a number that keeps being pushed back) possessed the identical cranial capacity as they do today. Instead of a bunch of grunting ape-men, there were likely individuals among them with IQ's similar to modern geniuses. It is probable that, as today, there were human beings living in varying states of "civilization," with some prehistoric humans wearing rough skins and living in caves, while other early humans created more advanced culture.

Also, as concerns language and complex abstract concepts, it would seem that the ancients arrived at eloquence of speech and thought much earlier than has been suspected within mainstream science. A language such as Sanskrit, for example, represents the pinnacle of thousands of years of refinement, comparable in art to the progression from finger-painting to expert execution. Furthermore, languages can change quickly over a period of centuries, and it is likely that many languages now extinct existed in very ancient prehistoric times. Each "tribe" or grouping had its own words for local plants and animals that would create a distinct dialect, and no one can honestly say that other languages prior to Sanskrit did not attain as glorious a height. Surely, ancient humans of 100,000 years ago, some of them doubtlessly possessing genius IQ's, were not content with merely mumbling and grunting. And, certainly, they were not satisfied to live in caves, uncreatively struggling simply for survival. One thing these "primitives" *were* doing was studying the spectacular nature all around them, including the wondrous and awesome skies.

As stated, in the earliest known times the ancients were "moon-worshippers," or lunar cultists, a reflection of their pre-agricultural status. With the presence of geniuses among them, it would have been possible for the ancient peoples to develop agriculture, long prior to the current accepted timeframe of 10,000-12,000 years ago. However, it is apparent that many areas in which these earlier humans congregated are now underwater, and evidence of any agriculture practiced in these areas would thus be long lost. In any event, it was the moon, not the sun, that served as the first known chronometer or time-

measurer. In other words, time was divided into "moonths," each
one beginning on the new moon. Again, the horn in the
prehistoric "Venus" images represents the phase of the new moon
or the vanishing (crescent) moon.[8]

Interesting correspondences between the Venus of Laussel
and Indian/Near Eastern mythology may be found in ancient
Indian/Vedic texts, as revealed by Roy:

> In Vedic and the post-vedic literature, which carries the memory
> of the hoary forgotten tradition, the cusp and the half-crescent of
> moon is the emblem of the mother goddess: In *Candi*...the Bible
> of the Mother-worshippers of India, it is said:

> "*NAMAH SOMARDHA*-DHARINE'—we bow to the Mother who
> holdeth the half moon."

> It is strange how the figure of the mother goddess depicted in the
> French caves in 20,000 B.C. finds its reflection in an Indian
> Sanskrit text....

> The mother goddess is known by different names in different
> countries. Aditi is the most ancient stratum of the Rig Veda;
> Ishtar, Ashtarte, in Semitic languages; Cybele, Nana and Anahita
> in West Asia; Venus in Rome. She is Marie in Spain, where she is
> associated with these eerie caves still haunted by the ancient
> spirits. She becomes the mother Mary, of the Christians.

> The Semitic group of words Ishtar, Ashtar, Ashtarte, originate
> from the root STR. This root "str" connotes both a female (Skt.
> stri), as well as a star. Thus, the primary mother goddess was
> the female of the stars, and obviously she had a deep connection
> with the stars....

> Finally, the mother goddess is associated with the moon in
> almost every race and culture. Her emblem is generally the
> crescent or half-crescent moon. See for instance the iconography
> of the ancient figures of Isis, Ashtarte, or Nana. Incidentally,
> Nana means naked. Nana is, therefore, the primal mother-
> goddess naked: The Laussel figure would seem to represent her
> perfectly.[9]

This enchanting mystery deepens, as Roy quotes a hymn
(1.164-45) from the ancient Indian sacred text the Rig Veda
(commenting upon it in parentheses):

> "Four are the grades of speech (*Vak, secret words of power, or the
> Logos*): Those Brahmans (i.e., magis or the knowers of the
> secrets *of the heaven and the earth*) who are wise, know them.
> *These are deposited in the secret caves*: They indicate no
> meanings (i.e., *their secrets are sealed in the caves*: Men, *i.e.,
> ordinary men who do not know them*), only know and speak the
> fourth grade."[10]

Hymn RV 1.164 also describes the "mystic Word" that "exists
in four planes, of which THREE ARE DEPOSITED IN SECRET

CAVES."[11] Roy's conclusion is that the text records a "secret wisdom" found in "dark caves and known only to initiates."[12] In the Rig Veda we possess, among other germane concepts, a very ancient discussion of the divine creative Word or Logos, dating to at least 3500 years ago.

Roy postulates that various artifacts found deep in caves, such as the painting known as "Sorcerer with the Antelope's Head" from Les Trois Freres caves in the French Pyrenees, are representative of these secret deposits. These caves were occupied during the Magdalenian period, 10,000-16,000 years ago, although Robert Graves dates the paintings to "at least 20,000 B.C."[13] Regarding possible rituals performed in these caves, some of which are very inaccessible and would therefore likely represent the place of a secret, esoteric initiation, Roy remarks that they would "necessarily be performed at a particular auspicious moment," upon which their potency would depend. This auspicious moment would be dependent on the solar and lunar phases, as well as the seasons: "The ancient wise men looked up at the heavens to ascertain the proper timing, because the Moon was the most ancient timekeeper, says Yaska [1400 BCE]..."[14] Such "auspicious moments" can be dated using these astronomical keys.

Roy posits that the antelope-headed "sorcerer" was "a figure marking the onset of a season." The reasons for this assertion include that the "remote traditions" in the Rig Veda and in Vedic astronomy relate that the Stag's head represents the star L-Orionis and the winter solstice at the new moon, as well as the summer solstice at the full moon. Roy concludes that the sorcerer figure "marked the winter solstice," which was "a great day in the Ice Age of Europe." Based on the astronomy, the figure dates to 10,600 BCE.[15] Furthermore, this stag-headed sorcerer figure is similar to solar images on seals from the Indus Valley city of Mohenjo-Daro dating to the third millennium BCE.[16]

Dating the migration of the European Magdalenian cave-dwellers to the recession of the "fourth glacial Wisconsin-Valders final sub-phase," 10,000 years ago, Roy further states:

> In Northern Europe and Asia, in latitudes of 60° and higher, where Slavonic languages now prevail, the winter was then long and dark. It was very cold. Everyone looked to the day of the winter solstice when the sun would turn North. The astronomers would know the date even though the sun itself was not visible. This was the great day, for the spring would now come.[17]

Thus, the winter solstice was an important factor in human culture, particularly that of the cold, northern latitudes, at least 12,000 years ago. The winter solstice celebration that developed

throughout much of the inhabited world has been handed down as "Christmas," i.e., December 25th, the birthday of the *sun* of God. "Christmas" is thus an extremely ancient celebration, predating the Christian era by many millennia.

With the development of agriculture, the study and importance of the moon, stars and planets gave way to that of the sun. Agriculture was significant because it enabled humans to produce their own food and provided increased time to accomplish other things, including not only other work but also artistic and creative endeavors. So significant was agriculture that it was "regarded as a meritorious act and a religious duty prescribed by Zoroaster," the ancient Persian religious figure.[18] In fact, the Persian sacred texts the Sad-der and the Avesta repeatedly depict Zoroaster as extolling agriculture as "most pleasing to God":

> "That the action most pleasing to God is to plough and cultivate the earth, to water it with running streams, to multiply vegetation and living beings, to have numerous flocks, young and fruitful virgins, a multitude of children..."[19]

For agriculturalists, or "day-sky people," the sun became the most visible symbol or proxy of divinity. Hence, man became a "sun worshipper," and sun worship has been the prevalent form of religion the world over for the past several millennia. Along with this worship or reverence came complex myths and rituals, developed over thousands of years and based not only on the annual cycle of the sun but also on the phenomenon called the precession of the equinoxes, which played a huge role in the ancient myths. Although this astrotheology of the ancients is not widely known today, it has been widespread for millennia, its virtual omnipresence evidenced in story and stone the globally. Regarding the ancient astrotheology, Count Volney observes:

> The majority of philosophers, says Porphyry, and among others Chaeremon (who lived in Egypt in the first age of Christianity), imagine there never to have been any other world than the one we see, and acknowledged no other Gods of all those recognized by the Egyptians, than such as are commonly called planets, signs of the Zodiac, and constellations; whose aspects, that is, rising and setting, are supposed to influence the fortunes of men; to which they add their divisions of the signs into decans and dispensers of time, whom they style lords of the ascendant, whose names, virtues in relieving distempers, rising, setting, and presages of future events, are the subjects of almanacs...for when *the priests affirmed that the sun was the architect of the universe*, Chaeremon presently concludes that all their narratives respecting Isis and Osiris, together with their other sacred fables, referred in part to the planets, the phases of the

moon, and the revolution of the sun, and in part to the stars of the daily and nightly hemispheres and the river Nile; in a word, in all cases to physical and natural existences and never to such as might be immaterial and incorporeal.[20]

Within the astrotheological interpretation of the cosmos, the *sun* was the "Great Architect" or God. This association, identification and interpretation have not changed in the past few millennia; rather, the solar orb was animated and obfuscated by having the face and characteristics of an animal or human of a particular ethnicity and gender placed upon it.

Moreover, although the Judeo-Christian bible asserts in Genesis that this astral science was developed by the "children of Noah," evidently meaning the "wandering shepherds" of Shinar, etc., it is clear that illiterate and uneducated "shepherds" could only have taken the science so far and that it was eventually developed not only by ancient navigators but also by organized schools and priesthoods. Astrotheology was priestcraft, along with which came the construction of temples and, thus, masonry. Furthermore, this astronomical knowledge was important for not only agriculture but also medicine, as astrology was considered a "sacred science" crucial to health. Hence, ancient religious initiates were priest and healers. As Alexander Wilder says:

> Both Galen and Hippokrates insisted that astral knowledge is essential for physicians; and Galen derided those physicians who denied the necessity for such knowledge. He went so far as to declare medical men who were ignorant of astral learning, homicides. All the medical schools of Christendom and the "Moslem" world formerly taught astrology...[21]

Despite the vilification of astrology—the definition of which is not simply "judicial astrology" or the casting of horoscopes, but the intricately detailed astrotheology or knowledge of the heavens—this "godlike science" has permeated human culture from ancient times and ideologies to modern eras and theologies.

The Gods Revealed

The subject of what or who were the ancient gods has been the focus of much serious debate and wild speculation over the centuries. The reality is that the ancient gods were mainly astrotheological and/or based on natural, earthly forces. This fact is attested by numerous authorities over the millennia, including ancient writers reflecting upon their own religions and those of other known cultures. As related by respected Christian scholar Prof. Max Müller, the ancient authorities who knew that the gods were astronomical, i.e., the sun, moon, stars and planets, and elemental, i.e., water, fire, wind, etc., or natural, i.e., rivers and springs, included Epicharmos (c. 540-450 BCE), Prodikos (5th

cent. BCE); Caesar (100-40 BCE) and Herodotus (484?-425 BCE).[22]
In *Lectures on the Origin and Growth of Religion,* Müller states:

> Celsus, when speaking of the Persians, says that they sacrificed
> on hill-tops to *Dis,* by whom they mean the circle of the sky; and
> it matters little, he adds, whether we name this being *Dis,* or "the
> Most High," Ζευς, or Adonai, or Sabaoth, or Ammon, or with the
> Scythians, Papa.[23]

The Greek philosopher Pythagoras (c. 570-500 BCE), whose
works were widely studied, also understood the astrotheological
nature of the gods, portraying the celestial bodies, such as the
sun, moon and "all the stars," as "immortal and divine."[24]

Another ancient authority who wrote about astrotheology was
Marcus Varro, a Roman soldier, praetor and writer who lived from
116 BCE to around 27-29 BCE, and who served under the Roman
general Pompey at Spain (76 BCE) and Cilicia (67 BCE). Varro is
considered a "man of immense learning," "one of the most erudite
people of his day," the "most learned of the Romans," "Rome's
greatest scholar" and "the most erudite man and the most prolific
writer of his times." Writers who raved about Varro's brilliance
and erudition included "Tully" or Marcus Tullius Cicero (106-43
BCE) and Terentian (2nd century CE). Even Christians admired his
erudition. In *The City of God* (VI, 2), regarding the gods and
sacred rites of the ancients, Christian saint Augustine asks:

> Who has investigated those things more carefully than Marcus
> Varro? Who has discovered them more learnedly? Who has
> considered them more acutely? Who has written about them
> more diligently and fully?[25]

Augustine also relates that Varro "wrote forty-one books of
antiquities." Although Varro's works were burned during his
lifetime, after he was outlawed by Marc Antony, a significant
portion of his material was evidently extant in Augustine's day.

Varro's voluminous efforts totaled "about 74 works in more
than 600 books on a wide range of subjects...[including]
jurisprudence, astronomy, geography, education, and literary
history, as well as satires, poems, orations, and letters...."[26] This
most erudite of men wrote on "almost every field of knowledge";
yet, only one complete work survives: *De Re Rustica,* a book on
farming. Unfortunately, one of his most important books,
Antiquities of Human and Divine Things, suspiciously has not
survived. A number of early Church fathers studied Varro's
Antiquities, which means that it existed until at least the third or
fourth century. Naturally, these Christian writers were not very
favorable towards Varro's information and philosophy, making
typical disparaging comments. It is likely that Varro's work was

deliberately destroyed, for the purpose of concealing Christian secrets.

The surviving fragments of Varro's *On the Latin Language* (V, 65-67) contain important information about the ancient religions, such as that the Roman god Jupiter was the sky and the goddess Juno the earth. Quoting other ancient authorities, including Roman poet Quintus Ennius (239-169 BCE), Varro also relates that the Greeks considered "Jupiter" (Zeus) to be the air, wind, cold, clouds and rain. Jupiter was, Varro reports, "father and king of the gods and the mortals," and his name comes from "Diespater," or "Father Day." In chapter VII (6-7), Varro recounts that "the sky was also called templum, the temple of Iovis or Zeus."[27] In addition, while Juno or Hera was the earth, Apollo was the sun and Diana/Artemis the moon.

This knowledge of the astrotheological nature of the gods fortunately survived the many centuries of enormous destruction in the Western world, to be resurrected in the "Age of Enlightenment." During this period, one writer in particular rose through the ranks: Nevertheless, although his multi-volume opus was well-received and influential, Charles Dupuis's extensive knowledge of archaeoastrology has unfortunately not trickled down the masses. Such an omission in education regarding one of the world's most important subjects has been part of an apparently conscious effort to keep such knowledge hidden, as secrets and mysteries possessed by the religious and political hierarchy. In any event, in his *Origin of All Religious Worship*, Dupuis thoroughly explored the universal astrotheology of the ancients, leaving no doubt as to the nature of their gods. Per Dupuis, the Phoenicians and Egyptians, whose "theogonies" were widespread, "attributed Divinity to the Sun and Moon and the Stars." The Phoenician's great God was the sun, styled "Hercules." The "Ethiopians," whose ancient area was more extensive than today, with the term describing a wider variety of cultures, were sun worshippers but were mainly lunar because of the coolness of the night, which "made them forget the heat of the day." As Dupuis says, "All the Africans offered sacrifices to these great Divinities. It was in Ethiopia, where the famous table of the Sun was found."

Dupuis also relates that the moon was the "great divinity of the Arabs," as is evidenced by the crescent on the "religious monuments of the Turks." The moon rising in the zodiacal sign of Taurus was "one of the principal feasts of the Saracens and the sabean Arabs," and each "Arab tribe was under the invocation of a constellation... Each one worshipped one of the celestial bodies as its tutelar genius...." Before the advent of Islam, the Kaaba ("cube") at Mecca was a lunar temple and its revered black stone

"an ancient statue of Saturnus." This Arab lunar religion was called "Sabismus" or "Sabeanism" and was "universally spread all over the East." As Dupuis says, "Heaven and the Stars were the first objects" of Sabeanism. This "Sabean" religion was also that of the Chaldeans and Babylonians, who additionally worshipped the sun as both Bel and Mithra.[28]

As related by Church father Clement of Alexandria (150?-215?), the sun was "one of the great divinities of the East Indians" as well. There are in fact numerous correspondences between the Indians and the astrological priesthood of the Chaldeans, including the Chaldean language being found on the subcontinent. As is typical, the Indians considered the sun and moon the eyes of the Divine, and a number of Indian tribes "address their prayers to the fixed stars and to the planets." Dupuis concludes that "the worship of the Sun, the Stars and the Elements form the basis of the religion of the whole of Asia, in other words, of countries peopled by the greatest, the oldest and wisest of nations, by those which influenced the religion of the nations of the West and in general of those of Europe."

In discussing the Europeans, the French scholar reminds the reader of Plato's assertions that the Greek gods were no different than those of the "barbarians," i.e., the heavens, the sun, moon, stars and planets. In Italy, the Sicilians consecrated three oxen to the sun, while "Sicily" itself means "island of the Sun." Moreover, the various Northern European Celtic nations "rendered religious worship to Fire, Water, Air, Earth, to the Sun, the Moon and the Stars, to the vault of Heaven, to the Trees, Rivers, Fountains, etc."[29]

Extending through hundreds of pages, Dupuis's analysis of ancient religions covers practically the whole globe, revealing that there is scarcely a spot of any significance that did not extensively engage in this same astrotheological and nature worship. As Legge says in *Forerunners and Rivals of Christianity*:

> The great spread given to the Chaldaean star-worship throughout the East...had caused the stars to be accepted by every nation in the Hellenist world as the most convenient types of divinity. The planets, including in that phrase the Sun and Moon, were all known by the names of the most important gods in the various pantheons of all the nations of antiquity...[30]

It is clear from ancient and modern sources alike that this celestial and nature worship dates back many thousands of years. It is a tremendous pity that this absorbing and important knowledge has been so suppressed and ignored, as not only would it have brought joyous enlightenment but it also would have alleviated and prevented much suffering, including the

destruction of cultures and endless genocide worldwide, based on the religious divisiveness of the past millennia.

The Circle of the Zodiac

Included in this fascinating astrotheology is the development of the zodiac, the parts of which themselves were deemed "gods," "geniuses," "helpers" or "disciples," etc. The major divisions of the zodiac numbered 12, a sacred number reflected by "the twelve great Gods," the 12 Christian apostles and heavenly city gates (Revelation), Jacob's 12 sons, the 12 tribes of Israel, Hercules's 12 labors, Janus's 12 altars and Mars's 12 shields. The Indians possessed the 12 adityas ("suns"), while the Scandinavians had 12 asses. Also, as stated by famed Jewish historian Josephus, the 12 jewels on the Jewish high priest's apron numbered 12, arranged by threes, like the seasons.

Seven was likewise a sacred number, represented in the seven days of the weeks and their "planets," which are symbolized by the Jewish candlestick or menorah. Other "sacred sevens" include "the seven enclosures of the temple;...the seven prophetic rings of the Brahmins, on each of which the name of a planet was engraved...the seven castes adopted by the Egyptians and by the Indians since the highest antiquity;...the seven archangels of the Chaldeans and of the Jews..."[31]

As can be seen, mathematics too was a large part of the revered astral science. The number 360 also constitutes a sacred number, representing the days of the year in the ancient calendar, as well as the degrees of the zodiac. In fact, the ancients made astronomical, numerical groupings for gods that included three, seven, 12, 50 or 52 (representing the weeks), as well as the 360 and later 365 of the days of the year—all personified as tutelary genii or deities.

Another important factor in ancient astrotheology is the precession of the equinoxes, a phenomenon caused by the earth's off-axis tilt, whereby the sun at the vernal equinox (spring) is back-dropped by a different constellation every 2150 or so years, a period called an "age." One cycle of the precession, through the 12 signs of the zodiacal ages is called a "Great Year," and is approximately 26,000 years long. According to orthodox history, the precession was only "discovered" in the second century BCE by the Greek astronomer Hipparchus; however, it is clear from ancient texts, traditions, artifacts and monuments that more ancient peoples knew about it and attempted to compensate for it from age to age. In *Hamlet's Mill*, Santillana and Dechend demonstrate knowledge of the precession at much earlier times, stating: "There is good reason to assume that he [Hipparchus] actually rediscovered this, that it had been known some thousand

years previously, and that on it the Archaic Age based its long-range computation of time."[32]

Astronomer Dr. Krupp concurs:

> The earliest known direct reference to precession is that of the Greek astronomer Hipparchus (second century B.C.), who is credited with discovering it. Adjustments of the Egyptian temple alignments, pointed out by Sir Norman Lockyer, may well indicate a much earlier sensitivity to this phenomenon, however.[33]

Again, Krupp says:

> Circumstantial evidence implies that the awareness of the shifting equinoxes may be of considerable antiquity, for we find, in Egypt at least, a succession of cults whose iconography and interest focus on duality, the bull, and the ram at appropriate periods for Gemini, Taurus, and Aries in the precessional cycle of the equinoxes.[34]

The precessional ages are represented by the signs of the zodiac, which were developed over a period of thousands of years of observation. The zodiacal signs have changed from place to place and era to era, dependent on the climate of the area in which they were developed. The current zodiacal configuration as held in the West has been deemed to have been developed in India, Chaldea/Babylon or North Africa/Egypt, with a variety of arguments on all sides. The Indian zodiac is outlined as follows:

1. Aries (March/April) is "Mesha," a red ram.
2. Taurus (April/May) is "Wrashaba," a white bull.
3. Gemini (May/June) is "Mithuna, a woman and man, of a blue colour, holding an iron rod and a lute."
4. Cancer (June/July) is "Karkkataka," a red crab.
5. Leo (July/August) is "Singha," a red lion.
6. Virgo (August/September) is "Kanya," a dark virgin, "in a ship, holding a handful of ears of rice and a lamp."
7. Libra (September/October) is "Tula," a white man holding scales.
8. Scorpio (October/November) is "Wraschika," a black elk.
9. Sagittarius (November/December) is "Dhanu," a golden creature half-man and half-horse holding a bow.
10. Capricorn (December/January) is "Makara," a sea monster.
11. Aquarius (January/February) is "Kumbha," a white man holding a water-jar.
12. And Pisces (February/March) is "Mina," two fishes.[35]

As we can see, the Indian zodiac is essentially the same as the Western, except for Scorpio as a black elk, rather than a scorpion or eagle. The "sea monster" of Capricorn often takes the form of a half-goat, half-fish.

As to the zodiac's origins, respected and oft-cited Christian authority Rev. Thomas Maurice argued that it did not arise in Egypt, a contention contrary to the scholarship of such luminaries as Count Volney and Gerald Massey. Maurice's thesis includes that the depiction of seasons, such as the harvest time of Virgo, is wrong for Egypt, which harvests in March. The watery Aquarius, says Maurice, is symbolic of the "chilling rains of the bleak winter-season," whereas there is no rainfall in Egypt, and "winter is their finest season." He concludes that the zodiac was brought to Egypt from a place where it had been developed for agriculture and navigation, "some primeval country inhabited by them, before their migration to the banks of the Nile; and that primeval country, we are informed from the most sacred authority, was Chaldea."[36]

Egyptian advocates counter that Egypt was not always as dry as it is today. In previous ages much of the enormous Sahara desert was lush and fertile, and "millet was cultivated there over 8,000 years ago." It is thus in North Africa that a number of scholars have placed the origin of the zodiac, 17,000 years ago, per Volney and Massey, for example. In *The Astronomy of the Bible*, Christian astronomer Walter Maunder narrows the search, casting doubt on both the Egyptian and Chaldean origins:

> From [the latitude and longitude of the zodiac] we learn that the constellations were designed by people living not very far from the 40th parallel of north latitude, not further south than the 37th or 36th. This is important, as it shows that they did not originate in ancient Egypt or India, not even in the city of Babylon, which is in latitude 32°.[37]

Since northernmost Africa is in the 36th parallel, it is not ruled out as the origin of the constellations, based on this argument. Like the others, Maunder also indicates that the precession was known thousands of years before its "discovery" by Hipparchus. He further contends that the current zodiac signs originated about 5,000 years ago:

> ...Ptolemy makes the Ram the first constellation of the zodiac. It was so in his days, but it was the Bull that was the original leader...; the sun at the spring equinox being in the centre of that constellation about 3000 B.C. At the time when the constellations were designed, the sun at the spring equinox was near Aldebaran, the brightest star of the Bull; at the summer solstice it was near Regulus, the brightest star of the Lion; at the autumnal equinox it was near Antares, the brightest star of the

Scorpion; at the winter solstice it was near Fomalhaut, the brightest star in the neighbourhood of the Waterpourer. These four stars have come down to us with the name of the "Royal Stars," probably because they were so near to the four most important points in the apparent path of the sun amongst the stars.... [T]he first of Virgil's *Georgics*...speaks of the white bull with golden horns that opens the year. So when the Mithraic religion adopted several of the constellation figures amongst its symbols, the Bull as standing for the spring equinox, the Lion for the summer solstice, were the two to which most prominence was given, and they are found thus used in Mithraic monuments as late as the second or third century A.D., long after the Ram had been recognized as the leading sign....

The constellations, therefore, were designed long before the nation of Israel had its origin, indeed before Abraham left Ur of the Chaldees.[38]

Maunder apparently bases his terminus a quo on biblical chronology and does not account for civilization existing prior to 6,000 years ago. From its evident zodiacal representation, a disk from Bulgaria called the "Karanovo Zodiac" demonstrates that such knowledge is at least 6,000 years old. The zodiac of Denderah in Egypt depicts the circle as it appeared around 10,000 years ago, although the artifact itself and the building where it was found are only about 2,000 years old. What can be said definitely is that the study of the stars goes back tens of thousands of years, however the constellations were configured.

Using all this intricate information discerned and developed over millennia, the ancients created entire cultures around astrotheology, constantly attempting to reproduce below what was above. Because they believed that the heavens reflected the will of God, who was the Grand Architect, in imitation the ancients built wondrous edifices and marvelous cities. Legge expresses the astrotheological philosophy or religious ideology thus: "This was the notion that the earth in effect is only a copy of the heavens, and that the events which happen here below are nothing but a copy of those which are taking place above."[39] In this way, stonecutters and architects were established as keepers of the sacred knowledge on Earth, which included mathematics. Hence, the religious hierarchy constituted not only priests but also masons.

Chaldean and Sumero-Babylonian Astrotheology

The best-known astronomical priestly caste was that of the Assyro-Babylonian culture called the Chaldeans, who, with the demise of the Assyro-Babylonian empire, were eventually dispersed into other parts of the world, including Greece. After this development, the Chaldean occult science became less

hidden and more known to the masses. From ancient authorities it is evident that the term "Chaldean" ceased to be descriptive of an ethnicity but came to be considered an appellation for the astrological priestly order, from which the Hebrew priesthood, among others, was in large part derived, although the biblical imitators never reached the sublimity of the original. Reflecting their widely held esteem, in *On Mating with the Preliminary Studies* (X, 50), the Jewish philosopher Philo Judaeus of Alexandria (c. 20 BCE-c. 50 CE) described the Chaldeans as understanding to an "eminent degree" what he called "astronomy" and further termed "the queen of all the sciences."[40]

One ancient authority on Mesopotamian culture was Berossus, a citizen of Babylon during the 3rd century BCE who wrote a history for the purpose of educating Greeks and others regarding the Babylonian civilization. Berossus "identified himself as a priest of Bel of Chaldaean origin,"[41] and his name evidently means "Bel is my shepherd," referring to the god Bel or Baal and demonstrating that the shepherd-god concept preceded the Christian era by centuries. All that remains of Berossus's writings are fragments in the works of other writers, including Josephus and the Church historian Eusebius. Writing in the *Babyloniaca* around 281 BCE, Berossus "held to the traditional Mesopotamian view that civilization was not a product of history at all,"[42] and his writing is not strictly historical but philosophical and allegorical, as well as *astrotheological.*

Despite this lack of historical sense, Babylonian chronology is remarkable in that it dates back hundreds of thousands or millions of years: The Armenian text of Berossus gives a chronology of 2,150,000 years, while other authors relate Berossus's chronology as representing 480,000-490,000 years. In the shorter chronology, the Babylonian authority dates the appearance of the aqueous teaching god Oannes to 432,000 years "before the Flood," which allegedly occurred 38,000 years ago. Berossus considers the pre-Flood kings to have been "Chaldeans," which gives that order a claim to longevity far superior to anything biblical. Indeed, the kings themselves are assigned life-spans that outstrip those of the biblical patriarchs by thousands of years. In addition to the others, Berossus also lists pre-Flood "kings" whose names are suspiciously like those of gods, such as "Ammenon," which resembles the "Amen" or "Ammon" of the Egyptians, a sun god; and "Daonos," equivalent to Dumuzi or Tammuz, the solar and fertility god worshipped not only by the Sumerians and Babylonians but also by the Israelites. Tammuz's esteem, according to Berossus's chronology, would date back hundreds of thousands of years. Tammuz ostensibly represents the sun in the Age of Gemini, or

the Twins (Tammuz=Thomas= Twin), which would refer to the Age that began around 8800 BCE, or even earlier cycles, such as 26,000 years before that, and so on. Like Berossus, other ancient authorities such as Proclus, Cicero and Diodorus, relate that the Chaldean cosmology encompassed hundreds of thousands of years.

Berossus is also recorded as saying: "In the tenth generation after the Flood there was a man among the Chaldaeans who was just, great and knowledgeable about heavenly phenomena."[43] As his translator Burstein points out, Berossus's emphasis of this king's knowledge of the "heavenly phenomena" is indicative of how important was the science of astronomy/astrology or astrotheology. This king has been identified as the Hebrew "patriarch" Abraham, who was called "just" or "righteous" and was purported to be an astrologer who taught the Egyptians that art. However, according to the Babylonian chronology this Chaldean king lived some 32,000 years ago, so he could not be "the historical Abraham," who is dated in the Judeo-Christian chronology to less than 4,000 years ago. In any event, as demonstrated in *The Christ Conspiracy* and elsewhere, "Abraham" is likely not an historical character but the Indian god Brahma made into a man.

The Babylonian Flood itself predates the biblical by about 33,000 years, which demonstrates that the two inundations do not reflect *one* "historical" flood. Nevertheless, the story of Xisuthras or Ziusudra, the Babylonian Flood king, matches the later biblical account of Noah in important details, a common development with *myths*. Berossus is even recorded as stating that Ziusudra's ship landed "in the mountains of the Korduaians of Armenia," possibly the Kurdistans, located in the same area where ark-hunters have claimed to have found pieces of "Noah's ark." This story, however, is not historical, and the creation of stone "arks" or ships upon hills was more common than is realized. Moreover, the Noah tale also can be found in Mexican mythology: The Mexican Noah is named Nata, while his wife is Nena.[44] In the Indian mythology, in the reign of the "seventh Manu," Satyavrata, the "whole earth" is said to "have been destroyed by a flood, including all mankind, who had become corrupt." The prince and seven rishis, along with their wives, survived by entering a "spacious vessel," "by command of Vishnu...accompanied by pairs of all animals."[45]

The fact that Noah's Flood is a children's fable and a myth has been known or suspected by the less gullible for centuries. Flood tales abound worldwide "in every known tribe," along with the details of the floating vessel, etc. When discovered, this fact of ubiquity has been used to assert the historicity of Noah's Flood.

However, "it has been ascertained that the tale of Noah and his deluge is adapted from an Assyrian or Babylonian legend, written apparently with a view to make a story fitting to the sign of the Zodiac called Aquarius, one to the full as fabulous as that of the birth of Bacchus, and the amours of Zeus."[46] In other words, the flood myth prevalent globally reflects astronomical, not "historical," events, except that there have been numerous floods of varying size, including during the centuries at the end of the last Ice Age.

Apparently relying upon the famous Babylonian epic the "Enuma Elish," Berossus engages in further astrotheological discussion beginning with a "woman named Omorka," who is "Thalath" in the Chaldean and "Thalassa" in the Greek, a word meaning "sea" and equivalent to Mare or Mary. Omorka is equated with the goddess Tiamat, who represents the watery abyss or primordial ocean that the god Bel-Marduk divides into two, the same as the biblical division of the earth from "the firmament," i.e., the sky. In the Enuma Elish, Tiamat is said to have created "the eleven creatures," which likely refers to 11 of the 12 zodiacal signs, some of which are "destroyed" when Bel cuts Tiamat in half. Tiamat is possibly identified with the moon goddess, which would make her the "Queen of the Sea," an epithet of the later version of the goddess, the Virgin Mary. Furthermore, in his destruction of Tiamat, the watery abyss of the heavens, "Bel also created the stars and the sun and the moon and the five planets."[47] The "five planets" are those known to the ancients and represented by the days of the week: Mars, Mercury, Jupiter, Venus and Saturn. Bel/Baal thus gradually came to be thought of as the god of order and destiny, as well as a sun god.

The god to whom Bel was assimilated, Marduk, or Merodach, was the supreme Babylonian creator god and represented Jupiter, although as Bel-Marduk he incorporated aspects of the sun god as well, and was considered as such at a later period in his worship.[48] In *Babylonian Influence on the Bible and Popular Beliefs*, Dr. Palmer says:

> Merodach, the Vanquisher of the Chaos-Dragon, and so Creator of the ordered world, as being originally the Sun-God, occupied a place of supreme importance in the Babylonian religion, and by a reflex influence seems to have contributed shape to the theological conceptions of the Jews both as to the Godhead and the Logos.[49]

He further states:

> Indeed, the Babylonians themselves seem to have considered their Merodach (or Bel) and the Hebrew Ya (Jah=Jehovah) to be one and the same, as we may infer from the names they gave

their children, such as Bel-Yahu—*i.e.*, "Bel is Ya," identical with Bealyah, the name of one of David's warriors (1 Chron. 12:5); and Shamshi-Ya, "My Sun is Ya." It is remarkable, too, that the two typical Jews and protagonists of the Book of Esther, Mordecai and Esther, bear the names of the Babylonian deities, Merodach (Marduk) and Istar [Ishtar].[50]

Palmer also notes that Marduk is similar to the "fair and gentle" Mexican sun god Quetzalcoatl.[51]

Hence, Marduk is the sun is the Jewish tribal god Yahweh, as well as the Logos, a very ancient, pre-historic concept. That Marduk and Ishtar are the Mordecai and Esther of the biblical text is asserted by Herbert Cutner in *Jesus: God, Man or Myth?*:

> The story given in the Bible is quite unhistorical—see the article in the *Encyclopedia Biblica* on Esther. Mordecai is certainly the Babylonian god Marduk or Merodach, while Esther is Astarte or Ishtar.[52]

Ishtar is the goddess, representing among other things the moon. The moon is described in the Enuma Elish as having "luminous horns to signify six days," which is the time of the crescent moon and which is equivalent in the Egyptian mythology to Isis as the cow goddess Hathor. The Babylonian astronomy/astrology describes the sun as "robbing" the moon of her own light, rather than providing the light in the moon, the latter fact known to the ancients and also used in their myths. It is likely that this perspective arose from the precedence of lunar worship, later supplanted by solar worship.

Although Berossus speaks of the "disc of the sun,"[53] the historian's moon is not a flat disc but a *round sphere*, which indicates that, contrary to popular belief, at least some of the ancients knew the spherical nature of the earth, moon, sun and other planets—facts, then, not "discovered" but *rediscovered* in the West during the Christian era. It is probable that these facts were deliberately suppressed so that the astrotheological nature of Christianity would be lost to the masses. Evidence of this knowledge in ancient times can be found in the highly developed Indian astrotheology, which demonstrates that the Hindus knew—well before the Western world was *reawakened* to the fact—that the earth was a sphere and revolved around the sun. Included in this evidence is the "doctrine of the seven superior Bobuns, or purifying spheres," through which the Hindu soul is said to transmigrate. There is also the "Circular Dance," per Lucian's *Treatise de Saltatione*, during which the Indians "worshiped the orb of the Sun." These facts, says Rev. Maurice, give reason to believe the Hindus had, "in the most early periods, discovered the earth in form was *spherical*, and that *planets*

revolved round the sun...."[54] Also, "the names of the planets and zodiacal stars, which the Arabs borrowed from the Greeks, are found in the oldest Indian records."

Again, centuries before the Catholic world supposedly "discovered" the earth to be round, rather than a disk, it is also identified as a sphere by Greek historian Diodorus Siculus (c. 91-20 BCE), in his discussion of the reversed flow of the Nile: "...it seems totally impossible for a river to flow up out of the world opposite to our own, especially if one holds the earth to be a sphere."[55]

Moreover, the Catholic Encyclopedia ("CE") acknowledges that there is "inference" that the Egyptians were aware of the heliocentricity of the solar system, long before it was purportedly discovered by Christian Europeans.[56] In reality, the knowledge of the heliocentricity was a "sacerdotal secret" serving as part of the famed "mysteries": "The information that the earth revolves around the sun was once one of the most arcane of the mysteries."[57]

As noted, in addition to the knowledge of the earth as a sphere and the heliocentricity of the solar system, the ancients apparently knew about the precession of equinox long prior to its supposed discovery during the second century BCE. Berossus likewise discusses "the Great Year," although it is unclear as to whether or not by this moniker he means the equinoctial cycle. He does, however, specifically cite the signs of Cancer and Capricorn, thereby identifying the zodiacal nature of his Great Year.

Berossus's work represented an effort to educate the Greek-speaking world about Babylonian culture and Chaldean astrotheology. With the dispersal of the Chaldean astrologers into the Mediterranean came the expansion of organized brotherhoods that constantly tried to outdo themselves and each other in creating new forms of esotericism that would be useful in empowering themselves and befuddling the masses. A major center for these priest-astrologers and "practitioners of the occult arts" was Alexandria, the great Greco-Egyptian city of learning, whose library contained books that possessed "the secret knowledge pertaining to astrological and mystical subjects."[58]

Concerning Alexandria, the Chaldeans, and astrology in the Roman Empire, CE states that the Romans were skeptical of the "mystical and enigmatic doctrines of Alexandrian astrology." The Chaldeans in Italy were assailed by Roman writers such as Cato (234-149 BCE), and in 139 BCE "the Praetor Cneius Cornelius Hispallus drove all astrologers out of Italy." Under Caesar Augustus, however, the astrologers were protected and allowed to return. In about 45 BCE the first Latin work on astrology, the

"Astronomica" by Marcus Manillus, a probable Chaldean, was dedicated to Augustus. Concerning the importance of astrology during the early Christian era, CE continues:

> In spite of repeated attempts to suppress it, as in the reigns of Claudius and Vespasian, astrology maintained itself in the Roman Empire as one of the leading forms of culture.... After the death of Marcus Aurelius [d. 180], the Chaldeans were always important personages at the imperial court. As late as the time of Constantine the Great the imperial notary Julius Firmicus Maternus, who later became a Christian, wrote on "Mathematics, or the power and the influence of the stars," eight books which were the chief authority in astrology until the Renaissance.[59]

Included in this concerted "Roman" endeavor to develop and record the various priestly arts and sciences were the efforts of many Jews, Samaritans, proto-Christians and Christians.

Judeo-Christian Testimony to the Stars

We have seen how various ancient, pre-Christian writers explained that their gods were astrotheological and that astrology was a predominant ideology or "science" in the Pagan world. Like the Pagans, the early Church fathers discussed the pervasive astrotheology, as they could hardly avoid it, since it was their competition. Naturally, when they did address it their comments were often condescending or disparaging. For example, in *Against the Heathen*, theologian St. Athanasius (c. 293-373) attempted to raise the Christian god above all the rest, establishing the ancient worship as astrotheological and relating that mankind "gave the honour due to God first to the heaven and the sun and moon and the stars, thinking them to be not only gods, but also the causes of the other gods lower than themselves..."[60]

In "THE INSTRUCTIONS OF COMMODIANUS IN FAVOUR OF CHRISTIAN DISCIPLINE. AGAINST THE GODS OF THE HEATHENS" (3rd-4th cents.), the author mocks:

> If ye worship the stars, worship also the twelve signs of the zodiac, as well the ram, the bull, the twins, as the fierce lion; and finally, they go on into fishes—cook them and you will prove them... Concerning the Sun and Moon ye are in error, although they are in our immediate presence; in that ye, as I formerly did, think that you must pray to them.[61]

In his *Exhortation to the Heathen* (IV), Clement of Alexandria states that the "heathen" are "beguiled by the contemplation of the heavens," deifying the stars and worshipping the sun. As examples he mentions the Indians and the Phrygians.[62]

One of the most influential of Christian writers, Church historian Eusebius (c. 230-c. 341) likewise asserted the superiority of Christianity, while acknowledging that its

competitor Paganism was astrotheological. In "THE ORATION [OF] EUSEBIUS PAMPHILUS, IN PRAISE OF THE EMPEROR CONSTANTINE," Eusebius calls Jesus "the Sun of righteousness," a common designation based on the biblical text Malachi 4:2, a book and verse immediately preceding the New Testament, which shows that the gospel story was to be based on a hero with solar attributes.

In his plea, Eusebius addresses the astrotheological and element-worshipping Pagans, disparaging them and considering them absurd for giving such things "equal honor with the Creator of them all..."[63] In fact, Eusebius speaks many times of sun worship, apparently in an intensive effort to convince the Emperor into switching his religious allegiance from Sol Invictus—the Unconquered Sun—to the power behind the sun, i.e., "God."

In his condescending propaganda dismissing the wisdom of the ancients in order to impose the supposedly "superior" Christian ideology, Eusebius further confirms that astrotheology was the dominant form of religion, calling those who practiced it "our ignorant and foolish race," who were "incapable of comprehending him who is the Lord of heaven and earth..." Instead, he complains, they "have ascribed the adorable title of Deity to the sun, and moon, the heaven and the stars of heaven," as well as "deifying the earth, elements and creatures themselves."

Among the beguiled contemplators of the heavens were not only Pagans but also Jews. As noted, it has been claimed repeatedly over the past two millennia at least that the first Hebrew patriarch, Abraham, was an astronomer/astrologer or Chaldean. Israel was no less a nature-worshipping culture than its neighbors, as demonstrated by the constant excoriation of the Israelites by fanatic followers of the war god Yahweh for worshipping "all the host of heaven." In its proscriptions against astral religion, the Bible itself provides evidence of the ancient astrotheology. Despite the prohibitions, however, the ancient Hebrews and Israelites likewise followed the astrotheological religion, and the Bible has been described as the "greatest astrological work ever written." As Lord Kingsborough relates, in *Antiquities of Mexico*:

> That the Jews worshiped the Sun, the moon, and the planets, may be proved from the fourth, fifth, and eleventh verses of the [23rd] chapter of the Second Book of Kings...[64]

Both Jews and early Christians believed that the "sun, moon and stars were living entities possessed of souls." This belief was held, for example, by Philo Judaeus, "who considers the stars spiritual beings full of virtue and perfection..."[65] In *The Special*

Laws, I (III.13), Philo remarks, "Some persons have conceived that the sun, and the moon, and the other stars are independent gods, to whom they have attributed the causes of all things that exist."[66] Philo considered these celestial objects to be not independent but "viceroys" and "lieutenants" of the true God.

Living when the gospel events purportedly took place, yet making no mention of them, Christ or Christianity, Philo was famed for developing a Jewish, pre-Christian version of the Logos concept, as previously refined by the Greek sage Plato (c. 428-348 BCE). Like that of Plato, Philo's Logos, or Word, was the *sun*, which Philo apparently also believed to be a "spiritual being full of virtue and perfection." To wit, the sun was the Logos, the living Word, the *only* "*Son* of God." This Logos of the pre-Christian Jews was developed by the translators of the Old Testament/Torah/ Tenach into Greek, specifically in regard to the northern kingdom hero, Joshua, or *Jesus*, as the name is written in Greek. Indeed, Joshua/Jesus has been asserted to be a solar hero or sun god numerous times over the centuries, and, as it turns out, many of the Bible's major personalities and stories are not historical characters or literal history but are allegorical and, indeed, astrotheological.

In actuality, the ancient Judeans were a superstitious people who abundantly used "amulets, charms, mutterings, exorcisms, and all kinds of enchantments."[67] In this regard, it is a fact that astrotheology pervaded the area in which Judaism flourished and that it influenced Jews, as verified by the Catholic Encyclopedia:

> ...Astral worship was rife in Palestine, and they [the Jews] could hardly have attended closely to its objects without yielding to its seductions. Astronomy was, under these circumstances, inseparable from astrolatry... As the most glorious works of the Almighty, the celestial luminaries were indeed celebrated in the Scriptures in passage thrilling with rapture... The Jews used a lunar year.... The Jewish calendar, however, depended on the course of the sun, since the festivals it appointed were in part agricultural celebrations....
>
> ...The stellar vault, conceived to be situated above the firmament, is compared by Isaias [Isaiah] to a tent stretched out by the Most High.
>
> Astronomical Allusions in the Old Testament
>
> The "host of heaven," a frequently recurring Scriptural expression, has both a general and a specific meaning. It designates, in some passages, the entire array of stars; in others it particularly applies to the sun, moon, planets, and certain selected stars; the worship of which was introduced from Babylonia under the later kings of Israel.[68]

Beginning with the new moon nearest the vernal equinox, the Jewish calendar is "regulated both by the sun and the moon."[69]

The systematic astronomical observation used by the Jews had already been developed by their mentors, the Chaldeans, and, despite its overt proscription in the Bible, Jews continued to practice astrology, as demonstrated by "horoscopes" found at the Dead Sea and zodiacs on synagogue floors in northern Israel. Moreover, the Hebrew letters were considered personifications of the "rulers" or angels and demons of the planets, constellations and seasons.

Under Egyptian and Babylonian influence, Judaism thus became "an independent astronomical system...based on the solar calculation of time; indeed there was even a knowledge of horoscopes for determining character and the future..."[70] Regarding Jewish astrology, CE relates that after the Babylonian Exile, the science "spread so rapidly," particularly among "the educated classes of Israel," as to create a "Jewish astrological literature" that revealed a "strong Persico-Chaldean influence." Jewish prayers to the angels and demons of planets can be found in the Codex Paris, for example, dating to the third and second centuries BCE. The apocryphal Jewish text *The Book of the Secrets of Enoch* is a fantastical but "rich treasure-house of information concerning cosmological and purely astronomical problems in the Hellenic East."[71]

In the process of discussing Jewish astrology, however, CE must also assert the superiority of Christianity:

> The passion for astrology evinced by decadent Judaism, and preserved in the Bible, is only one more proof of the propensity of Semitic nations of fatalistic superstitions and of the purifying victorious power of the ethics of Christianity.

In any event, during the Hellenistic period, which directly preceded the creation of Christianity, "[a]strology was regarded as the highest of 'sciences'..."[72] In the pre-Christian apocryphal Jewish text *The Wisdom of Solomon* (13:1-2), the author criticizes this ancient and popular astrotheology, demonstrating its ubiquity and importance. Calling "all men...foolish by nature," the writer comments that they "had no perception of God" but worshipped nature and the elements, as well as the "circle of stars," and the "heavenly luminaries, the rulers of the world, they considered gods."[73]

In *The Stromata* (V), Clement of Alexandria described the Jewish ritual breastplate or apron called the ephod in astrological terms, as had Josephus before him, relating that the emerald stones "signify the sun and moon... The twelve stones, set in four rows on the breast, describe for us the circle of the zodiac..."[74] Clement addressed the sun and various aspects of astrotheology in greater detail than the majority of other Christian writers, but

he avoided exposing any mysteries that might implicate
Christianity as more of the same astrotheology.

Another text that demonstrates the astrotheological worship
of the Jews into the Christian era is the *Preaching of Peter*, which
reproaches them for such idolatry. The typical Christian
disparagement of Pagan astrotheology is hypocritical, however, for
a variety of reasons, including that Christians themselves
believed the various celestial bodies to be animated, "angels" with
souls. After much study and citation of scripture, theologian
Origen (185-232) deemed the sun, moon and stars to be "living
and rational beings" who were "illuminated by wisdom" and who
possessed free will. Church father Irenaeus (fl. 190) acknowledged
that the gods of the ancients were the celestial luminaries, also
making it clear that even to Christians, who claimed their god and
godman to be beyond the Pagan gods, such "idols" were nevertheless
personified as "beings" and viewed as creatures of the divine.[75]

Thus was astrolatry or astrology so common as the reigning
religion that the early Christian authorities were compelled to
address and refute it, while attempting to establish their own
religion in opposition and superiority to it. Hence, in their
attempts at destroying pre-Christian beliefs, Christian proponents
made a sharp division between their "revealed" religion and the
astrotheology of the ancients, roundly condemning astrology. This
division, however, was as artificial as the Great Wall of China, and
Christianity at its roots is little but Pagan astrotheology repackaged.

The astrotheology of the creators of Christianity is
immediately reflected in the story of the "wise men"—Persian
magi—appearing at the birth of Christ. As Hengel says, "One of
the most valuable 'products' of ancient astrology was the
horoscope of a wise 'world ruler' expected in the future."[76] The so-
called prophecies concerning the Jewish messiah are no less
astrological than those of the Roman rulers.

The Christian assault on astrology was furious and motivated
by a desire for dominance and the replacement of the Pagan
astrotheology with that of Christianity, with an eye to covering up
the latter's own astrotheological roots. The Christian fathers
eventually were responsible for vicious persecution of
"astrologers," i.e., those Chaldeans and others who were priests of
Pagan faiths. Arabic and Jewish universities and scholars kept
astrology alive throughout the Middle Ages, despite continued
persecution by Christians.[77] As time went on, this "false
doctrine," which never disappeared from Europe but was
condemned on the one hand and embraced on the other by
Church authorities, began to resurface more overtly. Indeed,
numerous emperors and popes "became votaries of astrology,"
including "Charles IV and V, and Popes Sixtus IV, Julius II, Leo

X, and Paul III," as related by the Catholic Encyclopedia. "Among
the zealous patrons of the art were the Medici," CE continues,
with Catharine de Medici popularizing astrology among the
French and making Nostradamus her "court astrologer." Popes
Leo X and Clement VII retained the same court astrologer,
Gauricus, who "published a large number of astrological treatises."
Moreover, during the Renaissance, CE further recounts,
"religion...was subordinated to the dictation of astrology," with
the rise of each religion given astrological foundation:

> Thus it was said that the conjunction of Jupiter with Saturn
> permitted the rise of the Hebrew faith; that of Jupiter with Mars,
> the appearance of the Chaldaic religion; of Jupiter with the sun,
> the Egyptian religion; of Jupiter with Venus, Mohammedanism;
> and of Jupiter with Mercury, Christianity.[78]

As can be seen, the world's cultures have for millennia
revolved in large part around the astrotheological interpretation of
the cosmos. Astrotheology has been the principal religious
concept globally since the dawn of human history. As will be
further demonstrated, it continues to be the basis of the world's
reigning popular religions.

Evemerism

Ever since humans began personifying the various natural
forces and celestial bodies as gods and goddesses, in an attempt
to make their stories easier to pass along from generation to
generation, there has been a tendency to forget the mystical,
mythical, allegorical, symbolical and non-historical origins of
these personified entities, and to believe that these ancient deities
and heroes were "real people" whose fabulous exploits occurred in
some remote era. Century after century, poets and other
imaginative writers have told tall tales about the ancient gods and
heroes, portraying them as actual "human" (or, currently, "alien")
beings who once "walked the earth." In the case of the ancient
gods, more often than not such an assertion is simply not true.

This erroneous tendency received a strong impetus in the
fourth century BCE with the writings of the Greek philosopher
Euhemeros, Euhemerus or Evemeras, who averred that the
ancient gods were kings and heroes given legendary dress and/or
deified. This thesis is called "euhemerism," or, for pronunciation's
sake, "evemerism" (as "euangelical" becomes "evangelical"). The
development of evemerism has been traced to the deification of
Alexander the Great:

> Within a few years from Alexander's death, Cassander's friend
> and envoy Euhemerus put forward, with the aid of a literary
> fraud something like that of Psalmanazar, the theory that all the

gods worshipped by the Greeks had once been kings or at least distinguished men and women upon earth...[79]

Euhemerus did not originate this thesis, as in the fifth century the Greek historian Herodotus (2:143-145) had recounted the belief that the Egyptian gods, such as Osiris and Horus, were "real people" who lived hundreds to thousands of years previously.[80] Other ancient writers, such as the pre-Christian authority Diodorus Siculus, followed the lead of Euhemerus, maintaining that, while Osiris and Isis represented the sun and moon, respectively, they had previously been mortals with long lives and global exploits. Such a concept as Horus ever being a "national hero" is strongly refuted by mythologists and other critics of evemerism. As abundantly shown, many ancient authors correctly identified astrological and natural entities and forces. Obviously, these perceptions are confused and contradictory. The knowledge that the gods were in reality the sun, moon, stars, earth and natural forces thus became hidden under long, rambling and irrational screeds, making this fact a secret or mystery.

Over the centuries, the Christian Church fathers themselves waffled back and forth between acknowledging that the ancient gods were largely astrotheological and denigrating them as "mere mortals," i.e., men of yore who were elevated to the status of gods. At times this dichotomy is displayed within one chapter of a single writer. Christian writers such as Clement Alexandrinus, Lactantius and Augustine[81] jumped on the evemerist bandwagon and used evemerism to demote the ancient gods to the status of mere mortals, upon whom they freely heaped vitriol and disparagement. At the same time, they denigrated these same Pagan "mortals" as "demons," thus paradoxically attributing supernatural qualities to them. For example, Church father Irenaeus calls the Pagan gods "demons" and speaks of them *not* as mortals. The word "demon" is Greek, i.e., daimon or daemon, and originally referred to a good or divine being, a household or tutelary god, called "genius" in Latin. Christian propaganda reversed the perception and made them into evil beings.

An effective use of evemerism to debunk ancient gods, who as mortals appear immoral, can be found in Clement's *Homilies* (VI, c. II), in which the author portrays the character "Appion" as declaring that "The Myths are Not to Be Taken Literally." In his discourse, "Appion" states that the "wisest of the ancients" kept their hard-earned knowledge secret from the "unworthy" and from those who "had not taste for lessons in divine things." In his denigration of the gods, Clement makes Appion recite the more bizarre and repulsive aspects of Greek mythology, such as the mutilation of Ouranos by Kronos; the birth of Aphrodite from

Ouranos's blood; Kronos's devouring of his "first-begotten son" Pluto, as well as his second son Poseidon; Kronos's eating and regurgitation of his next son Zeus; Zeus's overthrow of Kronos and his lusting after mortal women; Zeus's "association" with his own sisters, daughters and sisters-in-law, and his "shameful paederasty"; and so on.[82]

After Clement goads him to continue, in chapter X, entitled, "All Such Stories are Allegorical," Appion explains what some of these stories mean symbolically, describing Apollo, for example, as the "wandering Sun" and "a son of Zeus...also called Mithras." Clement then responds (ch. XIV) that "the twelve [Olympian gods] are these heavenly props of the Fates, called the Zodiac."

Typically unreasonable and condescending, Clement was unwilling to accept these fables as allegory, so in chapter XX he arrogantly dismissed the explanation and claimed that "These Gods Were Really Wicked Magicians," as well as that (chapter XXI) "Their Graves are Still to Be Seen." Clement's basic argument was that, because these entities had graves, they were not "gods" but mere mortals. In other words, he used the evemerist argument to denigrate the competing gods.

Augustine used the same reasoning to reduce the ancient gods to "mere mortals," believed to be so by the ancients, he suggested, since they had created sacred sites and relics to demonstrate that the gods had been born in or visited their areas. This argument is shallow and specious, however, since the priesthoods that created countless such graves and tombs were well aware that they were *symbolic*, not actual. As relic making is a very old part of priestcraft, these sites, fables and relics certainly do not "prove" any type of historicity for these various gods. Nor do they as concerns Jesus Christ, who, by Augustine's reasoning, would also be a "mere man and mortal," not a god.

Fortunately, despite the Christian apologists' sophistic arguments, many ancient writers recognized that the gods were allegorical, in large part representing the celestial bodies. Knowing that the ancients worshipped the "host of heaven," etc., it is ludicrous to suggest that these deities were "real people." It is clear that in the majority of cases, evemerism cannot be applied and is, in fact, discredited.

Adding to the confusion is the fact that priests were often called by the name of the gods they represented: "...priests took the titles of the Deities whom they served..." Hence, these gods were imagined to have been "real people" but were in actuality their priests or other representatives. As an example of this development, in discussing the eucharistic communion among the Aztecs, in *The Golden Bough* Sir Frazer refers to "a priest, who bore the name and acted the part of Quetzalcoatl..."[83]

Furthermore, the Greeks "mistook temples for Deities; and places for persons."[84] Indeed, entire cultures and tribes were called after their gods: "Colonies always went out under the patronage and title of some Deity. This conducting God was in after times supposed to have been the real leader."[85] In other words, tribal "patriarchs" and the like were in reality ancient gods made into men as one cult usurped another. In his defense of biblical "history," *The Legends of Genesis*, conservative scholar Hermann Gunkel was forced to concede that the patriarchs might be "disguised divinities," as he ran down a list of them and gave their equivalent within Levantine mythology. Said Gunkel:

> Sarah and Milkah are, as we know, names of the goddesses of Haran, with which the Biblical figures of Sarah and Milkah have perhaps some connexion. This suggests very easily the thought that Abraham, the husband of Sarah, has been substituted for the (moon-) god of Haran. The name Laban, too, suggests a god... In ancient as well as in modern times the attempt has been repeatedly made to explain the figures of Abraham, Isaac, and Jacob also as originally gods. There is no denying that this conjecture is very plausible.[86]

Again, the myth of the god and the history of his people have frequently been intermingled. As Christian scholar Jacob Bryant states:

> As in early times colonies went by the name of the Deity, whom they worshiped; or by the name of the insignia, and hieroglyphic, under which their country was denoted; every depredation made by such people was placed to the account of the Deity... Hence, instead of saying that the Egyptians, or Canaanites, or Tyrians, landed and carried off such and such persons, they said it was done by Jupiter in the shape of an eagle, or a swan, or a bull: substituting an eagle for Egypt, a swan for Canaan, and a bull for the city of Tyre.[87]

An "anti-evemerist" and pious bibliolater, Bryant further observes:

> ...most of the deified personages never existed, but were mere titles of the Deity, the Sun, as has in great measure been proved by Macrobius. Nor was there ever any thing of such detriment to ancient history, as...supposing that the Gods of the Gentile world had been natives of the countries where they were worshiped.[88]

Bryant remarks that, unlike the Church fathers, he does not believe that the ancient gods were "deified mortals" worshipped "in the countries where they died." He then declares the motives of the fathers to "convert the heathen," such that they "therefore argue with them upon their own principles; and confute them from their own testimony..."[89]

As we can see, the mystifying priestcraft has been abundantly practiced, and evemerism is one of its favored tools. Despite this trend, in his demonstration of the mythical and allegorical nature and symbolism of the ancient religions and mythologies, the great scholar Dupuis likewise did not concur with evemerism: "Christianity, along with most other major religions, is, in Dupuis's final analysis, mere corrupt sun worship."[90]

Nor did minister and mythologist Rev. George Cox agree with the "sins of Euemeros against truth and honesty..."[91] Cox remarked that Euhemeros was "not popular among his countrymen," as he had "reduced the gods" and resolved their religions into "mere atheism."

In fact, Evemerism robs us of the beauty and wisdom that lie behind the myths: To wit, the observances of the awesome natural world and the cosmos. As Santillana states:

> The attempt to reduce myth to history is the so-called "euhemerist" trend, from the name Euhemeros, the first debunker. It was a wave of fashion, which is now receding, for it was too simpleminded to last. Myth is essentially cosmological.[92]

In the final analysis, the immortals were not men made into gods but gods made into men. And these gods were personifications of celestial and terrestrial bodies and forces.

As is evident, the study and reverence of the heavens goes back many millennia, and has constituted in large part the original religious concepts developed by humanity. As is also clear, the ancients were well aware that they were worshipping the sun, moon, stars and "all the host of heaven." Entire cultures were based upon astrotheology, and numerous magnificent edifices were constructed for its glorification. Indeed, the proscription by biblical writers shows how important and widespread was this worship of the cosmic bodies and natural phenomena. The Church fathers and other Christian writers also acknowledged this astrotheology and its antiquity, but denigrated it as much as possible. Why? What would a detailed investigation reveal about their own ideology? As demonstrated in *The Christ Conspiracy* and here, the knowledge about astrotheology would reveal the Christians' own religion to be Pagan in virtually every significant aspect, constituting a remake of the ancient religion. Yet, this astrotheology devised by our remote ancestors over a period of millennia was symbolically and allegorically a treasure-trove. Hence, the restoration of this knowledge is not to be despaired but rejoiced.

[1] Funk & Wagnall's Encyclopedia, "Archaeoastronomy."
[2] www.sciencedaily.com/releases/1998/04/980403081524.htm
[3] Roy, 1.
[4] www.newadvent.org/cathen/02018e.htm

[5] Krupp, 37.
[6] www.donaldmiller.com/venus_of_laussel.htm
[7] Roy, 8.
[8] Roy, 3.
[9] Roy, 106-108.
[10] Roy, 105.
[11] Roy, 112.
[12] Roy, 105.
[13] Graves, R., 217.
[14] Roy, 105-106.
[15] Roy, 112.
[16] Singh, 13.
[17] Roy, 114.
[18] Volney, X.
[19] Volney, X.
[20] Volney, XXII.I. (Emph. added.).
[21] Iamblichos, 162.
[22] Müller, *LOGR*, 174.
[23] Müller, *LOGR*, 175.
[24] Dupuis, 47.
[25] www.ccel.org/fathers2/NPNF1-02/npnf1-02.htm
[26] www.britannica.com, "Varro"
[27] www.sentex.net/~tcc/fvarro.html
[28] Dupuis, 25-28.
[29] Dupuis, 32-36.
[30] Legge, I, 186.
[31] Dupuis, 39-41.
[32] Santillana, 66.
[33] Krupp, 33.
[34] Krupp, 218.
[35] Hardy, 23.
[36] Maurice, 35.
[37] Maunder, 157.
[38] Maunder, 160-161.
[39] Legge, I, 115.
[40] Yonge, 308.
[41] Burstein, 2.
[42] Burstein, 7.
[43] Burstein, 21.
[44] Spence, *MMP*, 122.
[45] Moor (Simpson), 108.
[46] Inman, *AFM*, 21.
[47] Burstein, 15.
[48] Palmer, 82.
[49] Palmer, 98.
[50] Palmer, 101.
[51] Palmer, 101fn.
[52] Cutner, 138.
[53] Burstein, 16.
[54] Maurice, 46-47.

55 Siculus, 52.
56 www.newadvent.org/cathen/02018e.htm
57 Tucker, 31.
58 www.newadvent.org/cathen/02018e.htm
59 www.newadvent.org/cathen/02018e.htm
60 www.newadvent.org/fathers/2801.htm
61 www.newadvent.org/fathers/0411.htm
62 www.newadvent.org/fathers/0208.htm
63 www.newadvent.org/fathers/2504.htm
64 Kingsborough, VI, 355.
65 Cassels, 130-131.
66 Yonge, 535.
67 Cassels, 137.
68 www.newadvent.org/cathen/02029a.htm
69 Maunder, 364.
70 Hengel, I, 251.
71 www.newadvent.org/cathen/02018e.htm
72 Hengel, I, 239.
73 Goodspeed, 202.
74 www.newadvent.org/fathers/02105.htm
75 www.newadvent.org/fathers/04165.htm
76 Hengel, I, 238.
77 www.newadvent.org/cathen/02018e.htm
78 www.newadvent.org/cathen/02018e.htm
79 Legge, I, 19.
80 Herodotus, 139.
81 www.ccel.org/fathers2/NPNF1-02/npnf1-02-12.htm
82 www.ccel.org/fathers2/ANF-08/anf08-50.htm#P4158_1244386
83 Frazer, 569.
84 Bryant, I, 175.
85 Bryant, I, 177.
86 Gunkel, 119.
87 Bryant, I, 379.
88 Bryant, I, 452.
89 Bryant, I, 455.
90 Dupuis, v-vii.
91 Cox, I, 170.
92 Santillana, 50.

Marshack's map of prehistoric cave sites

Star map from Lascaux Caves, France
c. 16,500 BCE

Map of stars in the precession of the equinoxes
and at the solstices. (Roy)

Venus of Laussel holding a horn
with 13 moons, c. 21,000 BCE

Swiss gold bowl with suns and moons
6th century BCE. (Singh)

Antelope-headed "Sorcerer" from Les
Tres Freres Cave, France. (Breuil)

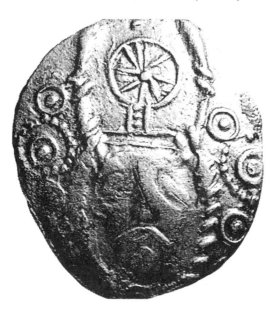

Celtic god Cernunnos, with the sun
between his antlers, c. 20 CE. (Singh)

Moon eclipsing the sun to
form the "Eye of God"

Artist's rendering of "God's
Eye" eclipses, 19th century

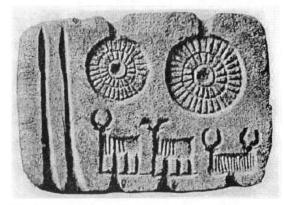

Archaic image of the sun and moon
as "God's Eyes"

Ancient Egyptian signs of the zodiac

Hindu signs of the zodiac, with the
chariot of the sun in the middle

Babylonian God Oannes the Dipper,
surrounding the winged sun disc

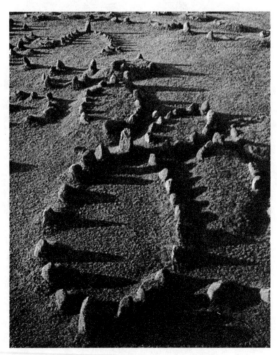

Viking stone burial arks
c. 500-100 CE

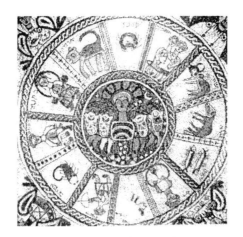

Helios and the zodiac
from a synagogue floor
at Beit Alpha, 6th century CE.

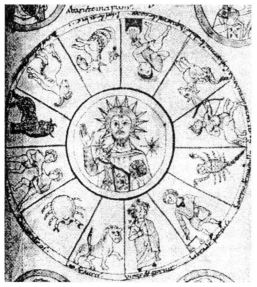

Christian Sun of Righteousness
surrounded by the zodiac,
11th century CE. (Seznec)

The God Sun

"O Sun, Ruler of all, Spirit of the world, Might of the world, Light of the world."

The god of day, or the god Sun, was the great god of the ancient world, and has been worshipped by every people on the globe; we shall find that it prevailed in both continents—the *old* as well as the *new* world, and was personified in all the sacred allegories, poetically described as suffering the destiny of mortals; everywhere read of the birth, death, and resurrection of the Sun; he had his cradle and tomb, whether called Adonis, Osiris, Hercules, Bacchus, Atys, Chrishna, Mithra, or Christ!

The Existence of Christ Disproved

Ancient peoples abundantly acknowledged that their religions, dating back centuries and millennia before the common era, were largely based on astrotheology, with their gods representing the sun, moon, stars and planets. One of their focuses was the sun, the benevolent luminary that gives its light and warmth so the world may continue to live and prosper. The Deity symbolized by the sun and its light has been the central point of religion worldwide, and the story of the sun became highly developed over a period of thousands of years, possibly tens of thousands or more. The observations of the sun and its daily, monthly, annual and precessional movements have led to complex myths in which it was personified as a god, usually male but sometimes female. Because of the sun's divine attributes, gods who may not have originated as solar heroes were eventually morphed or merged into sun gods. Also, the countless names for the sun based on its positions and characteristics were likewise personified as independent parts of the whole. Because the sun was regarded as responsible for so many events on Earth, it was considered not only divine but also practically omnipotent. Hence, the many gods, although performing different tasks, were nonetheless considered "sun gods" or "gods of the sun," who, combined, could be called the "God Sun."

Over a century ago, Prof. Max Müller elegantly described the pervasive sun worship of the ancients:

What position the sun must have occupied in the thoughts of the early dwellers on earth, we shall never be able to fully understand. Not even the most recent scientific discoveries described in Tyndall's genuine eloquence, which teach us how we live, and move, and have our being in the sun, how we burn it, how we breathe it, how we feed on it—give us any idea of what this source of light and life, this silent traveler, this majestic ruler, this departing friend or dying hero, in his daily or yearly course, was to the awakening consciousness of mankind. People

wonder why so much of the old mythology, the daily talk...was solar; what else could it have been? The names of the sun are endless, and so are his stories; but who he was, whence he came and whither he went, remained a mystery from beginning to end.[1]

The ancient reverence of the sun was likewise recounted by *Christian Mythology Unveiled* ("CMU"):

...the *Sun* was looked up to as the grand omnipotent nucleus, whose all-vivifying power is the vital and sole source of animative and vegetative existence upon the globe—the glorious foundation out of which springs all that man ever has, or ever can call good; and as such, the only proper object of the homage and adoration of mankind: hence the Sun, as we are informed by Pausanias, was worshipped at Eleusis under the name of "The Saviour."[2]

The sun was not only the Grand Architect and Logos but also the "Ruler," "Savior" and "Omnipotent Nucleus" who controlled human destiny. Deemed the "Primeval Being," the sun was the "God of gods," the "King of kings," all-powerful, all-encompassing, and representative of the "Universal Mind." The sun, or the "Great Father," and the moon, the "Great Mother," were mankind's "ancestors" and "benefactors."

Although it is perceived as being solely polytheistic, solar religion also represents a sort of "pantheistic monotheism," as well as monism. As Wilder says, "That the Supreme Being is One and Absolute is the leading principle of every ancient faith, however bizarre and polytheistic it may be esteemed."[3] The sun was therefore not simply one of the gods: It was for long periods *the* God, and any other god paled in comparison. In fact, other gods continually acquired solar attributes as empowerments without which they were feeble, such as light, heat, healing and fecundity—all divine gifts from the sun. The sun is the divine lamp, whose beauty and glory were extolled by the poets. " As the "Lord of lights," the sun drives away the darkness and illuminates the earth.[4] The sun, as the provider of rain, light and heat, is the source of fertility, vegetation and life itself. As the god presiding over agriculture and animal husbandry, "he" is the Cowherd, the Shepherd and the Pastor.

In many cultures, the sun has been considered not only the "savior" but also the great healer and physician, of both bodily and spiritual illnesses. The sun has also been believed to prevent nightmares and protect against demons. He (or she) is the bringer of good fortune, peace and prosperity. The sun was also the spiritual head and keeper of the mysteries. As Indian scholar V.C. Srivastava states in *Sun-Worship in Ancient India*, "it is said that as the Sun is veiled by his rays, similarly the ultimate reality is concealed in ignorance."[5] The sun officiates over betrothals and weddings, as well as initiations, including into the priesthood or

other mystery school/brotherhood. At such times, he is invoked through prayer and devotion; *daily* prayer is also commonly prescribed in the sun cult. Likewise, he is invoked during construction, of hearth and home, as well as destruction, when the body dies. The sun presides over death; he is the conveyor and purifier of the dead. The sun has been invoked as the Angel of Death against enemies, and, although mainly perceived as good and benevolent, in areas plagued with excessive heat he was considered evil and malicious as well.

Because of "his" regularity and reliability, the sun became viewed as the great judge and advocate, in whose presence the most solemn oaths were taken, important laws were created, and battles and sports contests were fought. The sun was also portrayed as responsible for the invention of writing and ciphers: In China, for example, some scholars have concluded that "sun images on the Neolithic pottery of the Da-wen-kou culture (4300-2500 BC) could have been the basis of primitive Chinese script."[6] Such solar images, including spirals, circles, wheels, dots, swastikas and haloes, are found on sculptures and petroglyphs around the world.

The kingly sun was also deemed the deity of royal families, many of whom claimed descent from him. Such assertions of ancestry in the sun, or "King of kings," were common in diverse places for millennia. For example, the first Egyptian dynasty was descended from the sun, and the Persian magi were offspring of Mithra, "the Lord Sun." The ancient Britons asserted that the sun god "Hu" was the "father of all mankind," and the Incas likewise were "children of the Sun." The Hindu rajahs claimed to be "children of the Sun" or "children of the Moon."[7] The Greeks portrayed themselves as a solar race descended from Helios or Apollo, while the Sumerians and Semites in Mesopotamia alleged the same, the latter as the progeny of the sun god Shamash.[8] In Africa and the Americas, various cultures likewise asserted the sun as their divine progenitor. In the same manner, conquering rulers laying claim to the throne sought to unify their realms under the all-encompassing light of the sun by emphasizing the solar cult as the highest form of religion and the sun god as the chief deity.

Ancient sun worship is found abundantly in story and stone, even though little is taught about it today. There is a reason for this omission, as this astrotheological knowledge reveals the origins of the most cherished religions of today. Despite the submersion of its pervasiveness and importance, we can find attestation to sun worship in numerous authorities, dating to the centuries before the common era, such as Epicharmos, Prodikos, Herodotus, Diodorus and Caesar. Concerning another such

writer, the Greek Empedocles (c.490-430 BCE), Clement of Alexandria relates in *The Stromata* (V.VIII):

> Empedocles says: "But come now, first will I speak of the Sun, the first principle of all things, From which all, that we look upon, has sprung. Both earth, and billowy deep, and humid air; Titan and Ether too, which binds all things around."[9]

In the first century CE, the Alexandrian stoic, philosopher and tutor of Nero, Chairemon or Chaeremon, "declared the Sun to be the Creator or Demiurgos."[10] In the same era, the "Jewish Plato," Philo, developed his personified solar Logos, which made its way into Christianity as a principal concept. Plato and Ptolemy (2nd cent. CE) are two ancient sources whose works should also be consulted for edification about astrotheology.

Clement of Alexander, Greek Theologian and Church Father (105?-215? CE)

The reverence of the sun as the visible representative of Deity continued well into the Christian era, as is evidenced by the admonishment against it by Church authorities. In his *Exhortation to the Heathen*, Clement Alexandrinus proscribes sun worship, demonstrating how prevalent it was; he nevertheless equates the "Word" with the "Sun of the soul." In Chapter IV, Clement exhorts his readers not to worship the sun but to turn to its Maker. Chapter VI discusses Menander (c 342-292 BCE), an Athenian playwright who "had fallen into error" when he claimed the sun as the "first of gods." With his comment that Menander had "fallen into error," Clement is obviously attempting a philosophical polemic to win converts, as, far from being in error, Menander had accurately reflected the sun worship of his people and era.

Porphyry, Greek Scholar and Neoplatonic Philosopher (c. 235-c. 305 CE)

Despite the exhortations by Clement and others, sun worship in the Roman Empire remained popular for centuries, as attested by a number of writers, including Porphyry, the Greek Neoplatonist of the 3rd century. Porphyry is known for his pro-pagan, anti-Christian work *Adversus Christianos* (*Against Christianity*), and for other writings now lost. Only fragments of Porphyry's work survive, including those of *Against Christianity* theorized to be contained in the writings of the Christian teacher Macarius Magnes's work of the 4th-5th century, recently edited and translated by R. Joseph Hoffmann. Fragments are also found in Church historian Eusebius's "Preparation for the Gospel." Such excerpts demonstrate that a learned individual of the day was quite aware of sun worship.

Eusebius relates Porphyry as explaining various sun gods, specifically personifications according to the sun's positions and characteristics. In his explanation, Porphyry discusses the ancient Greeks and their perception of divine power, ascribing such power to the sun, which was called Apollo. When the sun "wards off the evils of the earth," he is called Herakles/Hercules, and his twelve labors represent the signs of the zodiac, so says Porphyry. The healing power of the sun is called Asclepius, who carries a staff with a serpent around it. Citing etymologies for these various solar names, Porphyry continues with Dionysus, who represents the "fiery power of his revolving and circling motion, whereby he ripens the corps." The sun is termed Horus when he "revolves around the cosmical seasons (*hôras*)." As the ruler over agriculture—part of the Greek myth of Demeter and Kore—the winter solstice sun is Pluto/Hades, whose array includes a purple tunic and a scepter. The three-headed dog Cerberus represents the sun at morning, noon and night.

Porphyry likewise discusses the moon, as Artemis, the virgin, who "presides over childbirth, because the power of the new moon is helpful to parturition." He further says that Apollo is to the sun what "Athena is to the moon: for the moon is a symbol of wisdom..."[11] In addition, not only is the moon goddess a virgin but so too is the earth goddess or Gaia. She is nevertheless the Great Mother, a fact to be kept in mind for further discussion.

Eusebius also quotes Porphyry as referring to the "Orphic hymns," remarking of the Greek sky-god Zeus: "His eyes the Sun, the Moon's responsive light," verifying the ancient idea of the sun and moon as the eyes of the Divine.[12] This Orphic hymn also refers to the Earth as the "all-mother," demonstrating the antiquity of the concept of the earth goddess as well. In Porphyry's writings it is clear that "Zeus" is not just some anthropomorphic comic-book character, as he has been made out to be during the Christian era, but that he was essentially the same monotheistic god as found in Judaism, as well as in India, Egypt and elsewhere. Porphyry calls Zeus the "whole world" and "god of gods," as well as the mind by which his thought creates "all things."

Porphyry's etymology is fanciful, according to strict scientific standards; yet, one may presume, in fairness to his evident intelligence and erudition, that he was relating a true development in solar mythology. It must be emphasized that there are no hard and fast rules in religion, which is essentially mythology, a science highly imaginative and creative. Also, writers such as Porphyry likely were initiates into one or more mystery schools and secret societies, and thus relate esoteric information, such as deliberately created plays-on-words, based not

necessarily on those words' primary meanings and origins. The point needs to be made that ancient accounts are recited here principally to demonstrate, or, rather, to *prove*, that astrotheology has been the predominant religion of many peoples for millennia, and that numerous gods were at one time or another sun gods, solar heroes and aspects of the sun. Porphyry's words also serve to demonstrate that the ancients, far from being nincompoops who needed modern geniuses to come along and correct them, were well aware of what they were worshipping and revering.

Porphyry was evidently part of a concerted effort to make sense of the numerous sun gods around the world at the time, including providing explanations as to why they were called different names. Such efforts, as well as those of the Gnostics, assisted in a gradual unification process of the peoples of the Roman Empire and, eventually—as well as ironically, considering Porphyry's dislike of Christianity—culminated in the creation of Christianity. Since the Greek philosopher's comments occurred in a polemic against Christianity, it is possible that he was discussing these sun gods in comparison to Christ, which may be why his work only survives in fragments. As a synthesizing effort, Porphyry's work is interesting and satisfying, and evidently not far off the mark as a reconstruction of the sophisticated ideology, or astrotheological ritual and mythos, of eons past.

Iamblichus, Syrian Neoplatonic Philosopher (c. 280-c. 330 CE)

Despite the vast war of destruction waged for centuries against pre-Christian culture, the works of ancient authors and other archaeological evidence fortunately remain abundant enough that basic reconstruction of the ancient religion is possible to a large extent. One of these works is *Theurgia* or *On the Mysteries of Egypt* by Iamblichus, a Syrian writer knowledgeable about Chaldean astrotheology, and one of Porphyry's students. In this thick book, Iamblichus gives a long and detailed explanation of the minutiae that constituted much of the famous mysteries, or esoteric religion. The mysteries, naturally, also were not "set in stone" (although they *were* built into magnificent stone monuments around the world), but changed from era to era and culture to culture. Nevertheless, there has been a basic theme. Iamblichus's work sounds very "Gnostic," but represents knowledge that predates the Gnosticism of the first centuries CE. Insofar as the pre-Christian "gnosis," meaning "revealed knowledge," was the esoteric thread that tied religions together, it would be accurate to describe Iamblichus's writings as Gnostic.

With the development of the alphabet and writing materials such as papyrus, leaves and skins, it was bound to happen that

the ancient mysteries would be turned inside out, as increasing numbers of writers recorded them. In a time when books were expensive and scarce, processed by hand, secrecy from the masses at large could still be maintained, so the "lips" could be loosened somewhat. But, the mysteries had always been hiding in the open, in texts and myths, rituals, incantations, statues, icons and edifices, for centuries and millennia. The key to their decoding was essentially astrotheology and its permutations, including, of course, eternal life and complex levels beyond the third dimension, populated by all sorts of beings. In this regard, Iamblichus lays out the levels of the Egyptian Theosophers beginning with the "First Cause" or "Mind," whether alone or with others, "whether unbodied or embodied, whether the very same as the Creator of the Universe," whom he names as the "Demiurgos," a term employed by the Gnostics to connote the "god of this world." Iamblichus further discusses "Primal Matter" and mentions the Egyptian gods and "those called Planets, those that make up the Zodiac," as well as the rising signs and decans. He refers to those entities called the "Mighty Leaders," whose names are "preserved in the Almanacs." The "Sun-God," says Iamblichus, was also the "Demiurgos, or Creator of the Universe," while Osiris and Isis, "and all the Sacred Legends may be interpreted as relating to the stars, their phases..."[13]

Iamblichus's statements could not be clearer: The ancient religion constitutes nature worship and astrotheology, and the sun was considered the "Creator of the Universe" or the "Demiurge." Considering that the Demiurge came to be viewed as "inferior" to the "Supreme God" and was, in fact, disparaged in "formal" Gnosticism, it is not surprising that the sun itself began to lose its luster as a divine entity. Yet, its worship would continue for centuries, until it became veiled in the major religions of today, especially Hinduism, Buddhism and Christianity, which essentially represent solar cults, while Judaism and Islam are basically lunar.

In a section entitled, "THE SUN THE SOURCE OF ENERGY," Iamblichus writes: "Every department of the sky, every sign of the zodiac, every celestial course, every period of time according to which the world is put in motion, and all perfect things receive the forces which go forth from the Sun." He then discusses the nature of these forces and their effects on their "receivers," ostensibly explaining how there came to be "One God" with myriad forms. Iamblichus then reveals that the Sun changes according to the zodiacal signs and the seasons, and that the reverence of the sun is part of the Mysteries.[14] Iamblichus speaks frequently of the "gods of the sky," including the "Sun-King," the Moon, etc. He makes it clear that the Egyptian Mysteries, i.e., the

esoteric Egyptian religion, are astrotheological. As noted, within this mysteries astrotheology are multiple levels, such as those expressed in Gnosticism, with its Demiurge, Archons, Pleroma, etc.

Julian, Roman Emperor (c. 331-363 BCE)

The half-brother of infamous Roman Emperor Constantine, short-lived Emperor Julian was called "the Apostate" because he was born a Christian but renounced Christianity and became a Pagan, making Paganism the state religion and restoring Pagan rights and rites. An assassination attempt allegedly was made on Julian by some of his Christian soldiers, whom he supposedly forgave. It is claimed that Julian eventually was killed in battle with the Persians. However, Christians claimed that his death was "predicted" in a "dream," ordered by Christ and executed by "St. Mercurius," by which is probably meant that he was murdered by Christians, the pretext of the Persian battle used to cover up the crime. The Mercurius tale was told in the sixth century by Christian writer John Malalas (Chronicle 13.25), who related that the bishop of Caesarea, Basil, had seen the heavens open and "the Savior Christ seated on a throne" loudly commanding Mercurius to kill Julian, "who is against the Christians." Mercurius, "standing before the Lord," with a "gleaming iron breast-plate," disappeared and reappeared in a flash, saying the dirty deed had been done, "as you commanded, Lord."[15] Basil awoke in a fright, as he had some respect for Julian, only to discover the emperor had already been killed. The bishop's fellow churchmen exhorted him to tell no one of his "prophetic" dream. The important Christian text the *Chronicon Paschale* or Paschal Chronicle repeats the same tale. Interestingly, "St. Mercurius" is probably the god Mercury, traditional messenger of the sun. Concerning the death of Julian, Daniel Foss says: "The assassination of the Emperor Julian has not been solved to this day; not even the direction of the fatal arrow is agreed upon: whether from the Persian enemy or his own soldiers."[16]

Julian was an educated person who wrote eloquently, devoting writings to the sun, such as "Hymn to King Helios," the object of worship within his Pagan faith. Julian was also very much a leader of the people, as he opposed the elite and reduced the government, acts that made him powerful enemies.

Macrobius, Roman Scholar (fl. 400 CE)

In the 5th century CE, Latin writer Ambrosius Theodosius Macrobius explained many of the popular gods as solar deities or personified aspects of the sun. Macrobius was possibly a

Christian, by virtue of the fact that he was an "office holder" within the Roman Empire, which required conformity to the new state religion. His works, however, "contain no reference to Christianity" but address the world at large, including the status of several of the more cherished Pagan gods. It is from Macrobius that a large part of our knowledge regarding the solar religion comes. Macrobius was admittedly an expert in the religions of the day, such that his opinions are well founded that "all the gods of Greek and Roman mythology represents the attributes of one supreme divine power—the sun."[17]

Macrobius's most famous book, *The Saturnalia*, consists of a fictional conversation among 12 individuals, half of whom are "prominent members of the Roman nobility," including some who opposed Christianity in "real life." *The Saturnalia* was fortunately preserved throughout the Dark Ages and the Inquisition, apparently not making it on the infamous Index that allowed Catholic fanatics to burn books by the hundreds of thousands, if not millions. In the Middle Ages, *The Saturnalia* enjoyed a revival, as numerous writers were inspired by it and referred to it, particularly with the Christ-myth research beginning in the 18th century.

In *The Saturnalia* lecture on solar mythology and gods, Macrobius's characters discuss the many faces of the sun, believed in by the "men of old" to guide and direct "the rest of the heavenly lights." The conversation includes the Assyrian sun god Adad, the "highest and greatest of the gods," whose consort, Adargatis, is the moon. Also recorded are Orphic verses in which "Orpheus too bears witness to the all-embracing nature of the sun," focusing on his role as "Zeus Dionysus, Father of sea, Father of land, Sun, source of all life, all-gleaming with thy golden light."[18] Per Macrobius, the sun as Apollo is called "Liber," a Roman title that means liberty or freedom and that was applied to the Greek god Dionysus as well." Apollo, Macrobius relates, is the power of the sun that "presides over prophecy and healing," thus explaining his name, for which Macrobius gives an etymology different than Porphyry. [19] These names and titles for the sun are among a host of others, including those already provided by Porphyry, some of which are clarified by Macrobius as borrowed from the "secret places of philosophy," evidently referring to the mysteries. Certain names such as Apollo likely come from much older sources, possibly from peoples extinct by Macrobius's day.

Macrobius continues discussing the healing aspects of the sun, with its "kindly warmth," which conveys "health to everything that has breath." On the other hand, the sun at times

sends a "deadly pestilence by its darting rays." Mostly, however, the sun was the great healer and savior:

> ...for they call the god Iηιος [Ieios] and Παιαν [Paian]. And these names fit each activity, for in the one context Iηιος is derived from ιασθαι [iasthai], to heal... Indeed, it is customary in a prayer for health to pronounce the words ιη [IE]...Παιαν, meaning "Heal, O God of Healing"...

> Apollodorus [2nd century BCE], writing in the fourteenth Book of this treatise *On the Gods,* calls the sun Iηιος, and says that Apollos gets this name from the sun's moving (ιεσθαι) [iesthai] and going rapidly (ιεναι) [ienai] through its circuit...[20]

The word "IE" found at the sanctuary of Delphi refers to the sun god Apollo. It is well known that Dionysus was given the epithet of "IES," prior to the common era. With the Latin terminus "us," the word becomes Iesus, or *Jesus.* It is apparent that the (sun) god of healing was already called Ieios, Iesios or Iesus *before* the Christian era. It is also evident that practically all of the most powerful gods of the Roman Empire and beyond were in the main sun gods or possessed solar attributes.

St. John of Damascus, Syrian Father and Doctor of the Church (c. 675-749 CE)

In the 7th century, well into the Christian era, St. John of Damascus wrote a long treatise on astrology in Book II of his *An Exact Exposition of the Orthodox Faith.* The prologue of the translation by Michael Lequien indicates that these "*mysteries* of the orthodox faith" upon which St. John is expounding are not so much his but those of "Gregory the Theologian," i.e., St. Gregory of Nazianzus (329-390).

In his Exposition of these mysteries, John discusses the nature of God, who "created the ages Who Himself was before the ages..." He then writes about the different types of ages, leading into a discussion of astrology, noting that there are those who "have thought that the heaven encircles the universe and has the form of a sphere." John further addresses the planets: "For there are said to be seven planets: Sol, Luna, Jupiter, Mercury, Mars, Venus and Saturn." The Damascene saint disputes the notion that, per interpretation of scripture by other Christians, these luminaries are animate, calling them "inanimate and insensible."[21]

Nevertheless, John next says that "when we contemplate their beauty we praise the Maker as the Master-Craftsman." He goes on to describe the course of the sun, which creates the four seasons, explaining the equinoxes and solstices. Concerning the autumnal equinox and winter solstice, John states:

This season, again, is equinoctial, both day and night consisting of twelve hours, and it lasts from September 25th till December 25th. And when the rising of the sun sinks to its smallest and lowest point, i.e. the south, winter is reached, with its cold and moisture.

St. John then discusses the sun's role as the maker of the seasons as well as the day and night. He is aware that it is the sun's light that reflects off the moon and stars. John is also knowledgeable about the constellations and planets:

Further, they say that there are in the heaven twelve signs made by the stars, and that these move in an opposite direction to the sun and moon, and the other five planets, and that the seven planets pass across these twelve signs. Further, the sun makes a complete month in each sign and traverses the twelve signs in the same number of months.

Subsequently, John provides a list of each sign, with its appropriate zodiacal name and month. He then argues against the influence of astrology upon human lives. In an attempt to rationalize the "Star of Bethlehem," however, John must resort to sophistry, since the motif could not possibly be astrological if, as the saint insists, astrology is false. Thus, he claims that it was not a star but a comet and that such portents are not fixed but appear and disappear by divine will; hence, that which "the Magi saw at the birth of the Friend and Saviour of man, our Lord, who became flesh for our sake" is one of those that divinely emerged and melted away. St. John proceeds to delve into deeper astrology, describing the divisions of the zodiac, the lengths of solar and lunar months and years, the phases of the moon, etc. It is obvious that he was more knowledgeable about the subject than the average medievalist. In addition, his use of a masonic term "master-craftsman" is noteworthy. It is likewise obvious that, centuries into the common era, "Pagan" astrotheology continued to be a subject well known to the literate elite.

Francis of Assisi, Saint and Catholic Mystic (c.1181-1126 CE)

Even the beloved St. Francis of Assisi, founder of the order of Franciscans monks, understood the power of "nature-worship" and its place in the history of religion. One of Francis's most famous writings, the *Canticle of Brother Sun*, is a paean to the "Brother Sun," "Sister Moon," "Brother Wind" and "Sister Death," as "gifts from God."[22] The famous hymn "All Things Bright and Beautiful" was based on St. Francis's perception of the entire cosmos as divine.

Marsilio Ficino, Italian Neoplatonic Philosopher (1433-1499 CE)

Written at the end of the 15th century CE, Marsilio Ficino's *The Book of the Sun*, or *De Sole*, demonstrates that the sun worship of the ancients was still well known, almost a millennium and a half into the Christian era—and in midst of the Inquisition, albeit during a time when its ferocity had lessened. Nevertheless, Ficino was well aware of the dangerous waters he treaded with the Church: The Italian philosopher wrote an "Apology" to Philippo Valori, the pope's ambassador from Florence, entreating Valori "to defend him against future accusations of heresy stemming from his two little 'solar' works (*De Sole* and *De Lumine*)."

In the Preface to *The Book of the Sun*, Ficino expresses his purpose:

> I am daily pursuing a new interpretation of Plato... Therefore when lately I came to that Platonic mystery where he most exquisitely compares the Sun to God Himself, it seemed right to explain so great a matter somewhat more fully, especially since our Dionysius the Areopagite, the first of the Platonists, whose interpretation I hold in my hands, freely embraces a similar comparison of the Sun to God.[23]

In this statement, Ficino discusses two ancient sources: one from the 4th century BCE (Plato), and one from the 6th century CE (Dionysius), the latter of whom is a Christian, although, interestingly, Ficino considers him the "first of the Platonists," demonstrating the connection between Platonism and Christianity. Obviously, then, it was well understood that the sun was considered to be "God" at an early period, and that Christians themselves were conscious of the ancient significance of the sun. In reality, from the beginning Christians styled their savior "sol nostrum"—"our sun"—as well as "the sun of righteousness," as was the Messiah's title per the biblical book of Malachi, which leads into the New Testament.

In chapter II of *De Sole*, called, "How the Light of the Sun is Similar to Goodness Itself, Namely, God," Ficino says:

> Above all the Sun is most able to signify to you God himself. The Sun offers you signs, and who would dare to call the Sun false? Finally, the invisible things of God, that is to say, the angelic spirits, can be most powerfully seen by the intellect through the stars, and indeed even eternal things—the virtue and divinity of God—can be seen through the Sun.

It is important to remember that this writer was in a *Catholic* country, under the threat of the Inquisition. Yet, he was able to express the ancient perception of "God," as well as the pervasiveness and depth of sun worship. Knowing this fact, it is obvious that not only did sun worship permeate the world even

up to the 15th century, within the supposedly "non-Pagan" religions, but that the Christian elite were quite aware of it. Thus, it should come as no surprise that the foundation of religion in general and Christianity in specific is based on the *Sun* of God.

Ficino's chapter III is entitled, "The Sun, the Light-Giver, Lord and Moderator of Heavenly Things." In this chapter, he writes:

> The Sun, in that it is clearly lord of the sky, rules and moderates all truly celestial things... Firstly, it infuses light into all the stars, whether they have a tiny light of their own (as some people suspect), or no light at all (as very many think). Next, through the twelve signs of the zodiac, it is called living, as Abraham and Haly say, and that sign which the Sun invigorates actually appears to be alive. Moreover, the Sun fills the two adjacent signs with so much potency, that this space on both sides is called by the Arabs the *ductoria* of the Sun—that is the solar field. When the planets pass through them, avoiding being burnt up in the meantime, they acquire a marvellous power, especially if the superior planets, finding themselves in this position, rise before the Sun and the inferior ones after the Sun. The sign in which the Sun is exalted, that is Aries, in this way becomes the head of the signs, signifying the head in any living thing. Also, that sign in which the Sun is domiciled, that is Leo, is the heart of the signs, and so rules the heart in any living thing. For when the Sun enters Leo, it extinguishes in many regions the epidemic of the Python's poison. Moreover the yearly fortune of the whole world will always depend on the entry of the Sun into Aries, and hence from this the nature of any spring may properly be judged; just as the quality of summer is judged from the ingress of the Sun into Cancer, or that of autumn from its entrance into Libra, and from the coming into Capricorn the quality of winter is discovered; these things are gleaned from the figure of the heavens present at that time. Since time depends on motion, the Sun distinguishes the four seasons of the year through the four cardinal signs. Similarly when the Sun returns by the exact degree and minute to its place in the nativity of any person, his share of fortune is unfolded through the whole year. It happens in this way because the movement of the Sun as the first and chief of the planets is very simple (as Aristotle says), neither falling away from the middle of the Zodiac as the others do, nor retrograding.

In this analysis, Ficino confirms that astrology and the zodiac were not recent developments and that Arabs (Sabeans) were also knowledgeable about the "godlike science." He once again demonstrates that the sun is "clearly lord of the sky." Ficino continues to discuss the influence of the sun on the planets, saying, "When Venus and Mercury touch the Sun, if then they are direct, that is, obeying their Lord, they ascend to their heights.... For what is the light of the Moon if not the selfsame light of the

Sun sent to her and reflected in the lunar mirror." Thus, Ficino expresses the ancient perception that the sun was the Lord of the heavens, ruling over the various planets and stars. He also acknowledges the old comprehension that the moon did not contain light of "her" own but reflected the light of the sun. This scientific fact has been known for millennia, further revealing how developed was the ancient astrology/astrotheology. Ficino further writes that the Moon and Venus are the "feminine planets," and that the Moon is the "lady of generation." Once again appears an acknowledgement that the moon was considered "feminine," as was the planet Venus: These two celestial bodies were deemed goddesses in numerous cultures millennia ago. In fact, the lunar "lady of generation" was regarded as the "Virgin Mother" of the "Sun of God."

In chapter V, Ficino notes that astrologers call the Sun "God" and the Moon "Goddess." Not only are these celestial luminaries considered the Divinity Itself, the bearers of heavenly gifts, but also the sun, relates Ficino, is "like a prophet," who, upon rising, "is thought to bring prophecies to those who sleep." The moon is likewise a healer, whose curative strength is dependent on how much of the sun's light "she" mirrors.

In chapter VI, entitled, "The Praises of the Ancients for the Sun, and How the Celestial Powers are all Found in the Sun, and Derive from the Sun," Ficino quotes the Hymns of Orpheus, which represent a very ancient perspective:

> The Sun is the eternal eye seeing all things, the pre-eminent celestial light, moderating heavenly and worldly things, leading or drawing the harmonious course of the world, the Lord of the world, immortal Jupiter, the eye of the world circling round everywhere, possessing the original imprint in whose image all worldly forms are made. The Moon is pregnant with the stars, the Moon is queen of the stars.

Ficino further recounts that "the Sun is lord of all elemental virtues. The Moon by virtue of the Sun is the lady of generation." He also confirms that the Chaldean astronomy/astrology was heliocentric: "The Chaldeans put the Sun in the middle of the planets."

Ficino also calls the Sun "the King," and observes that the "old physicians" termed it the "heart of heaven." He then states that Heraclitus (c. 540-c. 475 BCE) deemed the sun the "fountain of celestial light" and that "Most Platonists located the world soul in the Sun."

In chapter VII, Ficino reiterates that the sun is "the king," and says that the moon is both the sister and wife of the sun, the "queen of heavenly things." Ficino calls the sun the "moderator of the whole," and in chapter VIII, relates that the astronomer

Ptolemy (1ˢᵗ cent. CE) deemed the sun and moon the "authors of life." Next we proceed to chapter IX, where the pervasive sun worship of the ancients could not be more clearly spelled out:

> *Chapter IX: The Sun is the Image of God. Comparisons of the Sun to God*

> Having very diligently considered these things, our divine Plato named the Sun the visible son of Goodness itself. He also thought that the Sun was the manifest symbol of God, placed by God himself in this worldly temple... Plato and Plotinus [205-270 CE] said that the ancients venerated this Sun as God. The ancient gentile theologians placed all their gods in the Sun, to which Iamblichus, Julian and Macrobius testify. Certainly whoever does not view the Sun in the world as the image and minister of God, has certainly never reflected upon the night, nor looked upon the rising Sun... But when Plato says that the Sun prevails over the whole visible realm, doubtless he alludes to an incorporeal Sun above the corporeal one—that is, the divine intellect.... In this way, in proportion to the strength you receive from the Sun, you will almost seem to have found God, who placed his tabernacle in the Sun.

Chapter IX also contains the inevitable comparison of the Lord Sun with the Lord Jesus Christ, an identification appropriately common among early Christian writers and, as evidenced by Ficino, long afterwards. Says the Italian philosopher:

> Hence Apollo pierces the dense body of the Python with the stings of his rays, purges it, dissolves it and raises it up. Nor must we forget that in whatever manner we hope that Christ will finally come into his kingdom, resurrecting human bodies from the earth with the splendour of his own body, similarly after the yearly dead winter, we look forward to the Sun's reign in Aries, which will recall to life seeds of things on earth, as if suddenly reviving dead or half-alive animals to life and beauty.

Shall we call a spade a spade? Another comparison is to be found in chapter X, "The Sun was Created First...":

> Surely too Christ, the source of life, for whom the Sun mourned with covered face at midday, rose again from the dead at the hour and in the day of the Sun, and will restore to us intelligible light in the same way as the Sun gives us visible light?

In chapter XII, Ficino compares the sun to the "Divine Trinity and the Nine Orders of Angels": "There is nothing in the world more like the divine trinity than the Sun." He further calls the sun the "highest god."

While Ficino continually waxes about the divinity of the sun, in chapter XIII, entitled, "That the Sun is not to be worshipped as the Author of all Things," he distinguishes between the corporeal and incorporeal suns of the esoteric tradition. Says he:

According to Plato, [Socrates] called the Sun not God himself but the son of God. And I say not the first son of God, but a second and more visible son. For the first son of God is not this visible Sun, but another far superior intellect, namely the first one which only the intellect can contemplate.

Thus, throughout history the perception has been that the sun *is* God, the divine King, etc. Yet, the monotheistic-polytheistic-pantheistic knowledge or *gnosis* of the ancients, as well as the development of Christianity, made it necessary to create a slight and subtle distinction between God and his son/sun. This distinction was refined over the ages as the ancients determined that the sun's movements were too regular for it to be a sovereign entity; thus, it could not be autonomous and omnipotent. In any case, the sun is God *and* the son of God, deemed such centuries before the Christian era.

It is a fact that astrology has played a huge role in human culture, forming the basis of practically all major religions. But this fact is suppressed, denied and reacted to with vitriol and erroneous contentions. Although the evidence of astrotheology is found ubiquitously, this one little book by Ficino itself proves that the denial of astrological influence on religious thought is plainly wrong. The antiquity of astrology or astrotheology is also clear, in that the system explicated by Ficino is very sophisticated and mature, proof that it had been developed and refined over a long period of observation.

Jacob Bryant, Christian Scholar and Etymologist (fl. late 18th century CE)

In *A New System, or An Analysis of Ancient Mythology*, using copious ancient authorities in their original languages, Jacob Bryant traces numerous words to the sun, and establishes as his main thesis that an early solar race, the Amonians, Ammonians or Amonites, dispersed from the Egypt/Levant area throughout the known world of the time. Per Herodotus, the Ammonians/Amonians were followers of the Egyptian sun god Amon, Amen or Amun, and "Amonians" was a name by which Plutarch said the Egyptians called each other. The word Amon is broken down to Am-On, two ancient words that mean "sun." This Am-On, Bryant evinces, is the biblical Ham, "son of Noah." As a Christian and bibliolater, the anti-evemerist Bryant paradoxically found "real people" in biblical mythology, while forcefully pointing out that the gods of other cultures were not "real people":

The supposed heroes of the first ages in every country are equally fabulous. No such conquests were ever achieved, as are ascribed to Osiris, Dionysus, and Sesostris. The histories of Hercules and Perseus are equally void of truth.[24]

Despite his own evemerism with such biblical characters as
Ham, Bryant's thesis is sound that Ham is Am, as is his
contention that much human culture has come from the worship
or reverence of the sun as the "source of all things." Ham or Am is
essentially the same as the Canaanite Bal or Baal, another name
for the sun. The Am/Ham/Cham/Cam solar title, Bryant states,
specifies heat, and can be found in numerous other words. The
sun in Persia, Bryant reminds, is "Hama." He further remarks:
"This Deity was the Sun: and most of the ancient names will be
found to be an assemblage of titles, bestowed upon that
luminary."[25]

Bryant abundantly uses etymology to prove his points:

> The most common name for the Sun was San, and Son;
> expressed also Zan, Zon, and Zaan.... It is mentioned by
> [Hesychius] that the Indian Hercules, by which is always meant
> the chief Deity, was styled Dorsanes... The name Dorsanes is an
> abridgement of Ador San, or Ador-Sanes, that is Ador-Sol, *the
> lord of light*. It was a title conferred upon Ham...[26]

Bryant notes that the Egyptian priests were called "Sonchin,"
or "Son-Cohen"—priests of the sun. Thus, the English word "son"
is not a false cognate with "sun," and **it is truthfully said that
the "*son* of God" is the "*sun* of God."** This son-sun connection
can also be found in the Indian language: In tracing many Indo-
European and Vedic words to a common root, Roy proffers,
among others, the root "son," representing "sunu" in Vedic and
"son" in Indo-European.[27]

Another common title for the sun is Aur, Ur and Or, from
which comes Orus or Horus, the Egyptian sun god. Likewise is
the word El, Al or Eli a title for the sun, whence the Greek word
Helios, which is "Elion" in Canaanite, or "Eli-On," as in "El
Elyon," one of the Israelite gods. "Adam," per Bryant, is Ad-Ham,
two names for the sun. Indeed, Adam is Atum, the Egyptian sun
god. Bryant's extensive analysis continues through a variety of
gods and cultures, thoroughly demonstrating that sun
worship pervaded the ancient world.

The Solar Revolution

As can be seen abundantly, the ancient world was full of
"Amonian" religion, or sun worship, as attested by ancient and
more modern authorities alike. To the Greeks, for instance, the
worship of the solar orb was so important and sacred that it was
deemed blasphemy when rationalists began to declare that the
sun was not a divinity, and the philosopher Anaxagoras (c. 500-
428 BCE) was executed for teaching that the sun was a fiery,
lifeless mass of iron, "about the size of the Peloponnesus."[28] While

honored in numerous cultures, the sun as an object of worship is traceable in large part to the Chaldeans:

> The authorities do not agree as to the place where the worship of the Sun was introduced, but perhaps those who claim Chaldea as the birthplace of Sun worship have the best argument, as it is well known that the Chaldeans were the first who observed the motion of the heavenly bodies, and astrology flourished in this reign in the earliest times...
>
> The gods of the Canaanite nations, Moloch, Baal, Chemosh, Baalzebub, and Thammuz, were all personifications of the sun or the sun's rays, considered under one aspect or another. These cruel gods, to whom human sacrifices were offered, represented the strong fierce summer sun.
>
> Solar worship was the predominant feature of the religion of the Phoenicians, and the source of their mythology. Baal and Astoreth, their chief divinities, were unquestionably the Sun and Moon, and a great festival in honour of the Sun-God called "the awakening of Herakles," was held annually at Tyre, in February and March, representing the returning power of the Sun in spring. The Phoenician Sun-God Melkarth, belonged to the line of Bel or Baal, and was the tutelary divinity of the powerful city of Tyre. Melkarth personified the Sun of spring, gradually growing more and more powerful as it mounts to the skies...
>
> The hardy Tyrian navigators soon spread this solar worship from island to island even as far as Gades/Cadiz...
>
> The Phoenicians also adored the Supreme Being under the name of Bel-Samen, and it is a remarkable fact that the Irish peasants have a custom, when wishing a person good luck, to say, "the blessing of Bel, and the blessing of Sam-hain be with you," that is, of the Sun and Moon.[29]

Thus, the Tyrians or Phoenicians spread their version of sun worship as they progressed "from island to island," as far as the British Isles. The Phoenicians, whose astrologer-priests could be called Chaldeans, were basically also Amonians, although sun worship goes back thousands of years prior to the rise of the Phoenicians.

Amidst the numerous sun-worshipping peoples worldwide were developed complex stories recording the "exploits" of the sun god or sun gods, as the case may be. Indeed, the list is long of the sun gods, or *names of the God Sun*, of which we have already encountered many. In "The Myth of the Great Sun-Gods," Dr. Alvin Boyd Kuhn demonstrates how pervasive was the solar revolution by enumerating "some thirty of the chief figures known as Sun-gods." This list is confined to the Eastern Mediterranean "before the advent of Jesus" and includes the Egyptian Osiris, Horus, Serapis and Thoth (Hermes,) as well as "Khunsu, Atum

(Aten, Adon, the Adonis of Phrygia), Iusa, Iu-sa, [and] Iu-em-hetep." The Egyptian Aten was less anthropomorphic than other sun gods, depicted as the solar disc with hands on the ends of his rays extending to Earth.[30] Interestingly, this solar disc image was used by Christians to depict the biblical "God the Father."

Kuhn's list of Syrian sun gods includes "Atis, Sabazius, Zagreus, and Kybele (feminine)." In Assyria, we find Tammuz, while in Babylon appear "Marduk and Sargon." The Persian sun gods and solar heroes are "Mithra, Ahura-Mazda and the Zoroasters," while the sun gods of Greece are "Orpheus, Bacchus (Dionysus), Achilles, Hercules, Theseus, Perseus, Jason, and Prometheus." In Rome, of course, was Sol, as well as the numerous other gods outlined by Macrobius. Extending beyond the Mediterranean, Kuhn cites the Indian Vyasa, Krishna and Buddha, as well as the Tibetan Bodhisattvas, as sun gods.

Kuhn further relates that the central character in the "ancient Mystery Dramas" was "ever the Sun-god," whose role was "enacted by the candidate for initiation in person." Concerning the biblical religion, Kuhn remarks, "Moreover, the Patriarchs, Prophets, Priests and Kings of Biblical lore are no less Sun-god figures. For in their several characteristics they are seen to be typical of the Christos."[31] Hence, the sun is the Anointed or *Christos*, Greek for Christ. As we have seen, the sun was the "King of kings" and the patriarch of royalty, and many royal families and divine kings traced their lineage to "him."

The God Sun's pervasiveness explains the presence of the countless purported tombs of this god and that, which are so frequently held up as "proof" of the physical and historical existence of the god. As Dupuis says:

> ...hence those tombs erected everywhere to the Divinity of the Sun under various names. Hercules had his tomb at Cadiz, where his bones were shown. Jupiter had his tomb in Greece; Bacchus had his also; Osiris had a great many in Egypt. They exhibited at Delphi that of Apollo, where he was deposited, after having been put to death by the Serpent Python. Three women came to weep at his tomb, just like those three women who came to weep at the tomb of Christ....Apollo took also the title of Savior.[32]

Dupuis likewise discusses the tomb of the Babylonian sun god Belus, built under "an immense pyramid." There was also Zeus's tomb or death cave on Crete, the tomb of Mithra in Persia, "that of the Sun Christ in Palestine," etc. In addition are the three tombs of Isis and Osiris at Memphis, Philae and Nusa in Arabia.[33] Concerning this typical priestcraft, Dupuis remarks, "All these various tombs prove absolutely nothing in favor of the historic existence of these imaginary personages, to whom the mystical

spirit of the Ancients had dedicated them."[34] The bottom line is that there have been birth and death places of numerous gods in countless areas around the world, and such sites do *not* prove the historicity of the god.

One culture whose object of worship was overtly known to be the sun, such that we need not weed through reams of personified myths to arrive at the astrotheological core of its religion, was that of Peru, a country known for its high level of civilization and astonishing architectural and engineering works. The Peruvian Inca were one of the most overt astral and nature-worshipping cultures, epitomizing the ancient astrotheology. Their chief god was the sun, to whom in every city temples were built and liberal burnt offerings were made. The sun's wife was the moon goddess; the planet Venus or "Chasca," a curly-haired youth, was the sun's "page." Other elements such as thunder and lightning were "God's ministers," while the rainbow was a solar emanation, and wind, earth, mountains and rivers "inferior deities," as were also the gods of conquered nations.[35]

The Inca considered themselves the "true children" of the great God Sun, building a golden temple to him at Cuzco, which was called the "Holy City." Like Jerusalem, this Holy City received pilgrims from "every part of the empire." So serious did the Inca hold their sun worship that "blasphemy against the sun was considered as bad as treason against the Inca, and both were punished by death."[36] Moreover, a "province, or city, rebellious against the sun was laid waste, and its people exterminated." Conquered tribes were forced to worship the sun, and temples were thus built in their territories in which priests were established to compel the locals to conform to the Peruvian religion. The native deities were taken to Cuzco and installed in the temples as demigods under the great God Sun.

Of course, the Peruvians were not the only sun-worshipping cultures in the Americas, as the God Sun was the supreme deity throughout both the north and south continents. Concerning Central American sun worship, Spence relates:

> The sun was regarded by the Nahua, and indeed by all the Mexican and Central American peoples, as the supreme deity, or rather the principal source of subsistence and life. He was always alluded to as *the teotl, the* god, and his worship formed as it were a background to that of all the other gods.[37]

As we have seen, the Central American religion was very similar to that of the Near Eastern Semites. The Inca priesthood and government too were nearly identical to that of Judea/Judah, with Peru possessing "the most absolute theocracy the world has ever seen." The Inca government was all encompassing,

controlling every aspect of its citizens lives, much like the biblical priesthood. As it was under "the Law," with its picayune details concerning nearly every aspect of life, in the Inca empire "there was no such thing as personal freedom."[38] Again like the Yahwists, the Inca priesthood allowed no "independent theological thought."[39]

The association between the Hebrews and Inca is also apt because, like so many others, Yahweh was not only that "invisible, immaterial creator" but also a sun god. Citing evidence of the fiery, solar nature of biblical texts and characters, Kuhn remarks:

> Let us hear first the Psalms. "Our God is a living fire," say they; and "Our God is a consuming fire." "The Lord God is a sun," avers the same book. "I am come to send fire on earth," says Jesus, meaning he came to scatter the separated sparks of solar essence amongst mankind, a spark in each soul.... The New Testament Jesus, following the well-known Egyptian diagram of the Ankh, the solar disk with the spread wings, is described as "the sun of righteousness, risen with healing in his wings."... We are adjured to "Rise, shine, for thy light is come." "The Lord is my light," reiterates the Psalms. And again, "In thy light shall we see light." "Light is sown for the righteous."... John declares that the Christos "was the true light" which was to come Messianically for the redemption of our lower nature. And again he declares that with the Christos "light is come into the world."

While the Peruvians were blatant and open in their astrotheology and sun worship, the Jews were secretive and furtive in their own astrotheology. However, sun worship and astrotheology solve a number of biblical riddles, as CMU relates:

> Many of the apparently gross absurdities of the Bible are easily explained by the key of ancient astronomy. Indeed, all the principal personages of that book, as well as those of remote Pagan antiquity, whether ranking as deities or men, were either personifications of constellations, planets, seasons, or other natural objects, or their effects...[40]

Those who understood the mysteries, "such as Herodotus, Philo, Origen, etc., knew that the literal sense could not be true" and that biblical characters and motifs were allegorical. The great heroes of old were mere reflection of the "grand immaculate chieftain," the sun, who was styled "a thousand different names" but was "always adored as the omnipotent *Creator* and *Regulator*."[41] CMU further states, "That those polytheisms of the East, from which emanated Judaism and Christianity, had their root in astronomy, is proved by the most authentic sources," including Chaeremon, the famed Egyptian philosopher who discussed Osiris and Isis as "sacred fables" revolving around the

stars, the "course of the Sun through the zodiac," etc. Also cited is Porphyry, who explained that educated Egyptians admitted "the existence of no other gods except what are called the planets, etc." "Such," concludes CMU, "were the Egyptian and Chaldean roots of Christianity."[42]

As they did with Judaism, elements of the Incan religion also closely paralleled those found in Christianity, with some differences as well, such as that the Peruvian hell was only temporary:

> The Peruvians believed in the future existence of the soul and the resurrection of the body. They had faith in a Hell, located in the earth's centre, and a Heaven, in which the good would revel in a life of luxury, tranquility, and ease. The wicked, however, were not to be hopelessly damned and tormented for everlasting, but were to expiate their crimes by ages of wearisome labor.[43]

The Peruvian tradition provides us with a clear picture of unadulterated, uncorrupted sun-worship rituals. The four principal festivals occurred at the equinoxes and solstices, with the summer solstice—"Midsummer"—the most important, during which time everyone who could afford it made a pilgrimage to the capital city. Before the grand feast, the penitents would fast for three days, during which time no fires were lit. On the day of celebration, large numbers of people in their "Sunday best" surged into the city streets and squares, and looked for the rising sun. As the sun appeared over the horizon, the crowd let out shouts of joy, accompanied by rising music. Once the entire sun was visible above the horizon, a fermented libation was poured, and the royalty and nobility retired to the main temple. The celebration turned to prayer, after which were made sacrifices and offerings; at times a child or "lovely maiden" was immolated to commemorate a coronation, royal birth or conquest, but the sacrifice was never cannibalistic. The Inca, in fact, abolished cannibalism wherever they conquered. The favorite animal sacrifice was the llama, which was first slaughtered singly and then in "great numbers" during the holiday celebration. Next was a eucharist, concerning which Inman says:

> In the distribution of bread and wine at this high festival, the invading Spaniards saw a striking resemblance to the Christian communion, and they recognised a similar likeness in the Peruvian practices of confession and penance.

The Peruvians also had virginal nuns who lived sequestered in convents from a young age, in the care of "elderly matrons" who instructed them in typical nunnery arts such as the weaving and embroidering of temple tapestries. The inviolate state of the virgin was so valued that, if she was found to have been despoiled, she

was "buried alive, her lover was strangled, and the town or village to which he belonged was razed to the ground, and sowed with stones, to efface even the memory of its site."[44] In the final analysis, the Peruvian religion is the product of a typical solar culture, accompanied by rituals, rites myths and legends concerning the sun god and various other gods.

An archetypical and basic tale of the sun god can likewise be found in the following Slavonic solar myths, from the *New Larousse Encyclopedia of Mythology*. The Slavonic myths were chronicled late, beginning in the 6th century CE; yet, they represent, as *Larousse* says, "vestiges and memories of bygone periods, a fact which allows us to utilise the present in order to reconstruct the past."[45] *Larousse* continues:

> According to Slavonic myths and legends the Sun lived in the East, in a land of eternal summer and abundance. There he had his golden palace from which he emerged every morning in his luminous chariot, drawn by white horses who breathed fire, to cross the celestial vault.
>
> In a popular Polish tale the sun rode in a two-wheeled diamond chariot harnessed to twelve white horses with golden manes.
>
> In another legend the sun lived in a golden palace in the East. He made his journey in a car drawn by three horses, one silver, one golden and the third diamond.
>
> Among the Serbs the Sun was a young and handsome king. He lived in a kingdom of light and sat on a throne of gold and purple. At his side stood two beautiful virgins, Aurora of the Morning and Aurora of the Evening, seven judges (the planets) and seven "messengers" who flew across the universe in the guise of "stars with tails" (comets). Also present was the Sun's "bald uncle, old Myesyats" (or the moon).
>
> In Russian folklore the Sun possessed twelve kingdoms—the twelve months or signs of the Zodiac. He lived in the solar disk and his children on the stars. They were served by "solar daughters" who bathed them, looked after them and sang to them.
>
> The daily movement of the Sun across the celestial sphere was represented in certain Slavonic myths as a change in his age: the Sun was born every morning, appeared as a handsome child, reached maturity towards midday and died in the evening as an old man. The annual movement of the Sun was explained in an analogous fashion.
>
> Certain Slavonic myths and legends give an anthropomorphic interpretation to the relationship between the Sun and Moon. Though the name of the Moon—Myesyats—is masculine, many legends represent Myesyats as a young beauty whom the Sun

marries at the beginning of summer, abandons in winter, and returns to in spring.

The divine couple of the Sun and the Moon gave birth to the stars. When the pair were in a bad mood and not getting on well together an earthquake would result.

In other myths Myesyats is, on the contrary, the husband, and the Sun is his wife. A Ukrainian song speaks of the heavenly vault, "the great palace whose lord is bright Myesyats with his wife the bright Sun and their children the bright Stars."[46]

The Slavonic or Slavic culture is Indo-European, as illustrated by the linguistical connection to Sanskrit: For example, the Slavonic sky god is "Svarog," the root of which, *svar*, meaning "bright, clear," is "related to the Sanskrit."[47] A Slavic name for the sun god is "Dazhbog," wherein "bog" means "god" and "Dazh" is apparently related to the Sanskrit "Dyaus," referring to the sky-god father-figure, who is Zeus in Greek, Deus in Latin, Dieu in French and Dios in Spanish. Dazhbog, the Sun, is the "son of Svarog," the sky god, a classic astrotheological relationship. Another Slavic son of the sky is "*ogon* which can be compared to the Sanskrit *agni*..."[48] As can be seen, sun worship was not only common around the globe, but it weaves together many of the world's cultures. Astrotheology is thus a very important area of study not to be dismissed or ignored, as it unites the world's cultures beyond their superficial and perilous divisiveness.

After the works of Dupuis, Volney, Bryant, Cox and others became popular in the 18th and 19th centuries, it was said that scholarship on religion and mythology had become "sun-happy," with too much emphasis on the solar religion. Such an assertion is true to the extent that the main focus of their research was the sun, as opposed to the moon, earth, other planets and stars. However, even with the amount of research and writing that has been completed to date on ancient sun worship, the surface has barely been scratched as to its importance and depth in the creation of human culture. Moreover, how many of the six billion or so people alive today know much if anything about ancient sun worship? In reality, the work, study and current knowledge of today are not commensurate with even a fraction of the pervasiveness, influence and significance of sun worship worldwide for thousands of years. Sun worship was not just some passing fancy, limited to a handful of individuals. It affected numerous aspects of countless cultures globally. Entire civilizations, from their laws to their edifices and city plans, were constructed around it. Its Platonic evolution, which was a logical extension of the ideology of Egypt, where the sun became "mind," "logos" and "christos," led to the development of Christianity.

The antiquity of the myths and doctrines of the God Sun is well established. It is clear that, for ages before the Christian era, the sun was the first and foremost visible agent of divinity and was often equated with the Divine, or "God," Itself. This ancient sun worship was not something easily destroyed; indeed, it survives to this day in the various monolithic religions. There is simply no escaping that fact, no matter how sophistic and casuistic become the arguments, as, again, numerous cultures to this day, from coast to coast, can be traced to sun worship. Sun worship is everywhere present. It has permeated human culture and constituted much of human religion.

1 Müller, *LOGR*, 200.
2 *CMU*, 62.
3 Iamblichos, 67.
4 Srivastava, 193.
5 Srivastava, 113.
6 Singh, 62.
7 Olcott, 46-47.
8 Singh, 44.
9 www.newadvent.org/fathers/02105.htm
10 Iamblichos, 257.
11 www.cosmopolis.com/texts/porphyry-on-images.html
12 *vide* Spence, *AEML*, 97.
13 www.esotericarchives.com/oracle/iambl_th.htm
14 Iamblichos, 242.
15 www.ucc.ie/milmart/mercsrcs.html
16 www.anatomy.usyd.edu.au/danny/anthropology/anthro-
 1/archive/april-1996/0120.html
17 Macrobius, 5.
18 Macrobius, 152-153.
19 Macrobius, 114-116.
20 Macrobius, 116-117.
21 www.ccel.org/fathers2/NPNF2-09/Npnf2-09-29.htm
22 Pelikan, 138.
23 www.users.globalnet.co.uk/~alfar/ficino.htm
24 Bryant, I, x
25 Bryant, I, xv.
26 Bryant, I, 34-35.
27 Roy, 93.
28 Olcott, 137.
29 Olcott, 146-147.
30 Spence, *AEML*, 162.
31 www.magna.com.au/~prfbrown/ab_kuhn.html
32 Dupuis, 264.
33 Bryant, I, 461.
34 Dupuis, 111.
35 Inman, *AFM*, 55.
36 Inman, *AFM*, 54.

[37] Spence, *MMP*, 97.
[38] Spence, *MMP*, 260.
[39] Spence, *MMP*, 291.
[40] *CMU*, 86.
[41] *CMU*, 87.
[42] *CMU*, 88.
[43] Inman, *AFM*, 54-55.
[44] Inman, *AFM*, 57-59.
[45] *Larousse*, 281.
[46] *Larousse*, 284-285.
[47] *Larousse*, 283.
[48] *Larousse*, 284.

Solar petroglyphs,
Late Neolithic, Kashmir

Bronze Age sun god
petroglyph, Kyrzgyzstan

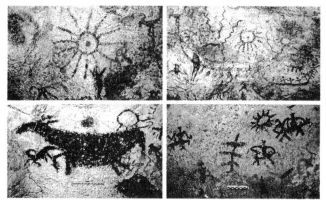

Prehistoric Indonesian solar petroglyphs. (Singh)

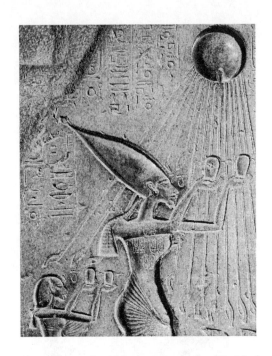

Egyptian Pharaoh Akhenaton and wife Nefertiri
revering the Sun God Aton,
whose rays end in hands,
14th century BCE

Greek Christians worshipping God,
who extends his hand, 10th century CE

Canaanite stela with hands raised to the sun,
13th-14th centuries BCE

Catholic magazine *Envoy* with
hands holding up the ancient
Pagan sun wafer used in the
Christian Eucharist, asking,
"Is This God?"

The Solar Pantheon

In the ancient world there was a very widespread belief in the sufferings and deaths of gods as being beneficial to man. Adonis, Attis, Dionysos, Herakles, Mithra, Osiris, and other deities, were all saviour-gods whose deaths were regarded as sacrifices made on behalf of mankind; and it is to be noticed that in almost every case there is clear evidence that the god sacrificed himself to himself.

Sir Arthur Weigall, *The Paganism in Our Christianity*

Osiris...was successively god of the Nile, a life-giver, a sun-god, god of justice and love, and finally a resurrected god who ruled in the afterlife.... The most popular legend about Osiris is one of a resurrected god. He was killed by Set, the god of darkness... Osiris was then resurrected and went to live on high.... Osiris became the first of a long line of resurrected deities—Tammuz, Mithras, Balder, Christ. Every spring the life of Osiris was re-enacted at Abydos in a stirring passion play, dating back to the eighteenth or nineteenth century before Christ. This play is the earliest record in history of drama.

Gerald L. Berry, *Religions of the World*

Osiris or the sun was now worshipped throughout the whole world, though under different names. He was the Mithra of the Persians, the Brahma of India, the Baal or Adonis of the Phoenicians, the Apollo of the Greeks, the Odin of Scandinavia, the Hu of the Britons, and the Baiwe of the Laplanders.

W. Winwood Reade, *The Veil of Isis; Or, Mysteries of the Druids*

Over the millennia, the great God Sun has been revered and worshipped around the globe, taking on many manifestations, depending on the solar aspect, as well as the ethnicity, race and other cultural factor of its devotees. In this regard, there have been numerous sun gods, with a variety of names and exploits. Despite the obliteration over the ages, there remains a significant amount of information regarding these gods; hence, we will address only the most salient to our present quest, as concisely as possible.

Osiris, God Sun

The Egyptian pantheon is highly important because Egyptian culture reached tremendous peaks and its influence has been found in much of the world over a period of centuries and millennia. Although it is perceived as a riotous "polytheism," the Egyptian religion was, like that of many cultures, polytheistic, pantheistic, monotheistic and henotheistic at once. In fact, it would be more accurate to refer to Egyptian *cultures* and *religions*, as these varied more or less widely over the thousands of years. As concerns Egypt's monotheism, famed Egyptologist E.

Wallis Budge related that a number of Egyptologists of his time "have come to the opinion that the dwellers in the Nile valley, from the earliest times, knew and worshipped one God, nameless, incomprehensible, and eternal."[1]

Polytheism and monotheism were "co-existent" in Egypt, flourishing "side by side" already in the 5th dynasty (25th century BCE), long before Akhenaton (14th century) and the Mosaic "discovery" of the "one god." Concerning the nature of the Egyptian religion, Budge also says:

> From a number of passages drawn from texts of all periods it is clear that the form in which God made himself manifest to man upon the earth was the sun, which the Egyptians called *Ra*...and that *all other gods and goddesses were forms of him.*[2]

Although Ra is the "chief" sun god, in the Egyptian pantheon sun gods "come before us in wild confusion," and numerous others possess solar attributes. In the "British Museum Papyrus" of the Egyptian *Book of the Dead*, parts of which may date to 7,000 years ago,[3] the God Sun Ra is called "the lord of heaven, the lord of earth, the king of righteousness, the lord of eternity, the prince of everlasting, ruler of gods all, god of life, maker of eternity, creator of heaven..."[4] The bulk of these epithets were later used to describe the Christian solar logos, Jesus. That the rest of the Egyptian pantheon were all forms of Ra or the sun means that they shared at least some of these divine attributes as well. A number of these gods were "sons of Ra," regarding whom Kuhn states: "In Egyptian scriptures the twelve sons of Ra (the twelve sons of Jacob, and the twelve tribes of Israel) were called the 'twelve saviors of the treasure of light.'"

One of the solar Ra's sons and remakes was the savior Osiris, who, along with his lunar wife, Isis, became two of the most popular gods ever conceived by the human mind. Worshipped in one form or another over a period of millennia, Osiris and Isis were widely esteemed in the ancient world, and entire cultures were established around them, including a huge amount of art and literature, as well as massive and magnificent edifices, sanctuaries and tombs, etc. Like today's supposed apparitions of "Jesus" and the "Virgin Mary," ancient gods such as Osiris and Isis often appeared to their numerous followers, centuries and millennia prior to the Christian era.

Osiris is thus a very old god, whose worship dated to thousands of years before the common era and who was one of the most powerful gods ever devised. As time went on, he took on the attributes of countless other gods and became the "king of kings" and "lord of lords," as he was called in the Egyptian texts. During the late 18th to early 19th dynasties (c. 1300 BCE), Osiris's

epithets included, "the king of eternity, the lord of everlastingness, who traverseth millions of years in the duration of his life, the firstborn son of the womb of Nut, begotten of Seb, the prince of gods and men, the god of gods, the king of kings, the lord of lords, the prince of princes, the governor of the world...whose existence is for everlasting."[5] At Osiris's birth a voice proclaimed, "The ruler of all the earth is born."[6] As can be seen, this exalted, divine status is entirely unoriginal with the Christian savior, as it long pre-dates Christ's purported advent.

On a stela dating from the 18th Dynasty (1570-1070 BCE) appears a hymn to Osiris that, per Christian Egyptologist Budge's translation, reads in part:

> Thou hast made this earth by thy hand, and the waters thereof, and the wind thereof, the herb thereof, all the cattle thereof, all the winged fowl thereof, all the fish thereof, all the creeping things thereof, and all the four-footed beasts thereof.[7]

The similarities between this passage as translated and the biblical creation account written centuries later are striking. In Genesis (1:24), "God" creates the earth and says:

> Let the earth bring forth living creatures according to their kinds; cattle and creeping things and beasts of the earth according to their kinds.

It is clear that Osiris was the Most High God of Creation, equivalent to Yahweh. Indeed, a Phoenician inscription invokes "Osiris Eloh," Eloh being "the name used by the Ten Tribes of Israel for the Elohim of Two Tribes."[8] The Hebrew "Elohim," a plural term, is used over 2600 times in the Hebrew Old Testament, translated most often as "God" in the singular.

It is not surprising that Genesis and other biblical texts, concepts and stories are largely Egyptian in origin, especially since Israel and Egypt are in such proximity. The historical, literary and archaeological evidence of the influence of Egypt on the Levant is abundant and includes the presence of Osiris in Israel. In an article in the *Biblical Archaeology Review* (5-6/00) entitled, "What's an Egyptian Temple Doing in Jerusalem?" Gabriel Barkay observes:

> The name of Osiris...appears on an inscribed stele fragment of reddish Nubia sandstone discovered at Hazor in northern Israel and on stelae found at Deir el-Balah, in the Gaza Strip. It seems that this Egyptian deity was especially popular in Canaan, when it was under Egyptian domination.[9]

Artifacts and historical records prove Egyptian presence and influence in the Levant, prior to the rise of the Hebrew/Israelite/Jewish people, and it is apparent that the Canaanite and Israelite peoples were infused with the Osirian myth, which thus affected

their own religions, including the Judaic offshoot, Christianity. Like Jesus, Osiris was once believed to have incarnated as a human savior who died and was resurrected for the good of mankind:

> ...Osiris has a human development. He is God in heaven and hell, but once appeared as man on earth...
>
> He is one of the Saviours or Deliverers of Humanity, to be found in almost all lands. As such, he is born into the world. He came, as a benefactor, to relieve man of trouble, to supply his wants.... In his efforts to do good, he encounters evil.... He is killed.... Osiris is buried. His tomb was the object of pilgrimage for thousands of years. But he did not rest in his grave. At the end of three days, or forty, he rose again, and ascended of heaven....[10]

In addition to the numerous Egyptian texts and the writings of Herodotus and Plutarch, one ancient source for information regarding Osiris and other Egyptian gods is Diodorus Siculus (c. 90-21 BCE), a contemporary of Julius Caesar and a Greek citizen of Sicily. Less than half of the 40 books he wrote still exist, with the others either allowed to perish or deliberately destroyed in the centuries of book-burning and general vandalism and mayhem committed by the Catholic Church and others. In his book *The Antiquities of Egypt*, Siculus first declares that Osiris is the sun and Isis the moon:

> Now when the ancient Egyptians, awestruck and wondering, turned their eyes to the heavens, they concluded that two gods, the sun and the moon, were primeval and eternal; and they called the former Osiris, the latter Isis...[11]

Siculus also relates, "Some of the early Greek mythologists call Osiris 'Dionysos,'" who, per the poet Eumolpos, shines like a star, "eyes aflame with rays."[12] Thus, Osiris is not only the "Sun-God of Amenti, the region of the dead"[13] but also "the Egyptian Bacchus" or Dionysus, the notorious Greek/Thracian god of the vine. Diodorus furthers states that, like Dionysus, Osiris is a "son of Zeus" who was raised at "Nysa, in Arabia Felix, not far from Egypt..."[14]

In telling the Osiris myth, Diodorus paradoxically lapses into the evemerist perspective that Osiris was a "real person" who walked the earth, did marvelous things, and then attained to immortality after death, as was later said of Christ, Osiris's "Jewish" counterpart. As a mortal, Osiris "conquered" India, where he "founded many cities," including another Nysa, where he planted ivy. Osiris "left in that country many other indications of his presence, by which the latter-day Indians were persuaded to claim the god and assert that he was born in India."[15] Rather

than representing the travels of a "real man," the tale records the *worship* of Osiris making its way to India and elsewhere in a remote age.

Furthermore, many scholars have claimed the spread of cultures occurred in the reverse direction, i.e., out of India. In any event, Osiris's presence in India can be found in, among other deities, the god Iswara, while Isis is Isi.[16] As British scholar and Indianist Sir William Jones states, "Iswara, or Isa, and Isani, or Isisi, are...unquestionably the Osiris and Isis of Egypt."[17] Like Osiris, Iswara was "*arghanautha*, the lord of the argha or boat."[18] From this boat myth comes the story of the "Ark of Noah" and Jason's Argo, which Plutarch (c. 45-c. 125 CE) reports was commanded by Osiris.[19] When Osiris's enemies pursue him, he enters into his "boat" on precisely the same date recorded of "Noah's" entrance into *his* ark, Athyr 17th (11/13), long before the biblical fable was invented.[20] Noah is not a Jewish "patriarch" but a sun god, and the tale of entering and exiting the Ark signifies the sun's death and resurrection.[21] The story of the eight passengers in a boat is an astral myth, reflecting the solar system. These eight are equivalent to the Egyptian octet of gods, who sail the ocean in a ship.[22]

The spread of the Egyptian culture included a purported migration to Mesopotamia, with the Egyptian priesthood supposedly becoming the famous "Chaldeans." Diodorus Siculus relates the Egyptians as maintaining that "a large number" of their colonies went "into the civilized world," with "Belus" taking his colonists to Babylon, where he "appointed priests [Chaldeans] who were exempt from taxes and free of all civic obligations, just like those of Egypt." Another colony went with Danaus to Argos, "nearly the oldest city in Greece." Diodorus also writes that the Egyptians claimed the Athenians and the Colchians of Pontus as their own, and that "the Jews lying between Syria and Arabia, were also settled by certain expatriates from Egypt." This latter assertion explains why the male children of these ethnicities are circumcised, as circumcision is "age-old custom imported from Egypt."[23] Siculus next remarks:

> In general, the Egyptians assert that their ancestors, because of the large surplus population and the ascendancy of their kings over other lands, sent numerous colonies to many parts of the known world. But since no one produces any clear proof of this, and no competent historian endorses it, we have judged their stories not worth recording.[24]

Rather than accepting him as a colonizing "real person," the Greeks associated Belus with Baal or Bel, the Canaanite god. Moreover, "Babylon was not an Egyptian colony, and Chaldean

astronomy and astrology owe little, if anything, to Egyptian influence."[25] It is paradoxical that Diodorus apparently believed the tale that Osiris was a "real person" who traveled widely and established *Egyptian* colonies, yet he did not believe the Egyptians' assertions regarding their numerous colonies!

Despite his incredulity regarding Egyptian colonies, Diodorus continues his travelogue, stating that Osiris "ranged over the entire inhabited world," bringing with him culture and the vine, as well as beer. Osiris then returned to Egypt, loaded with gifts from "every country," and was deified after his death. Diodorus also describes the origin of certain rituals—e.g., the focus on wine and not cutting one's hair—practiced by a widespread brotherhood that in Palestine would become known as Nazarites or Nazarenes, major players in the creation of Christianity.

In spite of the rampant evemerism regarding the Osirian earth-wandering legend, Osiris is essentially the sun, regularly identified as such in the Egyptian Bible, the Book of the Dead. In addition to those numerous texts, the hymn to Osiris from the stela previously cited continues thus:

> O thou son of Nut, the whole world is gratified when thou ascendest thy father's throne like Ra. Thou shinest in the horizon, thou sendest forth thy light into the darkness, thou makest the darkness light with thy double plume, and thou floodest the world with light like the Disk at break of day.[26]

Osiris's solar nature is laid plain, by those who both worshipped and created him. Like that of other nations, including India, Egyptian mythology is complex, and Osiris also represents the *light* in the sun and moon. As Osiris took on the attributes of other gods, he eventually became the god of the afterlife, which is likewise a solar attribute. As Budge says, "The deceased is always identified with Osiris, or the sun which has set, the judge and god of the dead."[27] Like the sun, the newly dead must pass through the Hall of Judgment (nighttime) before proceeding "to the east to begin a new existence."

In the same hymn above, Osiris's "sister" Isis is described in lunar terms, and Isis and Osiris's child, Horus, is said to have "waxed strong in the house of Seb." Seb is Osiris's earthly "father"; yet, it is clear that Horus—who is not only the son but also the father of Osiris, who is thus the "father and son of Horus"[28]—is likewise a "son of Seb" in the same way that Jesus is the "son of David." Seb is also known as "Geb," and "Horus the Elder...was believed to be the son of Geb and Nut."[29] In addition, Seb is "Io-sef," or Joseph; hence, like Jesus, Horus is the "son of Joseph."

Osiris's "once-and-future son," Horus, signifies the solar orb renewed at the winter solstice. On her temple at Sais, Horus's lunar mother, Isis, is depicted as saying, "The fruit that I have brought forth is the Sun." The major solar roles include the sun as a child when rising and as an old man when setting. The sun is also a child at the winter solstice ("Christmas"), a youth at the vernal equinox or spring, a bearded man in his strength at the summer solstice, and an old man at the autumnal equinox. Horus with the shaved head represents the time of the year "when the light is reduced..."[30] Concerning Horus, or the renewed solar incarnation, Olcott says:

> In the Sun-God Horus we see the dawn personified, and the triumphant conqueror of the shades of darkness and the demons of the underworld emerges in the glorious light of victory each morning. He was figured as the eldest son of Osiris, a strong and vigorous youth, who avenged his father by waging a successful war against the monster who had swallowed him up.

> Horus is depicted in the inscriptions as sailing forth from the underworld up the eastern sky at dawn, piercing the great python, born of night, as he advances.[31]

Like Jesus, Ra, Osiris and Horus all battle with Satan, i.e., Apep, Set or Typhon, as is typical of the God Sun, whose enemy is the "serpent" of night and darkness, the sun-devouring monster present in "nearly every mythology."[32] In the Egyptian mythology, as in the Christian, Apep/Set is "thrown from his high estate" to become a devil.[33] In addition, one of the several appellations of Horus was "Jaoai,"[34] which is also "Iaoai," essentially the same as "Iao," the Egyptian epithet adopted by Jews that became equated with "Yahweh." Also, one of Ra's daughters is named "Iousaas,"[35] which is intriguingly similar to "Joshua" and "Jesus" or *Iasios*, as was one form of the name in Greek.

Osiris's fathers are not only Ra and Seb but also Tmu, Atmu or Atemu, according to mummy wrappings of the pharaoh Thothmes III (1503-1449 BCE).[36] Atum or Tmu's myth appears to be that of *Tammuz*, the Syrian-Israelite solar-fertility god, as Tmu is depicted as viewing the earth as "an abomination, and he will not enter into Seb; for his soul hath burst for ever the bonds of his sleep in his house which is upon earth."[37] In other words, like Tammuz, Tmu is a dying and rising savior god who is "dead" when in the tomb of the earth. Tmu or Temu[38] is also said to have usurped Ra, making him a solar deity, the same as Tammuz. Tmu/Temu/Atemu symbolized the setting, evening or night sun,[39] the same role ascribed to Osiris, the god of the underworld.

Osiris, the sun and afterlife god, assumed the shape of a bull and carried his followers into the afterworld on his back.

Furthermore, Osiris is "O-*Sur*-is," Sur meaning sun in Sanskrit and bull in Hebrew. As the Bull, Osiris is the sun in the Age of Taurus (c. 4400-2250 BCE), which would make him date to at least that period, although it is claimed that he is 10,000 years old or more.

The story of Osiris's death and resurrection has been the source of much discussion, especially since it is so similar to the Christian myth but pre-dates the latter by millennia. In the various Osirian legends, Osiris's "brother and rival," the "great python" Typhon or Set, swallows Osiris up, or in Plutarch's version, throws Osiris's body into the Nile. Osiris's renewed incarnation/son, Horus, kills Set or Sata, the night sky, darkness, desolation and fertility-destroying pestilence. The initial destruction of the god by the "Prince of darkness" represents the overthrow of the sun and its light reflected in the moon. The dismemberment of Osiris into 14 pieces symbolizes the 14 days of the month when the moon is waning and the sun's light in it is "dying." Osiris's passion was said to take place on the 17th day of the month of Hathor, "when Osiris was in the twenty-eighth year either of his reign or of his age,"[40] the number 28 signifying the days in the lunar month. Osiris's body parts were said to have been retrieved and buried in separate sacred sites by Isis. As is common in priestcraft, there were many tombs of Osiris in Egypt and Arabia, a development that reflects the *mythical* nature of Osiris, not that he was a "real person" interred in all these places.

The Passion and Resurrection of Osiris have been major mythical motifs that made their way into Christianity: "That the Passion—as it was distinctly called—and Resurrection of Osiris were yearly and openly celebrated by the worshippers of the Alexandrian gods with alternate demonstrations of grief and joy, the classical poets have put beyond doubt."[41] The closeness to the much later Christ myth is unmistakable, as "Osiris was to his worshippers 'the god-man, the first of those who rose from the dead,' [whose] death and resurrection were therefore supposed to be in some way beneficial to mankind."[42] Concerning this ancient, pre-Christian ritual, Budge relates:

> ...we find that the doctrine of eternal life and of the resurrection of a glorified or transformed body, based upon the ancient story of the resurrection of Osiris after a cruel death and horrible mutilation, inflicted by the powers of evil, was the same in all periods [of Egyptian history], and that the legends of the most ancient times were accepted without material alteration or addition in the texts of the later dynasties.

> ...everywhere, and in texts of all periods, the life, sufferings, death and resurrection of Osiris are accepted as facts universally admitted.[43]

Thus, the Passion and Resurrection of Christ are archetypical, not actual, representing a common religious and mythical motif, not the death and resurrection of a "real person." The archetypical death and resurrection of the god provide a spiritual example for his followers: "Osiris...was regarded as the principal cause of human resurrection, and he was capable of giving life after death because he had attained to it. He was entitled 'Eternity and Everlastingness,' and he it was who made men and women born again."[44] This mystery of the resurrection is depicted in thousands of tombs in the Nile valley: "Osiris died and rose again from the dead, so all men hoped to arise like him from death to life eternal."[45] These important religious and spiritual concepts were popular in Egypt "from very early times," long before the purported advent of Christ. Again, when the god was reborn, "a loud voice was heard throughout all the world saying, 'The lord of all earth is born!'"[46] Indeed, "it is astonishing to find that, at least, five thousand years ago men trusted an Osiris as a risen Saviour, and confidently hoped to rise, as he arose, from the grave."[47]

In his mockery of Pagans, Christian writer Minucius Felix (3rd cent.) revealed that the Egyptians, and afterwards the Romans, beheld an empty tomb of Osiris or Serapis,[48] another motif found in the later Christian myth. In addition to being placed in a tomb, Osiris was also covered in a shroud, relics of which were exhibited by unscrupulous priests long before the Christian era, a tradition continued with the two dozen or so bogus shrouds possessed by medieval churches including the infamous "Shroud of Turin" much ballyhooed to this day.

Another Egyptian tradition adopted by Christianity is the notion of the blood of the god being represented by wine, as described in a magic papyrus in the British Museum addressed to "Asklepios of Memphis."[49] It is noteworthy that the heart of fine viniculture in Egypt was Mareotis, the Therapeutan cult center outside of Alexandria,[50] the crucible of Christianity, which plagiarizes the water-to-wine motif and emphasizes Jesus's role as a winebibber.

As do Christians today, the millions of followers of Osiris were quite certain that, even though he was the Omnipotent Lord of Lord and King of Kings, he had at some point walked the earth. As Bonwick relates:

> ...he was a person who had lived and died. They had no manner of doubt about it. Did they not know his birthplace? Did they not celebrate his birth by the most elaborate ceremonies, with cradle, lights, etc.? Did they not hold his tomb at Abydos? Did they not annually celebrate at the Holy Sepulchre his resurrection? Did they not commemorate his death by the

Eucharist, eating the Sacred Cake, after it had been consecrated by the priests, and become veritable flesh of his flesh?[51]

Providing further evidence of Osiris's pre-Christian role as a dying and rising savior god, several early Church fathers, including Athanasius, Augustine, Theophilus, Athenagoras, Minucius Felix, Lactantius and Firmicus, discussed the Egyptian god's death as mourned "every good Friday."

The death and resurrection of the sun god have astrotheological meaning, signifying the waxing and waning of the moon, which reflects the sun's light, as well as the daily rising and setting of the sun and the annual shortening and lengthening of the day. As part of his astrotheological journey, Osiris "traverses the twelve sections of the Duat,"[52] and, as the sun god, Osiris "has twelve companions—the Signs of the Zodiac."[53] Thus, in the myth of Osiris is the great teaching god with the twelve disciples who dies and resurrects, millennia before the Christian era. The evidence abundantly points to Jesus Christ as a nearly identical, mythical remake of the highly popular Osiris, whose story was known by millions of pilgrims for thousands of years in precisely the same areas in which the Christian myth arose.

Dionysus, Sun of God

Like his alter ego Osiris, Dionysus, the most popular god in the Roman Empire, was considered an immensely old deity, according to Herodotus (2:145-146), who imparted that, even though he was one of the "youngest" gods, Dionysus supposedly appeared "15,000 years before Amasis" (Ahmose, fl. 1550 BCE). The Egyptians, reports Herodotus, claimed to be "quite certain of these dates," having kept careful records. The assertion that Dionysus is an old god is proved by the appearance of his name at the Greek Bronze Age palace of Pylos (13th cent. BCE).[54] Dionysus/Bacchus's presence on Crete, where he was said to have been born, extends back even further, as his epithet "Iakchos" is found at the palace at Knossos, with an apparent Egyptian connection.[55]

With such antiquity also came an enormous territory, as Dionysus was much beloved in a widespread area from Egypt to Greece to Macedonia, the Near East and beyond. One of the major reasons for the spread of the Dionysian religion is that it encouraged proselytizing. In discussing Dionysus as "the god who arrives" and the god of epiphany, definitive Dionysian expert Kerenyi observes: "The second form would be the very concrete arrival of a missionary cult. The Dionysian religion shows so many indications of such an arrival that it has been termed a 'missionary religion' and in this sense a precursor of Christianity."[56] This pre-historic and archaic

Dionysian missionary cult predated Christianity by over a millennium and was well developed by the time the Jewish creators of Christianity began to merge the numerous cults and religions of the Roman Empire. Any such missionaries of another religion would have to overturn this highly ancient and popular worship, using whatever means necessary, including creating similar myths and rituals, which is precisely what the architects of Christianity did.

Like Osiris, Dionysus was annually sacrificed and resurrected, representing the death of winter and the fertility of spring, an event celebrated in his cultic mysteries. These mysteries became so extreme in their debauchery that they were banned in 186 BCE by the Romans, although they continued in some form for at least a couple of centuries afterwards. At the time the mysteries were prohibited, thousands of initiates were slaughtered,[57] serving as martyrs for their faith centuries before the Christian era and its alleged martyrs.

Dionysus was not merely a god of revelry: "In his gentler aspects he is the giver of joy, the healer of sicknesses, the guardian against plagues. As such he is even a lawgiver, and a promoter of peace and concord."[58] These benevolent qualities are those of the God Sun, and, indeed, Dionysus is a sun god, not a "real person," despite efforts to evemerize him. The poem of Nonnus (5th century CE) regarding Dionysus/Bacchus is a record of the "course of the sun through the signs." Per Macrobius, Dionysus was born on December 25th, the same as Osiris/Horus and many other sun gods. Like Osiris, Dionysus was torn into 14 pieces, and also like Osiris/Horus, Dionysus was considered both the son and father of Zeus, according to an Orphic verse.[59] Quoting the Orphic verses, Macrobius reveals that "Liber Pater," or Dionysus/Bacchus, is the sun: The line, "The sun, which men also call by name Dionysus," is easy enough to understand. However, the verse "One Zeus, one Hades, one Sun, one Dionysus," is more difficult, and needs explanation, provided by Macrobius:

> The warrant for this last line rests on an oracle of Apollo of Claros, wherein yet another name is given the sun; which is called, within the space of the same sacred verses by several names, including that of Iao. For when Apollo of Claros was asked who among the gods was to be regarded as the god called Iao, he replied:

> "Those who have learned the mysteries should hide the unsearchable secrets, but, if the understanding is small and the mind weak, then ponder this: that Iao is the supreme god of all gods; in winter, Hades; at spring's beginning, Zeus; the Sun in summer; and in autumn, the splendid Iao."[60]

The mysterious supreme god "Iao" was identified in the first century BCE by Diodorus as the same as the Jewish tribal god Yahweh. The "IAO" is an Egyptian, Chaldean and Phoenician designation for Divinity, which is represented by and identified with the sun. As we can see, Dionysus is Zeus is the Sun is Iao is Yahweh.

Orpheus himself is not a "real person" but a tradition, like Hermes Trismesgistus and Jesus Christ: "All scholars seem now agreed that the legendary Orpheus never really existed, and that the many verses and poems attributed to him were the work of various hands."[61] Called by Preller "eine litterarische Collectivperson"—"a literary collective-person"—Orpheus is "only a name, applied to a school of priests who brought the new cult of Dionysos into Greece."[62] As Rev. Lundy states, "Orpheus was a title under which the Deity was worshipped; and he was the same as Horus of Egypt, and Apollo of Greece." In other words, Orpheus too was a sun god, initially separate from Dionysus but eventually fused.[63] Moreover, Orpheus appears with Moses and David in a Jewish catacomb, and was evidently embraced by Jewish Gnostic-Christians as a "prefiguring" of the Logos,[64] i.e., Christ.

Orpheus's followers constituted a band of priests and proselytizers quite similar to their later Christian counterparts, as they traveled around the Mediterranean and pawned off on the rich their texts forged in the name of Orpheus, selling also their purification rites and other priestcraft. The pre-Christian "apostle" Orpheus, legendary proselytizer of the Samothracian mysteries and their spiritual head, the disincarnate healing and savior god IHΣ or *IES*, has much in common with the Apostle Paul, who proselytized in the same places the religion of the god *IESUS*. Paul is evidently a compilation of mythical characters and historical personages, including Orpheus, Apollonius of Tyana, the Saulus of Josephus and the Old Testament Saul. The hypothesis that Paul is in part based on Apollonius (1st cent. CE) is even more intriguing when it is understood that seemingly "Pauline" writings appeared long after the apostle's supposed death but before Apollonius's demise. These texts include the Apocalypses of Baruch and Ezra, both written after the fall of the Temple in 70 CE.[65] It is also noteworthy that the word "Saule" in Latvian refers to the sun, with the Latvian sun goddess Saule similar to the Indian sun god Surya.[66]

Like Orpheus and many others, Dionysus/Bacchus is not, as has been erroneously assumed, an evemerized hero:

> ...we shall endeavor to eradicate the error of those who might fancy that Bacchus, the son of Semele, born at Thebes, is an

ancient hero, whose glorious conquests in the East were the cause of his having been put in the rank of the Gods. There will be no difficulty to prove that he is, like Hercules, also born at Thebes, nothing else but a physical being, the most powerful as well as the most beautiful agent of Nature, in other words the Sun, the soul of universal vegetation. This truth, which is established by many ancient authorities, will appear hereafter in a new light by the explanation of the poem... Bacchus and Hercules were the God Sun, worshipped by all nations under many different names... the Sun especially, was the principal hero of the marvelous romances, about which ignorant posterity has been grossly deceived. Should the reader be well convinced of this truth, he will then easily admit our explanation of the solar legend, known by the Christians under the title of the life of Christ, which is only one of the thousand names of the God Sun, whatever may be the opinion of his worshippers about his existence as a man, because it will not prove anymore than that of the worshippers of Bacchus, who made of him a conqueror and a hero. Let us therefore first establish as an acknowledged fact that the Bacchus of the Greeks was merely a copy of the Osiris of the Egyptians, and that Osiris the husband of Isis, and worshipped in Egypt, was the Sun... The testimonies of Diodorus of Siculus, of Jamblicus [Iamblichus], of Plutarch, of Diogenes-Laertius, of Suidas, of Macrobius, etc., agree in order to prove that it was a generally acknowledged fact by all the Ancients, that it was the Sun, which the Egyptians worshipped under the name of Osiris...[67]

Like that of Osiris, the story of Dionysus includes his own mythical conquest of India. In *City of God* (XVIII), Augustine writes:

"...Dionysus...was also called Father Liber." & "Then also Father Liber made war in India, and led in his army many women called Bacchae, who were notable not so much for valor as for fury. Some, indeed, write that this Liber was both conquered and bound and some that he was slain in Persia, even telling where he was buried..."

Dionysus is not only Osiris but also the counterpart of Moses, who is likewise a mythical personage: "That the god Bacchus was the archetype of Moses seems to have been the opinion of many learned men, particularly the celebrated Bishop Huet, and I. Vossius, who agree that the Arabian name of Bacchus is *Meses*."[68]

Biblical scholarship and archaeology have basically proved that the Pentateuch, or first five books of the Bible, were not composed by the great lawgiver Moses himself. In *The Bible Unearthed*, archaeologist Israel Finkelstein demonstrates that much biblical composition was done from the 8th century BCE onward. Even in ancient times it was recognized that Moses did

not compose the Pentateuch, which was probably partly attributable to Ezra, among others. As early as the third century, Porphyry wrote that "nothing of what [Moses] wrote has been preserved; his writings are reported to have been destroyed along with the Temple. All the things attributed to Moses were really written eleven hundred years later by Ezra and his contemporaries."[69] The author of *Christian Mythology Unveiled* evinces that the Pentateuch is a copy of "the *five* books of the Egyptian Hermes."

According to the myth, the Jews at the time of the Exodus celebrated the feast of the Lamb, which refers to the Age of Aries. In the Dionysian myth, the sacred Lamb or Ram provides water to Dionysus's army in the middle of the desert, the water-in-the-desert motif also being in the Moses myth. Like Dionysus and Amon, Moses is depicted wearing ram's horns. These various elements are aspects of astronomical fables.[70] As it turns out, Moses too is in many essentials a sun god: Ma-shu, Shumash, or Shamash/Samas,[71] as the sun is called in Hebrew, the same as the Moabite Chemosh, a god the Israelites also worshipped.

Another tale that found its way into the Bible is that of Bacchus's miracle of stopping the motion of the sun and moon, replayed in the story of Joshua. Joshua too is a sun god, whose Greek name, Jesus, was essentially an epithet of Dionysus. In reality, there are a number of important similarities between Dionysus and the later Christ. In *The Paganism in Our Christianity*, Christian apologist Sir Arthur Weigall describes the Dionysus myth:

> Dionysos, whose father, as in the Christian story, was "God" but whose mother was a mortal woman [Semele], was represented in the East as a bearded young man of dignified appearance, who had not only taught mankind the use of the vine, but had also been a law-giver, promoting the arts of civilisation, preaching happiness, and encouraging peace. He, like Jesus, had suffered a violent death, and had descended into hell, but his resurrection and ascension then followed; and these were commemorated in his sacred rites. According to one legend, he had turned himself into a bull, and in this guise had been cut to pieces by his enemies; and according to another he had been transformed into a ram. His worshippers were wont to tear a bull or a goat to pieces and to devour the meat raw, thereby eating the flesh and drinking the blood of their god in a frenzied eucharist. Various animals were sacred to him, amongst which were the ram and the ass; and in regard to the latter there was a story that he had once ridden upon two asses and had afterwards caused them to become celestial constellations, in which legend we may perhaps see him as a solar god and may connect him with the zodiacal sign of Cancer which, in the

Babylonian zodiac, was the Ass and Foal, and which marked the zenith of the sun's power and the beginning of its decline towards winter.

...the connection of Jesus with Dionysos in men's minds is shown by the introduction into the Gospel story of the incident of the turning of water into wine at the marriage-feast of Cana...[72]

As Weigall outlines, the similarities between the Dionysus and Jesus myths include not only the torturous death and the resurrection but also the water-to-wine miracle, the Christian myth even keeping the same Pagan date for its celebration, January 6th. That this "miracle" predates Christianity is proved by the ruins of the water-to-wine sluice used by Greek priests at Corinth at least four centuries before the common era. Indeed, correspondences between the Dionysian and Christian cults can be found in "Paul's" epistles to the Corinthians, which is appropriate since Corinth in specific was a locus for the Dionysian mysteries. The water-to-wine "ritual-miracle is certainly very ancient, an account of it being quoted by Athenaeus from Theopompus the Chian, who flourished about 350 B.C."[73] Again, the miracle represents the ripening of the grape on the vine, as well as the fermenting of the grape juice, by the sun. Kerenyi, speaking of Jesus as an historical personage, avers that the "founder of Christianity," in describing himself as "the true vine," was acknowledging the "existence of a massive non-Greek religion of Dionysos between the lake of Genesareth and the Phoenician coast..."[74]

The correspondences between the Dionysian cult and the later Christian one include the use of "theophagic" imagery, i.e., the eating of the flesh and drinking of the blood of a sacrificial victim in the stead of the god, as well as the focus on the grape and wine as substitute for the god's blood. Moreover, the later Jesus was addressed in the same manner employed by the followers of Dionysus. As Hoffmann relates:

Pagan critics of the early movement pointed to the fact that Christians addressed Jesus in terms equivalent to those used by the bacchantes (Dionysus' worshipers). Jesus was *kyrios* (lord) and *lysios* (redeemer). In the Dionysiac cult, the god redeemed adherents from a world of darkness and death by revealing himself in ecstatic visions and providing glimpses of a world-to-come.[75]

Another of the motifs that Dionysus and Jesus share is the virgin mother. In one version of the Dionysian myth, his mortal mother, fecundated by Zeus Pateras, or "God the Father," is consumed at the god's birth by the attendant blaze, which is appropriate for a sun god. Because in the one version the mother

does not survive the birth, and the baby is born from Zeus's thigh, it is claimed that Dionysus was not "born of a virgin." Oddly enough, despite his numerous paramours Zeus himself was called "the virgin"; thus, even in this version it could be argued that Dionysus was "born of a virgin." However, in *The Bacchae* by Euripides (c. 484-406 BCE), Dionysus is an infant when rescued by Zeus "from the lightning-flame, and brought...to Olympus..."[76] The baby is not placed in Zeus's "thigh" but surrounded by "the ether which encircles the earth," in order to protect him from Zeus's jealous wife, Hera.

Furthermore, the Laconian legend as related by ancient Greek writer Pausanias (ii. 24, § 3) claimed that after Dionysus was born he and Semele were placed in "a chest...and carried to Brasiai, where Semele was found dead."[77] Rev. Cox further states that "there was a tale which related how, when Kadmos heard that Zeus had made his child Semele a mother, he placed her and her babe in a chest, and launched them, as Akrisios launched Danae and her infant, upon the sea."[78] Thus, Semele is alive after having given birth, and the babe set adrift is paralleled in the Moses myth. In short, Semele is a virgin impregnated by God the Father who gives birth to the son of God. Semele is a remake of the Phrygian Earth Goddess Zemele[79] and not a mortal woman, like other goddesses remaining a "perpetual virgin." That Semele was considered a virgin was maintained by famed mythologist Joseph Campbell in *Occidental Mythology*: "And the virgin conceived the ever-dying, ever-living god of bread and wine, Dionysus, who was born and nurtured in that cave, torn to death as a babe, and resurrected."[80] The version in which Semele dies quickly parallels the myth of Buddha, whose mother also dies shortly after giving birth. The reason for this mythical speedy demise is that the virgin mother represents the dawn, which fades at the birth of the new sun daily. In addition to the various other correspondences between the Dionysian and Christian myths, both Dionysus and Jesus were said to have been carried in their mothers' wombs for *seven* months, per Siculus and the Gospel of the Hebrews,[81] respectively.

Another version of Dionysus's birth, as the Cretan Zagreus, makes him born of *Persephone*, who was "visited" by Zeus "in the form of a snake."[82] Since Persephone is the archetypal *Maiden/Virgin* in Greek mythology, it would be logical to assume that she was remained a "virgin mother," in the same manner as Mary after she was "visited" by the "Holy Ghost." It is noteworthy that "Zagreus," which means "hunter of living animals," was a title held by the Dionysian priest at Pylos.[83] Such a priest likely also possessed the name of his god, i.e., Dionysus, serving as an

example of how gods become "mortalized" as men, when the latter take on their names and are remembered in history. It is likely that numerous individuals over the centuries took on the name of "Dionysus," particularly in regard to the Dionysian mysteries, as indicated by the fact that it became necessary to differentiate between the mortal and the god, with the word *theos*, i.e., *god*, eventually being included in inscriptions concerning Dionysus.[84]

Like his birth, Dionysus's death is also archetypical, resembling that of Osiris and the later Jesus: The Greek god dies violently, is resurrected and ascends to heaven. As is the case with Christ, Dionysus's followers periodically reenacted his passion.[85] In *Contra Celsus* (IV, XVI-XVII), Church father Origen (c. 185-c.254 CE) discusses the death, resurrection and ascension of Dionysus, attempting to compare it unfavorably with the Jesus tale, thus demonstrating that Dionysus's death, resurrection and ascension were known and admitted by at least one early Christian authority. Furthermore, as is also common in the stories of pre-Christian saviors, Dionysus was depicted as descending into Hell, a tradition later related of Christ: "A different form of the myth of the death and resurrection of Dionysus is that he descended into Hades to bring up his mother Semele from the dead."[86]

Like his Syrian counterpart Adonis, Dionysus was called "Dendrites," or "he of the tree," which would seem to convey that Dionysus was also hung on a tree, a motif and ritual common in the areas in which Dionysus worship thrived. As Freke and Gandy show, there are in fact representations of Dionysus hanging "on a wooden pole."[87] Further evidence of this Dionysian crucifix is provided by the amulet with the image of a crucified man bearing the inscription "Orpheus-Bakkikos" beneath it.[88] Since Orpheus and Dionysus are equated, and "Bakkikos" is Bacchus, this amulet evidently represents the god himself. This amulet is from the 3rd century CE, postdating the Christian era, so it is regarded as evidence of the plagiarism *by* Paganism *from* Christianity, rather than the other way around. However, such concepts, motifs, doctrines, etc., as are in common between Paganism and Christianity, including the crucified godman, almost always, if not always, existed prior to the Christian era and must have passed from Paganism to Christianity. Additionally, Christ was not depicted as crucified until the 6th-7th centuries, so there is no scientific reason to conclude that the Orpheus image was copied from Christianity.

In the story of Dionysus is to be found not only these various significant correspondences to biblical characters and the Christ myth, but also an apparent explanation of the tale of Jesus ben Pandira, Pandera or Panthera, who has been supposed by many

to represent the "historical Jesus." This Jesus or Joshua ben Pandira is found only in the Talmud, reflecting an event that purportedly happened around 100 BCE, with Jesus a magician from Egypt who was hanged. In the story of Dionysus or Bacchus, the god is reborn as one of twins suckled by a female panther, hence his title "son of a panther," the same as "ben Panthera." Regarding the surviving twin, Dupuis says, "This is the new Bacchus or the child of the mysteries." As the "God of Nysa," Dionysus came out of Egypt, and his moniker was IHΣ, or IES in Latin, in which language "Jesus" is likewise IES, plus the terminus US; hence, "Jesus ben Panthera" may have been a reference to Dionysus. It is, of course, also possible that this "Jesus ben Pandira" was a "real person" who was sacrificed ritually as a sacred king, *in the name of the pre-Christian savior god, Joshua/Jesus*. In any case, Jesus ben Pandira is *not* the gospel Jesus.

As it was with Dionysus, the name "Jes" was also an epithet of the Hindu avatar Vishnu, as well as the Slavic sun god:

> Jes Chrishna was the name of the ninth incarnation of Jesnu, or Vishnu, whose animal is the fish, as in the case of Joshua, the son of the fish Nun... Jes is a title of the sun. Jesse was the name of the sun-god of the southern Slavs.[89]

As both Jesnu and Joshua are symbolized by the fish, so too is Jesus: All three are solar avatars and essentially the same.

In discussing the influence of the Dionysian religion on Christianity, it is important to keep in mind that not only was the former widespread and popular in the very areas in which Christianity arose but also that Jews were enticed to be initiated into the Dionysian mysteries in order to receive citizenship in Alexandria.[90] Philo estimated there were a million Jews in Alexandria at the beginning of the common era, occupying "two out of five quarters of the town."[91] Such a development would indicate that many thousands of Jews were initiated into the Dionysian mysteries, before the Christian era, and would thus possess the secret knowledge that was later used to create Christianity.

Like Jesus and so many other gods, Dionysus too had his "sacred sites." Visitors in Pausanias's day to the Greek city of Thebes, where Dionysus had been said to have been born of Semele, were shown "the bridal chamber where Zeus visited her, begot Dionysos upon her, and finally burned her with his lightning."[92] These sites, and the supposed tomb(s) of Dionysus, etc., do not prove that the god ever existed "in the flesh." Like Jesus and countless others, Dionysus was never a "real person"; instead, he is "indestructible life" personified.

Hercules, Light of the World

As Dionysus was asserted to have been originally an Egyptian god, so too was the Greek Herakles, or Hercules, as he was called in Latin, a god popular in numerous cultures in ancient times. In the modern era, no one seriously considers Hercules to have been a "real person" who walked the earth and experienced extraordinary exploits full of mystery and magic, wild monsters and wild-eyed Olympians. Yet, in the centuries before the Christian era there were many hundreds of thousands who believed Hercules to be an historical character, just as there are those today who believe Christ to have been a "real man." One such believer was Diodorus, who echoed the evemerist perspective in his recounting of the Hercules legend:

> ... Heracles, who courageously roamed much of the inhabited earth and erected his Pillar in Libya, was of Egyptian birth; and the Egyptians take their evidence in support of this assertion from the Greeks themselves. For, although everyone agrees that Heracles fought alongside the Olympian gods in the war against the giants, the Egyptians point out that in no way is it conceivable for the earth to have harbored giants in the age at which the Greeks say Heracles was alive, a generation before the Trojan War; but it was rather, they argue, nearer the first origin of mankind: for from that time the Egyptians reckon more than ten thousand years, but from the Trojan War less than twelve hundred. And likewise both the club and the lion's skin cloak are more consistent with a primitive Heracles, since in those times, before the invention of arms, men defended themselves against enemies with wooden clubs and used wild animals' hides for defensive armor.[93]

Siculus next recounts that "Greeks of more remote antiquity" claimed Herakles "rid the earth of wild beasts" and "tamed the earth," which refers to an era long before that of the "late Heracles." As we can see, there has been uncertainty as to how many Herculii there were; in fact, Marcus Varro counted 44. Like so many other gods, Hercules is a confused compilation of characters, not a "real person."

While there likely were a number of mortals who carried the name or title of Hercules, the commonly known Herculean mythos revolves around the sun and its 12 exploits or "labors" as it passes through the heavens. As confirmed by Porphyry, Herakles/Hercules is the sun god who wards off evil, which is why his exploits—the sun's movements through the months—are considered "labors," as opposed to the deeds of the sun god who enlightens and enlivens the months and signs of the zodiac. Macrobius also discusses Hercules's solar nature, saying "he is that power of the sun which gives to the human race a valor after

the likeness of the gods." This Hercules was "born" at Thebes of Alcmena, yet was preceded by many others so-named, although the Theban Hercules "was the last to be deemed worthy of the honor of the name..." Macrobius also mentions the Phoenician cult of Hercules at Tyre, "although it is the Egyptians who worship him with the greatest reverence and respect and also from time out of mind (and yet recorded time with them is very long) pay homage to him as one who has no beginning in time." Macrobius further states:

> That Hercules is indeed the sun is clear from his very name, for the derivation of his Greek name "Heracles" is obviously Ηρας κλεος, the "Pride of the Air"—and why, pray, is the pride of the air but the light of the sun, since, when the sun sets, the air is hidden in deep darkness?[94]

Hercules is thus not a "petty Grecian Prince, renowned for his romantic adventures," but the "mighty luminary." And this divine luminary has been worshipped "everywhere," with countless temples and altars set up, and songs and paeans composed, in his honor. Hercules's worship extended from Libya and Egypt to Britain and the Atlantic, and he was an Egyptian god long before the story of the son of Alcmena was recited in Greece. In his Egyptian version, Hercules has been identified with Horus, among others, including the gods Shu and Herishef (or Harsaphes).[95] As Shu, Hercules was dated by Egyptian priests at Thebes to "17,000 years before the reign of King Amasis,"[96] or about 20,500 years ago. Shu, the "son of Ra and Hathor...typified the sunlight and separated the earth from the sky..."[97] A dawn god,[98] Shu was also the "first air" and "life force," emerging as a *word* or *logos* out of Ra's mouth.[99]

Per Herodotus, who recorded the Egyptian story of Heracles, the "Greek hero" likely was also the Egyptian god "Chonsu, the son of Amon-re [Amen-Ra] and Mut."[100] Cons, Chon, Khon, Chonsu or Khunsu was a "son of the Sun-God," an epithet for Horus, who at Easter was called "Pa-Khunsu." As Bryant shows, Chon or Kunsu is a title of the sun, the word Chon, the same as Cahen or Cohen—*priest* or "lord and master." In the older Egyptian trinity of Amen, Mut and Khonsu, Khonsu is equivalent to the later Horus, while Amen is Osiris and Mut is Isis.[101] Concerning Horus and Khunsu, Massey states:

> The mythical Messiah was Horus in the Osirian Mythos; Har-Khuti in the Sut-Typhonian; Khunsu in that of Amen-Ra; Iu in the cult of Atum-Ra; and the Christ of the Gospels is an amalgam of these characters.[102]

Khunsu, who was both a lunar and solar god,[103] is equivalent to the biblical Cain,[104] an appropriate association since Khunsu's

father is Amon or Amen, the same as Atum or *Adam*, the father of
Cain. Moreover, Zeus, father of the Greek Hercules is equated
with Amun, Ammon, Amon, or Amen, the sun god of the
Egyptians and Amonians or, biblically, Ammonites. Like Horus/
Khonsu and Hercules, Cain too is a "sun hero and among his
descendants none but solar figures are to be found."[105]

Herodotus relates (2:43-44) that Hercules is one of the "twelve
gods" and that "the Egyptians have had a god named Heracles
from time immemorial," counting him among the oldest of the
gods, when the 12 gods "were produced from the eight."
Herodotus further states that the temple of Hercules at Tyre,
which he visited, was reputed to be 2,300 years old in his day.
"The result of these researches," says the historian, "is plain proof
that the worship of Heracles is very ancient."[106] Herodotus's
editor Marincola notes that "no group of twelve gods in Egypt is
known," an erroneous assertion, as the number twelve was
sacred to the Egyptians, and there were several groupings of 12
gods in Egypt. The sun god Ra had 12 divine sons, a common
motif that reflects the twelve months of the year, each of which
was "assigned to a deity," as Herodotus observes (2:82),
equivalent to the Greek daemons and Roman genii.[107] The Twelve
are represented at the Horus temple recently found in the Sinai,
which consists of a central court or "sun" surrounded by 12
rooms, i.e., the zodiac. In the solar mythos, this schematic
symbolizes the sun and his twelve "helpers" or "disciples," who
were themselves gods. In discussing the Egyptian mysteries, the
ancient writer Iamblichus related that the Egyptians marked off
"the sky into two parts, or four, or twelve,"[108] the twelve parts
ruled by "Mighty Leaders," i.e., gods. In an illustration from the
"Book of the Lower Hemisphere," the god Apheru rests in a boat
"borne by twelve gods with poles or oars..."[109] Another illustration
portrays 12 goddesses standing, "while serpents are casting fire
from their mouths."[110]

Regarding the Ennead, or group of nine gods, called in
Egyptian *paut*, Budge says that "though *paut* means 'nine,' texts
do not always limit a *paut* of the gods to that number, for
sometimes the gods amount to twelve."[111] In describing a vignette
from the Book of the Dead (ch. XV), Budge also relates that in the
upper portion of this scene of the "weighing of the Heart of the
Dead" appear "twelve gods, each holding a scepter [and] seated
upon thrones before a table of offerings of fruit, flowers, etc."
Budge then names these 12 gods as Harmachis, Tmu, Shu,
Tefnut, Seb, Nut, Isis, Nephthys, Horus, Hathor, Hu and Sa.[112]

Massey's identification and assignment of the Egyptian 12 differs from Budge's and is as follows:

1. The ram-headed Amen is the constellation Aries.
2. Osiris, the "Bull of Eternity," is Taurus.
3. The Sut-Horus twins are Gemini.
4. The beetle-headed Kheper-Ptah is Cancer, the Beetle and, later, the Crab.
5. The lion-faced Atum is Leo.
6. The Virgin Neith is the constellation Virgo.
7. Harm-Makhu of the Scales is Libra.
8. Isis-Serkh, the scorpion goddess, is the sign of Scorpio.
9. Shu and Tefnut, "the Archer," represent Sagittarius.
10. Num, the goat-headed, is Capricorn.
11. Menat, the divine wetnurse, is Aquarius.
12. Horus, of the two crocodiles, is the sign of Pisces.[113]

In his discussion of "The Twelve Gods," Egyptologist Bonwick says they "may be identified with the Hebrew Mazzaroth, or the twelve signs of the Zodiac, through which the sun passed every year."[114] Bonwick's list includes Khunsu and Thoth, who together with the other 10 were called by the Neoplatonist Proclus (c. 410-485 CE) the "twelve super-celestial gods."

In the classical Herculean legend, the 12 represent his exploits or labors, i.e., the annual course of the sun through the months:

1. Leo, the Lion, corresponding to July-August, is the month in which Hercules slays the Nemean lion.
2. In Virgo, or August-September, when the constellation of Hydra sets, rising heliacally with Cancer the Crab, Hercules kills the Hydra, while being "cramped in his labor by a crawfish or Cancer."
3. Libra, the equinoctial Balance of September-October, is fixed by the rising of the constellation of the Centaur, represented by a wine jug and a thyrsus adorned with grape leaves and vines. In the evening rises the constellation of the Boar. In this labor, Hercules battles with the Centaurs over wine and slays the wild boar.
4. Scorpio, or October-November, is "fixed by the setting of Cassiope, a constellation," represented by a hind or

stag. Hercules's fourth labor is to subdue the deer with the golden horns.

5. The sign of Sagittarius, November-December, is "consecrated to the Goddess Diana, whose temple was at Stymphalia," where there were vicious birds. In this labor, Hercules chases away these Stymphalian Birds.

6. In Capricorn, or December-January, the sun's passage is "marked by the setting of the River of the Aquarius, which flows under the stable of the Capricorn." In this labor, Hercules cleans the Stables of Augias by diverting a river through it.

7. In the sign of Aquarius, January-February, a full moon "served to denote the epoch for the celebration of the Olympic games." Among other tasks within this labor, Hercules "institutes the celebration of the Olympic Games."

8. Pisces, or February-March, is "fixed by the rising in the morning of the celestial Horse." Here Hercules conquers the Horses of Diomedes.

9. In March-April, Aries is represented by the Ram, or the Golden Fleece, "marked by the rising of the ship Argo." This Herculean labor includes the voyage aboard the Argo in search of the Golden Fleece.

10. Taurus, or April-May, is represented by the Bull. After returning from the Argo, Hercules conquers the Oxen.

11. In Gemini, or May-June, the constellation of the Twins is fixed by the "setting of the Dog Procyon." Among other tasks, Hercules must conquer a "terrible Dog."

12. Finally, in Cancer, or June-July, "when the constellation of the Hercules Ingeniculus is descending towards the occidental regions, called Hesperia, followed by the Polar Drago, the guardian of the Apples in the garden of the Hesperides." In this labor, Hercules journeys to Hesperia, to "gather the Golden Apples, guarded by a Dragon."[115]

At this point in his journey, our solar hero is consumed by flames, to be born again in a new year and repeat his labors.

Hercules was given a number of wives and children, so that families could claim him as their divine ancestry. These royal "children of the Sun" included the family called the "Heraclides." In this pursuit of the divine right to rule, among other things Hercules's enormous footprints were pointed to as evidence of his existence,[116] much like the Christian relics of the past centuries. The establishment of dynasties based on descent from mythical heroes and godmen is an old concept, having its revival in assertions over the centuries that European royal families are

descended from Jesus, a spurious notion that gives them "divine right to rule."

As is the case with the legends of Osiris and Dionysus, Herculean elements are found not only in Egypt but also in India, in the image of the Indian warrior-hero Bala Rama, for example, who, like Hercules, is depicted carrying a club and a lion's skin on his shoulders.[117] In his *Asiatic Researches* article "On the Chronology of the Hindus," Capt. Wilford relates that the Roman statesman Cicero (106-43 BCE) surnamed Hercules "Belus" (Bel/Baal), a god who "is the same as Bala, the brother of Chrishna." Bala and Krishna were worshipped "conjointly" and "are considered as one *Avatara*, or incarnation of *Vishnu*."[118] Hence, Hercules is Krishna, who is likewise Baal. Interestingly, Baal/Bel "is also the sun in Irish," as is "Krishna."[119]

The Hercules myth also makes it into the Old Testament, in the tale of Samson, whose name means "sun" and is the same as Shams-on, Shamash, Shamas, Samas and Saman. Both solar heroes are depicted with their gates or pillars, those of Hercules at Gadiz, while Samson's were at Gaza. Each is associated with lion killing, and each was taken prisoner but breaks free as he is about to be sacrificed, killing his enslavers in the process.[120] In the end, the Hercules/Samson myths are astrotheological, with the pillars representing solar symbols: "The two pillars...are simply ancient symbol-limits of the course of the sun in the heavens..."[121] "Now just as Samson in one story carries the pillars, so did Herakles... And in ancient art he was actually represented carrying the two pillars in such a way under his arms that they formed exactly a cross..."[122] Like many others, "St. Augustine believed that Samson and the sun god Hercules were one."[123]

In addition, the Palestinian term "Simon," "Semo" or "Sem" is likewise a name for the sun god Shamash/Shemesh, who, like Hercules, has been equated with the Canaanite/Phoenician god Baal.[124] This god "Semo or Semon was especially worshipped in Samaria," also known as the "Cyrenian Saman," who is evidently the character traditionally represented among early Christians and Gnostics as the "Simon of Cyrene" who legendarily bore Christ's cross. Interestingly, the Cyrenians were some of the earliest proselytizers of Christianity (Acts 11:20). In Hebrew "Sem" or "Shem" means "name," which is the term pious Jews use to address Yahweh, the latter being one of the ineffable, unspoken names of God. As "Sem" or "Shem" is a name for the God Sun, so is Yahweh; it is apparent that "Sem" is the northern kingdom version of Yahweh, whence come "Semites" and "Samaritans." Indeed, the "early Israelites were mostly sun worshippers," as the

fables concerning "Moses, Joshua, Jonah, and other biblical characters are solar myths."[125]

As has been demonstrated, there are a number of important elements in the Hercules myth that are also found in not only Judaism but also Christianity. In regard to the Hercules-Christ connection, Volney comments that "these [Herculean] labors are so similar to the sufferings of Jesus, that the Rev. Mr. Parkhurst has been obliged, much against his inclination, to acknowledge that they were types of what the real Saviour was to do and suffer." Also like Jesus, who was traditionally held to be "the seed of the woman who would bruise the serpent's head" (Gen. 3:15), Hercules was depicted with his foot on the "Dragon's head."

As concerns Hercules's death, Robert Graves reconstructs it from "a variety of legends" as follows:

> At mid-summer, at the end of a half-year reign, Hercules is made drunk with mead and led into the middle of a circle of twelve stones arranged around an oak, in front of which stands an altar-stone; the oak has been lopped until it is T-shaped. He is bound to it with willow thongs in the "five-fold bond" which joins wrists, neck and ankles together, beaten by his comrades until he nearly faints, then flayed, blinded, castrated, impaled with a mistletoe stake, and finally hacked into joints on the altar-stone. His blood is caught in a basin and used for sprinkling the whole tribe to make them vigorous and fruitful....[126]

The parallels between this account of the sacrifice of the sacred sun-king and that of Jesus are evident: The hanging on a tree/wooden cross, the beating, and the wounding with a "spear." The sprinkling of the blood upon the congregation was common in both Pagan and Jewish sacrifices, and is present in the gospel story in the line "Let his blood be upon us and our children." (Mt. 27:25)

As in Jerusalem with Christ's fabricated tomb, so too in Cadiz were the faithful shown the tomb of Hercules, which to them proved his incarnation as God on Earth. Hercules's worshippers were also shown numerous towns he founded, canals he dug, rocks he had worked, columns he had raised, etc., in Italy, Greece, Egypt and Phoenicia. There were countless temples, statues, altars, games, festivals, hymns and traditions "spread half the world" centering on Hercules and held up as "proof" of his physical, earthly existence. As the author of *The Existence of Christ Disproved* says, "The Greeks believed in the existence as a man of Hercules quite as sincerely as the Christians believe in the existence as man of Christ..."[127]

Apollo, Sun of God

Like Hercules, Horus, Krishna and Christ, the Greek god Apollo is depicted as overthrowing the serpent, a motif of the sun god rising in the morning. Fortunately, Apollo's status as a sun god is well known and overt, so there is no need to argue about whether or not he was a "real person" or what he "really" represented. In his tragedy *Thyestes*, Roman statesman and philosopher Seneca (4 BCE?-65 CE) includes a lamentation to the sun, or Apollo as "Phoebus," the "Bright One." The play demonstrates the reverence with which the solar hero or sun god was held, as well as his extreme importance in creating and sustaining life on Earth. In his paean, Seneca also demonstrates that astrotheology and the "Western" zodiac were well developed before the Christian era:

> Phoebus, god of the sun, who suffers so much, even though you've fled back and plunged the broken day out of the sky, still you've set too late... Even though the sun god turned his chariot back, and sent night from the east at a strange time to bury the foul horror in a new darkness, still it must be seen. All evils get laid open.
>
> Sun, where have you gone? How could you get lost half way through the sky? The evening star's not there yet, the chariot hasn't turned in the west and freed the horses, the ploughman whose oxen still aren't tired can't believe it is supper time.
>
> The way things take turns in the world has stopped. There'll be no setting anymore and no rising. Dawn usually gives the god the reins; she doesn't know how to sponge down the tired sweating horses and plunge them into the sea.
>
> Whatever this is I hope it is night. I'm struck with terror in case it's all collapsing, shapeless chaos crushing gods and men. No winter, no spring, no moon racing her brother, planets piled together in a pit.
>
> The zodiac's falling. The ram's in the sea; the bull's bright horns drag twins and crab; burning lion brings back the virgin; the scales pull down the sharp scorpion; the archer's bow is broken; the cold goat breaks the urn; there go the fish.
>
> Have we been chosen out of everyone somehow deserving to have the world smash up and fall on us? or have the last days come in our lifetime? It's a hard fate, whether we've lost the sun or driven it away...the earth is unmoved.[128]

To the ancients with poetic souls like Seneca, the sun was more than a mere inorganic ball of gas.

As stated, Dionysus/Bacchus and Apollo were both called "Liber Pater," identified as such by Macrobius, who elucidated

how these various gods represented different aspects of the sun, along with outlining the solar orb's basic story, as follows:

> In performance of sacred rites a mysterious rule of religion ordains that the sun shall be called Apollo when it is in the upper hemisphere, that is to say, by day, and be held to be Dionysus, or Liber Pater, when it is in the lower hemisphere, that is to say, at night. Likewise, statues of Liber Pater represent him sometimes as a child and sometimes as a young man; again, as a man with a beard and also as an old man... These differences in age have reference to the sun, for *at the winter solstice the sun would seem to be a little child, like that which the Egyptians bring forth from a shrine on an appointed day, since the day is then at its shortest and the god is accordingly shown as a tiny infant.* Afterward, however, as the days go on and lengthen, the sun at the spring equinox acquires strength in a way comparable to growth to adolescence, and so the god is given the appearance of a young man. Subsequently, he is represented in full maturity, with a beard, at the summer solstice, when the sun's growth is completed. After that, the days shorten, as though with the approach of his old age—hence the fourth of the figures by which the god is portrayed.[129]

Apollo and Dionysus were considered by ancient writers such as Pindar, Aeschylus, Euripides and Plutarch to be "different forms of the same god." Like Dionysus, Apollo also had his birthday at the winter solstice or December 25th. From Macrobius it is clear that the Egyptians brought out an image of a baby god, lying in a shrine or "manger," on the "shortest day," around December 25th. It is also apparent from Macrobius's statements that this annual ritual occurred for ages *before* the Christian era. The newborn sun god about whom he writes is Horus, whom Macrobius equates with Dionysus. Both Dionysus and Apollo are identified with Horus, [130] as is further evidenced by the fact that Apollo and Horus were represented by the hawk. Macrobius too equates Apollo with Horus and provides an etymological analysis of "Horus," as well as other astrotheological customs and aspects, including that "Horus" is equivalent to "hours" (Greek *horae*) and the four seasons (ωραι).[131]Massey states that Apollo is "the same soli-lunar personification as is Thoth...and Khunsu (or the soli-lunar Horus)," who is "the child of the supreme divinity in Egypt, the solar *Ra*..."[132] As noted, Hercules is also Khunsu, demonstrating once more that numerous ancient gods eventually resolve themselves into each other as the one God Sun.

As the typical twin sun god, Apollo is also called "Didymaios," the same title applied to Jesus's "twin," Thomas Didymus. Macrobius explains Apollo's "twin" status as referring to his light in the moon and illumination of both the day and night. The Roman authority also connects Didymaean Apollo with the

double-faced Roman god Janus.[133] The "twin" god represents, as in the case of Horus and Set, the day and night, as well as the sun in the two halves of the year, ascending and declining towards the solstices.

Apollo is important in our quest for the true meaning of popular religious concepts because he is admittedly a sun god and because he possesses significant similarities to the Christian savior, as well as to the Hindu avatar Krishna. Concerning the Apollo-Christ connection, in *Sun Lore of All* Ages Col. Olcott observes:

> The resemblance between the lives of the Sun-God Phoebus Apollo, and Jesus Christ, the central figure and Exemplar of the Christian religion, is striking. The circumstances of their birth were in many respects similar, in that they were born in comparative obscurity. The mother of Apollo sought in vain for a suitable place to bring forth her offspring, and had recourse at last to a desolate and barren island in the midst of the sea. The Virgin Mary found her only refuge in a comfortless and humble shelter for the beasts of the field. Three gifts were presented the Far-Darter [Apollo] at his birth by Zeus, and the Magi presented the same number of gifts to the infant Jesus. Further, the infant Apollo was hurried away to a peaceful land soon after his birth, and in like manner the child Jesus was conveyed to a place of safety to escape a threatened danger.

> For a while Phoebus Apollo hid his greatness in a beggar's garb, bearing with patience the gibes and sneers of his comrades, preferring to bide his time when all men should acknowledge his greatness. This mode of existence was in every way similar to the life of Christ.

> Again, as personifying the sun, Phoebus Apollo must necessarily be born weak and suffer hardships, he must wander far and lead a life of strife and action, but above all it was imperative that he should die. It is this last act which makes the character of the Sun-God approach the nearest to human nature.

> Although the Sun-God's death at night-fall is ignominious, akin in this respect to the crucifixion, still its predominant feature is one of glory, and the reappearance of the triumphant sun after death is in every way typical of the resurrection, thus portraying in a startling manner the completeness of the analogy between the lives of Christ and Apollo.[134]

In addition to all these similarities, Apollo was also called "Physician"[135] and "Savior," the same as was said of Jesus. Like Christ, Apollo was the "God of the Shepherds," because "the sun feeds all that the earth brings forth..."[136]

Like Hercules and so many other gods, Apollo had a tomb, at Delphi, where the faithful would go to weep the death of the god.

As in the Christ fable, *three females* "went to shed their tears upon the tomb of Apollo..."[137]

Hermes, Light of the World

Like the majority of divinities, the Greek god Hermes was not a "real person" but an ideal, based on numerous factors, including solar attributes. The son of Zeus and Maia, the daughter of the Titan Atlas, Hermes was also the brother of Apollo. Hermes is equivalent in the Egyptian pantheon to Thoth, who, as we have seen, is identified with Apollo. Per Diodorus, in the Egyptian mythology Hermes/Thoth was revered "above all others" by Osiris and was credited with providing inventions useful to humanity.[138] As Thoth, Hermes was originally a moon god and "the lord of heaven."[139] Hermes is also the planet Mercury, which was considered by its proximity to the sun, its small size and its short year to be the closest and speediest companion of the sun; in fact, Hermes was equated with the sun, as "his" proxy. Like the old Egyptian god Shu, Thoth/Hermes/Mercury, the "messenger of the gods," is the Divine Word by which the universe is created.[140] Hermes's role as a sun god is explained by Macrobius:

> To prove that Mercury is the sun we have the support of our previous exposition, for the identification of Apollo with Mercury is clear from the fact that among many peoples the star Mercury is called Apollo and that, as Apollo presides over the Muses, so speech, a function of the Muses, is bestowed by Mercury. There are many further proofs, too, that Mercury is held to represent the sun....[141]

As the Egyptians and Babylonians portrayed the sun as winged, a common solar symbol, so too was Hermes/Mercury pictured, as was the Jewish "sun of righteousness" who at Malachi 4:2 was to rise "with healing in its wings."

As "Hermes Trismesgistus," the "earliest teacher of astrology in Egypt" and the "mythical founder of Egyptian astrology,"[142] the god was depicted as a great teacher, or *teachers*, since Hermes "Thrice-Great" is a compilation of characters. Hermes/Mercury was viewed as "the trainer of Christs,"[143] which indicates that educated Christians esoterically understood "Christ" to be a title, rather than a person, and that their secret wisdom emanated from Egypt. "Hermes" too is a title, not a person, and in the ancient world it was common for texts to be written by many different individuals under the name of a single "person," "god" or "patriarch." In fact, it has been so common that there is a term for it: pseudepigraphy. In this pseudepigraphical manner, a Hermetic tradition was created that spawned thousands of books on a wide variety of subjects. To the outsider, deprived of

the esoteric knowledge, it appears as if a "great man" existed who was virtually omniscient and omnipotent. Nevertheless, Hercules is an astrotheological construct.

Jason and the Argonauts

Another of the many important pre-Christian myths is that of the Greek hero Jason, who, along with his sailors, went on fabulous adventures around the Aegean Sea. Even though the story is set in a particular area on Earth, as is the gospel tale, the fable of Jason and the Argonauts is not a true, "historical" account but an astronomical myth. In reality, the Jason story is yet another solar myth, the apparent product of Thessalian priests of the sun. As stated, the Jason myth is connected to the biblical fable of Noah, as the "Ark of Noah" is the same as the Greek *argonaut* and the Indian *arghanatha*. "Arghanatha" is an epithet of the Indian Osiris, Iswara, the "Hindu Dionysus," who is "the lord of that divine ship [Argo] which bore the Achaian warriors from the land of darkness to the land of morning."[144]

Furthermore, "Jason," "Iasios," "Iesios," or other variant, is essentially the same as Iesous, Iesus or *Jesus*, meaning "healer" or "savior,"[145] an epithet applied to the sun god in numerous places, long before the Christian era. As Drews relates:

> Jaso (from *iasthai*, to heal) was the name of the daughter of the saver and physician Asclepios. He himself was in many places worshipped under the name of Jason. Thus we read in Strabo that temples and the cult of Jason were spread over the whole of Asia, Media, Colchis, Albania, and Iberia, and that Jason enjoyed divine honours also in Thessaly and on the Corinthian gulf, the cult of Phrixos, the ram or lamb, being associated with his (I, 2, 39). Justin tells us that nearly the whole of the west worshipped Jason and built temples to him (xlii, 3), and this is confirmed by Tacitus (*Annals*, vi, 34). Jason was also supposed to be the founder of the Lemnic festival, which was celebrated yearly at the beginning of spring, and was believed to impart immortality to those who shared in it. Jasios (Jason) was called Asclepios, or the "mediating god" related to him in this respect, and the conductor of souls, Hermes, at Crete and in the famous mysteries of Samothracia, which enjoyed the greatest repute about the beginning of the present era, and were frequented by high and low from all the leading countries. Here again the idea of healing and saving is combined in the name, and would easily lead to the giving of the name to the saviour of the Jewish mystery-cult. Epiphanius (*Haeres.* c, xxix) clearly perceived this connection when he translated the name Jesus "healer" or "physician" (*curator, therapeutes*).[146]

Thus, the healer and savior god Jason/Jesus was worshipped widely throughout the Roman Empire long before the purported

advent of "Jesus Christ." Moreover, Asclepius and Serapis, two healing gods with long, dark and curly hair, much resembling the later "Jesus" in form and function, were "both gods of the cult of the Therapeutae,"[147] Hebraic "spiritual physicians" headquartered at Alexandria who were highly involved in creating Christianity, as admitted by Church historian Eusebius in the fourth century.

In addition, the "Golden Fleece" that Jason seeks symbolizes the sun in Aries, the Ram, at the vernal equinox. Jason's myth is thus set in the Age of Aries, circa 2100-4300 years ago, and the "Ram" is the same as the Lamb in Christian mythology.

Yahweh, God Sun

When comparative mythology is studied, the precedent for Christianity becomes evident in numerous "Pagan" cultures. So too is the astrotheological religion present in Judaism, the other predecessor of Christianity. Although Judaism is today primarily a lunar creed, based on a lunar calendar, as a result of the nomadic nature of its early tribal proponents, the religion of the ancient Hebrews and Israelites was polytheistic, incorporating the solar mythos as well. The desert-nomad tribes that Judaism came to comprise were essentially moon worshipping or night-sky people, but they eventually took on the solar religion as they came to be more settled. This astrotheological development is reflected in the use of different calendars: For example, the Dead Sea scrolls contained a solar calendar, as opposed to the luni-solar calendar used by the rabbis.[148] The Dead Sea collection also contained treatises on the relation of the moon to the signs of the zodiac, such as the "Brontologion" (4Q318).[149]

The polytheism of the Israelites is reflected in a number of scriptures, including Jeremiah 11:13-14, wherein the writer laments:

> For your gods have become as many as your cities, O Juda; and as many as the streets of Jerusalem are the altars you have set up to shame, altars to burn incense to Baal.

The word for "gods" in this passage is Elohim, which is regularly translated as "God" when referring to the Jewish "Lord." The singular form of "Elohim" is "Eloah" or "Eloh," used 57 times in the Bible, to indicate both "God" and "false god." "Baal," used over 80 times in the Old Testament, means "lord" and represents the sun god worshipped by the Israelites, Canaanites, Phoenicians and throughout the Levant. It is noteworthy that at this late date when "Jeremiah" was written (c. 625-565 BCE), the Jews were still polytheistic, as they had been for centuries prior.

This polytheism is further demonstrated in a confused passage at Psalms 94:7, which states: "...and they say, The LORD

does not see; the God of Jacob does not perceive.'" (RSV) The word translated as "The Lord" is actually "Jah," while the "God" of Jacob is "Elohim" or *gods*. A better translation would be "...Jah does not see; Jacob's Elohim do not perceive." This Jah is the IAO of the Egyptians, while the Elohim are the multiple Canaanite deities. According to Dr. Parkhurst and others, the Elohim of the Israelites referred to the seven planetary bodies known and revered by the ancients. These seven Elohim are also the seven powerful Cabiri of the Phoenicians and Egyptians,[150] one of whom was "Axieros," whom Fourmont identified as the biblical Isaac.[151] The Elohim and polytheism of the Hebrews are dealt with extensively in *The Christ Conspiracy* and elsewhere.[152] In any event, the worship of the Hebrews, Israelites, and Jews long before the Christian era was both polytheistic and *astrotheological*, the same as that of their so-called Pagan neighbors.

In *Pagan Rites in Judaism*, Theodor Reik outlines the ancient moon worship and polytheism of the Hebrews, relating that the famed Jewish philosopher Moses Maimonides (1135-1204 CE) cited moon worship as "the religion of Adam." Reik additionally discusses the origins of the Adam-Eve myth and the fact that the Jewish tribal god Yahweh had female consorts, reflecting Israelite polytheism. "Eve," or *Adamah*, as the earth goddess was called by Semites, was the same as the "Great Mother-Goddess," also known as Ishtar, Isis, Cybele, Aphrodite and Venus. After Nebuchadnezzar destroyed Judea, the Jews who fled to Egypt "blended" Yahweh with the goddess "Anath Yahu."[153]

Hebrew/Jewish lunar worship is further demonstrated by the fact that the moon "was the emblem of Israel in Talmudic literature and in Hebrew tradition." Indeed, remarks Reik, "The mythical ancestors of the Hebrews lived in Ur and Harran, the centers of the Semitic moon-cult."[154] Hence, Reik is asserting not only Hebrew moon worship but also that the Hebrew ancestors from Ur and Harran, i.e., Abraham, his father, Terah, and his wife, Sarah, were mythical. Reik comments that Terah was traditionally a star-worshipper, as was Abraham until he "found the real God and found himself." Nevertheless, Abraham was deemed an astrologer, and has been credited with teaching Chaldean astrology to the Egyptians. Reik also relates the legend of Joseph, who "once dreamed that the sun, the moon, and eleven stars bowed down before him," reflecting Jewish astrotheology:

> Jacob understood the meaning of the dream because he, Jacob, had once been called the sun. The moon stood for Joseph's mother, the stars for his brothers. Jacob was so convinced of the truth of the dream that he believed in the resurrection of the

dead, since Rachel, his mother, was then dead. Jacob thought that she would return to earth.[155]

Hebrew moon worship is echoed in the "*Birkat Lewana*, which means sanctification of the moon." Having observed this ritual carried out by his pious grandfather, young Reik believed that the elder man had "performed an ardent act of worship" of the moon. Reik further says:

> The experts assure us that the observance of Rosh Chodesh, the first of the month, was once a major holiday, more important than the weekly Sabbath. They also say that this festival was a reminder of the cult of the moon god.[156]

Per Reik, the Hebrews originated as a wave of migrants from Arabia whose cult center was Mount Sinai, "the mountain of the moon," *Sin* being the Babylonian moon god. Concerning Semitic moon worship, Reik continues:

> All Semites once had a cult of the moon as supreme power. When Mohammed overthrew the old religion of Arabia, he did not dare get rid of the moon cult in a radical manner.... Before Islamic times the moon deity was the most prominent object of cults in ancient Arabia. Arab women still insist that the moon is the parent of mankind.[157]

Reik next recounts the moon mythology of the Chaldeans and Babylonians, who worshipped Ishtar, the moon, as "Our Lady" and "Queen of Heaven." Ishtar, like Isis and others, was represented as a horned cow, a lunar icon. Reik further says:

> In the Old Testament, which is a collection of much earlier, often edited writings, the moon appears as a power of good (Deut. 33:4) or of evil (Ps. 12:16). Traces of ancient moon-worship were energetically removed from the text by later editors. A few remained, however, and can be recognized in the prohibitions of Deuteronomy... The Lord predicts (Jer. 8:2) that the bones of the kings and princes of Judah will not be buried, but spread "before the sun, and the moon, and all the host of heaven, whom they have loved, and whom they served, and whom they have worshipped."[158]

Jewish moon worship has been further evidenced by recent finds such as artifacts excavated in caves near Ein Gedi in the Judean Desert that date to the 6th century BCE. These artifacts postdate the "Babylonian Exile" and include a "Babylonian stamp bearing the figure of a priest worshiping the moon god," as reported by Zafrir Rinat in *Haaretz*.

As is said, the more widespread the "objectionable" practice, the greater its denouncement. From the repeated biblical proscriptions against the worship of the heavens, it is clear that the pre-Yahwist Israelite religion was astrotheological. Yahweh's

usurpation of this polytheistic, astrotheological religion, however, was not its death, but merely drew it underground behind a veil of allegory that was mistaken for "history." In reality, the astrotheology continued with Yahweh, who himself is the God Sun. This solar takeover is apparently depicted in a Jewish legend in which Yahweh punishes the moon for wishing to be "greater than the sun," by reducing the moon's light to "one sixteenth" and by increasing the sun's light "sevenfold." This legend ostensibly also represents the usurpation of the mother goddess by the father god, reflecting, as Reik comments, the battle between the matriarchy and patriarchy.

In Jewish theology, Yahweh came to dominate the extensive ancient pantheon, originating as a local, tribal volcano and fire god, to become "the" God of the cosmos. Concerning Yahweh, in *Moses and Monotheism* Sigmund Freud observed: "Jahve was undoubtedly a volcano-god.... I am certainly not the first to be struck by the similarity of the name Jahve to the root of the name of another god: Jupiter, Jovis [Jove]."[159]

The term "Yahweh" itself has a number of correlations in other languages and dialects: For example, in Vedic (proto-Sanskrit), the word "Yah" means "he, who," indicating a logical connection to the later Hebrew. Regarding Yahweh and the Indian sacred scriptures the Vedas, in *The Fountainhead of Religion* Prasad relates:

> In a posthumous work entitled "*Vedic chronology and Vedanga Jyotish,*" the late B.G. Tilak traces the word *Jehovah* or *Jahve* directly to the Vedic literature. He says, "Jehovah is undoubtedly the same word as the Chaldean *Yahve,*" and then proceeds: "The word *Yahu...Yahva, Yahvat,* and the feminine form *Yahvi, Yavhati* occur several times in the Rigveda... *Yahva* [meaning great] is applied in the Rigveda to Soma...to Agni...and to Indra.... *Yahva* in one instance (Rv. X, 110.3) is used in the vocative case, and Agni is there addressed as 'O Yahva!'" He thus concludes that *Yahva* was originally a Vedic word, and "though Moses may have borrowed it from the Chaldeans, yet the Chaldean tongue in which the various other cognate forms of the word are wanting, cannot claim it to be originally its own."... Mr. Tilak is of opinion that the Chaldeans borrowed it from the Indians in their mutual intercourse.[160]

The term "Yahweh," transliterated "Yahuh," is also pronounced "Yahouyeh," "Yahuh," "Yahu," or "Yho."[161] In *The Ancient Gods*, Rev. James avers that Yahweh was possibly a minor Canaanite god named "Yahu" or "Yo." "Thus," says he, "on a cuneiform tablet at Tanaach, dated between 2000 and 3000 BC, the name *Ahi-yahu* occurs, and the abbreviation *Yo* appears on the handles

of jars at a later date in Palestine, as well as in the form *yw* at Ugarit..."[162]

The presence of "Yahweh" as a divinity in other cultures is proved by the names found in inscriptions, such as the Assyrian "Yahou-behdi" or the Phoenician "Yahu-melek," the latter of which means "Yahweh is my king."[163] In addition, on "a coin from Gaza of the fourth century B.C., now in the British Museum, is a figure of a deity in a chariot of fire, over whose head is written Yho in old Phoenician characters."[164] The deity in the "chariot of fire," of course, is the sun, as he was frequently depicted in a number of religions/cults/cultures.

Another infamous sun and fire god was Melek, Melech, Molech, Moloch or Milcom to whom the Canaanites, Phoenicians and Israelites sacrificed their children. Bryant says that Melech was "a title of old given to many Deities in Greece" and that rivers were often named Melech, Malcha or other derivation. He also sees the word Amalekite as an abbreviation of Ham-Melech. It is apparent that Malchom, Milcom, etc., are contractions of Melech and Om.

Still another alter ego of Yahweh was the "God of Abraham," El/Bel/Baal Shaddai, the Canaanite fire and sun god; Yahweh was also Baal himself (Hosea 2:16). He is likewise "El Elyon," the Most High God (Gen. 14:18), the sun at its zenith. Concerning the word "El," Strong's Concordance states that it is the shortened form of "Ayil," the first meaning of which is "Ram."[165] It would appear, therefore, that "El" was the Semitic name of the God Sun in the Age of Aries, the knowledge of which is reflected in the Bible at Daniel 8:2-8, which fixes upon the Ram and which demonstrates "the knowledge of ancient *astral geography*." Per Hengel, Daniel 8 shows the ram representing "the star of Persia and the he-goat which attacks him is the star of Seleucid Syria." Other possible "astral allusions" are apparent at Daniel 2.21 and following. "The influence of the stars on fate and history is denied," continues Hengel, "and God's omnipotence is proclaimed. A similar opposition can be found in a still more acute form in Qumran, where astrology is simultaneously rejected and practised..."[166]

As noted, the Yahweh of the Jews is the Iao of the Egyptians, Phoenicians and Chaldeans, identified as such in the 1st century BCE by Diodorus Siculus. First, Siculus recounts that Zoroaster and others claimed that their laws were given to them by "the Good Spirit." He then says, "Among the Judaeans, Moyses attributed them [the laws] to the God called by the name of Iao."[167] As the "Kenite Smith-god," Yahweh is "Elath-Iahu," the name "Iahu" appearing in Egypt as early as around 2500 BCE, "as a title of the God Set."[168] "Iahu" is also an epithet of Set's brother,

Horus, as well as of Dionysus, as "Iacchus." The Egyptians thus possessed a high-ranking god named "Iahu" or "Jahouh." Concerning this fact, CMU comments that Philo and Josephus do not deny that "the Jews borrowed circumcision from the Egyptians," and he next asks, "why then, might they not borrow a god also?"[169] Yahweh's title of Iahu indicates him to be "a ruler of the solar year, probably a transcendental combination of Set, Osiris and Horus..."[170]

The Semitic "Yava" or Iao was likewise "Sabazios, Sabaoth, or Sabbat, the god of the Planet Saturn," who was also known as Dionysus or Bacchus.[171] Indeed, "Dionysus Sabazius was the original Jehovah of the Passover"; in this regard, Plutarch identified "the Jehovah of the Feast of the Tabernacles with Dionysus Liber," the god of wine. Plutarch further remarked that "the Jews abstain from swine's flesh because their Dionysus is also Adonis, who was killed by a boar."[172] The identification of Yahweh with Dionysus is evident as well from a coin found near Gaza dating to the 5th century BCE and possessing "on the obverse a bearded head of Dionysus type on the reverse a bearded figure in a winged chariot, designed in Hebrew characters JHWH—Jehovah."[173] In the magical texts and elsewhere in the early Christian era, "Osiris, the Greek gods, and the archangel Sabaoth are mentioned in the same breath."[174] As "Sabazios," etc., represents Saturn or Cronos, so Yahweh is identified with that planet as well.[175] As we have seen, Saturn is yet another "sun god" or aspect of the God Sun—to wit, the noon-day sun—as well as that of the mid-winter, "when the Sun attains its most southerly point and halts for a day."[176]

Demonstrated by his playing the same cosmic role in creation as is depicted in Genesis, Yahweh has been identified with Osiris: "Osiris, whose name was often equated by the Alexandrian Jews with their own divine name Jaho or Jah...was also considered a Moon-god."[177] Osiris was the "moon god" insofar as he was the light in and power behind the moon. As Osiris was Jah or Yahweh, so was his son Horus Yahweh's son Jesus.

As suggested by Freud, Yahweh or Jahveh is also Zeus, Jupiter or *Jove*, confirmed by Alexander Pope, in his "Universal Prayer":

"Father of all in ev'ry age,
In ev'ry clime, ador'd,
By saint, by savage, and by sage,
Jehovah, Jove, or Lord."[178]

Zeus is an epithet of the God Sun, as is, ultimately, Yahweh. As another example, the cult from which John the Baptist purportedly learned baptism, the Hemero-Baptists, were "a

mysterious Hebrew sect usually regarded as a branch of the Pythagorean Essenes, who worshipped Jehovah in his Sun-god aspect."[179]

The solar nature of the Jewish god is also discussed by Lord Kingsborough, who cites Isaiah 60:20 and Psalm 84:11 as evidence.[180] A paean to the sun god occurs in the 68th Psalm, which praises the Lord as "Jah," and sings about him riding in the heavens. Also, the term "Adonai" (Ps. 110:1), plural of Adonis, is used frequently in describing the biblical god—31 times for "the Lord," i.e., Yahweh, and 335 times overall in the text. Yahweh's request for Adonai, Adonis or Adon to "sit at the right hand" is an obvious device used by the Yahwists to subjugate the Greco-Syrian fertility and sun god Adonis under their "superior" god.

An epithet of Zeus and another term mistranslated repeatedly in the bible is the name of the Egyptian god Amon, Ammon or Amen as in Amen-Ra, "the hidden god."[181] For example, the scripture at Isaiah 65:16 reads, "Elohim Amen," i.e., the God(s) Amen or Ammon. In the Vulgate or Latin translation of the Bible made by Jerome in 405 CE, the phrase is "in Deo amen." The word "Amen" appears in the original Hebrew 30 times, but is translated as "verily," "truly," so be it," and "the God of Truth," where it should sometimes say "the God Ammon." While "amen" appears as an adverb or emphatic 281 times in the New Testament, the ruse is revealed at Revelation 3:14, where the scripture states: "...The words of the Amen, the faithful and true witness..." "The Amen" is not an adverb, i.e., "verily, truly," but a *noun*, referring to the God Amen/Amon/Ammon, who is interpreted in this passage as "Jesus Christ." "Amen" is apparently one of the "magic words" or ineffable names of God within the mysteries, as it is in reality the name of a very powerful, widespread and old Egyptian god: To wit, Ammon/Amon/Amen, the "chief deity of Egypt [who] must be accepted as the sun..."[182] Amon is identified with the Semitic god Baal, which "establishes him as a solar deity..."[183] Hence, *per the New Testament itself*, Jesus Christ is Amen, the God Sun. Regarding this development, in *Jesus: God, Man or Myth?* Cutner remarks, "If Elohim or Jehovah or Ihvh is a Sun-God, there surely can be nothing surprising in finding Jesus, who is at one with his Father, also a Sun-God."[184]

Another covert astrotheological biblical term is "Zion," which, CMU says, in its use throughout Psalms refers to the zodiac.[185] Strong's Concordance lists "Zion" as the same as "Tsiyuwn," which means "monument" or "signpost," an appropriate designation for the zodiac. The Israelite and Jewish astrotheology is evident from recent articles in *Biblical Archaeology Review* (9-

10/00 and 3-4/01), entitled, "The Sepphoris Synagogue Mosaic" and "Helios in the Synagogue," respectively. As excavations have revealed, a number of synagogues, particularly in Galilee, contain zodiacs and images of the sun god Helios in mosaics on their floors. These synagogue images do not represent an aberration, as it has been known for centuries that Judaism is astrotheological. Even the Jewish historian Josephus admitted as much, 2,000 years ago, when he explained the tabernacle, menorah and ephod (priestly "breastplate") in astrotheological terms.

Regarding the notorious "Ark of the Covenant," for which so many have sought in vain, the fact is that the numerous tribal gods of the Levant and Egypt had their arks in which to ride while carried by their followers. The "Jewish" ark of the covenant was "of classical Egyptian design,"[186] sharing many measurements and elements with the numerous Egyptian arks. Osiris's ark "was of the *same* size as the Jewish ark [and] was carried upon men's shoulders in the sacred procession."[187] Ancient Egyptian priests paraded a shrine to the Oracle of the sun god Ham/Am that was a "boat" or "ship" (ark) in which the God was carried.[188] The god Dionysus, widely worshipped for centuries around the Mediterranean, was carried about in a "ship car" or bark. In the Indian sun worship, sacred temple images were called "Arcas,"[189] while the Tibetans to this day carry arks in holy procession. The gods of Mexico and the goddesses of Greece were likewise borne in ritual arks.[190] The "ark of the covenant" is yet another common theme, present in a variety of cultures, and no single, all-powerful "Jewish" ark is to be found anywhere.

Although he is widely esteemed, because of the conditioning that the Bible is "God's Word," the Jewish tribal god Yahweh is actually a highly unpleasant character who has caused much trauma on planet Earth. As concerns Yahweh's nature, Harwood observes:

> Yahweh was a mass-murderer who slaughtered thousands of individuals for the crimes, real or imagined, of a single offender. But he was not above capriciously unleashing his malevolent, unstable temper against individuals for reasons only he could comprehend.[191]

Freud says Yahweh was "probably in no way a remarkable being," and calls him a "rude, narrow-minded local god, violent and bloodthirsty," who "encouraged [his adherents] to rid the country of its present inhabitants 'with the edge of the sword.'"[192]

As evidence of the atrocities committed by Yahweh, one need only look at 2 Kings 2:23-24, in which 42 children are ripped apart by two bears sent by the god, merely because they had laughed at Elijah's bald head. In addition to this sadistic incident

are many more in the Old Testament, including the genocide committed by the Israelites at Numbers 31, where Moses orders his followers to murder 90,000 Midianites and take their virgin girls for themselves. At 2 Samuel 24:15, Yahweh sends a pestilence that kills 70,000 Israelites, to punish David for having followed the Lord's command to "number" Israel. Fortunately, before the angel of God was able to destroy Jerusalem, "the LORD repented of the evil." Yahweh is thus the orchestrator of evil, as was so thoroughly asserted by the Gnostics, who doubtlessly had read the countless scriptures in which the Lord instigates murder and mayhem. As Amos says (3:6), "Does evil befall a city, unless the LORD has done it?" Or Lamentations 3:38: "Is it not from the mouth of the Most High that good and evil come?" And so on and so forth.

Mithra, The Lord Sun

Another god of militants and one of the most important sun gods in the Roman Empire and beyond was the Persian Mithra or Mithras, originally appearing as "Mitra" in the Indian Vedic religion, which is at least 3,500 years old. When the Iranians separated from their Indian brethren, Mitra became known as "Mithra" or "Mihr," as he is called in Persian. The ancient unity of the Indian and Iranian peoples is reflected in their religions and languages, as the language of the Persian scriptures, the Avesta, is closely related to that of the Vedas, the two being "dialects of the separate tribes of one and the same nations."[193] Regarding Mitra/Mithra, Swami Prajnanananda remarks:

> Mithra or Mitra is even worshipped as *Itu* (*Mitra-Mitu-Itu*) in every house of the Hindus in India... This Mithra or Mitra (Sun-God) is believed to be a Mediator between God and man, between the Sky and the Earth. It is said that Mithra or Sun took birth in the Cave on December 25th. It is also the belief of the Christian world that Mithra or the Sun-God was born of [a] Virgin. He travelled far and wide. He has twelve satellites, which are taken as the Sun's disciples.... [The Sun's] great festivals are observed in the Winter Solstice and the Vernal Equinox—Christmas and Easter. His symbol is the Lamb....

By around 1500 BCE, Mithra worship had made its way to the Near East, in the Indian kingdom of the Mitanni, who at that time inhabited Assyria. Mithra worship, however, was known also in that era as far west as the Hittite kingdom, only a few hundred miles east of the Mediterranean, as is evidenced by the Hittite-Mitanni tablets found at Bogaz-Köy in what is now Turkey. Mithraism's history, therefore, "reaches back into the earliest records of the Indo-European language," i.e., the Hittite tablets, which document Mitra, Varuna, Indra and other Indian gods.

It is erroneously asserted that because Mithraism was a "mystery cult" it did not leave any written record. In reality, much evidence of Mithra worship has been deliberately destroyed, including not only monuments, iconography and other artifacts, but also *numerous books by ancient authors*, such as Eubulus, who, according to Jerome in *Against Jovianus*, "wrote the history of Mithras in many volumes."[194] Also, Porphyry related that there were "several elaborate treatises setting forth the religion of Mithra," each one of which "has been destroyed by the care of the Church."[195] These many volumes doubtlessly contained much interesting information that was damaging to Christianity, such as the important correspondences between the "lives" and "teachings" of Mithra and Jesus, as well as identical symbols and rites.

Symbolizing the light and power behind the sun, once in Babylon the Persian Mithra was infused with the more detailed astrotheology of the Babylonians and Chaldeans, and his religion became notable for its astrology and magic, its priests or *magi* lending their name to the word magic. Included in the Mithraic development was the greater emphasis on his early Indian role as a sun god, as Mithra became identified with Shamash, the Babylonian sun god. Mithra is also Bel, the Mesopotamian and Canaanite/Phoenician sun god, who is likewise Marduk, the Babylonian god who represented both the planet Jupiter and the sun. According to Clement of Alexandria in his debate with Appion (Homily VI, ch. X), Mithra is also Apollo.[196]

Mithra's solar role is also evidenced by the "many hundreds of votive inscriptions" by his Roman legionnaire worshippers beseeching the "unconquered Sun Mithras."[197] He was said to be "Mighty in strength, mighty ruler, greatest king of gods! O Sun, lord of heaven and earth, God of Gods!"[198] Mithra was also deemed "the mediator" between heaven and earth, a role often ascribed to the god of the sun. Citing Alexandrian grammarian Hesychius (5th century CE), Bryant states, "Some make a distinction between Mithras, Mithres, and Mithra: but they were all the same Deity, the Sun, esteemed the chief God of the Persians."[199]

As stated by Christian authority and biblical commentator Matthew Henry (18th cent.), "Mithra, the sun," was the god of King Shalmaneser V of Assyria, who in the 8th century BCE conquered Samaria and "carried away the Israelites."[200] Mithra's popularity and importance is evident from the prevalence of the name "Mithradates" ("justice of Mithra") among Near Easterners by the seventh century BCE. Mithra was likewise the god of Cyrus, conqueror of Babylon, who was considered the Messiah or *Christos* by Jews during the "Captivity" (586-538 BCE). An

"important religion in Asia Minor," Mithraism became the royal cult under Artaxerxes (465-425 BCE) and continued under the Seleucids after Alexander the Great (356-323 BCE), demonstrated by "the reliefs from the tomb of King Antiochus [IV] Ephiphanes."[201] In the 5th century BCE, the Greek historian Herodotus mentioned the "Persian Mitra" (1:131), stating that the Persians "worship the sun, moon, and earth, fire, water and winds," and equating the god with "Aphrodite" and "the Arabian Alilat."[202] Some researchers believe that Mithra was thus bi-gendered: "Mithras, the Persian deity, was both god and goddess..."[203] Simone Weil avers that Mithra is "probably that Wisdom [Sophia] which seems to have appeared in the sacred books of Israel after the exile."[204]

Subsequent to the campaign of Alexander, Mithra became the "favorite deity" of Asia Minor. Regarding this era, Christian writer George W. Gilmore, an associate editor of the *New Schaff-Herzog Encyclopedia of Religious Knowledge* (VII, 420), says:

> It was probably at this period, 250-100 B.C., that *the Mithraic system of ritual and doctrine took the form which it afterward retained.* Here it came into contact with the mysteries, of which there were many varieties, among which the most notable were those of Cybele.[205]

According to Plutarch, Mithraism began to be absorbed by the Romans during the general Pompey's campaign against Cilician pirates around 70 BCE, eventually migrating from Asia Minor through the soldiers into Rome and the far reaches of the Empire. Syrian merchants also brought Mithraism to the major cities, such as Alexandria, Rome and Carthage, while captives carried it to the countryside. In short, Mithraism and its mysteries permeated the Roman Empire. In fact, Mithraism can be found from India to Scotland, with abundant monuments in numerous countries, appearing as the "most nearly universal religion in the Western world."[206] At first "probably organized as burial associations," the Mithraic mysteries eventually counted among their members emperors, politicians and businessmen, as Schaff-Herzog (VII, 421) relates: "Nero desired to be initiated; Commodus (180-192) was received into the brotherhood; in the third century the emperors had a Mithraic Chaplain; Aurelian (270-275) made the cult official; Diocletian, with Galerius and Licinius, in 307 dedicated a temple to Mithra; and Julian was a devotee."[207]

In the fifth century, the emperor Julian, having rejected his birth-religion of Christianity, adopted Mithraism and "introduced the practise of the worship at Constantinople." For Mithraism and Paganism in general, Julian's demise was the straw that broke the camel's back. Following Julian's death "the attack of

Christianity was definite and furious." After this point, Mithraism declined and disappeared until the end of the 15th century, when it reappeared sparsely and briefly in European literature and imagery. Nevertheless, Mithraism had existed for several centuries and had made a significant impact on the Roman world. Factoring in his Vedic roots as the "shining one" Mitra, Mithra could be considered the oldest "Roman" god, "with the single exception of the Alexandrian gods."[208]

One of the most famous rites within Mithraism was the "Tauroctony" or slaying of a bull by Mithra. Images of this bloody act did not appear in Mithraic iconography until Mithraism became influenced by Greek and Roman art. However, similar imagery existed much earlier in the same places in Asia Minor and the Near East where Mithraism became homogenized, and Mithra was associated with bull symbolism in literature long before the Greco-Roman era. In fact, the bull motif is a reflection of the Age of Taurus (4500-2300 BCE), one of the 2,150-year ages created by the precession of the equinoxes.

The discernment of the Mithraic bull as representing the sign and age of Taurus is not new: In the 18th century, Dupuis discussed the identification, as did Volney. At the end of the 19th century, Bunsen also wrote about the Taurean bull, discussing Buddha as represented by the Lamb, but not the Bull, unlike Mithra and "the more ancient solar heroes of the time when Taurus was the spring equinoctial sign."[209] Another god who "rides the bull" is Ahura Mazda, the Persian Supreme God; his Jewish counterpart, Yahweh, is likewise depicted "riding on the Cherub, Kirub or bull." As Bunsen further remarks, "This bull is almost certainly the constellation of Taurus." Like the bull, the other Mithraic initiation degrees have been determined to represent constellations, as part of a "star map," demonstrated most recently by David Ulansey in *The Origins of the Mithraic Mysteries: Cosmology and Salvation in the Ancient World.* Says Ulansey: "The Mithraic tauroctony, then, was apparently designed as a symbolic representation of the astronomical situation that obtained during the Age of Taurus."[210]

The solar-bull motif is found in very ancient cultures, including the Sumerian, on seals depicting the flaming "Bull of Heaven," representing the sun's "fierce aspect." Long before the Christian/Roman-Mithraic era, numerous gods were worshipped in the form of the bull, including Zeus and his Indian counterpart, Shiva, as well as the Egyptian gods Min, Ra and Amen, the latter of whom was called "the young bull with sharp pointed horns."[211] The very ancient Osiris and the later Egyptian god Apis likewise were portrayed as bulls, as was Osiris's Greek

counterpart, Dionysus/Bacchus. A number of goddesses also were represented as cows, such as Neith and Hathor.

The bull motif appears early in India as well, "profusely presented" in the imagery of, and as an apparent object of worship in, the Harappan culture of the Indus Valley,[212] which is conservatively dated to 2500-1700 BCE. In fact, the taurine solar symbol is found repeatedly on Harappan pottery, and on its seals are numerous depictions of the "unicorn or urus bull," possibly also signifying the sun god.[213]

In the sacred Indian text the Rig Veda, which is by conservative estimates 3,500 years old, the sun god Surya appears as a bull, as does the fire and sun god Agni, who is "often invoked as 'the Bull,'" a symbol of the god's strength.[214] Another sun god, Rohita, is addressed in the Atharvaveda as "a bull or the bull of prayers"[215] and "the bull arranging the day and night." Rohita is also identified with the sacrifice, offering himself and a "primaeval sacrifice," from which all are born and the universe is created.[216] In many rites depicted in that Veda "the bull is a symbol of the Sun."[217] In the Indian text *Taiit. Brahmana* (ii. 7, 11, 1), the sun and storm god Indra is described as a bull, and bulls were sacrificed to him.[218]

Hence, in the millennium or millennia before the common era, and in the culture that spawned the Persian, appears *the motif of the sun god as a bull, performing a sacrifice or sacrificing himself for the welfare of the universe.* Concerning the Mithra sacrifice and its connection to both India and Persia, Christian authority Rev. Lundy made some interesting assertions:

> ...inasmuch as the Persian Fire-worship and the main part of the Persian religion were derived from India, the sacrifice, death, and Resurrection of Mithra become but counterparts of Vishnu's incarnation, sacrifice, etc., in Krishna.[219]

Lundy thus maintained that Mithra himself was sacrificed and resurrected, and that the motif corresponds to the life of Krishna, also an Indian sun god. Another learned Christian, Colonel Tod, described the Indo-Persian bull sacrifice thus:

> The Bull was offered to Mithras by the Persians, and opposed as it now appears to the Hindu faith, he formerly bled on the altars of the sun God (BAL-ISWARA), on which the Buld-dan (*offering of the bull*) was made.[220]

In reality, bulls were sacrificed in many cultures millennia before the common era, including on the Greek island of Crete, some 4,000 years ago. In the "Epic of Gilgamesh," composed more than 4,000 years ago, the Sumero-Babylonian demigod/hero Gilgamesh is represented as wrestling and killing the "Bull of Heaven," the same motif as Mithra slaying the bull. The bull-

slaying theme in the Near East "goes back to an ancient Assyrian cult which produced monuments of a divine or kingly personage slaying a lion or a bull by thrusting a sword through him."[221]

The sacrifice to, or reverence of, the bull can also be seen in an image (c. 1400 BCE) from the palace of Alaça Hüyük in Turkey, near Bogaz-Köy, where the Hittite-Mitanni tablets were discovered. In this relief, a man and priestess approach a bull on a pedestal in front of an altar.[222] Each figure has its arm raised, as if to sacrifice the beast. Also, in the mythology of the Hurrians, southern neighbors of the Hittites, the god Teshub has attached to his chariot two bulls representing Night and Day, and, like Mithra centuries later, Teshub was "frequently depicted standing on a bull."[223]

In addition, in an early image "Mithra" is portrayed as a sun disc in a chariot drawn by white horses, a solar motif that made it into the Jesus myth, in which Christ is to return on a white horse. Concerning Mithra's solar journey, the *Larousse Encyclopedia of Mythology* states:

> In the pre-Zoroastrian period Mithra, often associated with the supreme Ahura, was a god of the first magnitude. His military valour was without rival. He possessed not only strength but at the same time knowledge; for in essence he was Light. As such he led the solar chariot across the sky.... Beasts were sacrificed to him...[224]

Larousse clearly states that "beasts were sacrificed" to Mithra, in the "pre-Zoroastrian period," which would be at least 600 years before the common era.

A symbol for Mithra himself, when the Heavenly Bull is slain the act represents the god sacrificing himself "for the sins of mankind," in order to save the world, as the bull "appears to signify the earth or mankind," with the implication that Mithra, "like Christ, over came the world." In the Mithraic rite, "Mithra, like Osiris and Dionysus, was the bull as well as the God to whom the bull was sacrificed."[225] As Weigall says, "Mithra sacrificed a bull, but this bull...was himself."[226] Drews too states: "Mithras too offers himself for mankind. For the bull...was originally none other than the God himself—the sun in the constellation of the Bull, at the spring equinox."[227] Early Persian texts depict Mithra himself as the bull, "the god thus sacrificing himself," similar to the Christian sacrifice.[228] That Mithra is himself the bull is further evident from the assertion that the "Persian Mithras was also eaten in bull form."[229]

In any event, the bull motif was anciently associated with Mithra, centuries before the Christian era, further verified by a Greek magical papyrus dating to the Hellenistic period (3rd-2nd

cents. BCE) that "instructs the adept on achieving a detailed trance-vision of the sun god Mithra and his bull..."[230]

Mithra's slaying of the bull was an act that became as central to Mithraism as was the crucifixion to Christianity. The bull represented rebirth, fertility and fecundity, with his blood corresponding to the wine of the mysteries. The sacrifice of the bull was reenacted in the Mithraic baptism, a mystery rite in which the initiates were splattered with the blood after which they were "born again" and "cleansed of sins."[231] This initiation, then, represented a "spiritual birth," the same as the Christian baptism.

This ritual can also be found abundantly in the Jewish culture from which Christianity partly sprang, as reflected at Exodus 24:6-8. The purpose of this rite is not only to perform ritual magic that provides future abundance or the cleansing of sins, but also to intimidate the people through gore into obeying the priesthood. In the Epistle to the Hebrews, this sanguinary sacrifice is addressed, as the author usurps it with the sacrifice of the High Priest, Christ (9:22). At Hebrews 12:24 and 1 Peter 1:2 is depicted the sprinkling of the blood, the latter scripture referring to the blood of Jesus Christ "the Lamb."

The sprinkling or splashing of the sacrificed animal's blood is considered a baptism, especially since it is designed to convey immortality. Like this bloody rite, baptism with water, whether by immersion or sprinkling, is found in numerous pre-Christian religions/cults, dating back to ancient times. Baptism or lustration for the removal of evil or sins existed in the Sumerian culture, for example, 2,000 or more years before the Christian era. In Sumero-Babylonian religion, baptism was used as a rite of exorcism, likewise a concept long pre-dating the Christian era. The Sumero-Babylonian Trinity included Anu, Enlil and Ea, the last of whom was the "personification of divine healing power." This Triad, along with Marduk, was invoked to dispel sickness.

Baptism was therefore quite common among the pre-Christian "heathen" and Jews, as admitted even by the Catholic Encyclopedia ("Baptism"), which claims that it was "natural and expressive" to wash the exterior as being symbolic of "interior purification." Says CE: "The use of lustral water is found among the Babylonians, Assyrians, Egyptians, Greeks, Romans, Hindus, and others. A closer resemblance to Christian baptism is found in a form of Jewish baptism, to be bestowed on proselytes, given in the Babylonian Talmud..."[232] Indeed, "Baptism is a very ancient rite pertaining to heathen religions, whether of Asia, Africa, Europe or America. It was one of the Egyptian rites in the mysteries."[233] In the Egyptian baptism by water to remove sins, Osiris, acting as a scapegoat, takes into himself impurities, sins

and "all that is hateful" in the deceased, "and the dead is purified by the typical sprinkling of water."[234] This baptism for the remission of sins was "in vogue" in the 5th and 6th Dynasties, 2400 or so years before the Christian era. The antiquity of baptism within Judaism is indicated not only by the story of Christ's baptism but also by the words of Paul at 1 Corinthians 10:1-4, where, in addressing his "brethren, Paul refers to the passing of "our ancestors" "through the sea, and all were baptized in Moses..."

Possessing not only baptism but also other "Christian" rituals and motifs, Mithraism was so similar to Christianity that it gave fits to the early Church fathers, as it does to this day to apologists, who attempt both to deny the similarities and yet to claim that these (non-existent) correspondences were plagiarized *by* Mithraism *from* Christianity. However, by the time the Christian hierarchy prevailed in Rome, Mithra had already been the official cult, with popes, bishops, etc., and its doctrines well established and widespread, reflecting antiquity. Mithraic remains on Vatican Hill are found *underneath* the later Christian edifices, which *prove* the Mithra cult was there first. In fact, while Mithraic ruins from the first and second centuries are abundant throughout the Roman Empire, the "earliest church remains, four in Dura-Europos, date only from around 230 CE."

Correspondences between the religions include the portrayals of their separate godmen: Like Christ, Mithra was considered the remover of sin and disease, the creator of the world, God of gods, the mediator, mighty ruler, King of kings, lord of heaven and earth, the Sun of Righteousness, etc. As was Jesus, Mithra too was called "the Way," "the Truth," "the Light," "the Life," "the Word," the "Son of God" and the "Good Shepherd."[235] Mithra as the Mediator is unquestionably a concept that predated Christianity by centuries, and the deliberate reference to Christ as the Mediator at Hebrews 9:15 is an evident move to usurp Mithra's position.

Further correlations between Mithraism and Christianity can be found in the Christian catacombs, where there are numerous images of Christ as the "Good Shepherd," also a title of Apollo, who in his solar aspect, and as the "patron of the rocks," is identified with Mithra. Indeed, "Petra, the sacred rock of Mithraism, became Peter, the foundation of the Christian Church."[236] Another remnant of militant Mithraism within Christianity can be found in the phrases "soldiers of Christ" and "putting on the armor of Christ."

Other elements within Mithraism paralleled in Christianity include the miter or mitre, the bishops' headdress; and the *mizd*, or "hot cross bun," which was shaped like the sun with a cross in

the middle. The similarities between Mithraism and Christianity continue with their chapels, the term "father" for priests, celibacy, the mass and, most notoriously, the December 25th birthdate. Apologists claiming that Mithraism copied Christianity nevertheless admit that the December 25th birthdate was taken *from* Mithraism.[237] Another correlation exists in the fact that the Mithraic "Lord's Day," like that of other solar cults, was celebrated on *Sun*day, also adopted by Christianity from Paganism.

Robertson elucidates other Mithraic-Christian correspondences:

> From Mithraism Christ takes the symbolic keys of heaven and hell and assumes the function of the virgin-born Saoshyant, the destroyer of the Evil One. Like Mithra, Merodach [Marduk] and the Egyptian Khousu [Khonsu], he is the Mediator; like Horus he is grouped with a divine Mother; like Khousu he is joined with the Logos; and like Merodach he is associated with a Holy Spirit, one of whose symbols is fire.[238]

As concerns the origins of various "modes of expression and images" found in the New Testament, Drews traces them to "the common treasury...of the secret sects of the Orient," especially the Mandaean religion and Mithraism. Naming "the rock," "the water," "the bread," "the book," "the vine," "the good shepherd" and other concepts already discussed, Drews also states that these expressions are "in part known" from the Rig Veda, concerning the Indian sun and fire god Agni.[239] Therefore, all of these "Mithraic" rites, closely paralleled in the later Christianity, existed independent of Mithraism long before the common era.

In addition, according to Dupuis's original multi-volume work in French (not included in the English translation), Mithra was "put to death by crucifixion, and rose again on the 25th of March." Concerning the Persian crucifixion, Robertson states, "...the Persian Sun God Mithra is imaged in the Zendavesta 'with arms stretched out towards immortality.'"[240] Mithra's suffering was considered an act of salvation, and his resurrection was celebrated with his priests shouting, "He is risen," as they do to this day in Eastern Orthodox Christianity at Easter.

Mithra's genesis out of a rock, analogous to the birth in caves of a number of gods, including Jesus, was followed by his adoration by shepherds, another motif appearing in Christianity. Regarding the birth in caves common to pre-Christian gods, and present in the early legends about Jesus, apologist Sir Weigall relates:

> ...the cave shown at Bethlehem as the birthplace of Jesus was actually a rock shrine in which the god Tammuz or Adonis was

worshipped, as the early Christian father Jerome tells us; and its adoption as the scene of the birth of our Lord was one of those frequent instances of the taking over by Christians of a pagan sacred site. The propriety of this appropriation was increased by the fact that the worship of a god in a cave was commonplace in paganism: Apollo, Cybele, Demeter, Herakles, Hermes, Mithra and Poseidon were all adored in caves; Hermes, the Greek *Logos*, being actually born of Maia in a cave, and Mithra being "rock-born."[241]

Unlike various other rock- or cave-born gods, Mithra is not overtly depicted in the Roman mythology as having been given birth by a mortal woman or a goddess; hence, it is claimed that he was not "born of a virgin," as asserted by numerous writers over the centuries, including Robertson and Evans. In *Pagan Origins of the Christ Myth*, Jackson states: "Mithra, a Persian sun-god, was virgin-born, in a cave, on December 25. His earliest worshippers were shepherds, and he was accompanied by twelve companions." In *The Christ Myth*, Drews says that the Goddess "appears among the Persians as the 'virgin' mother of Mithras."[242] Stating that the Romans added "much of the ritual of their most popular cult, Mithraism, to Christianity," Berry adds, "Mithras was supposed to have been born of a virgin, the birth being witnessed by only a few shepherds."[243] Berry further relates: "As Mithraism moved westward it proved a fertile ground for the addition of mystic meaning. Practically all of the symbolism of Osiris was added to the Mithraic cultus, even to the fact that Isis became the virgin mother of Mithras." In *Pagan and Christian Creeds*, Carpenter recounts, "The saviour Mithra, too, was born of a Virgin, as we have had occasion to notice before; and on Mithraist monuments the mother suckling her child is not an uncommon figure." Carpenter's assertion is backed up by John Remsburg in *The Christ* (ch. 7), in which he reports that an image found in the Roman catacombs depicts the babe Mithra "seated in the lap of his virgin mother," with the gift-bearing Magi genuflecting in front of them. As such iconography was common in Rome as representative of Isis and Horus, it would not be surprising to find it within Mithraism as well.

In addition, there existed widely a pre-Christian "virgin of the mysteries," and Mithraism was a famous mystery religion. Moreover, Mithra's prototype, the Indian Mitra, *was* born of a female, Aditi, the "mother of the gods," the inviolable or *virgin* dawn. Also, despite his depiction of being "rock-born," the myths surrounding Mithra include that he was the son of the Persian goddess Atagartis.[244] Interestingly, Atagartis or Adargatis was the consort of the Assyrian god Adad, who in Syria was considered a sun god and was depicted standing on the back of a bull. In any

event, the pervasive virgin birth motif of other gods and men, especially the sun gods, could certainly not have been unknown to Mithraic initiates.

The theme of the teaching god and "the Twelve" is also found within Mithraism, as Mithra is depicted surrounded by the 12 zodiac signs on a number of monuments[245] and in the writings of Porphyry, for one. As they have been in the case of numerous sun gods, these signs could be called Mithra's 12 "companions" or "disciples."

The motif of the 12 disciples/followers in a "last supper" is also recurrent in the Pagan world, including within Mithraism:

> [Mark] gave Jesus a last supper with twelve followers, identical in every way with the last supper of the Persian god Mithra, down to the cannibalisation of the god's body in the form of bread and wine (14:22-26).

> The Spartan King Kleomenes had held a similar last supper with twelve followers four hundred years before Jesus.[246]

Hence, another pre-Christian doctrine found in Paganism in general and Mithraism in specific is the Eucharist, Last Supper, Lord's Supper or Holy Communion. From early ages, the Mithraic eucharist, which was said to bestow immortality upon the participants, has been recognized as parallel to the Christian. The rite is very old and certainly did not find its way into Paganism from Christianity, its antiquity conceded by the Catholic Encyclopedia, which admits, "Mithraism had a Eucharist, but the idea of a sacred banquet is as old as the human race and existed at all ages and amongst all peoples."[247]

Another nuisance to Christian apologists is the Mithraic mark upon the forehead, a rite similar to that within Catholicism. The mark on the forehead as a sign of religious respect is well known to have been used in India for millennia. Even the Bible records Ezekiel (9:4) as marking the foreheads of the "righteous." In *The Chaplet (De Corona)*, Church father Tertullian (160?-230?) comments on the "mimicry of martyrdom," as well as the crown and the mark of Mithraism, and says that these are devices of the devil, "who is wont to ape some of God's things" for the sole purpose of humiliating God's faithful servants.[248]

Mithraism was so popular in the Roman Empire and so similar in important aspects to Christianity that several Church fathers such as Tertullian were thus compelled to address it, disparagingly of course. In his *Dialogue with Trypho*, Justin Martyr (100?-165?) acknowledged the mysteries of Mithra and claimed in chapter LXX that they were "distorted from the prophecies of Daniel and Isaiah.[249] Like Tertullian, Julius Firmicus Maternus (4th cent.) fell back on "the devil did it

argument," the proponents of which claim that the numerous similarities between Paganism and Christianity are the work of Satan anticipating Christ's advent. In this regard, it is noteworthy that the fathers did not maintain that the Mithraic mysteries were copied *from* Christianity; their appeals to "prophecies" purportedly written centuries before, and to "the devil's aping," represent admissions that Roman Mithraism, with rites well developed and known at the time, preceded Christianity. In any event, the germane elements of Mithraism antedated Christianity by hundreds to thousands of years, whether or not they existed within Mithraism itself for that length of time.

In its attempts at distinguishing Catholicism from Mithraism and other Pagan religions, the Catholic Encyclopedia boasts that, unlike those ideologies, Christianity is intolerant and exclusive. One of the reasons Mithraism did not last, in fact, is because *it* excluded women, who were in need of "a God, not towering above them like the Eternal Sun...but a God who had walked upon the earth in human form, who had known like themselves pain and affliction, and to whom they could look for sympathy and help."[250] It has also been asserted that the reason Mithraism failed while Christianity succeeded is because the former "did not spring from a strong personality such as Jesus."[251] In other words, the creators of Christianity needed to make their god into a "real person." In actuality, neither Mithra nor Christ was a "real person" but both are personifications of the God Sun.

Other Gods of the Sun

Other manifestations of the God Sun include Adonis, the Greco-Syrian solar-fertility god identified with Yahweh: "That Adonis was known also by the name Iao cannot be doubted."[252] The Adonis myth includes that he was killed by a boar, an unkempt, rude animal "intended to represent winter," says Macrobius. Winter, therefore, "inflicts a wound on the sun," the origin of the side wounding found in the myths of Christ and other gods. Adonis's death occurred at the winter solstice, appropriate for a sun god.

The Adonis myth has much in common with the Christ fable, so much so that the similarities vexed the early Church fathers to no end. Included in these parallels is the fact that the Syrian capital of Antioch, fourth largest city of the Roman Empire and the site where Christians were first so called, was the seat of an annual death and resurrection of Adonis, also called Tammuz. Like Jesus, Adonis ("the Lord") was born at Bethlehem, where his birthplace was visited by pious pilgrims. As Christian apologist Sir Weigall relates, St. Jerome was "horrified to discover" the "early shrine of this pagan god." Weigall also observes:

This god was believed to have suffered a cruel death, to have descended into Hell or Hades, to have risen again, and to have ascended into Heaven; and...on the next day, his resurrection was commemorated with great rejoicings, the very words "The Lord is risen" probably being used.[253]

Furthermore, on the altar in the Jewish Temple where Adonis/Tammuz was mourned (Ezek. 8:14) stood the "Ashera," or "upright emblem" (sexual symbols). Concerning the altar and Adonis's worship there, Cox remarks:

Here also, on the third day, they rejoiced at the resurrection of the lord of light. Hence, as most intimately connected with the reproduction of life on earth, it became the symbol under which the sun, invoked with a thousand names, has been worshipped throughout the world as the restorer of the powers of nature after the long sleep or death of winter.[254]

Adonis, the "lord of light," dies and is resurrected on the third day, a solar motif that predates Christianity and is an archetype used in the later gospel tale.

The Syrian Tammuz (Sumerian "Dumuzi") is evidently related to the Egyptian god Tum or Tmu, who, Budge says, was a "more ancient form" usurped by Ra, the "local form of the Sun-god."[255] Tammuz has been demonstrated to be the prototype of the mythical disciple Thomas and is also identified with Osiris.

Yet another dying-and-rising god predating and influencing Christianity was the Phrygian Attis, who, as Macrobius asserts, was also the sun. His virgin mother, Cybele, the "Mother of the Gods," is the earth, with the Attis-Cybele relationship comparable with that of Osiris and Isis, "for it is no secret that Osiris is none other than the sun and Isis, as we have said, none other than the earth or world of nature." As in the rites of Osiris, in the mysteries of Attis the worshipper engaged in an immortality ritual designed to unite him with the god. In this quest for eternal life, "an effigy of the god was buried, and when on the third day the sepulcher was opened and found to be empty the resurrection of the god was hailed by his worshippers as a guarantee of their own resurrection."[256] As related by Berry in *Religions of the World*, such mystery cults, which included that of Cybele and Attis, "the older Tammuz, Osiris, Dionysus, or Orpheus under a new name," appeared in Rome at least two centuries before the common era. Berry also states: "The festival began as a day of blood on Black Friday and culminated after three days in a day of rejoicing over the resurrection."[257]

Concerning Attis, apologist Weigall remarks:

Then again, there was the worship of Attis, a very popular religion which must have influenced the early Christians. Attis was the Good Shepherd, the son of Cybele, the Great Mother, or

alternatively, of the Virgin Nana, who conceived him without union with mortal man, as in the story of the Virgin Mary... In Rome the festival of his death and resurrection was annually held from March 22nd to 25th; and the connection of this religion with Christianity is shown by the fact that in Phrygia, Gaul, Italy and other countries where Attis-worship was powerful, the Christians adopted the actual date, March 25th, as the anniversary of our Lord's passion.[258]

Attis, whose mother Nana "conceived him virginally" by swallowing a pomegranate or almond seed, was equivalent to "Adonis-Tammuz-Dionysus-Rimmon," to whom the pomegranate was sacred, as it was to Jehovah at Jerusalem.[259] As we can see, the Attis myth possesses some important elements echoed in the Christ tradition. Since it was mainly Jews who created Christianity, it is significant that an ancient Jewish inscription found at Rome reads, "To Attis the Most High God who holds the Universe together."[260]

Also solar in nature is the god Saturn, who was the same as El, the Canaanite/Israelite god. Saturn is the "author of time and the seasons";[261] in other words, he is Kronos. Saturn is also the planet by that name, which was considered the "central sun" of the night sky. One reason why the planet Saturn was thus deemed may be found in Ficino's explanation that, of all the planets, Saturn deviates the least from the "regal path of the Sun." Macrobius also relates that Saturn was called the "chief of the gods." He further states that the Egyptians would not admit the worship of either Saturn or Serapis into "the secret places of their temples until after the death of Alexander of Macedon," a prohibition caused by the fact that the followers of these two gods engaged in animal sacrifice.[262] Apparently, the "Saturn" referred to Macrobius is specifically El, worshipped by the large Alexandrian population of Hebrews, Israelites and Jews.

Included in the solar pantheon is Ptolemy's syncretic state god, Serapis, created in the fourth century BCE to synthesize the Greek and Egyptian worship, as well as, apparently, that of Jews, Samaritans, Hebrews, etc. Diodorus points out that, as Osiris's later incarnation, Serapis is Dionysus as well. Macrobius relates that even in his day (5th century CE) Serapis and Isis were worshipped at Alexandria, "with a reverence that is almost fanatical." Macrobius then cites as evidence that Serapis is the sun the basket on the god's head and the image of a "three-headed creature" placed near the god's statue.[263] This curly-haired god was extremely popular around the Roman Empire, extending even into Britain.[264]

In an Egyptian letter possibly dating from the 3rd century CE, from "Nephotes to Psammetichos king of Egypt," the writer

invokes "King Aberamenthôu," or, as Legge says, "*Aber-amenti*: 'Lord (lit. Bull) of Conqueror of Amenti,' the Egyptian Hades." This quote clearly refers to Osiris/Serapis. Yet, as Legge further remarks, "Jesus, in one of the later documents of the *Pistis Sophia*, is called *Aberamenthô*."[265] Hence, Jesus is equated with Osiris and Serapis. This letter contains many "spells," as do the magical papyri found in abundance and dating from the 3rd century BCE to the 4th or 5th centuries CE. Another prayer/spell in this letter is addressed to the "ruler of the gods, high-thundering Zeus, O king Zeus Adonai, O Lord Jehovah," which demonstrates that Zeus and Yahweh were considered the same, as they are also one with Serapis, likewise revealed in this spell. Regarding this spell and its evidently Hebrew magician, Legge comments:

> Although the magician parades his learning by using the name of one of the Syrian Baals...he is evidently well acquainted with Hebrew, and one of the phrases used seems to be taken from some Hebrew ritual. It is hardly likely that he would have done this unless he were himself of Jewish blood; and we have therefore the fact that a Jewish magician was content to address his national god as Zeus and to make use of a "graven image" of him under the figure of the Graeco-Egyptian Serapis in direct contravention of the most stringent clauses in the Law of Moses. A more striking instance of the way in which magicians of the time borrowed from all religions could hardly be imagined.[266]

Those who used these spells and prayers were not only "magicians" but also *priests*, as the two are essentially the same, both employing "voodoo" or mystical rituals to invoke a god or supernatural power, both presenting smoke-and-mirror illusions to their audience. Such priestcraft was used to create Christianity, incorporating, among many others, Serapis, whose long- and dark-haired, bearded image was later used to depict Jesus the Savior. Legge relates that Aristides called Serapis "the Saviour and leader of souls, leading souls to the light and receiving them again." Serapis also raised the dead and revealed to them the "longed-for light of the sun."[267]

It is widely reported that the Emperor Hadrian during the second century declared Serapis "the peculiar god of the Christians." The Serapis cult also held favor among the elite, who made a point of visiting its popular oracle at Alexandria. One such visitor, who, legend claims, obtained healing powers there, was the Emperor Vespasian. Reputedly a member of the ultra-secret society the "Sons of the Sun," Vespasian visited the famous sanctuary on Mt. Carmel, where he purportedly discussed with its high priest the creation of a religion that would unify Judaism and Paganism: In other words, a hybrid, eventually called Christianity.

By the time of Macrobius, Serapis had been lifted up to center stage, before the god's fate was sealed, however, with the vicious assault on his temple, library and priesthood by crazed Christian fanatics under Alexandrian patriarch Theophilus (385-412). Nevertheless, the sun god Serapis, "the peculiar god of the Christians," was not destroyed but morphed into Jesus. Serapis's status as a sun god—and therefore that of all the other permutations associated with him, including Jesus—is evident from his hybridization with Helios, as depicted in bust from the 2nd century BCE.

Another god who represented the healing aspect of the sun was the Greek Asclepius, called Iasios/Jason/Jesus and similar in several respects to Serapis/Christ, including in his ability to raise the dead. Macrobius describes Asclepius as representing "the healthful power which comes from the essence of the sun to give help to mortal minds and bodies." Asclepius was also identified with Apollo, another solar healer, based on Asclepius's status as Apollo's son and his power of prophecy.[268] The priesthood of Asclepius, "which was derived from that of Thoth, the Egyptian god of healing and inventor of letters," was expelled from Phoenicia, possibly around 1400 BCE.[269] By Roman times, Asclepius's worship was widespread throughout the empire, found even in Great Britain.[270]

The double-faced Roman god Janus, the genius of the month of January, was likewise the sun, identified with Apollo, the sun god, and Diana, the moon goddess.[271] Hence, Janus represents both the sun and moon. Yet, like the dual-nature god of Egypt and Babylon, he may also be the day and night, spring and winter, fertility and sterility, as well as the setting and rising sun. Placed above doorways and depicted holding a key, Janus was the "doorkeeper of heaven and hell." As evidence of Janus's solar nature, Macrobius cites a popular image of the god "expressing the number three hundred with his right hand and sixty-five with his left," marking the days of the year.[272] As has been evinced by a number of scholars, *Janus Pater*, the keyholder and gatekeeper, is the prototype of St. Peter.

Yet another significant manifestation of the God Sun was the Celtic Son of the Mother Goddess, about whom Stewart states, "Christ was similar, if not exactly identical, to a god who had long been worshipped extensively in Celtic regions under various names: the Son of Light."[273]

The solar mythos and astrotheology are not confined to the "Old World," as they can also be found in the Americas, with the tales of the virgin-born Quetzalcoatl, for example, and the Peruvian sun god Viracocha, who, after the Flood that destroyed "all mankind," rose out of Lake Titicaca to become the founder of

the city of Cuzco. It was claimed that the sun god hid during the flood on the small island in Titicaca, where a temple was dedicated to him, similar to the Egyptian island Chemmis and the Greek island Delos, sites sacred to the sun.[274] Viracocha's rising from the lake and moving to the west while battling foes, before vanishing into the "western sea," demonstrate his solar nature.[275]

The "New World" god Quetzalcoatl, whose "life" and religion so startlingly resemble that of Christ and Christianity, was the personification of the "Sun of today," while his father, Camaxtli, was the "Sun of yesterday."[276] Hence, Quetzalcoatl is depicted as the *son* of the sun, much like Horus and other solar heroes. Called Kukulcan on the Yucatan, Quetzalcoatl means "feathered serpent," whose cult that was "unquestionably a branch of sun-worship."[277] A number of characteristics demonstrate Quetzalcoatl's solar nature, including the traveling staff, serpent and solar disc he is portrayed as or with; his gilded reign; and his emergence from the sun.[278] The principal Mexican solar festival was held at the vernal equinox, i.e., Easter, when sacrifices were made to sustain the sun.[279]

The eminent authority on Mexican antiquities, Lord Kingsborough, repeatedly confirms Quetzalcoatl's solar nature:

> The Mexicans appear to have blended together the worship of Quecalcoatle and of the Sun; and the remark of Tertullian, that there were some inclined to assimilate the religion of the primitive Christians *to that of the Sun,* is deserving of notice; since the symbolical name of "the Sun,"...was given to the Messiah in the Old Testament.[280]

In a number of places, Kingsborough emphasizes that "the Mexicans worshiped Quecalcoatle as the sun,"[281] and that the ancient Jews also "typified" the Messiah "under the image of the sun." [282] Kingsborough's remarks reveal the solar nature of not only Quetzalcoatl but also the Jewish Messiah, i.e., Jesus. Moreover, Quetzalcoatl was portrayed as white and black, as was Jesus, but most frequently red. Thus, the Mexican god is not a "real person" but an archetypical sun god, represented in these three colors, symbolizing day, night and sunset or sunrise.

Quetzalcoatl's many similarities to Jesus include his virgin birth, his crucifixion, and his resurrection from the dead, wherein he is depicted as a bird rising from ashes, like the famed Phoenix, with whom Jesus was identified from earliest times by the Church fathers. Before his resurrection, the Mexican god "wandered in the underworld," as did Jesus. Also, like Jesus, Quetzalcoatl was the "morning star," called the "Lord of the Dawn."[283] Another Mexican god, Huitzilopochtli, was pierced by an arrow and resurrected annually.[284]

Conclusion

It is abundantly evident that mankind's predominant religious worship globally for many thousand years has been astronomical and astrological, and that this astrotheology has continued within the faiths popular today. These facts, however, have been hidden under a cloak of historicity, with the astromythological players being presented as "real people."

As has also been demonstrated thoroughly, one of the principal objects of worship over the millennia has been the sun. In this regard, the ancient authority on the solar religion, Macrobius, ends his dissertation on the numerous sun gods, placed mainly in the mouth of his character Praetextatus, by portraying the others present as staring at the speaker with "wide-eyed wonder and amazement." The reasons for their awe are multiple:

> ...one of the guests began to praise his memory, another his learning, and all his knowledge of the observances of religion; for he alone, they declared, knew the secrets of the nature of godhead, he alone had the intelligence to apprehend the divine and the ability to expound it.[285]

Thus, one who understands the solar mythology or astrotheology is one who knows the nature of godhead and the divine. Without this knowledge, humanity continues to wallow in erroneous concepts that blind it to its unity and allow for dangerous divisiveness. With the knowledge of the astrotheological core of mankind's religions, including the predominant sun worship, the human race can become enlightened regarding its own connection to the cosmos and divinity.

[1] Budge, *EBD*, xci.
[2] Budge, *EBD*, xciii. (Emph. added.)
[3] Bonwick, *EBMT*, 188.
[4] Budge, *EBD*, 7.
[5] Budge, *EBD*, liii.
[6] Reade, 3.
[7] Budge, *EBD*, liii fn.
[8] Bonwick, *EBMT*, 154.
[9] www.bib-arch.org
[10] Bonwick, *EBMT*, 155.
[11] Siculus, 14.
[12] Siculus, 15.
[13] Iamblichos, 195.
[14] Siculus, 20.
[15] Siculus, 24-25.
[16] Higgins, I, 137.
[17] Moor (1810), 151.

[18] Bonwick, *EBMT*, 168.
[19] Wilford, *AR*, III, 365.
[20] Bonwick, *EBMT*, 165.
[21] Olcott, 149.
[22] Olcott, 298-297.
[23] Siculus, 34-37.
[24] Siculus, 34-37.
[25] Siculus, 35fn.
[26] Budge, *EBD*, liii fn.
[27] Budge, *EBD*, 247fn.
[28] Budge, *EBD*, 253fn.
[29] Spence, *AEML*, 84.
[30] Macrobius, 141, et seq.
[31] Olcott, 157.
[32] Spence, *AEML*, 131.
[33] Spence, *AEML*, 300.
[34] Rylands, 235fn.
[35] Bonwick, *EBMT*, 94.
[36] Budge, *EBD*, lix.
[37] Budge, *EBD*, lxxvii.
[38] Spence, *AEML*, 134.
[39] Budge, *EBD*, cx, 281fn.; Spence, *AEML*, 136.
[40] Budge, *EBD*, l.
[41] Legge, I, 69.
[42] Legge, I, 126.
[43] Budge, *EBD*, xlviii.
[44] Spence, *AEML*, 79.
[45] Frazer, 426.
[46] Spence, *AEML*, 65.
[47] Bonwick, *EBMT*, xviii.
[48] www.newadvent.org/fathers/0410.htm
[49] Legge, I, 87.
[50] Spence, *AEML*, 46.
[51] Bonwick, *EBMT*, 163.
[52] Spence, *AEML*, 117.
[53] Bonwick, *EBMT*, 152.
[54] Kerenyi, 69.
[55] Kerenyi, 77.
[56] Kerenyi, 140.
[57] Freke and Gandy, 228.
[58] Cox, II, 295.
[59] Legge, I, 47.
[60] Macrobius, 131.
[61] Legge, I, 121.
[62] Lundy, 190.
[63] Siculus, 122fn.
[64] Rylands, 21.
[65] Leidner, 107, et seq.
[66] encyclopedia.thefreedictionary.com/Saules%20meitas

[67] Dupuis, 115-118.
[68] *CMU*, 13.
[69] Hoffman, *PAC*, 41.
[70] Dupuis, 174.
[71] Robertson, *CM*, 31fn.
[72] Weigall, 220-224.
[73] Carpenter, *CM*, 329.
[74] Kerenyi, 257.
[75] Hoffmann, *PAC*, 139.
[76] Muir, V, 260.
[77] Cox, I, 80.
[78] Cox, II, 296.
[79] James, 166-1667.
[80] Campbell, *OM*, 27.
[81] Freke and Gandy, 29.
[82] Frazer, 450.
[83] Kerenyi, 82.
[84] Kerenyi, 354.
[85] Frazer, 450.
[86] Frazer, 452.
[87] Freke and Gandy, 51.
[88] Freke and Gandy, 52.
[89] Drews, *CM*, 197.
[90] Hengel, 68.
[91] Reik, 31.
[92] Kerenyi, 194.
[93] Siculus, 29.
[94] Macrobius, 138-139.
[95] Siculus, 30fn.
[96] Graves, R., 125.
[97] Budge, *EBD*, 281fn.
[98] Robertson, *CM*, 150.
[99] Bierlein, 51.
[100] Herodotus, 562.
[101] Lundy, 65.
[102] Massey, *GML*, 10.
[103] Spence, *AEML*, 176.
[104] Massey, *GML*, 173-174.
[105] Olcott, 57.
[106] Herodotus, 102-103.
[107] Herodotus, 114.
[108] Iamblichos, 255.
[109] Bonwick, *EBMT*, 202.
[110] Bonwick, *EBMT*, 204.
[111] Budge, *EBD*, xcvii.
[112] Budge, *EBD*, 255.
[113] Jackson, *CBC*, 152.
[114] Bonwick, *EBMT*, 99.
[115] Dupuis, 91-93.

[116] Dupuis, 96.
[117] Moor (Simpson), 121.
[118] Wilford, *AR*, V, 270.
[119] Bonwick, *IDOIR*, 194.
[120] *CMU*, 23.
[121] Robertson, *CM*, 368.
[122] Jackson, *CBC*, 208.
[123] www.positiveatheism.org/hist/rmsbrg10.htm
[124] Bell, I, 113; Robertson, *CM*, 369.
[125] www.positiveatheism.org/hist/rmsbrg10.htm
[126] Graves, R., 125.
[127] *ECD*, 110.
[128] sunnyokanagan.com/joshua/seneca.html
[129] Macrobius, 129. (Emph. added.)
[130] Siculus, 130.
[131] Macrobius, 141, et seq.
[132] Massey, *GML*, 190.
[133] Macrobius, 125-126.
[134] Olcott, 173-174.
[135] Bell, I, 241.
[136] Macrobius, 121.
[137] *ECD*, 94.
[138] Siculus, 20.
[139] Spence, *AEML*, 107.
[140] *ECD*, 34.
[141] Macrobius, 134.
[142] www.newadvent.org/cathen/02018e.htm
[143] wisdomworld.org/additional/ancientlandmarks/
 EgyptianImmortality.html.
[144] Cox, II, 127.
[145] Cox, II, 128fn.
[146] Drews, 196-197.
[147] Stewart, 108.
[148] Eisenman and Wise, 106.
[149] Eisenman and Wise, 258-263.
[150] *CMU*, 7.
[151] Bell, I, 145.
[152] *vide* Hoffmann, *PAC*, 100-104, et al.
[153] Reik, 69.
[154] Reik, 69.
[155] Reik, 95.
[156] Reik, 93.
[157] Reik, 97.
[158] Reik, 98.
[159] Freud, 55fn.
[160] Prasad, 53-54.
[161] www.infidels.org/library/historical/m_d_aletheia/
 rationalists_manual.html
[162] James, 148.

163 www.infidels.org/library/historical/m_d_aletheia/
 rationalists_manual.html
164 www.infidels.org/library/historical/m_d_aletheia/
 rationalists_manual.html
165 www.blueletterbible.org/
166 Hengel, 184.
167 Siculus, 119-120.
168 Graves, R., 337.
169 *CMU*, 5.
170 Graves, R., 338.
171 Iamblichos, 121.
172 Graves, R., 336.
173 Graves, R., 336.
174 Spence, *AEML*, 309.
175 Graves, R., 118, 264.
176 Graves, R., 264fn.
177 Legge, II, 150.
178 Lundy, 72.
179 Graves, R., 135.
180 Kingsborough, VIII, 5fn.
181 www.infidels.org/library/historical/m_d_aletheia/
 rationalists_manual.html
182 Bonwick, *EBMT*, 122-123.
183 Bonwick, *EBMT*, 125.
184 Cutner, 145.
185 *CMU*, 62-63.
186 Knight and Lomas, 159.
187 Bonwick, *EBMT*, 221.
188 Bryant, I, 248.
189 Pandey, 68.
190 Bonwick, *EBMT*, 222.
191 Harwood, 235.
192 Freud, 61.
193 Prasad, 84.
194 www.ccel.org/fathers/NPNF2-06/treatise/jovinan2.htm
195 Robertson, *PC*, 114.
196 www.ccel.org/fathers2/ANF-08/anf08-50.htm
197 Legge, II, 240.
198 Legge, II, 266.
199 Bryant, I, 230.
200 www.ccel.org/h/henry/mhc2/MHC23010.HTM
201 Halliday, 286.
202 Selincourt, 55.
203 Bell, I, 224.
204 Weil, 128.
205 *New Schaff-Herzog*, VII, 420. (Emph. added.)
206 Robertson, *PC*, 102.
207 *New Schaff-Herzog*, VII, 421.
208 Legge, II, 230.

[209] Bunsen, 41.
[210] www.well.com/user/davidu/mithras.html
[211] Budge, *EBD*, xcvi.
[212] Srivastava, 155.
[213] Srivastava, 32-33.
[214] Drews, *CM*, 142.
[215] Srivastava, 148.
[216] Srivastava, 149.
[217] Srivastava, 32-33.
[218] Muir, V, 154.
[219] Lundy, 171.
[220] Higgins, I, 640.
[221] Robertson, *PC*, 108.
[222] James, 94.
[223] James, 95.
[224] *Larousse*, 311.
[225] Robertson, *PC*, 110; Kerenyi, 54-55.
[226] Weigall, 154.
[227] Drews, *CM*, 132fn.
[228] Weigall, 131.
[229] Graves, R., 219.
[230] Singh, 244.
[231] Halliday, 308.
[232] www.newadvent.org/cathen/02258b.htm
[233] Bonwick, *EBMT*, 416.
[234] Budge, *EBD*, cxxxviii.
[235] Berry, 58.
[236] Berry, 58.
[237] *vide* Weigall, 126-127.
[238] Robertson, *PC*, 53.
[239] Drews, *CM*, 140.
[240] Robertson, *CM*, 272.
[241] Weigall, 52.
[242] Drews, *CM*, 116.
[243] Berry, 56.
[244] Baring, 408.
[245] Robertson, *PC*, 112.
[246] Harwood, 311.
[247] www.newadvent.org/cathen/10402a.htm
[248] www.ccel.org/fathers2/ANF-03/anf03-10.htm
[249] www.ccel.org/fathers2/ANF-01/anf01-48.htm
[250] Legge, II, 275.
[251] Drews, 294.
[252] Cox, II, 113fn.
[253] Weigall, 110-111.
[254] Cox, II, 113.
[255] Budge, *EBD*, xxvii.
[256] Rylands, 186.
[257] Berry, 20.

[258] Weigall, 115-116.
[259] Graves, R., 371fn.
[260] Graves, R., 335.
[261] Macrobius, 148.
[262] Macrobius, 57.
[263] Macrobius, 139.
[264] Spence, *AEML*, 287.
[265] Legge, I, 102.
[266] Legge, I, 107.
[267] Legge, I, 60.
[268] Macrobius, 137.
[269] Graves, R., 132-133.
[270] Spence, *AEML*, 287.
[271] Macrobius, 66.
[272] Macrobius, 66.
[273] Stewart, 104.
[274] Olcott, 108.
[275] Olcott, 102.
[276] Olcott, 186.
[277] Spence, *MMP*, 83.
[278] Spence, *MMP*, 82.
[279] Spence, *MMP*, 102.
[280] Kingsborough, VIII, 22fn.
[281] Kingsborough, VIII, 46fn.
[282] Kingsborough, VIII, 69.
[283] Spence, *MMP*, 80.
[284] Spence, *MMP*, 75.
[285] Macrobius, 154.

The Resurrection of Osiris.
(Campbell, *THWTF*)

"The Return of Jason."
(Campbell, *THWTF*)

The Ascension of Dionysus,
in quadriga chariot surrounded by
12 signs of the zodiac,
4th-1st cents. BCE. (Kerenyi)

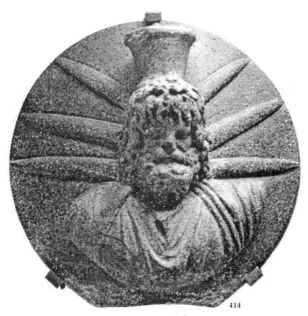

Helios-Serapis, 2nd cent. CE.
(Singh)

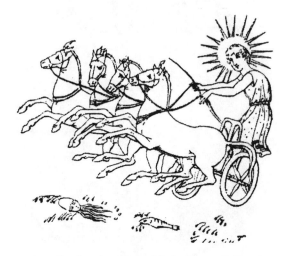

Apollo in chariot with horses. (Moor)

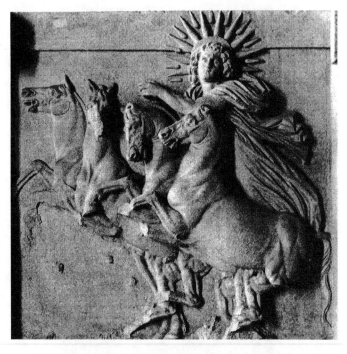

Helios in chariot with rays around his head,
c. 300 BCE. (Singh)

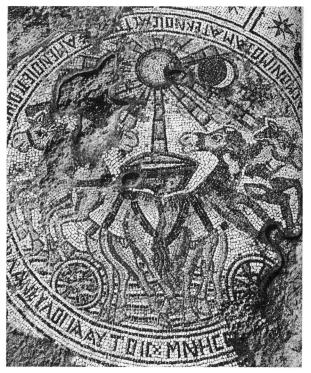

Helios in chariot with horses.
Mosaic on synagogue floor. (BAR)

Persian sun god in quadriga chariot.
(Lundy)

Assyrian winged sun disc

Egyptian winged sun disc

Hermes, solar Messenger with winged shoes

Egyptian "Arks of the Covenant" carrying the
images of the goddess Isis. (Bryant)

Ark of Horus at Edfu. (Hancock, *HM*)

Bull-baiting from Catal Hüyük
c. 7000-3500 BCE. (*Past Worlds*)

Bull-jumping on Crete, c. 2200 BCE.

Cretan bull-slaying
c. 1400-1100 BCE. (Baring)

Babylonian God Adad riding on a
Bull, 8th cent. BCE. (*Larousse*)

Mithra slaying the Bull,
surrounded by the 12 Signs of the
Zodiac.

Jesus Christ the Militant,
standing on the head of the lion and snake,
holding a book saying:
"I am the Way, the Truth and the Life."
6th century mosaic
(Pelikan)

Aztec sun god Quetzalcoatl holding up the heavens

Jesus Christ holding up the heavens.

Life of Krishna

The Greeks had a life of Hercules and of Bacchus, which contained the history of their glorious exploits and of the blessings which they had spread over the whole Earth; and those narrations were ingenious poems, the production of learned men. The history of Christ, on the contrary, is nothing but a tiresome legend, having the same character of sadness and dryness which is the attribute of the legends of the Indians.... [The Indian] God Vishnu, who became man in Chrisnu [Krishna], has a great many traits in common with Christ.

<div align="right">Charles Dupuis, The Origin of All Religious Worship</div>

...Krishna, the Indian god...also was born of a Virgin (Devaki) and in a Cave...and his birth announced by a Star. It was sought to destroy him, and for that purpose a massacre of infants was ordered. Everywhere he performed miracles, raising the dead, healing lepers, and the deaf and the blind, and championing the poor and oppressed. He had a beloved disciple, Arjuna, (cf. John) before whom he was transfigured.... His death is differently related—as being shot by an arrow, or crucified on a tree. He descended into hell; and rose again from the dead, ascending into heaven in the sight of many people. He will return at the last day to be the judge of the quick and the dead.

<div align="right">Edward Carpenter, Pagan and Christian Creeds</div>

Like various gods and goddesses around the globe, the Hindu god Krishna has been the source of much confusion and speculation over the centuries. His purported earthly life has been asserted to have occurred anywhere from hundreds to thousands of years before the common era, and his very nature has been debated thoroughly, with all manner of suggestion put forth. Moreover, while he is a favorite of millions of people, Krishna has also been assailed, not only by Christian missionaries and other foreign fanatics, but also by Indian natives as well. In fact, there have been "numerous tribes of Hindus" who have labeled Krishna "an impious wretch, a merciless tyrant, an implacable mind and most rancorous enemy."[1] Nevertheless, Krishna is currently the defining deity within Hinduism and one of the most popular godmen in the world.

Although it appears to be a monolithic faith, "Hinduism" is a term adopted in the modern era to describe the *many* religions of India. As Col. Wilford states:

The mythology of the Hindus is often inconsistent and contradictory, and the same tale is related many different ways. Their physiology, astronomy, and history, are involved in allegories and enigmas, which cannot but seem extravagant and ridiculous...[2]

Naturally, in consideration of the sundry sects within all major religions, the same could be said of them as well.

Moreover, the texts from which our knowledge of Hinduism comes represent a miniscule portion of Hindu scriptures, which comprise at least 10,000 manuscripts in Sanskrit,[3] the majority never having been translated into other languages. Furthermore, for centuries to millennia these texts were preserved and passed along either orally or by writing on leaves, imperfect and perishable media. Nevertheless, the preservation of such texts over the ages was taken very seriously and extraordinary methods were used, which included learning the scriptures "entirely by memory, but memory kept under the strictest discipline." The great Indianist Max Müller related that it was considered a "sacred duty" to learn line by line the holy scriptures, "the neglect of which entailed social degradation." In this regard, "the most minute rules were laid down as to the mnemonic system that had to be followed."[4] This sacred duty was taken so seriously that in the epic the Indian epic the Mahabharata it is said that those who wrote down the Vedas would "go to hell."[5]

It must also be kept in mind that the nation of India is huge with an enormous and heterogeneous population. In discussing the "life" of Krishna, therefore, we will not encounter a single story set in stone, as his myth is very ancient and has been developed by numerous sects in this highly populous nation. As has been the case in the rest of the world, religious stories in India have been adapted to the time and place, as well as to the audience, with a variety of languages producing differing concepts. The particulars of the religions of the vast subcontinent have varied widely over the millennia, among diverse peoples and languages, affected by migrations, invasions, degrees of civilization, etc.

A number of these disparate particulars involve the nature and history of the wildly popular god Lord Krishna. Over the centuries and millennia, many millions of people have believed in Krishna as a "real person" who appeared on Earth in a remote age. Krishna's basic childhood "biography," as accepted by the orthodoxy, is as follows, told in *Kriya: Finding the True Path* by the Hindu Swami Satyeswarananda Giri:

> Lord Krishna was born in a prison. One day King Kansa was giving a ride to his sister, Devaki (the mother of Lord Krishna), and his brother-in-law, Basudev (the father of Lord Krishna). The king heard a voice from the sky (the Voice of the Lord from heaven) saying, "[The son of the person] to whom you are giving this ride will kill you."
>
> The king became nervous and decided to kill his sister immediately, but at their repeated entreaties and joint promise

that they would bring all children born to them to him, he spared their lives. Just to be on the safe side, he had them imprisoned.

All of their children were brought to the King immediately after birth, and he killed them. But when Lord Krishna was born, it was the eighth day of the dark fortnight of August, in the monsoon season. A gigantic storm arose that night, and all the locked doors of the prison burst asunder by the power of the Wind.

Basudev took the child and fled from the prison. Basudev had to cross the Yamuna River, whose waters were rapidly rising. He took Him in a basket made of woven cane and carried Him on his head. Then he began to edge his way across the treacherous river. Unknown to Basudev, a great Cobra appeared from behind and acted as an umbrella to protect the Lord from the downpour.

When the water of the river rose up to Basudev's neck, he became very anxious. The Lord (baby Krishna) touched the top of the water with His feet, and the water level receded. Thus, the Lord played....[6]

The story resumes with Krishna being raised at Gakul ("secret") by Basudev's friends Nanda and Yasoda, previously known as Gautama and Aditi. In exchange for Krishna, Basudev takes Yasoda's baby girl, Yogamaya ("Divine Mother"), who was born on the same night as Krishna. Next, Basudev returned via the same river and gave Yogamaya to the king, who killed her. "The spirit" told the king that his eventual assassin was still in Gakul, which made the king "very apprehensive." Thinking "Gakul" meant "secret," the king "ordered all the children up to the age of three to be killed." The tyrant subsequently came to know about Krishna living in the *city* of Gakul, with Nanda and Yasoda, and Krishna eventually killed him, per the prophecy.

Continuing the Krishna myth, Giri says:

One day, Yasoda asked her Gopal [Krishna] to open his mouth so that she could be sure that he was not eating mud from the ground. The baby Krishna opened his mouth and Yasoda saw therein the universe.

...Lord Krisna's real parents, Basudev and Devaki, were eager to ask him for Liberation. His father asked him for release—"People say that you are the Lord so please save us and give us liberation."[7]

Krishna, whose epithet "Gopal" means "cowherd," was also "in his young days" a "shepherd at Vrindaban."

An encapsulation of the basic orthodox Krishna myth is also found in a respected, conservative Protestant publication:

McClintock and Strong's Cyclopedia notes the following events in the history of Krishna which correspond with those related of

Christ: "That he was miraculously born at midnight of a human mother and saluted by a chorus of Devatas [angels]; that he was cradled among cowherds, during which period of life he was persecuted by the giant Kansa, and saved by his mother's flight; the miracles with which his life abounds, among which were the raising of the dead and the cleansing of the leprous" (Art. "Krishna").[8]

From the mainstream, orthodox depiction of Krishna, it may be evident why India has remained largely un-Christianized, despite countless attempts over the centuries to convert it, as the Hindu fables are even more entertaining and fantastic than the biblical myths. Also, the similarities between this tale and biblical fables are clear: To begin with, an incarnation of God "miraculously born" is prophesied to overthrow the reigning king, who is thwarted in his attempt at killing the babe first, and instead slaughters numerous other infants. Like Jesus, Krishna is a "shepherd god," and his birth is very similar to that of Christ: "There are pictures of Krishna lying in a manger surrounded by shepherds and shepherdesses, oxen and asses."[9] Both are also considered to have been born in "caves," or an "underground chamber," a description of Krishna's prison. Christ's birth in a cave is found in apocryphal, or noncanonical, Christian texts such as the *Protevangelion.* When their families are forced to flee, both Krishna's and Jesus's foster fathers are forewarned in a "dream" or by an angelic voice. Like Moses, the baby Krishna ends up in a reed basket in a river. Like Krishna's mother, legend held that Mary too saw the universe in Jesus's mouth. Another Christian legend, that of "St. Christopher," who ferries Christ across the river, echoes Krishna's river-crossing motif.

Moreover, Krishna is called "the lord of the Yadus," or *Jadus,* and is depicted as being born in Madura or Mathura, a major site of sun worship, where the child Krishna did many miracles, including healing a leper, the blind and deaf, and raising the dead. The infant Christ, "king of the Judeans," was portrayed in the apocryphal Gospel of the Infancy of the Savior as visiting "Maturea," where he too did many miracles. The Infancy Gospel parallels in many instances the Hindu holy text the Bhagavat Purana, which represents the childhood of Krishna. Another correspondence between Krishna and Christ is the tale of young Krishna astonishing his teachers "with his precocious wisdom."

Like Christ, the adult Krishna is depicted as battling the "Evil One," overcoming the "Tempter" and crushing the head of the serpent. Both godmen produce abundant miracles, including raising the dead and healing the sick. As was Jesus depicted, the great Indian avatar was portrayed as the meekest and humblest, pure and chaste, and "he even condescended to

wash the feet of the Brahmans." Another motif found in both
the Krishna and Christ myths is that of a woman anointing the
savior's head with expensive oils. Like Christ, Krishna was a
defender of the poor and weak, and was mobbed and revered as a
god. As do many other gods, Krishna and Christ both end up
descending into Hell, Jesus's journey being part of apocryphal
tradition. Both saviors come back from Hell with two young men,
restoring them to life.[10] Furthermore, like Christ, Krishna is
depicted as resurrecting after three days, and ascending "bodily
into heaven," his ascension being seen by "all men." Krishna's
death is accompanied by "calamities and omens of every kind,"
including a black ring around the moon, and the darkening of the
sun at midday—another motif found in the Christ myth.
Krishna's death is somewhat more dramatic and miraculous than
Christ's, however, as "the sky rained fire and ashes; flames
burned dusky and livid; demons committed depredations on
earth; at sunrise and sunset thousands of figures were seen
skirmishing in the sky, and spirits were observed on all sides."[11]

Both Krishna and Christ were said to have taken birth to
provide "liberation" or "salvation." In this regard, the Catholic
Encyclopedia ("Brahminism") defines an *avatar*, or incarnation of
God, as a *savior*:

> The incarnation of a god descending from heaven to assume a
> human or animal form as a sort of savior, and to achieve some
> signal benefit for mankind, is known as an avatar.[12]

As demonstrated thoroughly, the concept of a divine savior
was not new with Christianity. In other words, the Supreme Being
coming to Earth as a human was an idea in existence long prior
the Christian era, and therefore is not original with the Christ
myth.

Dating Indian Holy Scriptures and the God Krishna

The fact that the Krishna and Christ myths have so much in
common has led to much speculation as to how this development
occurred, including accusations of plagiarism by the priesthoods
of both camps. Part of this important debate, naturally, revolves
around the age of the Indian sacred texts, in order to determine
which godman and religion came first. The numerous Hindu holy
scriptures include the following: the four Vedas, i.e., Rig, Yadjoor,
Sama and Atharva; the Brahmanas; the Upanishads, or
commentaries; the six Chastras, which are concerned with
"theology and the Sciences"; and the 18 Puranas, which deal with
mythology and history.[13] Conservative authorities of the past
couple of centuries dated the Vedas as being about 3200 years
old, while the Puranas were dated to 2700 or 2800 years ago.

Regarding the Vedas, French writer and justice in colonial India Louis Jacolliot remarked:

> In point of authenticity, the Vedas have incontestable precedence over the most ancient records. These holy books which, according to the Brahmins, contain the revealed word of God, were honored in India long before Persia, Asia Minor, Egypt and Europe were colonized or inhabited.[14]

The dates for the Puranas and other texts were later significantly reduced as the correspondences between Hinduism and Christianity became more widely known and as it was contended that Hinduism "copied" Christianity. Nevertheless, while some of the texts were not physically recorded until the 18th century CE, many of the most salient Hindu concepts have their origins in the hoary mists of time.

The Catholic Encyclopedia ("Brahminism") dates the four Vedas as ranging from 1500-800 BCE, while the Brahmanas, which CE defines as "a series of verbose and miscellaneous explanations of the texts, rites, and customs found in each of the four Vedas, composed expressly for the use of the Brahmins, or priests," date to 1000-600 BCE. The Upanishads, according to the CE, are from 800-500 BCE, and the Sutras, "compendious guides to the proper observance of the rites and customs," date to 600-400 BCE. The Catholic Encyclopedia places the Bhagavad Gita in the second or third century CE and the Puranas in the ninth and tenth centuries CE. The Bhagavad Gita is the portion of the Mahabharata in which appear many of the sayings and qualities that parallel those of Christ. It is therefore denied that the Gita, with its "Christian" bent, predates Christ; instead, it is alleged that "lying Brahmin priests" plagiarized from Christianity, an allegation that has been lobbed in the opposite direction as well. In discussing the Mahabharata, the Catholic Encyclopedia declares that the role Krishna plays is not integral to the story and seems to have been interpolated after the substance of the epic had been written.[15] While the Gita may have been a later addition to the tale designed to introduce Krishna as the main savior god, most of the concepts contained in it predate the Christian era by centuries to millennia. In any case, the earliest references to Krishna in the Indian holy books are *not* interpolations.

Concerning the Hindu scriptures, CE further remarks:

> But what is at first sight astonishing is to find in the religious writings subsequent to the "Mahabharata" legendary tales of Krishna that are *almost identical* with the stories of Christ in the canonical and apocryphal Gospels.

From the birth of Krishna in a stable, and his adoration by shepherds and magi, the reader is led on through a series of events the exact counterparts of those related of Our Divine Lord. Writers hostile to Christianity seized on this chain or resemblances, too close to be mere coincidence, in order to convict the Gospel writers of plagiarism from Hindu originals. But the very opposite resulted. All Indianists of authority are agreed that these Krishna legends are not earlier than the seventh century of the Christian Era, and must have been borrowed from Christian sources.[16]

Unlike less informed apologists, the Catholic Encyclopedia does not deny the Krishna-Christ correspondences. In fact, it states that the tales are *almost identical* and that the resemblances could not be "mere coincidence." In other words, one must be copied from the other. Not surprisingly, however, this major Catholic authority insists that the Krishna myth postdated the Christian era and was "borrowed from Christian sources," rather than the other way around. The claim that "all Indianists of authority are agreed" on the late date of these texts and stories is incorrect. In reality, a number of the world's leading *Christian* Indianists, including Sir William Jones and Reverend Cox, as well as numerous *Indian* scholars, have contended that the Krishna tale *predates* the Christian era by centuries at least. Furthermore, these writers "hostile to Christianity" usually *became* so after studying the matter and discovering that the ideology is a rehash of Paganism and not, as has been so fanatically and piously portrayed, a "divine revelation," superior to and apart from all other religions.

In addition, Indian scholars do not abide by the various late Western dates of their texts, especially as concerns the Vedas. For example, using astronomy Indian scholar S.B. Roy dated the first hymn of the Rig Veda to around 2400 BCE, or 4400 years ago, almost a millennium earlier than the conservative Western date. Other Indian scholars claim an even greater antiquity for that important text. Even if the Vedas themselves are "only" 3,500 years old, they record traditions much older, as asserted by the great Indian scholar Tilak: "...as regards the Vedic religion itself [Tilak] says over and over again that 'its ultimate origin is still lost in geological antiquity.'"[17] Tilak's thesis is that the Vedic religion dates to earlier than the last interglacial period, 12,000 to 10,000 years ago.

In *The Aryan Hoax (That Dupes the Indians)*, Paramesh Choudhury, like other Indian revisionists, asserts that Christian scholar Max Müller's conservative chronology of Indian texts is based on the "Aryan Invasion Theory" and is wishful thinking by Western colonials who wanted to make civilization a European or

"Aryan" invention. Choudhury notes that since Müller's time other Western scholars such as Schroeder and Jacobi have pushed back the dates for the Vedas by centuries and millennia, based on astronomical observations, and that Tilak "goes so far as to date some Vedic texts back to the year 6000 B.C...."[18] While various astronomical arguments for such dates apparently were discovered to be flawed, D.N. Mookerjee's "Notes on Indian Astronomy" established other datable observations, prompting A.C. Das to remark: "It is clear that the Hindus carried their observations assiduously at least from 12,000 B.C. to about 3500 B.C. to expound the Libration of the Equinoxes, in which case the Hindu civilization is at least 14,000 years old."[19]

The early dates of the Vedas have been ascertained by other means as well. For example, the Vedic topography reflects a geological age of at least 9500 years, based on its documentation of the Saraswati River and the Rajputana Sea, both of which dried up millennia ago. Factoring in such geological data, A.C. Das further claimed that "it was not wrong and absurd to put down the age of the Rig-Vedic civilisation to more than one hundred thousand years."[20] This extraordinary claim, Choudhury states, is supported by modern Indian archaeology:

> "...early man lived on the Govardhan Hill—often mentioned in the tales of Lord Krishna's valour—over 120,000 years back.... Tools, both finished and unfinished, have been found. The main artifacts were hand axes, cleaver, choppers, discoids and scapper points.'..."[21]

Moreover, a bronze head of one of the Vedic priest-poets, Vasistha, evidently dates to around 3700 BCE,[22] which also would place the Vedic period earlier than the orthodox paradigm dictates.

As concerns the emergence of Lord Krishna himself, who is not overtly manifest in the Vedic literature and era, Sir William Jones, a British supreme court judge in India[23] and the editor of the esteemed texts *Asiatic Researches* (18th-19th centuries), a series popular among elite scholars, believed that Krishna was a real person who lived around 900 BCE and that the Indian god's basic story dated to that time as well. As Jones says:

> One singular fact...must not be suffered to pass unnoticed. That the name of CRISHNA, and the general outline of his story, were long anterior to the birth of our Saviour, and probably to the time of HOMER we known very certainly.[24]

To reiterate, the Krishna myth varied from era to era and place to place; yet, the general story is certainly ancient. As Rev. Cox observes:

> It is...true that these myths have been crystallised round the name of Krishna in ages subsequent to the period during which

the earliest Vedic literature came into existence; but the myths themselves are found in this older literature associated with other gods, and not always only in germ... There is no more room for inferring foreign influence in the growth of any of these myths than...there is room for tracing Christian influence in the earlier epical literature of the Teutonic tribes. Practically the myths of Krishna seem to have been fully developed in the days of Megasthenes, who identifies him with the Greek Herakles.[25]

Thus, Cox, a Christian minister, maintained that, despite Krishna not being explicitly developed in the Vedas, elements of his story *are* present in those ancient texts and "not always only in germ." He also disagreed with the claim that there was "foreign influence" in these myths, i.e., that Hindu priests plagiarized the myth from Christianity. The fact that the Greek historian Megasthenes (c. 350-290 BCE) identified Krishna with Hercules indicates that much of the Hercules story was reflected in the Krishna myth, already in the fourth century BCE. Therefore, these Herculean elements of the Krishna myth, at least, were not composed after the common era.

In addition, Patanjali's *Mahabhashya* or "Great Commentary," predating the Christian era by two centuries, contains the Kansa/ infant-slaughtering theme and treats it as if it were very ancient, which indicates that Krishna was by then a popular deity and that there were other myths concerning him by that time.[26] The Commentary also suggests the existence of the Puranas, even if they had not been written down. Concerning the birth and childhood stories of Krishna, Robertson avers, "We are left with the irresistible conclusion that the myths of Krishna's birth and youth are not only pre-Christian but pre-historic."[27]

Other evidence of the Krishna myth's antiquity exists in inscriptions on stone, in temples and caves, although this evidence has often been mutilated and destroyed by Christian fanatics and others. As an example, the tyrannical infant-slaughtering scene is depicted in one of the caves on the island of Elephanta, in Bombay harbor, in a temple with a flat roof, indicating it was built centuries before the Christian era. Regarding the Elephanta cave, Moor, a British Christian missionary to India, remarks:

> An admirer of the remains of *Hindu* superstition will follow with regret the course of the former possessions of the *Portuguese*, marked with the destruction to their finest monuments: scarcely a figure is seen unmutilated in the cavern of *Elephanta*. The furious bigotry of this semi-christian people, let us hope, is sufficiently punished in the wretchedness and contempt of their present miserable existence: let us farther hope that it will serve as a beacon, warning the *English* from following such a vile example, and from deserving such a signal chastisement.[28]

Despite such destruction, and regardless of the dates of the Indian sacred texts, extant evidence demonstrates that legends "prophesying" divine incarnations or avatars abounded before the Christian era. For example, in a perplexing article in *Asiatic Researches* entitled "Origin and Decline of the Christian Religion in India," Col. Wilford recounts the tale of "Salivahana," the "virgin-born" and "cross-borne" savior, a fable which so closely parallels the gospel story that it was considered a "prophecy" of the Jewish godman—or as part of a hoax played upon Wilford. The story of Salivahana is purportedly found in the "appendix to the *Agni-Purana*." In his article, Wilford synopsizes the "prophecy" of the divine child, which the Colonel places *before* the Christian era:

> His conception was miraculous, and in the womb of a virgin: he was the son of the great artist, and the virtue of his mother was at first suspected: but choirs of angels came down to worship her. His birth was equally wonderful: choirs of angels with the celestial minstrelsy attended on the occasion, showers of flowers fell from on high. The King of the country, hearing of these prodigies, was alarmed, and sought in vain to destroy him. He is made absolute master of the three worlds, heaven, earth and hell: good and bad spirits acknowledge him for their lord and master. He used to play with snakes, and tread upon the adder, without receiving the least injury from them: he soon surpassed his teachers; and, when five years of age, he stood before a most respectable assembly of the doctors of the land, and explained several difficult cases, to their admiration, and utmost astonishment; and his words were like ambrosia.[29]

This fascinating tale is understood by Indians as having taken place *in India, in the past,* and is not considered a "prophecy." Pious Hindus have claimed the subject of this story to be Krishna, centuries before the Christian era. Because of its obvious resemblance to the infancy stories of Jesus, Christian defenders accused the handy "lying Brahmin priests" of plagiarizing the tale from *their* books. Yet, Salivahana is considered a great *astronomer,* "or as a prince remarkably fond of astronomy," by Hindus "all over *India*"—nowhere has this attribute ever been applied to Jesus, except, perhaps, in recognition of the solar mythos. Significantly, in the *Scanda-Purana* this divine child or savior who "will appear and remove wretchedness and misery from the world" is called "Saca," i.e., *Buddha.*[30] In any case, prophecies of a divine savior or avatar predate the Christian era by several centuries.

The Bhagavad Gita: The Proto-Gospel?

It is understandable that Christian authorities and apologists would wish to shortchange the Hindus as concerns the age of their texts and myths, since the "exact counterparts," as the Catholic Encyclopedia calls the similarities between Krishna and Christ, are many and profound. In addition to those already related that are recorded in orthodox texts and accepted by mainstream authorities are a number of other correspondences, mostly orthodox and some esoteric. In the orthodox depiction, Krishna's very name and place of origin are *almost identical* to those of the Christian savior, as Swami Giri relates:

> Lord Krisna colloquially is called Krist (Christ). He was born in the *Jadu* dynasty, so often he is called Jadav Krist, Christ [or Jadava the Christna].... Jesus was born in *Judea*.[31]

In the Bengali language, Krishna is "Christo":

> Christ comes from the Greek word "Christos," which means "the anointed one." ...the word "Krishna" in Greek is the same as "Christos." A colloquial Bengali rendering of Krishna is "Kristo," which is the same as the Spanish for Christ—"Cristo."..."When an Indian person calls on Krishna, he often says, Krsta." [32]

The title of "Krishna" has been transliterated in a number of ways over the centuries, with a variety of etymological interpretations: Crishna, Cristna and *Christna*, a version that shows the close connection between the Indian god and Christ. Interestingly, the "Krishna" river in southern India was originally transliterated as "Kistna," which lends authority to the transliteration of "Cristna" or "Christna."[33]

Numerous sayings in the Hindu scriptures are paralleled in the Bible, scriptures in which Krishna is addressed in terms used to describe Christ as well. For example, in the Bhagavad Gita (10:12, 15), Krishna's "beloved disciple," Arjuna (Arjoan or Ar-*john*), equivalent to Christ's beloved disciple John, says of his Lord:

> You are supreme, the infinite spirit, the highest abode, sublime purifier, man's spirit, eternal, divine, the primordial god, unborn, omnipotent....

> You know yourself through the self, Krishna; Supreme among Men, Sustainer and Lord of Creatures, God of Gods, Master of the Universe![34]

At BG 10:20, Krishna says of himself:

> I am the self-abiding in the heart of all creatures; I am their beginning, their middle, and their end.[35]

Krishna also declares:

"...O Arjuna. I am the great Sage, without beginning; I am the Ruler and the All-sustainer" "...I am the cause of the whole universe; through me it is created and dissolved; on me all things within it hang and suspend, like pearls upon a string." "I am the light in the sun and moon, far, far beyond the darkness. I am the brilliancy in flame, the radiance in all that's radiant, and the light of lights." "I am the sustainer of the world, its friend and Lord; I am its way and refuge." "I am the Goodness of the good; I am Beginning, Middle, End, Eternal Time, the Birth, the Death of All."[36]

"I am, of things transient, the beginning, the middle, and the end: the whole world was spread abroad by me in my invisible form... I am the creator of mankind; uncreated, and without decay.—There is not any thing greater than I; and all things hang on me, even as precious gems on a string.—I am the understanding of the wise, the glory of the proud, the strength of the strong; I am the eternal seed of all nature; I am the father and mother of this world, the grandsire, and the preserver; I am death and immortality; I am entity and nonentity; I am never-failing time; I am all-grasping death; and I am the resurrection." [37]

Arjuna responds by calling Krishna "the Supreme Brahm: the most holy; the most high God; the Divine Being before all other Gods; without birth; the mighty Lord; God of Gods; the universal Lord."[38] Krishna's epithets include "Saviour, Redeemer, Preserver, Comforter, and Mediator." The Indian avatar was also called "the Resurrection and the Life, the Lord of Lords, the Great God, the Holy One, the Good Shepherd."[39]

Also in the Gita, Krishna is transfigured in front of his beloved disciple, and he tells Arjuna that he will deliver the disciple from his sins and that he should have faith in him. Like Christ, Krishna is the second person in the Hindu Trinity, and, as Vishnu, he is destined to return to the earth "in the latter days," riding on a white horse, appearing as "Judge of the dead, at the last day."

The correlations between Krishna and Christ are obvious: "Of Krishna's gospel, the 'Bhagavad-Gita,' Appleton's Cyclopedia says, 'Its correspondence with the New Testament is indeed striking.'"[40] Even if it could be proved that the Bhagavad Gita was not in existence before the Christian era, these various divine concepts themselves nevertheless existed in many religions long before the creation of Christianity, as we have seen from the Egyptian scriptures in particular. The resurrection, for example, demonstrated to have been in the Near Eastern and Egyptian religions for centuries to millennia before Christianity, is also

found in the East at an early era, in the Persian religion, which is closely related to the Indian. As Hengel says:

> The indications of the historical origin of resurrection are on the one hand in the direction of Iranian religion, where they are already attested by Theopompus (fourth century BC), while on the other hand conceptions of resurrection communicated by the dying and rising vegetation deities had certainly been known in ancient Israel for some time.[41]

Besides the "exact counterparts" between the Krishna and Christ myths already mentioned, there are many more examples of correlations between Hinduism and Christianity, including various artifacts and rituals, such as the rosary, in use in India for more than four thousand years.

Krishna and Christ—The Same God?

Archaeological, historical, mythological and linguistical evidence indicates that the basic orthodox, mainstream story is a watered-down version of the Krishna myth, with variations occurring depending on place and era. These variations, a few of which have been contested over the centuries, bring the story even closer to the Christ myth, revealing once more that the latter religion is not unique or original, and that there exists a core religious mythos and ritual in a variety of cultures.

For example, a number of researchers and scholars have related that Krishna's mother was a *virgin*, to whom it was announced by an angel that she would miraculously conceive and give birth to one who would give "all nations cause to rejoice." Like that of Christ, Krishna's birth was marked by a star and attended by wise men who presented him with sandalwood and perfume. The cave in which Krishna was born was brightly illuminated, as was also recounted in the Protevangelion regarding Jesus's birth cave. Both infants started to speak shortly after birth, this part of the Christ myth likewise found in apocryphal texts. In *Christianity Before Christ*, John Jackson relates that, just as Jesus's foster father, Joseph, went to the city to pay a tax, so too was Krishna's adoptive father, Nanda, "in the city to pay his tax to the King." [42]

Another researcher who recorded virtually the same story as above, with the same points not found in the orthodox myth, was Sarah Titcomb. In *Aryan Sun Myths* (1899), Titcomb discussed the Vedas, relating that these very ancient scriptures demonstrate "the development which changes the Sun from a mere luminary into a Creator, Preserver, Ruler, and Rewarder of the world—in fact, into a Divine or Supreme Being." Titcomb also remarked, "These hymns contain the germ-story of the Virgin-born God and Saviour, the great benefactor of mankind, who is finally put to

death, and rises again to life and immortality on the third day."[43] Titcomb further asserted that Krishna, as an incarnation of God who came to Earth to remove "misery and sin," was born on December 25th of the *virgin* Devaki.[44] This account is mostly orthodox, with the contested points the virginity of Devaki and the birthday of December 25th, the former of which was also asserted first by Higgins and later by Jackson.

Titcomb also related that Krishna "had twelve favorite disciples who accompanied him on his missionary travels." That Krishna had 12 disciples is not found in the orthodox account; however, as we have seen, the theme of the god with the 12 helpers or disciples predates the Christian era by at least 1,000 years, as existing in Egypt for one. This solar motif revolving around the sun and the 12 signs of the zodiac is appropriate for Krishna as well.

As Jesus was wounded by a spear, so the orthodox version of Krishna's death depicts him being shot in the heel, reminiscent of the story of the Greek warrior Achilles, who was called *Issa*,[45] which is also, coincidentally, the Eastern name for Jesus, as well as for the Indian god Lord Shiva. The piercing of the heel or other body part of the sacred king is another common motif, likewise found in the Greek myths of Hercules and of Talus, who was wounded by Medea. Moreover, the Norse god Balder was pierced by the mistletoe spear, and the Egyptian Ra's heel was "stung by the magic snake sent by Isis," etc.[46] The piercing of the heel is the same as that of the crucifixion victim, who in Canaan was "originally the annual sacred king."[47] Indeed, it has been asserted that esoteric traditions depict Krishna as having been *crucified*, a contention that will be explored in detail in a subsequent chapter.

The contested elements of esoteric tradition concerning Krishna, i.e., that his mother was a virgin, that he was born on December 25th, and that he was crucified, were also made by the much-maligned Kersey Graves in *The World's Sixteen Crucified Saviors*, in which Graves outlined hundreds of such correspondences. Contrary to popular opinion, Graves did not fabricate any of these correlations, which means that he has been unfairly judged over the past century, although more careful citation on his part would have avoided much of the problem.

Even without these very few elements, the orthodox Krishna tale remains strikingly similar to that of Christ, which indicates that one was copied from the other or that both had a common source. If the several important, *uncontested* correspondences did not exist, the numerous Christian authorities would not have gone to such lengths to establish that the Krishna tale was plagiarized from the Christ story, rather than the other way

around. In reality, the implications of such correlations led
Christian fanatics to wreak havoc and devastation wherever they
went. Such wanton criminal destruction of property makes it
difficult to prove the dating of the Krishna myth. Seemingly
indignant at this conspiratorial situation, one writer summarizes
the Krishna-Christ correspondences thus:

> ... Krshna, an incarnation of the Hindu deity Vishnu, who
> predates Christianity, also was killed to atone for the sins of
> mankind. Is this just a chance coincidence? Or, evidence that
> the Christians plagiarized the concept from more ancient
> religions? Jesus was a deity, the son of god fully human. Krshna
> was also the "full measure of the god-head" according to the
> Ramayana, which was written 300 years B.C. Is this just another
> coincidence, or was it stolen by the authors of Christianity?
> Krshna, according to the Bhagavad Gita, a more ancient book
> than the New Testament, was born miraculously by a virgin, his
> birth attended by shepherds and angels. Krshna survived an
> edict by the tyrant Cansa, who ordered all the first born children
> to be put to death. Krsna escaped from being slain by being
> smuggled across a river. Krshna's baptism, or ablution, in the
> river Ganges, corresponds to Jesus' baptism by John the
> Baptist. As a child, Krshna was known for miracles, and for
> having slain demons. Krshna had a favorite disciple, Arjoon. He
> was anointed with oil by women, and enabled his disciples to net
> large amounts of fish with little effort. Krshna was "transfigured"
> at a place called Madura. Interestingly, in the Gospel of the
> Infancy, a writing once regarded by the church as authentic,
> Jesus and his parents once lived in a place called Maturea.
> Krshna spoke in parables when he taught. Krshna taught that
> you should love your neighbor, forgive your enemies, avoid
> unchaste thoughts, and condemn worldly wealth. Are these just
> chance coincidences?"[48]

The various discrepancies in the Krishna legends demonstrate
that we are not dealing with the biography of a real person,
although many Hindus certainly believe his myth to be a "true
story." As is the case with other gods, Krishna has been turned
into a man, with his "life" confused with individuals of the same
name. For example, Rev. Maurice writes about an ancient rajah
named "Krishen" (Maurice's spelling of Krishna):

> In the Mahabarat, Owde [Oude], the capital of a province of the
> same name to the northeast of Bengal, is said to have been the
> first regular imperial city of Hindostan. It was built in the reign
> of Krishen [Krishna], one of the most ancient rajahs, a name
> which is likewise applied to a deity of the Hindoos. "That ancient
> city...is supposed to have been the birthplace of Rama."[49]

The stories concerning gods and goddesses in the world's
mythologies are confused and confusing, such that the more

experienced and knowledgeable researcher will understand that there is leeway in which priests and other followers interpret according to their own spiritual, psychological and material needs. Such a development is abundantly evident even in today's major religions, with their umpteen competitive sects.

A Common Lingo, Mythos and Ritual

It should not surprise us that similar religious and mythical concepts, motifs and rituals are widespread among numerous nations of the world. Such a development reflects common sense and does not require a doctorate degree to understand. As is well known and undisputed, many of the world's languages are related, to more or less degrees. Along with language goes culture, and, in general, the more complex the language, the more culture there will be. Considering the relationship of languages, revealing commonality, what would be surprising is if these cultures did *not* possess the same religious and mythological concepts and traditions.

As is indicated by the terms "Indo-European," "Indo-Germanic" and "Indo-Iranian," the Indian culture has many correspondences with others as well, including the European, Germanic and "Aryan." In his *Original Sanskrit Texts*, Muir discusses these linguistic connections and acknowledges religious and mythological commonality as well:

> In the Second Volume of this work I have stated the reasons, drawn from history and from comparative philology, which exist for concluding that the Brahmanical Indians belong to the same race as the Greek, the Latin, the Teutonic, and other nations of Europe. If this conclusion be well-founded, it is evident that at the time when the several branches of the great Indo-European family separated to commence their migration in the direction of their future homes, they must have possessed in common a large stock of religious and mythological conceptions. This common mythology would, in the natural course of events, and from the action of various causes, undergo a gradual modification analogous to that undergone by the common language which had originally been spoken by all these tribes during the period of their union...[50]

One of the more important language commonalities in the discussion of comparative mythology is that of Greek with Sanskrit and proto-Sanskrit, i.e., Vedic. The name "Sanskrit" means "sun script,"[51] which itself shows its influence on Western language; in other words, "san" is the root of "sun," and "skrit" of "script." When the Europeans first started to become literate in Sanskrit, they were astonished to find numerous correspondences between that highly developed Indian language and the classical languages of Greece and Rome. Furthermore,

they discovered that the Greek and Roman mythologies closely paralleled the Indian and that the Greeks especially possessed numerous gods, demigods and heroes whose very names had Indian counterparts. From Greece, many of the "Indian" gods and religious and mythological concepts spread to Europe and the Middle East, where not a few of them already existed in some form or another.

In the centuries following the British takeover of India, much scholarship was produced on the subject of linguistical connections between India and Europe, resulting in the "Indo-European" family tree. The conclusion reached then was that Greek and Latin came from Sanskrit, which dated to at least a couple of thousand years BCE. While it is still true that "Sanskrit" is an early language, as shown by the proto-Sanskrit language of the Vedas (Vedic), modern linguistics has been revised within the last few decades to demonstrate that Sanskrit and Greek are derived from another, common source, rather than the Greek directly from the Sanskrit. In any case, the two are intimately connected; indeed, it is possible to determine that they split by the time some of the Vedas were composed, i.e., more than 3,000 years ago. Muir, Müller and others contended that the split occurred at least a thousand years before that. Müller's reasoning was as follows:

> The language of Vedic literature differs from the ordinary Sanskrit. It contains many forms which afterwards have become extinct, and those the very forms which exist in Greek or other Aryan dialects. Ordinary Sanskrit, for instance, has no subjunctive mood. Comparative Philology expected, nay postulated, such a mood in Sanskrit, and the Veda, when once discovered and deciphered, supplied in it abundance.[52]

As stated, a number of Indian and Western scholars have pushed the Vedic era to an earlier period than that of conservative scholarship. Also, the proto-Vedic root language may yet be traced to India, as is propounded by the "Nostratic Theory," which posits a common language dating back to at least 12,000 years ago on the subcontinent. In any event, it is clear that much Western culture is derived from the Indo-Iranian, including several of its important gods and many of its salient religious concepts.

In this regard, several researchers have asserted that nearly "every act in the drama of the life of Jesus, and every quality assigned to Christ, is to be found in the life of Krishna." Naturally, there are differences between the myths, which serve to demonstrate that the authors of Christianity picked and chose what they thought would be best accepted by their audiences. For example, the giant cobra protecting Krishna would not be appropriate for a Western audience who had never seen or heard

of a cobra. Obviously, the Krishna story incorporates many more miracles and extraordinary feats than does the Christ story. These differences actually illustrate that the Krishna myth is superior in its miraculous, magical and mystical nature, reflecting a far more powerful Lord within Hinduism. In comparison, the Christ fable is but a diluted version. In the end, the stories of Krishna and the innumerable other Hindu deities are voluminous and wildly entertaining: Page after page of the miraculous, for thousands of pages. Overall, Hinduism is the most magical and miraculous of the major religions. For a believer, its stories truly reveal the omnipotence of "the Lord," omnipotence that does not begin or end with the lives of a few pious men in a relatively small book such as the Bible.

Are we really to believe, however, that the story of Krishna is that of a "real person?" If so, he would have to be considered much more powerful than Jesus! Indeed, we would have to accept him as the "true Lord." However, the story of Krishna, full of magic and miracles, cannot in any sense be considered "historical." It is not a "biography" but a myth, a fable, a legend. As such, it is a wondrous story, but a story nonetheless. There is much to be learned from it, but it is also meant as entertainment, not to be taken so seriously as to commit murder and mayhem in its defense, as has happened in Hinduism, as well as in so many other religions concerning their own myths.

In the final analysis, it is clear that the story of Krishna has its "exact counterparts" in the gospel tale, that Krishna is a pre-Christian god, that he is not a "real person," and that we must look elsewhere to ascertain his true nature, as well as to explain why these correspondences exist between him and Christ. As we have already seen, a number of the correlations, in fact, occur in the "lives" and religions of numerous other gods, the majority of whom represent aspects of the sun.

1 Moor (Simpson), 145.
2 Jones, *AR*, III, 296.
3 Müller, *LOGR*, 129.
4 Müller, *LOGR*, 148.
5 Robertson, *CM*, 143.
6 Giri, 7-8
7 Giri, 10-11
8 www.positiveatheism.org/hist/rmsbrg11.htm
9 Evans, 34.
10 Jackson, *CBC*, 85.
11 Titcomb, 40-41.
12 www.newadvent.org/cathen/02730a.htm
13 Volney, XXI.
14 Jacolliot, 50.

[15] www.newadvent.org/cathen/02730a.htm

[16] www.newadvent.org/cathen/02730a.htm (Emph. added.)

[17] Prasad, 221-222.

[18] Choudhury, 277-278.

[19] Choudhury, 284.

[20] Choudhury, 287.

[21] Choudhury, 287-288.

[22] Choudhury, 312, 321.

[23] www1.cord.edu/faculty/sprunger/e315/i-e.htm

[24] Jones, *AR*, I, 233.

[25] Cox, II, 137-138fn.

[26] Robertson, *CM*, 157.

[27] Robertson, *CM*, 253.

[28] Moor (1810), 249; *vide* 334-335.

[29] Jones, *AR*, X, 49.

[30] Jones, *AR*, X, 47.

[31] Giri, 22. (Emph. Added.)

[32] hinduism.about.com/library/weekly/aa122200a.htm

[33] *vide Historical Atlas of the World; Past Worlds: Atlas of Archaeology; Funk & Wagnalls Encyclopedia.*

[34] Miller, 90-91.

[35] Miller, 92.

[36] Titcomb, 39-40.

[37] Moor (Simpson), 135.

[38] Moor (Simpson), 135.

[39] Titcomb, 43.

[40] www.positiveatheism.org/hist/rmsbrg11.htm

[41] Hengel, I, 196.

[42] Jackson, *CBC*, 79-85.

[43] Titcomb, 36.

[44] Titcomb, 37.

[45] Graves, R., 213fn.

[46] Graves, R., 303.

[47] Graves, R., 318.

[48] www.angelfire.com/band/kissed/stolen.html

[49] Maurice, I, 181.

[50] Muir, V, 2.

[51] Higgins, I, 468.

[52] Müller, *LOGR*, 138.

Krishna, The Lord Sun

The Egyptians have it that Horus, the Sun, overcomes and kills the serpent Apophis, the Waters. The Hindus say that Krishna, the Sun, destroyed the serpent Anatha, the Waters. And the Greeks record that Apollo, the Sun, overcomes Python, the Waters.

Col. James Churchward

Not only was the solar nature of Krishna recognized by the first European investigators, being indeed avowed by the Brahmans, but the main elements of the whole myth were soon judiciously analyzed.

J.M. Robertson, *Christianity and Mythology*

The ancient astrotheological religion of the past several millennia has been widely practiced in India, which has a long solar tradition. The sun-worshipping Indians possess many gods, rituals, prayers and invocations that revolve around the solar orb, extending back several thousand years. In fact, Indian sun worship dates to aboriginal times, so it is to there that we must direct our attention in our quest to understand the primal religion, its many offspring and the world's numerous deities.

In *The Religions of India*, Edward Hopkins identifies the "two great classes" of "native wild tribes," the Kolarians and Dravidians, as "the Yellow and Black races respectively." Oddly enough, Himalayan Academy Publications says the ancient Dravidians were "a Caucasian people of dark skin."[1] In any event, called "Indo-Chinese" by some, the Kolarians displaced the earlier black race, in a "yellow wave" coming from the northeast, "prior to the Aryan white wave (from the Northwest), which latter eventually treated them just as they had treated the aboriginal black Dravidians."[2] Within this Kolarian group are the Savaras or Sauras, a term used to describe worshippers of Surya, the main Indian sun god. Two of the "chief representative" tribes of the Dravidians are the Khonds and Gonds of central India. Both of these tribes esteemed the sun as the central figure and "chief divinity" in their religious worship.

To the Khonds, who possessed a "polytheistic monotheism" more typical than is recognized, the supreme god was the sun, to whom they, like so many other cultures, sacrificed humans. The Khond sun god's wife was the earth goddess, Tari, a term apparently cognate with the Egyptian "Ta," meaning "earth,"[3] and Latin "Terra." The sun god himself was called "Bella Pennu," which is ostensibly related to the Bel or Baal of Canaan, and which would represent a very old point of contact or singularity between these cultures.

Like those already named, other Dravidians, such as the Oraons, and other Kolarians, such as the Sunthals, have been sun worshippers, the former of whom "recognize a supreme god in the sun."[4] Regarding the Sunthals, Hopkins states that the sun is their "highest spirit" but that they are animistic and polytheistic as well, recognizing deities in the natural world all around them. One of the Sunthal holidays is a "particularly nasty festival," as Hopkins terms it, that serves as a "preliminary to marriage": "All unmarried men and women indulge together in an indescribable orgy, at the end of which each man selects the woman he prefers."[5] This licentious festival by sun worshippers finds its counterpart in "civilized" cultures such as the ancient Greeks, with their bacchanals, and early Christians, with their agape "love feasts."

Hopkins describes the worship of another tribe, the Koles ("pig-stickers"): "Like the last, this tribe worship the sun, but with the moon as his wife, and the stars as their children. Besides these they revere Manes ['spirits of ancestors'], and countless local and sylvan deities. Like Druids, they sacrifice only in groves, but without images."[6]

Regarding the god Vetala, worshipped as an avatar of Shiva by natives of the Deccan (the Indian peninsula south of the Krishna River), Hopkins states:

A monolith in the middle of twelve stones represents this primitive Druidic deity. The stones are painted red in flame-shape for a certain distance from the ground, with the upper portion painted white. Apparently there is here a sun-god of the aborigines. He is worshipped in sickness, as is Shiva, and propitiated with the sacrifice of a cock, without the intervention of any priest. The cock to Aesculapius...may have had the same function originally, for the cock is always the sun-bird.[7]

Here we have a primitive solar religion, with 12 stones that signify the signs of the zodiac, much the same as the stones set up by the biblical Joshua, and as the Sinai temple of Horus with the sun in the middle surrounded by the 12 "helpers" or geniuses of the months. Furthermore, the cock as the sun bird is present even in the Christian gospel, in which the cock crows three times before Peter will admit Christ, representing the rooster's role as the gatekeeper and announcer of the rising sun.

In any event, solar worship in India dates to an early and primitive aboriginal period, possibly as early as 10,000 years ago, if not much before. In *Sun-Worship in India*, Srivastava remarks that the belief in and worship of the sun as a divinity has been "an essential feature" of Indian religiosity and spirituality "throughout their history," dating to at least the Neolithic period. Srivastava further states:

It may be suggested that the Sun as an object of worship attracted the attention of mankind in the Neolithic period in India, as is the case with Europe also. The farming economy appears to have played [a] leading role in the origin of Sun-worship. The Sun was a god of the farmers more than that of the hunters.[8]

In establishing the age of sun worship on the subcontinent, Srivastava describes and includes plates of a number of Indian rock paintings that depict the sun, such as at "Singanpur," where there is an image of the sun with "seven rays in the sky" and a human figure evidently worshipping beneath it. The seven rays likely represent the seven "planets," i.e., the sun, moon, Mars, Mercury, Jupiter, Venus and Saturn, which constitute the days of the week. Regarding other sun symbols from pre-historic India, Srivastava says:

> There are representations of the Sun in full radiance in the rock paintings from Sitakhardi (Chambal valley). Broadly speaking, there are two varieties of such representations: the circle with radiating rays, and the circle with radiating rays but encircled by a bigger circle. Figures of the Sun in full radiance usually in isolation but sometimes shown with other figures have been reported from Neolithic rock paintings of Europe, also such as from Pala Pinta de Carlao in Portugal. Similar figures are reported from Neolithic settlements of the Iberian peninsula as well. A comparative study of these symbols reveals that there is a marked similarity in them.[9]

Solar imagery is also found on potsherds, such as at Mohenjo-Daro and Harappa, enormous cities of the Indus Valley civilization, on the border of Pakistan, dating to at least 2500 BCE and possibly centuries earlier. Discovered among the Harappan cemetery sherds was a lotus-like image, about which Srivastava comments that the lotus was in "later Hinduism" a "regular cult symbol" of the sun god, as it was also "closely connected" in Egypt with the solar religion.[10]

Another pattern found at Mohenjo-Daro is the spoked wheel, a common solar symbol, also part of the Harappan script inscribed on Indus Valley seals. The wheel, an emblem of the Babylonian sun god Shamash, was a "popular solar symbol" in India during the historical period, as demonstrated by India coins. The wheel, or *chakra*, was likewise a symbol of Vishnu, "the Sun god of India," in post-Vedic times. Srivastava further states, "The wheel was used as the symbol of the Sun god in many Vedic sacrifices, as the *Vajapeya Agnicayana* and at the Solstial festival."[11]

Another sun symbol on Harappan pottery is a circle with "twelve leaf-like rays," representing the aspect of the sun god

responsible for creating the 12 months.[12] That the motif of the sun god with "the twelve" is very ancient is proved by this artifact—as is, evidently, the knowledge of the length of the solar year and its division into 12 months, although it is likely that the year represented at Harappa was the archaic 360-day measure.

As in Egypt and Mesopotamia, the "falcon represented the sun-god in the Indus Valley culture." Srivastava asserts that Indian sun worship was not derived from Mesopotamia and Egypt, even though "protohistoric India had cultural contact with these countries." That there was protohistoric contact between these nations is evident from numerous cultural correspondences, but the debate as to which came first and who influenced whom remains open as a fascinating subject for another volume.

The progress and advancement of Indian astrotheology, beginning at least with the Rig Veda, some 3,500 or more years ago, is described thus in the Catholic Encyclopedia:

> The [Indian] division of the zodiac into twenty-eight houses of the moon is worthy of notice; this conception like all the rest of the fundamental beliefs of Hindu astrology, is to be found in the Rig-Veda. In India both astrology and the worship of gods go back to the worship of the stars. Even today, the Hindus, especially the Brahmins, are considered the best authorities on astrology and the most skillful casters of horoscopes.[13]

As to the enduring ubiquity of the Indian solar religion, in an article in *The Kashmir Sentinel* entitled, "Sun Worship in Kashmir," Prof. M.L. Koul says:

> The sun-god is in essence a Vedic god, and its reverential worship has been widely prevalent throughout [India,] including Kashmir. In the Rig-veda we find a web of mythology woven around the sun-god known as Aditi. During the upanishadic era the sun-worship had assumed tremendous significance, and the Chamdogya upanishad is replete with references to the sun-worship, as it created life and also nourished it. In the Mahabharata the sun-god attained a sweeping sovereign status and in some respects was deemed more significant than most other gods in the Hindu pantheon. The sun-worship was so pervasive that massive temples were built in honour of the sun-god. The magnificent Konarak temple, built in the eleventh century A.D., testifies to the importance and prevalence of the sun-god worship.[14]

In *Sun-Worship in Ancient India*, Pandey presents an extensive list of sun-worship sites throughout India, with synopses, naming over 140 temples that date back centuries and millennia. He then notes, "In addition to these there were many more Sun-temples scattered in every part of the country."[15] In the last several centuries alone, enormous, ornate temple sites have been

constructed in numerous places. By the 12th or 13th century CE, Indian sun worship was highly popular, with rituals three times a day, at dawn, noon and "in the evening by sectaries who professed to find a particular divinity attached to him in these different manifestations of his splendour." By Moor's day, the early 1800s, sun worship had become "confined to a mere invocation or...absorbed into the adoration paid to Vishnu."[16]

Unfortunately, invading Muslims destroyed many Hindu temples, such as the splendid temple to the sun known as Martand, thus demolishing much of the evidence of the existence and antiquity of the Hindu solar religion. This destruction was followed by that of the (Christian) Portuguese and British. Fortunately, enough archaeological evidence, texts and legends have survived to piece together to a certain degree the early Indian sun worship. Indian sun worship as evidenced by coins and pottery predates the common era by centuries and millennia; Indian texts demonstrate it to be over 3500 years old, based on the orthodox dating of the Vedas. Common among the aboriginal tribes, however, Indian sun worship in all probability dates to at least the early Neolithic period, 10,000 years ago. There was, in fact, "hardly any period of ancient Indian history when Sun-worship would have been non-existent."[17]

It is obvious that the sun has been worshipped for thousands of years in India. It is further evident that the Indian study of the sun, moon, planets and stars dates back millennia and that the system is well developed and complex, reflecting its antiquity. As elsewhere, sun worship in India has led to the development of entire solar civilizations, so highly regarded has been the sun as the creator of life on Earth.

The God of Love

In India, the sun was extolled in the highest of terms, as Srivastava relates:

> The Sun-god is invoked as the soul of all corporeal existence and the origin of all existence...the goal of emancipation, the beginning and end of the day of Brahma. He is the highest god... He discovers, sustains and annihilates the universe.[18]

The sun was "God of gods," the "Primeval Being," the "Supreme Soul" and the "God of love."[19] Indeed, Müller shows that the sun was called "Deva," the Divine, or "God":

> When we are told that the poets of the Veda represent the sun as a god, we ask at once what is the name for god, and we are told *deva*, which originally meant *bright*. The biography of that single word *deva* would fill a volume, and not until we know its biography from its birth and infancy to its very end would the

statement that the Hindus consider the sun as a *deva*, convey to
us any real meaning.[20]

Müller continues:

> In other places...the tone of the Vedic poets changes. The sun is
> no longer the bright Deva only, who performs his daily task in
> the sky, but he is supposed to perform much greater work; he is
> looked upon, in fact, as the ruler, as the establisher, as the
> creator of the world.[21]

In the "holiest text of the Vedas," the *Gayatri*, the sun is the
Supreme Godhead:

> "Let us adore the supremacy of that divine Sun, the Godhead
> who illuminates all, who recreates all, from whom all proceed, to
> whom all must return; whom we invoke to direct our
> understanding aright in our progress toward his holy seat."[22]

This passage from the Gayatri also calls the sun "Being of
beings" and "the great supreme pervading Spirit."[23] Over
the millennia, this supreme position continued, into the Puranic
era, as Pandey relates:

> In the Puranas, Sun-God is praised several times. In the
> Markandeya Purana, the Sun-god is given epithets like "abode of
> knowledge," "cleanser of darkness," "stainless and supreme
> Soul," and "universal cause." He is also described as "the highest
> and the lowest," "material and non-material," "minute and yet
> existing in massive shape."[24]

This "sun" is not only the gross material orb but also the
"divine and incomparably greater light, which illumines all,
delights all, from which all proceed, to which all must return, and
which alone can irradiate our intellects." Clearly, however, some
of these hymns refer *also* to the visible sun, as a representative of
deity.

The sun was viewed in India as the "home of the dead," as it
was in the esoteric traditions of other nations, where it was
believed that the soul passed through several stages, including
the ultimate—the sun—in order to be purified.

Although Hinduism is overtly polytheistic, Indian sun worship
was also monotheistic, again a seemingly paradoxical perception
pervasive in the ancient world. As Srivastava states, a few of the
hymns in the Rig Veda exhibit "a sort of 'solar' monotheism," as
the sun was deemed the "one supreme and original god," while
the other gods were "various names and forms of the supreme
reality."[25] In other words, the other gods were expressions of the
one supreme God Sun.

One of these monotheistic hymns is provided by Prasad:

We shall quote a hymn from the Rig Veda which will show what a clear and consistent, pure and perfect monotheism is taught in the Vedas:...

"In the beginning there existed God, the source of light. He was the *one* lord of all created beings. He upholds this earth and the heavens. He, it is to Whom we shall offer our prayers."

"He, who is the giver of spiritual knowledge and giver of strength, Whom the world worships; Whose command all learned men obey; Whose shelter is immortality; Whose shadow is death; He it is to Whom we shall offer our prayers."

"He, who by his greatness is the one sole king of this animate and inanimate world, Who is the creator and lord of all bipeds and quadrupeds..."

"By whom the heavenly bodies are uplifted and the earth is made stable; by Whom the firmament and heaven are established; Who pervades the entire space by His spiritual essence..."

"To Whom the earth and heavens look up, being upheld by His protection, and moved by His will; in Whom the sun rises and shines forth..."

"May the lord of truth and righteousness, creator of the earth, who has also created the heavens, and who manifested the vast and shining diffused matter; may He not inflict pain upon us; He, it is to Whom we shall offer our prayers."

"O lord of all creatures, none other than Thee can control and govern all these created things...."[26]

The Indian adoration of the one, solar God is apparent from this exuberant hymn. In the Mahabharata and other texts, "it is said that in reality there is only one Sun."[27] However, the God Sun possesses numerous aspects, which become its names, epithets, titles or adjuncts, such as the following: Surya, Savitri, Mitra, Vishnu, Pusan, Asvins, Adityas, Rohita, Vivasvat, etc.

Beginning millennia ago and enduring to this day within Hinduism and Brahmanism, oaths have been taken under the sun, and prayers offered to it. There have also been astrotheological holy days and tremendous festivals, particularly during the four cardinal days of the year: the vernal equinox, the summer solstice, the autumnal equinox and the winter solstice. One or the other of these cardinal points has been used as the beginning of the new year, depending on the era and location. As Roy states:

...all important festivals and rituals of prehistory are linked with one or other of the points or days." Thus, in India, Vagdevi (i.e., the fifth day of the white fortnight of the month of lunar *Magha*). Winter solstice once took place there, and on that day, Vak announced her celebrated Devi Sukta, because it was an auspicious day.[28]

The "Vag" in "Vagdevi," along with "Vak," is short for Vagambhrini, the author of the *Devisukta* who "knew astronomy" and was renowned for establishing the winter solstice.[29] The "white fortnight" comprises the two weeks when the moon is waxing, while the month of Magha corresponds to January-February. The winter solstice falling in Magha would occur during the Age of Aries (per the Western zodiac), around 2300-4400 years ago. Roy further states that the autumnal full moon was "the day of great rejoicing" and subsequently discusses the ancient astronomy:

> Then followed astronomy, i.e., the knowledge that seasons were connected with the moon and stars. According to the Indian tradition, the credit for this discovery goes to a great matriarch who was deified as the mother goddess *Aditi*—the mother of devas—i.e., the mother of the gods of time.[30]

It is claimed that Vagambhrini, the "mother of astronomy," was later deified as Aditi, the "mother of the gods." Aditi's reverence seems to date to at least 8,000 years ago, which may indicate that the winter solstice had been celebrated in India by that early a date, if not earlier, based on rock drawings. In any event, on the equinoxes or solstices, a solemn vow was performed: the *Suryasankranti vrata*.[31] Surya is a principal name for the sun god, and vrata is a vow, while a sankrati is a festival of the sun moving into a new sign of the zodiac.[32] In the West, this crossing at the vernal equinox is called Passover or Easter, at which point the sun is "crucified" in the heavens.

In an article in *Asiatic Researches* entitled "The Lunar Year," Sir William Jones observes that, while the majority of the Indian "fasts and festivals" are lunar based, "the most solemn and remarkable of them have a manifest reference to the supposed motions of the sun." Two of these holidays, the *Durgotsava* and *Holica*, are linked to the autumnal and vernal equinoxes, "as the sleep and rise of Vishnu relate to the solstices." The solar year, Jones says, "anciently began with *Pausha* [December-January] near the winter solstice."[33]

As noted, the Indian year began at various of the cardinal points, including Pausha, the month of the winter solstice, which corresponds to December 22-25, when the sun is "born," "born again" or "resurrected." The solstices in India have been celebrated as the "sleep and rise of Vishnu," or the death and rebirth of the sun god. In the freezing, dark latitudes far above or below the equator, the winter solstice has been the most important time of the year, because it represents the sun's return to life. Nearer the equator, the sun has been deemed more of a pestilence, bringing stifling heat and desiccation. The choice of

the cardinal day celebrated as the "new year," then, is likely dependent upon the latitude. Indeed, in some texts various festivals and fasts are unmentioned; yet, "they may be mentioned in other books, and kept holy in other provinces, by particular sects."[34] The fact that the solar year "anciently began" at the winter solstice indicates that ancient Indians considered that time of the year as the "birth" of the new sun, as did numerous other peoples, including and especially the Europeans, who share a common cultural heritage with the Vedic- and Sanskrit-speaking peoples of India.

The festivals and holidays of today are not necessarily those of yesterday. One thing can be stated, however: In general, the four cardinal points, including the winter solstice, were highly esteemed. Also revered was the proposed author of these auspicious days, the manifestation of supreme power, the supreme being: the God Sun.

Brahma, the Creator

The sun as the Indian Supreme Being is "Trimurti," or Three-faced, represented by Brahma, Vishnu and Shiva, the creator, preserver and destroyer. Among the primitive "hill tribes" of Central India, the sun has been invoked as "the Holy One, the Creator, and Preserver."[35] Regarding this "Trinity," Sanjay Rath says:

> The Sun is the Creator, Preserver and Destroyer, and takes the three forms of "BRAHMA," "VISHNU," and "RUDRA." [Shiva] Hence the Sun symbolizing godhead is said to be Omniscient (all-seeing/knowing Brahma), Omnipresent (present everywhere and preserving Shri Vishnu) and Omnipotent (all-powerful like Lord Shiva). Thus the Sun becomes the "Ayana" (direction) of the *Nara* (humans) and is called "Narayana" (God).[36]

While Shiva is the setting sun, the destroyer of the day, Brahma is the rising sun, the creator of the new day. Brahma is depicted as red, representing the red-colored sun's creative power. Red also symbolizes fire and "the earth or matter," Brahma being these elements as well. The designation of "setting" has also been applied to Vishnu, the preserver, and Shiva has been associated with noon, perhaps in areas where the midday heat imparts death and destruction. Lord Shiva's "prototype" in the Rig Veda is Rudra, the counterpart of Typhon[37] and Set, the destroyer of the newborn sun.

In the Gayatri, which Lundy terms the "holiest verse of the Vedas" and which in the Mahabharata is called the "mother of the Vedas,"[38] appear the following solar hymns that express epithets for the sun, including "Brahm," the "Eternal One" or Supreme Being:

"...On that effulgent power, which is Brahm himself, and is called the light of the radiant Sun, do I meditate..."

"Let us meditate on the most excellent light and power of that generous, sportive and resplendent Sun; (praying that) it may guide our intellects."

"This new and excellent praise of thee, O splendid and playful Sun!... Be gratified by this my speech: approach this craving mind, as a fond man seeks a woman. May that Sun (Pushan), who contemplates, and looks into, all worlds, be our protector.

"Let us meditate on the adorable light of the Divine Ruler (Savitri).—May it guide our intellects. Desirous of food, we solicit the gift of the splendid Sun (Savitri), who should be studiously worshipped. Venerable men, guided by the understanding, salute the divine Sun (Savitri) with oblations and praise."[39]

These hymns express several profound concepts that have existed in other cultures and have constituted much religious thought over the millennia. Most, if not all, of the Hindu deities symbolize "the three powers," which in turn are Brahm, the Eternal One, and the sun.[40] Although a distinction is made between "Brahm" and "Brahma," in the end both are solar phenomena.

The followers of Brahma are called Brahmans or Brahmins, who constitute a solar priesthood, concerning whom Müller relates:

When the young Brahman lights the fire on his simple altar at the rising of the sun, and prays, in the oldest prayer of the world, "May the Sun quicken our minds"...[41]

Thus, one of the Brahman rituals is daily recitation of a prayer for the divine sun to "rouse" the mind. Brahmans do this ritual while "facing the east, standing on one foot, and stretching out their hands to the sun..."[42] This prayer is extremely old, reaching back into prehistory.

In his "Dissertation on *Egypt* and the *Nile*," Col. Wilford relates some interesting facts concerning the ancient and secretive Brahman priesthood:

There is no subject, on which the modern *Brahmans* are more reserved, than when closely interrogated on the title of *Deva*, or God, which their most sacred books give to the Sun: they avoid a direct answer, have recourse to evasions, and often contradict one another and themselves. They confess, however, unanimously, that the Sun is an emblem or image of their great deities, jointly and individually; that is, of Brahm, or the Supreme One, who alone exists really and absolutely: the three male divinities themselves, being only *Maya*, or delusion. The body of the sun they consider as *Maya*; but since he is the most

glorious and active emblem of God, they respect him as an object of high veneration.[43]

The sun is the Supreme Godhead, the Trinity, of which Brahma is a member. In actuality, Brahma is only one of the sun gods or solar aspects given prominence in Indian religion, depending on the era and part of India.

The Adityas

Several of the Indian sun gods are called "Adityas," who vary in number from 6 to 7 to 8 to 12, the last of which became more concretized over the centuries, to represent the geniuses presiding over the months.[44] In an editorial in *Vaishnava News*, Arijit Das provides names of the 12 and outlines their different functions:

> The twelve adityas are nothing but different forms of Surya [the sun]. Their names are Indra, Dhata, Parjanya, Tvashta, Pusha, Aryama, Bhaga, Vivasvana, Vishnu, Amashumana, Varuna and Mitra. As Indra, Surya destroys the enemies of the gods. As Dhata, he creates living beings. As Parjanya, he showers down rain. As Tvashta, he lives in the trees and herbs. As Pusha, he makes foodgrains grow. As Aryama, he is in the wind. As Bhaga, he is in the body of all living beings. As Vivasvana, he is in fire and helps to cook food. As Vishnu, he destroys the enemies of the gods. As Amshumana, he is again in the wind. As Varuna, Surya is in the waters and as Mitra, he is in the moon and in the oceans.[45]

In his articles entitled "Surya Mantra," Sanjay Rath explains that the Adityas represent the sun in the 12 signs of the zodiac, which are to be worshipped in particular directions, per Lord Krishna's instructions. Rath further says that the planets "came from different forms of the Sun," and he too lists the 12 Adityas, along with their roles and planets: First is Surya, from "svar," meaning bright. Surya's direction is East, ruled by the sun. As the sun rising from the water at daybreak, Varuna is the "oldest of the Gods," equivalent to the Greek Ouranos. Possessing "great wisdom," his job is to punish sinners; he is worshipped facing West, ruled by Saturn. Mitra, "the friend," in the Rig Veda plays the role later assigned to Krishna in urging men to action. Mitra's worshippers faced the Northwest, ruled by the moon. Aditya, son of Aditi, is an aspect of the sun "responsible for [the] heavens." He is also Vishnu, in that both are the "Vamana avatar." Aditya is worshipped in the North, ruled by Mercury. Vishnu means "one who is omnipresent" and represents the pervasive sun, as in sunlight. His worshippers face the Northeast, ruled by Jupiter.

In *Hindu Pantheon*, Rev. Moor also names the 12 adityas as "emblems of the sun for each month," relating that they are the

children of Aditi, the "mother of the gods."[46] Regarding Aditi, Müller says that she is "one of the oldest names of the dawn," the sky just before sunrise. Müller further states:

> As the sun and all the solar deities rise from the east, we can well understand how Aditi came to be called the mother of the bright gods, and more particularly of Mitra and Varuna...and at last of the seven, or even eight so-called Adityas, that is, the solar deities, rising from the east.

Müller submits that the concept of Aditi and the sun produced the idea of future life, with the continuous sinking and rising of the solar orb and other celestial bodies:

> The sun was supposed to be born in the morning and to die in the evening; or, if a longer life was given to him, it was the short life of one year. At the end of that the sun died, as we still say, the old year dies.[47]

Since the sun was depicted as dying at the end of the year, or the winter solstice, it would be logical to assert that "he" was also born again at the winter solstice, or new year.

Indian astrotheology extends to pre-Vedic times and includes "seasonal rituals" that were "connected with bright stars." During the Vedic era, the gods were "linked with certain stars." As Roy observes, "*Vedic astronomers knew that, astronomically, the god meant the star and vice versa.*"[48] In this regard, Aditi's role is multifold, as she also has been deemed the constellation of Pollux, "of which she was the presiding deity." As noted, her esteem appears to have begun at least 8,000 years ago,[49] and it is apparent she was not originally a "great matriarch" or "real person" but the genius of Pollux, which inspired scientists of the day. She is also the Dawn, which gives birth to the Sun every morning. Aditi is described in the Indian sacred texts as being "eternal" and "inviolable,"[50] as well as "sinless,"[51] all of which would signify "perpetual virginity." The suns/sons of Aditi are said to be born from her "womb"; yet, she is not a "person," has no body and lacks female genitalia. Being sinless, Aditi, the "mother of the gods," including Mitra and Vishnu, was also considered to be the "forgiver of sins." In the Rig Veda, Aditi, Agni, Mitra and Varuna are viewed as intercessors:

> 5.82.6 "May we be free from sin against Aditi through the help of the divine Savitri"...

> 7.93.7 "Whatever sin we have committed, be thou (Agni) compassionate; may Aryaman and Aditi sever it from us"...

> 10.12.8 "May Mitra here, may Aditi, may the divine Savitri declare us sinless to Varuna"...[52]

Hence, Aditi, although a mother, remains untainted and chaste; in other words, she is a *virgin mother* more than 3,000 years before the creation of Christianity. Aditi's 12 sons/suns eventually became fused into a single sun god called Dvadasatman,[53] as well as Dvadasarka and Dvadasaditya. Also, "in the Veda, the sun, in the form of Martanda, is the eighth son born of Aditi";[54] this factor, among others, makes Martanda's myth an earlier version of Krishna's.

Indra, the Warrior

One of the adityas, Indra is another name for the sun in the Vedic texts. As Sir Jones plainly states, "*indra*...is a name of the *sun*,"[55] and Moor observes, "Indra, as well as the deity presiding over the firmament, and over atmospheric or meteoric phenomena is himself...a star, or a constellation: his name is among the twelve Adityas, or Suns." [56] Olcott confirms this identification, saying that while Indra's worship "constitutes the very essence of Vedic religion," he was only one of many sun gods adored in India, in its sun worship similar to that of Egypt.[57]

The storm god, as well as the "most celebrated Vedic god," Indra later became subordinate to the Trinity of Brahma, Vishnu and Shiva. Regarding Indra's nature, Srivastava says, "Indra has got many solar features in his personality, and it is quite probable that his role as the rain-maker and later on as the war-god was derived from the Sun."[58] Rev. Cox relates that Indra, the "sun-god," is portrayed in the Vedic hymns as fighting with the "dark power" and the "throttling snake," as well as "pursuing the beautiful Dahana," who, as the Dawn, is the "mother or bride of the sun..."[59] The story of Indra represents a classic solar myth: light versus darkness, the night as a "snake" or serpent, the sun as son and/or husband of dawn, etc.

Indra's "chief musician" was depicted as riding in a "painted car, which on one occasion was burned by Arjuna, the confidential friend and agent of Krishna, or the Sun."[60] This myth signifies a "battle" between the "chief musician" or charioteer of one sun god and that of another. Indra being usurped by Krishna represents one solar aspect, or sun god, overcoming another. Also, in the Mahabharata, Indra and the Suras, or stars of the northern hemisphere, lose a fight with the Asuras, the stars of the southern hemisphere, who are "under the dominion of Yama," the god of death, "son of the sun" and southern sun "who holds his court in the antarctic circle..." The conclusion is that the clash between the Suras and Asuras is an astrotheological fable, representing the precession of the equinoxes or the "annual motion of the stars from east to west." Rev. Maurice considered the Mahabharata to be "only a corruption of the ancient Chaldean

history and traditions..."[61] It has been maintained by others, however, that the Chaldean culture emanated out of India.

Surya, God among gods

The predominant name of the sun in Indian literature is Surya, a title applied to both the solar Godhead and the material orb itself. Surya is the name of the sun god in both the Ramayana and the Mahabharata, in which epics he is considered "a great moral and ethical force." Never to be offended, Surya is "the beholder of good and bad deeds of men."[62] The earlier Vedas also depict the sun as Surya, who holds the "superlative" position of "God of the gods" and "divine leader of all the gods." In the Rig Veda (7.63.1), Surya is "the bliss-bestowing" and "all-seeing" eye of Mitra and Varuna. At RV 7:60.2, the sun is "the protector of everything that moves or stands, of all that exists."[63] Like Apollo, Surya drives a chariot, pulled by one to seven white or bright horses, the "Harits," who are evidently the forerunners of the Greek "Charites," the beautiful "maidens and ministers of the dawn-goddess Aphrodite."[64]

As is the case with so many sun gods, Surya is the "son of the sky," the latter named in the Rig Veda as "Dyaus Pitar," or "God the Father," equivalent to the Greek Zeus Pateras and the Roman Jupiter. Dyaus's wife is the dawn, who is also depicted as the sun's daughter, as well as the sky's daughter, which would make her the sun's sister as well,[65] a confusing but common development in astromythology. In any event, Surya is the son of Aditi, the Inviolable Dawn. Hence, in this myth, which predates the Christian era by over 1,500 years, is the motif of the son of God the Father and the Virgin Mother. Here, too, is a (more natural) Holy Trinity: Dyaus (Father), Aditi (Mother) and Surya (Son).

The name Dyaus Pitar provides additional evidence of the connection between India and other cultures. For example, Roy argues that the "most ancient pre-Indo-European word for the day was *Dyu*," appearing in the Rig Veda. He further shows how the root is found in more modern words, such as "Dieu, Deity, Diurnal, Divine and Day." From "Dyaus" also come the words "Deos," "Dios," "Dieu," etc.

Surya's wife,[66] the Goddess Usa, corresponds to Isis, while Surya is Osiris.[67] As stated, Osiris is also Iswara, Isvara or Esvara, the same as Shiva/Siva,[68] who is also called Isa or Issa, the title by which "Jesus" has become known in the East. The moon is a "form of Iswara," who bears its mark on his forehead, and the lunar aspect of Osiris is apparently to be found in the Indian story of Isa and Isi, which indicates that the cultural commonality between Egypt and India was pre-solar.

Surya is one of the sun god's principal "five forms," the others being Vishnu, Shiva, Shakti and Ganesha.[69] Ganesha, it has been shown over the centuries, is essentially the same as the Roman god Janus. Ganesha's brother, Kartikeya, is "generally esteemed the second son of Siva and Parvati." At some point, Kartikeya is recognizable as the "Orus [Horus] of Egypt, and the Mars of Italy."[70] Hence, Kartikeya is the son of Shiva, who is Isvara or Osiris, and is equivalent to Horus.

Like the God Sun of Egypt, Greece and Rome, Surya possesses many additional appellations or adjuncts:

> Aryama, Vivaswata, Martunda, Sura, Ravi, Mihira, Bhanu, Arka, Heridaswa, Karmasakshi, Savitri Pushan, Bhascara, Tapana, Twashti, Bhaga, Mithra, Heli, Varuna, Vedanga, Indra, Gabhasti, Yama, Divakara, Vishnu, Krishna.[71]

As we can see, in addition to Surya's names of Mitra/ Mihira/Mithra, Indra and Vishnu are Heli (Greek *Helios*), and *Krishna*.

The names of Surya are also 108, a sacred and mystical number in Eastern spirituality and the number of beads in the Buddhist mala or rosary. The following selection of the 108 names comes from the Brahma Purana:

> Surya, Archana, Bhagavana, Tvashta, Pusha, Arka, Savita...
>
> Dhata, Prabhakara, Prithivi, Jala, Teja, Akasha, Vayu, Parayana, Soma, Brihaspati, Shukra, Budha, etc....

In these long lists are reproduced not only Indra, Vishnu and Krishna but also "Budha," another name for the sun, as well as for the planet and god Mercury or Hermes. This "Budha" or "Bhood" a number of scholars have equated with "the Buddha" and with the Gothic Woden. In other words, Buddha is Mercury, Hermes and Woden.[72]

Another of Surya's names or epithets is "Heridaswa" or simply "Heri." Regarding "Hare" or "Heri," Count Volney says: "In Hebrew *heres* signifies the sun, but in Arabic the meaning of the radical word is, to guard, to preserve, and of *haris*, guardian, preserver. It is the proper epithet of Vichenou [Vishnu], which demonstrates at once the identity of the Indian and Christian Trinities, and their common origin."[73] The words for "sun" in other languages are traceable to Surya and his title "Heri," "Hare" or "Hari": "The variants of Surya are as follows: *Hvare* (Avestan), *Sol* (Latin), *Sauil* (Goth), *Heure* (Welsh), *Saule* (old Prussian), *Saule* (Lith)."[74] Interestingly, the language of Lithuanian, in which the word for sun is "Saule," is believed to be the closest living relative of the original Indo-European tongue.

The numerous epithets relate to the different positions of the sun as they were worshipped during the Vedic era, e.g., the rising sun, the sun at noon, the setting sun and the night sun. Surya in specific represents the rising sun and "symbolizes the sun's light-giving aspect."[75] Another of Surya's aliases, Pusan, is "distinctly a shepherd god,"[76] a title applied to Krishna and Christ. The Shepherd God likely dates to the time sheep herding first began, many thousands of years ago.

In the Mahabharata, Surya is described as the "center of all, the movable and immovable on earth," which indicates ancient Indian knowledge of the heliocentricity of the solar system, as well as the pivotal role on Earth played by the sun. In addition, later Indian art portrays Surya as surrounded by the 12 Adityas. Concerning Indian astrotheology, Srivastava relates:

> Among the Greeks and Romans also, the Sun under the influence of Semitic astrology was supposed to be the centre of the planetary system. Similar thought is envisaged in the early Puranas when the Sun is said to occupy the central position among the planets and is said to be moving to twelve Zodiacal signs at different times of the year.[77]

The heliocentricity of the solar system was known centuries, if not millennia, before its supposed discovery by Copernicus in the 16th century. As noted, this secret and sacred knowledge was part of the mysteries.

Mitra, the Friend

Born of Aditi, the inviolable Dawn, Mitra was one of the original six adityas, or aspects the sun, which indicates his antiquity. Mitra's role was the "new light," the "bright and cheerful sun of the morning," or day.[78] The Indian Mitra became the Persian Mithras, and it is evident that Mithra's famous birthday, December 25th, was also part of the myth of his predecessor Mitra. As D.P. Maharaj says in "Christmas' Hindu Roots":

> The festival that is now known as Christmas was actually a celebration for the Vedic Deity Mitra. According to "A Classical Dictionary of Hindu Mythology and Religion" by John Dowson...the Hindu Mitra was connected to the Persian Mithra which later was adopted by Rome. Mitra was a form of the sun, and in the Vedas he is generally associated with Varuna.

Hence, Mithra's birthday on "Christmas," or the winter solstice, is a very ancient solar holiday traceable to the Vedic Mitra, millennia before the Christian era. Mitra's role as the "new light" or "new day" is appropriate for the god born anew at the winter solstice.

Vishnu, the Preserver

The popular god Vishnu, one of the Trimurti and a title for Surya, is the "Preserver" or "Protector" and a solar entity or sun god.[79] As noted, Vishnu and Aditya are both the "Vamana avatar," referring to a solar story in the Ramayana in which Vishnu becomes a dwarf who takes "three strides" that cover the earth. Vishnu's three strides are the sun's daily course, representing sunrise, noon and sunset. Concerning this Vamana role, Cox says, "In the Mahabharata this fact is ascribed to Krishna, who, having become the son of Aditi, was called Vishnu."[80]

Thus, Krishna is Vishnu, who is the sun.[81] In Indonesia, Vishnu "retained his solar associations throughout his manifold transformations," and his "most adored incarnations, Rama and Krishna, are often likened to the radiant sun."[82] Pandey states that Vishnu's solar nature is "beyond doubt" and that the Vedas concur that Vishnu was a sun god.[83] To the opinions of other authorities, including Dupuis, Moor and Müller, Srivastava adds:

> Visnu is another god of the Vedic tradition who is generally considered to be a solar deity. Many scholars in the past have traced solar features in his personality....
>
> ...It is no wonder if Visnu as a Sun-god was conceived of as the spirit of the ancestors because the Sun was believed to be the abode of the dead in the Vedic literature.[84]

Vishnu is the "eye in the sky" and is further equated with the sun by virtue of the 284th of his names, "Bhanu," which means "luminous or shining" and "sun," and is also a name for Surya.

Vishnu is not simply the passive preserver but also a "destroyer" when incarnate. Regarding the sun god, Pandey says, "As Visnu, he is always born to destroy the enemies of god."[85] In discussing the banners and "ensigns of the sects of India," Count Volney relates that the first standard is that of Brahma, the creator, symbolized by a four-headed figure, and he then describes the standard of Vishnu as bearing a "kite with a scarlet body and white head." Vishnu is also depicted in the "hideous form of a boar or a lion, tearing human entrails." He is likewise shown as a "horse, shortly to come armed with a sword to destroy the human race, blot out the stars, annihilate the planets, shake the earth, and force the great serpent to vomit a fire which shall consume the spheres." This scary stuff is reminiscent of the bizarre biblical book of Revelation. In a footnote regarding the boar, lion and horse, Volney explains: "These are the incarnations of Vichenou, or metamorphoses of the sun. He is to come at the end of the world, that is, at the expiration of the great period, in the form of a horse, like the four horses of the Apocalypse [Revelation]." In another connection to Revelation, Vishnu is the

name of the sun when it passes into the month of the Lamb or Ram, i.e., Aries.[86] Thus, Vishnu, who was called *Jes*, was also the "Lamb of God," long before the Christian era.

Like so many other sun gods, Vishnu is not just the material, visible sun but also the light in the sun and the force behind it, as well the light in the moon and the cosmos as a whole. He is also the sun's annual passage: "In the Brahmanas, the head of Visnu when cut off becomes the Sun, and he has been directly identified with the year."[87] Vishnu's yearly role includes setting in motion "his ninety steeds with the four names, 'an allusion probably to the 360 days of the year, divided into four seasons.'"[88]

By the epic period, when the Mahabharata was compiled, according to orthodox dating no later than the 5th century BCE, Vishnu, while retaining his solar characteristics, had become the god of a particular sect: Vaishnavism. As Srivastava relates, "The solar nature of Visnu is not forgotten in the Epics, but he has got a sect of his own, in which other cults such as those of Vasudeva, Krisna and Narayana are mixed up."[89]

By the age of the early Puranas, the sun god is "meditated upon as the visible form of Visnu and as the impersonation of *Om*."[90] "His subtle form is enunciated by uttering the word '*Om*.'"[91] "Om," like "On," therefore signifies not only "beingness" but also the sun.

Like other solar deities, Vishnu is the god of fertility as well, represented, like Shiva, by a lingam or phallus.[92] This status is a reflection of the fecundating nature of the sun, which brings light and life to the earth, as it penetrates the ground with its rays and causes plants to grow.

As stated, Vishnu is the genius of Pausha/Pausa, which is the month in which the winter solstice falls. Indeed, Vishnu is depicted as "sleeping" and "rising" at the solstices, representing the sun's power declining from the summer solstice to the winter, when it begins to increase again. An ancient Indian festival, *Bhascara septami*, occurs on the seventh day of the month of Magha, representing a "fast in honour of the Sun, as a *form* of Vishnu." "This day," says Jones, "has also the names of *Rathya* and *Ratha septami*, because it was the beginning of the *Manwatara*, when a new Sun ascended his car."[93] When this new sun "ascends his car" would generally be during the winter solstice, which, as we have seen, was in ancient times the beginning of the new year, i.e., the new sun.

As in many parts of the world, in India the sun was said to assume human form, appearing to people as a Brahman, for example. Srivastava relates the story of Kunti, in which the sun takes on two forms "by his power of Yoga," one maintaining his

normal state as the sun, and the other appearing as a human being to Kunti.[94] There is no concrete consensus concerning the myths of these various solar incarnations or avatars. In other words, the story of the solar deity is not "set in stone" but changes from place to place and age to age. Moreover, the portrayal in art of the sun god as a person seems to have begun during the time between the later Vedas and the epic period of the Mahabharata and Ramayana. Hence, whereas it was prehistorically symbolized by the wheel, lotus, bull, etc., the sun became increasingly anthropomorphized, a progression eventually leading to its "incarnation" or personification in Krishna.

Krishna, Sun of God

Although he has several incarnations, Vishnu's most famous and complete avatar is Krishna, the blue-skinned shepherd god traditionally born at Mathura. In the Gita, Krishna says, "Among the Adityas, I am Vishnu."[95] As is the case with gods and their myths, and as we have seen, Krishna's nature and story varies. Indeed, he is depicted as both a mortal and the supreme being. As Cox relates:

> Krishna...is said to be sometimes a partial, sometimes a perfect manifestation of that god [Vishnu]; but the phrases in which Krishna is spoken of are as indefinite and elastic as those which speak of Agni, Indra or Vishnu. In some passages Krishna is simply a son of Devaki. But as Vishnu is Brahma, so is Krishna also the supreme deity.[96]

Krishna is not only the most popular Indian god and the eighth incarnation of Vishnu but also a personification of the sun. As the solar Vishnu is "the impersonation of Om," so is Krishna the sun incarnate. Again, "Krishna" is one of Surya's numerous names, which, to reiterate, also include Mihira, Bhanu, Arka, Heridaswa, Savitri, Pushan, Mitra, Heli, Varuna, Indra, Yama and Vishnu.[97]

In a section entitled "THE SUN-GODS OF LATER HINDU MYTHOLOGY," Rev. Cox says:

> As being Vishnu, Krishna performs all the feats of that god.

> "And thou, Krishna, of the Yadava race, have become the son of Aditi and being called Vishnu, the younger brother of Indra, the all-pervading, becoming a child, and vexer of thy foes, hast by thy energy traversed the sky, the atmosphere, and the earth in three strides." [Muir, *Sanskrit Texts*, part iv. p. 118][98]

A "son of Aditi," Krishna is identified with the Vamana avatar, the dwarf with the three strides, also called "Hari." He is the sun, as well as the son of the sun (Vishnu): "In short...'he is the soul of all, the omniscient, the all, the all-knowing, the producer of all,

the god whom the goddess Devaki bore to Vishnu."[99] Hence,
Krishna's mother, Devaki, is equated with the Dawn Goddess,
Aditi, while his father is Vishnu.

Regarding the sun and Krishna, Moor states, "The 'all-
pervading Deity' is the Sun, or Crishna, or Heri, or Vishnu."[100]
Krishna's solar attributes are also laid plain in a number of
Hindu scriptures. In the Bhagavad-Gita, verse 7.8, Krishna says
to his beloved disciple:

> I am the taste in water, Arjuna, the light in the moon and sun,
> OM resonant in all sacred lore, the sound in space, and valor in
> men.[101]

At verse 10.21, Krishna states:

> I am Vishnu, striding among sun gods, the radiant sun among
> lights; I am lightning among wind gods, the moon among the
> stars.[102]

And at 15.12, Krishna says:

> Know that my brilliance, flaming in the sun, in the moon, and in
> fire, illumines this whole universe.[103]

At verses 11.17-19, Arjuna describes his master in solar
terms, including the common motif of the moon and sun as
"God's eyes":

> I see you blazing through the fiery rays of your crown, mace, and
> discus, hard to behold in the burning light of fire and sun that
> surrounds your measureless presence.

> You are to be known as supreme eternity, the deepest treasure of
> all that is, the immutable guardian of enduring sacred duty; I
> think you are man's timeless spirit.

> I see no beginning or middle or end to you; only boundless
> strength in your endless arms, the moon and sun in your eyes,
> your mouths of consuming flames, your own brilliance scorching
> this universe.[104]

The description of Krishna as the supreme, all-pervading,
eternal, infinite being is the same classically used in India and
elsewhere regarding the sun. Krishna's wife, Kalindi, is the
daughter of Surya, the sun god, demonstrating further the solar
connection. As we have seen, the "daughter" of the sun is also his
"mother," "sister" and "wife." Hence, as Kalindi's husbands,
Krishna and Surya are equated, as they are also joined by virtue
of the same epithets.

In addition, a number of festivals reveal Krishna's solar
nature. For example, on the fourth day of Bhadra is celebrated
the *Heritalica*, a festival commemorating Krishna, who was
accused of stealing in his childhood a "gem from Prasena" and

hiding himself in the moon.[105] The "hiding" of the light in the moon is another motif of the sun god.

In the festival of the sun called "Rasa," Krishna is depicted as surrounded by his *Gopis*—female consorts or "cowherds," also called "shepherdesses," an appropriate circumstance for the "God of love," which, as stated, is a solar epithet:

> Rasa...The mystery-dance performed by Krishna and his *Gopis,* the shepherdesses, represented in a yearly festival to this day, especially in Rajastan. Astronomically it is Krishna—the *Sun*— around whom circle the planets and the signs of the Zodiac symbolised by the *Gopis*. The same as the "circle-dance" of the Amazons around the priapic image, and the dance of the daughters of Shiloh *(Judges* xxi.), and that of King David around the ark.[106]

Furthermore, Krishna has been called "the Indian Apollo":

> Under the name of Gopala, or the herdsman, he is the pastoral Apollo, who fed the herds of Admetus, surnamed Nomios by the Greeks.[107]

Krishna with his nine Gopis is Apollo with his nine muses: "Krishna...and the nine Gopia, who are clearly the Apollo and Muses of the Greeks, usually spend the night in music and dancing."[108] In his *Hindu Pantheon*, the missionary Moor provides an image of Krishna surrounded by his Gopis, and says:

> The subject so beautifully represented in Plate 63 is said to be Krishna—and his *Gopia*, as well in their characters of Apollo and the Muses, as in those of the Sun, and the planets in harmonious movements round him; and was formerly adduced in support of the idea, that the Hindus had a knowledge of the true solar system, a point that no longer requires proof.[109]

Not only is Krishna thus comparable to the Greek sun god Apollo, but, again, the ancient Indian solar priesthood was well aware of the heliocentricity of the solar system. Concerning the Krishna-Apollo connection, Moor reiterates:

> The comparison between Krishna and Apollo runs parallel in a great many instances. The destruction of Python by Apollo, the commentators tell us, means the purification of the atmosphere by the sun...; and Krishna's victory over the noxious *Kaliya naga* may, by those who, allegorizing all poetical extravagance, deprive poetry of half its beauties, be explained in the same manner. In honour of Krishna's triumph, games and sports are annually held in India, as the Pythic games were at stated times exhibited in Greece.[110]

In an image at Buddha Gaya, the sun god Surya is depicted in a chariot with four horses, like that of Apollo and Helios. Like Helios and Surya, Krishna is portrayed in modern Indian art in a

chariot with four white horses: Sometimes the god himself is driving; other times his beloved disciple, Arjuna, holds the reigns. Indeed, "in the later Hindu mythology, Arjuna comes before us as standing to Krishna in the relation of Luxman to Rama, of Phaethon to Helios, or of Patroklos to Achilleus."[111] In other words, Krishna is depicted as the God Sun.

On a piece of pottery from the Mauryan (Asokan) period (3rd century BCE) is a figure of Surya standing in his chariot with his charioteer *Aruna*, who has a whip in his right hand. A modern depiction portrays Krishna himself (whose charioteer is *Arjuna*) holding a whip in his right hand. Furthermore, "Arunaditya" is another name for the sun god, which would suggest that Aruna is also an Aditya or sun. The solar attributes of these images are clear, as is the correlation between Krishna, Helios, Apollo and Surya.

When Krishna became popular in the West, he was identified with Hercules/Herakles, as attested by Greek historian and geographer Megasthenes (c. 350-290 BCE). Like that of Hercules, Krishna's "life" has been explained as the sun's annual course: "The myth of the Hindu sun-god Krishna has also been interpreted as an allegory of the annual passage of the sun through the twelve signs of the Zodiac."[112] It is also evident from the Greek historian Arrian (2nd century CE) that Krishna was equated with Hercules, and hence was a sun god: "...Arrian says that the *Suraseni*, or people of *Mathura*, worshipped HERCULES, by whom he must have meant CRISHNA and his descendants."[113]

The name "Herakles" is evidently related to "Heru," the archaic name of the Egyptian sun god, Horus. Again, the Indian sun was called "Heri," "Hari," or "Hare," meaning "Savior," a title also applied to Krishna. As Moor states, "Like the other Hindu deities, Indra is distinguished by several names...Heri is sometimes applied to him, as well as to Vishnu and Krishna: and Hari, a name of both Siva and Vishnu."[114]

Moreover, Krishna, as Heri, the sun, shines upon his people, the Yadus:

> In the following animated apostrophe [from the Gita Govinda of Jayadeva] Krishna is immediately identified, not only with Vishnu...but with the Sun, "from whom the day star derives his effulgence;"...:

> "Oh thou...who beamedst, like a sun, on the tribe of Yadu...O Heri, lord of conquest!"[115]

Expounding upon the Krishna-Yadu theme, Gerald Massey says:

> We also learn from the *Purana* that the incarnation of Vishnu as Krishna was to be in the tribe of the Yadu. *'I am born in the lunar*

race of the tribe of Yadu,' says Krishna.... The lunar race of Yadu was identical in the Hindu mythos with the lunar tribe of Judah, in the Hebrew, and the Christ that was to be born of both was one in the celestial allegory, the youthful luni-solar god who was to succeed and supersede the earlier manifestors of time and cycle as the Messiah of the great year of precession—just as the soli-lunar Khunsu had done in the cult of Amen-Ra in Egypt.[116]

The early, nomadic Hebrews were a "lunar race," as they were principally night-sky cultists or "moon worshippers." It is likely that a number of such nomadic tribes or gypsies made their way from India to the Levant, over a period of centuries or millennia. Like Khonsu/Horus/Hercules, Krishna is soli-lunar in nature, also like the Egyptian sun god Osiris, who, as may be expected, has correspondences with Krishna. For instance, one meaning of the name Krishna is "black": Like Osiris, he evidently represents not only the sun but also the "black sun," as it resides in the gloom of night. In the Sanskrit Dictionary, the word "kR^ishhNaH" (krishna) also means "the fortnight of the dark moon,"[117] representing the two weeks of the month when the moon is waning—in other words, when the sun's light in it is fading. This aspect is also Osirian.

Although Krishna in his distinct personality does not appear in the earliest Hindu texts, the Vedas, the term "Krishna," meaning "black" or "darkness," *is* found numerous times in those scriptures, dating to more than a millennium and a half before the Christian era. At Rig Veda 7.63.1, for example, the sun is the god "who has rolled up his darkness like a skin." "His darkness" and "skin" go hand in hand with the depictions of Krishna, who is portrayed with blue or navy skin, the color of the evening and night skies.

Another example appears in a hymn (RV 1.92.5) to Ushas, the Dawn Goddess, who is described thus:

> Her brilliant flame has become visible once more; she spread herself out, driving back the formless black abyss.[118]

The language for "black abyss" is *krishnam abhvam*, the accusative case, *krishna* being the nominative. At RV 1.113.2, 3, it is said of Ushas:

> 2. The fair and bright Ushas, with her bright child (the Sun) has arrived; to her the dark (Night) has relinquished her abodes; kindred to one another, immortal, alternating Day and Night go on changing colour. 3. The same is the never-ending path of the two sisters...[119]

The Vedic here for "the dark" is *krishna*, who as "Night" is anthropomorphized as the immortal sister of Day, to whom she

relinquished her abodes. As the Sanskrit scholar Muir observes: "In vii. 71, 1, and elsewhere...Ushas is called the sister of Night..."[120]
Concerning the Dawn, RV 1.113.14 says:

She has shone forth with her splendours on the borders of the sky; the bright goddess has chased away the dark veil of night...[121]

"Dark veil" is *krishnam nirnijam*, again in the accusative case. Here, the Dawn chases away Krishna—how a listener of the hymns would hear it when the rishis recited the Vedas.

At RV 1.123.9, Ushas, the dawn, is associated with "the black":

Knowing the indication of the earliest day, the bright, the lucid (goddess) has been born from the black (gloom).[122]

In this verse too "black" is *krishna*. Hence, it could be said that Ushas, the Dawn, also called Aditi, was born from Krishna, who is Surya, the Dawn's father.

The Night Goddess is immortalized at RV 10.127, which, O'Flaherty remarks, is a tribute to the night as a "bright creature, full of coloured stars," rather than the feared dark night of other verses.[123]

Like the dawn, the fire and sun god Agni is also described in the Rig Veda in terms of his ability to overcome "the dark," or *krishna*. "Krishna" is present in the passage concerning Agni that says, "*krishnadhvan, krishnavarttani, krishna-pavi, i.e.* his path and his wheels are marked by blackness..."[124] When the fiery Agni blackens wood with his tongue, the word for "blacken" is *krishna*. The suggestion is that *krishna* is the *charring* quality of the sun. Also, whereas Agni is the autumnal equinox, Krishna is the vernal equinox,[125] which explains the struggle between them and again suggests an early personification of Krishna in the Rig Veda, more than 3,500 years ago.

At RV 8.23.19, Agni, the "bright sun" or fiery solar aspect, is again called *Krishna-varttani*, which Muir translates as "he whose path is marked by blackness." The original phrase is an epithet, and "varttani" is evidently the same as "varttini," which means "chariot," "golden chariot" or "having a golden path."[126] Hence, it could be said that Agni is the "black chariot," "Krishna chariot" or "chariot of Krishna." Indeed, Agni shares a number of characteristics with Krishna: Among other qualities, Agni is the "black-backed" and "the lover of the maidens, the husband of the wives."[127]

In the Atharva Veda (v. 30, 11), Agni the sun rises from the "black darkness," *gambhirat krishnat*, associated with "deep death": "May this adorable Agni rise here to thee as a sun.

Rise up from deep death, yea, even from black darkness."[128] As we have seen, "black darkness" is in some verses anthropomorphized. Also, as we know from other mythologies, death is frequently personified; in Indian mythology specifically, he is Yama, the solar god of death.

In some verses, Agni is identified with Vishnu and Mitra, among others.[129] Hence, Agni is Mitra is Vishnu is Krishna—all aspects of the sun, or sun gods. Before becoming a god himself, "Rudra" was an epithet of Agni, Mitra, Varuna, et al.[130] It appears the same phenomenon occurred with Krishna. The mechanism by which epithets become personified as gods, as is obviously the case with the "black" or "darkness," i.e., *krishna*, is illustrated by Cox: "In India...as in the western world, there was a constant tendency to convert names into persons, and then to frame for them a mythical history in accordance with their meaning."[131]

The Agni connection not only to Krishna but also to Christ is brought out in detail by Arthur Drews in *The Christ Myth*, in which he calls Krishna a "form of Agni."[132] Like Christ, Agni is the "Lamb of God," as in the Latin term *Agnus Dei*, who is sacrificed at "Hulfeast," i.e., the spring equinox or Easter.[133] Concerning Agni, Drews states, "There is no doubt that we have before us in the Vedic Agni Cult the original source of all the stories of the birth of the Fire-Gods and Sun-Gods."[134]

Drews further says:

> Of all the Gods of the Rigveda Agni bears the closest relationship to the Perso-Jewish Messiah... He is rightly called king of the universe, as God of Gods, who created the world and called into life all beings that are upon it. He is the lord of the heavenly hosts, the guardian of the cosmic order and judge of the world... Sent down by his father, the Sky-God or Sun-God, he appears as the "light of the world." He releases this world from the Powers of Darkness... He is the messenger between this world and the beyond... He is a mediator between God and men...[135]

The story of Agni and its relationship to that of Krishna, as well as to that of Christ, is highly significant. It is Agni, "the Fire-God," identified with the sun, who is "the prototype of the modern Krishna," the latter manifested in the Vedas as a "demon."[136]

Tracing the development of the solar Krishna, we find the hymn at Rig Veda 6.9, which opens thus: "ahasca *krsnam* ahar *arjunam* ca," translated by O'Flaherty as "The dark day and the bright day..." It seems likely that, since the two terms *krsnam* and *arjunam* are used together, they later became personified as gods who were associates, i.e., Krishna and Arjuna. Krishna is the "dark day," to wit the "hidden sun-god of the night,"[137] since Day is also personified as a deity in many mythologies. Moreover, the "dark day and bright day" are clarified as "Night and day, the

dark and light sides of the sun...part of the dark and light halves of the universe." Hence, the "dark and light sides of the sun" are Krishna and Arjuna, the latter of which in Sanskrit means "white," "clear," "color of the day," "bright one" and "of the dawn." Also in the Rig Veda, these two "days," the dark and bright, are subsequently said to be "the two realms of space, [who] turn by their own wisdom," which again indicates anthropomorphism. Therefore, in these verses appear a somewhat personified Krishna and Arjuna in the early Vedic literature, long before the emergence of Krishna in the Mahabharata, in which Arjuna and Krishna figure together, with "Arjuna" as the "son of Indra" as well as "a name of Krishna."[138]

The personification process of Krishna is also present at RV 10.61.4, which says:

> *Krishna yad goshu arunishu sidad Divo napatav Asvina huve vam.* "When the dark stands among the tawny cows (rays of dawn), I invoke you, Asvins, sons of the Sky."[139]

The phrase "stands among" could be interpreted as anthropomorphic behavior; the passage above, then, could be translated thus: "When Krishna stands among the tawny cows..." This passage makes sense in light of Krishna's role as Govinda, the cowherd, and it could be asserted that this scripture represents an early depiction of a motif from the Krishna myth. Concerning these buff bovines, Singh remarks, "Cows are identified with sun rays in the *Rg Veda*, and the solar deity Krishna is their benefactor."[140] The "sons of the sky" in this scripture, also known as the "sons of Surya," the Asvins or Aswins, are considered, among many other things, to be the "physicians of the gods," who heal those who propitiate them.

In another instance of early Krishna mythology, the god Soma, a personification of the drink that bestowed immortality and invulnerability to Indra, is said to dispel the darkness and "light up the gloomy nights" (*krishna tamamsi janghanat*).[141] Further in the Rig Veda, at hymn 10.89, Indra himself, ostensibly the sun, is said to overcome the darkness: *krishna tamamsi tvishya jaghana.*[142] Hence, Soma and Indra overpower Krishna. In the later stories, Krishna is depicted as defeating Indra, and it is evident that the tension between the two is an ancient theme. Also, Krishna overthrowing Indra apparently represents the usurpation of one priesthood by another.

The "dark day" or "black" appellation evidently represents a few important concepts: 1. Krishna as the black and night sun, also personified as Hermes and Osiris, among other sun gods; 2. the blackening aspect of the sun; and 3. Krishna as depicted iconographically, as a black or Negroid god, an aboriginal

Dravidian deity. Evidence of the third development appears at RV 1.130:8, wherein Indra is depicted as "subjecting the black skin to Manu," the latter word interpreted as "Aryan man."[143] The term used for "black" is *krishnam*. As we have seen, Krishna ostensibly represents the charring or blackening aspect of Agni the sun. Dark skin may be said to be "sun-burnt" or *charred*. If this perception is true, it is understandable that people with tanned or "charred" skin (i.e., blacks) would worship the charred-skinned sun god as their own. Apparently, those black-skinned people who were culturally solar, as opposed to stelli-lunar, needed a dark-skinned version of the sun god; hence, they chose the semi-personified (though generally female) black or darkness of the Vedic texts and developed "him" as a sun god.

If, as in this Vedic verse, the "Krishnas" are the black men of India, it is possible that they originated the concept of Krishna as a god. Indeed, Roberston concurs that "a Krishna myth was probably ancient among the pre-Aryan Dravidians in India."[144] *The Dravidian Encyclopedia* confirms this aboriginal origin of Krishna:

> Krishna was an adaptation from an aboriginal deity; his life is an instance of the mingling of the Aryans and the Yadavas. After the ninth century A.D. the incarnations of Krishna were most popular in Indian regional languages. In earlier times, Krishna was treated as a God, the philosopher of the Bhagavad Gita. Now it was the pastoral and erotic aspect which attracted more worshippers. Krishna, meaning *dark*, has led to his being associated with the flute-playing Tamil god Mayon, the dark one, the herdsman who is found in the company of the milkmaids, which is what the cowherd of Mathura is associated with, in northern tradition.

> Tamil tradition speaks of Mayon (krishna) as the God of the pastoral tract, though Mayon was worshipped in the Sangam Age all over Tamil country. The pastoral aspect of the Krishna myth grew in prehistoric Tamil country. In fact, the earliest reference in Indian literature to Krishna's pranks with milkmaids is in the Sangam anthology. Krishna's dance with shepherdesses is also first mentioned in the Tamil epic Cilappatikaram....

> It is believed that the Abhiras, a pastoral tribe of the peninsula, brought this god to northern India when they settled there. First the Krishna cult became popular in Mathura, then spread rapidly to other parts of northern India.[145]

This entry explains why Krishna was said to have been born at Mathura; however, he is evidently a much older god who migrated from the south, where there is both a Krishna River and a Krishna province. In support of this southern, Dravidian origin

of Krishna is the fact that his alter ego Vishnu is called "the Hindu law-giver of the South."

The pastoral Tamil tribe of the Abhiras, the Dravidian Encyclopedia explains, became powerful rulers of the Deccan, or southern, peninsular part of India, during the early part of the common era, at which point, apparently, their "dark god," Mayon or Mal in the Tamil language, became popular as the Abhiras spread throughout India. As he was brought into Sanskrit-speaking areas, this dark god was called "Krishna," although it is also asserted that the process occurred the other way around and that Krishna is far older than Mayon.

Worldwide, gods tend to look like their human worshippers, e.g., in this case, black-skinned. Interestingly, all around the Mediterranean the Christian Madonna and Child appear in very old images and statuary as *black*, like their Egyptian predecessors: Examples may be found in the Cathedral at Moulins, the Chapel of the Virgin at Loretto, the Church of St. Stephen at Genoa, that of St. Francisco at Pisa and in many other places. There is "scarcely an old church in Italy where some remains of the black virgin and black child are not to be met with." In this regard, "the black god Chrishna was but a symbol of the Sun, and...the black virgin mother was nothing more than the virgin of the constellations, painted black..."[146]

In any event, from the numerous comparisons of Krishna to the sun found in Hindu scriptures, commentaries and images, it is clear that his nature and myth essentially represent the attributes and exploits of a solar hero. Krishna's solar nature is further evident in the fact that the root term "Kris" also means "sun." Indeed, "Krishna," "Chrishna" or "Chreeshna" in ancient Irish means "sun," as does "Budh." As Moor relates:

> General Vallancey, whose learned inquiries into the ancient literature of Ireland were considered by Sir William Jones as highly interesting, finds that Krishna, in Irish, is the Sun, as well as in Sanskrit. In his curious little book, "On the Primitive Inhabitants of Great Britain and Ireland"... is given an Irish ode to the Sun, which I should, untaught, have judged of Hindu origin: the opening especially, "Auspiciate my lays, O Sun! thou mighty Lord of the seven heavens; who swayest the universe through the immensity of space and matter;" and the close, "Thou are the only glorious and sovereign object of universal love, praise and adoration;" are in the language precisely of a Saura [sun worshipper], be he of Hindustan or Hibernia.[147]

Asiatic Researches editor Jones's exact words regarding Krishna are as follows:

> Colonel Vallancey, whose learned inquiries into the ancient literature of *Ireland* are highly interesting, assures me that

Crishna in *Irish* means the SUN; and we find APOLLO and SOL considered by the *Roman* poets as the same deity: I am inclined, indeed, to believe that not only CRISHNA or VISHNU, but even BRAHMA and SIVA, when united, and expressed by the mystical word OM, were designed by the first idolaters to represent the Solar fire; but PHOEBUS, or the *orb of the Sun* personified, is adored by the *Indians* as the god SURYA.[148]

An expert on ancient Ireland, as well as Indo-European culture in general, Col. Vallancey traces "some appellations for the sun to the Chaldaic and Sanscrit."[149] It is apparent that the ancient Irish worshipped the sun under the name of "Krishna," as well as "Buddha."

In a recent article entitled "Our Druid Cousins," Peter Ellis— "one of Europe's foremost experts on the Celts"—highlights the striking correspondences between the Indian and Celtic civilizations, including their priesthoods, i.e., the Vedic and the Druidic. The 19th century religious genius Rev. Robert Taylor called the Druids "priests of Apollo" and regarded them as "at first missionaries of India, of the order of Buddha."[150] It is surmised that the two cultures branched apart at least 5,000 years ago. A significant number of scholars have identified the Irish religion as "Buddhism," remarking to the effect that "it is impossible but to believe that Ireland was the centre from which a great deal of the religion of Budh developed."[151]

Like so many others, Krishna is not a human being who was turned into a god, but the sun turned into a human being. As Higgins remarks, "It is allowed that Cristna is the sun, and yet they talk of him as of a man. He is like Hercules, Bacchus, etc., always the sun..."[152] Since Krishna is a sun god or solar hero, it is therefore not surprising to find attached to his story common solar motifs, although these characteristics are not necessarily made obvious in the sacred texts or orthodox sources. Indeed, if they were spelled out clearly the current study would not be necessary. In any event, as has been and will continue to be demonstrated, a number of salient motifs, found in the Christ myth, have been associated with the Krishna and Buddha stories as well, for apparently good reason.

[1] himalayanacademy.com/books/weaver/i_three.htm
[2] Hopkins, 525.
[3] Budge, *EBD*, 16.
[4] Hopkins, 532.
[5] Hopkins, 533.
[6] Hopkins, 533.
[7] Hopkins, 538.
[8] Srivastava, 341.
[9] Srivastava, 22-23.

[10] Srivastava, 27.
[11] Srivastava, 29-30.
[12] Pandey, 8.
[13] www.newadvent.org/cathen/02018e.htm
[14] kashmirsentinel.com/maya1999/4.6.html
[15] Pandey, 307.
[16] Moor (Simpson), 353.
[17] Srivastava, xi-xiii.
[18] Srivastava, 179.
[19] Pandey, 41.
[20] Müller, *LOGR*, 84.
[21] Müller, *LOGR*, 255.
[22] Moor (Simpson), 377.
[23] Villanueva, 211fn.
[24] Pandey, 131-132.
[25] Srivastava, 62.
[26] Prasad, 111-113.
[27] Srivastava, 190.
[28] Roy, 42.
[29] Roy, 23.
[30] Roy, 3.
[31] Srivastava, 228.
[32] Pandey, 245.
[33] Jones, *AR*, III, 258.
[34] Jones, *AR*, III, 259.
[35] Olcott, 164.
[36] sanjayrath.tripod.com/Hindu/surya.htm
[37] Graves, R., 278fn.
[38] Muir, V, 343fn.
[39] Moor (Simpson), 379.
[40] Moor (Simpson), 6.
[41] Müller, *LOGR*, 13.
[42] Olcott, 166.
[43] Moor (Simpson), 9.
[44] Srivastava, 118, 191, 194, 207, 214, 240.
[45] www.vnn.org/editorials/ET9905/ET28-3969.html
[46] Moor (1810), 92.
[47] Müller, *LOGR*, 220-223.
[48] Roy, 14.
[49] Roy, 15.
[50] Muir, V, 37.
[51] Muir, V, 46.
[52] Muir, V, 47.
[53] Pandey, 113.
[54] Roberston, *CM*, 228.
[55] Jones, *AR*, I, 127.
[56] Moor (Simpson), 178.
[57] Olcott, 165.
[58] Srivastava, 111.

59 Cox, I, 50.
60 Moor (Simpson), 178.
61 Maurice, 29.
62 Srivastava, 196.
63 Müller, *LOGR*, 256-258.
64 Cox, II, 295.
65 Müller, *LOGR*, 252.
66 Pandey, 25.
67 Higgins, I, 136-137.
68 Iamblichos, 254.
69 Pandey, 118.
70 Moor (Simpson), 102-103.
71 Moor (Simpson), 203.
72 Maurice, I, 125.
73 Volney, ch. XXII.
74 Srivastava, 41fn.
75 Srivastava, 43-44.
76 Pandey, 16.
77 Srivastava, 214.
78 Müller, *LOGR*, 253.
79 Moor (1810), 16.
80 Cox, II, 104-105.
81 Olcott, 60.
82 Singh, 198.
83 Pandey, 17.
84 Srivastava, 86-88.
85 Pandey, 135.
86 Dupuis, 284-285.
87 Srivastava, 93.
88 Pandey, 18.
89 Srivastava, 192.
90 Srivastava, 209.
91 Srivastava, 211.
92 Pandey, 19.
93 Jones, *AR*, III, 273.
94 Srivastava, 188.
95 Moor (1810), 93.
96 Cox, II, 107.
97 Moor (1810), 287.
98 Cox, II, 120.
99 Cox, II, 131.
100 Moor (1810), 33.
101 Miller, 72.
102 Miller, 92.
103 Miller, 129.
104 Miller, 100.
105 Jones, *AR*, III, 290.
106 www.theosociety.org/pasadena/etgloss/q-rec.htm
107 Moor (1810), 198.

[108] Moor (1810), 446.
[109] Moor (1810), 200-201.
[110] Moor (Simpson), 128.
[111] Cox, I, 425.
[112] Jackson, *CBC*, 162.
[113] Jones, *AR*, III, 408.
[114] Moor (Simpson), 187.
[115] Moor (Simpson), 134.
[116] Massey, *HJMC*, 106-107.
[117] sanskrit.gde.to/dict
[118] O'Flaherty, 179.
[119] Muir, V, 188.
[120] Muir, V, 235.
[121] Muir, V, 189.
[122] Muir, V, 189.
[123] O'Flaherty, 199.
[124] Muir, V, 212.
[125] Hari, 18, 19.
[126] Muir, V, 341fn.
[127] Cox, II, 192.
[128] Muir, V, 440, 442.
[129] Muir, V, 219.
[130] Cox, II, 132.
[131] Cox, II, 193.
[132] Drews, *CM*, 132fn.
[133] Drews, *CM*, 145.
[134] Drews, *CM*, 100.
[135] Drews, *CM*, 112-113.
[136] Robertson, *CM*, 246.
[137] Robertson, *CM*, 147.
[138] Robertson, *CM*, 147.
[139] Muir, V, 239.
[140] Singh, 184.
[141] Muir, V, 267.
[142] Muir, V, 97fn.
[143] Muir, V, 113.
[144] Robertson, *CM*, 132, 274.
[145] *DE*, 403-404.
[146] *ECD*, 54.
[147] Moor (1810), 280.
[148] Jones, *AR*, I, 225.
[149] Bonwick., *IDOIR*, 194.
[150] Taylor, *DP*, vii.
[151] Bonwick, *IDOIR*, 272-273.
[152] Higgins, II, 515.

Sun disc, Mohenjo-Daro
1st millennium BCE

Urus bull with solar
symbols, 3rd millennium
BCE, Harappa

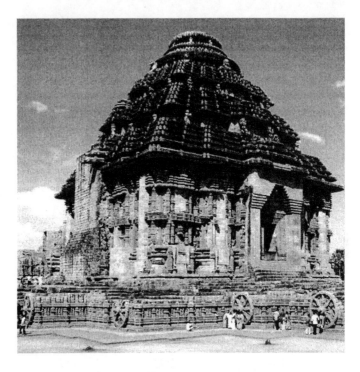

The magnificent Konarak temple to the sun,
13th century CE

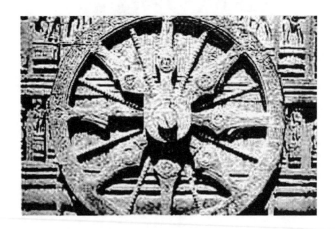

One of the chariot wheels of
the Konarak sun temple

Surya in chariot with four horses
driven by Aruna. (Moor)

Krishna driving a quadriga chariot
carrying Arjuna

Indian sun god Vishnu taking three steps
across the sky

Krishna as the sun surrounded by his Gopis.
(Moor)

Krishna Born of a Virgin?

Let our Christian readers bear in mind that the worship of the virgin and her child was common in the East, ages before the generally received account of Christ's appearance in the flesh...

Existence of Christ Disproved

Crishna was born of a chaste virgin, called *Devaki*, who, on account of her purity, was selected to become the *"mother of God."*

Doane, *Bible Myths and Their Parallels in Other Religions*

A recurring theme in ancient religion revolves around the manner of the sun god's birth, as well as the chastity of his mother. In numerous instances the sun god has been perceived as being born of the inviolable dawn, the virgin moon or earth, or the constellation of Virgo. The virgin status of the mothers of pre-Christian gods and godmen has been asserted for centuries by many scholars of mythology and ancient religion. Nevertheless, because of the motif's similarity to a major Christian tenet, it is claimed that these Pagan mothers were *not* virgins, for a variety of reasons, including their marital status, number of children and the manner of impregnation. However, the immaculacy of the ancient goddesses or mothers of gods remains, regardless of the manner of impregnation, because the fathers, like that of Jesus, are gods themselves, as opposed to mortals who physically penetrate the mothers. Also, the mothers are not "real people" but goddesses themselves, who therefore do not possess genitalia. Hence, despite being a mother, the goddess retains her virginity. In fact, the Virgin is one face of the Triple Goddess of ancient times, comprising the Maiden, Mother and Crone:

> The more general archetype was often seen in mythology as threefold; thus, for example, Aphrodite was seen as Aphrodite the Virgin, Aphrodite the Wife, and Aphrodite the Whore. A similar triplicity is found in the figure of Isis as Sister, Wife and Widow of Osiris.[1]

In Babylon more than 3,000 years ago the constellation of Virgo the Virgin was identified as the "Great Mother," constituting a significant example of a virgin mother preceding the Christian era by at least a millennium. Regarding the Great Mother Goddess, called by numerous names including Sophia, Ishtar and Isis, whose cult extended all over the Mediterranean and beyond, Legge observes:

> Her most prominent characteristics show her to be a personification of the Earth, the mother of all living, ever bringing forth and ever a virgin...[2]

In *The Once and Future Goddess*, Gadon remarks:

> Many goddesses were called virgin but this did not mean that chastity was considered a virtue in the pagan world. Some, like "Venus, Ishtar, Astarte, and Anath, the love goddesses of the Near East and classical mythology, are entitled virgin despite their lovers, who die and rise again for them each year."[3]

Concerning the Great and Omnipresent Goddess of the ancient world, Rev. James relates:

> Among the Sumerian and Babylonians...she had been known as Inanna-Ishtar, while in Syria and Palestine she appeared as Asherah, Astarte...and Anat, corresponding to Hera, Aphrodite and Artemis of the Greeks, representing the three main aspects of womanhood as wife and mother, as lover and mistress, and as a chaste and beautiful virgin full of youthful charm and vigour, often confused one with the other.[4]

Like the Christian Mary, the Canaanite goddess Astarte, mentioned in the Old Testament, was the "Virgin of the Sea," as well as the "blessed Mother and Lady of the Waters."[5]

One famous example of the triple goddess is the Egyptian Isis, whose virgin status has been challenged because, according to one popular legend, she fecundated herself using the severed phallus of her husband, Osiris. However, in another tradition Isis was miraculously impregnated "by a flash of lightning or by the rays of the moon."[6] In *The Golden Bough*, Frazer tells yet another version in which Isis conceived Horus "while she fluttered in the form of a hawk over the corpse of her dead husband."[7] In this story, Horus is born before Osiris is rent into pieces; hence, Isis does not use the dead god's phallus to impregnate herself. Regarding Isis and her parturition, Frazer further says:

> The ritual of the nativity, as it appears to have been celebrated in Syria and Egypt, was remarkable. The celebrants retired into certain inner shrines, from which at midnight they issued with a loud cry, "The Virgin has brought forth! The light is waxing!" The Egyptians even represented the new-born sun by the image of an infant which on his birthday, the winter solstice, they brought forth and exhibited to his worshippers. No doubt the Virgin who thus conceived and bore a son on the twenty-fifth of December was the great Oriental goddess whom the Semites called the Heavenly Virgin or simply the Heavenly Goddess...[8]

As is proper for goddesses, Isis retained her virginity, maintaining her epithets of "Immaculate Virgin"[9] and the "uncontaminated goddess,"[10] regardless of her distinction as "Mother of God" and "Magna Mater" or Great Mother. The same motif exists within Christianity, in which the Virgin Mother is essentially impregnated by the "holy ghost" but nonetheless remains a virgin. Isis is, in reality, the *virgin* or new moon, receiving or *being impregnated by* the light of the sun. In the

mythos, the moon gives birth monthly and annually to the sun; consequently, although she remains a virgin, she is mother of many. Confirming Isis's rank as perpetual virgin, in *The Story of Religious Controversy* Joseph McCabe, a Catholic priest for many years, writes:

...Virginity in goddesses is a relative matter.

Whatever we make of the original myth...Isis seems to have been originally a virgin (or, perhaps, sexless) goddess, and in the later period of Egyptian religion she was again considered a virgin goddess, demanding very strict abstinence from her devotees. It is at this period, apparently, that the birthday of Horus was annually celebrated, about December 25th, in the temples. As both Macrobius and the Christian writer [of the "Paschal Chronicle"] say, a figure of Horus as a baby was laid in a manger, in a scenic reconstruction of a stable, and a statue of Isis was placed beside it. Horus was, in a sense, the Savior of mankind. He was their avenger against the powers of darkness; he was the light of the world. His birth-festival was a real Christmas before Christ.[11]

The *Chronicon Paschale*, or Paschal Chronicle, is a compilation finalized in the 7th century CE that seeks to establish a Christian chronology from "creation" to the year 628, focusing on the date of Easter. In establishing this date, the Christian authors naturally discussed astronomy/astrology, since such is the basis of the celebration of Easter, a pre-Christian festival founded upon the vernal equinox, or spring, when the "*sun* of God" is resurrected in full glory from his winter death. The vernal equinox during the current Age of Pisces commences on March 21st and lasts three days, after which the sun overcomes the darkness, and the days begin to become longer than the night. Hence, Easter is the resurrection of the *sun* of God.

As does ancient Latin authority Macrobius, the Paschal Chronicle recounts that the sun (Horus) was presented every year at the winter solstice, as a babe born in a manger. Concerning this Christian text, Dupuis relates that "the author of the Chronicle of Alexandria...expresses himself in the following words: 'The Egyptians have consecrated up to this day the child-birth of a virgin and the nativity of her son, who is exposed in a "crib" to the adoration of the people...'"[12] Another important source who cites the Chronicle and mentions Isis's virginity is James Bonwick in *Egyptian Belief and Modern Thought*:

In an ancient Christian work, called the "Chronicle of Alexandria," occurs the following: "Watch how Egypt has consecrated the childbirth of a virgin, and the birth of her son, who was exposed in a crib to the adoration of her people..."[13]

The anonymous author of *Christian Mythology Unveiled* ("CMU") cites the "most ancient chronicles of Alexandria," which "testify as follows":

> "To this day, Egypt has consecrated the pregnancy of a virgin, and the nativity of her son, whom they annually present in a cradle, to the adoration of the people; and when king Ptolemy, three hundred and fifty years before our Christian era, demanded of the priests the significance of this religious ceremony, they told him it was a mystery."[14]

CMU further states, "According to Eratosthenes [276-194 BCE], the celestial Virgin was supposed to be Isis, that is, the symbol of the returning year."[15]

Regarding Isis's baby, Count Volney remarks:

> It is the sun which, under the name of Horus, was born, like your [Christian] God, at the winter solstice, in the arms of the celestial virgin, and who passed a childhood of obscurity, indigence, and want, answering to the season of cold and frost.

Isis's virginity was clearly a tenet fervently held by her numerous ancient devotees. By Budge's assessment, Isis is not only the moon but also "the deity of the dawn,"[16] which would likewise make her "inviolable" and "eternal," i.e., a perpetual virgin.

The worship of the Virgin Isis was eventually transformed into that of the Virgin Mary:

> The worship of the Virgin as the Theotokos or Mother of God which was introduced into the Catholic Church about the time of the destruction of the Serapeum, enabled the devotees of Isis to continue unchecked their worship of the mother goddess by merely changing the name of the object of their adoration, and Prof. Drexler gives a long list of the statues of Isis which thereafter were used, sometimes with unaltered attributes, as those of the Virgin Mary.[17]

Like Aphrodite, Astarte, Cybele, Demeter, Hathor, Inanna, Ishtar and Isis, Mary is "both virgin and mother, and, like many of them, she gives birth to a half-human, half-divine child, who dies and is reborn."[18]

Concerning this usurpation, which simply constituted the changing of the goddess from one ethnicity to another, apologist Sir Weigall observes:

> ...while the story of the death and resurrection of Osiris may have influenced the thought of the earliest Christians in regard to the death and resurrection of our Lord, there can be no doubt that the myths of Isis had a direct bearing upon the elevation of Mary, the mother of Jesus, to her celestial position in the Roman Catholic theology... In her aspect as the mother of Horus, Isis was represented in tens of thousands of statuettes and paintings, holding the divine child in her arms; and when

Christianity triumphed these paintings and figures became those of the Madonna and Child without any break in continuity: no archaeologist, in fact, can now tell whether some of these objects represent the one or the other.[19]

Again, the tri-fold nature of the Goddess in general reflects, or is reflected in, the moon. In Greek mythology, the "triple moon" is represented by Selene; other goddesses also are lunar, such as Artemis, who was the "virgin" moon, and Hera, Zeus's wife and mother of several children. Despite being portrayed as having relations with Zeus, Hera remains a virgin, or, rather, becomes a "born-again virgin," by virtue of ritualistic bathing. As McLean says:

Hera's three facets link her to the three Seasons and the three phases of the Moon. In her earliest appearance in myth she is associated with the cow, showing her connection with fecundity and birth, especially associated by the Greeks with this animal. She renewed her virginity each year by bathing in the stream Canathos near Argos, a place especially sacred to her.[20]

Like Hera, Artemis too renewed her virginity annually by bathing nude in a "sacred fountain."[21] Even a promiscuous *male* god such as Zeus was both "Father" and "Eternal Virgin."[22]

Despite hair-splitting and denials, the virgin-mother motif is common enough in pre-Christian cultures to demonstrate its unoriginality and non-historicity in Christianity. In *Pagan and Christian Creeds*, Carpenter recites a long list of virgin mothers:

Zeus, Father of the gods, visited Semele...in the form of a thunderstorm; and she gave birth to the great saviour and deliverer Dionysus. Zeus, again, impregnated Danae in a shower of gold; and the child was Perseus... Devaki, the radiant Virgin of the Hindu mythology, became the wife of the god Vishnu and bore Krishna, the beloved hero and prototype of Christ. With regard to Buddha, St. Jerome says "It is handed down among the Gymnosophists of India that Buddha, the founder of their system, was brought forth by a Virgin from her side." The Egyptian Isis, with the child Horus on her knee, was honored centuries before the Christian era, and worshipped under the names of "Our Lady," "Queen of Heaven," "Star of the Sea," "Mother of God," and so forth. Before her, Neith, the Virgin of the World, whose figure bends from the sky over the earthly plains and the children of men, was acclaimed as mother of the great god Osiris. The saviour Mithra, too, was born of a Virgin, as we have had occasion to notice before; and on Mithraist monuments the mother suckling her child is not an uncommon figure.

The old Teutonic goddess Hertha (the Earth) was a Virgin, but was impregnated by the heavenly Spirit (the Sky); and her image with a child in her arms was to be seen in the sacred groves of Germany. The Scandinavian Frigga, in much the same way, being caught in the embraces of Odin, the All-father, conceived

and bore a son, the blessed Balder, healer and saviour of mankind. Quetzalcoatl, the (crucified) saviour of the Aztecs, was the son of Chimalman, the Virgin Queen of Heaven. Even the Chinese had a mother-goddess and virgin with child in her arms; and the ancient Etruscans the same...[23]

Carpenter also mentions the black virgin mothers found all over the Mediterranean and especially in Italian churches, representing both Isis and Mary, having been refigured or "baptized anew" as the "Jewish" Mother of God.

The pre-Christian virgin-birth motif was admitted early in the Christian era by Church fathers such as Justin Martyr (c. 153 CE) and Tertullian (fl. 197). In his *First Apology*, Justin remarks:

And when we say also that the Word, who is the first-born of God, was produced without sexual union, and that He, Jesus Christ, our Teacher, was crucified and died, and rose again, and ascended into heaven, we propounded nothing different from what you believe regarding those whom you esteem sons of Jupiter.

He further states:

As to his being born of a virgin, you have your Perseus to balance that.

In *Dialogue with Trypho the Jew*, Martyr invokes the old "devil got there first" argument:

And when I hear, Trypho, that Perseus was begotten of a virgin, I understand that the deceiving serpent counterfeited also this.

In the third century, in response to the Platonist Celsus's mocking of Christ's virgin birth, Origen (*Contra Celsus*, I, xxxvii) responded by naming the virgin births in Pagan myths, specifically to underscore the precedence of the concept.[24]

In their attempts at fending off warranted criticism, Christian apologists were forced to admit against interest, such as Justin discussing the virgin birth of Perseus and other correspondences to the pre-Christian "sons of Jupiter" or "sons of Jove," including their crucifixion, resurrection and ascension. The apologists nevertheless resorted to the most awful sophistry, such as "the devil did it," and foolish ad hominems, such as that Celsus "wrote more like a buffoon than a philosopher." In reality, Celsus's brilliance shines through even today with his astonishingly modern critique of Christianity.

It should also be noted that "Jove" is essentially the same as "Jehovah" or "Jahveh"; thus, Jesus would be yet another of these "sons of Jove." The Jove-Jahveh connection is validated by the existence of a "temple of Jove" or Jupiter, without any image, atop mysterious Mt. Carmel in Israel.[25] Indeed, Yahweh and Jupiter

were identified with each other by Hellenized Jews and Pagans alike, as previously demonstrated.

The theme of the virgin-born god is not only abundant in the Levant, the specific area in which the Christ myth began to be formulated, but can also be found in the Americas, including in the story of Quetzalcoatl, as well as in Brazil, among the Manicacas.[26] As demonstrated, it can be further observed in India, where natives have revered for eons "Devi" or "Maha-Devi," the "One Great Goddess," in whose name temples have been built. Doane relates that a researcher named Gonzales found an Indian temple dedicated to the *Pariturae Virginis...*the Virgin about to bring forth."[27]

This "Devi" is apparently the same as Krishna's mother, Devaki, and, as was the case with these many ancient gods, Krishna has likewise been considered to have been "born of a virgin." Like Christ, Krishna's father was a god, Lord Vishnu, rather than the mortal Basudev, and his mother was Devaki/Aditi, the inviolable or virgin dawn: "According to the religion of the Hindoos, *Crishna...*was the *Son of God*, and the Holy Virgin Devaki."[28]

The ex-priest McCabe also reports Krishna's mother as a virgin, with Vishnu as his father:

> Thus one of the familiar religious emblems of India was the statue of the virgin mother (as the Hindus repute her) Devaki and her divine son Krishna, an incarnation of the great god Vishnu. Christian writers have held that this model was borrowed from Christianity, but...the Hindus had far earlier been in communication with Egypt and were more likely to borrow the model of Isis and Horus. One does not see why they should borrow any model. In nearly all religions with a divine mother and son a very popular image was that of the divine infant at his mother's breast or in her arms.[29]

None of these writers originated this contention, as, moving back in time, we find reference to Devaki's chastity in the writings of the esteemed Christian authority Sir William Jones from the 18th century:

> Sir William Jones says:
>
> "The Indian incarnate God Chrishna, the Hindoos believe, had a virgin mother of the royal race, who was sought to be destroyed in his infancy about nine hundred years before Christ. It appears that he passed his life in working miracles, and preaching, and was so humble as to wash his friends' feet; at length, dying, but rising from the dead, he ascended into heaven in the presence of a multitude."[30]

Regarding Krishna and Jones, CMU, who wrote around 1840, possibly 1842, states:

> It has been admitted by most of the learned that the Shastras and Vedas, or scriptures of the Hindoos, were in existence 1400

years before the alleged time of Moses... Sir William Jones, of
pious and orthodox memory, confesses that, "the name of
Chrishna, and the general outline of his story, *was long anterior
to the birth of our Saviour, and, to the time of Homer, we know
very certainly*. I am persuaded also (continues he) that a
connection existed between the old idolatrous nations of Egypt,
India, Greece, and Italy, *long before the time of Moses*. In the
Sanscrit Dictionary, compiled more than two thousand years
ago, we have the whole story of the incarnate Deity, BORN OF A
VIRGIN, and miraculously escaping in his infancy from the
reigning tyrant of his country." This tyrant, alarmed at some
prophecy, sought the infant's life; and, to make sure work, he
ordered all the male children under two years of age to be put to
death. Here is the true origin of the horrid story about Herod, of
which no Greek or Roman historian says a single word. That the
Christian story was taken from the Indian allegory, is traceable
in every circumstance—the reputed father of Chrisna was a
carpenter—a new star appeared at the child's birth—he was laid
in a manger—(celestial)—he underwent many incarnations to
redeem the world from sin and mental darkness, (ignorance and
winter) and was, therefore, called *Saviour*—he was put to death
between two thieves—he arose from the dead, and returned to
his heavenly seat in Vaicontha.

In this paragraph is a significant portion of disputed
information found in Kersey Graves's *The World's Sixteen
Crucified Saviors*: To wit, Krishna's virgin birth, his father as a
carpenter, and his death between two thieves. Yet, CMU's book
was written decades *before* Graves (1875), which means that
Graves may be absolved from the illegitimate charges of
fabrication slung his way for the past century and a half.

Concerning Sir Jones's quote in specific, which contains the
claim that Krishna was born of a virgin, CMU does not cite where
it can be found in the former's voluminous works. Nevertheless,
we know that the first part of the quote attributed to Jones by
CMU is accurate, since, in *Asiatic Researches*, vol. 1, p. 233,
published in *1788*, Jones says:

> One singular fact, however, must not be suffered to pass
> unnoticed. That the name of CRISHNA, and the general outline of
> his story, were long anterior to the birth of our Saviour, and
> probably to the time of HOMER we know very certainly.[31]

Jones also made the remarks concerning Egypt, India and
Moses, etc., in vol. 1, p. 232 of *AR*. However, this statement
appears on the page *preceding* the comment regarding Krishna
and the "general outline of his story," although CMU places it
after the first part. The latter part of Jones's quote can be found
on p. 223 of the same volume, where it says, "...in the principal
Sanscrit dictionary, compiled about two thousand years ago,"

followed by completely different and irrelevant text. The alternative spelling of "Sanscrit" and the language "compiled," et seq., indicate that the quote in question did originate with Jones. The part about the Krishna's mother being a virgin, however, is not in this text.

Adding to the intrigue, in his *Syntagma*, written in 1828 from an English jail where he was being held for "blasphemy," Rev. Robert Taylor quotes Jones's vol. 1, p. 259, as follows:

> "[Krishna] was born from the left intercostals rib of a Virgin, of the royal line of Devaci, and after his manifestation on earth, returned again to his heavenly seat in Vaicontha."[32]

Taylor also quotes this volume in *The Diegesis* (1829), likewise citing the pertinent information as located on p. 259.[33]

Graves too relates the latter part of the same Jones quote cited by CMU, except that Graves's citation is longer:

> In the Sanscrit dictionary, compiled more than two thousand years ago, we have the whole history of the incarnate deity (Chrishna), born of a virgin, and miraculously escaping in his infancy from the reigning tyrant of his country (Cansa). He passed a life of the most extraordinary and incomprehensible devotion. His birth was concealed from the tyrant Cansa, to whom it had been predicted that one born at that time, and in that family, would destroy him"; i.e., destroy his power. (Asiat. Res. vol. i. p. 273).[34]

Taylor quotes this same passage, in a shorter version, lacking Graves's parenthetical comments, as well as the last two sentences. Hence, Graves's quote is *not* from Taylor, who also cites the source for this part of the quote as *AR*, 1, p. 273. Nor is Graves's quote from CMU, which is a briefer account. Nor did CMU use Taylor, evident from the fact that CMU's quote is longer than Taylor's and that CMU uses the small-caps style peculiar to Jones: "BORN OF A VIRGIN." Thus, we possess three independent attestations for this quote from Jones.

The mystery of the diverse quotes begins to unravel when Taylor finishes his citation from *Asiatic Researches* by stating:

> The above extracts are taken literally from the 1st volume of the Asiatic Researches, chapter 9th, on the Gods of Greece, Italy, and India, written in 1784, and since revised by the president, Sir William Jones.[35]

Hence, we discover that Jones's text had been changed, expurgated in fact, four years after the original volume was published in *1784*. Regarding Jones, Taylor further says:

> I have thought it supremely important to present the text of this great author, and leave the reader to draw his own conclusions. Higher authority could not be quoted.... The unquestionable

orthodoxy of Sir William Jones must, therefore, give to
admissions surrendered by him, the utmost degree of cogency;
while his unequalled and unrivalled learning stands as a tower of
strength...[36]

Considering both Jones's exalted status as a Christian
authority and Britain's blasphemy laws, of which Taylor was an
unfortunate victim, it is reasonable to conclude that, under
pressure, Jones removed numerous offensive passages in not only
his own writings but also those of others in the important and
influential *Asiatic Researches* series. It is evident that the
pertinent quote including "BORN OF A VIRGIN" was original to the
first edition of *Asiatic Researches*, vol. 1, but that Jones gutted
this publication, removing remarks obviously injurious to
Christianity, as well as modifying the bit of original language left
with the words *"principal Sanscrit dictionary"* and *"about* two
thousand..."

The precedent of mutilating books of this nature is well
established. The edition of volume 1 as we have it today was
published in 1788, four years after the publication of the original,
representing time enough to rework the entire book. The
publisher's note in the 1788 edition was composed in 1784 and
apparently formerly appended to the original, since it is somewhat
unusual to write a foreword more than four years in advance of
publication. Furthermore, the original publication was done by
subscription, no doubt circulated among the wealthy elite, which
would mean that there were only dozens or perhaps hundreds of
copies in print, as opposed to the thousands and millions
published today. These relatively few copies could be closely
held—and destroyed—by these elite members of society, which
included clergy and theologians. Reverend Taylor was one of these
clergymen of privilege, although he could not have been an
original subscriber to *Asiatic Researches*, since he was born in
1784. Yet, he certainly had access to one or more libraries,
including private clergy collections. It is likely that Taylor's
discovery of Jones's works precipitated or inflamed the
clergyman's zeal to expose the truth. In cases where texts have
been mutilated or destroyed, we must be grateful that such
undaunted researchers have recorded what might have been lost
forever.

Interestingly, there is another curious development in vol. 6 of
Asiatic Researches, wherein three pages regarding a Persian-
Buddhist-Abraham connection are compressed into one, reading
"467 to 469" at the top of the page, leaving one to wonder what
the original pages contained.

In any event, we can find other hints as to the original
contents of volume 1, including that, whereas the entry for

Krishna in the 1788 edition is only three pages long, with information scattered here and there throughout the rest of the volume, the original apparently contained some 15 or more pages on the Indian god. For example, in relating that Krishna was "associated or identified with Vishnu the Preserving god or Saviour," Doane refers the reader to "Asiatic Researches, vol. i. pp. 259-275."[37] Citing *Asiatic Researches* again, Doane says, "*Crishna*, the Hindoo virgin-born Saviour, was born in a *cave*, fostered by an honest *herdsman*, and, it is said, placed in a *sheepfold* shortly after his birth,"[38] a quote that indicates he used the original volume 1. Higgins cites vol. 1 of *Asiatic Researches*, p. 260, as the source of his assertion that, "All the Avatars or incarnations of Vishnu are painted with Ethiopian or Parthian coronets."[39] In the 1788 edition, this comment is on p. 223. The information regarding Krishna in the later edition is sanitized and practically useless. Again, we have independent confirmations that the original vol. 1 of *Asiatic Researches* was substantially different than the subsequent edition, and that it contained several pages with Krishna-Christ correspondences unfavorable to Christianity's claim to originality.

Yet, the mystery does not end there, as recounted by a close observer of the affair:

> No doubt the mystification played, in the last century at Calcutta, by the Brahmins upon Colonel Wilford and Sir William Jones was a cruel one. But it was well deserved, and no one was more to be blamed in that affair than the Missionaries and Colonel Wilford themselves. The former, on the testimony of Sir William Jones himself (see Asiat. Res., Vol. I., p. 272), were silly enough to maintain that "the Hindus were even now almost Christians, because their Brahma, Vishnu and Mahesa were no other than the Christian Trinity." It was a good lesson. It made the Oriental scholars doubly cautious; but perchance it has also made some of them too shy, and caused, in its reaction, the pendulum of foregone conclusions to swing too much the other way. For "that first supply on the Brahmanical market," made for Colonel Wilford, has now created an evident necessity and desire in the Orientalists to declare nearly every archaic Sanskrit manuscript so modern as to give to the missionaries full justification for availing themselves of the opportunity. That they do so and to the full extent of their mental powers, is shown by the absurd attempts of late to prove that the whole Puranic story of Chrishna was *plagiarized by the Brahmins from the Bible!* But the facts cited by the Oxford Professor [Müller] in his Lectures on the "*Science of Religion,*" concerning the now famous interpolations, for the benefit, and later the sorrow, of Col. Wilford, do not at all interfere with the conclusions to which one...must unavoidably come. For, if the results show that neither the *New* nor even the *Old* Testament borrowed anything

from the more ancient religion of the Brahmans and Buddhists, it does not follow that the Jews have not borrowed all they knew from the Chaldean records... As to the Chaldeans, they assuredly got their primitive learning from the Brahmans, for Rawlinson shows an undeniably Vedic influence in the early mythology of Babylon; and Col. Vans Kennedy has long since justly declared that Babylonia was, from her origin, the seat of Sanskrit and Brahman learning.[40]

Concerning this brouhaha, which has ostensibly caused enduring tumult, this same writer notes:

See Max Müller's "Introduction to the Science of Religion." Lecture *On False Analogies in comparative Theology*, pp. 288 and 296 *et seq.* This relates to the clever forgery (on leaves inserted in old Puranic MSS. [manuscripts]), in correct and archaic Sanskrit, of all that the Pundits of Col. Wilford had heard from him about Adam and Abraham, Noah and his three sons, etc., etc.

The implication is that important correspondences between the religions and mythologies of India and Judea were bogus, part of a prank played by Brahmans upon the luminaries of the Asiatic Researches Society. But why would such a hoax be "well deserved," unless the Brahman priests were attempting to impress that the Indians in fact possessed these stories or concepts in some form from their distant past? The writer also states that attempts to prove the Brahmans plagiarized the story of Krishna are "absurd."

Furthermore, the footnote suggests that the "hoax" was confined to Old Testament stories. Nevertheless, it is well known now that germane biblical stories are paralleled in older Sumero-Assyro-Babylonian texts and are not original to the Jewish bible in any case. Indeed, in addition to the more famous stories such as those of Adam and Eve, Noah, Moses, Samson and Jonah found in other cultures, is the very tale of the Creation itself.[41]

Although Müller is a formidable scholar, his essay on "False Analogies" serves merely as an ipse dixit and is less than conclusive. Page 288 cited above simply discusses the Indian backlash against the efforts following the British conquest of India to make the imposing Hindu religion derive from biblical tradition. Basically, Müller's screed addresses the work of the Asiatic Researches Society and the scandal surrounding Col. Wilford, whose enthusiasm caught him in a net:

The coyness of the Pandits yielded; the incessant demand created a supply; and for several years essay after essay appeared in the Asiatic Researches, with extracts from Sanskrit MSS., containing not only the names of Deukalion, Prometheus, and other heroes and deities of Greece, but likewise the names of

Adam and Eve, of Abraham and Sarah, and all the rest.... it was found that a clever forgery had been committed, that leaves had been inserted in ancient MSS., and that on these leaves the Pandits, urged by Lieutenant Wilford to disclose their ancient mysteries and traditions, had rendered in correct Sanskrit verse all that they had heard about Adam and Abraham from their inquisitive master.[42]

In *The Bible in India*, French scholar and Indianist Jacolliot indicated that he himself received the "Adima-Heva" (Adam-Eve) story from priests of Ceylon/Sri Lanka, his journeys taking place decades after those of the Jones-Wilford crew. Were members of the same priesthood playing the same joke upon Jacolliot? Jacolliot claimed his Indian Adam-Eve story came from the "Ramatsariar, texts and commentaries on the Vedas." Müller cut Jacolliot little slack in his condemnation of the French justice's assertions, remarking that the latter was "without any critical scruples" and claiming that Jacolliot was simply out to prove that Christianity was a "mere copy of the ancient religion of India..."[43] Jacolliot's credentials are impressive—he was appointed "President of the Court of Justice at Chandernagore"—and his claim that much of western culture emanated out of India has proved true over the past centuries since Europeans started investigating the subcontinent. Yet, according to Müller, "what M. Jacolliot calls a simple translation from Sanskrit is, as far as I can judge, a simple invention of some slightly mischievous Brahman, who, like the Pandits of Lieutenant Wilford, took advantage of the zeal and credulity of a French judge..."[44] It is difficult to believe that these two eminent members of western society, Jacolliot and Wilford, could be so easily fooled.

Moreover, Jacolliot's version of the Hindu scriptures could plausibly be considered an "Indian original" by the same standards that the Bible is a "Jewish original," since, despite assertions to the contrary, modern scholarship has *proved* repeatedly that the Bible is *not* a "Jewish original." This fact is the real issue at hand, regardless of a few pranks a couple of centuries ago. Also, Max Müller was not an impartial scholar but a fervent Christian who was responding to the Eastern reaction against Western scholars attempting to make everything originate with the Bible. Up until recently, in their efforts to fit everything into the puny biblical timeline Western scientists had to discount entire cultures whose antiquity was far greater than could be accounted for.

As further evidence that at least some of the comparative conclusions were appropriate, the names of Abraham and Sarah, for instance, may indeed be found in the god and goddess Brahma and Sarasvati. Despite whatever fraud was perpetrated

against Wilford and, possibly, Jacolliot, there is every reason to suppose that these and other biblical tales existed in India, even emanating from there, especially when one considers the fact that some 10,000 or more Indian texts have never been translated. In reality, the Brahman priesthood considered foreigners to be "Mlecchas," or outcasts and savages unworthy of knowing their mysteries, and thus held back much material, providing these missionaries and scholars with passages from *rejected* books.

Entering into this important debate is the erudite and pious Christian Rev. Dr. Lundy (1889), who makes the following eye-opening remarks:

> Just as the story of Krishna does not occur in the Vedas, so there is no account of Orpheus in the works of Homer or Hesiod. And yet, if we may believe so good an authority as Edward Moor, both the name of Krishna, and the general outline of his story, were long anterior to the birth of our Saviour, as very certain things, and probably extend to the time of Homer, nearly 900 years B.C., or more than a hundred years before Isaiah lived and prophesied; that same Edward Moor, who deprecates "the attempts at bending so many of the events of Krishna's life to tally with those, real or typical, of Jesus Christ;" and yet has nothing to say of such events as do bear a striking resemblance to our Lord's life. Krishna's childhood and absurd miracles may be, as some affirm with Sir Wm. Jones, interpolations from the Apocryphal Gospels into the original story; but the fact remains of the Eighth Incarnation of Vishnu in the Hindu religion and literature long before the Apocryphal or genuine Gospels were written.

> From that candid and cautious Bampton Lecturer of 1809, the Rev. J.B.S. Carwithen, also the author of an excellent history of the Church of England, I cite the following passages on this subject, viz.: "From some passages in the Puranas, which are thought to be of modern insertion, and especially from a similarity which has been discovered in the Bhagavat Purana, between the life of Krishna the Indian Apollo, and the life of Christ, a similarity which has caused a modern infidel to draw an impious parallel between them, it has been conjectured, not without some appearance of probability, that the Apocryphal Gospels, which abounded in the first ages of the Christian Church, might have found their way into India; and that the Hindus had engrafted the wildest part of them on the adventures of their own divinities. Any coincidence, therefore, which may be discovered between the Sanscrit records, and the Mosiacal and Evangelical histories, is more likely to proceed from a communication through this channel, than from ancient and universal tradition."

> "On this opinion (*sic*) it may be remarked that both the name of Krishna and the general outline of his story are long anterior to

the birth of our Saviour; and this we know, not on the presumed antiquity of the Hindu records alone. Both Arrian and Strabo assert that the God Krishna was worshipped at Mathura on the river Jumna, where he is worshipped to this day. But the emblems and attributes essential to this deity are also transplanted into the mythology of the west." (pp. 98-99.) Hence the similarity between Krishna and Apollo and Orpheus.[45]

The identity of the "modern infidel" is unclear, but it may have been either Dupuis or Volney. In any case, like Moor in the first paragraph, Rev. Carwithen in the last paragraph produces an almost verbatim quote from Jones in his declaration that "both the name of Krishna and the general outline of his story are long anterior to the birth of our Saviour." It has been stressed time after time that Krishna appeared at least by the time of Homer, some 900 years before the Christian era; also, as we have seen, germane aspects of his myth and doctrine exist in the Rig Veda. Even so, various Christian authorities deemed it expedient to denounce the less general outline, i.e., the details, as plagiarism by Brahman priests from Christian texts.

Rev. Lundy, while acknowledging the numerous important correspondences between Paganism and Christianity, and straining to establish the superiority of Christianity, does not agree with Jones that the Hindu books were interpolated from the Apocryphal Gospels; nor does he admit the opposite, i.e., that Christianity copied Paganism. While repeatedly claiming that the ancient religions were universal, Lundy nevertheless attempts to explain these circumstances as being coincidental and dependent on the Hindu and Jewish minds, the latter—as "chosen" in Lundy's estimation—being "informed by the One Great Mind and Heart of all, God in Christ, not as the God of the Jews only, but also of the Gentiles."[46]

In any event, the pious Lundy synopsizes the Krishna tale thus:

Krishna, then, is an incarnate god and a shepherd-god, long anterior to Christianity. He is exposed like Moses [and Jesus] to the fury of a tyrant; like Moses he lived among cattle and flocks, and their keepers; or like David he rises from a low condition among his father's sheep to be a king; or like David's Lord, he becomes the shepherd of his people, feeding them in a green pasture, and leading them forth besides the waters of comfort.[47]

Obviously, either these erudite and devout Christian authorities are utterly incorrect in what must have been difficult admissions as to the unoriginality of their Savior, or we possess in the story of Krishna a close parallel to that of Jesus, *centuries before the Christian era.*

Additionally, in his revision of *Asiatic Researches* Jones did not remove all the inferences of the virgin birth of Krishna. For instance, in his article "On Egypt and the Nile," which presents evidence "From the Ancient Books of the Hindus" of Indian knowledge about Egypt, Wilford, another pious Christian, first states that "Crishna was Vishnu himself" and next remarks:

> The Supreme Being, and the celestial emanations from him, are *niracara*, or *bodiless*, in which state they must be invisible to mortals; but when they are *pratyacsha*, or *obvious to sight*, they become *sacara*, or *embodied*, either in shapes different from that of any mortal, and expressive of the divine attributes, as Crishna revealed himself to Arjun, or in a human form, which Crishna usually bore; and in that mode of appearing, the deities are generally supposed to be born of woman, but without carnal intercourse.[48]

In this admission, while discussing Krishna's incarnation in human form, the good Colonel relates that a common motif for gods is to be "born of woman," *without carnal intercourse*. There is no reason to believe that this assertion was part of a hoax played upon Wilford, and it would be unfair to dismiss Wilford's entire body of work based on the purported "joke," since he was a diligent, thoughtful and knowledgeable researcher. In any case, the few important correspondences between Krishna and Christ that have been contested, such as the chastity of Krishna's mother, can be established independent of the *Asiatic Researches* resources.

As demonstrated, much of the world had its virgin births of gods and heroes; thus, discovering the motif in India—that ancient and vast repository of knowledge and religious concepts of all sorts—is not terribly surprising. Indeed, we have already addressed it in the discussion regarding the Indian sun god's birth, in which his mother, the dawn, was considered inviolable and chaste. Further evidence of this contention can be found in the epithet of Indian gods, *ayonija*, as related by Dr. Inman:

> In the Vedic Mythology, we may say generally, that the means of producing offspring are curiously numerous; for example, we find in Goldstücker's *Sanskrit and English Dictionary*...
>
> ...Under the word *Ayonija*...[appear] the following examples of individuals "not born from the *yoni*," viz.:..."*Draupadi*, who at a sacrifice of her father Drupada, arose out of the sacrificial ground." "*Sita*," who sprang into existence in the same manner as Draupadi." The same [*Ayonija*] is also an epithet of Vishnu or Krishna.[49]

As can be seen, *ayonija*, or "not born from the yoni" (vagina), is a theme so common that it warranted the creation of a term.

"Ayonija" indicates that there is a status problem with vaginal birth, which would likewise infer a prejudice or taboo against vaginal penetration or "deflowering." Moreover, it is probable that the creators of this mythology were aware that they were discussing *myths* and not "real people." Again, since these various goddesses are not "real people," despite being personifications, they do not possess genitalia in the first place. That Krishna was called *Ayonija* certainly implies that he was "born of a virgin."

The apparently acceptable language concerning Krishna and other deities is that they are "generally supposed to be born of woman, without carnal intercourse." It could be claimed, however, that this lack of "carnal intercourse" refers to an immaculate conception "only," in which the woman is not necessarily a "virgin," but, during this particular conception, did not have anyone impregnate her via her yoni (if such mythical characters possessed yonis in the first place). However, in the case of gods the usual idea behind the birth "without carnal intercourse" is that the female had never "known man" and was pure and chaste—i.e., she was a *virgin*. It is clear from these various statements that Krishna was deemed to have been conceived immaculately *and* that his mother was "chaste," despite having previously given birth.

Devaki, Mary and the Seven

The most common, orthodox claim regarding Krishna is that he was conceived through "miraculous conception," which is not necessarily the same thing as "virgin birth," an assertion made because his mother, Devaki, was married and had produced seven children, with Krishna as the eighth. Nevertheless, in spite of her marital status it was not her mortal husband but the Supreme Being who impregnated Devaki. Thus, even though she bore these seven others, Devaki remained chaste, i.e., a "virgin": "Like Mary, the mother of Jesus, Devaki is called the '*Virgin Mother*,' although she, as well as Mary, is said to have had other children."[50]

In fact, the same objection to Devaki's virgin status can be raised in regard to Jesus's mother, Mary. "Coincidentally," it was claimed of Mary—*who was also married*—that not only did she have other children, but also, like those of Devaki, they were *seven* in number. Indeed, as Christian apologist Sir Weigall relates, legend holds that Joseph and Mary had "at least seven children." That Mary bore other children is indicated in Christian scriptures themselves. For example, Matthew 12:46 refers to Jesus's "brothers":

While he [Jesus] was still speaking to the people, behold, his mother and his brothers stood outside, asking to speak with him.

And at Mt. 13:55-56, the writer asks:

Is not this the carpenter's son? Is not his mother called Mary? And are not his brothers James and Joseph and Simon and Judas? And are not all his sisters with us?

At Mark 3:32, the crowd calls to Jesus, saying, "Your mother and your brothers are outside, asking of you." The RSV bible notes, "Other early authorities add *and your sisters*" to this sentence. But, if they are to be considered Mary's children, it would mean that, despite her status as "Perpetual Virgin," Mary had engaged in intercourse, unless all of these brothers (and sisters) were, like Jesus, "born of a virgin," thus making Christ's virgin birth rather mundane! There are few choices regarding these scriptures mentioning Jesus's "brothers" and/or "sisters." Early apologists forged texts to make it seem as if Joseph had been previously married, such that these children were his and not Mary's. Another excuse is to admit that Jesus's followers were called "brothers (and sisters) of the Lord," which would serve to acknowledge that a church organization was already established very early in his ministry. Such an assertion would also mean that the apostle James, the "brother of the Lord," was not necessarily a blood relative and could not serve as "proof" that Jesus ever existed.

Apologists claiming Mary's "perpetual virginity" must also contend with the passage at Matthew 1:18, which refers to Mary being pregnant before she and Joseph "came together." The phrase "came together" is translated from the Greek verb "synerchomai," which means not only "to assemble" but also, per Strong's Concordance, "conjugal cohabitation," implying Mary and Joseph were intimate after Jesus was born. Naturally, the Catholic Encyclopedia ("Virgin Mary") tries to rationalize this phrase by saying it meant "before they lived in the same house." Another passage, Matthew 1:25, relates that Joseph "knew her not till she had brought forth her first-born son," referring to Jesus. "To know" biblically generally means to have carnal intercourse, so this passage likewise indicates that Mary and Joseph consummated their marriage after Jesus was born. Moreover, "*her* firstborn son" indicates that there were others born to Mary herself, i.e., not just Joseph's children. Again, CE attempts to explain away this scripture by asserting that it does not say that Mary and Joseph were actually intimate, just that there was a time when they were not. The "firstborn son," CE

avers, was a "legal name, so that its occurrence in the Gospel cannot astonish us."[51]

Church fathers Epiphanius and Jerome dealt with the "opinion" that Mary "had ever borne other children" simply by calling it "heresy,"[52] while the CE merely pronounced Jesus's siblings "cousins," even though the Greek word "adelphoi" does not mean "cousins." Taking such liberty with texts and traditions, one could make the same argument regarding Devaki: To wit, her "sons" were not really "sons" but nephews, and Krishna's "brothers" were really his "cousins."

In any case, Mary herself was believed in early Christian times to have been born of a virgin, which, if taken literally, would represent a virgin birth prior to Christ, thus again rendering him unoriginal and mundane. One source of Mary's immaculate conception was John of Damascus, who asserted that Mary's parents were "filled and purified by the Holy Ghost, and freed from sexual concupiscence." The Catholic Encyclopedia ("Immaculate Conception") says, "even the human element" of Mary's origin, "the material of which she was formed, was pure and holy."[53] In other words, Roman Catholic doctrine dictates that, like Jesus, "the Blessed Virgin Mary" was "conceived without sin."[54]

In order to maintain the "uniqueness" of Christ's virgin birth this contention regarding Mary is not taken seriously. What it proves, however, is that fabulous Christian motifs are based on pious *speculation*, not historical fact, speculation by the faithful that changes from era to era, depending on the need.

Despite the tradition that Mary, Mother of Jesus, was married and was the mother of seven children following Jesus, she is nevertheless considered the "ever-Virgin Mary." Regardless of how many children she bore, Devaki is, like Mary, the "Mother of God" yet "undefiled," styled the "eternal virgin" or *Kanyabava*.

The resemblances between Mary and Devaki do not end there, as even the name "Mary" or "Mari" is an epithet for the Indian Goddess. Rev. Simpson relates that in Southern India the goddess Kali is invoked to cure smallpox as "Mari," as well as "Mariamman, Mariammei, Mariattal."[55] Krishna's mother, Devaki, too was known as "Mari." Adding to this fact, in discussing apologists' denials of the correspondences between Paganism and Christianity Drews observes:

> ...on the theological side we find men contesting the obvious affinity of the Easter-story of the gospels with the myths and ceremonies of the Attis-Adonis-Osiris religion, saying that "there is no such thing" as a burial and resurrection in the myths of Attis and Adonis, and that the difference between the death of Jesus and that of his Asiatic kindred can only be explained by

the "hard fact"—the famous theological bed-rock—of the death on the cross. [German theologian] Weiss is unable to recognise in Mary Magdalen and the other Marys at the cross and the grave of the Saviour the Indian, Asiatic, and Egyptian mother of the gods, the Maia, Mariamma, or Maritala, as the mother of Krishna is called, the Mariana of Mariandynium (Bithynia), Mandane, the mother of the "Messiah" Cyrus (*Isaiah* 45:1), the "great mother" of Pessinut, the sorrowing Semiramis, Miriam, Merris, Myrrha, Maira (Maera), and Maia, the "beloved" of her son.[56]

Fortunately, apologist Weigall was not in such denial, and likewise related that Krishna's mother was called "Maritala":

...so many gods and semi-divine heroes have mothers whose names are variations of "Mary": Adonis, son of Myrrha; Hermes, the Greek Logos, son of Maia; Cyrus, the son of Mariana or Mandane; Moses, the son of Miriam; Joshua, according to the Chronicle of Tabarí, the son of Miriam; Buddha, the son of Maya; Krishna, the son of Maritala; and so on, until one begins to think that the name of our Lord's mother may have been forgotten and a stock name substituted.[57]

Weigall further notes that Jesus's virgin birth is not referred to in the earliest Christian texts, or in the Gospels of Mark and John or the Book of Revelation. Weigall then states that the addition of the virgin-mother motif in Christianity is understandable, because "tales of the births of pagan gods and heroes from the union of a deity with a mortal maiden are common."[58]

The Virgin-Born Savior "Prophecy"

Another apology for the pre-Christian virgin-birth motif is that the virgin status of the Divine Redeemer's mother was "prophesied" long before the common era, a claim that generally admits the virgin birth to have been commonly applied to numerous gods, godmen and heroes. This apology could be used in regard to Krishna as well: In other words, the prophecy was fulfilled in *him*, long before Christ's purported advent. Indeed, pious Hindus believe as much, and Hindu texts expound upon the subject in like manner. For example, prophecies regarding the Indian Redeemer, Avatar and Incarnation of God may be found in the texts the Vedangas, in which it is said that the pure and undefiled *virgin* will "bring forth" the "ray of the divine Splendor." The Pourourava speaks of "the divine Paramatma (soul of the universe)" being "born of a virgin who shall be fecundated by the thought of Vischnou." Moreover, the Vedanta relates that during the "early part" of the Kali-Yuga, which began five thousand years ago, "shall be born the son of the Virgin," i.c., Krishna.[59]

To reiterate, these scriptures have been purported to be "prophecies"; in reality, they lay down a *blueprint* for a myth about a savior who is to be born of a *virgin*. It appears that the priests of Krishna were well aware of these "prophecies" when they created his myth and that they included in it the chaste state of his mother. By the same method, Christ was created out of these ancient Pagan concepts, as well as the Jewish scriptures, which the priests twisted in order to find "prophecies" of his incarnation. That the motif of the godman, avatar or messiah being born of a virgin is *pre-Christian* is *proved* by the deliberate mistranslation of Isaiah 7:14 in the Septuagint or Greek Old Testament: "Therefore the Lord himself shall give you a sign; Behold, a virgin shall conceive, and bear a son, and shall call his name Immanuel." In the original Hebrew, this scripture—again, representing not a "prophecy" but a blueprint used by the creators of the Christ myth—refers to an *almah*, which is a young maiden but not necessarily a virgin. In the Greek, the word has been translated as *parthenos*, which refers exclusively to a virgin. Moreover, the context is not in the future but designates what has already happened, to Isaiah's wife.[60] In any event, the "tradition of the Virgin-Mother, brought from India, is common to the whole East—in Burma, China, and Japan—the Apostles have but recovered and applied it to their doctrine."[61]

In addition to the numerous gods and heroes already named, the list of various pre-Christian "mortals" who were purported to have been born of a virgin includes the following:

- Egyptian queen Hetshepsut, whose father was alleged to be the sun god Amon
- Pharaoh Amenophis III, as portrayed on the Theban temple of Amon
- Persian prophet Zoroaster, whose future incarnation will also be virgin-born
- Melchizedek, biblical High Priest and King of Salem
- Lao-kiun, "Chinese philosopher and teacher, born in 604 B.C."[62]
- Persian king Cyrus, thought by some Jews to be the Messiah
- Plato, "the divine" and "son of Apollo," according to Greek philosopher Speusippus (4th cent. BCE)
- Julius Caesar (100-44 BCE)
- Apollonius of Tyana (1st cent. BCE), Greek sage
- Taliesin, Merlin and Llew Llaw of the British Isles[63]

King Cyrus's actual name is "Koresh," which means "sun" and which is not much different than Krishna. Adding to these examples, the "legend of twin brothers born magically of a virgin...is repeated in various forms in Celtic mythology and folk tradition."[64] The Zoroastrian virgin birth legend extends into the future, as the coming Savior or Redeemer is likewise to be born of a virgin, a "prophecy" that existed well before the Christian era, again demonstrating that the concept of a virgin birth was commonplace and unexceptional.

Discussing the tale of Fohi, "the first historical Chinese emperor," Lundy says:

> Here, then, we have the tradition of a Chinese virgin-born King and deliverer 2,952 years B.C., as well as the traditional prophecy of Confucius respecting his advent in the West.[65]

Hence, by the Chinese chronology the virgin-born king motif precedes the Christian era by nearly 3,000 years. Moreover, the prophecy concerning the virgin-born king's "advent in the West" refers to Buddha, rather than Christ, as has been assumed.

Regarding this popular theme, Dr. Inman observes that "the feminine idea of the Creator has, from time immemorial, been associated, in one form or another, with that of a lovely virgin holding a child in her arms."[66] Indeed, the wildly popular image of the Egyptian Mother Isis suckling the Child Horus dates back "at least six thousand years."[67] Like these many others, Krishna, the sun god, is pictured in the arms of his mother, Devaki, one of the numerous versions of the "Immaculate Lady." That the virgin-birth motif was common in the pre-Christian world is a fact, as is that it has been applied to some of the most popular gods, godmen and heroes, including Krishna, the "general outline" of whose story existed "long anterior to the birth of our Saviour."

The Virgin Goddess

The truth is that the ancient world abounded with "prophecies," tales, fables and myths of miraculous conceptions and births, long before the Christian era. The virgin-goddess theme is prevalent in the ancient world because it is astrotheological, symbolizing not only the moon but also the earth, Venus, Virgo and the dawn. As the Roman poet Virgil described or "prophesied" in his *Eclogues* in 37 BCE, the "return of the virgin," i.e., Virgo, would, along with other astrotheological events, bring about "a new breed of men sent down from heaven," as well as the birth of a boy "in whom...the golden race [shall] arise."[68] This virgin-born "golden boy" is in actuality the sun. In *Christ Lore,* Hackwood describes the astrotheological development of this theme:

The Virgin Mary is called not only the Mother of God, but the Queen of Heaven. This connects her directly with *astronomic lore.* The ornamentation of many continental churches often includes a representation of the Sun and Moon "in conjunction," the Moon being therein emblematical of the Virgin and Child....

As the Moon...is the symbol of Mary, Queen of Heaven, so also a bright Star sometimes symbolizes him whose star was seen over Jerusalem by the Wise Men from the East.[69]

Concerning the astrotheological nature of the gospel story, including the virgin birth/immaculate conception, the famous Christian theologian and saint Albertus Magnus, or Albert the Great, (1193?-1280) admitted:

"We know that the sign of the celestial Virgin did come to the horizon at the moment where we have fixed the birth of our Lord Jesus Christ. All the mysteries of the incarnation of our Saviour Christ; and all the circumstances of his marvellous life, from his conception to his ascension, are to be traced out in the constellations, and are figured in the stars."[70]

The knowledgeable elite were aware of what the Virgin truly represented, even if they attempted sophistically to explain its relationship to the life of "our Lord." The Judeo-Christian scriptures, considered "absurd and revolting, if taken literally," are "pregnant with truth as astronomical allegories," in reality symbolizing the sun, zodiac and seasons.[71] A more cynical researcher, such as the author of CMU, might suggest that the virgin-birth fiction has benefited the priesthood very nicely, as it could be used to cover up their sexual dalliances. Appending this observation, CMU notes:

In the ancient zodiacs of India and Egypt, there is seen this virgin nursing a male child, with sun rays around his head...which is emblematical of the infant sun at the winter solstice, and of his being then in the sign of the Virgo.[72]

As Albert the Great acknowledged, the virgin birth is astrotheological, referring to the hour of midnight, December 25th, when the constellation of Virgo rises on the horizon. The Assumption of the Virgin, celebrated in Catholicism on August 15th, symbolizes the summer sun's brightness blotting out Virgo. Mary's Nativity, observed on September 8th, occurs when the constellation is visible again. Such is what these "Christian" motifs and holidays represent, as has obviously been known by the more erudite of the Catholic clergy. Thus, the virgin who will conceive and bring forth is Virgo, and her son is the *sun.*

The virgin goddess was not only the constellation of Virgo but also the "rosy-fingered dawn," called "Aditi" in India. Aditi is a name or title for the universe, the sun god and the mother of the

gods, who included Mitra and Vishnu. The material sun in India is styled "one of the eight sons of Aditi." Aditi, the Dawn, who gives birth daily, is a title also applied to the mother of another of Vishnu's incarnations, Krishna, *one of eight sons*. Krishna's adoptive mother too was originally named Aditi, an apparent contrivance to split the epithet from Devaki, in order to increase the personification of the characters in the Krishna myth. It is nonetheless clear that Aditi and Devaki are one: Thus, like those of Aditi, Devaki's "eight sons" are "eight *suns*" or "eight planets."

In his translation of the *Vishnu Purana*, Wilson reproduces a hymn to "Devaki," or Prakriti, the Infinite, "which formerly bore Brahma in its womb." She is the "goddess of speech, the energy of the creator of the universe," as well as light, "whence day is begotten." Hence, again, Devaki, "the infinite," who begets day, or the sun, is the dawn,[73] the same as Aditi:

> Devaki, the virgin mother of Crishna, was also called Aditi, which, in the *Rig-Veda*, is the name for the *Dawn.*... Devaki is Aditi; Aditi is the Dawn; the Dawn is the Virgin Mother; and the Saviour of mankind, who is born of Aditi, is the Sun. Indra, worshipped in some parts of India as a crucified god, is represented in the Vedic hymns as the son of Dahana, who is Daphne, a personification of the dawn....[74]

After referring to a hymn recounting the glorious birth of Krishna to Devaki, Rev. Cox notes:

> This song would of itself suffice to prove how thoroughly Krishna, like Dyu, Indra, Varuna, Agni, or any other names, denotes the mere conception of the One True God, who is but feebly shadowed forth under these titles and by the symbolism of these myths. "As Aditi," say the gods to Devaki the mother of the unborn Krishna, "thou are the parent of the gods..."[75]

As stated, Aditi is depicted as eternal, inviolable and sinless, indicating her perpetual virginity, regardless of how many *suns* she bears. Another name for the dawn is Ushas, whence comes the Greek "Eos." The word "dawn" is related to the Indian word Dahana (Greek "Daphne") or Ahana ("Athena"). Concerning Ushas, Cox says, "Like the Greek Athena, she is pure and unsullied, the image of truth and wisdom."[76] Cox calls Athena (Doric "Athana" and Vedic "Ahana") the "greatest of Hellenic dawn-goddesses" and relates that she was a "pure," "unsullied" and "undefiled" virgin. The Greek myth of Athena springing from Zeus's forehead is also found in India, as "Ushas, the dawn, sprang from the head of Dyu...the East, the forehead of the sky."[77] Moreover, the Dawn "flies from the pursuit of the sun-god Phoibos [Apollo]."[78] Originally the dawn, Athena was eventually viewed as "an embodiment of moral and intellectual greatness."[79]

Among the Greek gods, Apollo and Athena were known for their "personal purity"; indeed, Athena, representing Divine Wisdom, is Apollo's "virgin sister."[80] Nevertheless, "pure and undefiled though the dawn may be, she is yet followed by the sun, who may therefore be regarded as her offspring..."[81]

In the story of the dawn and her offspring appears the virgin-born savior god, centuries and millennia before the Christian era. In addition, the sun god was born of a virgin not just once, but daily, monthly and annually for thousands of years. The daily exchange between the sun and dawn included the dawn driving her "bright flocks," or morning clouds, into the "blue pastures of heaven." She is followed by the "lord of the day," born from the night's "toiling womb."[82] This daily process of the sun was repeated, amid great drama, as the sun was born, lived out the day and again passed away. During this daily struggle, it was said that the sun "strangled the serpents of night" before going forth "like a bridegroom out of his chamber." The sun god is also frequently depicted as battling with "clouds and storms," the clouds at times overcoming his light, leading to him being called the "hidden sun"[83] (Ammon, Amon or Amen). The myth of the virgin dawn begetting the sun and then dying explains the quick deaths of the mothers of saviors such as Semele, Dionysus's mother, and Maya, mother of Buddha. Additionally, the sun as the "child of night, or darkness" is appropriate for Krishna, "the black."

Even Christian writers understood the connection between the Virgin and the dawn, as exemplified in "one of the homilies of St. Amedus on the Virgin," which includes the following regarding Mother Mary:

> "She is the Fountain that waters the whole earth, the Dawn that precedes the True Sun. She is the health (salus) of all, the reconciler (conciliatrix) of the whole world, the inventress of grace, the generatrix of life, the mother of salvation."[84]

Hence, the Virgin Mary is the ancient Goddess, mother of the Sun, the Dawn, etc., given a new dress.

In any event, "the doctrine of the Immaculate Conception was known in India long before it was enunciated by a Christian Pope in Rome."[85] In vain do apologists attempt to debunk the virgin status of Krishna's mother, because, even if she were not considered as such—although she certainly has been—the other virgin birth stories preceding Christianity are abundant enough to demonstrate that this important aspect of Christian doctrine is of Pagan origin. In addition to the virgin-born deities and heroes already named were a number of others, which is to be expected since the motif applies to the sun god, who was worshipped

all over the world by a wide variety of names and epithets. Concerning these miraculous births, Dr. Inman comments:

> Jupiter had Bacchus and Minerva without Juno's aid, and Juno retaliated by bearing Ares without conversation with her consort. We deride these tales, and yet think, that because we laugh at a hundred such we will be pardoned for believing one.[86]

Again, the Christian virgin birth is no more historical or believable than that of these numerous other gods. In the end, the "idea of a Virgin-Mother-Goddess is practically universal."[87] The list of Pagan virgin mothers includes the following:

- Alcmena, mother of Hercules who gave birth on December 25th
- Alitta, Babylonian Madonna and Child[88]
- Anat, Syrian wife of "the earlier Supreme God El," called "Virgin Goddess"[89]
- Cavillaca, Peruvian *huaca* (divine spirit) impregnated by the "son of the sun god" through eating his semen in the shape of a fruit[90]
- Chimalman, mother of the Mayan Kukulcan
- Chinese mother of Foe (Buddha)
- Coatlicue, mother of the Mexican god Huitzilopochtli
- Cybele, "Queen of Heaven and Mother of God"[91]
- Danae, mother of Perseus
- Demeter/Ceres, "Holy Virgin" mother of Persephone/Kore and Dionysus
- Devaki, mother of Krishna
- Frigga, mother of the Scandinavian god Balder
- Hera, mother of Zeus's children
- Hertha, Teutonic goddess
- Isis, who gave birth to Horus on December 25th
- Juno, mother of Mars/Ares, called "Matrona" and "Virginalis," i.e., the Mother and Virgin[92]
- Mandana, mother of Cyrus/Koresh
- Maya, mother of Buddha
- Mother of the Indian sun god Rudra[93]
- Nana, mother of Attis, the Phrygian sun and vegetation god[94]
- Neith, mother of Osiris, who was "worshipped as the Holy Virgin, the Great Mother, yet an Immaculate Virgin."[95]

- Nintud, mother of Dangalnunna, the Sumerian god Enki's wife[96]
- Nutria, mother of an Etruscan Son of God[97]
- Ostara, the German goddess[98]
- Rohini, mother of an Indian "son of God"
- Semele, mother of Dionysus/Bacchus, who was born on December 25th
- Shin-Moo, Chinese Holy Mother
- Siamese mother of Somonocodom (Buddha)
- Sochiquetzal, mother of Quetzalcoatl
- Vari, Polynesian "First Mother," who created her children "by plucking pieces out of her sides."[99]
- Venus, the "Virgo Coelestis" depicted as carrying a child[100]

It is interesting that one of Isis's numerous epithets is *Sochit*, which means "a corn field,"[101] while Quetzalcoatl's mother, *Sochi*quetzal, was in one aspect a corn goddess.

Concerning Isis's predecessor and prototype, the virgin goddess Neith, who predated the Christian era by millennia, Rev. James observes:

> ...She too was the virgin mother of the Sun-god, having given birth to Re as the great cow, and was identified with Isis as the wife of Osiris, later becoming one of the forms of Hathor. Indeed, she was "the Great Goddess, the mother of all the gods."...
>
> ...She was eternal, self-existing, self-sustaining and all-pervading, personifying the female principle from very early times. She was believed to have brought forth the transcendent Sun-god without the aid of a male partner, very much as in the Memphite Theology Ptah created all things virtually *ex nihilo* by thinking as the "heart" and commanding as the "tongue."[102]

Obviously, the correspondences between Christianity and Paganism, including between the Christ and Krishna myths, are dramatic and not "non-existent," as some have attempted to contend. The debate then becomes whether or not the Christ fable was plagiarized from the Krishna myth, vice versa, or both come from a common root. In this regard, it should be kept in mind that there was plenty of commerce, materially and religiously, between India and Rome during the first centuries surrounding the beginning of the Christian era.

Since it is possible to show that most of the salient comparisons can be found in pre-Christian Pagan mythology, dating back millennia and existing independently of the Krishna story, the point becomes moot as to whether or not Christianity

took its godman and tenets from Hinduism, as it already had many other antecedents from which to draw. In reality, the virgin-birth motif is primitive and prehistoric, extending back to ages and cultures in which impregnation was considered mysterious and magical,[103] and representing an important astrotheological concept found around the globe.

[1] McLean, 16.
[2] Legge, II, 45.
[3] Gadon, 191.
[4] James, 86.
[5] Baring, 459.
[6] Robertson, *CM*, 194.
[7] Frazer, 422.
[8] Frazer, 416.
[9] Bonwick, *EBMT*, 141.
[10] James, 86.
[11] www.infidels.org/library/historical/joseph_mccabe/
 religious_controversy/
[12] Dupuis, 237.
[13] Bonwick, *EBMT*, 143.
[14] *CMU*, 100.
[15] *CMU*, 87-88fn.
[16] Budge, *EBD*, cxiv.
[17] Legge, I, 85.
[18] Baring, 548.
[19] Weigall, 121-123.
[20] McLean, 72.
[21] Graves, R., 217.
[22] Graves, R., 361.
[23] Carpenter, 159-161.
[24] www.newadvent.org/cathen/15448a.htm
[25] Higgins, I, 151.
[26] Olcott, 27.
[27] Doane, 326.
[28] Doane, 245.
[29] www.infidels.org/library/historical/joseph_mccabe/
 religious_controversy/
[30] Graves, K., 86.
[31] Jones, *AR*, I, 233.
[32] Taylor, *SECR*, 150fn.
[33] Taylor, *TD*, 169.
[34] Graves, K., 282-283.
[35] Taylor, *TD*, 170.
[36] Taylor, *TD*, 170.
[37] Doane, 113.
[38] Doane, 156.
[39] Higgins, I, 145.
[40] Blavatsky, *SD*, I, xxx-xxxi.
[41] *vide* Palmer.

[42] Müller, *LSR*, 296-299.
[43] Müller, *LSR*, 320.
[44] Müller, *LSR*, 321.
[45] Lundy, 151-152.
[46] Lundy, 161.
[47] Lundy, 155.
[48] Jones, *AR*, III, 373.
[49] Inman, *AFM*, 283.
[50] Doane, 113fn.
[51] www.newadvent.org/cathen/15464b.htm
[52] Hardy, 142fn.
[53] www.newadvent.org/cathen/07674d.htm
[54] Hackwood, 17.
[55] Moor (Simpson), 83fn.
[56] Drews, *WHJ*, 163-164.
[57] Weigall, 42.
[58] Weigall, 44.
[59] Jacolliot, 226-227.
[60] www.geocities.com/Athens/Ithaca/3827/virginborn.html
[61] Jacolliot, 300.
[62] Titcomb, 75.
[63] Graves, R., 159.
[64] Stewart, 85.
[65] Lundy, 456.
[66] Inman, *AFM*, 8.
[67] Bonwick, *EBMT*, 140.
[68] classics.mit.edu/Virgil/eclogue.4.iv.html
[69] Hackwood, 30-31.
[70] *CMU*, 97-98.
[71] *CMU*, 97-98.
[72] *CMU*, 105.
[73] Lundy, 218.
[74] Titcomb, 41
[75] Cox, II, 133fn.
[76] Cox, I, 416.
[77] Cox, I, 439-440.
[78] Cox, I, 228.
[79] Cox, I, 68.
[80] Cox, I, 57.
[81] Cox, I, 442.
[82] Cox, I, 41.
[83] Cox, I, 43.
[84] Lundy, 221.
[85] Inman, *AFM*, 188.
[86] Inman, *AFM*, 264.
[87] Robertson, *CM*, 171.
[88] Robertson, *CM*, 169.
[89] James, 90, 305.
[90] Bierlein, 147-148.

[91] Titcomb, 73.
[92] Lundy, 215.
[93] Hari, 16.
[94] Frazer, 403.
[95] Titcomb, 65; Bonwick, *EBMT*, 115-117.
[96] Perry, 217.
[97] Titcomb, 73
[98] Titcomb, 74
[99] Robertson, *CM*, 295.
[100] Robertson, *CM*, 169.
[101] Frazer, 444.
[102] James, 84.
[103] Robertson, *CM*, 294.

Celtic Triple Goddess:
Maiden, Mother and Crone. (Stewart)

"Goddess and baby as bear
mother and cub," c. 4500
BCE, Yugoslavia. (Baring)

Cretan "Mother
goddess and child"
c. 1350 BCE. (Baring)

"Enthroned goddess holding her child," 5th millennium BCE. (Baring)

Ubaid Mother and Child, 5th millennium BCE. (*Past Worlds*)

Hittite Mother and Child 13th century BCE. (Singh)

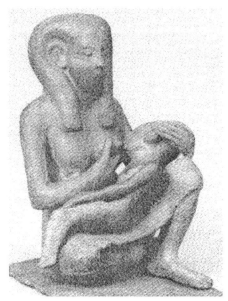

Egyptian Isis and Horus
3rd millennium BCE

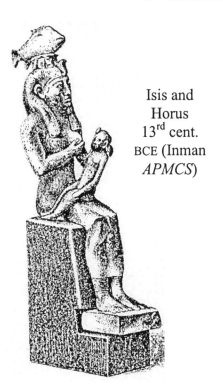

Isis and
Horus
13rd cent.
BCE (Inman
APMCS)

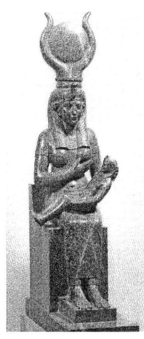

Egyptian Mother and Child
3rd century BCE

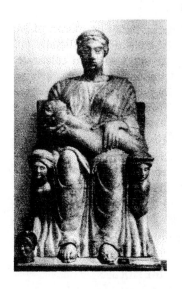

Etruscan Mother Goddess
5th century BCE. (Baring)

Roman Goddess Juno,
"Matrona and Virginalis,"
with Child. (Lundy)

Devaki suckling Krishna

Mary suckling Christ
15th century, Netherlands.
(Baring)

Krishna's Birthdate

Vishnu, being moved to relieve the earth of her load of misery and sin, came down from heaven, and was born of the virgin Devaki, on the twenty-fifth of December.

Sarah Elizabeth Titcomb, *Aryan Sun Myths*

According to Gubernatis (*Zool. Myth.* i, 51) it is customary "towards the end of December" to give presents of cows "in celebration of the new solar year, *or the birth of the pastoral God Krishna*"...

J.M. Robertson, *Christianity and Mythology*

It has been established that Krishna was not a "real person" but a solar incarnation or sun god and that his dawn-goddess mother was a pure and chaste virgin. Since Krishna is not a "real person" but the personification of the solar Vishnu, combined with various other gods and heroes, as well as the "wisdom sayings" of numerous human sages, it needs to be reiterated that there is no set-in-stone biography of his "life." As such, Krishna's story has changed over the centuries. Yet another indication that the story of Krishna is not a "biography" of an "historical person" can be seen in the debate as to not only the day but also the year, or even the epoch, of his birth, none of which can be found in any Indian text.[1] The time when Krishna purportedly lived has been variously placed in widely disparate eras: For example, "the Brahmanical calculations fix it at about 6,877 years ago," but it has also been placed around 3000 BCE, 2500 BCE, 1600 BCE, 1400 BCE, 1200 BCE, 900 BCE and 600 BCE, the latter of which would reflect his association with Buddha, another supposed incarnation of Vishnu.

Obviously, there is no agreement even as to the epoch in which Krishna was "born." Nor is there concurrence as to the particular month of his birth. Even in modern times there is no consensus, except that he was born on the eighth day of a dark fortnight. Indeed, "in Krishnaism itself there are different dates for the Birthday Festival, the Varaha Purana entirely departing from the accepted view."[2] Robertson states that the "Krishna Birth-Festival" corresponds with "the Birthday of the Eyes of Horos, when the Sun and Moon come together in a straight line," which is equivalent to July 24th.[3] Another writer gives Krishna's exact birthdate as July 20, 3228 BCE. Yet another source says that it happened in "the dark half of *Bhadrapada*," a month beginning on August 23rd and ending on September 22nd, according to the Indian civil calendar, and occurring from August 16th to September 15th, according to the religious calendar.[4] The "birthday of Crishna, son of Mahamaya, in the form of Devaci,"[5]

has also been placed on the 8th of the month *Sravana,* which in the civil calendar runs from July 23rd to August 22nd, making it equivalent to the zodiac sign of Leo, while in the religious calendar, it is July 16th to the 15th of August. That these dates are not "historical" but manipulated is revealed in the fact that, "while the Birth Festival falls in July, the date of the birth in later texts appears to be August."[6] Furthermore, Krishna's birthday is also called "Jayanti," which is the eighth day of "*any* dark fortnight..." In fact, since *krishna* means "dark," the term itself refers to the dark fortnight of any month.[7] As we can see, there is much confusion.

Moreover, Krishna's birthday, also called Jananashtami, Krishnaastami, Crishnajanmashtami, Gokulashtami, etc., occurs on different days in different years. In 1993, Krishna's birthday was celebrated in July, in some parts of the world. However, in 1996, it was celebrated on September 4th or 5th, again depending on the place. In 1997, his birthday occurred on August 25th. In the year 2000, it fell on August 22nd or 23rd:

> Krishna took birth at midnight on the *ashtami* or the 8th day of the *Krishnapaksha* or dark fortnight in the Hindu month of Shravan (August-September). This year Janmashthami, as this auspicious day is called, falls on the 23rd of August, 2000.[8]

Other dates include September 2nd or 3rd, September 12th, September 27th and so on. As can be seen, the month, like the day and year, is not agreed upon: Some sources claim Lord Krishna was born in the month of Bhadra or Bhadrapada, which is August/September; others say the month is Sravana or Shravan, corresponding to July/August. Adding to the confusion, in the Bhagavad Gita (10:35), Krishna is identified *as* the month of November/December, which indicates that said month is very important for his followers: "Of all the nuwsas (months), I am the *margasira* (November-December)."

The solar festival Rasa, earlier discussed as demonstrating the Indian knowledge of heliocentricity, represents the "sports of Krishna," who is worshipped as the sun, and occurs in the month of Kartika (October/November).[9] From a number of such festivals, the astrotheology of the Indian holidays is evident, and in the "dark fortnight" birthdate of Krishna appears another astrotheological festival, representing the two weeks when the moon is waning, i.e., the sun's light is "dying," to be "born again." In some cultures, the "dark fortnight" was "peculiarly sacred," which is to say that they were "*new*-moon cultists." Naturally, the new-moon "birthday" would occur in "*any* dark fortnight," representing the monthly rebirth of the sun's light in the moon. As the light of the sun in the moon "born again" every month,

Krishna is the same as Osiris, whose 14 body parts are the days of the dark fortnight. In this regard, it is also maintained that Krishna was born on January 6th, an early birthdate of Osiris: "One of the principal feasts of the Krishna cult in India is the birthday of Krishna, or rather the day of his birth and baptism, which is celebrated on the sixth of January."[10] Moreover, January 6th is also one of the earliest birthdates of Osiris's remake, Jesus, a date especially celebrated by the eastern churches. Regarding Jesus's January 6th birthday, Sir Weigall states:

> ...they selected, in part deliberately and in part under the influence of ancient custom, the date January 6th, because this was the day on which the sacred waters were blessed both in the religion of Osiris and in that of Dionysos.[11]

Like Krishna and other non-historical godmen, Jesus has no fixed birthdate: His nativity was represented variously as January 5th, January 6th, March 25th, March 28th, April 19th, April 20th, May 20th, August 21st, November 17th and November 19th. The January 5th birthdate of "light" in Egypt, i.e., that of Osiris, dates back to at least 1996 BCE.[12] Jesus's December 25th birthdate was established in 354 CE. This most famous date, however, was already celebrated in some Christian sects at least as early as the end of the second century, a critical time in the formation of Christianity. Like December 25th, these various other dates have symbolic, astrotheological meaning, especially the March 25th or 28th birthdays, as these represent the end of the vernal equinox, when the sun is reborn in "manly" strength, i.e., "full bloom":

> There were...many speculations in the 2nd century about the date of Christ's birth. Clement of Alexandria, towards its close, mentions several such, and condemns them as superstitions. Some chronologists, he says, alleged the birth to have occurred in the twenty-eighth year of Augustus, on the 25th of Pachon, the Egyptian month, i.e. the 20th of May. These were probably the Basilidian gnostics. Others set it on the 24th or 25th of Pharmuthi, i.e., the 19th or 20th of April. Clement himself sets it on the 17th of November, 3 B.C. The author of a Latin tract, called the *De Pascha computus*, written in Africa in 243, sets it by private revelation...on the 28th of March. He argues that the world was created perfect, flowers in bloom, and trees in leaf, therefore in spring; also at the equinox, and when the moon just created was full. Now the moon and sun were created on a Wednesday. The 28th of March suits all these considerations. Christ, therefore, being the Sun of Righteousness, was born on the 28th of March.[13]

The Catholic Encyclopedia ("Christmas") admits that the text "De paschae computus" (243 CE) "places Christ's birth on 28 March, because on that day the material sun was created." CE

further discusses Church fathers and other early Christian
writers who created a "rapprochement of the births of Christ and
the sun...." Early Christian writers who marveled at the "fact"
that Christ and the sun were "providentially" born on the same
day included Cyprian and Chrystostom. Tertullian, in the
third century, was compelled to remark that Pagans believed
Christians to be sun worshippers, and, centuries later, Augustine
denounced "the heretical identification of Christ with Sol."

The discrepancies in Jesus's birthday indicate his non-
historical nature. The idea that the followers of an "historical"
Jesus would have no clue as to when he was born is ridiculous,
particularly in consideration of how significant birthdays were to
Jewish mothers.

The birthdates of the most famous godmen are thus not
"historical" and concretized but have varied, based on
astronomical observations. This situation exists, of course,
because these gods are not "real people" but astrotheological
motifs.

December 25th

The December 25th birthday of the sun god is a common motif
globally, dating back at least 12,000 years as reflected in winter
solstices artfully recorded in caves. "Nearly all nations," says
Doane, commemorated the birth of the god Sol to the "Queen of
Heaven" and "Celestial Virgin." The winter solstice was celebrated
in countless places, from China to the Americas. The winter
solstice festival in Egypt has already been mentioned several
times, with the babe in a manger brought out of the sanctuary.

Ancient Greeks celebrated the birthday of Hercules and
Dionysus on this date, as we have already seen Macrobius to
maintain. Even the Greek father god, Zeus, was supposedly born
at the winter solstice.[14] The "Christmas" festival was celebrated at
Athens and was called "the Lenaea," during which time,
apparently, "the death and rebirth of the harvest infant Dionysus
were similarly dramatized." This Lenaea festival is depicted in an
Aurignacian cave painting in Spain (34,000-23,000 Before
Present), with a "young Dionysus with huge genitals," standing
naked in the middle of "nine dancing women."[15]

The Greco-Syrian sun god Adonis—the "Adonai" of the Bible—
was also born on December 25th, a festival "spoken of by
Tertullian, Jerome, and other Fathers of the Church, who inform
us that the ceremonies took place in a cave, and that the cave in
which they celebrated his mysteries in Bethlehem, was that in
which Christ Jesus was born."[16]

Nor is the winter solstice celebration a purely "Pagan"
concept, as the Jews also observed it in reference to the birth of

their god, Yahweh. The "Feast of Illumination," "Feast of Lights" or "feast of the Dedication," occurred in winter (John 10:22-23; Josephus's *Antiquities* XIII, 7.7) and represented the "ancient Hebrew Winter Solstice Feast." The legend of Chanukah was created by the Talmudist authors in order "to conceal the antiquity of the feast, which was originally Jehovah's birthday as the Sun-God." Moreover, this solar birthday dates back to "at least as early as the time of Nehemiah (*Maccabees, I,* 18)."[17]

For millennia Indians have celebrated the winter solstice, as a cardinal point, the new year and the birth of the sun god. In the Indian solstice celebration—a "great religious festival"—there is "rejoicing everywhere." As in the West, the Indians "decorate their houses with garlands, and make presents to friends and relatives," a "custom of very great antiquity." One way the Brahman priests of Orissa have celebrated the solstice is by carrying images of "the youthful Krishna to the houses of their disciples and their patrons, to whom they present some of the red powder and tar of roses, and receive presents of money and cloth in return."[18] Thus, in India the winter solstice has been as much a major holiday as it was anywhere, which is to be expected in a land permeated with sun worship for thousands of years. Moreover, the winter solstice was called "Agnistoma," for Agni, the sun and fire god, representing the time when the sacred fire was celebrated.[19] As shown, the very ancient Agni has many germane correspondences to both Krishna and Christ.

The winter solstice festival is also called "Makara Sankrati," a famed celebration of which is held at the holy site of Allahabad, at the confluence of Ganges and Yamuna, the river across which Vasudeva/Basudev fled with the baby Krishna. Makara refers to Capricorn, while Sankrati is the day of the sun's passage from one zodiacal sign to the next.[20] The celebration's name changes from region to region, but that it has been widespread is evident:

> The festival of winter solstice, Makar Sankranti, is celebrated all over India, as 'Mahavrata' or New-Year. In Punjab the festival is called 'Lohadi' in Assam 'Bhogali-Bihu' in Bengal 'Navvannoh' in Andhra Pradesh 'Bhoghi', in tamil Nadu 'Pongal', and in Kerala 'Pooram'.[21]

Makara Sankrati, while a "winter solstice" celebration in honor of the sun's increasing in strength, usually occurs on the 14th of January, at the end of Pausa and beginning of Magha. Thus, it is said to occur in either Pausa or Magha. The Makara Sankranti "marks the beginning of longer days and shorter nights," which means it is truly the festival of the winter solstice; its date in January reflects that Indian astronomy/astrology is different in dating from Western astral sciences, based on

calculations of the equinoctial precession. In any case, Makara Sankranti is the winter solstice celebration equivalent to Christmas; it is the "morning of the gods" or the new year. [22]

The millennia-old Indian solstice festival represents the time when the sun god, in a chariot drawn by seven horses, returns to the north from the south.[23] The theme of the cart-drawn sun god likewise occurs in Persia, and the Indo-Iranian connection is highly important. As noted, Mithra is the Indian sun god Mitra, whose festival was also celebrated on December 25th. Regarding the Mithraic sacrifice and rebirth, Rev. Lundy says:

> For let it be borne in mind that it was precisely at the season of this sacrifice, near the beginning of the new year, that the birth of Mithra was celebrated over all Persia and the world, in temple-caves, on the night of the 24th of December, *the night of light.* Even the British Druids celebrated it, and called the next day, the 25th of December, *Nollagh* or *Noel, the day of regeneration,* celebrating it with great fires on tops of their mountains. In fact, all nations, as if by common consent, at the first moment after midnight of the 24th of December, celebrated the birth of the sun-god, type among the Gentiles of Christ, the Incarnate Son of God, as the Desire of all nations and the Saviour of the world.[24]

Lundy was thus well aware of the sun gods, whom he deemed "types of Christ," indicating Christ's solar nature as well. In the discussion of Noel ("Christmas"), a tremendous occasion, it should be kept in mind that the ancient Irish word *krishna* means "sun," such that Noel was likely said at some point in Ireland to be the birth of "the krishna." Concerning the winter solstice festival in Ireland, CMU relates: "The Baal-fire feast, or meeting, was a great festival in Ireland, on the 25th of December, and midsummer eve. Baal, or Bel, was a name of the sun all over the east."[25] As we have already seen, there are a number of significant correspondences between the Irish and Indian cultures, including language, as there are also among the Indian, Irish and Semitic cultures.

Despite this omnipresent "Christmas" celebration of the God Sun's birth, in the comparisons between Krishna and Christ is an assertion that has been contested for over a century: To wit, Krishna's birthday was observed on December 25th or the winter solstice. This claim is supposed to have originated with Kersey Graves, in *The World's 16 Crucified Saviors,* for which contention and several others he has been disparaged—erroneously, as it turns out. In reality, when one looks beyond the encyclopedia articles and other sanitized mainstream resources, one uncovers information that tends to verify such an assertion. In his contention concerning Krishna's birthday, Graves represented

Shravan, Sravana or Saravana as *December*, which is evidently where the controversy begins:

Bacchus of Egypt, Bacchus of Greece, Adonis of Greece, Chrishna of India, Chang-ti of China, Christ of Chaldea, Mithra of Persian, Sakia of India, Jao Wapaul (a crucified Saviour of ancient Britain), were all born on the twenty-fifth of December, according to their respective histories. Chrishna is represented to have been born at midnight on the twenty-fifth of the month of Savarana [sic], which answers to our December, and millions of his disciples celebrated his birthday by bestowment of presents to friends.[26]

Since Graves's time, a number of other writers have made the same claim regarding the December 25th date, possibly based on his statement or not. For example:

Tammuz of Babylon, Attis of Phrygia, Horus of Egypt, Mithra of Persia, Krishna of India, Heracles of Greece and, last of all, Jesus of Nazareth are just some of the ancient man-gods whose births were celebrated on the Winter Solstice.[27]

Graves's book was published in 1875, but by 1882 Doane was compelled to note the following, in his own detailed comparison of Krishna and Christ:

Some writers have asserted that *Crishna* is said to have been born on December 25th, but this is not the case. His birthday is held in July-August.[28]

Doane asserts the Bhadra (July/August) birthday, while various Indian authorities claim it is in Sravana (August/ September), on a variety of days. Thus, again there is no consensus. Unfortunately, Doane never names these writers, nor is there any indication he read Graves, although his comment could refer to Graves and others influenced by him in the years between the publication of the two men's books. However, this concept of Krishna being born at the winter solstice occurred earlier than Graves. In fact, writing in the 1830's, Godfrey Higgins makes the following statements:

John the Baptist was born on the 25th of June, the day of the solstice, so that he began to decline immediately. St. John the Evangelist, or the enlightener, or teacher of glad-tidings, was born at the same time of the year; (but, as it is said, two days after Jesus;) and as Osiris, and Bacchus, and Cristna, and Mithra, and Horus, and many others. This winter solstice, the 25th of December, was a favourite birth-day.[29]

Higgins's comments are obtuse, as he starts out with the summer solstice and, without clarifying, ends up at the winter. Since John the Evangelist's "feast day" is December 27th ("two days after Jesus"), we can fairly bridge Higgins's train of thought

that "at the same time of the year" refers to the *winter* solstice. Since Krishna is included in a list of sun gods whose "known birthdays" fall on the winter solstice, and Higgins immediately follows with a comment concerning December 25th, we can presume that he meant that Krishna's birthday likewise occurred at Christmas. This assumption is confirmed in volume II of Higgins's *Anacalypsis*, wherein he says:

> Osiris, Bacchus, Adonis, were all incarnate Gods: taught by the priests; despised by the philosophers; believed by the rabble. They were probably all derived from the story of Cristna born in the eighth month, which answers to our December, on a Wednesday night at midnight...[30]

The statement that Osiris, Bacchus and Adonis were derived from Krishna cannot be validated, as there remains a debate as to which of these various gods and cultures came first, with Osiris way ahead of the field per tradition, literature and archaeology. Since the name Krishna means "black," and Osiris is the "black sun," as must also be Krishna, it may be that at some point Osiris's Indian counterpart Iswara was described by the epithet "black" or *krishna*. Obviously, in the west the "eighth month" is *August*, not December; however, the Indian new year began on different days in different eras and places, often on one of the cardinal days. The ancient Indian new year at the winter solstice, celebrated on January 14th, would yield the eighth month as August/September, or Sravana. The start of the year at other cardinal points would make for a different eighth month. In the south, whence comes the Dravidian Krishna/Mal/Mayon, the winter solstice is not as important as in the north. Therefore, it is possible the year started at the vernal equinox (April 13rd, per the *religious* calendar), yielding an eighth month date of November/December or Margarsirsa, which may be why in the Gita Krishna is made to *be* that month. However, the Hindu *civil* new year in the modern era begins with Aries (March/April),[31] which would make the eighth month Kartika, or Scorpio (October/ November).

The birthday variances likely also occurred because there were different calendars in use in different places and eras, e.g., lunar and solar, some of which accounted for the precession of the equinoxes, while others did not. For example, the Roman calendar established around the seventh century BCE consisted of only 10 months, comprising 304 days for the year; this calendar constitutes the reason "December" means "ten" but represents the 12th month.

In their contention regarding Krishna's birthday, it is feasible that Higgins and Graves possessed texts that have been since censored or were never published. Since both of these writers

used the original work of Christian authority Sir William Jones, it is possible that they garnered their information from his *Asiatic Researches*. We have already seen that the virgin status of Devaki's mother, asserted by Jones, is correct, in spite of claims to the contrary and despite the fact that Jones revised his work to remove the motif. In reality, it is possible to extrapolate from Jones's *extant* writings that Krishna could be considered to have been "born" on Christmas day. *Indeed, the determination of the winter solstice as Krishna's birthday likely came from the tradition regarding Vishnu's "sleep and rise," or death and rebirth, at the solstices.* As Moor says:

> The festival of *Durgotsava*, and that of *Huli* [Holi], *Sir* W. Jones decided to relate to the autumnal and vernal equinoxes; and the sleep and rise of VISHNU to the solstices, (*As. es.* Vol. III. Art. XII. p. 258)...
>
> The Huli, among the Hindus, reminds one strongly of the Saturnalia with the Romans....The Huli seems a festival in honour more especially of KRISHNA.[32]

The missionary Moor was an influential writer of the early 19th century; however, his principal work, the *Hindu Pantheon*, originally published in 1810, was badly mutilated in later versions, particularly the edition by Rev. Simpson, published in the late 1800's, decades after Moor's death. Simpson, a pious Christian, took it upon himself to remove entire chapters of Moor's book, as well as numerous individual pages and plates that, in Simpson's estimation, were "erroneous" or, in reality, deleterious to Christianity. In connection to this last section about Holi, in a footnote Simpson says, "The festival of *Huli* will be more particularly referred to under the head of Kama Deva." However, there is no discussion of Holi/Huli in the chapter on Kama, in either Simpson's edited version or the original, as, fortunately, Moor's 1810 edition was reprinted in 1999. A following chapter on "Linga-Yoni" is completely missing from Simpson's edition. The text resumes in the middle of a discussion of Indian sacrificial practices, including human. It is clear that these missing 30+ pages were not torn out but must have been omitted during the printing, although it is not possible to say if such an omission was deliberate.

In any case, Moor further explains that Holi occurs at the vernal equinox and is "one of the greatest festivals among the Hindus," with the participation of virtually every sect. In the south, Holi is sacred to Kama, the god of love, while in the north it is "peculiarly dedicated to Krishna."[33] Moor, or his postmortem editor, Simpson, also states:

According to one account Holi is the same as the female demon Putana, of whom it is related in the Vishnu and Bhagavat Puranas, and in the popular biographies of Krishna taken from them, that she attempted to destroy the baby Krishna, by giving him her poisoned nipples to suck.[34]

Since Holi is the special (spring) festival of Krishna, but it is also the she-demon who tried to destroy him at *birth*, it could be suggested that Krishna's birth fell on the vernal equinox, with Holi/Putana, perhaps, playing the role of the "serpent" as in the myths of other sun gods. In any case, Holi, especially associated with Krishna, is an astrotheological holiday, essentially the same as Easter. The vernal equinox or Easter celebration represents a "rebirth" or "resurrection" of the sun, when the day begins to be longer than the night, at which point it was said that the sun was starting to attain "manhood." In Holi, Krishna is associated with a cardinal point; indeed, he *is* the vernal equinox, among other things. As already shown, he is likewise the focus of several other holidays and festivals, a number of which are solar. It is impossible to believe that Krishna would not thus also be associated with what has been widely and from very ancient times considered the most important solar holiday of all: the winter solstice. In these two celebration dates, i.e., that of the winter solstice and vernal equinox, Krishna would resemble Horus, who had his birthday annually at both these times, as did Apollo.[35]

Furthermore, although Holi is currently celebrated at the vernal equinox, Moor says the holiday "reminds one strongly of the Saturnalia," a Roman festival representing winter's advent, in the week preceding the solstice. In addition is the "sleep and rise" of Vishnu at the solstices. As previously shown, Vishnu is the genius of Pausa, which is both the month and the day of the winter solstice, during which occurred his "rising"; it could thus be said that Vishnu was "born again" every year at Pausa, or Christmas, which would be sensible for a sun god. It would also be logical to submit that an *incarnation* of the solar Vishnu, such as Krishna, was "born" at this time, which would represent a similar relationship to that of Osiris and Horus.

Concerning Vishnu and the winter solstice, in "Pre-Historic Indian Astronomy" K. Chandra Hari, mentioning Tilak's antiquity for the Vedas (6000-4000 BCE), explains the origin of the story of Vamana the dwarf:

> Indra lost his sovereignty due to the prevalence of the sidereal Calendar independent of the receded solstices. This loss could be avenged only after the advent of Visnu as "Vamana" on the 12th tithi of the bright half of Bhadrapada, i.e., Sravana naksatra, known as Hari or Visnu.... A.J. Karandikar identifies Vamana as the winter solstice, i.e., the shortest day....

Hari also states that "major characters like Rudra, Bhisma, Krsna [Krishna], Durga, etc." can be identified astronomically, and that "much of the Puranic and Epic mythology can be satisfactorily interpreted as astronomical allegories arising out of a pre-historic astronomical tradition." It is suggested that Vishnu's "dwarf" incarnation, Vamana, symbolizes the winter solstice, which makes sense, since such is the time when the sun is at its smallest. Since Krishna is also the Vamana dwarf, he would likewise represent the winter solstice. Furthermore, one of the 12 adityas, Yama, the Indian equivalent of Pluto or Hades, the god of death, symbolized the sun at the winter solstice. In the Gita, Krishna is made to say, "Among all those who rule I am Yama."[36] Hence, Krishna is Yama, who signifies the winter solstice.

As noted, professor of Sanskrit Count Gubernatis wrote that Krishna's birth was celebrated at the end of December; however, Robertson thinks the claim is erroneous, instead finding the midsummer birthday sensible in astronomical terms, in that Krishna is the "black Sun-God." "It is the white Sun-God," asserts Robertson, "who is born at Christmas."[37] Nevertheless, since Krishna has also been considered the *white* sun god, even called "Arjuna," it is logical to submit that at some point and in one part or another of the large nation that now constitutes India, some of its natives worshipped the birth of "Krishna" on December 25th. When critics claim that this idea is erroneous because this date is not found in any "original" ancient texts, in return we would ask where is the evidence of the December 25th birthday of Christ in the "original" Christian texts? It is not in the Bible—if future archaeologists were to rely on such texts for proof that Christians celebrated the birth of Christ on December 25th, they would certainly come up empty-handed.

The truth is that the Indians, like much of the world, have esteemed the cardinal points of the year, generally above all other times, with the exaltation of a particular solstice or equinox largely dependent on the latitude in which it was celebrated. The traditional birthdates for Krishna possess astronomical meaning and special significance for a particular sect; however, they do not approach the importance of the cardinal holidays, a fact that would reduce Krishna's importance as well—unless, as the incarnated sun, he shares in the sacred inheritance of one of the sun's salient days, the winter solstice. Since Vishnu the sun god was essentially the genius of the winter solstice, and his "rising," as well as one of his incarnations, took place at that time, it is logical and reasonable to propose that the anthropomorphized sun, or Krishna, another of Vishnu's avatars, was also deemed to have been "born" during that time, i.e., around December 25th. In

any case, the December 25th birthdate is that of the sun, not a "real person," revealing its unoriginality within Christianity and the true nature of the Christian godman.

1 Robertson, *CM*, 174.
2 Robertson, *CM*, 234.
3 Robertson, *CM*, 177.
4 webexhibits.org/calendars/calendar-indian.html.
5 Jones, *AR*, III, 289.
6 Robertson, *CM*, 230.
7 webexhibits.org/calendars/calendar-indian.html.
8 hinduism.about.com/religion/hinduism/library/weekly/aa082000a.htm
9 Moor (Simpson), 128fn.
10 Evans, 34.
11 Weigall, 220.
12 Kerenyi, 299.
13 www.skeptictank.org/xmaspage.htm
14 Graves, R., 319; 469.
15 Graves, R., 399.
16 Doane, 362-5.
17 Graves, R., 469.
18 Moor (Simpson), 140.
19 Drews, *CM*, 100.
20 www.webonautics.com/ethnicindia/festivals/makarasankranthi.html.
21 www.vedicbooks.com/magazine.htm
22 www.webonautics.com/ethnicindia/festivals/makarasankranthi.html
23 www.webonautics.com/ethnicindia/festivals/makarasankranthi.html.
24 Lundy, 167.
25 *CMU*, 97.
26 Graves, K., 69.
27 www.crystalinks.com/indiadieties.html
28 Doane, 363fn.
29 Higgins, I, 656.
30 Higgins, II, 98.
31 Frazer, 398.
32 Moor (Simpson), 91.
33 Moor (Simpson), 138.
34 Moor (Simpson), 142.
35 Robertson, *CM*, 33fn.
36 Moor (1810), 304, 305.
37 Robertson, *CM*, 177.

Krishna Crucified?

Blood sacrifice is the oldest and most universal act of piety. The offering of animals, including the human animal, dates back at least twenty thousand years, and, depending on how you read the scanty archaeological evidence, arguably back to the earliest appearance of humanity. Many religions recount the creation of man through the bloody sacrifice of a God-man—a divinity who is torn apart to sow the seeds of humanity.

Patrick Tierney, *The Highest Altar: The Story of Human Sacrifice*

[A] peculiarity noticed in some of the Irish Pre-Christian illustrations of the Crucifix is the absence of nails; the legs being bound with cords at the ankles... It is singular that the dress of one crucified figure, as worn about the loins, corresponds with that of the fabled crucified Christna.

James Bonwick, *Irish Druids and Old Irish Religions*

The orthodox depiction of Krishna's death relates that he was shot in the foot by a hunter's arrow while under a tree. As is true with so much in mythology, and as we have seen abundantly, there are variances in Krishna's tale, including the account of his death. In *The Bible in India*, citing as his sources the "Bagaveda-Gita and Brahminical traditions," French scholar and Indianist Jacolliot recounts the death of "Christna" as presciently understood by the godman, who, without his disciples, went to the Ganges to "work out stains." After thrice plunging into the sacred river, Krishna knelt and prayed as he awaited death, which was ultimately caused by multiple arrows shot by a criminal whose offenses had been exposed by Krishna. The executioner, named Angada, was thereafter condemned to wander the banks of the Ganges for eternity, subsisting off the dead. Jacolliot proceeds to describe Krishna's death thus:

> The body of the God-man was suspended to the branches of a tree by his murderer, that it might become the prey of the vultures.

> News of the death having spread, the people came in a crowd conducted by Ardjouna, the dearest disciple of Christna, to recover his sacred remains. But the mortal frame of the Redeemer had disappeared—no doubt it had regained the celestial abodes... and the tree to which it had been attached had become suddenly covered with great red flowers and diffused around it the sweetest perfumes.[1]

Jacolliot's description includes a number of arrows, instead of just one, which, along with the suspension in the tree branches, resembles the pinning of the god to a tree using multiple "nails." Krishna's subsequent disappearance has been considered an ascension. Moreover, this legend is evidently but a variant of the *orthodox* tale, constituting an apparently esoteric tradition

recognizing Krishna's death as a "crucifixion." Indeed, as John Remsburg says in *The Christ*:

> There is a tradition, though not to be found in the Hindoo scriptures, that Krishna, like Christ, was crucified.[2]

In *Bible Myths and Their Parallels in Other Religions*, Doane elaborates upon the varying legends concerning Krishna's death:

> The accounts of the deaths of most of all virgin-born Saviours of whom we shall speak, are conflicting. It is stated in one place that such an one died in such a manner, and in another place we may find it stated altogether differently. Even the accounts of the death of Jesus...are conflicting...
>
> The *Vishnu Purana* speaks of *Crishna* being shot in the *foot* with an arrow, and states that *this* was the cause of his death. Other accounts, however, state that he was suspended on a tree, or in other words, *crucified.*

Doane then cites M. Guigniaut's *Religion de l'Antiquité*, which states:

> "The death of Crishna is very differently related. One remarkable and convincing tradition makes him perish on a *tree*, to which he was *nailed* by the stroke of an arrow."

Doane further relates that the pious Christian Rev. Lundy refers to Guigniaut's statement, translating the original French "un bois fatal" as "a cross." Doane next comments:

> Although we do not think he is justified in doing this, as M. Guigniaut has distinctly stated that this "bois fatal" (which is applied to a gibbet, a cross, a scaffold, etc.) was "un arbre" (a *tree*), yet, he is justified in doing so on other accounts, for we find that *Crishna* is represented *hanging on a cross*, and we know that a *cross* was frequently called the "so cursed *tree.*" It was an ancient custom to use trees as gibbets for crucifixion, or, if artificial, to call the cross a tree.[3]

To wit, the legend of Krishna's death has been interpreted to mean that he was pinned to a tree, essentially representing a crucifixion. However, it is not just tradition but artifacts that have led to the conclusion that Krishna was crucified. Indeed, there have been found in India numerous images of crucified gods, one of whom apparently is Krishna, important information not to be encountered in mainstream resources such as encyclopedias.

Moreover, it appears that Krishna is not the first Indian god depicted as crucified. Prior to him was another incarnation of Vishnu, the avatar named Wittoba or Vithoba, who has often been identified with Krishna. As Doane further relates:

> It is evident...that to be hung on a cross was anciently called hanging on a *tree*, and to be hung on a tree was called

crucifixion. We may therefore conclude from this, and from what we shall now see, that Crishna was said to have been *crucified.*

In the earlier copies of Moor's *Hindu Pantheon,* is to be seen representations of Crishna (as *Wittoba*), with marks of holes in both feet, and in others, of holes in the hands. In Figures 4 and 5 of Plate 11 (Moor's work), the figures have *nail-holes in both feet.* Plate 6 has a *round hole in the side;* to his collar or shirt hangs the emblem of a *heart* (which we often see in pictures of Christ Jesus)...

Rev. J. P. Lundy, speaking of the Christian crucifix, says:

"I object to the crucifix because it is an image, and liable to gross abuse, just as the old Hindoo crucifix was an idol."

And Dr. Inman says:

"Crishna, whose history so closely resembles our Lord's, was also like him in his being crucified."[4]

Thus, we discover from some of the more erudite *Christian* writers, admitting against interest, that images of a Indian god crucified, with nail holes in the feet, had been discovered in India, and that this god was considered to be Krishna, as Wittoba. As we have seen, Moor's book was mutilated, with plates and an entire chapter removed, which have luckily been restored in a recent edition of the original text. Fortunately, Higgins preserved for posterity some of Moor's statements and plates, recounting and commenting upon the missionary's remarkable discovery:

Mr. Moor describes an Avatar called Wittoba, who has his foot pierced....

This incarnation of Vishnu or CRISTNA is called Wittoba or Ballaji. He has a splendid temple erected to him at Punderpoor. Little respecting this incarnation is known. A story of him is detailed by Mr. Moor, which he observes reminds him of the doctrine *of turning the unsmote cheek to an assailant.* This God is represented by Moor with a hole on the top of one foot just above the toes, where the nail of a person crucified might be supposed to be placed. And, in another print, he is represented exactly in the form of a Romish crucifix, but not fixed to a piece of wood, though the legs and feet are put together in the usual way, with a nail-hole in the latter. There appears to be a glory over it coming *from above.* Generally the glory shines from the figure. It has a pointed Parthian coronet instead of a crown of thorns....[5]

The images provided by Moor evidently constitute representations of an Indian god, Wittoba/Krishna, in cruciform, with nail holes. The image of the godman crucified without the wood, "in space," can also be found reproduced in Lundy's book, wherein he insists that it is indeed non-Christian, uninfluenced by Christianity, representing an older tradition of a crucified god.

With this transcendent cruciform and others in mind, Higgins continues his intriguing detective tale:

> ... I cannot help suspecting, that it is from this Avatar of Cristna that the sect of Christians heretics got their Christ crucified in the *clouds*.
>
> Long after the above was written, I accidentally looked into Moor's Pantheon, at the British Museum, where it appears that the copy is an earlier impression than the former which I had consulted: and I discovered something which Mr. Moor has apparently not dared to tell us, viz. that in several of the icons of Wittoba, there are marks of holes in both feet, and in others, of holes in the hands. In the first copy which I consulted, the marks are very faint, so as to be scarcely visible....
>
> Figure 1, plate 91, of Moor's Pantheon, is a Hanuman, but it is remarkable that it has a hole in one foot, a nail through the other, a round nail mark in the palm of one hand and on the knuckle of the other, and is ornamented with doves...
>
> It is unfortunate, perhaps it has been thought prudent, that the originals are not in the Museum to be examined. But it is pretty clear that the Romish and Protestant crucifixion of Jesus must have been taken from the Avatar of Ballaji, or the Avatar of Ballaji from it, or both from a common mythos.[6]

As Higgins relates, Moor was compelled by Christian zealots not to publish the volume intact. Elaborating on Higgins's contentions regarding Christian mutilation of documents, Graves says:

> [Higgins] informs us that a report on the Hindoo religion, made out by a deputation from the British Parliament sent to India for the purpose of examining their sacred books and monuments, being left in the hands of a Christian bishop at Calcutta, and with instructions to forward it to England, was found, on its arrival in London, to be so horribly mutilated and eviscerated as to be scarcely cognizable. The account of the crucifixion was gone—cancelled out.[7]

In recounting his experiences in India regarding the images he subsequently used as plates in his book, the missionary Moor states: "A man, who was in the habit of bringing me Hindu deities, pictures, etc., once brought me two images exactly alike..." Moor's censor, Rev. Simpson, notes at this point that these images were of a crucifix. Simpson then comments, "The subject, a crucifix, is omitted in the present edition, for very obvious reasons."[8] In other words, the crucifix image was removed so it would not offend Christian sensibilities.

Moor himself resumes his story concerning the presentation to him of the crucifix images:

Affecting indifference, I inquired of my Pandit what Deva it was: he examined it attentively, and, after turning it about for some time, returned it to me, professing his ignorance of what Avatara it could immediately relate to; but supposed, by the hole in the foot, that it might be Wittoba, adding, that it was impossible to recollect the almost innumerable Avataras described in the Puranas.

The subject of plate 98 is evidently the crucifixion; and, by the style of workmanship, is clearly of European origin, as is proved also by its being in duplicate. These crucifixes have been introduced into India, I suppose, by Christian missionaries, and are, perhaps, used in Popish churches and societies...[9]

Moor thus claimed the image was originally Christian, introduced into India. Higgins—whom Rev. Taylor calls a "sincere Christian"—did not concur with Moor's conclusions that the crucifix image is of "European origin," although it is somewhat different in style from typical Indian art. Higgins's arguments include that the halo is not surrounding the figure as in Western images but emanates from above. Also, the figure is wearing a "pointed Parthian coronet" instead of a crown of thorns. Higgins then remarks, "I apprehend this is totally unusual in our crucifixes." The magistrate Higgins continues with his analysis by reminding that *all* avatars or incarnations of Vishnu "are painted with Ethiopian or Parthian coronets," and that in Moor's book Wittoba "is thus painted," while Christ is "never described with the Coronet." "This proves," says he, "that the figure described in Moor's Pantheon is not a Portuguese Crucifix." Higgins continues:

...The crucified body without the cross of wood reminds me that some of the ancient sects of heretics held Jesus to have been crucified in the clouds....

I very much suspect that it is from some story unknown, or kept out of sight, relating to this Avatar [Wittoba], that the ancient heretics alluded to before obtained their tradition of Jesus having been crucified in the clouds.... I therefore think it must remain a Wittoba....

...I repeat, I cannot help suspecting, that it is from this Avatar of Cristna that the sect of Christian heretics got their Christ crucified in the clouds.[10]

Overall, the image is more European than Indian in style; however, the insight about the Parthian coronet is interesting, as it was also asserted by Sir Jones that *all* Vishnu avatars, of which Krishna was one, possess such headdresses. Nevertheless, Robertson argues that the particular crucifixion in question is Christ, not Wittoba or Krishna. Yet, he is certain that there *were* depictions of crucified gods in India before the common era: "[In] Nepal it was customary in the month of August to raise in honour of the God Indra *cruces amictas abrotono*, crosses wreathed with

abrotonus, and to represent him as crucified, and bearing the sign *Telech* on a forehead, hands, and feet."[11]

Rev. Lundy also contended, no doubt reluctantly, that the Indian god "crucified in the clouds" was pre-Christian. Regarding this "crucified man in space," the good reverend remarks:

> There is a most extraordinary plate, illustrative of the whole subject, which representation I believe to be anterior to Christianity. (See Fig. 72.) It is copied from Moor's *Hindu Pantheon*, not as a curiosity, but as a most singular monument of the crucifixion. I do not venture to give it a name, other than that of a *crucifixion in space*. It looks like a Christian crucifix in many respects, and in some others it does not. The drawing, the attitude, and the nail-marks in hands and feet, indicate a Christian origin; while the Parthian coronet of seven points, the absence of wood and of the usual inscription, and the rays of glory above, would seem to point to some other than a Christian origin. Can it be the Victim-Man, or the Priest and Victim both in one, of the Hindu mythology, who offered himself a sacrifice before the worlds were? Can it be Plato's Second God [*Republic*, c. II, p. 52. Spens' Trans.] who impressed himself on the universe in the form of the cross? Or is it his divine man who would be scourged, tormented, fettered, have his eyes burnt out; and lastly, having suffered all manner of evils, *would be crucified?* Plato learned his theology in Egypt and the East, and must have known of the crucifixion of Krishna, Buddha, Mithra, etc. At any rate, the religion of India had its mythical crucified victim long anterior to Christianity, as a type of the real one, and I am inclined to think that we have it in this remarkable plate....[12]

Lundy's decisive assertions regarding the crucifixion of Indian gods, as well as the "mythical crucified victim long anterior to Christianity, *as a type of the real one*," are more than noteworthy. Throughout his book, Lundy strains himself with this "type of" argument, because he simply cannot deny—and maintain his honesty and integrity—that there were numerous correspondences between pre-Christian Paganism and Christianity. In his extensive defense of Christianity, Lundy—a more reverent Christian could not be found—repeatedly acknowledges that virtually every salient point of Christianity existed in earlier "Pagan" religions:

> The ancient Christian monuments...reveal so many obvious adaptations from the Pagan mythology and art, that it became necessary for me to investigate anew the Pagan symbolism: and this will account for the frequent comparisons...and the parallels drawn between Christianity and Paganism. Many of the Pagan symbols, therefore, are necessarily used in this work—such, for instance, as seem to be types of Christian verities, like Agni, Krishna, Mithra, Horus, Apollo, and Orpheus. Hence I have drawn largely from the most ancient Pagan religions of India, Chaldea, Persia, Egypt, Greece, and Rome, and somewhat from

the old Aztec religion of Mexico. These religions were all, indeed, systems of idolatry, perversions and corruptions of the one primeval truth as held by such patriarchs as Abraham and Job; and yet these religions contained germs of this truth which it became the province of Christianity to develop and embody in a purer system for the good of mankind.

It is a most singular and astonishing fact sought to be developed in this work, that the Christian faith, as embodied in the Apostles' Creed, finds its parallel, or dimly foreshadowed counterpart, article by article, in the different systems of Paganism here brought under review. No one can be more astonished at this than the author himself. It reveals a unity of religion, and shows that the faith of mankind has been essentially one and the same in all ages. It furthermore points to but one Source and Author. Religion, therefore, is no cunningly devised fable of Priest-craft, but it is rather the abiding conviction of all mankind, as given by man's Maker.[13]

With this type of reasoning, and with tremendous prejudice, Lundy tries to make a distinction between Paganism and Christianity, while admitting that Christianity "borrowed" from Paganism. Unlike modern apologists, who seem quite unaware of the erudite works of Lundy and so many other leading Christians of the past two to three centuries, Lundy does not honestly dare to deny that Christianity is founded upon Paganism. Yet, he claims that the former is superior because it represents "religion," while the latter is "mythology," as well as "perversion" and "corruption" of biblical "truths." In his sophistic argumentation, Lundy cites the cases of primitive peoples:

Two illustrations, in what is called savage life, may serve to express more clearly the difference between mythology and religion. Paul Macroy informs...that the Mesaya Indians of the river Japura, cannibals out of revenge, eating only their hereditary enemies, the Miranhas, but whose last cannibal war-feast was held in 1846, and who have only mathematical capacity enough to count as far as three, have yet a well-defined religion, consisting in the belief of a Supreme Being, the Creator and Moving Power of the universe, whom they fear to name, and whose attributes are power, intelligence and love....[14]

Lundy goes on to compare unfavorably another primitive "savage" tribe, the Yuracares, who "neither adore nor respect any deity, and yet are more superstitious than all their neighbours." Nevertheless, as Lundy explains, the Yuracares *do* possess a variety of gods. Now, as this learned Christian is certainly not unintelligent, it cannot be suggested that he himself could not see the paradox in his various statements; yet, again, he exerts every effort in creating a difference between mythology and "true religion," without much success. Also, it is somewhat ironic that

Lundy is compelled to use as examples *savages*, including—as proof of his assertion of the superiority of "religion," as he attempts to define it—a group notorious for the brutality and atrocity of cannibalism. After apparently considering himself successful in thus distinguishing between mythology and religion, Lundy triumphantly remarks:

> Religion, then, differs from the myth in being the product of the reason and understanding rather than the imagination.[15]

Evidently, Lundy considers the beliefs of these savage cannibals to be the "product of reason and understanding!" Furthermore, in page after page of comparison between Paganism and Christianity, the minister shows that the *Christian* imagination could not have been more overworked in its creation of myth, ritual and dogma.

In any case, concerning the Indian crucifix, Lundy continues:

> The annexed plate (Fig. 72) is an exact facsimile of Moor's. Wittoba is one of the incarnations of Vishnu, with holes in the feet, of which Moor gives several examples.[16]

Lundy subsequently seconds his "enemy" Higgins's opinion, contrary to that of Moor, reiterating that the plate is *not* of Christian origin:

> Now this Wittoba or incarnation of Vishnu is Krishna... And so...the hole in the foot must refer to the fatal shot of the hunter's arrow as Krishna was meditating in the forest, and whom he forgave; but the hands also have holes, and these must refer to the crucifixion of Krishna, as spoken of above.

> ...The Pundit's Wittoba, then, given to Moor, would seem to be the crucified Krishna, the shepherd-god of Mathura, and kindred to Mithra in being a Saviour—the Lord of the covenant, as well as Lord of heaven and earth—pure and impure, light and dark, good and bad, peaceful and warlike, amiable and wrathful, mild and turbulent, forgiving and vindictive, God and a strange mixture of man, but not the Christ of the Gospels.[17]

Here Lundy is asserting that the image is of the crucifixion of Krishna, who was a savior, the Lord of the covenant, etc. Regarding his latter declaration that the Indian divinity is "God and a strange mixture of man, but not the Christ of the Gospels," we ask, how not? Christ is all of the things Lundy lists, especially when one factors in the Savior's biblical "Father," the architect of good *and* evil, who is generally not amiable but almost always wrathful, etc. Moreover, Lundy, evidently dismayed by this non-Christian crucifix, unconvincingly attempts to justify its existence as a "prophecy of Christ," as had the early Church fathers done with so many mythical motifs when confronted with their

existence prior to the creation of Christianity. Regarding Lundy's admissions, one writer exclaims:

> One is completely overwhelmed with astonishment upon reading Dr. Lundy's *Monumental Christianity*. It would be difficult to say whether an admiration for the author's erudition, or amazement at his serene and unparalleled sophistry, is stronger. He has gathered a world of facts which prove that the religions, far more ancient than Christianity, of Christna, Buddha, and Osiris, had anticipated even its minutest symbols. His materials come from no forged papyri, no interpolated Gospels, but from sculptures on the walls of ancient temples, from monuments, inscriptions, and other archaic relics, only mutilated by the hammers of iconoclasts, the cannon of fanatics, and the effects of time. He shows us Christna and Apollo as good shepherds; Christna holding the cruciform *chank* [crook] and the *chakra* [wheel], and Christna "crucified in space," as he calls it.... Of this figure— borrowed by Dr. Lundy from Moor's *Hindu Pantheon*—it may be truly said that it is calculated to petrify a Christian with astonishment, for it is the crucified Christ of Romish art to the last degree of resemblance.
>
> As it is, Dr. Lundy contradicts Moor, and maintains that this figure is that of *Wittoba*, one of the avatars of Vishnu, hence Christna, and *anterior to Christianity*, which is a fact not very easily put down. And yet although he finds it prophetic of Christianity, he thinks it has no relation whatever to Christ!"[18]

To be sure, a purported image of a crucified Krishna, preceding Christianity, is a fact not easily ignored, and one must wonder how it came to be so disregarded.

Interestingly, the Wittoba temples whence came these images are located at Terputty and Punderpoor, the former of which was, in Moor's time, under the control of the British, who had purchased the site. It may be asked why the British would be so interested in an avatar purportedly so minor and unimportant as to warrant exclusion of his story from their reports. The avatar was in fact important enough to be widespread and to have designations in a number of dialects—names or titles that included Wittoba, Ballaji, Vinkatyeish, Terpati, Vinkratramna Govinda and Takhur.[19] Concerning Ballaji, Higgins says, "The circumstance of Ballaji treading on the head of the serpent shows that he is, as the Brahmins say, an Avatar of Cristna."[20] Higgins also states that very ancient monuments of the crucified god Bali of Orissa can be found in the ruins of Mahabalipore.[21] It is interesting to note the correlation between Bali and Baali, Baal, Bal or Bel, the Phoenician, Babylonian and Israelite god, whose Passion is represented on a 2,700-year-old Assyrian tablet in the British Museum.[22] Furthermore, among others with the prefix "Bhel" or some other variant, there is an Indian sun-worshipping

site of some antiquity called Bhelapur or Bhaila Pura, "a place of Bhailasvamin," the latter being a name of the sun god.[23] The name Bhailasvamin is quite similar to the Belsamen of the British Isles, with "Brit" also apparently related to "Bharat," the indigenous name of India.

Any evidence of crucified gods in India—asserted by some to be fairly common in sacred areas, but hidden by the priesthood—may today be scant. It is an intriguing coincidence that many of the scholars who unwillingly and against interest exposed this information were not only Christian but also British, and that the British took over pertinent places, possibly with the intent of destroying such evidence, among other motives. As Higgins—himself a Brit—says, "And when we perceive that the Hindoo Gods were supposed to be crucified, it will be impossible to resist a belief that the particulars of the crucifixion have been suppressed." [24] Higgins also states:

> When a person considers the vast wealth and power which are put into danger by these Indian manuscripts; the practice by Christian priests of interpolating and erasing, for the last two thousand years; the well-known forgeries practised upon Mr. Wilford by a Brahmin; and the large export...to India of orthodox and missionary priests; he will not be surprised if some copies of the books should make their appearance wanting certain particulars in the life of Cristna...[25]

And, Higgins further observes:

> Neither in the sixteen volumes of the Transactions of the Asiatic Society of Calcutta, nor in the works of Sir. W. Jones, nor in those of Mr. Maurice, nor of Mr. Faber, is there a single word to be met with respecting the crucifixion of Cristna. How very extraordinary that all the writers in these works should have been ignorant of so striking a fact! But it was well known in the Conclave, even as early as the time of Jerome.

The "Conclave" is the Catholic cardinals' clique that elects popes, a fascinating but un-cited claim.

In his comments concerning these various enigmatic images of an Indian god crucified, Rev. Lundy acknowledges other startling discoveries, of purported *Irish* crucifixes:

> Was Krishna ever crucified? Look at Fig. 61 and see. It is indeed an ancient Irish bronze relic, originally brought to the island from the East by some of the Phoenicians. It is unlike any Christian crucifix ever made. It has no nail marks in the hands or feet; there is no wood; no inscription; no crown of thorns, but the turreted coronet of the Ephesian Diana; no attendants; the ankles are tied together by a cord; and the dress about the loins is like Krishna's. It is simply a modification of Krishna as crucified. Henry O'Brien thinks it is meant for Buddha. But

another most accomplished Oriental scholar says it is Krishna crucified: "One remarkable tradition avers the fact of Krishna dying on the fatal cross (a tree), to which he was pierced by the stroke of an arrow, and from the top of which he foretold the evils that were coming on the earth, which came to pass from thirty to forty years afterwards, when the age of crimes and miseries began; or about the same length of time as intervened between our Lord's crucifixion and the destruction of Jerusalem, an age of bitter calamities and crimes...."[26]

Lundy was obviously convinced that a pre-Christian image of a god was found in Ireland and was Phoenician in origin, representing *Krishna crucified*, as described in the *orthodox* tale. In the first place, pre-Christian Ireland possessed numerous crosses and cruciforms, as at least one of their gods, Hu, the god of light, "died on the cross at the equinox, descending to the southern hemisphere, and was re-born at Christmas, when rising toward the northern summer."[27] In addition, the red-haired Phoenicians are believed to be "Celtic" and therefore related to both the Irish and the Indians, which would make religious correspondences among them more than plausible.

Furthermore, the good reverend provides images of "Irish" and "Egyptian" crucifixes, and remarks:

Here are two crucifixes, one with the wood, and the other without it. Fig. 65 is the old Irish cross at Tuam, erected before Christian times, and is obviously Asiatic; Fig. 66 is from an old Nubian temple at Kalabche, long anterior to the Christian era...[28]

Again, we possess pre-Christian images of crucified gods, according to a pious and learned Christian authority. The same Christian authority verifies, against interest, the crucial information also provided by his "enemy" Higgins, as Lundy terms him.

In his argument against the charge that the Indian priesthood fabricated both the Krishna and the Buddha stories based on the gospel fable, Higgins claims that "Buddha" too was crucified, as he referred to "the immaculate conception, crucifixion, and resurrection of Buddha, in Nepaul and Tibet."[29] In Higgins's assertions, he discusses the equinoctial date (March 25th) for the death and resurrection of a number of solar-fertility gods, and refers to the writings of famed Catholic missionary to the East, Father Georgius, saying:

The following passage from Georgius will show that the crucifixion and resurrection of Buddha took place *precisely at the same time* as all others: In plenilunio mensis *tertii*, quo mors Xacae accidit.[30]

The priest Georgius's remarks, found on p. 510 of his *Alphabetum Tibetanum*, translate as follows: "On the full moon of the third month, wherefore death befalls Saca [Buddha]." Hence, Saca/Buddha dies at the vernal equinox, as is appropriate for a sun god, who would in three days rise again.

Higgins continues with logical and sound arguments against the charge of plagiarism *by* Indians *from* Christians: He notes, for example, the archaeological evidence found at Ellora and Elephanta, as well as the intricacy of the Indian religious system, which indicates antiquity. He then definitively states that the Krishna stories are "most clearly no interpolation" and that they are an intrinsic part of Brahmanism. He further points out the absurdity of supposing that the Christian religion—with its miniscule enclaves in India—could have so influenced the vast subcontinent and its well-established religious system, i.e., the enormous Hindu population, with its "great variety of dialects." Concerning the correspondences between Buddha and Krishna, and the relationship between their two priesthoods, Higgins remarks:

> ...In the history of Buddha, as well as Cristna, are to be found many of the stories which are supposed to be forged; so that the two sects hating one another, and not holding the least communication, must have conspired over all the immense territories east of the Indus, to destroy and to rewrite every old work, to the amount almost of millions; and so completely that they have succeeded that all our missionaries have not, in any of the countries where the Brahmins are to be found, or in which there are only Buddhists, been able to discover a single copy of any of the works uncorrupted with the history of Cristna. Buddha is allowed by Mr. Bentley to have been long previous to Cristna, and he is evidently the same as Cristna, which can only arise from his being the sun in an earlier period.[31]

As can be seen, the charges of plagiarism by the Indians of Christian concepts are unsustainable, and we are left with Indian images of crucified gods, at least some of which likely represent Krishna. Another Indian god depicted in cruciform is Agni,[32] the fire and sun god who so resembled both Krishna and Christ, yet whose story dates to the earliest Vedic period, well over a thousand years before Christianity was created. Also interchangeable with Wittoba and Krishna is the solar hero Indra, who, as noted, was frequently portrayed as crucified as well. The crucifixion of Indra is likewise recorded in Georgius's *Alphabetum Tibetanum*, p. 203, according to Higgins, who provides pertinent passages in the original Latin:

> Nam A effigies est ipsius Indrae crucifixi signa *Telech* in fronte manibus pedibuseque gerentis.

This passage is translated thus:

> For A is the representation of *Indra* himself *crucified,* bearing on
> his forehead, hands and feet the signs *Telech.*[33]

Although written in the 18th century, Georgius's work is in
Latin, which was commonly used in order to go over the heads of
the masses and keep secrets from them. Father Georgius or
"Giorgi's" book contained images of this *Tibetan* savior "as having
been nailed to the cross. There are five wounds, representing the
nail-holes and the piercing of the side. The antiquity of the story
is beyond dispute."[34] Titcomb also relates the crucifixion of Indra
as found in Georgius:

> The monk Georgius, in his *Tibetanum Alphabetum* (p. 203), has
> given plates of a crucified god worshipped at Nepal. These
> crucifixes were to be seen at the corners of roads and on
> eminences. He calls it the god Indra.[35]

In *Asiatic Researches,* Col. Wilford verifies that the "heathen"
Hindus venerated crosses in public places and at crossroads.[36]
The appearance of crucified gods as roadside protectors is logical:
If one were to put up an image of a god as a protector, would one
not make his arms as widespread as possible, i.e., in cruciform?
In fact, it would be surprising if such images did *not* exist. The
same can be said concerning crucifixes situated on eminences or
high places, as well as doorways and other spots.

The Cross and Crucifix

Claims concerning cruciform Indian gods are not implausible
but to be expected, as it is well known that the reverence for the
cross has been found in numerous cultures, long prior to the
Christian era. This germane fact is acknowledged even by the
Catholic Encyclopedia ("Archaeology of the Cross and Crucifix"):

> The sign of the cross, represented in its simplest form by a
> crossing of two lines at right angles, greatly antedates, in both
> the East and the West, the introduction of Christianity. It goes
> back to a very remote period of human civilization.
>
> ... It is also...a symbol of the sun...and seems to denote its daily
> rotation.[37]

The cross existed in the most primitive cultures, including the
Indian Khonds, who regularly lit crosses, a practice also found in
Scotland and Ireland.[38] Thus, a common pre-Christian symbol,
the cross, was revered as a divine sign and emblem of the solar
deity, representing the times of the year when the sun appears to
be "hung on a cross," i.e., the vernal and autumnal equinoxes.

Continuing its discourse on pre-Christian crosses, CE relates,
"In the proto-Etruscan cemetery of Golasecca every tomb has a

vase with a cross engraved on it."[39] Hence, even the practice of marking graves with the cross precedes the Christian era by centuries.

There are a number of different shapes for the "sacred cross," including the "crux gammata," or swastika, which is found around the globe beginning in prehistoric times and appears on Christian monuments as well.[40] As CE further states:

> Many fantastic significations have been attached to the use of this sign on Christian monuments, and some have even gone so far as to conclude from it that Christianity is nothing but a descendant of the ancient religions and myths of the people of India, Persia, and Asia generally; then these theorists go on to point out the close relationship that exists between Christianity, on the one hand, Buddhism and other Oriental religions, on the other.... [The crux gammata] is fairly common on the Christian monuments of Rome, being found on some sepulchral inscriptions, besides occurring twice, painted, on the Good Shepherd's tunic in an arcosolium in the Catacomb of St. Generosa in the Via Portuensis, and again on the tunic of the fossor Diogenes (the original epitaph is no longer extant.)[41]

The "crux ansata" or ankh of the Egyptians, which is a cross with a loop on top—resembling a human stick figure, with arms extended, i.e., a cruciform—is likewise a common motif, representing eternal life.

Regarding the so-called Christian cross, the "crux immissa," with the crossbeam above center, the CE says, "In the bronze age we meet in different parts of Europe a more accurate representation of the cross, as conceived in Christian art, and in this shape it was soon widely diffused."[42] The Bronze Age in Europe extended from around the 3rd to the 2nd millennia BCE; hence, this "Christian" cross was an important symbol long before the common era.

The cross has also been discerned in the Old Testament, predating Christianity by centuries. As the Catholic Encyclopedia further relates, "The cross, mentioned even in the Old Testament, is called in Hebrew...'wood,' a word often translated crux by St. Jerome (Gen., xl, 19; Jos., viii, 29; Esther, v, 14; viii, 7; ix, 25)."[43] Christian writers such as Barnabas asserted that not only was the brazen serpent of Moses set up as a cross but Moses himself makes the sign of the cross at Exodus 17:12, when he is on a hilltop with Aaron and Hur. Concerning the constant, tortured habit of Church fathers to find reference to the Cross in Scripture, i.e., the "Old Testament," Edwin Johnson asks: "Had there been a picture living on amidst the most sacred treasures of memory from the time of Pilate, of a beloved Crucified one, what

need to hunt for the Cross in writings where it is not to be found?"

Along with the sign of the cross in the pre-Christian world are represented gods and humans in *cruciform*, with arms extended. As one example already cited, Mithra—once an Indian god—was so depicted in the ancient Persian sacred text the Avesta. Concerning the cross and cruciform, so obviously Pagan in origin, CE stunningly admits that early Christian artists "did not disdain to draw upon the symbols and allegories of pagan mythology," so long, continues CE, as such symbols and allegories "were not contrary to the Christian faith and morals." These symbols were many, as were the allegories, which is the point comparative mythologists have been proving for centuries: To wit, Jesus Christ's fable is a series of "allegories of pagan mythology"—here admitted in black and white by the Catholic Encyclopedia!

As evidence of this startling disclosure, CE discusses an image from a pre-Christian sarcophagus found in the St. Callistus catacomb, portraying the Greek hero Odysseus/Ulysses "tied to the mast while he listens to the song of the Sirens." He is surrounded by his sailors, whose ears are plugged with wax. This image, the Catholic Encyclopedia declares, "is symbolical of the Cross, and of the Crucified, who has closed against the seductions of evil the ears of the faithful during their voyage over the treacherous sea of life in the ship which will bring them to the harbour of salvation."[44] Thus, CE asserts that the Greek hero Ulysses or Odysseus is bound to a *cross* and symbolizes "the crucified," three centuries before Christ's alleged advent.

In reality, the cruciform image of a god or human with arms extended dates to at least several centuries before the common era:

> Cruciform objects have been found in Assyria. The statues of Kings Asurnazirpal and Sansirauman, now in the British Museum, have cruciform jewels about the neck (Layard, Monuments of Nineveh, II, pl. IV). Cruciform earrings were found by Father Delattre in Punic tombs at Carthage.[45]

It is evident that the images of gods in the shape of a cross were commonly used, likely for protection as well as eternal life. It is therefore not surprising to find *crucifixes* in Pagan iconography, especially as concerns the sun god. It is clear that *a cross with a man on it*, or a crucifix, was revered in pre-Christian times, thus rendering yet another supposedly Christian motif unoriginal, unexceptional and, ultimately, as insignificant as the crucifixes of the pre-Christian gods. The existence of such crucifixes was admitted by early Christian writer Minucius Felix (c. 250) in his *Octavius*, in which Felix denied that Christians worship a

"criminal and his cross," which may signify a denial of Jesus being a "criminal," rather than that Christianity did not then possess the tradition of a god crucified. Nevertheless, Felix asserted that the Pagans *did* so venerate the crucifix, which verifies that the image of a crucified man or god existed among the pre-Christians:

> Chapter XXIX.-Argument: Nor is It More True that a Man Fastened to a Cross on Account of His Crimes is Worshipped by Christians, for They Believe Not Only that He Was Innocent, But with Reason that He Was God....

> *...in that you attribute to our religion the worship of a criminal and his cross, you wander far from the neighbourhood of the truth...* Crosses, moreover, we neither worship nor wish for. *You, indeed, who consecrate gods of wood, adore wooden crosses perhaps as parts of your gods.* For your very standards, as well as your banners; and flags of your camp, what else are they but crosses gilded and adorned? *Your victorious trophies not only imitate the appearance of a simple cross, but also that of a man affixed to it.* We assuredly see the sign of a cross, naturally, in the ship when it is carried along with swelling sails, when it glides forward with expanded oars; and when the military yoke is lifted up, it is the sign of a cross; and when a man adores God with a pure mind, with hands outstretched. Thus the sign of the cross either is sustained by a natural reason, or your own religion is formed with respect to it.[46]

Again, Christian writer Felix, in the 3rd century, takes umbrage at the notion that Christians worshipped a "criminal and his cross," and retorts that the Pagans' own "victorious trophies not only imitate the appearance of a simple cross, but also that of a man affixed to it."

Another early Christian authority, Tertullian (Apol., XVI; Ad. Nationes, XII), likewise confirms the Pagan cross and crucifix, in his response to the charges that Christians adored the cross.[47] In *The Apology*, Tertullian writes:

> ...Then, if any of you think we render superstitious adoration to the cross, in that adoration he is sharer with us. If you offer homage to a piece of wood at all, it matters little what it is like when the substance is the same: it is of no consequence the form, if you have the very body of the god. And yet how far does the Athenian Pallas differ from the stock of the cross, or the Pharian Ceres as she is put up uncarved to sale, a mere rough stake and piece of shapeless wood? Every stake fixed in an upright position is a portion of the cross; we render our adoration, if you will have it so, to a god entire and complete. We have shown before that *your deities are derived from shapes modelled from the cross.* But you also worship victories, for in *your trophies the cross is the heart of the trophy.* The camp

religion of the Romans is all through a worship of the standards, a setting the standards above all gods. Well, as *those images decking out the standards are ornaments of crosses. All those hangings of your standards and banners are robes of crosses.* I praise your zeal: you would not consecrate crosses unclothed and unadorned. *Others, again, certainly with more information and greater verisimilitude, believe that the sun is our god.* We shall be counted Persians perhaps, though we do not worship the orb of day painted on a piece of linen cloth, having himself everywhere in his own disk. The idea no doubt has originated from our being known to turn to the east in prayer. But you, many of you, also under pretence sometimes of worshipping the heavenly bodies, move your lips in the direction of the sunrise.... But lately a new edition of our god has been given to the world in that great city: it originated with a certain vile man who was wont to hire himself out to cheat the wild beasts, and who exhibited a picture with this inscription: The God of the Christians, born of an ass. He had the ears of an ass, was hoofed in one foot, carried a book, and wore a toga. Both the name and the figure gave us amusement.[48]

In this pithy paragraph, Tertullian has given an interesting picture of the Pagan impression of Christianity in the 3rd century, as well as an acknowledgement of the Pagan reverence of the cross and cruciform or crucifix. This Christian writer must also address the allegation that Christians worship the sun, thus admitting that non-Christians perceived the solar orb to be the object of Christian adoration, an assertion, therefore, that has existed essentially from the beginning of the Christian era and that has been made countless times since. Furthermore, Tertullian raises the issue of Christians being accused of worshipping an ass, not as blasphemous a notion as it may appear, since the ass-headed god was popular in Egypt as Set or Seth. In the "quarters of the imperial pages" of Rome was an image of a crucified ass-headed god.[49] Also, "the legend that the Jews worshipped an ass-headed God doubtless derives from the fact that the Samaritan God Tartak (2 Kings 17:31) was so figured."[50]

As the Catholic Encyclopedia points out, Christ was not represented as crucified in iconography until the 6th-7th centuries CE. CE further relates that even though (according to legend) the Emperor Constantine supposedly instituted the "outline of the 'chrisme,' i.e., the "Greek monogram of Christ," chi-rho, the image of Christ crucified was at that time "a Christian emblem...as yet practically unknown."[51] The "chi-rho" (X+P) itself resembles a human cruciform, as CE implies, and examples of it may be found in ancient mason's marks, such as at the palace of Phaestos on Crete, dating from the third millennium BCE.

Regarding the archaeological record, Lundy, an expert on early Christian monuments, concurs that the crucifix in Christianity is a late artistic development: "In the earliest monuments there is no scene of the Crucifixion.... Neither the Crucifixion, nor any of the scenes of the Passion, was ever represented; nor the day of judgment, nor were the sufferings of the lost."[52]

Nevertheless, CE maintained that a "very important monument" dating to the early third century depicts the crucifixion "openly." This image—the one of the ass-headed god, mentioned by Tertullian—is Pagan-made, apparently to ridicule the Christian religion. This graffito, discovered on a beam "in the Pedagogium on the Palatine," depicts a man with an ass's head, wearing a loincloth and affixed to a crux immissa or "regular Latin cross." Near the crucified ass-man is another man "in an attitude of prayer," underneath whom it is written "Alexander adores God." This image, housed in the Kircherian Museum in Rome, "is but an impious caricature in mockery of the Christian Alexamenos," drawn, concludes the CE, "by one of his pagan comrades" in the Pedagogium. CE claims this crucifixion scene is relevant in that it shows that Christians "used the crucifix in their private devotions, at least as early as the third century."

If this ass-headed god is not Christ, it is another god, centuries before Christ himself was ever pictured as crucified, which would explain the Catholic Encyclopedia's insistence on making it a mockery of Christ himself. Lundy claims that this image is in reality the Egyptian god Anubis, although Anubis's original head was that of a jackal. Anubis, the "forerunner" of Osiris, is the "personification of the summer solstice,"[53] equivalent to John the Baptist, and he is indeed depicted in cruciform. The debate over whether or not the Pedagogium image represents him, Christ or the Egyptian god Set/Seth is inconclusive,[54] and it must be kept in mind that there was a Gnostic Christian group called Sethians, who may well have worshipped the ass-headed god. In reality, both sides of the twin-faced god—Horus and Set, in this case—have been depicted as crucified.

In this regard, Doane asserted that the Romans' "man on a cross" referred to by Tertullian was the "*crucified Sol*, whose birthday they annually celebrated on the 25th of December..."[55] It is interesting that the sun god Sol is portrayed with a crown of seven rays, the same number found on the Parthian coronet of the Indian god "crucified in space," and it is likely that this latter image is a depiction of the sun god and solar logos. That the Roman crucifix portrayed the sun god is also asserted by Evans:

Just as the Brahmans represented their god Krishna as a crucified man with a wreath of sunbeams around his head, just as the ancient Assyrians represented their sun god Baal as a man surrounded by an aureole, and with outstretched arms, thus forming a perfect cross, so the Romans reverenced a crucified incarnation of the god Sol, and many ancient Italian pictures of Jesus as a crucified Savior bear the inscription, "*Deo Soli*," which may mean "*To the only God*," or "*To the God Sol*."[56]

To reiterate, the sign of the cross and crucifix were sacred motifs relating mainly to the sun or solar deity. The sun, as a symbol or proxy of the divine, was deemed to sacrifice "himself" and to bestow eternal life; hence, the cross and crucifix became symbols of these concepts. In fact, in India exists an "early Aryan initiation," in which a character named Visvakarma "crucifies the Sun," called "Vikkartana," who is "shorn of his beams," on a cross or "*cruciform* lathe."[57] Here, then, is a non-Christian account of the *sun* of God being crucified on wood.

In any event, the cross and crucifix are astrotheological. After discussing ancient depictions of a god within the circle of the zodiac, Lundy remarks:

So too, are the Pagan crucifixes...and notably the Hindu one, fig. 72, p. 175...doubtless intended to convey the idea of the sacrifice of this central Zodiacal figure for the life of the universe—his going out in space to give life to all others, or the great sacrifice continually going on in nature and in human society whereby crucifixion and death minister to the general welfare and higher life.[58]

Lundy readily acknowledges the pre-Christian reverence of the cross, attempting to trace it to the Hebrew religion, from which, he claims, so many of the "perverted" and "corrupt" Pagan "mythologies" borrowed their ideas. We know through historical studies and archaeology that the assertion that Paganism was plagiarized from the Bible is false; so, any borrowing must have been in the opposite direction. In any case, like others, Lundy observes that when Moses lifted up the serpent of brass, the latter's image was affixed upon a cross, which, as Lundy says, is a "sign of symbol, expressed by the author of the book of Wisdom, according to the Septuagint, as συμβουλον σωτηριας, *the symbol of salvation*. (Num. 21:8-9, and Wisdom, 16:6)."[59]

The cross and crucified god were symbols of salvation, which is essentially immortality of the soul, a concept highly developed millennia ago in Egypt, where we find the crucified god as well. As Cox relates, "To the Egyptian the cross...became the symbol of immortality, and the god himself was crucified to the tree which denoted his fructifying power."[60] "The god himself was crucified to the tree"—the *Egyptian* god, asserts this pious Christian

authority. This fructifying god, again, is the solar deity, i.e., Osiris/Horus. Osiris himself is depicted in the temple ruins at Philae "in the form of a crucifix,"[61] while Horus was also shown in cruciform, *between two thieves*. Indeed, the cross "had symbolic significance in the cult of Osiris.... In the temple of Serapis at Alexandria there was a large image of the god with arms outstretched crosswise."[62]

In describing an Egyptian image of the sun reaching down to his worshippers with hands at the ends of his rays holding the crux ansata/ankh, Lundy states:

> The sun's disc is sending forth rays of light, each ending with a hand; and some are bestowing life's hopes and blessings in the symbol of immortality, the cross. All that was dear in this life, and the life to come, is here intended by these hands holding forth the very sign of eternal life, and coming forth from the one source of all life and blessing.[63]

As is evident, the concept of a divine incarnation who bestows eternal life, salvation, and redemption from sins by his suffering, often on a cross, is old and widespread, anterior to the Christian era.

The list of crucified gods and godmen does not end with the Indian, Egyptian and Roman deities. Kuhn relates that Zoroaster, who was born of an immaculate conception, was "called a splendid light from the tree of knowledge" whose soul in the end "was suspended *a ligno* (from the wood), or from the tree, the tree of knowledge." Kuhn then remarks, "Here again we find the cross or tree of Calvary, the tree of the Christ, identified with the tree of knowledge of *Genesis*."[64] In the centuries before the Christian era, Zoroastrianism was of tremendous interest to the Hellenistic world, which included the peoples of Palestine, i.e., Samaria and Judea. In the library of Alexandria, a city predominantly Jewish or Hebrew (c. 200 BCE) were said to have existed at least 800 scrolls ascribed to Zoroaster, comprising "about two million lines."[65] It is clear that the Jewish priests brought to bear this massive library in their creation of Christianity.

Another crucified god was Prometheus, the Greek titan of fire and foresight. It has been charged by a number of scholars that the version of the Prometheus story passed down through Christian censors has been mutilated to hide its similarities to the Christ myth. As Graves evinces:

> In the account of the crucifixion of Prometheus of Caucasus, as furnished by Seneca, Hesiod, and other writers, it is stated that he was nailed to an upright beam of timber, to which were affixed extended arms of wood, and that this cross was situated near the Caspian Straits. The modern story of this crucified God, which represents him as having been bound to a rock for thirty

years, while vultures preyed upon his vitals, Mr. Higgins pronounces as an impious Christian fraud. "For," says this learned historical writer, "I have seen the account which declares he was nailed to a cross with hammer and nails."[66]

Graves further relates that the "New American Cyclopedia" (i. 157) states that Prometheus was "crucified." Verifying this claim, Lundy first discusses the widely used solar symbol, the swastika, and then remarks:

Dr. Schliemann found it on terracotta disks at Troy, in the fourth or lowest stratum of his excavations, indicating an Aryan civilization long anterior to the Greeks, say from two to three thousand years before Christ. Burnouf agrees with other archaeologists in saying that this is the oldest form of the cross known; and affirms that it is found personified in the ancient religion of the Greeks under the figure of Prometheus, the bearer of fire; the god is extended on the cross on Caucasus, while the celestial bird, which is the *Cyena* of the Vedic hymns, every day devours his immortal breast. The modification of this Vedic symbol became the instrument of torture and death to other nations, and was that on which Jesus Christ suffered death at the hands of the Jews and Romans.[67]

In *Intimations of Christianity Among the Ancient Greeks*, Jewish-Catholic philosopher Simon Weil likewise refers to the "crucifixion of Prometheus upon the rock," as "first shown" in Aeschylus's *Prometheus Bound*, written in the 5th century BCE.[68] Per Weil, Prometheus is also he "whom a tradition recalled by Hesiod [c. 800 BCE] regarded as perpetually crucified..."[69] Even the Catholic Encyclopedia admits that Prometheus was portrayed in ancient times as bound to a *cross*:

On an ancient vase we see Prometheus bound to a beam which serves the purpose of a cross....

...Speaking of Prometheus nailed to Mount Caucasus, Lucian uses the substantive and the verbs...the latter being derived from which also signifies a cross [sic]. In the same way the rock to which Andromeda was fastened is called crux, or cross.[70]

Although the writing is somewhat garbled, the meaning is clear: Prometheus was depicted in pre-Christian times as crucified. Lucian, the Roman writer of the second century, specifically described Prometheus as being "crucified by Zeus."[71] CE also says:

The penalty of the cross goes back probably to the arbor infelix, or unhappy tree, spoken of by Cicero (Pro, Rabir., iii sqq.) and by Livy, apropos of the condemnation of Horatius after the murder of his sister.[72]

Regarding the execution or, rather, expiatory sacrifice upon an "unhappy tree," CE further comments:

> This primitive form of crucifixion on trees was long in use, as Justus Lipsius notes ("De cruce", I, ii, 5; Tert., "Apol.", VIII, xvi; and "Martyrol. Paphnut." 25 Sept.). Such a tree was known as a cross (crux). On an ancient vase we see Prometheus bound to a beam which serves the purpose of a cross.[73]

Obviously, with such an admission against interest made by the world's most powerful Christian organization, we can safely assume that Prometheus *was* bound to a *cross*, and that this information has been suppressed. We can also be assured that other gods and humans were depicted on crosses, since, as admitted by CE, the "primitive form of crucifixion on trees was long in use." In fact, this primitive crucifixion was part of ancient human sacrifice rituals committed in numerous parts of the world.

Prometheus's similarities to the Christian savior do not end with his crucifixion. One of the god's "faithful friends," as portrayed and acted out in Aeschylus's *Prometheus Bound*, some 500 years prior to Christianity, appears Oceanus, the titan equivalent to the Olympian god Poseidon. Poseidon was called *Petreus*, i.e., *Peter*, by the Thessalonians. In the Greek drama, Oceanus/Peter forsakes his friend "when the wrath of God had made him a victim for the sins of the human race."[74]

Yet another deity hung a tree was the Norse god Odin, as Rev. Cox states:

> The myth of Baldur [Odin's son], at least in its cruder forms, must be far more ancient than any classification resembling that of the Hesiodic age [8th cent. BCE].... The Kosmos so called into existence is called the "Bearer of God"—a phrase which finds its explanation in the world-tree Yggdrasil, on which Odin himself hangs, like the Helene Dendritis of the Cretan legend—
>
> | I know that I hung | On a wind-rocked tree |
> | Nine whole nights | With a spear-wounded, |
> | And to Odin offered, | Myself to myself, |
> | On that tree, | Of which no one knows |
> | From what root it springs.[75] | |

In *The Golden Bough* Sir Frazer relates:

> The human victims dedicated to Odin were regularly put to death by hanging or by a combination of hanging and stabbing, the man being strung up to a tree or a gallows and then wounded with a spear.[76]

Thus, the god or his proxy hung on the tree and wounded in the side is a *Pagan* motif, predating Christianity by centuries, if not millennia. As further evidence, the Greek historian Strabo

(64/63 BCE-c. 23 CE) reported that sacrificial victims among the Albanians and the Cypriots were *lanced in the side* by a priest, the Albanian victim being first *anointed with oil*, rituals that also found their way into Christianity.

Regarding these rituals and symbols, Bonwick observes that "not only the Cross, but the Crucifixion, was a sacred symbol many hundreds of years before the birth of Jesus..." "Mithras, as the Sun," he continues, "is represented as crucified at the winter solstice. Vishnu, Buddha, and Indra were, also, said to have been crucified on the cross. The Scandinavians had a crucifixion of the sun ceremony on the shortest of the days."[77]

Moving to the Levant and the area in which Christianity was fomented, the Persian king Cyrus, called the "Anointed" or *Christos* in the Old Testament and whose real name was *Koresh*, similar to *Krishna* and meaning "sun," was depicted as *crucified* in one of the several accounts of his death, as related by Herodotus (6th century BCE).[78]

In reality, the dying-and-rising savior god motif was popular in the pre-Christian era in the very places where the later dying-and-rising savior Jesus made his appearance, a fact admitted by the Catholic Encyclopedia, in its entry under "Paganism":

> Nature worship generally, and Agrarian in particular, were unable to fulfill the promise they appeared to make. The latter was to a large extent responsible for the Tammuz cult of Babylon, with which the worships of Adonis and Attis, and even of Dionysus, are so unmistakably allied. Much might have been hoped from these religions with their yearly festival of the dying and rising god...

The Syrian sun and fertility god Attis was annually hung on such a tree, dying and rising on March 24th and 25th, an "Easter celebration" that occurred at Rome as well. The March dates were later applied to the Passion and Resurrection of Christ: "Thus," says Sir Frazier, "the tradition which placed the death of Christ on the twenty-fifth of March was ancient and deeply rooted. It is all the more remarkable because astronomical considerations prove that it can have had no historical foundation...." This "coincidence" between the deaths and resurrections of Christ and the older Attis was not lost on early Christians, whom it distressed and caused to use the old, dishonest "devil got there first" inanity.[79]

The rites of the "crucified Adonis," the dying and rising savior god, were also celebrated in Syria at Easter time. As Frazer states:

> When we reflect how often the Church has skillfully contrived to plant the seeds of the new faith on the old stock of paganism, we may surmise that the Easter celebration of the dead and risen Christ was grafted upon a similar celebration of the dead and

risen Adonis, which, as we have seen reason to believe, was celebrated in Syria at the same season.[80]

The Syrian god Tammuz, worshipped also by Israelites and Jews (Ezek. 8:14), was crucified around 1160 BCE, says Graves, who asserted that Higgins related this story, and that Julius Firmicus wrote about Tammuz (Thammuz) "rising from the dead for the salvation of the world." Titcomb recounts the same information regarding Tammuz, as well as others, giving the solar meaning of this pervasive mythical motif:

> The crucified Iao ("Divine Love" personified) is the crucified Adonis, or Tammuz (the Jewish Adonai), the Sun, who was put to death by the wild boar of Aries—one of the twelve signs of the zodiac. The crucifixion of "Divine Love" is often found among the Greeks. Hera or Juno, according to the Iliad, was bound with fetters and suspended in space, between heaven and earth. Ixion, Prometheus, and Apollo of Miletus were all crucified.[81]

Interestingly, Tammuz was represented by a tau (T) or *cross*. In *History of the Cross: The Pagan Origin and Idolatrous Adoption and Worship of the Image* (1871), Christian minister Henry David Ward quotes "The Illustrated History of the British Empire in India" as saying, "The mystic **T**, the initial of Tammuz, was variously written. It was marked on the foreheads of the worshippers when they were admitted to the mysteries."[82] This mark was also famously made upon the heads of the initiates into the Mithraic mysteries, during their baptism. In reality, this mark of the cross upon the forehead was common among a number of pre-Christian peoples, including the Persians and Hebrews. In the end, traditions and images of crosses and crucified gods existed abundantly not only in the Pagan world at large but also in the Israelite/Jewish world, and in the very areas in which Christianity was created. The "crucifix-style cross" was an ancient Egyptian symbol that meant "savior," i.e., *Joshua* in the Hebrew or *Jesus* in the Greek.[83] In other words, the cross was already associated with "Jesus" long before the Christian era.

Plato's Second God

In addition to the cross and crucifix images being sacred prior to the Christian era, the "crucifixion in the clouds" of the early Christian "heretics" is a pre-Christian *Platonic* concept, representing the "Second God," who was mystically "crucified" in the lowest of the seven heavens. The Platonic God was "Absolute Being," wholly separate from the rest of creation and only accessible through an intermediary, i.e., his Second God, the "Word" or *Logos*. This Logos "revealed God" and was the "emanation" by which humans could know the Supreme Being.

The Platonic Logos was Judaized when the Old Testament was translated into Greek, producing the Septuagint, which also Hellenized the OT "hero/patriarch" Joshua, a.k.a. *Jesus,* giving him Logos qualities. Plato's Logos eventually became anthropomorphized and historicized in Jesus Christ. In this transition, Philo, the influential Jewish-Alexandrian philosopher of the early part of the first century CE, was very instrumental in giving the Logos, or Son, a more concrete form, short of making it a "personal divine being" in itself.[84] These concepts were carried into Pauline Christianity, which, as a form of Gnosticism, appeared first, rather then being "heretical," and which was followed by the personification and historicization of the Logos as "Jesus of Nazareth" decades later. The similarities between Platonic and Mosaic concepts, as well as between Platonism and Christianity, are admitted by both Jewish and Christian writers:

> In Mosheim's Commentaries, the secret doctrines of Plato and Moses are compared, and it is shown *that by Clement Alexandrinus and Philo* they were held to be the same in every respect; and that it is also held, that they both are the same as the esoteric doctrines of the Christians...[85]

Furthermore, the Pagan philosopher Celsus objected that Platonism was "the original and purer form of many Christian doctrines," forcing Church father Origen to be "constantly forced to discuss Plato..."[86]

The original Pauline Jesus was a mystical, disincarnate entity: the Logos, Wisdom or Son of the Pagans and Hellenistic Jews, who was "crucified in space," precisely the same as Plato's Second God. This concept of a heavenly Word was apparently developed out of the old solar motif of the sun god being "crossified" or crucified during the equinoxes and other transits in heaven. As Marsilio Ficino in 15th century wrote in *The Book of the Sun,* Plato "most exquisitely compares the Sun to God Himself." Again, Ficino said that "our divine Plato named the Sun the visible son of Goodness itself. He also thought that the Sun was the manifest symbol of God, placed by God himself in this worldly temple..."[87] Ficino further remarked that Plato asserted the sun to be the "son of God," a designation commonly found long before the Christian era.

According to the esoteric or gnostic perception—"gnostic" referring to knowledge in general, rather than merely the movement during the Christian era—as this Logos/sun god descended to the earthly realms, he had to become increasingly materialized, experiencing pain and suffering caused by other supernatural agencies, or demons. This suffering, or passion, takes place on a spiritual plane higher than the material world

but lower than the highest non-material level. This spiritual crucifixion is described in the *Ascension of Isaiah*, a transitional text between Judaism and Christianity. The text's relationship to Christianity is evident, such that it could be pronounced an interpolation or forgery by Christians. However, since the concepts essentially existed within Philo's philosophy, as well as in the pre-Christian Septuagint—which includes the title of "Christ"—the *Ascension* may in truth be fairly intact and original. In *The Jesus Puzzle*, Doherty relates the "key passage" from *The Ascension*:

> "The Lord will descend into the world in the last days, he who is to be called Christ after he has descended and become like you in form, and they will think that he is flesh and a man. And the god of that world will stretch out his hand against the Son, and they will lay their hands upon him and hang him upon a tree, not knowing who he is.... And when he has plundered the angel of death, he will rise on the third day and will remain in the world for 545 days. And then many of the righteous will ascend with him."[88]

If this passage is in actuality pre-gospel, it would serve as a *blueprint* for the creation of the "historical Jesus," rather than a "prophecy" fulfilled by his coming. The "god of that world" is a Gnostic expression, indicating its pre-Christian origin, and the "hanging upon a tree" is likewise not a reflection of the gospel depiction, although the tree appears in the descriptions of Jesus's crucifixion in Acts and Galatians, conflicting with the gospel account. The "they" who "lay their hands upon him" are interpreted by Doherty as the "rulers of the age" or archons of the aions, who rule above the material world in the lower spiritual dimension. Hence, in the *Ascension of Isaiah* we possess the "heretical Christian" concept of a Christ crucified in the heavens. Even in orthodox Christianity, Christ is said to have been "allegorically" or "spiritually" crucified in "Sodom and Egypt" (Rev. 11:8). In other words, in the New Testament—held as "gospel truth" and "God's Word"—Christ is depicted as having been crucified three different times in three different places!

In 1 Corinthians 1:23, Paul avers that the crucifixion of the Messiah was a "stumbling block to the Jews," which is to say that it was an alien or *foreign* concept; yet, it is clear that the evangelists used the *canonical* Isaiah's "man of sorrows" as an archetype for their savior. It is likely that when the Jewish creators of Christianity studied the crucified savior-god concept of other cultures, as well as Plato's all-important Second God, they sought precedent in their own scriptures, striking upon Isaiah and Psalms as toeholds for establishing their own crucified messiah. In reality, the idea of a sacred king put to death on a

tree certainly was *not* alien to the Hebrews, Israelites and Jews, as they, like their neighbors and others in numerous parts of the world, practiced this human sacrifice rite for centuries prior to the Christian era.

Indeed, Psalms 22 "predicts" (or, rather, records) the "suffering servant" as having his palms and feet pierced—it is obvious that this type of execution or sacrifice was known at the time this passage in Psalms was written, centuries before the Christian era. Psalms 22 even contains the phrase, "My God, my God, why has thou forsaken me?" put into the mouth of Jesus upon his crucifixion. This biblical chapter is not "prophecy" but obviously a *blueprint* used by the creators of the Christ myth. Also obvious is that, even though the typical crucifixion on a hewn cross had to be committed with nails through the wrists, not the palms, the palm motif is very old. It too can be found in images of Indian gods, even in the seated Buddhas with cross-shaped flowers in their palms.

An encapsulation of the Passion, pretended to be unique to Jesus, is found at Isaiah 53, translated from the Septuagint:

> He bears our sins, and is pained for us...But he was wounded on account of our sins, bruised because of our iniquities...All we as sheep have gone astray, everyone has gone astray in his way, and the Lord [delivered him up] for our sins...because his soul was delivered up to death...and he bore the sins of many and was delivered because of their iniquities.[89]

The depiction of this scapegoat ritual is Platonic as well. As Arthur Drews says in *Witnesses to the Historicity of Jesus*:

> Isaiah 53 speaks of the "griefs" of the just one. But Plato, who also has described, in his *Republic*, the persecutions and sufferings that befall the just man, makes him be *scourged, tortured, cast in prison*, and finally *pilloried* ("crucified"); and in *Wisdom* the godless deliberate about condemning the just to a "shameful death." According to *Deuteronomy* (21:23), there was no more shameful death than "to hang on a tree" (in Greek *xylon* and *stauros*, in Latin *crux*); so that this naturally occurred as the true manner of the just one's death.[90]

Plato's crucified man was well known to the early Christians, such that it is logical to assert that their savior, Jesus Christ, was in significant part based on the Greek philosopher's portrayal. For example, Drews notes that Christian writer Apollonius (c. 180-210) in his Apology referred to Plato's scourged man: "For one of the Greek philosophers also says: The just man will be martyred, spat upon, and at last crucified."

This scapegoat sacrifice was offered up centuries *before* the Christian era and does not refer to the later Jesus, except that, again, it was used as a blueprint in creating the gospel fable. That

Jesus was such a scapegoat is confirmed in the Epistle of Barnabas, who identifies "Jesus" (or Joshua) with the scapegoat in Leviticus 16. To the trained eye, Isaiah 53 concerns the sacrifice of sacred kings, carried out by numerous cultures, including the Canaanites, Israelites and Jews. Indeed, the man of sorrows/suffering servant was common "on all sides of Israel," as Weigall relates:

> The worship of suffering gods was to be found on all sides [of Israel], and the belief in the torture of the victims in the rites of human sacrifice for the redemption from sin was very general. The gods Osiris, Attis, Adonis, Dionysos, Herakles, Prometheus, and others, had all suffered for mankind; and thus the Servant of Yahweh was also conceived as having to be wounded for men's transgressions.[91]

The crucified suffering servant and scapegoated man of sorrows constituted common concepts centuries and millennia prior to the Christian era, in both Judaism and Paganism, in which the servant/man is basically Plato's "Second God." Regarding Plato and the Second God's crucifixion in space, Kuhn remarks:

> If the Christ was in most real truth crucified in space, the physical timber on Golgotha's ghastly height, hewn and sawed and nailed, might be accepted with enlightenment as pure symbol of cosmic process. But as it stands in common thought among Christian people it is a gruesome sign of the most abject stultification of the godlike principle of intelligence known to history.

> Lundy says that Plato must have learned his theology in Egypt and the East, and doubtless knew, from the stories of Krishna, Buddha and Mithra, that other religions had their mythical crucified victims long antecedent to Christianity. Witoba, one of the incarnations of Vishnu, is pictured with holes in his feet.[92]

Even if, despite the evidence, we were to remove the crucifixion theme from the Krishna myth, we would nonetheless find it in pre-Christian Paganism, regarding *some* god or gods, including the Second God of the philosopher Plato, whose works so influenced the Christians and proto-Christians. The crucifixion in the clouds is akin to the castration of Attis, the slaying of the Bull by Mithra, the impregnation of the Virgin Goddess, the labors of Hercules, the exploits of Zeus or any other number of mythical motifs. In other words, it happens "in the sky" or in our imaginations, as a reflection of actual natural processes, such as the courses of the planets, the quality of fertility, etc.

The Two Thieves

The crucifixion between two thieves is likewise a mythical motif found in Pagan cultures, including in the stories of Horus and the Mexican god Quetzalcoatl. Concerning Krishna, after presenting Sir Jones's quotes regarding the Indian avatar's virgin mother, etc., and remarking that they were taken from the earlier, unrevised edition of *Asiatic Researches* (1784), Rev. Taylor comments:

> Had we ventured to supply to these admissions, the further discoveries which unbelieving historians have made, we might have enriched our matter with still more striking coincidences of the facts; that the reputed father of Chrishna was *a carpenter*, and that he was put to death at last *between two thieves*; after which, he arose from the dead, and returned again to his heavenly seat in Vaicontha; leaving the instructions contained in the Geeta to be preached through the continent of India by his disconsolate son, and disciple Arjun."[93]

Taylor ends this paragraph with a quotation mark, but it is difficult to ascertain where the first one appeared. Nor does he cite the source of this apparent quote, unfortunately, but one suspects that it was likewise from *Asiatic Researches*.

Listing over 340 "striking analogies between Christ and Chrishna," Kersey Graves, states:

> Chrishna, as well as Christ, was crucified.... Darkness attended the crucifixion of each.... Both were crucified between two thieves.[94]

After making these statements, Graves informs the reader:

> The author has in his possession historical quotations to prove the truth of each one of the above parallels. He has all the historical facts on which they were constructed found in and drawn from the sacred books of the Hindoo religion and the works of Christian writers descriptive of their religion. But they would swell the present volume to unwieldy dimensions, and far beyond its proper and prescribed limits, to present them here; they are therefore reserved for the second volume, and may be published in pamphlet form also.[95]

It has been proved that Graves did not originate the major contested contentions elucidated herein, such as the virgin status of Krishna's mother and his crucifixion. In fact, these two contentions are located in the earlier works of erudite *Christian* authorities. It would be safe to assume that the two-thieves theme was from the same or similar source. The motif's appearance in Taylor, decades before Graves, and in Georgius/Giorgi over a century before Graves, proves once again that the latter did not fabricate his data. Moreover, several decades prior to Graves it

was told to *Asiatic Researches'* Col. Wilford that "the holy Brahman Mandavya...was crucified among thieves in the Deccan..."[96]

In addition, the two-thieves motif existed in regard to the crucified Mexican savior god, Quetzalcoatl, who, according to one of the four surviving codices, the Codex Vaticanus, was born of the *Virgin Mother* Sochiquetzal. In an account given to the Spaniards, the Mexican natives called their high priest "Pope" (Papa) and referred to crosses "found in Gozumi and Yucatan by the Spaniards," who also saw "a man brighter than the sun...suffering on the Cross."[97] The "man brighter than the sun...suffering on the Cross" is the sun god Quetzalcoatl or Kukulcan, as the Maya called him. That Quetzalcoatl was crucified was demonstrated by Christian scholar Lord Kingsborough in his magnum opus, the *Antiquities of Mexico*, in which he states that there are "several paintings in the *Codex Borgianus*, which actually represent Quecalcoatle [Quetzalcoatl] crucified and *nailed* to the cross."[98] These images are on pages 4, 72, 73 and 75 of the Borgian manuscript (MS.), and Quetzalcoatl's burial, descent into hell and resurrection after three days are depicted on pages 71 and 72. As Kingsborough says, Quetzalcoatl's death represents atonement for sins. In the image on page 72 of the crucified Quetzalcoatl, with nail holes in his hands and feet but no cross, his body "seems to be formed out of a resplendent sun." Kingsborough further says:

> The seventy-third page of the Borgian MS. is the most remarkable of all, for Quecalcoatle is not only represented there as crucified upon a cross of the Greek form, but his burial and descent into hell are also depicted.

Kingsborough next observes that on page 75 of the Borgian MS. one of Quetzalcoatl's palms and both of his feet are apparently pierced. The crucified god in this image also seems to be uttering last words, such as Jesus is depicted as doing while on the cross. Moreover, the god's body is "strangely covered with suns." "If the Jews had wished to apply to their Messiah the metaphor of the sun of righteousness," Kingsborough remarks, "they would perhaps have painted him with such emblems..."[99]

Kingsborough further reports that Quetzalcoatl's crucifix was placed between *two thieves*:

> In the fourth page of the Borgian MS., he seems to be crucified between two persons who are in the act of reviling him, who hold, as it would appear, halters in their hands, the symbols perhaps of some crime for which they themselves were going to suffer.[100]

Furthermore, these images are not the only crucifixes found in Mexico: Others were discovered at Merida and Cozumel, and there is no way to know how many others were destroyed by the Christian conquerors.

As has been demonstrated, the Mexican religion was determined to have much in common with Christianity, at the time of "first contact." In fact, the invading Catholic Spaniards were so stunned to discover in Central America practically their entire religion, along with that of the Jews, combined as one, that they desperately attempted to find a reason for the astounding correspondences. One suggestion was that the Americas had been colonized previously by both Jews and Christians, on separate occasions. However, the "devil got there first" excuse suited the invaders better, as they could then say that the people were possessed of evil and needed to be butchered and their culture destroyed. CMU recounts the "discovery" of Central and South America:

> The Spaniards, in their murderous invasion of Mexico and Peru, were astonished to find there the whole machinery of Christianity; but the priests and the court of Spain smothered the fact as much as lay in their power. The immaculate conception was in full force, by a *Virgin* of Peru becoming pregnant by the *Sun*: the cross was the principal emblem, and had been sacred from time immemorial: one of their Trinity was crucified upon a mountain, *between two thieves*; and also in the sky or heavens, where the serpent...is depriving him of the organs of generation. Here is an astro-fable, known positively to have existed in Syria, and even among the Jews, long anterior to the present version of Christianity; and, therefore, when the early Christians carried over their religion to America, they must have been wicked enough to carry over also the whole of heathen mythoses of Africa and Asia. The Spaniards had likewise the mortification to find the resurrection of the crucified *Saviour*, after three days—the ascension through the clouds, and that his return was expected, to save the human race.

> There is no accounting for these astronomical fables being found in the new world, and their indisputable identity with those of the old, but in the one clear solution of there being, in remote antiquity, one universal solar mythos, or fable history of the planetary system, in which the sun, under a thousand different appellatives, as redeemer or saviour, and as the grand ruling principle of the whole, was the chief object of adoration. This mythos is still prevalent, though abused for the most atrocious purposes.[101]

Undeniably, these stories are "astronomical fables" or astrotheological myths, which is why they are encountered

worldwide. As Lundy relates, the crucified Mexican god was placed among the signs of the zodiac:

> In the Mexican Calenda of the Vatican *MS.* No 3738, copied in Lord Kingsborough's great work, vol. II, p. 75, a nude man, with hair as long as a woman's, is represented outstretched in the midst of the 20 signs of the Zodiac, each sign having relation to some part of the body.[102]

The recognition of the Quetzalcoatl story as occurring in the stars is appropriate, since he is basically a sun god, with the attendant motifs, including the crucifixion between two thieves. This thieves theme is likewise found in the stories of the actual sacrifice of humans, some of whom preceded the Christian era. As Weigall relates:

> ...in a fragment of Ctesias, it is recorded that the Egyptian usurper Inarus was crucified by Artaxerxes I between two thieves; and a Persian saint, Hitzibouzit, of unknown date, is said to have been "offered up as a sacrifice between malefactors on a hill-top facing the sun."[103]

In the solar mythology, the sun god is regularly "crucified" as he crosses over the equinoxes and when he wanes towards the end of the year. The "thieves" denote the stars, or constellations/signs of the zodiac, in particular Sagittarius and Capricorn, which, as the winter descends, steal the sun's strength.

In the Vedic hymns, the stars are indeed considered thieves: "The stars depart before the sun's rays, like thieves." And, "They have been seen in the evening like thieves."[104] Concerning the thieving stars in Indian mythology, Srivastava states, "In the *Rigveda* it is said that at the approach of the all-illuminating Sun the constellations depart with the night like thieves."[105]

Regarding the "long hours" and "gloomy prison house" of night, during which time the sun must be sought after, Cox observes:

> Thus is the daily taking away in the West of all that gives life its value, of all on which life itself depends; and it must be taken away by robbers utterly malignant and hateful. Thus there is also the nightly search for these thieves—a search which must be carried on in darkness amidst the many dangers and against almost insurmountable obstacles...[106]

In addition, concerning the Greek legend of the return to Ithaca by Odysseus/Ulysses, another "crucified" solar hero, Cox relates:

> He has fought the battle of the children of the sun against the dark thieves of night, and now his history must be that of the lord of the day as he goes on his journey through the sky in storm and calm, in peace or in strife.[107]

It is clear that the story of the sun god suspended or "crucified" in space who is surrounded by and battles the thieving stars or constellations is an old pre-Christian theme found in a number of places globally.

The Cult of Human Sacrifice

The crucifixion of the god is astrotheological, but it is also an aspect of fertility worship, as well as an appeasement of an angry deity or evil spirit. In fact, the crucifixion or "hanging on the fatal tree" has another, more sinister meaning: human sacrifice, which has been carried out thousands of times in numerous places the world over for centuries and millennia since the dawn of human history. The list of cultures that practiced human sacrifice over the ages is long and varied. In *Phoenician Ireland*, Villanueva recites several such cultures around the Mediterranean:

> The Thessalians we find used annually to sacrifice a man to Peleus and Chiron; so used the Scythians foreigners to Diana. As the Syrians used to slay a virgin annually in honor of Pallas, so used the Arabians a boy. The Curetes, like the Phoenicians, used to sacrifice some of their children to Saturn; the Lacedemonians, a man to Saturn; the Chians, another to Bacchus; the Salaminians, another to Diomed; and the Rhodians, another to Saturn; whilst the Phrygians, in the heat of their superstitious zeal, used miserably to burn and sacrifice *themselves* to the great mother, Cibele.[108]

Far from being a "unique event" in Christianity, the expiatory sacrifice was widespread, found in Babylon, Gaul, Carthage, Italy and Egypt, as other examples. The ancient authority on the mysteries Iamblichus stated that in Egypt "the human being is everywhere sacred," to which his editor Wilder responded:

> In other words, likely to be a victim at the altar. "As Manetho related, they were used in archaic times to burn living men in the city of Ilithyia, styling them Typhonian." Aahmes, who expelled the Hyksos rulers, put an end to the custom. It existed in Asian countries, where Semitic worship existed, and even the Hebrews seem not to have been an exception.[109]

These rituals were also carried out by the Israelites/Jews, the very people from whom Christianity sprang.

Despite the constant emphasis on differences and the exhortations to be separate from the "goyim," Judaism, like Christianity, is simply Paganism repackaged, with its own idiosyncratic twists and ethnic quirkiness. The Paganism in Judaism is readily demonstrated in the Israelites' propensity to "whore after other gods," i.e., to be polytheistic. One of the favorite Canaanite and Israelite gods was El, who was the same as the Roman Saturn. Saturn was also the main god of the

Carthaginians, colonists of the Phoenicians, who worshipped the god as Molech/Moloch, to whom human sacrifices, including children, were frequently made. In this regard, rulers often "offered up their most beloved children" in order to insure good fortune. Eventually this sordid ritual trickled down to the masses, with children purchased for the purpose if there were none readily available. "This horrid custom prevailed long among the Phoenicians, the Tyrians, and the Carthaginians, and from them the Israelites borrowed it, although expressly contrary to the order of God."[110] As Tierney says:

> Our own society has child sacrifice written on our twin foundation stones—the attempted sacrifice of Isaac, son of Abraham, on Mount Moriah, and the sacrifice of Jesus, Son of God, on Mount Calvary.[111]

To the Old Testament writers human sacrifice was apparently so well known that, when Abraham was called by God to sacrifice his son, Isaac, it was implicit that the (ancient) reader or hearer would not even blink an eye at such a concept. No explanation is given; indeed, the story is a lesson in not making such sacrifices, an injunction that would only be necessary if it were commonly practiced. Concerning the sacrifice, Robertson observes:

> The sacrifice of children was at one time as normal among the Semites as among the ancient Mexicans and Peruvians. Such practices became more and more rare as civilization advanced, though they persisted in one or two places even in the Roman Empire. It was only in the time of Hadrian that the annual human sacrifice to Zeus was abolished at Salamis in Cyprus.[112]

So common was the Hebrew human sacrifice that the Catholic Encyclopedia ("Sacrifice") is forced to admit:

> It is true that the baneful influence of pagan environment won the upper hand from the time of King Achaz to that of Josias to such an extent that in the ill-omened Valley of Hinnom near Jerusalem thousands of innocent children were sacrificed to Moloch.[113]

Widespread too was the cannibalistic eucharist, or sharing of the "god's" body and blood after the sacrifice ("theophagy" or "god eating"). In the very areas overtaken by Christianity, with its story of a godman sacrificed for the sins of the people and eaten for the purpose of communion, were abundantly practiced just such a scapegoat ritual and eucharist. In reality, these violent and bloody rites are very old concepts that link many of the world's religions together, despite their divisive facades. The significance of the cannibalistic eating and drinking of the blood and body is explained by Budge:

The notion that, by eating the flesh, or particularly by drinking the blood, of another living being, a man absorbs his nature or life into his own, is one which appears among primitive peoples in many forms. It lies at the root of the widespread practice of drinking the fresh blood of enemies—a practice which was familiar to certain tribes of the Arabs before Muhammad... The flesh and blood of brave men also are, among semi-savage or savage tribes, eaten and drunk to inspire courage.[114]

Budge makes these comments in regard to a passage from the pyramid of the Egyptian ruler Unas, in which Unas is depicted as "eating" all the gods, thereby taking on their magical powers and eternal life. Arabs, of course, were not the only culture to practice cannibalism, which was a solemn rite in a number of religious groups and ethnicities, eventually becoming sanitized as the Christian eucharist. Ancient Jews were also known to practice it, to the extent that they have been called "horrible cannibals." In *Antiquities of Mexico*, Lord Kingsborough writes:

In nothing did the Mexicans more resemble the Jews than in the multitude of their sacrifices...

It was customary amongst the Jews to eat a portion of the flesh of sacrifices, and to burn the rest; and Peter Martyr in allusion to that custom says in the fourth chapter in his fifth Decad, that, "As the Jews sometimes eate [sic] the lambs which were sacrificed by the old law, so do they eat mans [sic] flesh, casting only away the hands, feet, and bowels."[115]

Kingsborough also says:

All the Spanish authors agree that no suffering from famine could induce the Mexicans, when closely besieged by Cortes, to eat the flesh of their country men who had been killed: whence it must be inferred that they only ate the flesh of sacrificed and devoted victims. The Jews were less able to withstand the torments of hunger.[116]

In support of this contention, Kingsborough cites biblical passages, including 2 Kings 6, in which a woman confesses to the king of Israel to have eaten her own son, during a siege by the king of Syria. Kingsborough notes that the woman is Samaritan, i.e., northern Israelite, rather than Judean; however, Judeans have also been represented as practicing cannibalism, both in the Bible (e.g., Deut. 28:53-57, Micah 3) and by other writers, such as Appion and Strabo. Micah 3, in fact, represents God chastising the "heads of Jacob" and "rulers of the house of Israel" for flaying and eating His people:

And I said: Hear, you heads of Jacob and rulers of the house of Israel! Is it not for you to know justice?—you who hate the good and love the evil, who tear the skin from off my people, and their flesh from off their bones; who eat the flesh of my people, and

flay their skin from off them, and break their bones in pieces, and chop them up like meat in a kettle, like flesh in a caldron.

From the description, it sounds as if the writer had witnessed such grotesque events firsthand. It does not surprise us that, along with the pervasive general human sacrifice, this grisly ritual also took place in Palestine. In any case, that the Jewish priesthood committed human sacrifice, as did that of so many other cultures, cannot be denied. As Kingsborough further remarks, "We have...the highest authority—that of the Scriptures—for affirming that the Jews did frequently perform human sacrifices..." He then cites Garcia's *Origin of the Indians* for scriptural authority regarding Jewish human sacrifice. Kingsborough also reiterates that there were significant similarities between the Jewish and Mexican priesthoods:

> We must further observe that as amongst the Jews it was customary for the priests to flay the victims, and afterwards take their skins—as may be proved from the following texts of Scriptures...

His Lordship proceeds to name 2 Chron. 20, Lev. 7 and Num. 25, the latter of which demonstrates the construction of a charnel house for the heads, much as was found in Mesoamerica. Moreover, the Mexican-Jewish connection does not end there, as the "Mexicans were accustomed to break the legs of a crucified person on one of their most solemn festivals, and to leave him to die on the cross."[117]

Like the Semites, the Mexicans engaged in theophagy, or god eating; indeed, one such communion occurred at the winter solstice, when the Aztecs, as Frazer relates, "killed" the god Huitzilopochtli "in effigy," after which they ate him. Presumably, the effigy was a human proxy. Preceding this ceremony, a man-shaped image of the god was created with dough made of assorted seeds and the blood of children.[118]

Frazer further recounts that, according to the Franciscan monk Sahagun, who was "our best authority on the Aztec religion," another human sacrifice was committed at the vernal equinox, i.e., Easter, the precise time when the archetypical Christian Son of God was put to death in an expiatory sacrifice.[119] As it was in so many places, the Mexican Easter ritual was practiced for the purpose of fertility and the resurrection of life during the spring. Another example of the astrotheological human sacrifice can be found in North America, where the Pawnees sacrificed a victim at the vernal equinox.[120]

The human sacrifice ritual around the Mediterranean, birthplace of Christianity, was virtually identical in important aspects to the Passion portrayed in the gospel story. This ritual

often required a sacred king, whose death, it was believed, would propitiate a god and ensure good fortune and fecundity. During a national crisis, it was deemed necessary for the king to sacrifice his own son or sons, "to die for the whole people," for the same reason.[121] In the ancient Semitic sacred-king sacrifice, which was the same as the Passion of Christ but which preceded Christianity by centuries and millennia, the proxy of the god was first anointed as king and high priest. Next, he was clothed in a purple cloak and crown, and led through the streets with a scepter in his hand. The crowd adored him, and then he was stripped and scourged. Finally, in the third hour, he was killed, often by being hung on a tree and stabbed, with his blood collected and sprinkled upon the congregation in order to ensure their future fertility and fecundity. At that point, the faithful crowd ritually cried, "His blood be upon us and our children!" (Mt. 27:25) After the sacrificial victim's death, the women mourned, wailed and tore their hair at their loss, and his body was eventually removed at sunset, buried in a sepulcher and covered with a stone. Adonis and Tammuz are two of the pre-Christian Near Eastern gods in whose names were practiced such sadistic rites, echoed in the New Testament.[122]

In more "civilized" eras and areas, the "sacred king" ritual required a condemned criminal, such as was used to appease the "ancient Semitic deity Kronos at Rhodes," as Porphyry relates. After being given wine, this criminal was paraded through the streets, to the outside of the city, where he was executed. In the case of "king" Kronos, the victim was likely a proxy either for Kronos himself or for his "only begotten son," Ieoud, a name that actually means "only begotten." In the myth, Kronos first dresses Ieoud in royal robes and then sacrifices him upon an altar.[123] As reported by Philo of Byblus (1st cent. CE), in their own human sacrifices the ancient Jews practiced much the same scapegoat ritual. Interestingly, Kronos, "whom the Phoenicians call *Israel*," and who is the father of "the only begotten son," is also *Moloch*, the "king" and burning aspect of the sun, a god to whom sacrificial victims were immolated, including by the Israelites. Another pre-Christian example of a Semitic scapegoat, provided by both Herodotus and Diodorus Siculus, exists in the legend that King Cyrus—the Messiah/Anointed ("Christos") of biblical Jews—himself was a victim of the sacred king sacrifice or "crucifixion."

These sacrifices were actual, physical events that took place at a nauseating rate. The facts that a principal motivation of the Christian creators was to produce a "once-for-all" sacrifice, and that this grotesque and pitiful act is central to the supposedly

revealed religion, demonstrate how pervasive and important was
this practice. The sacrificial ritual was, in reality, a core tenet in
numerous religions around the globe for millennia, including
those of "inferior" and "barbaric" cultures. The sacrifice of Jesus,
in actuality, is as barbaric as was the sacrifice by these cultures
of *their* sacred kings. In other words, Christianity does *not*
represent a "stunning break" from "vulgar Paganism." It *is* vulgar
Paganism.

Frequently, the sacred victim was hung on a "fatal tree," also
considered a "cross," as in the gospel myth. This part of the ritual
was practiced by the Hebrews, Israelites and Jews as well. For
example, the sacred king sacrifice is represented in the story of
Joshua hanging the king of Ai:

> And he hanged the king of Ai on a tree until evening; and at the
> going down of the sun Joshua commanded, and they took the
> body down from the tree, and cast it at the entrance of the gate
> of the city, and raised over it a great heap of stones, which
> stands there to this day. (Jos. 8:29)

The same ritual takes place when Joshua hangs the five
Amorite kings (Jos. 10:26). There can be no question, knowing
the propensity of the theocentric, or megalomaniacal, Israelites to
make everything into a religious affair, that these hangings
possessed ritualistic significance. Even the most mundane
activity had its religious prescription; obviously, greater events
did as well. Indeed, to be hung on a "bois fatal" or "fatal tree" in
the name of the Jewish Lord was to be consecrated to him, in the
same manner as in the human sacrifice practiced in numerous
other cultures globally for millennia. In this regard, in *Ancient
History of the God Jesus* Dujardin elaborates that the kings in the
biblical book of Joshua were killed first, then "crucified" or hung
on trees, from which they were removed at sunset and buried
beneath stones. He then states that this "mode of crucifixion"
doubtlessly "represents the survival of a sacrificial custom," an
expiatory sacrifice, as were from the earliest times "all criminal
executions." Dujardin continues:

> Lastly, the legal provision, in stating that the crucified was
> "accursed of God," testifies that in ancient times the victim was
> consecrated to the God, for we know that in primitive times
> cursing was equivalent to consecration. The punishment of
> crucifixion flourished among the Persians, Egyptians and
> Carthaginians; the Asmonean princes made a horrible custom of
> it, and the Romans adopted it. The punishment of crucifixion
> differed essentially from sacrificial crucifixion in that sacrificial
> crucifixion, at least in Palestine, was practised after death, while
> in the penal the living man was crucified.[124]

The story of Joshua in general relates the sacrifice to Yahweh of thousands of humans by the Israelites, as the latter are depicted slaughtering their way through Canaan:

> Then they utterly destroyed all in the city, both men and women, young and old, oxen, sheep, asses, with the edge of the sword. (Jos. 6:21)

> When Joshua and the men of Israel had finished slaying them with a very great slaughter, until they were wiped out... (Jos. 10:20)

> So Joshua defeated the whole land, the hill country and the Negeb and the lowland and the slopes, and all their kings; he left none remaining, but utterly destroyed all that breathed, as the LORD God of Israel commanded. (Jos. 10:40)

> And Joshua turned back at that time, and took Hazor... And they put to the sword all who were in it, utterly destroying them; there was none left that breathed, and he burned Hazor with fire. And all the cities of those kings, and all their kings, Joshua took, and smote them with the edge of the sword, utterly destroying them, as Moses the servant of the LORD had commanded.... And all the spoil of these cities and the cattle, the people of Israel took for their booty; but every man they smote with the edge of the sword, until they had destroyed them, and they did not leave any that breathed. (Jos. 11:10-15)

And so on, ad nauseam. The Jewish hanging ritual continued at least into the second century BCE, when the Hasmonean/ Maccabean king Alexander Janaeus allegedly hung 800 Pharisees on trees or "crosses." "Crucifixion" or tree hanging thus existed in the Levantine world centuries before the time of the Romans.

The most well known account of biblical human sacrifice is that of our Lord and Savior Jesus Christ. Jesus himself is depicted in the book of Acts both as crucified (2:23) and hung on a tree (5:30). At Galatians 3:13, Paul also refers to Christ as being hung on a tree:

> Christ has redeemed us from the curse of the law, having become a curse for us—for it is written, "Cursed be every one who hangs on a tree"...

Jesus's death is an *expiatory* sacred king sacrifice, not the punishment of a criminal. To reiterate, Christ is an archetypical, sacred-king human sacrifice, the most famous example of such in the world. Nevertheless, Jesus could also be considered a "criminal" since criminals were often used as proxies for the sacred king, which is evidently the source of the gospel story of *Jesus* Barabbas. Because of the propagation of the Christ fable, with the conditioning that it is somehow a wonderful story, this primitive and bloody "mystery" still mesmerizes the atavistic

faithful, reflected in exuberance such as that expressed by Rev. Lundy:

> The highest and best exponent of this love of God is in the sacrifice of Christ on the Cross, typified by animal sacrifices of old, and perpetuated in the memorial Eucharistic oblations now and until the end of time.[125]

The notion that this savage and barbaric act is "the highest and best exponent" of God's love is illogical, irrational and repulsive, as is the cannibalistic concept of the eucharist, the eating and drinking of the god's body and blood ("theophagy"), which, as we have seen, was actually carried out in ancient times with real persons as the god's representatives.

The cornerstone of Christianity, the expiatory sacrifice for the cleansing of sins, was commonplace and routine, having occurred countless times in numerous eras and places, among a variety of cultures and ethnicities, with a plethora of victims. To claim its uniqueness within Christianity is not only absurd but also untruthful. In addition, it is frankly inconceivable why any decent ideology would claim such a horrid and barbaric act as its central tenet—and as one of God's highest concepts!

It is to be expected that this widespread practice—recorded in "sacred" texts, including the Bible, *The Iliad* and others—was found abundantly in India as well, in much the same manner and for the same reasons. As Tierney relates, "The [Indian text] *Rajasuja* frankly states that human sacrifice is the most auspicious ritual, one that turns the victim into the creator god, Prajapati, the Great Victim."[126] Another text, the *Satapatha Brahmana*, affirms that "in the beginning the sacrifice most acceptable to the gods was man," which implies that early Indians broadly practiced the rite.

In reality, human sacrifice and cannibalism were practiced by a number of Indian cultures, such as the aboriginal races called the Gonds and Khonds, subgroups of the Dravidian family. The Khonds and Gonds are very similar, with the same human sacrifice rites. Regarding the Gonds, in *The Religions of India* Hopkins states:

> Their religion used to consist in adoring a representation of the sun, to which were offered human sacrifices. As among the Oraons, a man of straw (literally) is at the present day substituted for the human victim. Besides the sun, the moon and stars are worshipped by them. They have stones for idols, but no temples.[127]

In their rite, during the year preceding the sacrifice the Gonds treated the victim like royalty.[128] At the appointed time, the "king" was anointed with oil, and a sacred spear was thrust through his

side, into his heart, the parallels with the Christian myth being obvious.

To the Khonds, human sacrifice was their "chief rite" and, although it was committed to the earth goddess, *Tari*, their "chief divinity" also was the sun. The sacrifice to the sun or war god served as a territorial boundary marker, with these particular victims captured young and treated kindly until adults. When the time came, they were "slowly crushed to death or smothered in a mud bath, and bits of their flesh [were] then cut out and strewn along the boundary lines." The preferred gender of the victim has been male, but girls have been used as well. The Khond victim was called the "Meriah," the representative or proxy of the god;[129] hence, he is essentially a "sacred king" whose sacrifice was considered an act of salvation. The Khond sacrifice occurred as follows:

> The Khonds, an aboriginal hill tribe, have a supply of victims who know they will be sacrificed one day. They have either been bought as children, or they have volunteered, since by such death they are made gods. They are slain while bound to a cross, but at one stage they are given a stupefying drug and their legs are broken.[130]

Here is a recurring ritual of primitive tribes, involving a would-be savior god and sacred king, who is "bound to a cross," given a drug and suffers his legs to be broken! This ritual is what is depicted in the gospel fable: It did in fact happen, repeatedly, in numerous places, over a period of centuries and millennia, not as a one-time occurrence in Judea to the "only begotten son of God." In reality, the sacred-king ritual victims were typically considered "incarnations of God." Even if the gospel tale were true, in this sacrificial part, it would represent an entirely mundane event. However, the New Testament story is *archetypical* and *allegorical*, not "historical."

The breaking of the legs, as an apparent act of mercy that hastened death, was common in Jewish but not Roman crucifixion,[131] while the crucifixion upon a *hewn* cross was purportedly not introduced into Palestine/Judea until Roman times. This leg-breakage dates to an earlier time, when the victim was hung on an unhewn "fatal tree." Yet, the Khonds, for one, also used an *adjustable cross*:

> Finally he was either fastened to a cross of which the horizontal bar, pierced by the upright, could be raised or lowered at will; or alternatively placed in the cleft branch of a green tree, which was made to grasp his neck or chest. The effect was to imprison him in the wood so that he himself was virtually the upright of the cross. One of the most significant acts in the entire ritual occurred at this stage. It was essential that the victim should not

finally resist. To make sure, his arms and legs were broken and
he could be made passive by drugs. The priest then slightly
wounds him with an axe, and the crowd instantly cuts him to
pieces, leaving only the head and intestines untouched. These
are subsequently burned and the ash spread over the fields or
laid as a paste on houses and granaries. Portions of the flesh
were solemnly carried to the participating villages and
distributed to the people for burial in the fields.[132]

This primitive Khond religion included the supposedly
superior notion of one all-powerful God:

> Despite their acknowledged barbarity, savageness, and
> polytheism, they have been soberly credited with a belief in One
> Supreme God, "a theism embracing polytheism," and other
> notions which have been abstracted from their worship of the
> sun as "great god."

> Since these are by far the most original savages of India, a
> completer sketch than will be necessary in the case of others
> may not be unwelcome. The chief god is the light- or sun-god. "In
> the beginning the god of light created a wife, the goddess of
> earth, the source of evil." On the other hand, the sun-god is a
> good god. Tari, the earth-divinity, tried to prevent Bella Pennu
> (sun-god) from creating man. But he cast behind him a handful
> of earth, which became man. The first creation was free of evil;
> earth gave fruit without labor (the Golden Age); but the dark
> goddess sowed in man the seed of sin. A few were sinless still,
> and these became gods, but the corrupt no longer found favor in
> Bella (or Boora) Pennu's eyes. He guarded them no more. So
> death came to man. Meanwhile Bella and Tari contended for
> superiority, with comets, whirlwinds, and mountains, as
> weapons. According to one belief, Bella won; but others hold that
> Tari still maintains the struggle. The sun-god created all inferior
> deities, of rain, fruit, hunt, boundaries, etc., as well as all
> tutelary local divinities. Men have four kinds of fates. The soul
> goes to the sun, or remains in the tribe (each child is declared by
> the priest to be...deceased and returned), or is re-born and
> suffers punishments, or is annihilated.[133]

Here we have not only the hanging on a fatal tree but also a
form of monotheism among savages. Moreover, a resemblance
exists between Bella and Bel/Baal, the Babylonian/Canaanite/
Phoenician/Israelite god who suffered a passion practically
identical to that in the gospels, and to whom the Israelites, for
one, sacrificed humans and devoured them afterwards.[134]
Concerning the word "Pennu," it is interesting that, in the Book of
the Dead, Osiris is the "Bennu," the Egyptian term for the
"phoenix bird," representing the "soul of Ra, and the guide of the
gods into the underworld."[135] The bennu is thus a "sun bird."[136]

In describing the aboriginal Indian religion, Hopkins also notes the worship of another tribe, the Paharias, known for their honesty:

> They believe in one god (over each village god), who created seven brothers to rule earth. The Paharias descend from the eldest of these brothers. They believe in transmigration, a future state, and oracles. But it is questionable whether they have not been exposed to Buddhistic influence, as "Budo Gosain" is the name of the supreme (sun-)god.

These "seven brothers" are likely the seven "planets" that constitute the days of the week, demonstrating the astrotheological nature of the primitive religion as well. Hence, we encounter one extraordinary assertion after another concerning these primitive tribes, assertions no doubt correct but loaded with implication as to the origins of current, seemingly more sophisticated religions. The last statement is remarkable for a couple of reasons, not the least of which is that, if "Budo Gosain" is not derived *from* Buddhism, it may actually be a source *of* that religion. And, how came this primitive tribe to worship the sun god by the name of "Buddha," unless that avatar is likewise an ancient sun god?

Another tribe, the Garos, near Bengal, "eat everything but their totem" and "immolate human victims..."[137] At weddings, they also sacrifice a cock and hen to the sun, the cock in particular being a solar symbol, as it announces the rising of the sun. This solar motif is reproduced in the New Testament, with the story of Peter and the thrice-crowing cock. Moreover, the sun-worshipping Savaras or Sauras of the Deccan possess as their "most interesting deity" a "malevolent female called Thakurani, wife of Thakur," the latter being a sun god whose effigy is bathed in the "holy water" of Indian rivers.[138] It is noteworthy that "Takhur" is one of the names of the (Wittoba) avatar evidently depicted as crucified. Indeed, this primitive tribe also possessed the concept of an avatar, i.e., a god incarnate on Earth, represented in the human sacrifice, as was the case with the Khonds and in other parts of the world, including the Middle East and Mexico.

In these remarkable paragraphs regarding the Indian aborigines are many major religious concepts, including those found in biblical theology, fables and rituals. Yet, they are conceived and practiced by the "lowest savages!" Furthermore, these various religious ideas are obviously original to the aborigines and predate the biblical era by centuries to millennia. A number of researchers have asserted that Judaism, which in large part spawned both Christianity and Islam, is traceable to

India, with, for example, one migration represented by the story of Abraham and Sarah migrating from "Ur of the Chaldees" to Canaan. In discussing another of the wild Indian tribes, the Bhars, or Bharats, who lived in Oude, Hopkins posits that the tribe is the same as that which contributed the indigenous name of India, *Bharata*, as in "Mahabharata."[139] A relationship between "Bharat" and "Brith," Hebrew for "covenant," has been propounded, as well as between "Oude" or "Ayodia" and "Iudea" or "Judea." These are but a few of the correspondences between the Indian and Judean cultures. In any event, again, the primitive aboriginal religions and traditions possessed most if not all of the salient religious concepts developed over the millennia and found in today's major faiths.

The custom of sacrificing a sacred victim by hanging him on a tree/cross was widespread in ancient times, long before the Christian era. Is it reasonable to insist that this common and all-important rite was never *depicted* in any form in India, where it had existed for millennia? It is this aboriginal rite in part being portrayed in the images of the crucified Indian god. As noted, the Lord Krishna is evidently an aboriginal god, the Dravidian dark god Mal or Mayon; since the Dravidian Gonds and Khonds were essentially sun worshippers, offering their victims to the sun god, and Mayon/Krishna is a sun god, it is more than logical to submit that he was depicted as crucified. As the sun god is astrologically "crucified" in the heavens, as well as being the recipient of the sacrifice and its victim by proxy, so the sacred sun king "Krishna" was crucified or hung on a tree.

Conclusion

Over the centuries, Christian travelers and scholars recorded the existence of images and legends of crucified gods in India, including Wittoba or *Krishna*, evidently independent of Christian influence. These images of Wittoba/Krishna reveal a god crucified in space or on wood, sometimes with nail holes in the hands and/or feet. Summarizing this "crucifixion conspiracy," the author of *Christian Mythology Unveiled* writes:

> The name Chrishna, Christna, or Christ, was common to Egypt as well as to India, in the remotest known antiquity. In the Sanscrit Dictionary, the name of the Nile is Christna; which is further proof of what Sir William Jones says about the exceedingly ancient intercourse which subsisted between India and Egypt "before the time of Homer." And...this pious author, and several other writers on eastern affairs, seem carefully to have avoided saying a word about the crucifixion of the Hindoo Saviour; and many Christians have exulted in the similarity of the legends being entirely broken off by this pretended

discrepancy. But the fact is incontrovertible that not only was Christ, or Christna, crucified in India, but in Egypt, "also," as we have already shown on Scripture authority. Mr. Higgins asserts that the Brahmin "crucifixion was well known in the time of St Jerome," who, like the Evangelist John, *was rather apt to tell astronomical secrets.*

Mons. Guigniaut says, "The death of Chrishna is variously related: one averred tradition very remarkably represents him to have perished on a fatal tree, or *cross*, where he was pinned, or nailed with an arrow." Mr. Moor, in the "Hindoo Pantheon," states that many of the plates and pictures of India, of undoubted antiquity, represent the god Christna, with cicatrix, or scars in his hands and feet, the very points of the nails by which he was suspended from that fatal tree. Plate 98, in the Hindu Pantheon, shows the figure of a man suspended on a cross; and it appears that when the Romish artists imitated this Indian crucifixion in their carvings and paintings, *they omitted the cross itself*: their reason for this is very obvious. The figure appears hanging in the sky, with arms distended, and the feet overlapping each other, so that one nail might perforate both at once. Now it is not a little extraordinary *that some of the earlier Christian sects maintained that Christ was crucified in the sky.* Here is a direct demonstration that the Brahmin crucifixion is, wholly and radically, an astronomical allegory of the equatorial *crossings* of the sun at the Equinoxes; and that the Christian fable is identically the same, but the scientific meaning is lost, through the fraud of priestcraft, and the ignorance it fosters.

Mr. Moor further observes that having some apprehension of giving offence to the bigoted and prejudiced on these points, he showed the plates and paintings above-mentioned to a friend, who suggested the propriety of omitting plate 98.

"I very much suspect," says Mr. Higgins, in his Anacalypsis, "that it is from some story, now unknown, *or kept out of sight,* relating to this Avatar, that the ancient heretics alluded to, obtained their tradition of Jesus being crucified in the clouds."[140]

Particularly apparent were crossroads images of gods, which were cruciform and commonplace. In fact, the cross and crucifix were revered worldwide centuries or millennia prior to the Christian era, representing protection not only during this life but also in the afterlife, as symbols of eternal life itself. Furthermore, the Jewish suffering servant and scapegoated man of sorrows, along with the Greek crucified "Second God" or Logos, are all pre-Christian concepts. The Romans as well, as asserted by early Christian writer Felix, possessed images of a god on a cross, long before the Christian savior was ever depicted as such. These images signify sun worship and also characterize the widespread cult of human sacrifice, which was practiced for hundreds and thousands of years before the Christian era, including in India,

where representatives of, and sacrifices to, the sun god were anointed with oil, hung on a tree, given a stupefying drug, pierced in the side, and had their legs broken, etc. Since this ritual was a Dravidian rite regarding the sun god, and since Krishna was apparently a Dravidian solar god, it is not at all surprising to find legends and images portraying Krishna as a crucified savior. In actuality, even the orthodox tale of Krishna, which depicts the god being pierced in the foot and suspended from a tree, can be interpreted as a typical sacred king sacrifice, where the god is "hung on a tree." In any event, the crucified savior motif, in detail, is a pre-Christian mythological concept and did not originate with Christianity. As Robertson concludes, "Not only was the cross-symbol...absolutely universal in pre-Christian times, and, as a rule, a recognized symbol of life or immortality, but the actual idea of a mystic or exemplary crucifixion was perfectly familiar in Pagan theology."[141]

This point of precedence and prevalence can scarcely be emphasized enough, since the opposite and erroneous perspective is so firmly entrenched: To wit, Christ is a unique expiatory sacrifice. The truth is that the Passion of the Christ represents an archetypical example of the ubiquitous sacred-king ritual, not a "one-time," "historical" event. It should also be emphasized that, as Frazer says, "the king is slain in his character of a god or a demigod, his death and resurrection, as the only means perpetuating the divine life unimpaired, being deemed necessary for the salvation of his people and the world."[142] In other words, these principal Christian tenets have been part of the religious world for millennia, and do not represent "revelation" from a divine founder. Since this ritual predated the Christian era by centuries, if not millennia, there is no question as to who is the latecomer in the dying-and-rising savior-god competition. The fact that the early Christian apologists used the "devil did it" argument readily reveals that these concepts preceded Christianity, a reality of which the apologists were obviously aware, such that they did not make the case that Pagan *humans* copied Christianity.

[1] Jacolliot, 253-254.
[2] www.positiveatheism.org/hist/rmsbrg11.htm
[3] Doane, 184-185.
[4] Doane, 185-186.
[5] Higgins, I, 145-146.
[6] Higgins, I, 146-147.
[7] Graves, K., 107.
[8] Moor (Simpson), 283.
[9] Moor (1810), 419-420.
[10] Higgins, I, 145-146.

[11] Robertson, *CM*, 271.
[12] Lundy, 173.
[13] Lundy, xvii.
[14] Lundy, xvii.
[15] Lundy, xviii.
[16] Lundy, 175.
[17] Lundy, 176.
[18] Blavatsky, *IU*, II, 557-558.
[19] Higgins, I, 147.
[20] Higgins, I, 148.
[21] Higgins, I, 257.
[22] www.bobkwebsite.com/belmythvjesusmyth.html
[23] Pandey, 198.
[24] Higgins, I, 149.
[25] Higgins, I, 141.
[26] Lundy, 160.
[27] Bonwick, *IDOIR*, 253-254.
[28] Lundy, 161.
[29] Higgins, I, 246.
[30] Higgins, II, 105.
[31] Higgins, I, 246.
[32] Robertson, *CM*, 370.
[33] Doane, 187.
[34] Graves, K., 126.
[35] Titcomb, 128.
[36] Jones, *AR*, 124.
[37] www.newadvent.org/cathen/04517a.htm
[38] Bonwick, *IDOIR*, 198.
[39] www.newadvent.org/cathen/04517a.htm
[40] www.newadvent.org/cathen/04517a.htm
[41] www.newadvent.org/cathen/04517a.htm
[42] www.newadvent.org/cathen/04517a.htm
[43] www.newadvent.org/cathen/04517a.htm
[44] www.newadvent.org/cathen/04517a.htm
[45] www.newadvent.org/cathen/04517a.htm
[46] www.ccel.org/fathers2/ANF-04/anf04-34.htm#P5530_808394
[47] www.newadvent.org/cathen/04517a.htm
[48] www.ccel.org/fathers2/ANF-03/anf03-05.htm (Emph. added.)
[49] www.newadvent.org/cathen/13164a.htm
[50] Robertson, *CM*, 197fn.
[51] www.newadvent.org/cathen/05248a.htm
[52] Lundy, 40-41.
[53] Spence, *AEML*, 105.
[54] www.newadvent.org/cathen/04517a.htm
[55] Doane, 488.
[56] Evans 108-109.
[57] Blavatsky, *IU*, 322fn.
[58] Lundy, xxv.
[59] Lundy, 12.

[60] Cox, II, 115.
[61] Robertson, *CM*, 376.
[62] Rylands, 188.
[63] Lundy, 95.
[64] Kuhn, *WTKG*, 412.
[65] Hengel, 230.
[66] Graves, K., 124.
[67] Lundy, 16.
[68] Weil, 60.
[69] Weil, 119.
[70] www.newadvent.org/cathen/04517a.htm
[71] Robertson, *CM*, 371.
[72] www.newadvent.org/cathen/04517a.htm
[73] www.newadvent.org/cathen/04517a.htm
[74] Taylor, *SECR*, 158fn.
[75] Cox, I, 371.
[76] Frazer, 412.
[77] Bonwick, *IDOIR*, 252.
[78] Robertson, *CM*, 182.
[79] Frazer, 417-419.
[80] Frazer, 401.
[81] Titcomb, 132.
[82] Ward, 19.
[83] Knight and Lomas, 242.
[84] Doherty, 89.
[85] Higgins, I, 825.
[86] Cassels, 539.
[87] www.users.globalnet.co.uk/~alfar2/ficino.htm
[88] Doherty, 106.
[89] Doherty, 80.
[90] Drews, *WHJ*, 170.
[91] Weigall, 106.
[92] Kuhn, *WTKG*, 214.
[93] Taylor, *TD*, 173.
[94] Graves, K., 261.
[95] Graves, K., 273.
[96] Robertson, *CM*, 272.
[97] Lundy, 390-391.
[98] Kingsborough, VI, 166fn.
[99] Kingsborough, VI, 166fn.
[100] Kingsborough, VI, 166fn.
[101] *CMU*, 122-123.
[102] Lundy, xxi.
[103] Weigall, 76.
[104] Muir, V, 467.
[105] Srivastava, 52.
[106] Cox, II, 148.
[107] Cox, II, 172.
[108] Villanueva, 259-260.

[109] Iamblichos, 221.
[110] Villanueva, 259-260fn.
[111] Tierney, 17.
[112] Robertson, *PC*, 30.
[113] www.newadvent.org/cathen/13309a.htm
[114] Budge, *EBD*, lxxxi.
[115] Kingsborough, VI, 232-233.
[116] Kingsborough, VI, 311fn.
[117] Kingsborough, VIII, 16fn.
[118] Frazer, 568.
[119] Frazer, 680.
[120] Bonwick, *IDOIR*, 199.
[121] Frazer, 341.
[122] Dujardin, 55-56.
[123] Robertson, *PC*, 32.
[124] Dujardin, 39.
[125] Lundy, 102.
[126] Tierney, 21.
[127] Hopkins, 526.
[128] Frazer, 662.
[129] Frazer, 507.
[130] Robertson, *PC*, 10.
[131] www.newadvent.org/cathen/04517a.htm
[132] Robertson, *PC*, 26.
[133] Hopkins, 528-530.
[134] Doane, 108fn.
[135] Budge, *EBD*, 359.
[136] Spence, *AEML*, 296.
[137] Hopkins, 534.
[138] Singh, 16.
[139] Hopkins, 535-536.
[140] *CMU*, 116-117.
[141] Robertson, *CM*, 369.
[142] Frazer, 329.

Egyptian God Anubis, "Guardian
of the Dead," in cruciform.
(Lundy)

Ass-headed God crucified,
possibly Christ, Set or
Anubis.

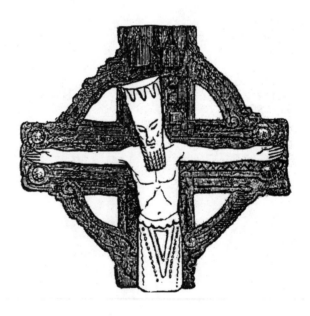

Irish crucifix with non-Christian
headdress and garments. (Lundy)

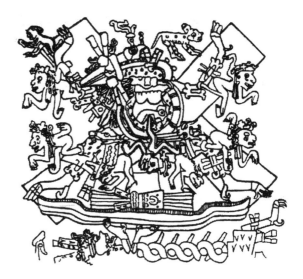

Crucifix of Orpheus,
3rd century CE.
(Freke and Gandy)

Crucifixion of Quetzalcoatl
Codex Borgianus. (Kingsborough)

Crucifix of Wittoba/Balaji/Krishna
(Moor)

Minoan "lord of the wild beasts" in cruciform. (Kerenyi)

Nubian God in cruciform. (O'Brien)

"Lady Bird" in cruciform, 4th millennium BCE. (Gadon)

"Cypriot Crucifix" (Lundy)

"Assyrian Cross and Star." (Lundy)

Mexican cross. (Spence)

Life of Buddha

The Buddhists of different parts of the East differ widely in their chronology. The Northern Division of the faith place the birth of Buddha in 1030 B.C., the Southern fix his death in 543 B.C., a discrepancy of five centuries. Other accounts reveal disagreements of still further magnitude. Upon this absence of even an approach to chronological accuracy, Professor Wilson has broached the idea that probably the existence of Buddha is a myth. "There are various considerations which throw suspicion upon the narrative and render it very problematical whether any such person as Sakiya Sinha, or Sakiya Muni, or Sramana Gautama ever actually existed."

<div align="right">Rev. Simpson, Moor's Hindu Pantheon</div>

As Krishna was said to be an avatar of the solar deity Vishnu, so too was Buddha, who, according to common belief, was the founder of Buddhism in the 6th century BCE. However, the tradition represented by "Buddhism" is in fact much older than the period attributed to "the Buddha," or Gautama, as there have been several sects of Buddhism, some dating back hundreds if not thousands of years before the "historical" Buddha. A number of researchers and scholars have evinced that what is termed "Buddhism," i.e., asceticism, is found around the globe, thousands of years prior to the common era. Some Buddhists themselves have maintained that their religion goes back 15,000 or more years, and the Buddhistic Jains of India claim to possess the oldest religion in the world. As Sir Jones says, "The Buddhists insist that the religion of Buddha existed from the beginning."[1]

In actuality, Buddha's "name" is a *title* that does not represent a single individual, and there were, according to Buddhist tradition, countless Buddhas prior to the purported advent of Gautama, he himself having myriad previous incarnations. Because of this fact of plurality, it is impossible and virtually pointless to attempt to create a "biography" of a "real person" named Buddha. Even the godman's title itself changes from country to country, era to era and writer to writer. As Doane observes:

> It is said that there have been several Buddhas... We speak of *Gautama*. Buddha is variously pronounced and expressed Boudh, Bod, Bot, But, Bud, Badd, Buddou, Bouttu, Bota, Budso, Pot, Pout, Pots, Poti and Pouti. The Siamese make the final *t* or *d* quiescent, and sound the word Po; whence the Chinese still further vary it to Pho or Fo. Buddha—which means *awakened* or *enlightened...*is the proper way in which to spell the name.[2]

In discussing "the same god, who reigns under different names in the nations of the East," Volney remarks:

> The Chinese adore him in Fot, the Japanese in Budso, the Ceylonese in Bedhou, the people of Laos in Chekia, of Pegu in Phta, of Siam in Sommona-Kodom, of Thibet in Budd and in La.

He then notes:

> The original name of this god is Baits.... The Arabs pronounce it Baidh, giving to the dh an emphatic sound which makes it approach to dz. Kempfer...writes it Budso, which must be pronounced Boudso, whence is derived the name of Budsoist.... Clement of Alexandria, in his Stromata, writes it Bedou, as it is pronounced also by the [Singhalese]; and Saint Jerome, Boudda and Boutta. At Thibet they call it Budd; and hence the name of the country called Boud-tan and Ti-budd: it was in this province that this system of religion was first inculcated in Upper Asia... The Chinese have neither b nor d, have supplied their place by f and t, and have therefore said Fout.[3]

In his studies of Buddhism, published in the 1850's in a number of books, including *A Manual of Budhism*, the pious Christian R. Spence Hardy used some 465 texts from Ceylon/Sri Lanka, in the original Sanskrit, Pali, et al. These texts were collected during Hardy's many years as a missionary in Sri Lanka, much of which time was spent with "Sramana priests," Sramana being a title for Buddha that means "tamer of the senses." Sramana also refers to priests who perform "hard penances" and are not allowed to speak falsehoods. In any event, as concerns "Buddha," Hardy, a respected authority on the subject (Dr. Inman calls Hardy's work "very prejudiced" yet "extremely suggestive"), relates:

> The name of the founder of Budhism has been spelled by European authors in the following modes, and probably in many others that have not come under my notice: Fo, Fod, Foe, Fohe, Fohi, Fho, Fuh, Futh, Pot, Pott, Poot, Poota, Pootah, Poth, Poti, Pout, Phuta, Wud, Bod, Bot, Bud, But, Buth, Budh, Buddh, Bood, Boodh, Boudh, Bhood, Baoth, Bauth, Budo, Buto, Budud, Booda, Bodda, Budda, Butta, Budha, Buddha, Budhu, Buddhu, Budho, Buddho, Buddow, Bodhow, Budhoo, Budso, Budha, Boudha, Boudhu, Boudhoo, Bouddha, Bouddhu, Boutta, and Bouddho.[4]

These copious variants are not only transliterations limited to Western writers; indeed, not a few of them are the result of the culture in which the ideology was developed. Moreover, this "founder" of which Hardy speaks is not a person at all but a mishmash of myths and sayings that go back centuries and millennia prior to the alleged advent of "the Buddha," i.e., Siddhartha, Gautama, Sakyamuni or other name.

Hardy's Manual is a comprehensive look at the profuse
Buddha legends, which include stories of many "Buddhas" and
"Bodhisattvas." As stated, some of these Buddhas represent
previous lives of "the Buddha" as well. The many stories related
by Hardy are abundant in fantasy and magic, and, although there
may be the sayings and exploits of "real people" intertwined
in them, they cannot serve as "biographies" of "historical"
individuals. Concerning these various tales, Hardy states:

> The attentive reader will observe numerous discrepancies. These
> occur, in some instances, between one author and another; and
> in others between one statement and another of the same
> author.[5]

In his exhaustive research, Hardy says he was unable to find
"any eastern work that is exclusively confined to the biography
of Gotama [Gautama], or that professes to present it in its
completeness."[6]

In his chapter attempting to trace the ancestry of "the
Buddha," regarding the numerous legends he encountered Hardy
remarks:

> Several of the names, and some of the events, are met with in the
> Puranas of the Brahmans, but it is not possible to reconcile one
> order of statement with the other; and it would appear that the
> Budhist historians have introduced races, and invented names,
> that they may invest their venerated sage with all the honors of
> heraldry, in addition to the attributes of divinity.[7]

Hardy also states that his sources are Tibetan, Nepalese,
Chinese, Indian, Burmese, Siamese and Sri Lankan (Ceylonese),
of which the sacred books of Burma, Siam and Ceylon are
"identically the same." Nevertheless, he continues:

> The ancient literature of the Budhists, in all the regions where
> this system is professed, appears to have had its origin in one
> common source; but in the observances of the present day there
> is less uniformity; and many of the customs now followed, and of
> the doctrines now taught, would be regarded by the earlier
> professors as perilous innovations.[8]

In reality, there have been identified at least 60 "translations,
versions, or paraphrases" of Buddha's life. Hence, his "life" has
changed from era to era and place to place. As was the case with
Krishna, the era in which "the Buddha" was supposedly born has
been variously placed. While it is currently held that "the
Buddha" or Gautama lived in the 6th century BCE, other writers,
including eastern ones, have placed it in a number of different
eras: "Professor Wilson...quotes no less than eleven authorities,
every one of which establishes the era of Budha more than 1000

years B.C., and five other authorities make it above 800 years
B.C."[9]

Moreover, in *Asiatic Researches* Sir Jones relates that the
Arab traveler Abul Fazel placed Buddha "in the 1366th year before
that of our Saviour," while the Chinese put the birth of Buddha,
or Fo, the "son of Maya," in 1036 or 1027 BCE.[10] The Catholic
missionary Georgius/Giorgi reported that the Tibetans claimed
Buddha's birth occurred in the year 959 BCE.[11] Basing his
estimations on the Chronology of the Hindus, Jones himself set
the birth of Buddha, "or the ninth great avatar of Vishnu," in
1014 BCE, while Krishna, the "Indian Apollo," he established more
than 1200 years before the common era.[12] In a subsequent
volume, Jones recounts that the French scholar Bailly placed
Buddha's birth at 1031, and apparently retracts his own early
dating:

> ...M. Bailly, with some hesitation, places him 1031 years before
> it, but inclines to think him far more ancient, confounding him,
> as I have done in a former tract, with the *first* Budha, or
> Mercury, whom the Goths called Woden...[13]

As we shall see, the "confounding" of "the first Budha" Jones
mentions is both common and warranted, although it positively
vexed Max Müller, who in a brief dismissal insisted that
"Buddha...is not a mythological, but a personal and historical
character" and that there was no connection between the Indian
Mercury/Budha and the sage Buddha, among other "false
analogies."[14] In any event, Count Volney averred that "the
Buddha" was born around 2000 BCE, and Higgins claimed he was
the avatar of the Taurean Age, beginning around 4400 BCE.

As concerns Buddha's death, the Ceylonese/Singhalese or Sri
Lankan account puts it at 543 BCE, while the chronology of the
Greeks, based on the king "Sandracyptus," "Sandracottos" or
"Chandragupta," places it at 477 BCE. According to Inman, the
date of Buddha's death or nirvana in Chinese accounts is circa
770 BCE.

Bell adds to the confusion, relating the claim that "Buddha"
or "Buddu" was born around 40 CE. However, this legend may
have been created by missionaries bent on making "Buddu" a
Christian, specifically the apostle Thomas:

> BUDDU, an idol of the inhabitants of Ceylon.—He is represented
> of gigantic stature, and is said to have lived a holy and penitent
> life. The inhabitants reckon their years from the time of his
> decease, and as that agrees with the fortieth of the Christian era,
> most the Jesuits are of the opinion that he was the apostle St.
> Thomas... It is, however, much more probable that Buddu was a
> native of China, and perhaps the same as the Chinese Fo.... It is
> the province of Buddu to watch over and protect the souls of

men, to be with them in this life, and to support them when dying; and the Ceylonese are of opinion the world can never be destroyed while the image of Buddu is preserved in his temple.[15]

As Prof. Wilson discerned, the lack of consensus bespeaks the mythical and unhistorical nature of "the Buddha." Recounting Wilson's arguments, Rev. Simpson gives other reasons to suspect that Buddha is mythical:

> "The tribe of Sakiya, from which the sage sprung is not mentioned in Hindu writings as a distinct people. The names introduced into the narrative are all symbolical. Buddha's father was Suddhodana; 'he whose food is pure.' His mother's name is Maya or Mayadevi, 'illusion, divine delusion;' as a prince, he was called Siddhartha, 'he, by whom the end is accomplished' and 'Buddha' signifies 'he, by whom all is known.'"[16]

Simpson also explains at least some of these dating discrepancies as a "back-reckoning" from a particular historical event of the various nations into which Buddhism spread.

As demonstrated, neither the story itself nor the sixth century date for the life of Buddha is conclusive, and we are left with a lack of historicity in the tale. It must be emphasized that, when discussing the legends of ancient gods, godmen and heroes, we are generally dealing with *myths* that change constantly in order to incorporate new information, adapt to a specific era, or reflect a particular culture. It should also be kept in mind that information is suppressed and expunged, for a variety of reasons and agendas.

At the beginning of the chapter on "Buddha and Buddhism" in the edited version of Moor's *Hindu Pantheon*, Rev. Simpson states that he has taken it upon himself to remove Moor's entire original chapter and substitute his own "biography." In his own chapter on Buddhism in Moor's book, Simpson remarks:

> It is but right that I should assign some reason for substituting a chapter of my own for the lengthened observations of Moor upon Buddha and Buddhism. That portion of the "Hindu Pantheon" is marked with defects common to the writers of that period.

> "We may next advert" says Professor Wilson, "to the strange theories which were gravely advanced, by men of highest repute in Europe for erudition and sagacity, from the middle to the end of the last century, respecting the origin and character of Buddha. Deeply interested by the accounts which were transmitted to Europe by the missionaries of the Romish church, who penetrated to Thibet, Japan, and China, as well as other travellers to those countries, the members of the French Academy especially set to work to establish coincidences the most improbable, and identified Buddha with a variety of personages, imaginary or real, with whom no possible congruity existed; thus it was attempted to show that Buddha was the

same as the Toth or Hermes of the Egyptians—the Turm of the Etruscans; that he was Mercury, Zoroaster, Pythagoras; the Woden or Odin of the Scandinavians; Manes, the author of the Manichaean heresy; and even the divine author of Christianity."[17]

In Simpson's comments we possess an extraordinary admission of tampering with the work of an author decades after his death. Simpson's reason for mutilating the work of the long-dead scholar is that it contained "defects." Considering what else Moor's book originally contained, such as the Wittoba/Krishna crucifix image, it is not surprising that a Christian minister would find "defects," such that he would need to remove an entire chapter. It is impossible to imagine that someone as scholarly and thorough—and reluctant, as a devout Christian—as Moor would make such a mess of Buddhism that nothing of value could be found in his chapter on the subject.

After mutilating Moor's work, Simpson provides a synopsis of the author's original chapter on Buddha:

> ...An inscription 800 years old is inserted at length in which Buddha is identified with Brahma, Vishnu and Siva, and the mystic formulae of Hinduism are intermingled with the doctrines of Gautama. Major Mahony's work on Ceylon and the Edinburgh Review furnish illustrations that Buddha was Vishnu and perhaps Krishna. Another long inscription is then inserted in which Buddha appears to be identified with Rama.[18]

In other words, Moor and others had evinced that Buddha was Vishnu and "perhaps Krishna," as well as being identified with Rama, the seventh incarnation of Vishnu, just prior to Krishna.

It is evident from the Jones and Moor scandals that "primary sources" are difficult to procure because they have been edited by the censorship machine that was confined for centuries to elite religionists. In reality, Moor's original chapter on Buddhism reflects his usual caution and erudition, rather than Simpson's erroneous claim that it is "marked with defects." In contrast, instead of providing us with a more enlightening account, Simpson's chapter on Buddhism is sanitized and whitewashed.

Moreover, it is odd that Prof. Wilson, understanding Buddha to be a myth, would object to the "confounding" of the godman with other myths and gods. Regarding Wilson's comments concerning "strange theories" gravely put forth, the fact is that the history of religion constitutes a confusion of myths and legends, along with "perilous innovations." There is a reason for this "confusion," and Wilson's assertion is not true that all these travelers, writers and scholars were so thoroughly mistaken in their identification of Buddha with Thoth, Mercury, Hermes,

Woden, etc. Many of these scholars, such as the Mason Higgins, were privy to "insider information," i.e., the esoterica of various religious traditions, no doubt based on their status as members of one or more brotherhoods and secret societies. These esoteric traditions consistently demonstrate astrotheology, with its complexities and sublimity, rather than focusing on the third-dimensional, material world, with its mundane, linear "history." Therefore, the "confusion" is not at all a "mistake" but quite deliberate, as, when one gains the arcane knowledge, one realizes that numerous deities and godmen, "divined" or created by humans over tens of thousands of years, represent basically the same *principle*, not a variety of "historical" superhuman personages confounded.

These same learned writers are well aware when confounding *has* occurred, often within the mainstream, orthodox perspective. In fact, to correct misapprehension is a major reason scholars write books. One of these erudite authors was Count Volney, who was able to discern which of these identifications of Buddha with other gods was incorrect and which was accurate:

> The eastern writers in general agree in placing the birth of Beddou [Buddha] 1027 years before Jesus Christ, which makes him a contemporary of Zoroaster, with whom, in my opinion, they confounded him. It is certain that his doctrine notoriously existed at that epoch; it is found entire in that of Orpheus, Pythagoras, and the Indian gymnosophists. But the gymnosophists are cited at the time of Alexander as an ancient sect already divided into Brahmans and Samaneans.... If, as is the case, the doctrine of Pythagoras and that of Orpheus are of Egyptian origin, that of Beddou goes back to the common source; and in reality the Egyptian priests recite that Hermes as he was dying said: "I have hitherto lived an exile from my country, to which I now return. Weep not for me, I ascend to the celestial abode where each of you will follow in his turn: there God is: this life is only death."...
>
> Such was the profession of faith of the Samaneans, the sectaries of Orpheus, and the Pythagoreans. Farther, Hermes is no other than Beddou himself; for among the Indians, Chinese, Lamas, etc., the planet Mercury and the corresponding day of the week (Wednesday) bear the name of Beddou, and this accounts for his being placed in the rank of mythological beings, and discovers the illusion of his pretended existence as a man; since it is evident that Mercury was not a human being, but the Genius or Decan, who, placed at the summer solstice, opened the Egyptian year... Now Beddou and Hermes being the same names, it is manifest of what antiquity is the system ascribed to the former.[19]

Like Volney's writing, Moor's "defective" chapter on Buddhism also contains the equation of Buddha with Thoth, Hermes, Mercury or Woden:

> A Buddha, whether the ninth Avatara or not may be doubted, has been deemed to answer in character with Mercury—so has the Gothic Woden; each respectively given his name to the same planet, and to the same day of the week; Budhvar, all over India...whether among Bauddhas, Saivas, or Vaishnavas, being the same with Dies Mercurii, or Woden's day, whence our Wednesday.[20]

Throughout his book *Manual of Budhism*, Hardy uses the transliterations "Budha" and "Budhism," although he too asserts that "the Buddha" has been "mistakenly confused" with Budha, the planet Mercury. Nevertheless, "Buddha" has also been transliterated as "Wud," as related by Hardy himself; hence, the identification with Woden is logical, all the more so since "Woden" or Mercury is called *Budha* in Vedic/Sanskrit. In addition to being equated with these various gods, the notion that "Buddha" may represent "a whole colony personified" is raised by Wilford in *Asiatic Researches*.[21]

It is obvious that the "biography" of Buddhism's alleged founder is not set in stone, and that following the ancient path of the religion's development is difficult. In light of such information, one can readily understand how Western scholars would "identify Buddha with a variety of personages, imaginary or real."

To reiterate, despite the hundreds of Buddhist texts he studied, Hardy himself admits the difficulty in discovering reliable information and sorting it all out:

> We have little information of the innumerable Budhas who have appeared in the past ages, until we come to the twenty-four who immediately preceded Gotama; and even their history consists of little more than names and correlative incidents....
>
> "...There is a verse in the Aparanita Dharani...purporting that 'the Budhas who have been, are, and will be,...more numerous than the grains of sand on the banks of the Ganges.'... These are evident nonentities, in regard to chronology and history, yet it is often difficult to distinguish them from their more substantial compeers."[22]

The 24 Buddhas are the same as the "Teerthankaras" of Jainism, another Indian faith that is essentially the same as Buddhism but is considered by its adherents to be the oldest religion in the world. Jainism teaches "ahimsa" or non-violence, to the point of caring for all creatures, including insects. Its most ardent adherents go naked (hence, they are "gymnosophs") and wear masks so they will not inconvenience or accidentally swallow

bugs. One of these Teerthankaras, or sages, is Mahavira, who is said to have been the teacher of Gautama Buddha, a godman revered in both sects.[23]

In addition to these 24, in long ages outlined in Buddhists texts are said to have appeared some 387,000 Buddhas. Several of these Buddhas are depicted as living tens to hundreds of thousands of years. We are also told that during the long epochs after the pre-existent Gautama "wished to become a Buddha, 125,000 Buddhas appeared; and during this period he was born many hundreds of times, either as a dewa [deva] or as a man."[24] (A deva is "a divinity," i.e., a divine being or an "angel.") Concerning these many lives of "the Buddha," Hardy says:

> A great part of the respect paid to Gotama Budha arises from the supposition that he voluntarily endured, throughout myriad of ages, and in numberless births, the most severe deprivations and afflictions, that he might thereby gain the power to free sentient beings from the misery to which they are exposed under every possible form of existence.[25]

Simpson puts a number to these "numberless births":

> Sakiya [Buddha] is supposed to have had a prior existence of indefinite length, during which he assumed five hundred and fifty births.[26]

Concerning the Chinese version of Buddha, Fo, Bell enumerates his lives at 8,000:

> FO, or FOE, an idol of the Chinese: he was originally worshipped in the Indies... His disciples after his death published a great number of fables concerning him, and easily persuaded the people that Fo had been born eight thousand times; that his soul had successively passed through several different animals...[27]

Some of these numerous lives of Buddha are as follows:

> An ascetic 83 times; a monarch 58; the deva of a tree 43; a religious teacher 26; a courtier 24; a prohita brahman 24; a prince 24; a nobleman 23; a learned man 22; the deva Sekra 20; an ape 18; a merchant 13; a man of wealth 12; a deer 10; a lion 10; the bird hansa 8; a snipe 6; an elephant 6; a fowl 5; a slave 5; a golden eagle 5; a horse 4; a bull 4; the brahma Maha Brahma 4; a peacock 4; a serpent 4; a potter 3; an outcaste 3; a guana 3; twice each a fish, an elephant driver, a rat, a jackal, a crow, a woodpecker, a thief, and a pig; and once each a dog, a curer of snake-bites, a gambler, a mason, a smith, a devil dancer, a scholar, a silversmith, a carpenter, a water-fowl, a frog, a hare, a cock, a kite, a jungle-fowl, and a kindura.[28]

Considering this overwhelming and bizarre list, it cannot be possible to write a "biography" of a "real person." In any event, there are several interesting incarnations here, including the

mason and carpenter. Although in the orthodox story Buddha is said to be the "son of a king," he was ostensibly also the "son of a carpenter," as suggested by other writers, because when Buddha was a carpenter, so likely was his father, since it was common for a son to take up his father's occupation. Furthermore, Buddha is also compared to a carpenter by Nagasena, an ancient priest represented in a dialogue called the "Milinda Prasna."[29] This carpenter motif linking the Buddha tale with the Jesus myth has been disputed because, in his "last incarnation," Buddha was a prince, son of a king, royalty. However, Christ too was deemed royal, the "son of (King) David," as well as a "prince" and "king of kings"; yet, he was also a carpenter and son of a carpenter. In addition, although Mary is claimed to have been the wife of a carpenter, she is called "queen," as in "Queen of Heaven."

Moreover, in the various apocryphal gospels Jesus is depicted not as a carpenter, but as a dyer, painter or potter. In *Contra Celsus*, Church father Origen (185-232) states that Jesus is not called a carpenter in any of the gospels then current in the churches. It appears, therefore, that the occupation of Jesus as a carpenter was an interpolated afterthought. Hence, it is clear that, in the tales of both Buddha and Jesus, we are not looking at "biographies" but fables created for a particular need. It is further evident that this process of mythmaking, as well as its central character, was essentially the same in both cases.

Is Buddhism Atheistic?

Many of the numerous lives of Buddha were spent as divine beings; yet, like so many religions that do not subscribe to the typical theology of other cultures, it is claimed that Buddhism is "atheistic." This contention was also made regarding early Christianity because that faith likewise did not acknowledge the reigning deities. As Church father Justin Martyr (c. 100-c. 165) writes in his *First Apology*:

CHAPTER VI—CHARGE OF ATHEISM REFUTED.

Hence are we called atheists. And we confess that we are atheists, so far as gods of this sort are concerned, but not with respect to the most true God, the Father of righteousness and temperance and the other virtues, who is free from all impurity.[30]

The Buddhist situation is quite similar to that of Christianity. In reality, every religion, sect and cult believes it has the "right god," and each could be deemed "atheistic" by another's standard. In the case of Buddhism, the Brahmans deemed Buddha an "atheist," because he supposedly did not believe in the Hindu

devas; yet, as we have seen, Buddha was himself considered a deva. Elucidating this debate, the Catholic Encyclopedia states:

> In the Buddhist conception of Nirvana no account was taken of the all-god Brahma. And as prayers and offerings to the traditional gods were held to be of no avail for the attainment of this negative state of bliss, Buddha, with greater consistency than was shown in pantheistic Brahminism, rejected both the Vedas and the Vedic rites. It was this attitude which stamped Buddhism as a heresy. For this reason, too, Buddha has been set down by some as an atheist. Buddha, however, was not an atheist in the sense that he denied the existence of the gods. To him the gods were living realities. In his alleged sayings, as in the Buddhist scriptures generally, the gods are often mentioned, and always with respect.[31]

As concerns CE's remark about Buddha's "*alleged* sayings," the skepticism is not misplaced, except that one could as easily say the same in reference to Jesus. It is clear that the aphorisms attributed to Jesus, like those of Buddha, are wisdom sayings or platitudes that had been floating around the world for centuries and millennia before being attributed to these mythical, spiritual figureheads.

Regarding Buddhism's purported "atheism," Dr. Inman comments:

> It is asserted that Siddhartha did not believe in a god, and that his Nirvana was nothing more than absolute annihilation....

> To my own mind, the assertion that Sakya did not believe in God is wholly unsupported. Nay, his whole scheme is built upon the belief that there are powers above us which are capable of punishing mankind for their sins. It is true that these "gods" were not called Elohim, nor Jah, nor Jahveh, or Jehovah, nor Adonai, or Ehieh (I am), nor Baalim, nor Ashtoreth—yet, for "the son of Suddhodana" (another name for Sakya Muni, for he has almost as many, if not more than the western god), there was a supreme being called Brahma, or some other name representing the same idea as we entertain of the Omnipotent.[32]

In its highest understanding Buddhism portrays the entire cosmos as divine. Concerning Buddhism's concept of the divine, Simpson observes:

> The Faith...began with the belief in a celestial, self-existent Being termed *Adi Buddha* or *Iswara*. Rest was the habitual statement of his existence. "Formless as a cypher or a mathematical point and separate from all things, he is infinite in form, pervading all and one with all."[33]

This last sentence concerning "Adi Buddha" being separate yet pervasive sounds paradoxical, which is the case with Buddhism, as well as all religious systems that conceive of God as

"omnipresent" yet wholly other. While Buddhism in general does not preach the notion of a giant, anthropomorphic male deity somewhere "out there," separate and apart from creation, the concepts of deity and divinity abound within it. In addition to the idea of Adi Buddha, Buddhism is full of wild, fabulous tales with divine beings of all sorts, especially Tibetan Buddhism, for example. Yet, like so many ancient religions, Buddhism is a polytheistic, pantheistic monotheism or monism. This polytheistic monotheism of Buddhism was described by Abbé Huc, a Catholic priest who traveled to the East and was startled to discover the many important correspondences between Buddhism and Christianity:

> With the respect to polytheism, Missionary Huc says, "that although their religion embraces many inferior deities, who fill the same offices that angels do under the Christian system, yet,"—adds M. Huc—"monotheism is the real character of Budhism;" and he confirms the statement by the testimony of a Thibetan.[34]

Among these "inferior deities" are the devas. Although Buddha himself was said to have been a deva many times, it is paradoxically claimed that no deva can become a Buddha, and that the latter must incarnate as a man, not as a woman, a sexist notion that includes avoiding "all sins that would cause him to be born a woman." The fact that Buddha was depicted as having been a deva, in several "lives" and before taking birth as Siddhartha, nevertheless makes him a divine being, or godman. Indeed, Buddhist inscriptions address not only the "celestial, self-existent Being" but also the "Supreme Being" *as Buddha*, exemplified by the following inscription, found in Bengal at Buddha Gaya, and part of Moor's original chapter on Buddhism:

> "Reverence be unto thee, in the form of Buddha: reverence be unto the Lord of the earth: reverence be unto thee, an incarnation of the Deity, and the Eternal One: reverence be unto thee, O God! in the form of the God of Mercy: the dispeller of pain and trouble; the Lord of all things; the Deity who overcomest the sins of the *Kali Yug*; the guardian of the universe; the emblem of mercy toward those who serve thee—O'M! the possessor of all things in vital form. Thou art Brahma, Vishnu, and Mahesa; thou are Lord of the universe;... Reverence be unto the bestower of salvation... I adore thee, who art celebrated by a thousand names, and under various forms, in the shape of Buddha, the God of Mercy.—Be propitious, O Most High God!"[35]

This inscription constitutes a primary source at least 1,000 years old that demonstrates a few important points, one of which is that Buddha himself is a *god—the* God, in fact. Another salient point is that he is identified as Brahma and Vishnu, and the third is the similarity between his nature and that of Jesus.

As seen from this inscription, Buddha is "Lord of the earth," "an incarnation of the Deity," "O God!" the "God of mercy," "Lord of all things," "Lord of the universe" and "Most High God." Along with these divine epithets, Buddha is also called "God of Gods," as well as "the great Physician," "Healer," "Savior," "Blessed One," "Savior of the World" and "God among gods."[36]

The following is from the translation of the Buddha Gaya inscription by Charles Wilkins:

> In the midst of a wild and dreadful forest, flourishing with trees of sweet-scented flowers, and abounding in fruits and roots...resided *Booddha* the Author of Happiness... This Deity *Haree*, who is the Lord *Hareesa*, the possessor of all, appeared in this ocean of natural beings at the close of the *Devapara*, and beginning of the *Kalee Yoog*: he who is omnipresent and everlastingly to be contemplated, the Supreme Being the Eternal one, the Divinity worthy to be adored by the most praise-worthy of mankind appeared here with a portion of his divine nature.

> Once upon a time the illustrious *Amara*, renowned amongst men, coming here, discovered the place of the Supreme Being, *Booddha*, in the great forest. The wise *Amara* endeavoured to render the God *Bouddha* propitious by superior service...[37]

The inscription goes on, with Amara having dreams and visions in which a voice speaks to him. Referring to "the Supreme Spirit *Bouddha*," the "Supreme Being, the incarnation of a portion of *Veeshnoo*," it continues with the same portion related by Moor, above, regarding the "Most High God," etc. This Most High God is also called the "purifier of the sins of mankind," "*Bouddha*, purifier of the sinful..." It is clear from this inscription that not only is Buddhism *not* atheistic, but also the Supreme Being, the Eternal One, is called *Buddha*. He is also, like Jesus, the "bestower of salvation." Again, the inscription equates Buddha with Vishnu, calling him "Hari," which is likewise an epithet of Krishna.

Another Christian scholar, Major Mahony, reported the Singhalese as claiming that, "before his appearance as a man," Buddha was a god and "the supreme of all the gods."[38] Also, in the second century, Church father Clement of Alexandria related the worship by Indians of the "*God Boutta.*" (*Stromata*, I.) In defining the Ceylonese word "Vehar," Christian travel writer Relandus (fl. 1714) stated, "Vehar signifies a temple of their principal God Buddou, who, as Clemens Alexandrinus has long ago observed, was worshipped as a God by the Hindoos."[39]

With all the divine beings, including the umpteen Buddhas themselves, and the Supreme Being even called Buddha, it is evident that Buddhism is not "atheistic." In addition, based on his

miraculous manner of birth, "*son* of God" is likewise a suitable title for Buddha:

> The sectarians of *Buddha* taught that he (who was the *Son of God* (Brahma) and the Holy Virgin Maya) is to be the judge of the dead.[40]

In reality, deeming Buddha as God, a god, a godman, or son of God is accurate and appropriate.

Miracles Galore

The divine, supernatural nature of Buddhism and the Buddhas is evident, as is the abundance of these Buddhas and their stories. Nevertheless, amid all the wild and miraculous tales concerning the countless Buddhas and assorted incarnations, an "orthodox" life of "the Buddha" has been created.

To begin with, Buddha's conception is portrayed as coming to his mother, Maya, in a dream, like the conflicting gospel tales of Joseph's dream or the angel appearing to Mary. Maya is represented as telling her husband, the king, about the dream "in the morning"; yet, the conception was said to have been accompanied by "32 great wonders," including the trembling of "100,000 sakwalas" ("solar systems") and the roaring of bulls and buffaloes, which surely would have woken up not only the king but also the entire town! In addition, Maya's pregnancy was attended by 40,000 devas keeping guard. She was "transparent," and the child could be seen in her womb. Certainly, these events—which historicizers would place only six centuries before the common era, when historians and travelers were abundant enough to have noticed—are not "historical" but mythical.

Buddha's birth is further depicted thus:

> During the period of pregnancy Maya was carefully guarded by 40,000 deities, while numberless divine personages stood watch over the royal palace and the royal city. As her time drew near its close, she wished to visit her parents in the city of Koli. The road was levelled; trees were planted; all the luxuries required for an eastern journey were provided, a cushioned litter of gold was her conveyance, and a thousand nobles were her bearers. Attended by a host of followers, she came to a garden of sal trees in bloom. She rested awhile to enjoy the fragrance of the flowers and the songs of the birds, she raised her hand to catch a bough of a tree; it bent of its own will; and without pain, or pollution, Buddha was born. Maha Brahma received the child in a golden net; from him, the guardian deities and nobles who wrapped it in folds of the finest and softest cloth. But Buddha was independent of their aid and leapt on the ground and where he touched it, a lotus bloomed. He looked to the four points and the four half points, above and below, and saw all deities and men

acknowledge his supremacy. He stepped seven steps northward and a lotus marked each foot fall. He exclaimed, "I am the most exalted in the world; I am chief in the world; I am the most excellent in the world, hereafter there is to me no other birth."[41]

This story is beautiful and magical, but it cannot be considered as biography. If it were "history," and if Buddha were a "real person," the author of such miracles and divine wonders, we would be compelled to pronounce him "God of gods," because his bio is much more impressive than that of Christ. However, it is obvious we are not dealing with the biography of any historical human being. And these fabulous tales are just a few of the many regarding "the Buddha," Bodhisat, etc., in his numerous incarnations.

As another example, in one story Buddha is depicted as pre-existing in the mystical land of Tusita, where he "had a crown four miles high." In this fable, he also possessed "sixty wagon-loads of gems and jewels, all other kinds of treasures and a kela of [numberless] beautiful attendants."[42]

Once he finally took incarnation, as an infant Buddha was brought by wise men to the temple, amid a tremendous precession graced by music, showered by flowers and attended by 100,000 deities who pulled the Divine Child's cart. The arrival at the temple was announced by an earthquake, as well as the flower-shower, and the temple idols representing gods came alive and welcomed the latest avatar.[43]

As he grew older, Prince Siddhartha, who would become Buddha, had 40,000 queens, princesses, "dancing women" or "inferior wives" with him in his palace.[44] This motif could hardly be an historical fact, and the number is identical to the amount of deities attending his birth. Moreover, when Siddhartha, rejecting the temptation of the Prince of Darkness, left his native city, he was preceded by 60,000 devas holding "torches of jewels."

In testing whether or not he would become Buddha, the prince threw his hair into the air, saying, "If I am to become Buddha, my hair will remain in the sky..." The hair not only stayed airborne but also attained a height of 16 miles!

During a reception of Buddha by his royal father in his hometown, the other Sakya princes were instructed to worship him, which they were reluctant to do. Having read their thoughts, Buddha contrived to convince them:

> Accordingly, he rose up from the throne, ascended into the air, and in their presence sent forth the six-coloured rays, and caused a stream of fire to proceed from his shoulders, ears, nostrils, eyes, hands, and feet, from the 99 joints and the 99,000

pores of his body; and this was followed by the issuing forth of a stream of water from the same places.[45]

In addition, while visiting the island of Ceylon, Gautama fought in the air with demons, appearing to them as the moon, and creating pillars of fire, after which an island approached the demons, who took refuge upon it.

In another example of the fabulous "life of Buddha," one of the sage's followers, a woman named Yasodhara-devi, who had attained to the status of rahat ("one entirely free from evil desire"), was depicted as follows:

> She...related the history of her former births, then rose into the air and worshipped Budha; in this manner she rose and descended many times; and performed many other wonders, in the presence of men, devas and brahmas.[46]

Again, if these fantastic events are to be considered the biography of a real person, we can only conclude that Buddha is a much more powerful figure than Christ! Furthermore, anyone trying to make a modern biography from this impossible mishmash, which includes talking animals and copious other miracles, would be spinning (dharma) wheels endlessly.

Buddha's Body

The physical description of Buddha is no less fantastic and likewise impossible as "biography." He is depicted as having feet like golden sandals, with chakras (wheels) in the center of the soles. His palms and soles were as soft as "cotton dipped in oil" and "appeared like richly ornamented windows." He possessed antelope-like legs and long, straight arms that reached to his knees. "His secret parts were concealed, as the pedicle of the flower is hid by the pollen," and his body was impervious to dirt and dust. Buddha also had magical hair and nerves, as well as perfectly sized and white-colored teeth, which looked like a "row of diamonds" and which "shone like the stars of a constellation." He had a neck "like a golden drum" and the strength of a lion, etc.[47] Obviously, this description reflects a very strange-looking "person."

Also, whereas Buddha is said to have had red hair, in ancient statuary Buddhas are depicted as *negroid* in feature. As Jones says:

> ...the ancient *Hindus*, according to Strabo, differed in nothing from the *Africans*, but in the straitness and smoothness of their hair, while that of the others was crisp and wooly; a difference proceeding chiefly, if not entirely, from their respective humidity or dryness of their atmospheres; hence the people *who received the first light of the rising sun*, according to the limited knowledge of the ancients, are said by Apuleius to be the *Arü* and

Ethiopians, by which he clearly meant certain nations *of India;* where we frequently see figures of Buddha with *curled hair* apparently designed for a representation of it in its natural state.[48]

Moor also relates that certain statues of Buddha "exhibit thick *Ethiopian* lips" and "wooly hair."[49] It may well be that these images of Buddha were called in Vedic/Sanskrit "black," i.e., *krishna,* or "dark," i.e., *tamas,* which may also explain why Buddha was taken for the "apostle Thomas."

In reality, Buddha's bizarre, amorphous appearance further demonstrates that his story is myth. Again, the understanding of myth is both important and entertaining, not to be dismissed as mere, worthless fabrication. Without creative and imaginative myth, human beings would be far less colorful and rich. It is only when the esoteric meaning of the myth is lost, and the myth becomes misapprehended as "historical fact," that it becomes insidious and harmful.

Buddha's Character

Although Buddha is considered a "divine" and "godly" figure, his behavior, as depicted in the orthodox stories, is not entirely exemplary, as is the case with Jesus and other godmen. First there is the story in which Buddha wishes to have the other princes worship him. Next, when a sage doubts Buddha, one of Buddha's ministers encourages the doubter to challenge the godman. Knowing this betrayal mystically, Buddha informs the minister that "if he again denied that he was the supreme Budha, he was not to approach him anymore, or his head would fall, like a tal fruit from its stalk, or would cleave into seven pieces."[50] These stories belie the commonly held notion of a peaceful teacher with no ego.

According to the priest Nagasena, founder of Mahayana Buddhism, Buddha is responsible for causing death:

> When Budha punishes any one, or casts him down, or takes his life, it is that he may be benefited thereby; for the same reason a father chastises his child.[51]

Like those of Jesus, a number of Buddha's edicts are harsh and sexist, as well as anti-sex. As he himself was celibate, so he expected his followers to be, even if they were married. Because of his decrees (or, rather, those made by priests in his name), it became unlawful to touch a woman. Indeed, one was to avoid women, as they have been deemed defiling. Moreover, as Simpson says:

> Four crimes involved permanent exclusion from the priesthood: sexual intercourse, theft, murder and a false profession of the

attainment of rahatship [state of liberation], or the highest order of sanctity.[52]

Thus, sex is basically equated with theft, murder and lying, not an uncommon development within religion, whose priests have recognized that their flocks are controllable through the manipulation of sex.

In addition, Gautama is also depicted as being humorless, not having smiled in all the years since he became Buddha. When he finally did smile, "he did not show his teeth, or make a noise like some...[but] rays came from his mouth like a golden portico to a dagoba of emeralds, went thrice around his head, and then entered again into his mouth."[53] If such a person really existed, he would have to be considered not only divine and wondrous but also aggressive and repulsive.

It is apparent that a number of important attributes and aspects of the Buddha myth such as the various mystical and magical motifs were part of mysteries kept secret over the centuries, possibly in order to make him look more "human" and "historical." Concerning Buddhist mysteries, Bunsen says:

> Buddhistic tradition is a comparatively late deposit of ancestral wisdom, written or unwritten. It can be rendered probable, though it cannot be proved, that such deeper knowledge was confined to a select number of initiated, among whom the mysteries were transmitted from one generation to another. Such an organization for the transmission of knowledge withheld from the people presupposes firmly established priestly institutions and a secluded mode of life, regulated by severe customs.[54]

The watered-down version of the Buddha tale now portrayed in mainstream sources and held as "gospel truth" by believers may have been the result of rivalry between, firstly, the Buddhist and Hindu priesthoods, and, later, Buddhist and Christian priesthoods, in establishing competing "historical" founders/reformers. Although rival priesthoods also attempt to outdo each other with fantastic stories (i.e., "My god is bigger and better than your god"), evidently the Christian priesthood exercised a bit of restraint in its mythmaking, perhaps because its European targets were more sophisticated and less gullible. Of course, some embarrassing moments remained in the New Testament. For example, the ludicrous claim at Matthew 27:51-53 that, when Jesus was crucified, saints came out of their graves:

> And behold, the curtain of the temple was torn in two, from top to bottom; and the earth shook, and the rocks were split; the tombs also were opened, and many bodies of the saints who had fallen asleep were raised, and coming out of the tombs after his resurrection they went into the holy city and appeared to many.

This fabulous bit of mythmaking is in no way historical. This supernatural event also never makes it into the endless Jesus movies—even Bible-proponents apparently realize that it is too ridiculous to believe and might cast doubt upon the story as a whole.

Buddhism and Christianity

Like Krishna and Jesus, Buddha is not a "real person" but a composite of gods and people. His exploits are fabulous, while his sayings, of course, are from humans. As is also the case with Krishna, some of the information regarding "the Buddha," including important correspondences to the Christ myth, is not found in mainstream books and likely constituted mysteries. Although the story and ideology have changed over the centuries and millennia, numerous elements of Buddhism closely resemble the Christian myth and ideology. In even the orthodox Buddha story, many aspects are strikingly similar to the Jesus tale, although, like that of Krishna, the Buddha myth is more elegant and miraculous.

To begin with, Buddha's mother, Mahamaya, is fecundated by the "Holy Spirit," while a "heavenly messenger" informs her that she would bear "a son of the highest kings." This Buddha would leave behind his royal life to become an ascetic and serve as a "sacrifice" for humanity, to whom he would provide joy and immortality.[55] In the Chinese version, in her 10th month of pregnancy Queen Maya is depicted as going on a journey to her father, during which she gives birth "in an inn."[56] Buddha's birth occurs when the "Flower-star" appears in the east, and is attended by a "host of angelic messengers," who announce the "good news" that a glorious savior of all nations had been born. The holy babe is also attended by "princes and wise Brahmans," or "rishis," one of whom prophesies that Buddha's mission would be to "save and enlighten the world." This last motif is paralleled in the New Testament at Luke 2:25-32, where the righteous Simeon is depicted as announcing Jesus's future mission.

According to the *Abhinish-Kramana Sutra*, the king of Maghada desired to know whether or not there were any inhabitants of his kingdom who would threaten his reign. In this quest, two agents embarked, one of whom discovered Buddha and reported him to the king, also advising the monarch to annihilate Buddha's tribe.[57] This theme of the divine child fleeing the murderous ruler is present in the Tibetan version of the Buddha myth as well.

Like Jesus and Krishna, Buddha escapes this fate, and, at a later point eluding his parents for a day, wows his wise elders with his sagacious discourses and marvelous understanding. The

correlations continue, as, while the adult Buddha fasts and prays in solitude in the desert, he is tempted by the Prince of Darkness, Mara, whose overtures of wealth and glory the sage resists. This story parallels that of Jesus being tempted by Satan. Concerning the temptation motif, Christian apologist Weigall acknowledges that "there is a pagan legend which relates how the young Jupiter was led by Pan to the top of a mountain, from which he could see the countries of the world."[58]

Subsequent to the temptation, Buddha takes a purifying bath in the river Neranjara, upon which "the devas open the gates of Heaven, and cover him with a shower of fragrant flowers," comparable to Jesus's baptism in the Jordan, with the appearance of a heavenly dove and voice pronouncing him the son of God. Upon setting out on his mission, Buddha encounters "the Brahman Rudraka, a mighty preacher," who becomes the sage's disciple, much as the Baptist becomes Jesus's follower. A number of Rudraka's own disciples decide to follow Buddha, but become disenchanted when they see he does not observe the fasts. Concerning Buddha's first followers, Titcomb relates:

> These disciples were previously followers of Rudraka. Before Buddha appoints a larger number of apostles, he selects five favorite disciples, one of whom is afterward styled the Pillar of the Faith; another, the Bosom Friend of Buddha. Among the followers of Buddha there is a Judas, Devadatta, who tries to destroy his master, and meets with a disgraceful death.[59]

As Buddha was said to have had five favorite disciples who left their former teacher to follow him, so too was Jesus, whose initial five left John the Baptist.[60] Buddha is also depicted as speaking with "two buddhas who had preceded him," a motif reminiscent of Jesus conversing with Moses and Elijah. Regarding the correspondences between Buddhism and Christianity, Prasad comments:

> It is not a little strange that the remarkable resemblance, which we have noticed between Buddhism and Christianity extends even to the lives of their founders. Gautama Buddha, as well as Jesus Christ, is said to have been miraculously born. The birth of each was attended with marvellous omens, and was presided over by a star...
>
> Both Gautama and Jesus are said to have twelve disciples each....[61]

The assertion that Gautama had 12 disciples is not found in mainstream accounts. Could it be, however, that this *Indian* scholar has more knowledge about the subject than the Western pundits and apologists? Archaeology proves that the theme of the Teaching God with the Twelve is present in Buddhism: For

example, 30 miles west of Beijing stands the "Temple of the Recumbent Buddha" ("Wofo Si"), originally built in the 7th century CE and renovated in the 13th. In the temple is a 17-foot high "recumbent" Buddha surrounded by "12 disciples in clay," each of whom are about four feet (1.2 meters) high.[62] This scene represents the Buddha, or Sakyamuni, giving his final instructions. Since this temple postdates the Christian era, it will be assumed that the Buddhists are the plagiarists of the Christians; however, the Teaching God with the 12 is an old theme that long predates Christianity.

Another motif found within both Christianity and Buddhism is the crowd requiring a sign from the godman in order to believe in his true nature. Like Jesus, Buddha is portrayed as walking on water, while one of his disciples also is able to walk on water at his instruction. In the Tibetan account, after spending 30 years in the desert, Buddha goes on his mission as a great healer, casting out demons and performing many marvelous miracles.[63] "At his appearance the sick were healed, the deaf cured, and the blind had their sight restored."[64] The miracle of the fishes and loaves, paralleling that of Jesus, is recounted in the *Mayana-Sutra*.[65] While riding a horse, Buddha's path is covered with flowers tossed by the devas or angels, like Jesus with the donkey and palms.

Moreover, Buddha takes a vow of poverty and wanders homeless, with no rest for his weary head. His disciples too are advised to "travel without money, trusting to the aid of Providence," as well as to renounce the world and its riches. They too are able to perform miracles, including exorcising evil spirits and speaking in tongues.[66] The resemblances do not stop there, as one of the disciples' miracles is also found in the Old Testament:

> Arresting the course of the sun, as Joshua was said to have done, was a common thing among the disciples of Buddha.[67]

Like those of Jesus, some of Buddha's disciples are imprisoned by "an unjust emperor," but are miraculously released by "an angel, or spirit." The story of the offensive eye being plucked out and thrown away by a disciple is also related in Buddhist lore.

The biblical story of the Samaritan woman (Jn. 4:7-26) is likewise found in Buddhism: One of Buddha's chief disciples, Ananda, encounters a low-caste woman near a well and requests some water from her. The woman informs Ananda of her offensive low caste, such that she should not approach him. Ananda responds that he is not interested in her caste, only in the water,

after which the woman becomes a follower of Buddha. As Evans says:

> This gentle reply [of Ananda] completely won the maiden's heart, and Buddha coming by, converted her dawning affection into zeal for the general good through the practice of his system of unselfish morality.[68]

Like Jesus, Buddha exhorts his disciples to "hide their good deeds, and confess their sins before the world." Furthermore, Buddha is portrayed as administering baptism for the remission of "sin." As Bunsen relates:

> In a Chinese life of Buddha we read that "living at Vaisali, Buddha delivered the baptism which rescues from life and death, and confers salvation."[69]

Buddha's teachings embrace the brotherhood of men, the giving of charity to all, including adversaries, and "pity or love for one's neighbor."[70]

In *The Fountainhead of Religion* (1927), Indian writer Ganga Prasad states, "The parables of the New Testament also bear a marked resemblance to those of Buddha."[71] Not only the anecdotes, miracles, sayings and parables but also many of Buddha's epithets correlate to those of Christ. Buddha's numerous titles include the following:

> He was called the Lion of the Tribe of Sakya, the King of Righteousness, the Great Physician, the God among Gods, the Only Begotten, the Word, the All-wise, the Way, the Truth, the Life, the Intercessor, the Prince of Peace, the Good Shepherd, the Light of the World, the Anointed, the Christ, the Messiah, the Saviour of the World, the Way of Life and Immortality.[72]

When he is about to die, Buddha turns over his mission to his disciples and informs them that even if the world were to "be swallowed up" and the heavens "fall to earth," etc., "the words of Buddha are true." He also instructs his followers to disperse upon his death and spread his doctrines, establishing schools, monasteries and temples, and performing charity, so that they may attain to "Nigban," or "heaven."[73]

Concerning Buddha's death, Titcomb states:

> It is said that towards the end of his life Buddha was transfigured on Mount Pandava, in Ceylon. Suddenly a flame of light descended upon him, and encircled the crown of his head with a circle of light. His body became "glorious as a bright, golden image," and shone as the brightness of the Sun and moon...

> At the death of Buddha, the earth trembled, the rocks were split and phantoms and spirits appeared. He descended into hell and preached to the spirits of the damned.

> When Buddha was buried, the coverings of his body unrolled
> themselves, the lid of his coffin was opened by supernatural
> powers, and he ascended bodily to the celestial regions.[74]

The resemblances to the Christ myth include the
transfiguration, the earthquake upon death, the descent into hell,
the burial shroud and the ascension. For the most part, Titcomb's
synopsis of Buddha's life and death reflects the mainstream,
orthodox tale. One exception is the assertion that Buddha
"ascended bodily" after his death, a claim not without merit, as
shall be seen. In any case, those who know the gospel story and
the canonical Acts of the Apostles in depth, as well as the
apocryphal Christian texts and legends recounted over the
centuries, will recognize numerous elements in the Buddha tale
that correspond to the Christ myth. In *Bible Myths and Their
Parallels in Other Religions*, Doane goes into even greater detail as
to these many resemblances.

In *The Christ Myth*, John Jackson relates other important
details of the Buddha myth, some of which also are "esoteric,"
i.e., not found in the orthodox story:

> The close parallels between the life-stories of Buddha and Christ
> are just as remarkable as those between Krishna and Christ.
> Buddha was born of a virgin named Maya, or Mary. His birthday
> was celebrated on December 25. He was visited by wise men who
> acknowledged his divinity. The life of Buddha was sought by
> King Bimbasara, who feared that some day the child would
> endanger his throne. At the age of twelve, Buddha excelled the
> learned men of the temple in knowledge and wisdom. His
> ancestry was traced back to Maha Sammata, the first monarch
> in the world. (Jesus' ancestry is traced back to Adam, the first
> man in the world.) Buddha was transfigured on a mountain top.
> His form was illumined by an aura of bright light. (Jesus was
> likewise transfigured on a mountain top. "And his face did shine
> as the sun, and his raiment was white as the light.") After the
> completion of his earthly mission, Buddha ascended bodily to
> the celestial realms.[75]

The motifs of Jackson's synopsis not emphasized or
mentioned in the orthodox tale are the virginity of Buddha's
mother and his December 25th birthdate, both of which claims are
judicious, however, as was the case in the Krishna myth. Also,
like Titcomb, Jackson asserts that Buddha "ascended bodily."

The profuse correspondences between Buddhism and
Christianity were noticed numerous times over the centuries by
Jesuits and other missionaries who traveled to the East,
including the clergy of the Portuguese, who invaded India in the
15th century. As Christian lawyer O'Brien relates in *The Round*

Towers of Ireland or The Mysteries of Freemasonry, of Sabaism, and of Budhism:

> ...the conformity...between the Christian and the Budhist religion was so great, that the Christians, who rounded the Cape of Good Hope with Vasco da Gama, performed their devotions in an Indian temple, on the shores of Hindostan! Nay, "in many parts of the Peninsula," says Asiatic Researches, "Christians are called, and considered as followers of Buddha, and their divine legislator, whom they confound with the apostle of India [St. Thomas], is declared to be a form of Buddha, both by the followers of Brahma and those of Siva..."[76]

Regarding these conformities, Prasad says:

> Dr. Fergusson, who is perhaps the highest authority on the subject of Indian Architecture, makes the following remarks about the Buddhist cave temple of Karli, the date of which he fixes at 78 B.C.: "The building resembles, to a great extent, a Christian Church in its arrangement, consisting of a nave and side aisles, terminating in an apse or semidome, round which the aisle is carried.... "

> "But the architectural similarity," says Mr. Dutt, "sinks into insignificance in comparison with the resemblance in rituals between the Buddhist and Roman Catholic Church." A Roman Catholic missionary, Abbe Huc, was much struck by what he saw in Tibet.[77]

The missionary Huc's travels in Tibet yielded acknowledgment of the following aspects of Tibetan Buddhism, which correlate closely to Catholic ritual and hierarchy:

> "...confessions, tonsure, relic worship, the use of flowers, lights and images before shrines and altars, the signs of the Cross, the trinity in Unity, the worship of the queen of heaven, the use of religious books in a tongue unknown to the bulk of the worshippers, the aureole or nimbus, the crown of saints and Buddhas, wings to angels, penance, flagellations, the flabellum or fan, popes, cardinals, bishops, abbots, presbyters, deacons, the various architectural details of the Christian temple."[78]

In its article on "Buddhism," the Catholic Encyclopedia outlines some of these correspondences between the Tibetan and Catholic religions, yet maintains that Catholicism was first and that the Buddhist correlations are "accretions" likely copied from the Christian faith:

> Catholic missionaries to Tibet in the early part of the last century were struck by the outward resemblances to Catholic liturgy and discipline that were presented by Lamaism—its infallible head, grades of clergy corresponding to bishop and priest, the cross, mitre, dalmatic, cope, censer, holy water, etc. At once voices were raised proclaiming the Lamaistic origin of Catholic rites and

practices. Unfortunately for this shallow theory, the Catholic Church was shown to have possessed these features in common with the Christian Oriental churches long before Lamaism was in existence. The wide propagation of Nestorianism over Central and Eastern Asia as early as A.D. 635 offers a natural explanation for such resemblances as are accretions on Indian Buddhism.[79]

The charge that Hinduism, Buddhism and other "Pagan" religions copied Christianity proves that there are indeed significant similarities between them, so much so that the most learned apologists and defenders of the faith have been compelled to acknowledge and find a reason for them. Naturally, since Christianity is depicted as "divine revelation" entirely new to the time, the Catholic hierarchy could not admit that the more ancient religion could have influenced the newer Christian faith. So began the tradition of claiming Christian influence on Indian and Tibetan religion. While the argument may be applicable to Tibetan Buddhism, although it seems highly unlikely, the fact will remain that most if not all of the ritualistic correspondences outlined above existed somewhere in some form prior to the Christian era, which means that they are not "divine revelation" within Christianity.

In response to the Christian charge that Tibetan Buddhism copied Christianity, in *The Ruins of Empires* (1791), Volney created a fictional conversation between a Christian and a Tibetan Buddhist in which the Buddhist retorts:

> "Prove to us," said the Lama, "that you are not Samaneans [Buddhists/Hindus] degenerated, and that the man you make the author of your sect is not Fot [Buddha] himself disguised. Prove to us by historical facts that he even existed at the epoch you pretend; for, it being destitute of authentic testimony, we absolutely deny it; and we maintain that your very gospels are only the books of some Mithraics of Persia, and the Essenians of Syria, who were a branch of reformed Samaneans."

At this point, Volney notes:

> That is to say, from the pious romances formed out of the sacred legends of the mysteries of Mithra, Ceres, Isis, etc., from whence are equally derived the books of the Hindoos and the Bonzes. Our missionaries have long remarked a striking resemblance between those books and the gospels. M. Wilkins expressly mentions it in a note in the Bhagvat Geeta. All agree that Krisna, Fot [Buddha], and Jesus have the same characteristic features: but religious prejudice has stood in the way of drawing from this circumstance the proper and natural inference. To time and reason must it be left to display the truth.

It is indeed time to throw away religious prejudice and display the truth. In this case, the truth is that Buddhism's traditions are very old, and there is no evidence of any magical Christian making his way, in the case of Tibet, to the "top of the world" and, overthrowing the religious hierarchy of the entire country, being able to implement the Christian myth and ritual, leaving no direct trace of either himself or the event.

Continuing its outline of correspondences between Christianity and Buddhism in general, the Catholic Encyclopedia again attempts to debunk the contention that the latter was influenced by the former. Nevertheless, the similarities between Buddhism and Christianity also include the orders of monks and nuns; various sayings; and most of all, says CE, "the legendary life of Buddha, which in its complete form is the outcome of many centuries of accretion" and which contains "many parallelisms, some more, some less striking, to the Gospel stories of Christ."

Having said that, CE disparages those who would "take for granted" that these parallelisms are pre-Christian. These "few third-rate scholars," says CE, "have vainly tried to show that Christian monasticism is of Buddhist origin, and that Buddhist thought and legend have been freely incorporated into the Gospels." CE then accuses these various scholars of grossly exaggerating or fabricating these resemblances, even though a number of those who outlined them were Jesuits and other Catholics who studied Buddhism firsthand. As we have seen, the resemblances are certainly not "grossly exaggerated" or fictitious; yet, CE avers that, when "all these exaggerations, fictions, and anachronisms are eliminated, the points of resemblance that remain are, with perhaps one exception, such as may be explained on the ground of independent origin." "Independent origin," yet copied *by* Buddhism *from* Christianity?

In any case, CE maintains that Buddhism did not spread westward but that Christianity spread eastward, and, again, that Buddhism is the "borrower," if there be one:

> It is chiefly the legendary features of Buddha's life, many of which are found for the first time only in works of later date than the Gospels, that furnish the most striking resemblances to certain incidents related of Christ in the Gospels, resemblances which might with greater show of reason be traced to a common historic origin. If there has been any borrowing here, it is plainly on the side of Buddhism. That Christianity made its way to Northern India in the first two centuries is not only a matter of respectable tradition, but is supported by weighty archaeological evidence. Scholars of recognized ability beyond the suspicion of undue bias in favour of Christianity...think it very likely that the Gospel stories of Christ circulated by these early Christian

communities in India were used by the Buddhists to enrich the Buddha legend, just as the Vishnuites built up the legend of Krishna on many striking incidents in the life of Christ.

The fundamental tenets of Buddhism are marked by grave defects that not only betray its inadequacy to become a religion of enlightened humanity, but also bring into bold relief its inferiority to the religion of Jesus Christ. In the first place, the very foundation on which Buddhism rests—the doctrine of karma with its implied transmigrations—is gratuitous and false.[80]

Here the CE blatantly contradicts itself in admitting that the life of Buddha contains "striking resemblances" to the life of Christ, even though it earlier declared that such resemblances were "grossly exaggerated" and "fictitious." CE also acknowledges that the life of Krishna is quite similar to that of Christ, whereas less educated apologists argue there are no correspondences. Next, CE baldly accuses the Vaishnava/Hindu priesthood of plagiarizing Christianity.

If it is admitted that priesthoods copy each other, cannot the charge be leveled in the opposite direction, i.e., that the Christian priesthood copied the Hindu and Buddhist, which are far older? It is a *fact* that a number of the most important rituals and motifs of the Christian faith are of *Pagan* origin, as has been and will continue to be demonstrated. Therefore, it is an *established fact* that Christianity copied Paganism, or, rather, was a continuance of it, instead of representing a "stunning break," as is falsely depicted.

Moreover, what is this "weighty archaeological evidence" of Christian influence in Northern India at that time? Do we possess Greek and Latin books, any Bible from the early centuries, translated into any Indian language, of which there are numerous? Any distinctly Christian monuments, etc., from this early period? Or mere tradition by Church fathers, who, unable to explain why the "Christian" religion was already in India, made up stories (as they were wont) about missionaries such as Thomas (a fictional character), Bartholomew (also likely fictional) and Pantanaeus proselytizing there? Furthermore, the theological argument in the end proves nothing, except that the CE feels it necessary to assert the superiority of its own ideology, a contentious act quite common in the competitive and lucrative industry of religion.

Apparently, what the Catholic Encyclopedia means by a "third-rate scholar" is anyone not a Catholic believer: for example, a Buddhist or Hindu native of India or Asia endeavoring to demonstrate that his faith preceded Christianity and contained much subsequently found therein. Interestingly, Robert

Eisenman relates the same experience in regard to the Dead Sea scrolls debacle: Those scholars who went along with the official, establishment party line were considered "first-rate," while those opposing it were "second-rate."[81] In any event, the CE's arguments against the priority of Buddhism and the "borrowing" by Christianity are unsatisfying and sophistic. They are useful, however, in establishing that the correspondences do indeed exist, even though CE itself also paradoxically attempts to deny that fact, before blaming these "non-existent" correspondences on "lying Brahman priests."

While modern defenders of the Christian faith flatly refuse to acknowledge the similarities between the story and religion of the Buddha and those of the Christ, more learned apologists of the past, their backs against the wall because of the abundance of such analogies, were compelled to argue that Christianity influenced Buddhism, rather than the other way around. Concerning this debate, which was obviously well known among the scholars of the past centuries, Inman comments:

> With the usual pertinacity of Englishmen, there are many devout individuals who, on finding that Buddhism and Christianity very closely resemble each other, asseverate [contend], with all the vehemence of an assumed orthodoxy, that the first has proceeded from the second. Nor can the absurdity of attempting to prove that the future must precede the past deter them from declaring that Buddhism was promulgated originally by Christian missionaries from Judea, and then became deteriorated by Brahminical and other fancies!...
>
> If, for the sake of argument, we accord such cavillers the position of reasonable beings, and ask them to give us some proof of the assertion, that early Christian people went to Hindostan and preached the gospel there; or even to point out, in history, valid proofs that India was known to a single apostle, we find that they have nothing to say beyond the vaguest gossip.[82]

Inman then proceeds to name as this gossip the writings of Church fathers who claimed that the disciples Thomas, Bartholomew and Pantanaeus, among others, traveled to India, and single handedly so affected the vast and diverse populace that it adopted and adapted Christianity, completely eradicating evidence of its Palestinian and Judean origin. As we have seen, rather than being a wandering disciple, "Thomas" is evidently not only the Syrian dying-and-rising god Tammuz but also *Tamas*, or "darkness," apparently an epithet for an Indian god such as Krishna or Buddha. In other words, the "St. Thomas Christians" of Malabar were not "Christians" at all but pre-Christian Tamas worshippers. Regarding this particular area and the Christian

justification for the presence of "Christianity" in India, Inman declares:

> There is positively no evidence whatever—except some apocryphal Jesuit stories about certain disciples of Jesus, found by Papal missionaries at Malabar—that any disciple of Mary's son ever proceeded to Hindostan to preach the gospel during the first centuries of our era.[83]

Evidence of Christian activity in India only appears as early as the 7th century, with the Nestorianism mentioned by the Catholic Encyclopedia. Moreover, the designation "India" did not necessarily indicate the subcontinent itself but was "a vague term referring to any country east of Ethiopia."[84] By their accounts, it seems that the Christian fathers were not speaking of India but of Arabia and Persia.[85]

Concerning this debate, Bunsen, a Christian, observes:

> The remarkable parallels in the most ancient records of the lives of Gautama Buddha and of Jesus Christ require explanation. They cannot all be attributed to chance or to importation from the West.

> We now possess an uninterrupted chain of Buddhist writings in China, "from at least 100 B.C. to A.D. 600," according to Professor Beal.[86]

Commenting upon the numerous correlations between Buddhism and Christianity, Dr. Inman maintains that the Buddhist tale came first:

> It will doubtless have occurred to anyone reading the preceding pages, if he be but familiar with the New Testament, that either the Christian histories called Gospels have been largely influenced by Buddhist's legends, or that the story of Siddhartha has been moulded upon that of Jesus. The subject is one which demands and deserves the greatest attention, for if our religion be traceable to Buddhism, as the later Jewish faith is to the doctrines of Babylonians, Medes, and Persians, we must modify materially our notions of "inspiration" and "revelation." Into this inquiry St. Hilaire goes as far as documentary evidence allows him, and Hardy in *Legends and Theories of the Buddhists* also enters upon it in an almost impartial manner. From their conclusions there can be no reasonable doubt that the story of the life of Sakya Muni...certainly existed in writing ninety years before the birth of Jesus; consequently, if the one life seems to be a copy of the other, the gospel writers must be regarded as the plagiarists.[87]

Non-Christian scholars, such as Indians themselves, also contend that the Indian religions, with various of their "Christian" motifs and rituals, long preceded the Christian era. Such scholars possess common sense and rationality on their side, since

Buddha and Buddhism antedated Christianity by centuries, if not millennia.

The Spread of Buddhism

The contention that Indian scriptures postdate the Christian era and, therefore, that pertinent Buddhist stories appeared later than Christianity is inaccurate and untenable. As stated, some Buddhists have claimed their religion dates back at least 15,000 years, long predating the advent of any "historical" Buddha, which itself purportedly took place several centuries before Christianity was created. It has been further maintained that what is called the "Buddhist" or "Hindu" religion existed in numerous places, thousands of years before the common era:

> Mr. Barrow, the great astronomer, says that, "The Hindoo religion spread over the whole earth; that Stonehenge is one of the temples of Boodh; and that astronomy, astrology, arithmetic, holy days, games, etc., may be referred to the same original."[88]

Factoring in that many of the Western world's languages are connected, via a proto-Indo-European root, there is much reason to conclude that one or more of the peoples who eventually inhabited the British Isles, for example, were emanations out of India, in the centuries to millennia prior to the Christian era, bringing with them the Vedic language and culture, including religious concepts. In the 19th century, lawyer Henry O'Brien, for one, demonstrated a number of connections between Irish and Indo-Iranian culture, and Magistrate Godfrey Higgins averred, "Many remains of the Buddhist religion are to be found in Ireland."[89] As one of his proofs, Higgins recalled meeting an old man in the Scottish Highlands who informed him that "the Gaelic language was called *Sanscrit*." When a waiter opened the door of the coach in which the two were traveling, the old man asked him the name of the Gaelic language, and the waiter affirmed his statement.[90]

Even ancient designations of Ireland indicate a Buddhist connection:

> ...they gave [the Sacred Island] two *other* names, viz., *Phud Inis*, and *Inis=na-Phuodha*—which, at once, associate the "worship" with the profession of the worshippers—for, *Phud Inis*, is *Budh Inis*—*Ph*, or, F, being only the aspirate of, *B*, and commutable with it—that is, Budh Island; and *Inis-na-Phuodha* is *Inis-na-Buodha*, that is, the island of Budha.[91]

In these statements appears evidence that "Buddhism" made its way to the West long prior to Christianity. Concerning the spread of Buddhism, O'Brien further relates:

The date of the Scythian invasion [of Ireland]...being fixed as B.C.
1002, it is agreed on all hands that that of the *Tuath-de-danaans*
[ancient Irish] was but two hundred years anterior, or B.C. 1202,
with this *exactly corresponds the time at which Marsden,
Koempfer, and Loubere date the arrival of the Buddists at Siam,*
viz., B.C. 1202. Among the Japanese also, they are stated by
Klaproth to have arrived not very distant from that era, or B.C.
1029. De Guignes and Remusat suppose 1029 as the epoch at
which they invaded China. B.C. 1000 is the epoch assigned by
Symes for their descent upon the Burman empire; and B.C. 1029
is that fixed by Ozeray for their entrance into Ceylon; while the
Mogul authors and Bagwad Amrita (Sir W. Jones) recognise their
appearance respectively at B.C. 2044 and B.C. 2099.[92]

Sir Jones's relevant comments concerning this dispersion are
as follows:

The *Scythian* and *Hyperborean* doctrines and mythology may
also be traced in every part of these eastern regions; nor can we
doubt that WOD or ODEN, whose religion, as the northern
historians admit, was introduced into *Scandinavia* by a foreign
race, was the same with BUDDHA, whose rites were probably
imported into *India*, nearly at the same time, though received
much later by the *Chinese*, who soften his name into FO.[93]

A surprising number of scholars and researchers of the 18th
and 19th centuries thus claimed Buddhism's dispersion a
millennium or more prior to the common era, leaving one to
wonder what happened within the past century that the religion
is now considered to have "sprung up" suddenly during the 6th
century BCE or later. In more recent times, scholar Peter Ellis has
demonstrated numerous cultural commonalities between India
and the West, in specific the Celtic-occupied territories, including
but not limited to the language. As an example of the linguistic
connection, Ellis says:

One fascinating parallel is that the ancient Irish and Hindus
used the name Budh for the planet Mercury. The stem budh
appears in all the Celtic languages, as it does in Sanskrit, as
meaning "all victorious," "gift of teaching," "accomplished,"
"enlightened," "exalted" and so on.

It is clear that "Buddhism" is an ancient Indian religious
export that extends back thousands of years. Officially, however,
conservative scholarship will grudgingly allow for the religion of
"the Buddha" to have made inroads in the West only during or
after the third century BCE. Addressing the evidence of
Buddhism's pre-Christian origins, the conservative and pious
Christian scholar Max Müller discussed the "great Buddhist
council" under the Indian king Asoka that occurred in 245 or 242
BCE, known from various inscriptions in India. He next asserted

that Buddhism is to Brahmanism or the Vedic religion what Protestantism is to Catholicism, and that the language of the Asokan inscriptions is to Sanskrit what Italian is to Latin. Hence, the third century BCE is the terminus ad quem for Sanskrit,[94] and Sanskrit-speaking peoples such as the ancient Irish much have separated from the Indians prior to that period. Also, even though Protestantism only dates to the 16th century, it is nonetheless Christianity, and its myths and tenets for the most part are much older than the sect itself. The same can be said of Buddhism. In reality, Buddhism's underlying system and language are much older than the era of "the Buddha" several centuries prior to the Christian era. The Asokan missionary effort, it should be noted, included spreading Buddhism among the Greek-speaking populace, as far west, it is asserted, as the Levant or Palestine and Judea.

One of several researchers to make such an assertion is the Indian scholar Prasad, who maintains that Buddhism existed centuries before the common era in the very area in which Christianity sprang up:

> "The moral precepts and teachings of Buddhism," says Mr. R.C. Dutt, "have so much in common with those of Christianity, that some connection between the two systems of religion has long been suspected." The teaching of Buddha had penetrated into the Greek world long before the birth of Christ. We know from Asoka's inscription of Girnar that in his reign Buddhist preachers had gone to Syria to preach the religion.[95]

The Catholic Encyclopedia, naturally, disputes this purported Buddhist spread and influence:

> ...is there any historical basis for the assertion that Buddhist influence was a factor in the formation of Christianity and of the Christian Gospels? The advocates of this theory pretend that the rock-inscriptions of Asoka bear witness to the spread of Buddhism over the Greek-speaking world as early as the third century B.C., since they mention the flourishing existence of Buddhism among the Yavanas, i.e. Greeks within the dominion of Antiochus.[96]

CE maintains that the "Yavanas" in the Asoka inscriptions refer not to Greeks of Syria, where the Macedonian Antiochus I reigned from 281 to 61 BCE, but only to the "Greek-speaking peoples on the extreme frontier next to India, namely, Bactria and the Kabul valley." This contention concerning limited contact with the Yavanas is made by, in CE's words, "first-rate scholars," as opposed to those "third-rate" scholars who contend Buddhist influence on Christianity. CE continues its argument against Buddhist influence in the Near East, declaring that Buddhist records do not provide "reliable evidence" of Buddhism's spread

BCE. CE also claims there is no archaeological or literary evidence of Buddhism in Palestine, Greece or Egypt, no monuments or stupas, no Greek translations of Buddhist texts, no references to a Buddhist community. Surprisingly, CE next states:

> To explain the resemblances in Christianity to a number of pre-Christian features of Buddhism, there is no need of resorting to the hypothesis that they were borrowed. Nothing is more common in the study of comparative ethnology and religion than to find similar social and religious customs practised by peoples too remote to have had any communication with one another. How easily the principle of ascetic detachment from the world may lead to a community life in which celibacy was observed, may be seen in the monastic systems that have prevailed not only among Buddhists, Essenes, and Christians, but also among the early Aztecs and Incas in the New World. Nor is this so strange when it is recalled that men everywhere have, to a large extent, the same daily experiences, the same feelings, the desires. As the laws of human thought are everywhere the same, it lies in the very nature of things that men, in so far as they have the same experiences, or face the same religious needs, will think the same thoughts, and give expression to them in sayings and customs that strike the unreflecting old server by their similarity. It is only by losing sight of this fundamental truth that one can unwittingly fall into the error of assuming that resemblance always implies dependence.

While protesting against Buddhist influence on Christianity, the Catholic Encyclopedia ironically acknowledges that there are "a number" of features in common that are *pre-Christian*; in other words, these aspects of Christianity are nonetheless *Pagan* in origin, and do not represent "divine revelation," as is misrepresented. Furthermore, CE says that there is no evidence for Buddhism in the various pertinent places and then paradoxically proclaims that the evidence for its ascetic monkishness is found globally! Monasticism, according to CE, is a natural inclination of the human mind, which would imply that one system is as good as the other and that Christianity is just another such manmade product, a reflection of its time and ethnic context. *These two contentions, that Christianity is not unique or original, and that it is a manmade ideology based on era and ethnicity, are central to our discussion and, as can be seen, have been conceded by the highest Christian authority.*

The acknowledgement that the pre-Christian Essenes are monastic or ascetic (i.e., "Buddhistic") verifies that Christian monasticism is unoriginal and tends to validate the well-argued thesis that Essenism became Christianity. The pre-Christian and proto-Christian writers of the Dead Sea scrolls, not Essenes but

Zadokites, also reveal such a brotherhood, which is evidently a monastic branch of the Sadducees.

> The Catholic Encyclopedia's argument concerning literature and artifacts is unimpressive and unsustainable, particularly considering that the Catholic Church itself went on a censorship rampage for centuries, destroying millions of books, trampling down and eradicating temples and artifacts wherever it could find them, and converting the remains to Christian monuments. There is also the problem of not seeing the clues in the ruins of these empires, as, for centuries, archaeology in these parts of the world has been in the hands of the vested believers. In the past decades a more scientific archaeology in Palestine and Israel has disproved many of the fantastic claims of the Bible. Moreover, the Library of Alexandria, with its more than half a million volumes, doubtlessly contained Buddhist and Hindu texts, prior to the Christian era. Factoring in the obliteration of this massive library, the discussion concerning lack of evidence merely serves to highlight the vast criminal destruction of ancient culture perpetrated in the name of Christ. Also, the Vatican sits on top of miles of underground tunnels filled with the booty from other nations—who can say what texts and other artifacts among the countless are contained there? Furthermore, what has survived and made it to the public more frequently than not has been badly mutilated by Christian censors.

As concerns CE's contention regarding extant Buddhist records themselves, many of which have been out of the reach of these Western censors, without having access to priests knowledgeable of surviving ancient texts in a variety of languages it is difficult to know what these thousands of texts may actually contain. Contrary to CE's contention, however, which is in itself ironic since there are no records to back up Christian claims either, the dispersion of various Indo-European cultures from India is clearly recorded in some Indian texts. For example, in one Indian tale, Bahm, the "Seventh King," died in humiliation and was avenged by his son, Sagara, whose reign Wilford estimates to have taken place around 2000 BCE.[97] By Sagara's hand apparently, various peoples, including the Sakas, Yavanas, Kambojas, Paradas and Pahlavas, were "about to undergo extermination."[98] The family priest intervened, and Sagara instead forced them to shave different parts of their heads, an act that made them into *Mlecchas* or outcasts. Of this group of outcasts, the Yavanas became the Greeks, the Sacas the Scythians, and the Pahlavas the Persians. It appears that this story reflects an exodus of these peoples from India some 4,000 years ago. It is a fact that the language of the Greeks is closely related to the Sanskrit, as is the "Scythian" of the British Isles. So too is the Persian related to the Vedic. Thus, there exists a

common cultural heritage, which, naturally, includes religion. This fact of commonality means that these peoples had been in the same place and had migrated, as is related in the Sagara tale; knowing about the early migrations, it is logical to assert that they crossed paths again over the centuries and millennia. That there was contact between the West and East by at least the second millennium BCE is a fact, proved not only by the Silk Road traffic but also by the presence of the Indian Mitanni and Kassite kingdoms in Asia Minor and Mesopotamia. These peoples are thus not "too remote" from each other but intertwined over a period of many centuries. With such precedents, it is not unreasonable for the erudite writers and scholars of the past, including Christian authorities, to have made conclusions regarding provenance and primacy pointing to India.

International exchange is also demonstrated in the stories of Osiris and Isis in India, in Egyptian or "Ethiopian" colonies in India, and in Indian colonies in Egypt, long before the common era. In this regard, there was reputedly a colony of "gymnosophs," i.e., Buddhists, Jains or Indian monks, at Lake Mareotis near Alexandria, Egypt, ages before the establishment of Christianity. During the centuries just before and after the beginning of the Christian era, Indians were abundant in Alexandria, the true crucible of Christianity. Some of the monks in Egypt were certainly Buddhist priests or "Rahans" who left India in opposition to the Brahman priests.[99] Another "Buddhist" or ascetic group situated near Mareotis constituted the Therapeuts, who were highly instrumental in the creation of Christianity. Many other inferences of Buddhistic and monastic communities in Egypt and elsewhere outside of India may be found in Higgins's *Anacalypsis*. Other monastic communities became known as Essenes, Gnostics, Christians, etc. Furthermore, Gnosticism contains much of the Persian religion, and at Nag Hammadi were discovered Gnostic texts called *Revelations of Zoroaster* and *Apocalypse of Zoroaster*. The religion of Zoroaster and the Persian language are traceable to India. Interestingly, while discussing the Medians (Persians) under the rule of Deioces, Herodotus mentions (I, 101), along with the Magi, a people named "Budii." Also, famed Gnostic teacher Basilides in the second century was reputed to have written a "book on Hindu teachings."[100]

Concerning this abundant religious intercourse between East and West, Col. Wilford observes:

> There were diviners and soothsayers in *Syria* and *Palestine*, from beyond the east, that is to say from beyond *Persia*, and of course from *India*, 700 years before CHRIST, according to ISAIAH; and these, long after, found their way even to *Rome*...[101]

Wilford further points out that the Carthaginians possessed *Indian* elephants, along with Indian drivers, three centuries before the common era. Also during these centuries surrounding the beginning of the Christian era, there was regular trade between India and Egypt, beginning with the Ptolemies and lasting until the seventh century CE, with the rise of Islam. In addition, in "the first century, *Hindu* astrologers were in high estimation and repute at *Rome...*"[102] "The constant embassies, sent from *India* to the Emperors of *Rome* and *Constantinople*, are well known to the learned."[103] One known example of a Brahman traveling to the West in order to participate in the Eleusinian mysteries, which originated by 1000 BCE at the latest,[104] is that of the priest Zarmaros, who visited Augustus (63 BCE-14 CE) as an ambassador from the Indian King Poros.[105] Also, in the year 103, Claudius was visited by "an embassy from a king of *Ceylon*." Moreover, there were "ambassadors from *India* sent to Antonius Pius, to Diocletian, and Maximian; to Theodosius, Hercluis, and Justinian..."[106] The Greek astronomer, geographer and mathematician of Ptolemy (2nd century CE) related that he had studied with "many learned Indians" at Alexandria as well. We know from Clement of Alexandria that the name "Buddha" was recognized by at least the second century by Western religionists and historians. It is further alleged that two of the important Christian centers, Alexandria and Antioch, had already been exposed to Vedic doctrines, as well as to the name "Krishna/ Christos," long before the middle of the 1st century CE. In this regard, it is implausible that, per CE's suggestion, no Greek ever returned from the "outer country" of the Yavanas and related his adopted religion.

The presence of Indian fakirs in the Roman Empire began at least by the first century BCE, and by the second century of the common era there were many of them at Rome itself. In the era when the gospel story was created, fiction proliferated in the Roman Empire, as did the bizarre and weird, with the citizens having an appetite for freak shows of all sorts, including such Indian fakirs performing "miracles" and other superhuman feats. It would therefore not be unexpected that Indian stories captured the imagination of the time. These stories evidently were not only in Rome at the time when Christianity began to be formulated, but they also served as inspiration thereof.

Even if the name "Buddha" as such (recalling that the *title* was highly varied) does not appear in the extremely censored Western literary record until the second century, it is impossible to believe that these various priestly and pious Indian visitors did not discuss their gods and doctrines with their Western

counterparts. In reality, the argument against "Buddhist" influence on pre-Christian brotherhoods and Christianity itself rests on the terminology "Buddhism" and "Buddha," and whether or not such Buddhism of the centuries prior to the Christian era came directly from India and retained Indian idiosyncrasies. Again, the names attributed to the spiritual shepherd of Buddhism have varied widely in different places and eras. The religion or, rather, *religions* of India were not called "Hinduism" until the 19th century—does this fact mean that these ideologies did not exist until then? Even if the names were not used and are thus not found in Western literature, Buddhistic concepts abound in Western ideologies. There is no doubt that Christianity was a continuation of what already existed, and that pre-Christian monasticism was much alike throughout the world, for centuries and millennia anterior to the Christian era.

As a notable example, one name of the spiritual and mystical archetype in the Greek world was Hermes, or Thoth in the Egyptian. Hermes was also a god in Israel and Canaan: "The Hermes of Egypt, or Buddha, was well known to the ancient Canaanites, who had a temple to μρη *erm.*"[107] Hence, "Buddha" by whatever name was known in the Levant long prior to the common era. From the tales identifying Buddha with St. Thomas, it appears that "Buddha *Tamas*" was also *Tammuz* in the Near East, centuries before the Christian era.

The epithet "Buddha" itself, pronounced and transliterated as "Poolah," "Phuta" or "Phta," closely resembles and is suggestive of "Ptah," the name of one of the most important Egyptian gods. Another form of the sun,[108] Ptah's epithets are essentially the same as those of Buddha, as he is described as "creator of the earth, father of the gods and all the being of this earth, father of beginnings."[109] Furthermore, the Greek asceticism named after Pythagoras is akin to Buddhism, and the name "Pythagoras, Pythagoreans" has been analyzed etymologically to represent "Buddha" and "guru," indicating Indian origin. The story goes that, as did many seekers of truth centuries prior to the Christian era, Pythagoras himself studied in India and adopted "Buddhism," by whatever name. Indeed, although Pythagoras was a Pelasgian from Samos, his adopted theory of metempsychosis, transmigration or reincarnation is Indian.[110]

One of the better-known ascetic brotherhoods was that of the Samaneans, which is understood to be a group of "Buddhist" monks. This term "Samanean" provides an intriguing clue as to the spread of Buddhism, as it apparently originates with the Siamese Buddha, "Sommonacadom," "Sramana" or "Saman." In Sri Lanka, "Saman" is "the deity of the morning sun" worshipped

on "Samanolakanda Mountain, also called Adam's Peak."[111] Count Volney calls "Budsoism" [Buddhism] the "religion of the Samaneans." Moreover, Moor relates:

...in Siam, [Buddha] is, among other names, called Sramana, or Sravana Gautama: the epithet, which means *holy*, is sometimes pronounced *Samana*; and in the name a *d* is sounded for the *t*, giving the Sommonacadom of former inquirers into *Siamese* and *Japanese* theology.[112]

Great travelers who brought their doctrines west and made numerous converts, ultimately influencing Christianity, "the Samaneans were the priests of Saman or Buddha," equated with the Magi, or Persian priestly caste; "consequently Buddha, or Maga, or Saman, must have been venerated in those regions."[113]

The appellation "Samanean" also reflects the *Syrian* worship of "Saman," a mystical epithet for the Deity that is essentially the same as "Simon," as in the Samaritan "Simon Magus" of Christian legend who so vexed the "true apostles." The term "Magus" is both the singular of Magi, the title of the Persian priests and mystics, as well as, evidently, the Latin for "Maga," another Syrian name for the mystical Being, the same as the Eastern term "Maya." In his *First Apology* (XXVI), Church father Justin Martyr stated that "Simon Magus" was "considered a god" by the Samaritans and that he was honored with a statue on the Tiber River in Rome:

"Simoni Deo Sancto,"

"To Simon the holy God." And almost all the Samaritans, and a few even of other nations, worship him, and acknowledge him as the first god...[114]

This inscription, either "Simoni Deo Sancto," or "Semoni Sanco Deo," translates as "Simon the Holy God."[115] The base of this statute was discovered in 1574, while the temple to which it belonged, also discussed by Justin, was known to have been a pre-existing sanctuary to a *god*—Semo Sanctus—founded in 466 BCE, per Christian writer Dionysius. Edwin Johnson, who is of the opinion that the "whole account of [Simon Magus] is a manifest myth," recounts that "semones was the general Sabine [ancient Italian] name of tutelar genii or lares," i.e., deities. Says the Catholic Encyclopedia: "The statue...that Justin took for one dedicated to Simon was undoubtedly one of the old Sabine divinity Semo Sancus. Statues of this early god with similar inscriptions have been found on the island in the Tiber and elsewhere in Rome."[116] Hence, "Simon" or "Semon" was a "divine being" who, in Christian and Gnostic legend, was coupled with "Helen," who in turn is the moon goddess.[117] It would appear, therefore, that the Christian tales of the rivalry between "Simon

Peter" and "Simon Magus" display the conflict between Christians and Samaneans, the latter of whom were abundant around the Mediterranean during the centuries surrounding the Christian era.

Interestingly, "Saman" is also the Druidic "Lord of the Dead," who supposedly released evil spirits on Halloween (Samhain), when Druids lit bonfires to thwart them. Samhain is considered by its celebrants the "Feast of the Dead," who in reality represent *ancestors*, not "evil spirits." In Near Eastern mythology, the "Dread Lord" or "Judge of the Dead" is *Sammael*, the "Semitic version of the Asiatic Sama" or Samana.[118] Sammael is also the "Angel of Death in the Book of Enoch."[119] Furthermore, the Babylonian and Hebrew word for sun, "Shamash," is also pronounced "Samas," as it is in the Sabean (ancient Arabian) language as well.[120] In fine, the followers of Samas, Saman, Semon or Simon, called Samaneans, provide an example of a very important *Buddhist* sect in the Near East before the common era.

By whatever name, a vast, loosely organized monkish order has existed for several thousand years, stretching from England to China, with plentiful legends and other evidence indicating that members of this more or less organized brotherhood spread throughout the world, teaching sciences and building marvelous edifices. This fraternity is found in India, with the Buddhists and Hindus; in Europe, Britain and Ireland, with the Druids; in Egypt, with the Hermetic order, Therapeuts and others; in Greece, with the Orphics and Pythagoreans; and in the Near East, with the Chaldeans, Samaneans, Essenes and Nazarenes, etc. The ascetic monkishness within the Hellenized world during the centuries around the common era would thus be part of an old, shared heritage. By the time of the creation of Christianity, the name of the asceticism and its "founder" varied in different places, largely depending on the epithets favored by the culture.

Concerning "Buddhism" in specific, Dr. Inman summarizes the case for its presence and influence in the Near East prior to the common era:

> There is a very strong reason for belief that the intercourse between the inhabitants of India and the successors of Alexander was considerable. For example, we find before the time of the Maccabees, B.C. 280, or perhaps somewhat later, that Antiochus [I], the king of Syria, had 120 elephants—things which had never been seen in Syria, Palestine, or Egypt, and which took their local name from the Phoenician aleph, a bull—the Jews supposing that they were a new kind of cattle. From the accounts given us we infer that these were Indian... We have already seen that the great missionary effort of Buddhism took place in the time of Asoka [c. 261 BCE], and it is not likely that

the West would be neglected when the Eastern countries received such attention as they did. The Greeks had by this time found their way by sea to India... There is then presumptive evidence that Buddhism was taught amongst the people frequenting the kingdom of Antiochus the Second, B.C. 261. At this period and subsequently, this king and his subjects came much into contact with the Jews, so that it is equally easy to believe that the Hebrews were found out by the Hindoo missionaries as that the Alexandrian Greeks were...

The Hebrews always showed during the Old Testament times a great aptitude to adopt the faith of outsiders—and as the Jewish people were in great abasement and misery at the period when it is probable that the Buddhist missionaries came into Syria, they would be prepared for the doctrine that they were suffering for bygone sins....

That after the Persian reign it is certain that three Jewish sects existed—the Pharisees, the Essenes, and the Sadducees—the last alone being purely Mosaic, and the two first being very like the Buddhists.

To strengthen the links of evidence, we may now say a few words about the remarkable sect of the Essenes, premising our belief that it was founded by missionaries of the faith of Sakya Muni [Buddha], whose doctrines and practice became, subsequently, modified by Mosaism...[121]

The Israelite, Levitical and Jewish priesthoods were notorious for taking religious concepts of other cultures and reworking them to revolve around themselves. One example is the adoption while in Babylon of the gods Marduk and Ishtar, who were changed into the biblical Mordecai and Esther. The evident diminution of the Hindu god and goddess Brahma and Sarasvati into the patriarch Abraham and his wife, Sarah, is a very old instance that reflects interaction between India and the Levant dating to possibly 4,000 years or more ago. If one or more fresh migrations out of India since the time of the Mitanni (15th cent. BCE) brought with them Hinduism and Buddhism anew, surely the Israelitish peoples would adopt what they wished and in like manner revolve these rituals and myths around themselves, especially if, as we contend, many of these peoples originally constituted inhabitants of India.

Considering all the contact and Indian influence in the Mediterranean beginning centuries before the Christian era and continuing well into it, it is not surprising that Indian religious elements and myths were used in the creation of Judaism and Christianity.

In germane aspects Buddhism and Christianity are practically identical; hence, the competition between them is irrational and

unnecessary. Regarding competitive claims that apologists have been compelled to put forth in the wake of revelations of the similarities between Buddhism and Christianity, and those between Buddha and Christ—arguments such as taking Jesus "on faith," or that "might makes right," or "popularity proves"—Inman observes:

> The natural rejoinder to this representation is the assertion by the Christian that he knows that Jesus of Nazareth really was what he represented himself, and he is sure that Sakya Muni was not; but, on the other hand, the Buddhist may say just the reverse with equal pertinacity. This argument, if such a name it really deserves, is so common amongst all careless religionists that it deserves a few words in reply. It is based upon the very natural notion, "what I believe must be true," and to an objector, the only answer is the question, "you don't fancy that I can be wrong, do you?" When two such persons as a Christian and a Mahometan [Muslim] met in days gone by, these were the only arguments used by each, and they were first of all enforced by such revilings as come naturally to the faithful—"hound of a Moslem"—"dog of a Christ," "you are a serpent"—"you are a viper," and the like; from words they came to blows, and the strongest arm was supposed to demonstrate the correctness of the victor's faith. If, instead of taking physical strength as a test of truth, we assume that a numerical preponderance on one side or another proves the correctness of the belief held by the greatest number, we come to the absurd conclusion that what is right today may be wrong tomorrow. Babylonians were once far more numerous than Jews, and Jews than Christians, today the last exceed vastly both the others. Now, there are more Buddhists in existence than true followers of Jesus, in the next century the proportion may be reversed.[122]

At the time Inman wrote (1875), Buddhists outnumbered Christians; thus, per the "popularity proves" argument, Buddhism was then the true and correct religion. Inman was accurate in his suggestion that there would be more Christians than Buddhists in the following century. Today, Muslims and Christians are neck and neck, numbers-wise, with Islam said to be the fastest-growing religion in the world. By this spurious numbers game, Islam would now be proved the "true religion."

In any event, what can be stated definitively is that Christianity is not original and that its myths and doctrines can be and repeatedly have been shown to have precedent in numerous parts of the world, dating back ages before the common era. The reason for all this similarity is not because there were various men with comparable lives popping up all over the place but because the spiritual figureheads of numerous religions, Christianity and Buddhism included, are mythical

characters based in large part on astrotheology. As we have seen abundantly, Buddhism is not "atheistic" but is full of deities, divinity, magic and mystery. Its major inspiration, Buddha, is not a real person but a variously-named mythical figure, whose "life" and "teachings" closely resemble those of Christ. It is apparent that, despite protestations to the contrary, "Buddhism," or the ascetic religion with its archetypical founder by whatever name, was largely influential in the creation of Christianity.

[1] O'Brien, 413fn.
[2] Doane, 115fn.
[3] Volney, XX.
[4] Hardy, 354.
[5] Hardy, xii.
[6] Hardy, 355.
[7] Hardy, 125.
[8] Hardy, 358.
[9] Hardy, 353fn.
[10] Jones, *AR*, II, 98.
[11] Moor (1810), 233.
[12] Jones, *AR*, I, 351.
[13] Jones, *AR*, II, 98.
[14] Müller, *LSR*, 318.
[15] Bell, I, 141.
[16] Moor (1810), 158-159.
[17] Moor (Simpson), 151.
[18] Moor (Simpson), 152.
[19] Volney, XXI.
[20] Moor (1810), 239-240.
[21] Moor (1810), 237.
[22] Hardy, 88.
[23] Bunsen, 12.
[24] Hardy, 92-93.
[25] Hardy, 98.
[26] Moor (Simpson), 153.
[27] Bell, I, 316.
[28] Hardy, 100.
[29] Hardy, 376.
[30] www.newadvent.org/fathers/0126.htm
[31] www.newadvent.org/cathen/03028b.htm
[32] Inman, *AFM*, 124.
[33] Moor (Simpson), 160.
[34] Graves, K., 119.
[35] Moor (1810), 222-223.
[36] Bunsen, 20.
[37] Jones, *AR*, I, 243.
[38] Moor (1810), 225.
[39] Jones, *AR*, I, 147.
[40] Doane, 244.
[41] Moor (Simpson), 154.

42 Hardy, 49.
43 Evans, 42.
44 Moor (Simpson), 155.
45 Hardy, 200.
46 Hardy, 342.
47 Hardy, 368-369.
48 www.eliohs.unifi.it/digilib/eliohs.testi/700/jones/
 Jones_Discourse_3.html
49 Moor (1810), 231.
50 Hardy, 332.
51 Hardy, 385.
52 Moor (Simpson), 162-163.
53 Hardy, 339.
54 Bunsen, 1.
55 Titcomb, 50.
56 Bunsen, 34.
57 Titcomb, 51.
58 Weigall, 61-62.
59 Titcomb, 52.
60 Evans, 47.
61 Prasad, 25.
62 www.travelchinaguide.com/attraction/beijing/wofo.htm
63 Volney, XXI.
64 Titcomb, 53.
65 Titcomb, 53.
66 Titcomb, 54.
67 Titcomb, 49.
68 Evans, 58-59.
69 Bunsen, 42.
70 Titcomb, 55.
71 Prasad, 22.
72 Titcomb, 56.
73 Titcomb, 57.
74 Titcomb, 54-56.
75 www.nbufront.org/html/MastersMuseums/JGJackson/ChristMyth/
76 O'Brien, 365.
77 Prasad, 22-23.
78 Prasad, 23.
79 www.newadvent.org/cathen/03028b.htm
80 www.newadvent.org/cathen/03028b.htm
81 Eisenman and Wise, 5.
82 Inman, *AFM*, 171-172.
83 Inman, *AFM*, 176.
84 Eusebius, 352.
85 *vide* Robertson, *CM*, 257.
86 Bunsen, vii-viii
87 Inman, *AFM*, 97.
88 *CMU*, 120fn.
89 Higgins, II, 287.

[90] Higgins, II, 290.
[91] Villanueva, ix-x.
[92] O'Brien, 435.
[93] Jones, *AR*, I, 350.
[94] Müller, *LOGR*, 132.
[95] Prasad, 17-18.
[96] www.newadvent.org/cathen/03028b.htm
[97] Jones, *AR*, II, 64.
[98] Choudhury, 211.
[99] Moor (1810), 238.
[100] Freke and Gandy, 220.
[101] Jones, *AR*, X, 106.
[102] Jones, *AR*, X, 103.
[103] Jones, *AR*, X, 108.
[104] Berry, 18.
[105] Freke and Gandy, 259.
[106] Jones, *AR*, X, 110.
[107] Higgins, I, 162.
[108] Spence, *AEML*, 21; Budge, *EBD*, cviii.
[109] Funk & Wagnalls, "PTAH."
[110] Graves, R., 69fn, 282.
[111] Singh, 25.
[112] Moor (1810), 251.
[113] Higgins, I, 163.
[114] www.newadvent.org/fathers/0126.htm
[115] Eusebius, 47.
[116] Eusebius, 417; www.newadvent.org/cathen/13797b.htm
[117] Rylands, 124fn. .
[118] Walker, *WEMS*, 888.
[119] Walker, *WEMS*, 1095.
[120] Graves, R., 259; *vide* Robertson, *CM*, 31fn.
[121] Inman, *AFM*, 141-143.
[122] Inman, *AFM*, 127.

Adi Buddha
The Original, Primeval Buddha
Infinite, Self-created
"Without beginning or end."

Buddha with black features.
(Moor)

Buddha, Light of the World

> Learned men have endeavoured to make out several Buddhas as
> they have done several Herculeses, etc. They were both very
> numerous, but at last there was only one of each, and that one
> the sun. And from this I account for the striking similarity of
> many of the facts stated of Buddha and Cristna.
>
> Godfrey Higgins, *Anacalypsis*

The orthodox story of Buddha cannot be considered a
"biography" of a "real person," and, in actuality, "the Buddha"
emerges as a compilation of characters dating back thousands of
years. Like Krishna, Buddha has been deemed an incarnation or
avatar of Vishnu, an aspect of the God Sun. Among other symbols
connecting Buddha to Vishnu are the "girdle" and its knot as
depicted in images of bodhisattvas and buddhas, as well as
Vishnu. According to Pandey, "The girdle on the waist is a
necessity when smartness and valour are ascribed to a deity,"[1]
which means additionally that Buddha is clearly portrayed as a
god. The insight that Buddha, like his alter ego Vishnu and
preceding avatar Krishna, is a solar entity or sun god has been
maintained by several scholars and researchers over the
centuries. Evans, for example, relates the esoteric knowledge of
both Buddha and Krishna as solar incarnations:

> The mythical stories concerning Buddha resemble those relating
> to Krishna; indeed, there is a family likeness in the presiding
> deities of all races and all times, and those personifications go
> back to the Sun—ALL OF THEM![2]

The association of Buddha with Krishna is so concrete that
one authority, Colonel Tod in his *History of Rajapoutana,*
pronounced the two "conjoined," while M. Creuzer determined
that the images of Krishna and Buddha were too similar to leave
any doubt as to their connection. Ancient representations of both
gods depict them as *black* men, not only in color but also in facial
characteristics and hair, etc. It is believed that such figures
suggest great antiquity, considering that there appears to have
been a time thousands of years ago when the black race
dominated a large portion of the inhabited world.

In *Christian Mythology Unveiled*, the author recounts the
Buddhist contention for antiquity of 15,000 years, and compares
Buddha to Krishna, identifying both with the sun:

> Christna and Buddha are identical in principle; both are
> incarnations of Vishnu, the second person in the Hindoo Trinity,
> and were born of virgin mothers, and each was the son of a
> carpenter; both suffer death by crucifixion. Christna raised the
> dead, by descending for that purpose, to the *lowest regions*. Both
> names signify Shepherd and Saviour. The crucified Christna is

represented in...plate 98 [of Moor's *Hindu Pantheon*], with rays of glory surrounding his head, as is also the head of Buddha... To the rational mind, this glory will appear emblematical only of the sun himself, in his radiant summer brightness, because it is manifestly so of no other object in nature.[3]

The correspondences with the Christ myth related in this paragraph, to wit, the virgin birth, carpenter-son status, death by crucifixion, are from a book that predates by decades the work of Kersey Graves, who may thus again be absolved of the charge of fabricating them. While a number of the germane contentions concerning Krishna are traceable to Sir Jones and *Asiatic Researches*, the assertions regarding Buddha may be traced to Godfrey Higgins, who exhaustively explored them and convincingly argued in their defense. In any event, since these correlations constitute solar motifs, it would not be surprising to find them attached to the Buddha myth.

Buddha is identified not only with the solar Vishnu and Krishna but also blatantly with the sun god Surya, as demonstrated by plate 69 provided by Moor, reflecting the "worship of Buddha and the Sun together."[4] Concerning this image, Moor remarks:

> The original of plate 69 is also in the museum at the *India house*... This image is, I think, of a very singular and curious description: its curly hair, thick lips, and position, mark I decidedly of *Buddhaic* origin, while its seven heads refer it to a sect of *Sauras*: hence the appellation of SURYA BUDDHA, appropriately applied to it.[5]

Also regarding these figures, Higgins observes: "It is admitted that Surya is the Sun, and that he is Buddha: hence Buddha is the sun."[6] Buddha's description with "seven heads" represents the sun "attended by five planets and the moon."

In another identification of Buddha with Surya and Vishnu/ Krishna, the Bengali inscription at Buddha Gaya calls the godman "this Deity Hari." As noted, Heri, Hari or Hare is an epithet of other Indian divinities as well, most if not all of whom represent the sun. In *Sun-Worship in Ancient India*, Indian scholar Srivastava elaborates on the Surya-Vishnu-Buddha classification:

> On literary and archaeological evidences it may be demonstrated that there has been occasional identifications of Surya with Siva, Brahma and Visnu and also with Buddha.... The association of Surya and Visnu is well known, and images of Surya-Narayana hailing from different parts of India have been reported. Besides, Surya has also been associated with Buddha, as in the composite sculpture from Bihar...where there are figures of the standing Buddha and Surya in the right and left side of Harihara.[7]

Another name for Surya is "Budha" (Mercury), and the fact that "the Buddha" is likewise equated with Surya, as demonstrated in imagery and attested by Indian scholars, reveals that the "confounding" by researchers of "Budha" with "Buddha" is not a mistake or "defect" but an accurate interpretation, being quite deliberate, based on esoteric knowledge and mysteries. Since Buddha is not a "real person" but God, a god, a godman and a son of God, possessing divine attributes and being identified with a number of gods, including Brahma, Surya and Vishnu, it is reasonable to equate him also with the god Budha/Mercury/Woden, who is likewise associated with Surya and Vishnu. Based on various such proofs, "Budha" has thus been correctly identified with "the Buddha" by many writers and scholars: To wit, "the name Buddha comes from Budha, 'Wisdom, divine intelligence'"[8] Higgins reported that "Buddha" in Tamulese or Tamilese is "Woden," and Sir Jones adamantly equated Buddha with Woden: "Wod or Oden, whose religion, as the northern historians admit, was introduced into *Scandinavia* by a foreign race, was the same with Buddha..."[9] Although he eventually backpedaled on this aspect of comparative mythology, Jones also referred to "the *supposed* incarnation of Buddha," revealing that even in his day a conservative scholar had doubts as to the historicity of "the Buddha."

Other scholars who identified Budha/Mercury with "the Buddha" included Volney and Moor. William Chambers, writing in *Asiatic Researches*, made the following statements:

> It is certain that *Wednesday* is called the name of *Bod*, or *Budd*, in all the *Hindoo* languages, among which the *Tamulic*, having no *b*, begins the word with a *p*... It is equally certain that the days of the week, in all these languages, are called after the planets in the same order as with us; and that *Bod*, *Budd*, or *Pood*, holds the place of *Mercury*. From all which it should appear that *Pout*, which, among the *Siamese*, is another name for *Sommonacodom*, is itself a corruption of *Buddou*, who is the *Mercury* of the *Greeks*. And it is singular that, according to M. De la Loubere, the mother of *Sommonacodom* is called, in *Balic*, *Maha-mania*, or the great *Mania*, which resembles much the name of *Maia* the mother of *Mercury*. At the same time that the *Tamulic* termination *en*, which renders the word *Pooden*, creates a resemblance between this and the *Woden* of the *Gothic* nations, from which the same day of the week is denominated, and which, on that and other accounts, is allowed to be the *Mercury* of the *Greeks*.[10]

Rev. Maurice, a missionary in India, stated that "Budha" was "another incarnation of Veeshnu" and also perceived Budha and Buddha to be the same; yet, Maurice distinguished the "elder Boodh," by which he evidently meant a buddha long anterior to

Gautama, and equated him with the Egyptian god Hermes
Trismesgistus. The basic stories of the Buddha and the Egypto-
Greek Hermes are similar in some important aspects, including
the names of their mothers: Buddha's mother was Maya, while
Mercury/Hermes was born of Maia, essentially the same word.
Maia, "the universal genius of nature," is apparently related to the
Egyptian Meth or Metis.[11]

The reason for the "confounding" by various scholars is not
because they were all confused but because they understood both
"Budha" and "Buddha" to represent esoterically the sun. The
mercurial Budha is identified with the solar Vishnu as early as
Vedic times: "He is considered Vishnu Rupi, because of his
beauty and resemblance..."[12] Budha is "the Wise," the conveyor of
secret wisdom and "the author of a hymn in the Rig Veda."[13] As
such, he is an early Indian deity, in reality one of the nine
planetary gods in Vedic astrotheology:

> 1. Rawi, the sun. 2. Sukra, Venus. 3. Kuja, Mars. 4. Rahu, the
> asur ["Titan"]. 5. Saeni, Saturn. 6. Chandra, the moon. 7.
> Budha, Mercury. 8. Guru, Jupiter. 9. Ketu, the asur.[14]

As the planet and god Mercury, Budha is the sun's
messenger:

> Mercury or Budha, as messenger between the sun in the cosmos
> and the sun in man: the bloom of buddhi [enlightenment].[15]

Mercury is thus associated with the sun, as well as identified
as such, by Latin authority Macrobius, among others. The Dutch
philosopher of the 17th century, Vossius, observed that Mercury is
the wisest of the gods and "is in such close proximity to the
Wisdom and Word of God (the Sun) that he was confused with
both."[16] Mercury/Budha is not only the bringer of wisdom and
wealth but also the remover of evil thoughts. As the "Lord
of Mithuna and Kanya" in the zodiac, the "devata" (lesser
god) Mercury "stays like the sun" and follows "more or less
closely in the footsteps of the Sun."[17] ("Mithuna" is apparently the
same as "maithuna," which is tantric or sexual intercourse, or
"twinning," i.e., Gemini, while "Kanya" means "virgin," as in Virgo,
and is also an epithet for Krishna. Since Krishna was said
to have had "16,000 wives who bore him 180,000 sons,"[18]
yet he is called "Kanya" or virgin, he would appear to be
another "perpetual virgin.")

In any event, Budha is not only the planet Mercury and the
sun but also the "son of the moon," a role commonly played by
sun gods. As Moor says:

> Chandra [Moon] is the offspring of Atri, who was a son of
> Brahma. Chandra's son, Budha, or Mercury, married Ila,
> daughter of Manu... The *Surya-vansu*, or offspring of the Sun,

also proceed from this seventh Manu, who is fabled to be the son of Surya...[19]

Furthermore, "*the* Buddha" was said to be a "moon to the three worlds," who, traveling with his disciple Ananda, "appeared like the full moon accompanied by the planet Guru (Jupiter)."[20]

Mercury the Wise was the "great instructor of mankind," appropriate for a Buddha, who is considered a "world teacher." Since "Budha" is Mercury, or Hermes, he is also "the Word. The term "Budha," meaning "Wisdom," would thus lend its name to "Budhism" or a wisdom religion. As has been true in many cultures, as an esoteric tradition this Indian wisdom religion would be very ancient, dating back thousands of years in India. Hence, it could be asserted that "Budhism" was morphed into Buddhism, in much the same way as Gnosticism, with its Sophia or Logos worship, was changed into Christianity, *by personifying and historicizing the Word.* The historicized Budha becomes Buddha, as the historicized Logos becomes Christ. The confusion has occurred because scholars have tried to place these various gods into "history," despite realizing abundantly, as is evidenced by their analyses, that Buddha/Budha/Hermes/Mercury is an astrotheological concept.

Buddhism is clearly astrotheological, as it incorporates into its mythology the personified and deified planets, with at least some of them even bowing to Buddha.[21] "Buddha," a title meaning "enlightened one," is an appropriate epithet for the sun, and "the Buddha" was said to be of the "solar race," the first prince of which, we are told in the orthodox myth, reigned for 1.7 million years! Moreover, Buddha was depicted as a member of the "tribe of Sakya": The Sakyas, as is apparent from ancient writers such as Varaha Mihira,[22] were a priestly caste, similar to the Chaldeans, an astrotheological order. As was done by the Christians with Christ and the Brahmans with Krishna, it is evident that the priestly Sakyas created "the Buddha" as their spiritual figurehead by turning their sun god into a "real man."

Buddha's solar nature is revealed in the "gesture of reassurance," a mudra in which his palms contain sun symbols, as found on "prehistoric petroglyphs in many parts of the world."[23] Other artifacts that demonstrate Buddha's solar character include an ivory throne from the second century BCE "embellished with the sun in gold and moon in silver."[24] In the Buddhist text *Samyutta Nikaya*, the godman is depicted as calling the sun "the fiery heart, my kith and kin," while the dwelling-place of the buddhas and bodhisattvas is believed by Indian, Chinese, Korean and Japanese Buddhists to be "located in the sun, the Truth."[25] Even Buddha's "curly hair" contains a well-

known solar symbol, the "mystic spiral."[26] Before his image was established during the first century CE, Buddha was represented iconographically by footprints with the solar swastika symbol in the middle.[27]

Another popular solar motif is the lotus blossom, "which grows as the Nile rises" and was a symbol of the Egyptian sun cult.[28] The lotus also connects Vishnu to Buddhism:

> Visnu, originally a solar deity, had the lotus kept in one of his hands; and the Buddhists too created a deity, the handsome Bodhisattva Padmapani, who is so called on account of the Padma or lotus that he holds in his hands.[29]

Solar symbols within Buddhism include the halo and the wheel, as in the Wheel of the law or Dharma, which, as Coomarswamy states, originally represented the sun. The chakra, wheel or golden disk was also the "discus of Visnu."[30]

In addition to the solar symbols and iconography are obvious solar attributes in the orthodox Buddha tale, including the temptation by the Prince of Darkness, Mara, during which Buddha/Siddhartha became like a "brilliant gem" and the darkness of his tempter was banished by "an offering of light." This temptation myth, like others, is representative of the sun in battle with darkness: "In the Buddhist literature...we have...the simple nature-myth of the demons of the tempest assailing the young Sun-God."[31] In addition, when the nobles of a city were confused as to who was the Buddha, whether Siddhartha/ Gautama or the sage Uruwel, Uruwel is depicted as flying in the air, revering Siddhartha, and comparing the avatar to the sun, while Uruwel himself was a mere firefly. Again, Buddha is imbued with celestial qualities when he is told, "Your father looks out for your coming as the lily looks out for the rising of the sun; and the queen as the night-blowing lily looks out for the rays of the moon."[32] The lily comparison is interesting, considering that the other "queen," the Virgin Mary, was associated with that flower, as were still other variations of the Goddess. As Walker says, "The lily was always a symbol of the miraculous impregnation of the virgin Goddess."[33]

More fantastic solar episodes that cannot possibly be deemed "historical"—or, if they were, again we would be compelled to accept Buddha as a much more powerful representative of divinity than anyone or anything found in the West—are related by Buddhist scholar Hardy in *A Manual of Budhism*:

> On some occasions, when Budha [Buddha] was about to ascend the throne upon which he sat, he came through the ground, and rose up at the place, like the sun rising over Yugandhara; and at other times he went through the sky. During his progress from

place to place, the light that shone from his body was like the glory proceeding from Maha Brahma...[34]

Furthermore, in one of his numerous births, Gautama was the son of the "monarch of Dhannya"; as such, he had a "magical chariot" with an "appointed place in the sky," very much like a typical sun god.

Like Jesus, Buddha was transfigured on a mount, that of Pandava, supposedly in Sri Lanka, where his body shone bright golden. Gerald Massey clarifies the astromythological meaning behind Buddha's transfiguration:

> If we take the transfiguration on the Mount, Buddha ascended the mountain in Ceylon called Pandava or Yellow-White. There the heaven opened, and a great light was in full flood around him, and the glory of his person shone forth with "*double power.*" He "*shone as the brightness of Sun and Moon.*" This was the transfiguration of Buddha, identical with that of the Christ, and both are the same as that of Osiris in his ascent of the Mount of the Moon.[35]

Additionally, Massey explains why the transfiguration of Christ in Matthew depicts Jesus as going up to the high mountain "after six days": "The sixth day was celebrated as that of the change and transfiguration of the solar god in the lunar orb, which he re-entered as the regenerator of light."[36] He further elucidates upon the mystical "six":

> ...in the Hindu myth of the ascent and transfiguration on the Mount, the Six Glories of the Buddha's head are represented as shining out with a brilliance that was blinding to mortal sight. These Six Glories are equivalent to the six manifestations of the Moon-God in the six Upper Signs, or, as it was set forth, in the Lunar Mount. During six months, the Horus, or Buddha, as Lord of Light in the Moon, did battle with the Powers of Darkness by night, whilst the Sun itself was fighting his way through the Six Lower Signs.[37]

Hence, Buddha is not only the Egyptian Thoth or Hermes but also the solar Horus, which is logical if he is also Ptah, an aspect of the God Sun. As is typical in the story of the God Sun, in which his light is extinguished when he "dies," darkness descends upon Buddha's death.

As stated, like Jesus Buddha is depicted with 12 disciples, a motif equivalent to the solar Surya and the 12 zodiacal adityas. Also like Christ, the Indian godman is portrayed with five disciples, one of whom was "beloved" and one a traitor. Other Buddhist figures include 10 and 60 disciples, who "acted as missionaries of the new doctrine."[38] The 10 or 12 disciples have astrotheological meaning, representing the signs of the zodiac. Added to the other 60, Buddha's immediate disciples totaled

70 or 72, the same as Jesus's. These numbers too are astrotheological, as the astronomical perceptions changed and the year was divided variously, different numbers took precedence. For instance, when the heavens were divided into 10 major sections, the subdivisions equaled 70; when there were established 12 divisions or months, the subdivisions of the zodiacal circle of 5 degrees each numbered 72, representing the "duo-decans." Hence, the 70 and 72 are interchangeable, as is elucidated in the "Astronomical Book of Enoch,"[39] for example.

Also portrayed in the Jewish "Book of Enoch" is the precession of the equinoxes. As concerns the precession, Higgins contends that Buddha was the epithet for the sun in the Age of Taurus, which began around 4400 BCE, and that "Cristna" or Krishna was the sun in the Age of Aries. He further states, "Buddha was Bacchus, Cristna was Hercules, in reality, one 2160 years after the other: this nearly agrees with what is said by Arrian,"[40] the Greek philosopher (c. 95-180 CE) wrote the *Indica*, a description of India based on the journey of Alexander the Great.

Furthermore, the concept of "Nirvana," or the Buddhist afterlife, which is not simply a place of annihilation but one of heavenly union with the Cosmic Divine, refers to the sun. As Bunsen says, the "spiritual body of the Arhats," or saints and sages, i.e., buddhas and bodhisattvas, is "like the shining body of Brahma," shimmering like the sun upon entering Nirvana. Regarding Nirvana, Bunsen further observes:

> ...Nirvana is identified with "the opening of the pure ways of heaven," of the "gates of eternal life," and is actually called the sun, and "the center of the supernatural light."...

> The explanation of Nirvana as the sun is confirmed by the presumable identity of the sun-god Abidha with the highest spirit, Isvara-Deva, who thrones in Nirvana, and also by the direct connection of Buddha with Nirvana as well as with the sun. The sun is the symbol of Buddha, who is represented as a ram or lamb—that is, as the stellar symbol of the spring equinox in his time, as the Sun in Aries. This interpretation is all the more admissible, as we have proved that, according to Buddhistic records, Gautama Buddha's birth was expected, and had taken place, on the sun's annual birthday. Again, the connection of the locality of Nirvana with the sun is confirmed by what seems to have been the aboriginal meaning of the "four paths" which lead to Nirvana, and which we may now connect with the "four kings" and the four cardinal points of the Zodiac, with "the four quarters of the world," towards each of which the new-born Gautama Buddha is said to have advanced seven steps. Buddhists describe Abidha as the god of light (of the sun), as surrounded by four mysterious beings, which form a striking

analogy to the four cherubim and four beasts of the Hebrew and Christian Scriptures.[41]

Differing from Higgins, Bunsen associated Buddhism with the Age of Aries (c. 2300-c. 150 BCE); presumably, the epithet "Buddha" was carried over from the Age of Taurus, just as it remains today at the end of the Piscean Age and beginning of the Aquarian. Yet another correspondence between Buddhist and Judeo-Christian mythology exists in the "four mysterious beings" or cherubs, which symbolize the cardinal points of the zodiac. Also contained in Bunsen's writing is the salient contention that Buddha's birthday occurred at the winter solstice, or "Christmas."

Bunsen notes that the sun god Abidha is another name for Amithaba, "the god of boundless light," who was reputed by the northern sect of the Buddhists to live in the Western paradise. Abidha is also apparently a name for "Adi-Buddha of the Nepalese."[42] As we have seen, Adi Buddha is the "celestial, self-existent Being," another name of "the Buddha." Hence, Buddha is Abidha, who is the sun.

Concerning overt sun worship in Buddhist texts, Indian scholar Pandey says:

> A few references to sun-worship are found in the Buddhist literature. Suriya, i.e., Surya, was present at the preaching of Mahasamaya Sutta. The Anguttara Nikaya mentions [the] Sun-god in its Suriya Sutta [Sun sutra or scriptural narrative]. Sarakani Sutta compares Buddha's doctrine to the sky-god who supplies constant rain. The Digha Nikaya mentions Adicca, i.e., Aditya, as another name for Surya. Buddhaghosa explains Aditya as meaning "Aditi's son" (Aditya-Putto). The Buddha is generally called Adicca-bandhu ["kinsman of the sun"]. In the Samyutta-Nikaya, Buddha speaks of the sun as "mam paja," which Buddhaghosa explains as meaning disciple and spiritual son. Adicca is described as the chief of heat-producing things...
>
> In a Suriya Sutta of the Samyutta Nikaya, Surya is shown invoking the power of the Buddha, asking for his protection and praying to him to get rid of Rahu, a lord of the Asuras.[43]

The sun god Aditya is the "son of Aditi," as is Krishna, likewise a solar hero. Pandey notes that Buddha is claimed to be "Adicca-bandhu" or "Aditya-bandhu" because both he and Aditya belonged to the same clan, and Buddha is the "descendant of the Sun." Pandey also says that "the sun is the Buddha's kinsman because the sun is the Buddha's 'orasaputta' (breast-born son)."[44] Additionally, it is "well known in Buddhist literature and inscriptions that Buddha was the kinsman of the Sun (Adityabandhu), who deserved his due regard from him."[45]

Other solar aspects in Buddhist texts are recounted by Pandey:

Some references to sun-worship are available also in the Jatakas. In the Mayura Jataka, Bodhisavata, born as a peacock, is mentioned as worshipping the morning and the setting sun on a plateau of a golden hill in Dandaka. Here the sun is described as a "King all seeing" and "a glorious being" making all things bright with his golden light, and is invoked for safety and to keep off evils.[46]

The peacock is itself a solar symbol, indeed "an attendant divinity" to the sun, such that the worshipper "Bodhisattva" himself, who could be "the Buddha" or any number of other buddhas, would be identified with or as the sun.

Pandey further relates that in the *Digha Nikaya*, Surya's charioteer, Aruna, is represented as one of the devas or deities present at the preaching of the *Mahasamaya Sutta* by Buddha. Yet, the *Brahmajala Sutta* in the same *Digha Nikaya* lists sun worship as a "wrong means of livelihood" for monks and priests; hence, Buddhists subjected sun worship to ridicule. The Buddhist priesthood evidently was determined to usurp the power of other priesthoods, such that Buddhist writers mocked the solar religion in their texts, and attempted to place their mythical Buddha higher than the sun, which is precisely what Christian did centuries later with their own mythical godman.

Nevertheless, despite the apparent antipathy, Buddhism is certainly a solar cult, as has been abundantly demonstrated. As Pandey also observes:

> Buddhism, which was the main religion of Bihar under the Mauryas, does not seem to have been ill-disposed towards Sun-worship. This fact is corroborated by the existence of a well-known figure of Sun-god on the railings of a temple at Bodhagaya.[47]

The association of Buddhism with the solar religion is further evident from the sun images at the Buddhist site of Bodhagaya or Buddha Gaya, where the inscription was found that identifies Buddha as Vishnu, Heri, the "Lord of the universe" and "Most High God"—all solar epithets. After describing the sun imagery on the temple at Buddha Gaya, and on a "Buddhist slab" or stela at Mathura, Pandey states:

> Thus, many of these images have been found in Buddhist and Jain shrines; and their presence there perhaps may be explained in this way. It is known that prior to the rise of Buddhism and Jainism, the Brahmanical religion dominated the religious field. Therefore, these two non-Brahmanical religious faiths tried to make their own gods popular by bringing them into relations with Hindu gods. That is why the followers of Buddhism, probably, made the Buddha the brother of Surya (Aditya-Bandhu), and had no objection to worshipping him also. This

might have been the policy also of the adherents of Jainism. And the Sun-worshippers too may have liked the alliance, for Buddhism was then the dominant religion of a great part of the country.[48]

The figures at Buddha Gaya and Mathura include the sun god in his chariot with four horses, the same as that of Helios and others. On the Mathura stela, alongside the representation of the sun god in his chariot are "three other Buddhist scenes." Mathura, or Matura, is related in the Puranas as "one of the great centres of Sun-worship."[49] It is also the "birthplace" of Krishna, which may well mean that he was historicized there by his solar priesthood. Matura, or "Maturea," is likewise the name of the place where Christ is depicted in the Infancy Gospel as playing and menacing as a child.

On a pillar dating to the first century BCE at Lala Bhagat appears another representation of the sun god Surya in his one-wheeled chariot drawn by four horses, along with a relief of the goddess Lakshmi, who is Vishnu's consort. Nearby, there is also a relief "showing a moving elephant," which indicates Buddhist influence: "This elephant-motif perhaps denotes Lord Buddha, who came as a small elephant into the womb of Maya Devi."[50]

A shrine at Bhaja portrays the sun god in his chariot on the "right hand section of the façade of the Buddhist cave." Regarding this image, Pandey comments:

> With this fact—the association of Sun-god with a Buddhist shrine, it seems reasonable to conclude that here, as in northern India, Buddhism had to face the keen rivalry of the Brahmanical Sun-god, was taken as a relation of the Buddha, "Adityabandhu."[51]

Even as late as the 12th century, Buddhism and solar worship were commingled, as demonstrated by a bronze "cover" in Sonakhara with the figure of the sun god: "The cover of the Sun-god was donated to the priest of the temple by Ballalasena, who was Buddhist..."[52] It is clear from all the evidence that Buddhism is a solar religion and that, despite the fervent evemerism over the centuries, its main figure, Gautama Buddha, is another solar hero or incarnation of the sun god.

Although Buddha is originally an Indian sun god, his solar nature is perhaps most obvious in the Land of the Rising Sun, which to this day uses a vast amount of solar imagery in depicting the Japanese godman and his precepts. For many centuries, Japanese Buddhists have revered the sun god as Bodhisattva Suryaprabha, while the moon is Chandraprabha, demonstrating not only that Buddhism is not "atheist" but also that it is astrotheological. As another example, the bodhisattva Ekadasmukhavalokitesvara is "the direct incarnation of the

sun,"[53] and solar iconography permeates Japanese religious art and culture in general. This Buddhist sun god Ekadasmukhavalokitesvara is also revered in China, depicted as "the incarnation of the Indian god Surya,"[54] called Suryaprabha in Japan. It has been believed that chanting the name of the bodhisattva Avalokitesvara, legendarily "the incarnation of Surya" whose abode is in the sun, could produce rescue from bad fortune.[55] Sun worship in China dates to at least 5,000 years ago, evidenced by solar symbols on potsherds. The Chinese sun god "Fuxi" is the same as "Fohi," another name for Buddha, who is depicted in a cave temple painting at Dunhuang along with the demigod Mani.

Buddha's Virgin Mother

As amply demonstrated, one of the principle astrotheological motifs is that of the virgin mother, and numerous gods and heroes globally were said to have been born of a virgin and/or immaculately conceived. Like these others, Buddha is an aspect of the God Sun, and his "life" follows the same, basic archetype, Virgin Mother included. In this regard, Buddha's birth is synopsized by Jackson, in *Christianity Before Christ*:

> He was said to have been born of the Virgin Maya, or Mary. His incarnation was accomplished by the descent of the Holy Ghost upon the Virgin Maya. The infant Buddha, soon after birth, spoke to his mother, saying: "I will put to an end to the sufferings and sorrows of the world." As these words are uttered, a mystical light surrounded the infant Messiah.[56]

Evans also recounts Buddha's miraculous conception and virgin birth:

> Buddha's mother was a virgin; Buddha was begotten through the power of the Highest; heaven and earth rejoiced at his birth and recognized in him the long-desired Savior. The wealth of Oriental imagination is lavished upon descriptions of the celestial joy which heralded that marvelous event and the terrestrial prosperity which accompanied the arrival of the Redeemer of the World....[57]

Doane too lists Buddha as one of the "*God-begotten* and *Virgin-born* Saviours of India...born of the Virgin Maya or Mary." He then states, "The resemblance between this legend and the doctrine of the perpetual virginity of Mary the mother of Jesus, cannot but be remarked."[58] The virgin-born motif attached to Buddha was so well known in the 19th century that it was even published in a newspaper, *The New York Correspondent* (1828), which related that the ancient Chinese god "Beddou," born in 1027 BCE as one of God's "incessant" incarnations, sprang from

the "right intercostal of a virgin of the royal blood, who, when she became a mother, did not the less continue to be a virgin."[59]

The agency by which the Virgin Maya was fecundated signified the "Holy Ghost," appearing as a "white elephant" because such is the strongest of animals, representing "power and wisdom," as well as "the power of the Highest." In the mythos, the "white elephant" also represents Buddha himself, emanating from the "Tusita heaven surrounded by light like the sun" and entering Maya's left side.

Although the virgin status of Buddha's mother is not commonly depicted in the orthodox tales, the assertion was well known enough in the West as early as the fifth century CE to warrant comment from St. Jerome, the prolific early Christian father who translated the Bible into Latin (the "Vulgate"). In *Adversus Jovinianum* (I, 42), Jerome relates:

> To come to the Gymnosophists of India, the opinion is authoritatively handed down that Budda, the founder of their religion, had his birth through the side of a virgin.[60]

The "Gymnosophists" were "holy men" who lived in the nude, essentially the same as followers of the Indian sect of Jainism. Jerome clearly states that the opinion was "authoritatively handed down," which means by an initiate or priest, while "handed down" indicates longevity, such that it was not simply developed, in a priestly competition, to counter the virgin status of the Jewish god's mother, an act of priestcraft that would be unnecessary, since the motif already existed abundantly long before the Christian era.

Like so many others, the Buddha myth is not a biography set in stone but varied in different eras and places. In this regard, the virgin mother of the Siamese divine child, Codom, was impregnated not by a "white elephant" but by sunbeams. As noted, "Somonacodom," as he is also called, is evidently a corruption of Sramana or Samana Gautam, one of "the Buddha's" numerous names, shortened to "Saman," the Ceylonese god of the rising sun. The virgin-mother motif is also present in the Chinese myth of Foe, Fohi or Fuxi, who was "the virgin-born 'Son of Heaven,'...of *royal descent*."[61] In Tibet, Buddha's birth was depicted in the same manner, with him springing from the royal virgin's "right flank."

In their attempts to deny the virgin births of pre-Christian gods, godmen and heroes, apologists contest the virgin status of Buddha's mother because she was married, and because Buddha was purported to have been the son of a king. However, Christ too, while "born of the Virgin Mary," who was likewise *married*, was deemed the "son of (King) David." It is obvious from

archaeological finds and testimonial consensus dating back over a millennium and a half that, like Mary and Krishna's mother, Devaki—also called "Mahamaya"—Budha's mother, *Mahamaya*, was considered a virgin, despite her marital status. Regarding this debate, ex-priest McCabe observes:

> Christian apologists deny that there is any parallel with Jesus on the narrow ground that Buddha's mother, Maya, was married. The real parallel is that the later Buddhists would not have their deity born of carnal intercourse, and he was therefore said to be the outcome of a miraculous conception. Whether in such case we ought or ought not to call his mother a virgin is a matter of words.[62]

Concerning Buddha's miraculous birth, the pious Christian Hardy acknowledges that the "resemblance between this legend and the doctrines of the perpetual virginity of the mother of our Lord, cannot but be remarked."[63]

In regard to Buddha's mother, Hardy further says, "Maha Maya was in every respect faithful to the king, and lived in all purity."[64] This state of purity, which Maya retained after the miraculous conception of Buddha, is a necessary part of the divine child's story:

> The womb that bears a Budha is like a casket in which a relic is placed; no other being can be conceived in the same receptacle; the usual secretions are not formed; and from the time of conception, Mahamaya was free from passion, and lived in the strictest continence.[65]

As we can see from this Christian scholar, despite being married, Buddha's mother, Maya, was pure at the time of the god's conception. Since Maya was impregnated during a dream, and only informed her husband about it "in the morning," it is evident that she was *not* impregnated by him. Hence, she remained chaste.

The birth of Buddha was depicted as without "any pain whatever, and entirely free from all that is unclean." Afterwards, the infant was received in a golden net by Maha Brahma, who, on presenting him to his mother said, "Rejoice, for the son you have brought forth will be the support of the world!"[66] The motif of the golden net is not historical but astrotheological. In patriarchal, misogynist religions, to be born "entirely free from all that is unclean" means without passing through the "impure route," or vagina. Additionally, the supernatural bit regarding the "white elephant" is not emphasized in the mainstream orthodox "biography" of Buddha, likely because it is symbolic and the Buddhist priesthood wished for the godman to be considered "historical." In any event, the white elephant is depicted as

entering through Maya's side, *not through the vagina*. Buddha's holy mother was *not*, therefore, impregnated by an elephant penetrating her vagina with his penis—an absurd notion polemically asserted by Christian apologists that would certainly be considered blasphemy by pious Buddhists.

The mythical side-born theme is not uncommon, as the birth through the side of the virgin was also portrayed in the story of Jesus by early Christian "heretics." It was likewise said that Caesar was born through the "side of his mother," whence comes the term "Caesarean section." So too was the Egyptian sun god Ra "born from the side of his mother,"[67] a motif that in reality reflects the relationship between the sun and moon: Part of the "lunar phenomenon," the mother's womb represents the moon, in which the solar child can be seen growing—hence, the depiction of Maya as transparent. So too was the pregnant Mary—also the lunar goddess—portrayed as transparent, "as may be seen in Didron's Iconography!"[68] Buddha's mother is a "queen" in the same sense as are Isis and Mary: All are the Queen of Heaven, or the moon.

In reality, like the mothers of Krishna and Christ, Buddha's mother is not an "historical" character who possesses genitalia and can get pregnant, but represents the moon and the power of creation. Indeed, the well-known term "Maya," i.e., "illusion," is also considered a personified deity—"the mother of all": "Maya, or Ada Maya, is a name of Lakshmi: she is thus the general attracting power; the mother of all; the *Sacti*, or *energy*, of Vishnu, the personification of *Spirit*..."[69]

The role of Maya is elucidated by McLean, in which he remarks that the Indian Triple Goddess archetype can be found in Maya, Shakti and Prakriti. Maya "is the web of the universe," eternally doing her "dance of illusion, making the world seemingly substantial..."[70] The word "Maya" or "Maga," as it was styled in the Near East, is a divine concept, representing the manner by which the cosmos is created. Both the "Brahmanic and Magian systems of religion" used priests who invoked this divine principle "against evil spirits."[71] The principle is likewise called Brahm, the "higher being" and "divine power" who is also the "divine mediator." Brahm serves as the "holy spirit of both worlds" and is basically the same as Maya. As Bunsen states:

> ...As the incarnation of the celestial Buddha was effected by the Holy Ghost, so it was this spiritual power, Maya or Brahm, which enlightened Gautama, and made him the human organ of the celestial Bodhi or Wisdom. The meaning of the word "Buddh," or "Bodh," corresponds with that of the Sancrit Vid, from which the name Veda is derived.[72]

Hence, Maya, Buddha's mother, is equated with Maya, "illusion" or spiritual power. Maya or Maia as not only the "virgin mother" but also a spiritual, creative force is a concept well known in the West as well. In its article "Archaeology of the Cross and Crucifix," the Catholic Encyclopedia describes the relationship of the cross to "Maia," the mother, the cross being "the apparatus used at one time by the fathers of the human race in kindling fire." Thus, the cross became viewed as representing the sacred fire, "whose mother is Maia, the personification of productive power..."[73]

The Buddhist version of this spiritual concept represents the "incarnation of the Angel destined to become Buddha" as taking place in a "spiritual manner," with both the elephant and Buddha "symbolised by the sun." Thus, "according to Chinese-Buddhistic writings, it was the 'Holy Ghost,' or 'Shing-Shin,' which descended upon the virgin Maya."[74] Maya is the personification of Wisdom, or Sophia, Sapentia, etc., as well as the "Holy Ghost" before it was masculinized. Before his birth, Buddha is portrayed as looking on from Heaven (Tusita) and choosing his parents. His mother is described as the "spiritual, creative and enlightened power" and "Wisdom from above." She is a "virgin-bride" who is also "the power, word, or spirit, the Brahm of the highest God." As in Christianity, the "holy mother" was chosen to bear the "holy son."

According to the myth, seven days after Buddha's birth, Maya dies, and is "translated" to heaven, from which she, like Mary, occasionally descends to provide solace to humankind. Yet, Maya first has to become a deva by changing her gender. As we have seen, the immediate death of the virgin mother after giving birth actually represents the dawn fading away as the sun rises. Again, like Krishna and other "suns of God," Buddha was also said to be the "son of Aditi," the dawn goddess, who daily "dies."

After Maya's death, Buddha is cared for by his stepmother, who, Bunsen relates, "sedulously attended him without intermission, as the sun attends...the moon during the first portion of each month, till the moon arrives at its fullness." Bunsen further states:

> This tradition seems to be very old, as Buddha is compared to the growing moon, not to the sun growing in strength, the birthday of which is described, perhaps by relatively later tradition, as the birthday of Buddha. When the sun had become Buddha's symbol, and when the tradition about his life on earth referred to him as "the glory of the newly risen sun," the mother's symbol must have been changed from the moon to the sun.[75]

Once more Bunsen contends that Buddha's birthday falls on the winter solstice, or December 25th, appropriate for a sun god.

Buddha's miraculous conception in the womb of Mahamaya, during which he vanished from the realm of the devas, was said to have occurred in the month Aesala (July/August), "on the day of the full moon..." Buddha's identification with the moon is the same as the solar Osiris's relationship to the moon, reflecting the lunar cult stage of astrotheology, which dates back millennia and in many places predated the solar cult. Again, in the Buddha myth appears astromythology commonly applicable to both the sun and moon.

Finally, in *Monumental Christianity* Rev. Lundy includes Buddha in his lofty discussion of the virgin-birth motif and its relationship to the sun, commenting:

> Parhelia ["mock suns"] is a term which Archbishop Trench applies to all such gleams and anticipations and types of Divine Truth in ancient Paganism... His remark is this, viz.: "The heathen religions boasted of their virgin-born, as of Buddha and Zoroaster, as of Pythagoras and Plato.... Are the parhelia, however numerous, to be accepted as evidence that all is optical illusion, that there is no such true body of light as the sun after all; or rather, does not the very fact of their delusively painting the horizon, tell of and announce a sun, which is surely travelling up from behind?" It is in this sense that all such Pagan types and anticipations of Christ, as Agni, Krishna, Mithra, Horus, Apollo, and Orpheus, are to be understood. The true Sun must have been somewhere to produce such remarkable phenomena as these on all the ancient Pagan horizon.[76]

Neither Archbishop Trench nor Rev. Lundy denied that the Pagans had their "anticipations" of Christ, including Krishna and Buddha, long before the Christian era; yet, they needed at all costs to justify their own existence, as proselytizers of the faith, by using the "type of" sophistry displayed above. At least this clever "parhelia" explanation is an improvement over the "devil did it" excuse formulated by the early Church fathers. Nevertheless, it is a sly, conscience-smoothing way around the fact that the Christian conspirators *copied* their religion from the Pagans, in an usurpation that irked all who were paying attention. In any event, the use of the astronomical term "parhelia," referring to "sundogs" or spots on either side of the sun, also considered "mock suns," is interesting in consideration of the contention that Jesus Christ and his numerous divine "anticipations" are sun gods.

Buddha's Birthdate

To reiterate, Buddha is not an historical personage whose story is concretized but, like Krishna, essentially represents a personification of the sun. Moreover, as we are not dealing with

one man but numerous "Buddhas," it is not surprising to find many traditions concerning his birthday or birthdays. Indeed, as was also the case with Krishna, Buddha's birthday falls on different days in different years and places. In Laos, a festival to commemorate the "birth story" of the Buddha called "Bun Pha Wet" is held on January 29th and other days in different villages. Sakyamuni Buddha's birthday is celebrated on April 8th in Japan and Korea, and on May 7th in Vietnam. The birthday of "the Buddha" is often observed on May 3rd or May 7th, although the "actual day" is claimed to be May 11th as well. It is also celebrated on May 22nd in various places. In the Mahayana tradition, it was observed on May 10th in the year 2000. In the Theravedic tradition, the date was May 17th, and in the Hinayana tradition, it was the 18th of May. In 2001, Sakyamuni's birthday fell on April 30th.

In some places and years, May 17th is the birth, enlightenment *and* death of "the Buddha." Within Japanese Zen Buddhism, Buddha's enlightenment day is celebrated on December 8th, "but the Festival of the Enlightenment is on December 25th." In Chinese Zen, or Ch'an, Buddha's enlightenment day is January 14th. In Tibet, Buddha's birth *and* enlightenment day is celebrated on June 16th.

In addition to these various celebrations are the birthdays of numerous *other* Buddhas: For example, February 10th is "Samadhi Light Buddha's Birthday," and September 19th is the "Burning Lamp Buddha of Antiquity's Birthday." The "Medicine Master Buddha's Birthday" is variously October 26th or November 18th. In China, February 2nd is the birthday of Buddha Dipamkara. The Amitabha Buddha of Infinite Light was born on December 12th. As we have seen, "Amitabha" is another name for Abidha, the sun god, which is appropriate for "the god of boundless light."

As is evident, there is no consensus and quite a bit of confusion as to Buddha's birthday. In fact, some writers have maintained that "the Buddha" was born on the winter solstice, or December 25th. Since December 25th was appointed the "Festival of the Enlightenment," and several cultures celebrate Buddha's enlightenment day and his birthday on the same day, it is not implausible to assert that the sun god Buddha was said at some point and era to have been born on the 25th of December or the winter solstice. In *The Angel-Messiah*, Bunsen states:

> Several centuries before the birth of Jesus Christ some figures of constellations had become symbols of moral doctrines. Sooner or later these were connected with transmitted words of Gautama Buddha. The Cosmical had become to that extent the symbol of the Ethical, that the son of the virgin Maya, on whom, according

to Chinese tradition, "the Holy Ghost" had descended, was said to have been born on Christmas day, on the sun's birthday, at the commencement of the sun's apparent annual revolution round the earth. On that day, the sun having entered the winter solstice, the sign of Virgo was rising on the Eastern horizon... The woman's symbol of this stellar sign was represented first with ears of corn, then with a newborn child in her arms.[77]

Hence, Buddha was considered by Bunsen to be a typical sun god born at the winter solstice, in the arms of the Virgin, i.e., Virgo. Bunsen continues to explain his thesis that Buddha's birthday was celebrated on December 25th. His argument is reproduced here at length because of its importance:

> The time of this heavenly Buddha's incarnation is marked by various statements. It is asserted to have taken place on the eighth day of the second month of spring: we hope to prove conclusively that this is our Christmas day.
>
> ...According to the calendar of the Brahmans of the Tirvalore the year began in November, and the first month was called after the Pleiades Cartiguey or Krittikas....
>
> This Indian year, determined by the Pleiades, began with the 17th of November, approximately at the time of the Pleiades culminating at midnight, and this commencement of the year was celebrated by the Hindu Durga, a festival of the dead.... [O]n the 17th of November, or Athyr—the Athyr of the Egyptians and Atauria of the Arabs—the three days' feast of the Isia took place, which culminated in the finding of Osiris, the lord of tombs, evidently contemporaneously with the culmination of the Pleiades, at midnight. It was the same day, in the second month of the Jewish year, which corresponds with our November, that Noah shut himself up in the ark, according to Genesis; that is, on the same day when the image of Osiris was by the priests shut up in a sacred coffer or ark. According to Greswell, this new year's commemoration on the 17th of November obtained among the Indians in the earliest times to which Indian calendars can be traced back. It is sufficient for our argument that its commencement can be proved long before the birth of Gautama Buddha.
>
> If the 17th of November was New Year's day, the second month commenced on the 17th of December, and the "eighth day," Buddha's birthday, was the 25th of December, the sun's annual birthday, when the power of the sun ceases to decrease and again begins to increase. The text in Buddhistic writings we are considering presupposes the commencement of the year on the 17th of November, and thus points to the 25th of December. This is confirmed by another statement in the same scripture. At the time of Buddha's birth, "the asterim Chin was passing and the asterim Koh was coming on." Evidently this refers to the contemporaneous rising and setting of certain stars on opposite

sides of the horizon. In the assumed but uncertain year of Buddha's birth, 625 B.C., in the latitude of Benares, on the 25th of December, and at midnight, when according to prophecies the birth of the Anointed One was expected, "the point of the ecliptic rising above the horizon was very close to the star λ Virginis, whilst the stars α and ξ of this sign had already risen at some distance..."... It would seem...that [the] asterim Sen was the one meant in the Buddhist record, where it is called Chin. On this supposition the two asterims mentioned as coming and going at the time of Buddha's birth would both be correctly referred to. But it is enough for our argument that an asterim in Virgo is clearly stated as coming on or rising on the horizon at that time, for the sign of Virgo was certainly rising on the eastern horizon at midnight on the 25th of December in the year 625 B.C., as seen in the latitude of Buddha's birthplace. The position of the sphere would not be materially altered in any of the possible other dates of Buddha's birth....

Buddhistic records imply that Buddha was born at the time of the sun's annual birthday, of its entry into the sign of the winter solstice, when its apparent evolution round the earth recommences. The Cosmical was regarded as a symbol of the Ethical, the sun as the symbol of divine light, of which Gautama the enlightened was believed to be a chosen instrument. The solar Messianic symbol is thus proved to be more ancient than the time of Buddha's birth. The sun was the symbol of Gautama Buddha and of Jesus Christ, who is described as "the sun of righteousness" and as "the day-spring from on high." This common symbolism may help to explain several parallels in Buddhistic and in Christian records. Here we have only to point out that as on the transmitted day of Buddha's birth, so on Christmas day the constellation of the sphere rising on the Eastern horizon is that of the Virgin, represented as holding the newborn Sun-God in her arms, and followed by the Serpent, who aims at her heel and almost touches it with its open mouth. The symbolism of the sphere on Christmas day points to Isis with her infant Horus; to the virgin Maya with her infant Buddha; and to the Virgin Mary with her infant Jesus, described in the Apocalypse of John as persecuted by the old serpent, the Devil....

The Angel who is to become Buddha

We have shown that among a certain circle of Indians, prophecies were accredited which announced the incarnation of an Angel, called the Anointed or Messiah, who should bring to earth the Wisdom or Bodhi from above and establish the kingdom of heavenly truth and justice. He would be of royal descent, and genealogies would connect him with his ancestors. "The Blessed One," the "God among Gods," and the "Saviour of the World," was, according to Buddhistic records, incarnate by the Holy Ghost of the royal virgin Maya, and he was born on

Christmas day, the birthday of the sun, for which reason the sun
became the symbol of Gautama Buddha.[78]

In addition to the assertion that Buddha was born of the royal
virgin Maya on December 25th appears yet another date for the
year of his birth: 625 BCE. Buddha's role as a "sin-atoning savior"
is also evident: It was said that he departed Nirvana in order to
return to the suffering and sinful Earth so that he could liberate
and enlighten all beings. Concerning these various "heroes of
light" who are tied in with human salvation, Bunsen relates that
they are "connected with the constellations of the spring-
equinox," i.e., Easter, the time of the sun's resurrection. He
reiterates that at the winter solstice, the birth of the sun god, the
constellation of the serpent is "all but touching and certainly
aiming at the heel of the woman," i.e., Virgo. Hence, the virgin-
born sun god crushes the head of the serpent; in other words,
upon rising the sun's light blots out the serpent constellation.
Bunsen further remarks, "This pre-Christian symbolism would
still be historical even if the existence of Gautama could be
doubted, whose symbol was the sun, and who is reported to have
been born on our Christmas day, like Jesus, the Sun of
Righteousness."[79]

It is an interesting "coincidence" that both Buddha and
Krishna were said to have been born on the *eighth* day of either
the "second month" or "second fortnight," the fortnight also a
common unit of monthly or *moon* measurement. The situation
regarding Buddha's birthday is obviously the same as that of
Krishna. In the final analysis, it is also obvious that Buddha *is*
Krishna, is Christ, and so on. That the highly astronomical and
sun-worshipping Brahmans were the establishers of the
birthdays of both Buddha and Krishna is a significant clue as to
the nature of their spiritual heads, or head, as the case surely is.

It is useful to repeat that in ancient India, long prior to the
Christian era, the winter solstice was a major holiday—as one of
the four cardinal-point holy days—and that, as in the Western
world, it was considered the sun's birthday. It is further
important to recall that the Indians have been avid sun
worshippers; hence, their god, by whatever epithet, whether
Buddha, Krishna, Vishnu or Surya, would be born on December
25th.

Death of Buddha

As demonstrated, there is no consensus as to the year or day
of either Buddha's birth or death, which makes sense since we
are not dealing with the "biography" of a "real person." Nor is
there a single account of his death, as is also appropriate for a

mythical character subjected to cyclical deaths and births. According to one standardized version of his death, Buddha's brother-in-law and erstwhile follower Devadatta—his "Judas"—requested the king of Rajagaha to send a band of archers to kill the sage, who magically thwarted their attempts, such that they ended up worshipping him. Devadatta also tried to kill Buddha by throwing a huge stone at him, but the stone broke into pieces, one of which injured the godman's foot,[80] reminiscent of the heel piercing and wounding of several other gods. Devadatta then loosed upon Buddha a surly, drunken elephant, but when the elephant smashed through the city and attempted to kill a young boy, Buddha convinced the beast to mend its evil ways, at which point the pacified elephant sat down and recited the five Buddhist precepts:

1. You shall neither destroy nor cause the destruction of any living thing.
2. You shall not, either by fraud or violence, obtain or keep that which belongs to another.
3. You shall not lie carnally with any but proper objects for your lust.
4. You shall not attempt, either by word or action, to lead others to believe that which is not true.
5. You shall not become intoxicated.[81]

We cannot suppose that this absurd scenario with the elephant and the precepts really happened. Regarding the Buddhist precepts themselves, Inman remarks: "We much fear, that if the commandments which nominal Christians observe are contrasted with those kept by the Buddhists, the former must be regarded as much lower in the scale of religious civilization than the latter."[82]

According to the Singhalese/Ceylonese account, Buddha eventually died of eating pork. On his deathbed, the godman said to the priests in attendance, "I depart to Nirvana; I leave with you my ordinances: the elements of the Omniscient will pass away; the three gems will still remain."[83] Of this anecdote, Simpson says, "As this little incident of the pork is found only in the Singhalese accounts, we may count it an interpolation and conclude that Buddha, like Krishna, died of old age."[84] The Singhalese tale of Lord Buddha's death from pork is strange in that it sounds Semitic, perhaps related to the myth of Adonis, whose name means "Lord" and who was killed by a boar. In any event, it is clear that the Buddha myth, like that of Krishna, Christ and other gods, varies in its details.

Per the orthodox tale, as Buddha was dying, he bathed in a river, "causing rays to emanate from his body and robe, that extended to both banks of the river."[85] Upon his death, Buddha's body was wrapped in a long shroud, as in the Jesus myth. The

Ceylonese story does not discuss his bodily attainment to Nirvana; rather, he is cremated. Yet, the miracles do not end there, as, before the priest Maha-kasyapa lights the funeral pyre, he requests to see Buddha's feet one more time. Upon his wish, Buddha's feet appear through the many layers of cloth, "emerging from the pyre like the moon coming from behind a cloud... After this the feet...returned to their original position, like the moon passing behind a cloud."[86] The pyre ignites spontaneously, and Buddha's body is consumed; yet, "parts of his body sent forth a delightful perfume, and afterwards remained like a heap of pearls," leaving behind four teeth, the cheekbones and his skull as relics.[87] Buddha's death, like his life, contains mythical and astrotheological motifs: To wit, the emanating rays, an obvious solar attribute; the miracles with the feet "emerging...like the moon"; the "delightful perfume" and "heap of pearls."

As shown, a number of writers have asserted that, like Christ, Buddha "ascended *bodily* into Nirvana" or heaven. As Doane states:

> *Buddha* also ascended bodily to the celestial regions when his mission on earth was fulfilled, and marks on the rocks of a high mountain are shown, and believed to be the last impression of his footsteps on earth.[88]

Obviously, if the Buddha did not have a body as he was ascending, he could not have left footprints, which is to say that, by this footprint story, common in the Buddhist world, we must presume there was a tradition of a *bodily* ascension. Yet, this theme is likewise mythical, as the "footprints of the gods" can be found in numerous places associated with a variety of deities.

As concerns the bodily ascension, Graves relates:

> Of Laotsi [Lao Tzu or Tse] of China, it is said that when "he had completed his mission of benevolence, he ascended bodily alive into the paradise above."... And it is related of Fo of the same country that, having completed his glorious mission on earth, he "ascended back to paradise, where he had previously existed from all eternity."[89]

Again, "Fo" is the Chinese name for Buddha; in any case, the Chinese account differs from the Ceylonese.

A later tradition contends that after his death in this world Buddha would assume a spiritual body in Nirvana that would be "spotless and pure," free from "contamination" and "all material influence."[90] It may be that the "bodily ascension" is based on this concept of Buddha maintaining a body in Nirvana, after he had died and left the earthly plane. Even if the bodily ascension were not traditionally associated with Buddha, there remain instances of such a miracle in other mythologies. For example, speaking of

Christ's Ascension, apologist Weigall admits the difficulty of taking it as "history," particularly in view of the fact that it was claimed of older, Pagan deities as well:

> ...one's doubts are increased when it is realised that such an ascension into the sky was the usual end to the mythical legends of the lives of pagan gods, just as it was to the very legendary life of Elijah. The god Adonis, whose worship flourished in the lands in which Christianity grew up, was thought to have ascended into the sky in the presence of his followers after his resurrection; and, similarly, Dionysos, Herakles, Hyacinth, Krishna, Mithra and other deities went up into heaven.[91]

The Judeo-Christian ascension stories include the "translation of Enoch" and the "ascent of Elijah in his whirlwind and chariot of fire." The representation of Elijah in early Christian art caused Rev. Lundy to remark that the prophet's fiery image is "always precisely like the four horses and chariot of Apollo and Mithra, the sun-gods of the Greeks and Persians."[92] Eli-jah is thus depicted as the sun god, which is appropriate, since his name is a compound of two epithets for the sun. Lundy himself confirmed this fact but attempted to explain it away, in his etymological discussion regarding the prophet, first relating that the "old Asiatic nations" called the divine sun "El," an epithet the Hebrews applied to "God Himself." Next, Lundy related that the "Phoenicians called the sun-god *Hel*, the Greek *Helios*," which he equated with Elijah, or *Elias*, as the name is translated in the Catholic Bible. He then defined Elijah as "My God is Jehovah," i.e., "the True God as distinguished from the mere sun-gods of Paganism." In a final flourish, Lundy triumphantly proclaimed, "Elijah, therefore, is a most fitting type of the Son of God ascending the heavens to the Eternal Father."[93]

In any event, the biblical Daniel's vision at 7:13 of "one like a son of man" could be classified in this same manner. Of the account of Jesus's ascension in the gospel of Luke, Cassels asserts that the author used Josephus's depiction of Moses's death, in which the historian claims Moses did not really die but, "reaching the mountain Abarim he dismissed the senate; and as he was about to embrace Eleazar, the high priest, and Joshua, 'a cloud suddenly having stood over him he disappeared in a certain valley.'"[94] In any case, the ascension motif is not original to Christianity and cannot serve as "evidence" that Jesus was "the only begotten son of God."

Buddha Crucified?

Another point of contention in the comparative mythology is whether or not Buddha was portrayed as "crucified." As we have seen, Krishna, Wittoba or Indra—all sun gods—were ostensibly

depicted as crucified and/or in cruciform. Since Buddha is likewise a sun god, another incarnation of Vishnu and essentially the same as Krishna, it would not be unexpected to find him portrayed as crucified as well. Indeed, a number of writers have asserted that he was so portrayed. In addition to the instances already noted, Graves claims that around 600 BCE "the Hindoo Sakia" died upon a cross for the sins of mankind:

> ...the death of the God...known as Sakia, Budha Sakia, or Sakia Muni, is distinctly referred to by several writers, both oriental and Christian, though there appears to be in Budhist countries different accounts of the death of the famous and extensively worshiped sin-atoning Saviors.
>
> In some countries, the story runs, a God was crucified by an arrow being driven through his body, which fastened him to a tree; the tree, with the arrow thus projecting at right angle, formed the cross, emblematical of the atoning sacrifice.
>
> Sakia, an account states, was crucified by his enemies for the humble act of plucking a flower from a garden...[95]

Unfortunately, we are not given the name of account that stated Sakia, or *Buddha*, was crucified by his enemies. It appears Graves took part of his report from Higgins, who says, "Buddha was crucified for robbing the garden of a flower..."[96] The assertion is surely correct that there were "different accounts of the death" of the various saviors, a development that occurred because *they were not "real people."* The contention that "a God was crucified by an arrow" sounds like the Krishna story, which in turn echoes the human sacrifice by hanging on a tree. Also cited is a Nepalese account recorded by Father Georgius concerning "Iao" being crucified on a tree in 622 BCE. Iao, again, is asserted by Diodorus and others to be the same as Yahweh, Dionysus, Zeus, etc. These seventh century dates for both Sakia and Iao would be appropriate for "the Buddha," per the current mainstream consensus.

In his discourse on Buddha crucified, Graves further describes the "numerous images of [the Indians'] crucified Gods, Chrishna and Saki, emblazoned on their old rock temples in various parts of the country, some of which are constructed of clay porphyry, now the very hardest species of rock, with their attendant inscriptions in a language so very ancient as to be lost to the memory of men..."[97] So it seems that there were "numerous images" of crucified gods in India; yet, as we have seen, there has been much destruction of Indian monuments by a variety of invaders. It appears that many such images have been casualties of this devastation.

In any event, Graves did not originate the crucifixion contention regarding Buddha and may thus be cleared yet again of the calumny against him. In the 1830's, decades before Graves, Christian lawyer Henry O'Brien made the case that "Budha" was a crucified god in *Ireland*, which he showed to be the "Budh Island" or the "Island of Budha." In *The Round Towers of Ireland*, O'Brien gives an alternative interpretation of these mysterious Irish edifices, about which one seldom hears anything. These phallic-shaped towers, of fine masonry and impressive design, were deemed long ago to be the construction of Christian monks, because churches were often built next to them. O'Brien, however, evinces that the towers are much older than Christianity and exhibit a better masonry than Christian clerics could muster. The Christian ruins nearby the round towers reveal that they are of distinct and inferior building methods and materials,[98] and it is obvious that the towers were there first and that the Christians built next to them in order to usurp their esteem by locals.

O'Brien concludes that these towers are "Budhist," or Sabian/ Sabean (ancient Iranian/Persian/Arabian, i.e., Mesopotamian), a group he maintains are the same as the famed Tuatha de Danaan, or ancient Irish. O'Brien specifically calls the builders of these towers "*Iranian* Buddhists."[99] He also claims that the Iranian language of *Pahlavi* is the "polished elocution of the Tuath-da-danaans."[100] "*The* Pahlavi," it will be recalled, are identified in Indian writings as one of the exiled peoples from the subcontinent. Citing a similarity between the Welsh and Iranian languages, Robert Graves also relates that Pliny had suggested a "strong connection between the Persian and British sun-cults."[101]

The towers do in fact resemble minarets more than anything else, so their Eastern origin would not be an illogical assertion. In deeming their Sabean builders "Buddhists," O'Brien refers to "the Buddha," although he is adamant that there was no "historical Buddha":

> ...if you look into any encyclopedia or depository of science for a definition of the word Budhism, you will be told that "it is the doctrine of solar worship as taught by Budha." There never was such a person as Budha—I mean at the outset of the religion, when it first shot into life, and that was almost as early as the creation of man. In later times, however, several enthusiasts assumed the name...[102]

The assertion that "Budha" taught the "doctrine of solar worship" is interesting confirmation of the solar nature of Buddhism, although, as O'Brien insists, Buddha was not a single "person." The spelling of "Budha" and description of his nature

indicates that O'Brien considered the solar-wisdom god and the "historical redeemer" to be the same.

The purpose of the Irish round towers, O'Brien states, is for the worship of the sun and moon, which orbs are "the authors of generation and vegetative heat."[103] O'Brien continues:

> Then be it known that the "*Round Towers*" of *Ireland* were temples constructed by the early Indian colonists of the country, in honour of the *fructifying* principle of nature, emanating, as was supposed, from the sun, under the denomination of Sol, Phoebus, Apollo, Abad or Budh, etc.; and from the moon, under the epithet of Luna, Diana, Juno, Astarte, Venus, Babia or Butsee, etc.[104]

In other words, the towers are temples to the sun and moon, as well as astronomical observatories, and their builders were "Indians" or "Aryans" who brought with them their gods and god-names, including "Buddha," or other variant thereof. Concerning the towers, O'Brien relates the words of an ancient Irish bishop, Corma, "the celebrated bishop of Cashel," who, in "defining the Round Towers in his Glossary of the Irish Language, under the name of *Gaill*," wrote the following:

> "*Cartha cloacha is aire bearor gall desucder Fo bith ro ceata suighedseat en Eire*"—that is, stone-built monuments, within which noble judges used to enclose vases containing the relics of Fo (i.e. Budh), and of which they had erected hundreds throughout Ireland![105]

Hence, according to this citation by O'Brien, an early Catholic authority claimed these towers were built in the name of "Fo," or Buddha. In support of this contention, O'Brien cites the "Dagobs" of Sri Lanka, often lofty buildings in which Buddhist relics have been deposited.

The towers are also symbols of fertility, their phallic nature obvious to the eye. Concerning these phallic symbols, O'Brien remarks:

> Such was the origin and design of the most *ancient* Indian pagodas... And that such, also, was the use and origin of the Irish pagodas is manifest from the name by which they are critically and accurately designated, viz., *Budh*, which, in the Irish language, signifies not only the *Sun*, as the source of *generative vegetation*, but also the *male organ of procreative generativeness*...[106]

That "Budh" in ancient Irish meant the sun is a most noteworthy assertion to be recalled, made by Col. Vallancey, a trusted Christian authority.[107] Again, Vallancey also stated that *krishna* in ancient Irish meant "sun."

Continuing his analysis, O'Brien refers once more to the phallic nature of the round towers and connects lingam (phallus) worship with sun worship, as well as with "Budh," saying:

> Hence the name *Budhism,* which I thus define, viz., *that species of idolatry which worshipped Budh* (i.e., the Lingam) *as the emblem of Budh* (i.e., the Sun)—Budh signifying, indiscriminately, Sun and Lingam.[108]

These phallic towers are also associated with the obelisks or "high places of Baal," which in the Septuagint are styled "stelae" or *pillars* of Baal, "consecrated to the sun."[109] The Christian lawyer further shows the etymological connection to the Levant, noting that the ancient Irish called their towers "Bail-toir, that is, the tower of Baal, or the sun." In this regard, Robert Graves stated that the "Bronze Age Amathaonians" worshipped "the Immortal Beli in his Stonehenge temple,"[110] Beli being equivalent to Apollo.[111] The Canaanite/Phoenician sun god Baal or Bel is thus found in Ireland, worshipped by the Danaans and Celts as Bel, Beli, Belus, Belenos or Belinus.[112] There is also an Irish connection to Moloch/Molech, the ancient Semitic sun god to whom the Canaanites, Phoenicians and Israelites sacrificed their children. As O'Brien states:

> ...St. Malloch adopted *this* name from the city of Malloch, that is, the Sun, or Apollo—the supreme idol of pagan Ireland's adoration—from which..., with the prefix "Kill," he made the name Kill-*malloch...*[113]

He also says:

> I next turn to Killmalloch, the ancient name of which, as given by Ptolemy, was Macollion—a metathesis for Mallochicon; and the final *icon,* which is only a Greek termination, being taken away, leaves Malloch, that is, Moloch, the Apollo or great divinity of the ancient universe.[114]

Nor is this the only place in Ireland named Moloch: "Ard-Mulchan" is a village in the county of Meath, the name of which comes from "*Ard,* the high place, or mound, *Mulchan,* of Moloch."[115] The Phoenicians, who are claimed to be Celts, possibly originating in India, were thus well acquainted with Ireland and established their gods and rites there. "Buddha" or "Mercury" was likewise a god worshipped by Phoenicians, as asserted in *Phoenician Ireland* by Villanueva, who refers to "Mercury...whom the Phoenicians worshipped as the god of calculation."[116] In regard to human sacrifice, which also connects the inhabitants of the British Isles and the Phoenicians, Villanueva further observes:

That from the Druids, as well as from the other sacrificial forms
of the Phoenicians and other nations, was introduced into Spain
and Gaul, and the British islands, the barbarous custom of
human immolation, called anthropothysia, together with that of
human divination, called anthropomanteia, is a question that no
one can contravene.[117]

The ancient Druids, like the Phoenicians, practiced human
sacrifice, and by Higgins's time (1820's) Scottish people were still
baptising their children by passing them through fire, both
practices found within the Molech cult. Reciting a passage in
Siculus (1st cent. BCE) concerning the mandatory presence of an
officiating priest at a Druid sacrifice, Villanueva reports:

They attended also at the sacrifices of the Gauls, at which,
Tertullian tells us, they were in the habit of offering human
victims to Mercury; and Menutius Felix says, "the Gauls slay
human, or rather, inhuman, victims." Strabo, speaking of their
sacrifices, which had been invented, or at least patronized, by
the Druids, says, "they used in their sacred offices to pierce some
individuals to death by arrows, or else crucify them; or having
reared up a pillar of hay and stuck a wooden pole therein, they
used to burn cattle and animals of every description, nay, men
themselves, whole and unmutilated." And Diodorus Siculus
[says], "criminals kept for five years, they nail to the stakes, and
sacrifice to the gods, and with other first fruits, immolate over
immense funeral piles." Which practices, as well as the others
appertaining to idolatrous ritual, were common to the Spaniards
and Britons, and its various Celtic tribes.[118]

Considering that Celts were *crucifying* sacrificial victims,
ostensibly to the god "Mercury," i.e., *Budha*, as he is called in the
Sanskrit, of which ancient Irish is a close relative, it is certainly
logical to conclude that any depictions of crucified gods in Ireland
may be those of "Budha" or other epithet of the sun god. In other
words, as in India and the Levant, one would expect to find also
in Ireland the ritual of the sacrificed or crucified sacred king, with
its attendant iconography.

In this regard, O'Brien provides an image of a round tower
with a crucified man above the door, between two standing
human figures and, below them, two bizarre animals lying down.
Concerning this image, O'Brien relates that Christian authorities
naturally want to make of it a Christian crucifix. However, our
Irish writer disagrees, first commenting on the strange animals,
and linking them with the elephant and bull on a Buddhist
temple in Sri Lanka. The "bull" and "elephant" figures depict
peculiar creatures that resemble neither animal, as if the artist
had never seen one. Concerning the same image, Lundy points
out a Hindu scene with strange animals resembling the Irish
"elephant," indicating that the "Irish" artist was Indian. O'Brien

further asserts that the crucified individual is not Christ but "Budha," and that the human figures surrounding the cruciform are not "St. John or the Virgin Mary," claimed by Christian authorities, but "Budha's Virgin Mother" and "his favorite disciple, Rama."[119] As Rev. Lundy relates:

> Henry O'Brien explains this Round Tower crucifixion as that of Buddha; the animals as the elephant and the bull sacred to Buddha, and into which his soul entered after death... The whole picture bears a close likeness to the crucifixion in the cemetery of Pope Julius, except the animals, which are conclusive proof that it cannot be Christian. It came ultimately from the far East to Ireland with the Phoenician colonists, who erected the Round Towers as symbols of the Life-giving and Preserving Power of man and nature, and how that universal life is produced through suffering and death.[120]

The crucified man or god is not necessarily a symbol of death; like the crucified crossroads god, the hanging image of a god may simply be a sensible style for the protection of doorways. In any case, the pious Rev. Lundy is resolute that the crucified-god motif was both pre-Christian and applicable to Buddha. After providing a depiction of Buddha in lotus posture with cross-shaped flowers in his palm and on his chest, Lundy further remarks:

> Now, as there were twenty-two Buddhas or incarnations of Vishnu, one of which was Krishna, why may not these cross-like flowers be intended as something more than offerings brought to Buddha, as Moor conjectures, and be really intended as symbols of his incarnation, or joining of heaven and earth, God and man, to give life to the world by his sufferings and death? Buddha, like Krishna, was crucified...and here he is naked as Jonah under his gourd, reposing under his canopy of shade and the guardianship of the Eternal One, showing the marks of his conquest over death in his hand and breast, and sometimes, in other examples, in his feet also, viz.: the sign of the cross.[121]

Describing a slab found in India with the "feet of Buddha" carved into it, Lundy states that each foot possesses the image of the "Wheel of the Law or the Sun," with the heels marked by a "Trismul or symbol of the triad" and surrounded by the "sign of Agni, the oldest form of the cross known." He then says:

> *These are the marks of an Incarnate God, believed by millions of human beings to have gone up into Heaven and attained the blessed eternal nirvana, after his crucifixion, death and burial.*[122]

Such assertions, made by a fervent and erudite defender of the Christian faith, are astounding, reflecting the high level of scholarship and candor attained in the late 19th century.

The cruciform discussed above is not the only one discovered in Ireland. As the German writer Elias Schedius (1615-1641)

observed, the Druids sought oak trees with "two principal arms, in the form of a cross." If they could not find such a tree, they would "fasten a cross-beam to it." Upon the right branch of the chosen tree, they carved the name "Hesus," their "principal god," followed by "Taramis" in the center, and "Belenus" on the left branch. Above and below all three names the priests carved "the name of God, *Thau*..."[123] Hence, we have the Druid god *Hesus*, represented by his name, hanging on a cross. Indeed, instead of Buddha, Graves and Higgins (II, 130) both claimed the god hanging on the round tower with the bizarre animals underneath was Hesus, a sun god and a "woodcutter," i.e., carpenter.

Also found in Ireland was a bronze image of a god crucified wearing a kilt, about which O'Brien declares that it "could not have been identified for our Saviour," as it lacked both the "INRI" and wore "the *Iranian regal crown*," rather than the "Jewish" crown of thorns. Once again, O'Brien states, here is an icon of "Budha,"[124] in other words, the Irish epithet for the sun god. Regarding the similarities between Buddhism and Christianity, O'Brien further observes:

> So astounding did the correspondence between the Christian and the Budhist doctrines appear to the early missionaries to Thibet and the adjacent countries—a correspondence not limited to mere points of *faith* and preceptorial maxims, but exhibiting its operation in all the outward details of *form*, the inhabitants going even so far as to wear *crosses* around their necks—that Thevenot, Renaudot, Lacroze, and Andrada, have supposed, in their ignorance of the cause of such affinity, that Budhism must have been a vitiation of *Christianity* before planted; whereas *Budhism* flourished thousands of years before it, or Brahminism either; and *this cross was the symbol of Budha crucified.*[125]

To reiterate, the assertion that "Budha" was crucified becomes plausible in light of the apparently pervasive crucified god in India, along with the fact that protector gods were often hung on doorways, walls and placed in the ground. Added to this strong claim is the fact that the cross was a popular pre-Christian symbol.

The contention that Buddha was "crucified" or died on a cross may be made from the extrapolation that Surya is Budha is Buddha is Vishnu is Wittoba or also Indra, who, as we have seen, was depicted in a number of places in Nepal as crucified at crossroads. It should be remembered that these are *titles* of the Deity, generally the God Sun, and that they do not represent "real people," such that all sorts of stories and legends concerning them have been woven together. Furthermore, the association of Buddha with Mercury or Woden/Odin likewise gives credence to

the notion that he was depicted as "crucified," as Odin was hung on a tree and pierced by a lance.

As further evidence, O'Brien cites the well-respected *Asiatic Researches* as discussing Buddha's crucifixion:

> I terminate the proofs of the primeval *crucifixion*, by the *united* testimonies of the *Budhists* and the *Freemasons*.
>
> "Though the punishment of the cross," say the Asiatic Researches, "be unknown to the Hindus, yet the followers of Buddha have some knowledge of it, when they represent Deva *Thot* (that is, the god *Thot*) crucified upon an instrument resembling a cross, according to the accounts of some travellers to Siam."
>
> "Christianity," says Oliver, "or the system of salvation through the atonement of a crucified Mediator, was the main pillar of Freemasonry ever since the fall."[126]

The original passage in *Asiatic Researches* is to be found in vol. X, on page 62 of Col. Wilford's essay, "Origin and Decline of the Christian Religion in India," in which he spells "Deva-Thot" as "Deva-Tat." The parenthetical comment regarding "the god Thot" is O'Brien's, and the last sentence should read "*several* travellers to Siam, and other countries."

This Deva Thot or Deva-Tat has been equated with Jesus, based on a number of striking correspondences between their stories, correspondences that in reality appear because the gospel story existed ubiquitously in bits and pieces for centuries and millennia prior to the Christian era. Significantly, "Thot" is the same as the Egyptian name for Budha/Mercury/Hermes, i.e., Thoth. It would seem, therefore, that this Siamese Buddhist tradition regarding "Deva Thot" is pre-Christian and has little to do with "Jesus Christ," except that the "punishment by cross" and other characteristics were eventually taken into Christianity.

O'Brien summarizes the debate regarding the crucified god:

> ...our Saviour was not the *only one* who was crucified for his faith. In my work upon the "Round Towers," I have shown that Budha, in *whose honor those temples were constructed*—was *crucified also*, in sustainment of a religion the *very counterpart* of Christianity, differing from it only in priority of date. And I have given, at the same time, an effigy of this idol, representing his godship in this attitude of crucifixion; which, with two other effigies, all representatives of Budha—in different bearings of his *incarnation*—have been dug up in the bogs of Ireland...
>
> Struck with this extraordinary similitude between the Christian and Budhistical religions, the Jesuits—who went to convert the Bedouins on the coast of Guinea, Madagascar, Socotora, and the countries thereabout—and unable, furthermore, to account for the veneration which those heathens universally paid to the

cross—all of them, without exception, wearing it about their necks—while they celebrated their divine service in Chaldee, a dialect of our ancient Irish—concluded *most absurdly* that Budhism must have been a modification of Christianity before promulgated—whereas Budhism was *propagated* many thousand years before Christianity, or Brahminism either; and this *cross* was the symbol of *Budha* crucified.[127]

The pious Christian O'Brien actually calls it blasphemy to pronounce these Irish crucifixes as images of Christ. He also declares it absurd that apologists have claimed Buddhism plagiarized Christianity, because "Buddha" *long* pre-dated the Christian era. Furthermore, Irish crosses date from some of the earliest periods of known inhabitation of that isle, including that of the Tuatha de Danaan, whose crosses "resemble those of Buddhist countries."[128] One of these numerous pre-Christian crosses, at Killcullen in the county of Kildare, "bears the figures of nine Buddhist priests in oriental garb, and even with a sort of Egyptian beard."[129] In the final analysis, it is not surprising to find cruciform images of the sun as "Budha" in Ireland.

The Carpenter

The crucifixion, the two thieves and the resurrection are astrotheological motifs that one would expect to find in the mysteries of a solar priesthood. And mysteries they have remained, as books containing them continue to be mutilated and destroyed. The carpenter motif is likewise solar in origin, and a number of gods were said to have been carpenters, sons of carpenters and/or woodcutters, such as the Druidic sun god Hesus. As noted, Fohi/Buddha is incarnated at least once as a carpenter and is evidently the spiritual head of the carpenter's guild in China, as "in Chinese mythology Fuxi holds a carpenter's square."[130]

In Sumero-Babylonian mythology, dating back centuries and millennia before the common era, appeared a sun-carpenter correspondence in the god "Nin-ildu," the "carpenter-god that carries the pure axe of the sun." The ancient Sumerian Great Mother goddess Ki-Ninhursag was also known as a "craftsman" and "carpenter." Millennia before the Christian era, Ninhursag was called:

> The Builder of that which has Breath
> The Carpenter of Mankind
> The Carpenter of the Heart
> The Coppersmith of the Gods,
> The Coppersmith of the Land,
> The Lady Potter.[131]

Moreover, the sun-as-carpenter turns up in the Jewish text the Talmud, at Yoma 20b:

> ...R. Levi said: Why is the voice of man not heard by day as it is heard by night? Because of the revolution of the sun which saws in the sky like a carpenter sawing cedars.

The Talmud (Chullin 60a) also compares Yahweh, who has been demonstrated to be an aspect of the God Sun, to a carpenter:

> The Emperor's daughter once said to R. Joshua b. Hananiah, 'Your God is a carpenter, for it is written: Who layeth the beams of His upper chambers in the waters..

The carpenter aspect of the sun can be seen in the word "sun-beam." A beam is not only a plank but also a "ray of light," while "to beam" is "to emit rays of light" and "to support with beams," as well as "to smile with joy" and to be hit with a plank. The beam is also a form of guidance, an appropriate role for the "God of gods," the Sun. In addition, like the sun, who builds his daily houses, the moon is considered a carpenter: "...the moon, because he divides and measures the sky, is a carpenter."[132]

As also noted, an Indian initiation included the Puranic tale of Surya the sun being crucified and shorn of his beams on a cross or "cruciform lathe," having part of his brightness cut away by the "woodcutter and carpenter," Viswakarma/Takshaka, after which Surya appears with a *crown of thorns* instead of rays.[133] This story, which recalls that not only of Samson but also of Christ, reflects a mystery-school rite within a builder's guild. Like that of the masonry, the carpenter guild has been very important within religion, as most houses of worship have been built of wood.

In the Indian "prophecy" regarding Salivahana related by Wilford, which is actually supposed to have taken place in the past, the virgin-born and cross-borne Salivahana is the "son of a *Tacshaca* [Takshaka], or carpenter."[134] Wilford further explains this carpenter motif:

> God is called DEVA-TASHTA, or God the artist or creator, in *Sanscrit*; and also DEVA-TASHTA, from which is derived DEO-TAT or TEUTAT [Celtic sky god] in the west... In Greece, according to Pindar, God the father of mankind, and creator of the world, was called πατηρ Αρισοτεχνης, the father and best artist. This carpenter, father of SALIVAHANA, was not a mere mortal, he was chief of the *Tacshacas*, a serpentine tribe, famous in the *Puranas.*[135]

Oddly enough, legend further holds that "Deva-Twashta," Deva-Tat or Deva Thot, who was the "Aryya-Raja" or "chief of the Aryas or *Christians*," as Wilford interpreted it, was "crucified by order of BUDDHA," after the Raja "loudly preached against the doctrine

of BUDDHA."[136] Wilford rationalized this evident anachronism by saying, "BUDDHA and DEVA-TWASHTA are made contemporaries in this romance: but this can be no objection; for it is only in allusion to the wars of their followers in subsequent times."[137]

The Salivahana tale is not an Indian recounting of the "historical" gospel story, and "Deva-Tat" is God the Father, not the Son. It is *God*, not the earthly father Joseph, who is the carpenter, for the reason that God is the Grand Architect of the Universe. His "carpenter" status is a reflection of his being the patron god of that architectural guild. In any event, the god's father-as-carpenter theme precedes the Christian era, as it can also be found in the myth of Adonis, whose father, Kinyras, "is said to have been some kind of artizan, a smith or carpenter."[138]

Another god represented as a carpenter is Tvashtar, the father of Agni, the Vedic fire and sun god, whose ancient tale so resembled the Christ myth. Tvashtar's name "characterises him simply as a modeller (world-modeller) or work-master, divine artist, skilful smith, or 'carpenter.'"[139] Thus, again, as in the Christ myth the god's father is a carpenter. Also, since "Tvashtar" is an epithet of Surya, it is apparent that this carpenter god is, like Krishna, also a sun god and that in India sun gods were considered "carpenters."

In Egypt too can be found the "son of the carpenter" theme, with the Egyptian buddha Hermes's father appearing as an "artisan." As Drews says, "Hermes closely resembles Agni as well as Jesus." The word in the New Testament translated as "carpenter," τεκτων (tekton), also means "artisan." Interestingly, the Greek word "Demiourgos," the "god of this world," means "artisan" as well, along with "architect" or "carpenter."[140] Hence, to be the "son of the carpenter" is to be the son of the Demiurge or "lord of this world."

As has been abundantly established, there are numerous common themes running throughout the "lives" and religions of the world's godmen, including Buddha, whose "life" is patterned after that of a typical sun god. That Buddhism has changed significantly over the past couple of millennia, losing its lofty esoteric meaning as it was reduced to mundane "history," is apparent. In this regard, a "primeval Buddha of great antiquity" who was the sun has been hidden "under the modern trash."[141]

Once the rubbish piled up over the ages has been removed, numerous correspondences, resemblances, similarities and correlations are revealed between the stories and religions of Krishna, Buddha and Christ. Many of these similarities are obvious, some less so, and still others are hidden in esoteric traditions within the mysteries. In any case, it is evident that these correspondences exist and that, for the most part, if not *in toto*,

they precede Christianity by hundreds to thousands of years. Regardless of any denials, the fact will remain that Buddhism preceded Christianity, and that the Buddha myth is so strikingly similar to the Christ fable that numerous writers and authorities over the past centuries have remarked extensively upon it.

1 Pandey, 180.
2 Evans, 41.
3 *CMU*, 118.
4 Moor (1810), 241.
5 Moor (1810), 249.
6 Higgins, I, 164.
7 Srivastava, 317-320.
8 www.blavatsky.net/blavatsky/arts/LePhareDeLInconnu.htm
9 www.eliohs.unifi.it/digilib/eliohs.testi/700/jones/
 Jones_Discourse_3.html
10 Jones, *AR*, I, 142-143.
11 Higgins, I, 156.
12 www.hindunet.org/god/planet_deities/budha/
13 Blavatsky, *SD*, II, 498.
14 Hardy, 24.
15 www.theosociety.org/pasadena/mysterys/mystsch1.htm
16 Blavatsky, *SD*, II, 28.
17 www.hindunet.org/god/planet_deities/budha/
18 DeMeo, 289.
19 Moor (Simpson), 201.
20 Hardy, 366.
21 Hardy, 47.
22 Pandey, 125.
23 Singh, 39.
24 Singh, 46.
25 Singh, 52.
26 Singh, 63.
27 Singh, 100.
28 Graves, R., 133.
29 Pandey, 73.
30 Pandey, 35fn.
31 Robertson, *CM*, 326.
32 Hardy, 199.
33 Walker, *WDSSO*, 428.
34 Hardy, 367.
35 Massey, *GML*, 57.
36 Massey, *GML*, 65.
37 Massey, *GML*, 75.
38 Evans, 49.
39 Massey, *GML*, 66.
40 Higgins, I, 251.
41 Bunsen, 27-30.
42 Bunsen, 31.
43 Pandey, 49-50.

[44] Pandey, 50fn.
[45] Pandey, 199.
[46] Pandey, 51.
[47] Pandey, 211.
[48] Pandey, 71.
[49] Pandey, 194.
[50] Pandey, 194.
[51] Pandey, 256.
[52] Pandey, 217.
[53] Singh, 148.
[54] Singh, 153.
[55] Singh, 160-161.
[56] Jackson, *CBC*, 87.
[57] Evans, 41.
[58] Doane, 115-117.
[59] Graves, R., 373.
[60] www.ccel.org/fathers2/NPNF2-06/Npnf2-06-10.htm
[61] Doane, 163.
[62] McCabe, XIV.
[63] Hardy, 142fn.
[64] Hardy, 137.
[65] Hardy, 141.
[66] Hardy, 145.
[67] Bonwick, *EBMT*, 107.
[68] Massey, *GML*, 181.
[69] Moor (1810), 447.
[70] McLean, 102.
[71] Bunsen, 4-5.
[72] Bunsen, 9-10.
[73] www.newadvent.org/cathen/04517a.htm
[74] Bunsen, 33.
[75] Bunsen, 37.
[76] Lundy, 197-198.
[77] Bunsen, x.
[78] Bunsen, 20-25.
[79] Bunsen, 110.
[80] Hardy, 320.
[81] Inman, *AFM*, 168.
[82] Inman, *AFM*, 168.
[83] Moor (Simpson), 157.
[84] Moor (Simpson), 157.
[85] Hardy, 344.
[86] Hardy, 348-349.
[87] Hardy, 349.
[88] Doane, 216.
[89] Graves, K., 153.
[90] Bunsen, 27.
[91] Weigall, 100-101.
[92] Lundy, 284.

93 Lundy, 286.
94 Cassels, 1020.
95 Graves, K., 115.
96 Higgins, II, 193.
97 Graves, K., 283.
98 O'Brien, 8.
99 O'Brien, 413. (Emph. added.)
100 O'Brien, 415.
101 Graves, R., 209.
102 O'Brien, 109.
103 O'Brien, 61-62.
104 O'Brien, 91.
105 O'Brien, 368.
106 O'Brien, 103.
107 Higgins, II, 287.
108 O'Brien, 112.
109 O'Brien, 75.
110 Graves, R., 127.
111 Graves, R., 285.
112 Graves, R., 56.
113 O'Brien, 44.
114 O'Brien, 201.
115 O'Brien, 203.
116 Villanueva, 173.
117 Villanueva, 255-256.
118 Villanueva, 257-258.
119 O'Brien, 301.
120 Lundy, 255.
121 Lundy, 275.
122 Lundy, 457. (Emph. added.)
123 O'Brien, 289.
124 O'Brien, 298.
125 O'Brien, 295.
126 O'Brien, 343-433.
127 Villanueva, 311fn.
128 Bonwick, *IDOIR*, 250.
129 Bonwick, *IDOIR*, 250.
130 Singh, 163.
131 Baring, 189.
132 Müller, *LOGR*, 184.
133 www.theosophy-nw.org/theosnw/ctg/chj-chz.htm
134 Jones, *AR*, X, 39.
135 Jones, *AR*, X, 39.
136 Jones, *AR*, X, 54.
137 Jones, *AR*, X, 95.
138 Drews, *CM*, 115.
139 Drews, *CM*, 114.
140 Robertson, *CM*, 305.
141 Higgins, I, 383.

Surya, the sun god, as Buddha
(Moor)

Korean gilded bronze
Buddha
with solar nimbus and
gestures, 6th century CE
(Singh)

Suryaprabha and
Chandraprabha, Buddhist
sun and moon gods, 12th
century CE, Japan. (Singh)

Buddha born from his Mother Maya's "side undefiled," 3rd century CE. (*Larousse*)

Buddha taming a drunken elephant, who recites the Five Precepts. (*Larousse*)

The Ascension of Prophet Elijah
16th century CE. (Singh)

Buddha with cross-
shaped flowers in palms
(Lundy)

Buddha under cruciform
Tree of Life
(Lundy)

Irish "Budha" or "Krishna" crucifix
(O'Brien)

Irish "Round Tower" with crucified "Budha"
surrounded by two disciples, with two strange
animals beneath. (O'Brien)

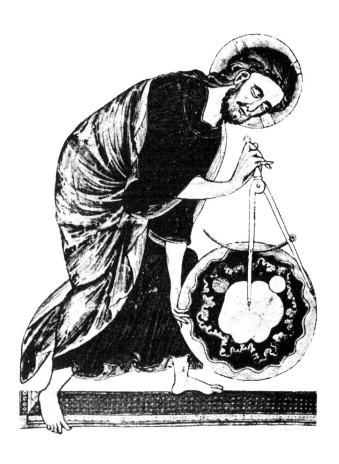

God as the Grand Architect of the Universe,
using a carpenter's compass
13th century, France.
(*Mysteries of the Past*)

The "Historical" Jesus?

I have examined all the known superstitions of the world, and I
do not find in our particular superstition of Christianity one
redeeming feature. They are all alike founded on fables and
mythology. Millions of innocent men, women and children, since
the introduction of Christianity, have been burnt, tortured, fined
and imprisoned. What has been the effect of this coercion? To
make one half the world fools and the other half hypocrites; to
support roguery and error all over the earth.

Thomas Jefferson

The gospel story is an artificial, non-historical work. It has been
fabricated from source materials that can be identified and
traced to their incorporation into the gospels. There is not a
particle of hard evidence that "Jesus of Nazareth" ever existed.

Harold Leidner, *The Fabrication of The Christ Myth*

For a long period of prehistory and history, the religious mind
of the world has been focused on the "sun of righteousness," both
the visible solar orb and the cosmic, divine power behind it. In
this regard, there have been numerous correspondences between
the various personifications of the sun—the God sun, sun god
or solar hero—in a variety of ethnicities and countries globally.
These correspondences point to a basic mythos that eventually
reveals itself in the gospel story of Jesus Christ. Hence, as it can
be asserted of these personifications of the sun that they are
mythical personages, so too can it be declared of Christ.

The debate over whether or not Jesus Christ existed as a
"real person" is not new, despite claims to the contrary. This
controversy has existed from the very beginning of the Christian
era, as is only natural: While the masses may be considered
gullible and credulous, there have always been those who have
wished to see proof before buying the shoddy goods of any priestly
huckster who has come along—and there have been many such
pitchmen over the millennia, peddling their "spiritual" wares.
Early Christian apologetic texts themselves demonstrate this fact
of the less gullible questioning Christian claims. One of these
texts, dating from the fourth or fifth century, is styled "The
Revelation of St. Paul," a disturbing, fictitious account of "Paul's"
journey to Heaven and Hell. This polemic depicts the apostle as
entering a fiery pit "reserved as a place of punishment for those
who denied that Christ had come, and that He had been born of
the Virgin Mary, and who declared that the Bread and Wine of the
Offering were not the Body and Blood of God." This pit is also
reserved for those who had "broken their baptismal vows."
Another area of ice and snow, with men and women "gnashing
their teeth," was reserved for those "who denied the Resurrection

of Christ..."[1] Thus, according to an early Christian text, hell's very fiery pit was specially saved for those who "denied that Christ had come," i.e., did not believe the gospel story with its "historical" Jesus, proving that from the beginning there were many who did so deny Christian contentions.

So fervent was the outcry against the Christian fable being "history" that a term was coined for the *unbelievers within Christianity itself*: "Docetists," or those who believed in a spiritual, disincarnate Christ who could never become a "real person." The true sentiment of the term has been glossed over by the interpretation that "Docetism" refers to a "phantom" Christ, but the inference is clear: Jesus Christ, as the Son of God and the Word, never existed as a human being. As Marshall Gauvin says in "Did Jesus Christ Really Live?":

> A large body of opinion in the early Church denied the reality of Christ's physical existence. In his "History of Christianity," Dean Milman writes: "The Gnostic sects denied that Christ was born at all, or that he died," and Mosheim, Germany's great ecclesiastical historian, says: "The Christ of early Christianity was not a human being, but an 'appearance,' an illusion, a character in miracle, not in reality—a myth."[2]

In Witnesses to the Historicity of Jesus, Arthur Drews observes:

> The Gnostics of the second century really questioned the historical existence of Jesus by their docetic conception; in other words, they believed only in a metaphysical and ideal, not an historical and real, Christ. The whole polemic of the Christians against the Gnostics was based essentially on the fact that the Gnostics denied the historicity of Jesus, or at least put it in a subordinate position.[3]

The early Christian Gnostics were essentially Docetists who "took some pains by the introduction of different terminology to make it more clear that their divine entities were not persons."[4]

The fact that Docetism is as old as the Christian myth itself can be determined by its condemnation in the epistles of John (1 Jn. 4:2-3; 2 Jn. 7), as well as by the following comment from St. Jerome's "The Dialogue Against the Luciferians" (23):

> When the blood of Christ was but lately shed and the apostles were still in Judaea, the Lord's body was asserted to be a phantom...[5]

Indeed, that early opponents of historicizing Christianity questioned the factuality of the gospel fable is clear from the writings of the Church fathers, including Lactantius (c. 240-320), in a chapter in his *Divine Institutes* (IV, 22) entitled,

"ARGUMENTS OF UNBELIEVERS AGAINST THE INCARNATION OF JESUS":

> ...They say that it was impossible for anything to be withdrawn from an immortal nature. They say, in short, that it was unworthy of God to be willing to become man, and to burthen Himself with the infinity of flesh; to become subject of His own accord to sufferings, to pain, and death: as though it had not been easy for Him to show Himself to men without the weakness incident to a body...[6]

These deniers of the Word made flesh were called "antichrist," as in the epistles of John, as well as "false teachers." As Bunsen, a Christian, remarks:

> ...the great mystery of "God manifested in the flesh" was by false teachers in those days denied, because Christ, the Word of God, was declared not to have come in flesh and blood, that is, because the presence of the Word or Spirit of God in man was denied...[7]

Bunsen further says:

> Most Gnostics of the Apostolic and after-apostolic age agreed in denying that Christ, whom they regarded as the Angel-Messiah, came in the flesh.[8]

Hence, this debate as to Christ's physical existence is not "modern," referring to the past couple of centuries, although it is during these centuries that much work has been done by mythicists, i.e., those who have determined Christ to be a myth. Prior to these past few centuries, the Catholic Church reigned supreme and widely suppressed its critics, torturing and murdering them, and stealing their possessions. The Church also forbid all but priests to read the Bible, and for centuries even the clergy itself was functionally illiterate. The investigation of Christian mythology thus needed to be pursued surreptitiously, and glimpses of it appear here and there, also represented in Christian iconography, revealing that the artists either knew, or were instructed by authorities who themselves knew, that Christ was the "Sun of God." Much of this surreptitious exposition was done in Latin, which remained the scholarly lingua franca for several centuries, until around the 18th century, when French writers such as Dupuis and Volney added to the dissension. These notables were followed in the 19th century by the English, Dutch and Germans weighing in heavily in Bible criticism. Among the dissenting voices were those of prominent scholars and the ruling elite. As the German critic Drews relates:

> Even Frederick the Great does not seem to have been entirely convinced of the historicity of Jesus. He speaks of "the comedy" of the life and death and ascension of Christ, and says: "If the

Church can err in regard to facts, I see reason to doubt if there is a Scripture and a Jesus Christ."[9]

These individuals were skeptical with good reason, as the history of the priesthood—including and especially that of Christianity—has been rife with chicanery and fraud. The enormous amount of pious fraud committed in the name of Christ need not be repeated here but can be found to a large extent in Joseph Wheless's *Forgery in Christianity*. A few comments should suffice to establish the atmosphere of the Church in the early centuries and onward:

> Mosheim tells us that among the early Christians, "it was an almost universally adopted maxim, that it was an act of virtue to deceive and lie, when by so doing they could promote the interest of the Church."[10]

In *Supernatural Religion*, a very thorough and scholarly examination and exegesis of the Christian writings of the first centuries of the common era, Cassels states:

> No period in the history of the world ever produced so many spurious works as the first two or three centuries of our era. The name of every Apostle, or Christian teacher, not excepting that of the great Master himself, was freely attached to every description of religious forgery. False gospels, epistles, acts, martyrologies, were unscrupulously circulated...[11]

The writings of the Church fathers themselves are "in great part forged, either anciently or in latter times." These writings are "full of frauds, both pious and malicious" against Paganism and are "absolutely not to be believed." In order to achieve its goal, the priesthood forged countless entire books, in the name of practically every character involved in Christianity. Words like "pervert," "misquote," "defame," "deface" and "destroy" are frequently used in the discussion regarding what the clergy did to their adversaries' work, as well as to the works of their own writers. This "pious fraud" and other nonsense is so extensive that it is difficult to figure out the Church history. Moreover, one of the most famed and respected Christian doctors was St. Augustine, who "stakes his eternal salvation" on his assertion that he preached the gospel to "a whole nation of men and women, *who had no heads*, but had their eyes in their bosoms," etc. Christian authority Justin Martyr believed in a literal Phoenix, and Tertullian reported that when Christians "cast out devils," the devils declared themselves to be Pagan gods.

In addition, for centuries Christians have proudly held up a notorious murderer as the great convert who somehow proved the veracity of Christianity! Concerning the Emperor Constantine, CMU observes:

As a cool family murderer, Nero and Caligula may hide their diminished heads in his presence. [Constantine] drowned his wife in boiling water; put to death his son Crispus; murdered the two husbands of his sisters, Constantia and Anastasia; murdered his own father-in-law, Maximian Hercules; murdered his nephew, his sister Constantia's son, only twelve years of age; with some others, not so nearly related, amongst whom was Sapator, a pagan priest, who refused absolution for the crimes of the royal assassin.[12]

With the participation of Constantine and his mother, Helena, the new cult really took off as its proselytizers began the profitable relic business. Like their Pagan predecessors, the Christian priests trafficked in countless bogus relics, including a shipload of wood from the one "true cross"; the Virgin Mary's "girdle," of which there were 11; and the remains of a number of asses said to be that which Jesus rode into Jerusalem.[13] The embarrassing list of "sacred relics"—which have been used to "prove" the historicity of the gospel fable—includes Jesus's bones and clothes, "utensils used by him, the cross, nails, bottles of his blood and also of Mary's nursing milk, etc."[14] In addition to these ridiculous items have been some two dozen shrouds, of which the Turin Shroud is but one.

As can be seen, the Christian Church has been created out of rampant fraud and forgery, based on the human craving for the supernatural and magical, and the subsequent exploitation of the gullible and naïve. Where such beguilement did not work, force was used, and death and destruction became the rule of the day. In this atmosphere of fraud, forgery, fear and force, we are told that there are a "loving" God and his Son *omnipotently in charge of everything*, which means that they and they alone are responsible for life on Earth. Except for all the atrocities—those are the work of the Devil, who, for some reason, frequently gets the better of the all-powerful, all-knowing and everpresent Father, Son and Holy Ghost. It is with very good reason that thousands of people over the nearly two millennia, from the beginning of the Christian era, have questioned the existence of the omnipotent Trinity.

Extrabiblical Evidence?

Over the past couple of centuries, each time an effort has been made to rectify the pious fraud of the historical Jesus, the same lame references to so-called extrabiblical evidence have been trotted out, to be refuted once more. Such was the case when Arthur Drews wrote *The Christ Myth* in 1910, and it continues to this day, with the same, tired, worn-out "references." Drews, in fact, responded to these discredited references with an

entire book, ironically entitled *Witnesses to the Historicity of Jesus*, of which—he and many others have repeatedly shown—*there were none.* Drews thoroughly refuted these so-called references, but his meticulous debunking did little good in penetrating the thickly conditioned noggins of the vested believers. Shamelessly, as if they just discovered these "references" themselves, believers today respond with the same nonsensical and discredited material.

Concerning these infamous references, which appear in the writings of the ancient Roman and Jewish authors Pliny, Josephus, Tacitus and Suetonius, Kuhn remarks:

> The total quantity of this material is given by Harry Elmer Barnes in *The Twilight of Christianity* as some twenty-four lines. It may total a little more, perhaps twice that amount. This meager testimony constitutes the body or mass of the evidence of "one of the best attested events in history." Even if it could be accepted as indisputably authentic and reliable, it would be faltering support for an event that has dominated the thought of half the world for eighteen centuries.[15]

Is it not a bit disturbing that such a hugely influential life is so sketchily drawn? And the embarrassing situation continues, despite the brilliant efforts of some of the world's best minds to remedy it. By Drews's time, for instance, the Josephus passage had been utterly discredited through astute and detailed scholarship over centuries by the educated elite, who were for the most part believers. Yet, a century later the less learned dredge it up again, in a simplistic and unsatisfying attempt to fend off the inevitable, i.e., the exposition of Christ as a character as mythical as the gods of other cultures.

Contrary to the meager morsels bandied about by apologists, there is so much material concerning this school of higher criticism that one could write at least one entire volume. Yet, such an effort would be unnecessary, because it has already been done extensively, as is evidenced by the fact that there *is* so much material.

In any case, to satisfy those who may be stuck on these "references" purporting to reveal an "historical" Jesus, further dissection shall be provided here. Interested parties should also study the sources cited herein, as well as in *The Christ Conspiracy* and on the website at www.truthbeknown.com/christcon.htm.

The Silence of Historians

If we were to look for evidence of Jesus's existence in the works of the historians of his era, who could possibly be eyewitnesses or had interviewed eyewitnesses, *we would find none.* This deficiency is not for want of historians of the period;

there were in fact plenty, and this era has been called one of the best documented in history. Nor is it possible to claim "obscurity" as an excuse for this silence, either for the area (Palestine) and its people, or for this purported wandering, miracle-making, rabblerousing rabbi who supposedly "shook up the world," according to the Christian legend and gospel story, gaining fame far and wide. (Mt. 4:23-24, 5:1, 8:1, 8:18, 9:31, 9:33, 13:2, 14:1, 14:13, 15:30, 19:2; Mk. 5:1, 10:1, etc.) It simply cannot be both ways: An "obscure" rabbi with little impact who escaped notice of dozens of historians is not going to be turned into an omnipotent son of God; and a man who was famed "far and wide" for purported world-shaking events could not be considered "obscure."

The following historians, rhetoricians, philosophers, poets and writers lived and wrote during or shortly after the time when Jesus allegedly existed, yet none of them makes any mention of the "famed" wonderworker. Nor do those who lived during this era, i.e., the first century, mention the Christian movement, which, according to the myth, sprang up after Christ's advent like mushrooms following a rainstorm.

Aulus Perseus (60 CE)
Columella (1st cent. CE)
Dio Chrysostom (c. 40-c. 112 CE)
Justus of Tiberius (c. 80 CE)
Livy (59 BCE-17 CE)
Lucanus (fl. 63 CE)
Lucius Florus (1st-2nd-cent. CE)
Petronius (d. 66 CE)
Phaedrus (c. 15 BCE-c. 50 CE)
Philo Judaeus (20 BCE-50 CE)
Phlegon (1st cent. CE)
Pliny the Elder (23?-69 CE)

Plutarch (c. 46-c. 119 CE)
Pomponius Mela (40 CE)
Rufus Curtius (1st cent. CE)
Quintilian (c. 35-c. 100 CE)
Quintus Curtius (1st cent. CE)
Seneca (4 BCE?-65 CE)
Silius Italicus (c. 25-101 CE)
Statius Caelicius (1st cent. CE)
Theon of Smyrna (c. 70-c.135 CE)
Valerius Flaccus (1st cent. CE)
Valerius Maximus (fl. c. 20 CE)

There are also a number of important philosophers, historians and science writers of the 2nd century as well, such as Appianus, Arrian, Favorinus, Aulus Gellius, Hermogenes, Justinus, Pausanias and Ptolemy, who likewise do not refer to Christ or Christians.

Although much of these authors' works has been either destroyed or mutilated by Christians, enough remains to compose a significant library. Also, from the Church fathers' writings it is obvious that most of these Pagan and Jewish writers' works were extant in their time and, importantly, were pored over by

Christian authorities in a vain hope of finding some mention of Christ and his movement. Considering how desperate was their plight, it is illogical to suggest that they would not have remarked even if the non-Christian writer's work contained information unfavorable to Christianity. Indeed, the Church fathers never shirked from addressing uncomplimentary commentaries concerning their religion and its alleged founder. In fact, they embraced these challenges and clearly enjoyed cranking out long polemics against their adversaries.

Philo Judaeus of Alexandria (20 BCE-50 CE)

One of the most important of the historians and philosophers who are silent on the subject of Christ and Christianity was Philo of Alexandria, a Jew born before the Christian era but who died long after Christ's purported death. Philo's works included a history of the Jews that discussed the very period when Christ was allegedly alive. Concerning Philo and the pretended biblical events, Remsburg remarks:

> He was living in or near Jerusalem when Christ's miraculous birth and the Herodian massacre occurred. He was there when Christ made his triumphal entry into Jerusalem. He was there when the crucifixion with its attendant earthquake, supernatural darkness, and resurrection of the dead took place—when Christ himself rose from the dead, and in the presence of many witnesses ascended into heaven. These marvelous events which must have filled the world with amazement, had they really occurred, were unknown to him. It was Philo who developed the doctrine of the Logos, or Word, and although this Word incarnate dwelt in that very land and in the presence of multitudes revealed himself and demonstrated his divine powers, Philo saw it not.

Philo was prominent and involved in life not only in Judea but also around the Mediterranean, "by no means a secluded scholar who took no interest in the fortunes of his people." Indeed, he was an Alexandrian Jewish activist who pleaded the case of Judaism at Rome and likely journeyed to Palestine at some point. "He even in one place makes an incidental reference to Pilate, who had caused an agitation among the Jews at Jerusalem by some offense against their religious ideas."[16] Moreover, Philo wrote about the Essenes and the Therapeuts, two significant monkish sects that preceded, and largely influenced, Christianity and/or became Christian.

All this, yet Philo makes no mention of Jesus or Christians. This silence is all the more perplexing when one considers that Philo was a prominent philosopher and theologian who wrote extensively about the Word/Logos, using the term some 1300

times in his writings, as well as developing other concepts that made their way into Christianity. As noted, Philo's Word was the "first-begotten Son," as well as the Sun and Wisdom, or Sophia, and his influence was so great on Christianity that Jerome called him one of the "Church fathers." One would think that if this solar Logos, i.e., Jesus, had suddenly appeared in Philo's homeland, during his life, when he was a sentient adult, Philo would have not only noticed but also jumped for joy, and written reams about the glorious event, seeing the promises and prophecies of Israel fulfilled. It could not be more obvious that nothing of the sort happened during Philo's lifetime.

In addition, as Leidner deftly details, in Philo's writings is an account of the Passion and Crucifixion of the "Suffering Servant" so close to the gospel rendering that one must have been copied from the other. Since Philo's work is devoid of Christ and Christianity, and since Christianity as we know it assuredly did not exist until the second century, it is certain that Christian writers liberally plagiarized Philo in their version(s) of Jesus's Passion. Moreover, as Ellegard remarks, it is peculiar that, if Jesus were a real, historical person, a simple Aramaic-speaking Jew from Galilee, he would "exhibit so many points of agreement" with Philo, a "learned hellenised Egyptian Jew."[17]

Another Jewish historian, Justus of Tiberius, wrote around 80 CE, including much about his homeland, Galilee; yet, he evidently never heard of the astounding wonderworker and messiah who had allegedly spent so much time in that very small region. Justus's absolute silence on the subject was a matter of astonishment to Photius, the Christian patriarch in Constantinople during the ninth century.

Regarding these historians and other writers of the first century, Inman concludes:

> We can find nowhere, in contemporary history—and there is an adequate account thereof, both Jewish and Roman—any records of the wonders said to have been done in Judea by the son of Mary.[18]

Again, a standard apology for this fact is that the "historical Jesus" was an "obscure preacher," so insignificant as to be ignored by the historians of his time. Such an argument represents a desperate attempt at maintaining what is untenable, since, in the first place, the gospel story itself contradicts such a notion, stating repeatedly that Jesus gathered "great crowds" and was "famed." Secondly, it is unbelievable that anyone with a "career" remotely resembling what is recorded in the gospel fable, with all the miracles and magic, would have been ignored or overlooked by dozens of historians of the day. Other, far lesser-

skilled miracleworkers were recorded by historians; yet, nary a mention of the most powerful man who ever lived! Thirdly, it is quite impossible that Roman nobles and politicians would have created a fanatical religion around this invisible, obscure Jewish preacher, particularly in consideration of the fact that the Roman hierarchy, like much of the "known world" at the time, was not at all fond of Judeans. Is it conceivable that the cynical politicos in Washington, for example, would fall on their knees to worship a magician only *rumored* to have lived in, say, Puerto Rico, several decades to a century or more ago, to the point where they changed their entire culture to do so? Such obsessive, devotional behavior, based on mere rumor, with no evidence of his existence? And none of these politicians previously having heard of him, no report from a small province under their own control? Not to mention that there was practically nothing original about this miracleworker, especially in Roman times, during which sons of God and wise sages were all the rage.

The silence of the historians is deafening in opposition to the idea of an "historical" Jesus. Because of this deafening silence, Christian apologists have repeatedly been forced to resort to the "references" in the works of the following non-Christian writers who were not even contemporaries of Jesus but lived decades later and thus would not be eyewitnesses. Instead, like the followers of our hypothetical magician, they would merely be repeating rumors from a generation earlier.

Flavius Josephus, Jewish General and Historian (c. 37-c.100 CE)

The most salient of these non-eyewitnesses was the Jewish Pharisee, General and famed historian Josephus, in whose *Antiquities of the Jews* appears the notorious passage regarding Christ called the "Testimonium Flavianum" ("TF"). The Testimonium Flavianum has been demonstrated repeatedly over the centuries to be a forgery, likely interpolated by Church historian Eusebius in the fourth century. So thorough and universal has been this debunking that very few scholars of any repute continued to cite it after the turn of the last century. Indeed, it was rarely mentioned, except to note that it was a forgery. In reality, numerous books by a variety of authorities over a period of a couple centuries basically took it for granted that the Testimonium Flavianum *in its entirety* was spurious, an interpolation and a forgery. As Dr. Gordon Stein relates:

> ...the vast majority of scholars since the early 1800s have said that this quotation is not by Josephus, but rather is a later Christian insertion in his works. In other words, it is a forgery, rejected by scholars.[19]

So well known was this fact of forgery that these numerous authorities did not spend their precious time and space rehashing the arguments against the TF's authenticity. Even such an apologist as Maurice Goguel in 1926 declared, "The testimony of Josephus is an established forgery."[20] Nevertheless, in the past few decades apologists of questionable integrity and credibility have glommed onto the TF because it represents the only "concrete" secular reference to a man who purportedly astounded the world. The debate is currently confined to those who think the TF was original to Josephus but was Christianized, and those who credulously and self-servingly accept it as "genuine" in its entirety. The TF goes as follows:

> Now, there was about this time, Jesus, a wise man, if it be lawful to call him a man, for he was a doer of wonderful works,—a teacher of such men as receive the truth with pleasure. He drew over to him both many of the Jews, and many of the Gentiles. He was [the] Christ; and when Pilate, at the suggestion of the principal men amongst us, had condemned him to the cross, those that loved him at the first did not forsake him, for he appeared to them alive again the third day, as the divine prophets had foretold these and ten thousand other wonderful things concerning him; and the tribe of Christians, so named from him, are not extinct at this day.[21]

To repeat, this passage was so thoroughly dissected by scholars of high repute and standing—the majority of them pious Christians—that it was for some decades understood by subsequent scholars as having been proved *in toto* a forgery, such that these succeeding scholars did not even bring it up, unless to acknowledge it to be spurious. The older scholars who so conclusively proved the TF a forgery made their mark beginning in the 18th century and continuing into the 20th, when a sudden reversal was implemented, with popular opinion hemming and hawing its way back first to the "partial interpolation theory" and now, among third-rate apologists, to the notion that the whole TF is "genuine." As Earl Doherty says, in "Josephus Unbound":

> Now, it is a curious fact that older generations of scholars had no trouble dismissing this entire passage as a Christian construction. Charles Guignebert, for example, in his *Jesus* (1956, p.17), calls it "a pure Christian forgery." Before him, Lardner, Harnack and Schurer, along with others, declared it entirely spurious. Today, most serious scholars have decided the passage is a mix: original parts rubbing shoulders with later Christian additions.[22]

The earlier scholarship that proved the entire TF to be fraudulent was determined by intense scrutiny by some of the most erudite writers of the time, in a number of countries, their

works composed in a variety of languages, but particularly German, French and English. The general conclusions, as elucidated by Christian authority Dr. Nathaniel Lardner (1684-1768), and related here by the author of *Christian Mythology Unveiled* (c. 1842), include the following reasons for doubting the authenticity of the TF as a whole:

> Mattathias, the father of Josephus, must have been a witness to the miracles which are said to have been performed by Jesus, and Josephus was born within two years after the crucifixion, yet in all the works he says nothing whatever about the life or death of Jesus Christ; as for the interpolated passage it is now universally acknowledged to be a forgery. The arguments of the "Christian Ajax," even Lardner himself, against it are these: "It was never quoted by any of our Christian ancestors *before Eusebius*. It disturbs the narrative. The language is quite Christian. It is not quoted by Chrysostom, though he often refers to Josephus, and could not have omitted quoting it *had it been then in the text*. It is not quoted by Photius [9th century], though he has three articles concerning Josephus; and this author expressly states that this historian has not taken the least notice of Christ. Neither Justin Martyr, in his dialogue with Trypho the Jew; nor Clemens Alexandrinus, who made so many extracts from ancient authors; nor Origen against Celsus, have ever mentioned this testimony. But, on the contrary, in chap. 25th of the first book of that work, Origen openly affirms that Josephus, who had mentioned John the Baptist, *did not acknowledge Christ*. That this passage is a false fabrication is admitted by Ittigius, Blondel, Le Clerc, Vandale, Bishop Warburton, and Tanaquil Faber."[23]

The remarks by Church father Origen (185-232) appear in his *Contra Celsus*, (I, XLVII):

> For in the 18th book of his Antiquities of the Jews, Josephus bears witness to John as having been a Baptist, and as promising purification to those who underwent the rite. Now this writer, *although not believing in Jesus as the Christ*, in seeking after the cause of the fall of Jerusalem and the destruction of the temple, whereas he ought to have said that the conspiracy against Jesus was the cause of these calamities befalling the people, since they put to death Christ, who was a prophet, says nevertheless—being, although against his will, not far from the truth—that these disasters happened to the Jews as a punishment for the death of James the Just, who was a brother of Jesus (called Christ)—the Jews having put him to death, although he was a man most distinguished for his justice...[24]

In his *Commentary on the Gospel According to Matthew*, (X, 17), Origen says:

And to so great a reputation among the people for righteousness did this James rise, that Flavius Josephus, who wrote the "Antiquities of the Jews" in twenty books, when wishing to exhibit the cause why the people suffered so great misfortunes that even the temple was razed to the ground, said, that these things happened to them in accordance with the wrath of God in consequence of the things which they had dared to do against James the brother of Jesus who is called Christ. And the wonderful thing is, that, though *he did not accept Jesus as Christ*, he yet gave testimony that the righteousness of James was so great; and he says that the people thought that they had suffered these things because of James...[25]

Here, in Origen's words, is the assertion that Josephus, who mentions more than a dozen Jesuses, did not consider any of them to be "the Christ." This fact proves that the same phrase in the TF is bogus. Nor does Origen even intimate the presence of the rest of the TF. Concerning Origen and the TF, Drews relates:

In the edition of Origen published by the Benedictines it is said that there was no mention of Jesus at all in Josephus before the time of Eusebius [c. 300 CE]. Moreover, in the sixteenth century Vossius had a manuscript of the text of Josephus in which there was not a word about Jesus. It seems, therefore, that the passage must have been an interpolation, whether it was subsequently modified or not.[26]

According to CMU, this "Vossius" mentioned by a number of writers as having possessed a copy of Josephus's *Antiquities* without the TF is "I. Vossius," whose works appeared in Latin. Unfortunately, none of these writers includes a citation as to where exactly the assertion may be found in Vossius's works. Moreover, the Vossius in question seems to be *Gerardus*, rather than his son, Isaac, who was born in the seventeenth century. In *Lectures on the Science of Religion*, Max Müller discussed G.J. Vossius's *De Origine et Progressu Idolatriae*, which may well be the work in which this statement is made.

In any event, not only do several Church fathers from the second, third and early fourth centuries have no apparent knowledge of the TF, but even after Eusebius suddenly "found" it in the first half of the fourth century, several other fathers into the fifth "often cite Josephus, but not this passage."[27] In the 5th century, Jerome cited it once, with evident disinterest, as if he knew it was bogus. In addition to his reference to the TF, in his "Letter XXII to Eustochium," Jerome made the following audacious claim:

Josephus, himself a Jewish writer, asserts that at the Lord's crucifixion there broke from the temple voices of heavenly powers, saying: "Let us depart hence."[28]

Either Jerome (or some future pious forger) fabricated this alleged Josephus quote, or he possessed a unique copy, in which this assertion had earlier been interpolated. However it happened, this instance constitutes "pious fraud," one of many committed by Christian proponents, including the TF.

Other Christian authorities who studied and/or mentioned Josephus but wrote not one word about the TF include the following:

- Justin Martyr (c. 100-c. 165), who pored over Josephus's works but made no mention of the TF.
- Theophilus, Bishop of Antioch, d. 180.
- Irenaeus, saint and compiler of the New Testament, c. 120/140-c. 200/203.
- Clement of Alexandria (c. 150-211/215), influential Greek theologian and prolific Christian writer, head of the Alexandrian school.
- Hippolytus, saint and martyr, c. 170-c. 235.
- The author of the ancient Syriac text, "History of Armenia," referred to Josephus but not the TF.
- Minucius Felix, lawyer and Christian convert, d. c. 250.
- Anatolius, 230-c. 270/280.
- Chrysostom, saint and Syrian prelate, c. 347-407.
- Methodius, saint of the 9th century—even at this late date there were apparently copies of Josephus without the TF, as Methodius did not mention it.
- Photius, Patriarch of Constantinople, c. 820-891, not a word about the TF, again indicating copies of Josephus devoid of the TF, or, perhaps, a rejection of it because it was understood to be fraudulent.

The Catholic Encyclopedia ("Flavius Josephus"), which tries to hedge its bet about the Josephus passage, is nevertheless forced to admit, "The passage seems to suffer from repeated interpolations." In the same entry, CE also confirms that Josephus's writings were used extensively by the early Christian fathers, such as Jerome, Ambrose and Chrysostom; yet, except for Jerome, the fathers never mentioned the TF.

In "Who on Earth was Jesus Christ?" David Taylor details the reasons why the TF *in toto* must be deemed a forgery, most of which arguments were put forth by Dr. Lardner:

1. It was not quoted or referred to by any Christian apologists prior to Eusebius, c. 316 AD.

2. Nowhere else in his voluminous works does Josephus use the word "Christ," except in the passage which refers to James "the brother of Jesus who was called Christ" (Antiquities of the Jews, Book 20, Chapter 9, Paragraph 1), which is also considered to be a forgery.

3. Since Josephus was not a Christian but an orthodox Jew, it is impossible that he should have believed or written that Jesus was the Christ or used the words "if it be lawful to call him a man," which imply the Christian belief in Jesus' divinity.

4. The extraordinary character of the things related in the passage—of a man who is apparently more than a man, and who rose from the grave after being dead for three days—demanded a more extensive treatment by Josephus, which would undoubtedly have been forthcoming if he had been its author.

5. The passage interrupts the narrative, which would flow more naturally if the passage were left out entirely.

6. It is not quoted by Chrysostom (c. 354-407 ad) even though he often refers to Josephus in his voluminous writings.

7. It is not quoted by Photius, Patriarch of Constantinople (c. 858-886 ad) even though he wrote three articles concerning Josephus, which strongly implies that his copy of Josephus' Antiquities did not contain the passage.

8. Neither Justin Martyr (110-165 ad), nor Clement of Alexandria (153-217 ad), nor Origen (c.185-254 ad), who all made extensive reference to ancient authors in their defence of Christianity, has mentioned this supposed testimony of Josephus.

9. Origen, in his treatise Against Celsus, Book 1, Chapter 47, states categorically that Josephus did NOT believe that Jesus was the Christ.

10. This is the only reference to the Christians in the works of Josephus. If it were genuine, we would have expected him to have given us a fuller account of them somewhere.

When the original Greek text is analyzed, it becomes obvious that the TF interrupts the flow of the primary material and that the style of the language is different from that of Josephus. There is other evidence that the TF never appeared in the original Josephus, including "an ancient table of contents in the *Antiquities*" without the TF.[29]

In some 20 books, Josephus goes into long detail about the lives of numerous personages of relatively little import, including "petty robbers and obscure seditious leaders." Almost 40 chapters "are devoted to the life of a single king." [30] It is unimaginable that the Jewish historian would only dedicate a dozen sentences to someone remotely resembling the character found in the New Testament. If the gospel tale constituted "history," Josephus's elders would certainly be aware of Jesus's purported assault on

the temple, and the historian, who was very interested in instances of messianic agitation, would surely have reported it, in detail. Yet, he does not, and the brevity of the TF "disproves its authenticity."

Lest it be suggested that Josephus somehow could have been ignorant of the events in question, the Catholic Encyclopedia observes:

> ...Josephus like the rest of the priestly nobility joined them, and was chosen by the Sanhedrin at Jerusalem to be commander-in-chief in Galilee. As such he established in every city throughout the country a council of judges, the members of which were recruited from those who shared his political views.[31]

Josephus was a well-educated Jew who lived in the precise area where the gospel tale was said to have taken place, as did his parents, they at the very time of Christ's alleged advent. It was Josephus's passion to study the Jewish people and their history; nevertheless, in his voluminous works he discusses neither Christ nor Christianity. Nor does it make any sense that he would not report on the Christian movement itself, were Christians extant at the time in any significant numbers.

Based on these and other arguments, it is clear that the entire TF is a forgery, a conclusion arrived at by numerous writers over the past couple of centuries. In *The Christ: a critical review and analysis of the evidences of His existence*, John E. Remsburg (1846-1919) relates the opinions of these important critics of the TF, the majority of whom were Christians, including Dr. Lardner, who said, among other things:

> A testimony so favorable to Jesus in the works of Josephus, who lived so soon after our Savior, who was so well acquainted with the transactions of his own country, who had received so many favors from Vespasian and Titus, would not be overlooked or neglected by any Christian apologist...[32]

Then there was Bishop Warburton, who called the TF a "rank forgery, and a very stupid one, too." Remsburg further recounted the words of the "Rev. Dr. Giles, of the Established Church of England," who stated:

> Those who are best acquainted with the character of Josephus, and the style of his writings, have no hesitation in condemning this passage as a forgery, interpolated in the text during the third century by some pious Christian, who was scandalized that so famous a writer as Josephus should have taken no notice of the gospels, or of Christ, their subject....

The Rev. Baring-Gould remarked that the TF was first quoted by Eusebius and that it was "unknown to Justin Martyr... Clement of Alexandria...Tertullian...and Origen...." Another

Christian authority who denounced the TF as either interpolated or "wholly spurious" was Cannon Farrar, who also said, "That Josephus wrote the whole passage as it now stands no sane critic can believe."

And so on, with similar opinions by Christian writers such as Theodor Keim, Rev. Dr. Hooykaas and Dr. Alexander Campbell. By the time of Dr. Chalmers and others, the TF had been so discredited that many authors understood it as a forgery *in toto* and did not even consider it for a moment as "evidence." In fact, some commented on how disturbing it was that *Josephus did not mention Jesus.*

For a more modern criticism, in *The Jesus Puzzle* and his online article "Josephus Unbound," Earl Doherty leaves no stone unturned in demolishing the TF, permitting no squirming room for future apologists, whose resort to the TF will show, as it has done in the past, how desperate is their plight in establishing an "historical Jesus."

After discussing the TF, in *The Jesus Mysteries* Freke and Gandy remark:

> Unable to provide any historical evidence for Jesus, later Christians forged the proof that they so badly needed to shore up their Literalist interpretation of the gospels. This, as we would see repeatedly, was a common practice.[33]

In *The Fabrication of the Christ Myth*, Harold Leidner does an excellent and comprehensive job reviewing the supposed evidence provided by the Testimonium Flavianum. Included in Leidner's novel approach is the listing of the 20+ Jesuses mentioned by Josephus, showing how atypical is the Jewish historian's treatment of "Jesus Christ" and discussing his utter lack of interest in the supposed constant clamor of the time that *this* Jesus's unfair murder had led to the destruction of the Jewish Temple and, ultimately, Judea, etc. Importantly, Leidner also points out that Josephus was a military man, a fighter and a fierce debater—it is unthinkable that he would pen his purported report in the TF without commentary, that he would not make some sharp remark about Christian beliefs and the conceit of their alleged founder, especially if said founder's crucifixion had been the cause of the destruction of the Temple! This absence of fierce defense is especially bizarre since Josephus was a priest—a Pharisee—and it was his own group being assailed for having murdered an innocent man—nay, put to death God Himself! In consideration of all these facts, it is inconceivable that Josephus knew anything whatsoever about any "Jesus of Nazareth" or his movement.

In addition to acknowledging the spuriousness of this passage, many authorities have agreed with the obvious: Bishop Eusebius was the forger. These writers have noted that not only does the passage first show up in Eusebius's writing but also it is in the Church historian's style, not that of Josephus. Eusebius's handiwork is blatantly evident in the use of the term "tribe" in the TF when describing Christians. The word in Greek is φυλον ("phylon"; "phylum" in Latin), and, although Josephus employs the term elsewhere 11 times, it is with a different meaning. "Tribe" is used in this manner by no Church father prior to Eusebius, who utilized it fairly often.

In *Antiqua Mater: A Study of Christian Origins*, Edwin Johnson remarked that the 4th century was "the great age of literary forgery, the extent of which has yet to be exposed." He further commented "not until the mass of inventions labelled 'Eusebius' shall be exposed, can the pretended references to Christians in Pagan writers of the first three centuries be recognized for the forgeries they are."[34] Eusebius's character has been frequently attacked over the centuries, and he has been called a "luminous liar" and "unreliable." Like so many others, Drews too assails Eusebius, stating that various of the Church historian's references "must be regarded with the greatest suspicion." The Swiss historian Jakob Burckhardt (1818-1897) declared that Eusebius was "the first thoroughly dishonest historian of antiquity."[35] Eusebius's apparent motives were to empower the Catholic Church, and he did not scruple to use "falsifications, suppressions, and fictions" to that end.

The Testimonium Flavianum has been used for almost 2,000 years as evidence of the existence of "God on Earth," yet "a ranker forgery was never penned." The dismissal of the passage in Josephus regarding Jesus is not based on "faith" or "belief" but on scientific investigation. Such investigation has been confirmed repeatedly by numerous scholars, Christian and non-Christian alike. However, even if the Josephus passage were authentic, it still would represent not an eyewitness account but rather a tradition passed along for several decades, long after the purported events. Concerning the TF, Dr. Lardner concluded, "It ought, therefore...to be discarded from any place among the evidences of Christianity."[36] Thus, we can at last dispense with the pretentious charade of wondering whether or not the infamous passage in the writings of Josephus called the Testimonium Flavianum is bogus and who fabricated it: It is a forgery *in its entirety*, likely composed by Church historian Eusebius during the fourth century.

The Slavonic Josephus

Another clue as to the forged nature of the Testimonium Flavianum is its presence in a Slavonic (old Russian) copy of Josephus's *History of the Jewish War*, which dates from the 10th or 11th century. This passage is different from the standard TF, and the fact that it appears in the *Jewish War*, rather than in the *Antiquities*, means that one or the other is certainly forged. Evidently whoever forged the Slavonic passage did so on an approximation from the Eusebian original and, not knowing where it was originally interpolated, stuck it in *Jewish War*.

Regarding the Slavonic Josephus, which survives in Russian and Rumanian manuscripts, one writer, Peter Kirby, states that its authenticity has been "near universally abandoned" and that it is "clearly unauthentic." He then says:

> This passage is a wildly garbled condensation of various Gospel events, seasoned with the sort of bizarre legendary expansions found in apocryphal gospels and acts of the 2d and 3d centuries. Despite the spirited and ingenious attempts of Robert Eisler to defend the authenticity of much of the Jesus material in the Slavonic Jewish War, almost all critics today discount this theory....[37]

Kirby next relates the scholarly debate concerning J. Spencer Kennard, who tried to authenticate some of the Slavonic Josephus but whose work was debunked by Solomon Zeitlin in "The Hoax of the 'Slavonic Josephus.'" Zeitlin's conclusion was that all "the Jesus passages are interpolations based on Christian literature." By Kennard's own admission, parts of the Slavonic text were founded upon the works of the Church fathers and the forged "Acts of Pilate." Zeitlin further revealed the falsity of this text in an article entitled "The Slavonic Josephus and the Dead Sea Scrolls: An Expose of Recent Fairy Tales," in which he demonstrated that it was forged in the 11th century.[38] In addition to this passage, the Slavonic Josephus in general is "known to have plentiful Christian interpolations..."[39] Among these interpolations are not only the bogus Jesus passage, but also tales about John the Baptist and other of Jesus's pals.[40] Hence, the only evidence the Slavonic Josephus serves to prove is our point about forgery.

The Arabic Recension

According to an Arabic manuscript of Josephus dating to the 10th century, in addition to the familiar Testimonium Flavianum was another version, altered to appeal to Muslims. This passage is mentioned by Agapius, a Christian Arab and the bishop of Hierapolis, in his *Book of the Title*, which purports to be a history

of the world until the 10th century.[41] This text was discovered and translated by Solomon Pines:

> ...Josephus, the Hebrew...says in the treatises that he has written on the governance (?) of the Jews: "At this time there was a wise man who was called Jesus. His conduct was good, and he was known to be virtuous. And many people from among the Jews and the other nations became his disciples. Pilate condemned him to be crucified and to die. But those who had become his disciples did not abandon his discipleship. They reported that he had appeared to them three days after his crucifixion, and that he was alive; accordingly he was perhaps the Messiah, concerning whom the prophets have recounted wonders."[42]

In reading this passage, what is "immediately obvious" in comparing the Arabic to the original Greek is that "the blatantly Christian passages are conspicuously absent in the Arabic version."[43] This fact leads to the conclusion that the Arabic recension is a late, forged passage based on Muslim beliefs. The Arabic recension, then, does not serve as "evidence" but merely adds to the atmosphere of fraud surrounding the TF and Josephus's works.

The James Passage

As is evident, no confidence can be placed in the TF; it is, in fact, an obvious forgery. Critical writers also assail the "James passage" found in Josephus's *Antiquities* (XX, iv, 1):

> ...when, therefore, Ananus was of this disposition, he thought he had now a proper opportunity. Festus was dead, and Albinus was but upon the road; so he assembled the Sanhedrim of judges and brought before them the brother of Jesus, who was called Christ, whose name was James, and some others; and when he had formed an accusation against them as breakers of the law, he delivered them to be stoned.

Several critics over the centuries have declared that the whole phrase "the brother of Jesus, who was called Christ" is an interpolation, particularly since it awkwardly breaks the narrative, but also because, since the TF is a forgery, this phrase would have no meaning to the reader. Other scholars have allowed the phrase "brother of Jesus" to be genuine, with the rest spurious. Because in the same section Josephus discusses Jesus, the High Priest replacing Annas, it is possible that the phrase "brother of Jesus" is genuine and refers to *that* Jesus.[44] The rest is a clumsy interpolation, an assertion made by several Christian writers cited by Remsburg as well. Remsburg supposes that the phrase "who was called Christ" was "originally probably a marginal note" by a Christian reader.

Doherty's reasons for suspecting as spurious the "identifying phrase"—*tou legomenou Christou* in the Greek—include that it closely resembles the Greek in which Matthew (1:16) describes Christ: *ho legomenos Christos*. This fact, of course, would mean that a *Christian* knowledgeable of Matthew wrote it, rather than a *Jewish* historian, i.e., Josephus, who had never seen that gospel.

The James passage is held up as evidence that the "James the Just" of Christian mythology is an historical personage. However, Remsburg remarks: "To identify the James of Josephus with James the Just, the brother of Jesus, is to reject the accepted history of the primitive Church which declares that James the Just died in 69 A.D., seven years after the James of Josephus was condemned to death by the Sanhedrim."[45]

Without this tag line of "the brother of Jesus, who was called Christ" the "James" or Jacob in Josephus cannot be definitively equated with the Christian James the Just. The original phrase is *Iakobos onoma autou*, which merely means "Jacob [is] his name." In any case, the James passage certainly does not verify the gospel story in any way, shape or form. As Drews relates, "eminent theologians such as Credner, Schürer, etc." evinced this passage a forgery, also pointing out that even if it were genuine it does not prove an historical Jesus.[46]

Furthermore, the word for "brother" is *adelphos* in the Greek, a term common within mystery schools, such that a mysteries initiate would be called "brother of the Lord" or "brother in the Lord." This fact confirms that the designations "brother of the Lord" and "brother of Jesus" concerning the apostle James and others refer not to a blood relationship to an "historical" Jesus but to fellowship in a brotherhood, as even today members of the Church are called "brothers" and "sisters." Concerning the expression "brother of the Lord," applicable to James among others, as at Galatians 1:19, Gordon Rylands remarks that applying it to James "in a literal sense" is improbable, and that, since "the Lord" in the first century referred "only to a divine being" who did not have "brothers in the flesh," it is "far more likely that the 'Brothers of the Lord' were a small group of men of exceptional piety in one of the Christian—presumably Judaic—communities."[47]

The same type of brotherhood appears in 1 Corinthians 15, wherein Paul addresses "brethren," including mention of more than 500 of such "brothers" having seen the risen Christ, an obvious reference to an initiation ritual in a mystery school. This sense of brotherhood by initiation rather than blood is given also by Jerome, in his Commentary on Galatians 1:19, in which he says that "James was called the Brother of the Lord on account of

his great character..."[48] Moreover, Origen explains James's appellation of "Brother of the Lord" as "not so much on account of their blood relationship" but, rather, "because of his virtues and doctrines."[49]

Regarding the James passage and the Testimonium Flavianum, Jewish writer ben Yehoshua asserts that both are spurious and not found "in the original version of the *Jewish Antiquities*, which was preserved by the Jews." He concludes that it is "fraudulent to claim that these passages were written by Josephus and that they provide evidence for Jesus. They were written by Christian redactors and were based purely on Christian belief."[50] Yehoshua claims that the historian Gerald of Wales (12th cent.) related that a "Master Robert of the Priory of St. Frideswide at Oxford examined many Hebrew copies of Josephus and did not find the 'testimony about Christ,' except for two manuscripts where it appeared that the testimony had been present but scratched out." Yehoshua states that, since "scratching out" requires the removal of the top layers, the deleted areas likely did not provide any solid evidence that it was the TF that had been removed. Apologists will no doubt insist that these Hebrew texts are late copies and that Jewish authorities had the TF removed. This accusation of mutilating an author's work, of course, can easily be turned around on the Christians.

Concerning the use of Josephus as "evidence" of Jesus's existence, Doherty remarks that because there is no other "supporting evidence from the first century," the Jewish historian "becomes the slender thread by which such an assumption hangs." He further adds, "And the sound and fury and desperate manoeuverings which surround the dissection of those two little passages becomes a din of astonishing proportions..."

It is obvious that the works of Josephus cannot be used as evidence of Jesus's existence, as, again, even if these passages were genuine, they were written far too late to serve as serious proof. If there were any other such proof of the existence of Jesus of Nazareth, Josephus surely would have incorporated it into his brief TF; however, he is completely unaware of it—because it did not exist.

Pliny the Younger, Roman Official and Historian (62-113 CE)

Another of the pitiful "references" dutifully trotted out by apologists is a slim passage in the works of the Roman historian Pliny the Younger. While proconsul of Bithynia, a province in the northwest of Asia Minor, Pliny purportedly wrote a letter in 110 CE to Emperor Trajan requesting his assistance in determining the proper punishment for "Christiani" who were causing trouble and would not renounce "Christo" as their god, or bow down to

the image of the Emperor. These recalcitrant Christiani, according to the Pliny letter, met "together before daylight" and sang "hymns with responses to Christ as a god," binding themselves "by a solemn institution, not to any wrong act." Regarding this letter, Rev. Robert Taylor remarks:

> If this letter be genuine, these nocturnal meetings were what no prudent government *could* allow; they fully justify the charges of Caecilius in Minutius Felix, of Celsus in Origen, and of Lucian, that the primitive Christians were a skulking, light-shunning, secret, mystical, *freemasonry* sort of confederation, against the general welfare and peace of society.[51]

Taylor also comments that, at the time this letter was purportedly written, "Christians" were considered to be followers of the Greco-Egyptian good Serapis and that the name of Christ [was] common to the whole rabblement of gods, kings, and priests."[52] The conclusion regarding Serapis comes in part from the revealing statements made by the Emperor Hadrian around 134 CE:

> The worshippers of Serapis are Christians, and those are devoted to the God *Serapis*, who...call themselves the bishops of Christ. There is no ruler of a Jewish synagogue, no Samaritan, no Presbyter of the Christians, who is not either an astrologer, a soothsayer, or a minister to obscene pleasures. The very Patriarch himself, should he come into Egypt, would be required by some to worship *Serapis*, and by others to worship Christ. They have, however, but one God, and it is one and the self-same whom Christians, Jews and Gentiles alike adore, *i.e.*, money.[53]

It is thus possible that the "Christos" or "Anointed" god Pliny's "Christiani" were following was *Serapis* himself, the popular syncretic deity created by the priesthood in the third century BCE. Or, they could have been agitating for the expected Jewish Messiah, called "Christos" in the Old Testament Greek centuries before the Christian era. In any case, this god "Christos" was *not* a man who had been crucified in Judea.

Moreover, like his earlier incarnation Osiris, Serapis was called not only Christos but also "Chrestos,"[54] centuries before the common era. Indeed, Osiris was styled "Chrestus"[55] long before his Jewish copycat Jesus was ever conceived. Significantly, in relating that under Emperor Claudius (10 BCE-54 CE) certain "mathematicians" or astrologers were expelled from Italy, individuals who were apparently Egyptian and Egypto-Jewish kabbalists, Drews cites the same Hadrian passage as above, with a different translation. According to him, the original contained the word "Chrestus," not "Christos," and "Chrestiani" instead of "Christiani":

"Those who worship Serapis are the Chrestians, and those who call themselves priests of Chrestus are devoted to Serapis. There is not a high-priest of the Jews, a Samaritan, or a priest of Chrestus who is not a mathematician, soothsayer, or quack. Even the patriarch, when he goes to Egypt, is compelled by some to worship Serapis, by others to worship Chrestus. They are a turbulent, inflated, lawless body of men. They have only one God, who is worshipped by the Chrestians, the Jews, and all the peoples of Egypt."[56]

Drews further states, "Chrestus was not only the name of the god, but, as frequently happened in ancient religions, also of his chief priest."[57]

In his *Divine Institutes* (IV), Church father Lactantius (fl. 4th cent.) discusses the importance of distinguishing between the terms Christos and Chrestus:

...for Christ is not a proper name, but a title of power and dominion; for by this the Jews were accustomed to call their kings. But the meaning of this name must be set forth, on account of the error of the ignorant, who by the change of a letter are accustomed to call Him Chrestus.[58]

The word "Chrestus," meaning "good" or "useful," was a title frequently held by commoners, slaves, freedmen, bigwigs, priests and gods alike, prior to the Christian era. "Chrestos," according to Mead, was "a universal term of the Mysteries for the perfected 'saint.'" Followers of any deity called "Chrestus" would be not "Christians" but *"Chrestians."* Because the Church fathers such as Justin Martyr pun on this word χρηστος (chrestos), apologists have haphazardly substituted χριστος (christos) for it. As do other early Church fathers, Justin uses the term "Chrestiani," not "Christiani," to describe his fellow believers.

Johnson considers "Chrestus" a distinction made to separate the "good god" of the Gnostics from the evil god Yahweh.[59] "Chrestus" is thus traceable to Samaria, where Gnosticism as a movement took shape and where the term may have referred to Simon Magus, whom we have seen to have been a god, rather than a "real person." These Chrestiani would possibly be Syrian Gnostics, not followers of the "historical" Jesus of Nazareth. Confirming this assertion that the first "Christians" were actually followers of the "good god" Chrestus, the earliest dated Christian inscription, corresponding to October 1, 318 CE, calls Jesus *"Chrestos,"* not Christos: "The Lord and Savior, Jesus the Good."[60] This inscription was found above the entrance of a Syrian church of the Marcionites, who were anti-Jewish followers of the second-century Gnostic Marcion. The evidence points to "Jesus the Chrestos" as a *Pagan* god, not a Jewish messiah who lived during the first century CE.

In any case, the value of the Pliny letter as "evidence" of Christ's existence is worthless, as it makes no mention of "Jesus of Nazareth," nor does it refer to any event in his purported life. There is not even a clue in it that such a man existed. As Taylor remarks, "We have the name of Christ, and nothing else but the name, where the name of Apollo or Bacchus would have filled up the sense quite as well."[61] Taylor then casts doubt on the authenticity of the letter as a whole, recounting the work of German critics, who "have maintained that this celebrated letter is another instance to be added to the long list of Christian forgeries..." One of these German luminaries, Dr. Semler of Leipsic, provided "nine arguments against its authenticity..."[62] Taylor also notes that the Pliny epistle is quite similar to that allegedly written by "Tiberianus, Governor of Syria" to Trajan, which has been universally denounced as a forgery.

Like the TF, Pliny's letter is not quoted by any early Church father, including Justin Martyr. Tertullian briefly mentions its existence, noting that it refers to terrible persecutions of Christians. The actual text used today comes from a version by a Christian monk in the 15th century, Iucundus of Verona, whose composition may have been based on Tertullian's assertions. Concurring that the Pliny letter is suspicious, Drews terms "doubtful" Tertullian's "supposed reference to it" and names several authorities who likewise doubted its authenticity, "either as a whole or in material points," including Semler, Aubé, Havet, Hochart, Bruno Bauer and Edwin Johnson. [63] Citing the work of Hochart specifically, Drews pronounces Pliny's letter "in all probability" a "later Christian forgery."[64]

Tacitus, Roman Politician and Historian, (c. 56-120 CE)

Turning next to another stalwart in the anemic apologist arsenal, Tacitus, sufficient reason is uncovered to doubt this Roman author's value in proving an "historical" Jesus. In *The Annals*, supposedly written around 107 CE, Tacitus purportedly related that the Emperor Nero (37-68) blamed the burning of Rome during his reign on "those people who were abhorred for their crimes and commonly called Christians." Since the fire evidently broke out in the poor quarter where fanatic, agitating Messianic Jews allegedly jumped for joy, thinking the conflagration represented the eschatological development that would bring about the Messianic reign, it would not be unreasonable for authorities to blame the fire on them. However, it is clear that these Messianic Jews were not (yet) called "Christiani." In support of this contention, Nero's famed minister, Seneca (5?-65), whose writings evidently provided much fuel for

the incipient Christian ideology, has not a word about these "most-hated" sectarians.

In any event, the Tacitean passage next states that these fire-setting agitators were followers of "Christus," who, in the reign of Tiberius, "was put to death as a criminal by the procurator Pontius Pilate." The passage also recounts that the Christians, who supposedly constituted a "vast multitude at Rome," were then sought after and executed in ghastly manners, including by crucifixion. However, the date that a "vast multitude" of Christians were allegedly discovered and executed would be around 64 CE, and it is evident that there was no "vast multitude" of Christians at Rome by this time, as there were not even a multitude of them in Judea. Oddly, this brief mention of Christians is all that appears in the voluminous works of Tacitus regarding this extraordinary movement, which purportedly possessed such power as to be able to burn Rome. Also, the Neronian persecution of Christians is unrecorded by any other historian of the day and supposedly took place at the very time when Paul was purportedly freely preaching at Rome (Acts 28:30-31), facts that cast strong doubt on whether or not it actually happened. Drews concludes that the Neronian persecution is likely "nothing but the product of a Christian's imagination in the fifth century."[65] In discussing this persecution, Church historian Eusebius does not avail himself of the Tacitean passage, which he surely would have done had it existed at the time. Eusebius's discussion is very short, indicating he was lacking source material; the passage in Tacitus would have provided him a very valuable resource.

Even conservative writers such as James Still have problems with the authenticity of the Tacitus passage: For one, Tacitus was an imperial writer, and no imperial document would ever refer to Jesus as "Christ." Also, Pilate was not a "procurator" but a prefect, which Tacitus would have known. Nevertheless, not willing to throw out the entire passage, some researchers have concluded that Tacitus "was merely repeating a story told to him by contemporary Christians."

Like the TF, the Tacitean passage is not quoted by any of the Christian fathers, including Tertullian, who read and quoted Tacitus extensively.[66] Nor did Clement of Alexandria notice this passage in any of Tacitus's works, even though one of this Church father's main missions was to scour the works of Pagan writers in order to find validity for Christianity. Again, Eusebius, who likely forged the Testimonium Flavianum, does not relate this Tacitus passage in his abundant writings. Indeed, no mention is made of this passage in any known text prior to the 15th century.

The tone and style of the passage are unlike the writing of Tacitus, and the text "bears a character of exaggeration, and trenches on the laws of rational probability, which the writings of Tacitus are rarely found to do."[67] To reiterate, Tacitus's voluminous other writings contain not "the least allusion to Christ or Christians." In his well-known *Histories*, for example, Tacitus never refers to Christ, Christianity or Christians. Based on these and other facts, several scholars have argued that, even if the Annals itself is genuine, the passage regarding Jesus is spurious. Furthermore, the entire Annals has come under suspicion, as the book had never been mentioned by any ancient author.

The history of the Annals begins with the Italian calligrapher, Latin student and Papal secretary Gian Francesco Poggio Bracciolini (1380-1459), who, writing in 1425, intimated the existence of unknown works by Tacitus supposedly at a Benedictine monastery in Hersfeld, Germany. The *Annals* was subsequently "discovered" in a copy of Tacitus's *Histories* at the monastery but was not named "Annals," however, until 1544, by Beatus Rhenanus.

In 1878, the "excellent Latin scholar" W.J. Ross wrote the book *Tacitus and Bracciolini*, which evinced that the entire Annals was a forgery in very flawed Latin by Bracciolini in the 15th century. Ross's work was assailed by various clergymen, who claimed the main defect in his argument was that "one of the MSS. [manuscripts] of the Annals is at least as early as the XI century."[68] However, the critics had not actually read Ross's book, in which he addresses this purported 11th century manuscript, showing that it was merely pronounced by dictum to be of that date.[69] Interested readers are referred to Cutner and Ross for further discussion of this debate, which includes, in Ross's dissertation, a minute examination of the Latin of the Annals. Suffice it to say that the evidence is on the side of those who maintain the 15th century date, in that the Annals appears nowhere until that time.

Again, accepting the Annals as genuine, the pertinent passage itself could easily be an interpolation, based on the abundant precedents. In reality, "none of the works of Tacitus have come down to us without interpolations."[70] Drews considers the Tacitus passage in its entirety to be one of these forgeries that just suddenly showed up centuries later, and he expressed astonishment that "no one took any notice during the whole of the Middle Ages" of such an important extract. Says he:

> No one, in fact, seems to have had the least suspicion of its existence until it was found in the sole copy at that time of

Tacitus, the Codex Mediceus II, printed by Johann and his brother Wendelin von Speyer [de Spire] about 1470 at Venice, of which all the other manuscripts are copies.[71]

The reason for this hoax may be the same as the countless others perpetrated over the millennia: The period when the Annals was discovered was one of manuscript-hunting, with huge amounts of money being offered for unearthing such texts, specifically those that bolstered the claims of Christianity. It is a fact that poor, desperate and enterprising monks set about to fabricate manuscripts of this type. Bracciolini, a Papal secretary, was in the position to collect "500 gold sequins" for his composition, which, it has been claimed, was reworked by a monk at Hersfeld/Hirschfelde, "in imitation of a very old copy of the *History of Tacitus*."

Regarding Christian desperation for evidence of the existence of Christ, Dupuis comments that true believers are "reduced to look, nearly a hundred years after, for a passage in Tacitus" that does not even provide information other than "the etymology of the word Christian," or they are compelled "to interpolate, by pious fraud, a passage in Josephus." Neither passage, Dupuis concludes, is sufficient to establish the existence of such a remarkable legislator and philosopher, much less a "notorious impostor."[72]

It is evident that Tacitus's remark is nothing more than what is said in the Apostles' Creed—to have the authenticity of the mighty Christian religion rest upon this *Pagan* author's scanty and likely forged comment is preposterous. Even if the passage in Tacitus were genuine, it would be too late and is not from an eyewitness, such that it is valueless in establishing an "historical" Jesus, representing in reality merely a recital of Christian tradition.

Suetonius, Roman Historian (c. 69-c. 122 CE)

Moving through the standard list of defenses, we come to the Roman historian Suetonius. A passage in Suetonius's *Life of Claudius*, dating to around 110 CE, states that Claudius "drove the Jews out of Rome, who at the suggestion of Chrestus were constantly rioting." The passage in Latin is as follows:

Claudius Judaeos impulsore Chresto assidue tumultuantes Roma expulit.

In the first place, this reference is to "Chresto," not "Christo." In any case, Claudius reigned from 41-54, while Christ was purported to have been crucified around 30, so the great Jewish sage could not have been in Rome personally at that time. Even such an eager believer and mesmerized apologist as Shirley

Jackson Case must admit that Christ himself couldn't have been at Rome then, that the "natural meaning" of the remark is that "a disturbance was caused by a Jew named *Chrestus*" living in Rome at the time, and that Suetonius's "references to Christianity itself are very obscure."

It is possible that these diasporic Jews—a mixture of Hebrew, Jewish, Samaritan and Pagan descent—revered their god under the epithet of "Chresto." Or, as Eisenman suggests, the incident may record Jews agitating over the appointment of Herod Agrippa I as king of Judea by his friend Claudius in 41 CE.[73] In this regard, Agrippa I is called "chrestos" by Josephus.

In his *Life of Nero*, Suetonius refers to "Christiani," whom he calls "a race of men of a new and villainous, wicked or magical superstition," who "were visited with punishment." This passage, although establishing that there were people called "Christiani" who were a fairly recent cult in Suetonius's time, obviously does not serve as evidence that Jesus Christ ever existed.

Regarding these various non-Christian "references," the "German Jew" author of *The Existence of Christ Disproved* declared that the Tacitus and Suetonius passages "cannot be admitted as of a feather's weight in the balance of arguments for or against the existence of Jesus."[74] Count Volney summarizes the debate thus:

> There are absolutely no other monuments of the existence of Jesus Christ as a human being, than a passage in Josephus (Antiq. Jud. lib. 18, c.3,) a single phrase in Tacitus (Annal. lib. 15, c. 44), and the Gospels. But the passage in Josephus is unanimously acknowledged to be apocryphal [false], and to have been interpolated towards the close of the third century...and that of Tacitus is so vague and so evidently taken from the deposition of the Christians before the tribunals, that it may be ranked in the class of evangelical records. It remains to enquire of what authority are these records. "All the world knows," says Faustus, who, though a Manichean, was one of the most learned men of the third century, "All the world knows that the gospels were neither written by Jesus Christ, nor his apostles, but by certain unknown persons, who rightly judging that they should not obtain belief respecting things which they had not seen, placed at the head of their recitals the names of contemporary apostles." See Beausob....a sagacious writer, who has demonstrated the absolute uncertainty of those foundations of the Christian religion; so that the existence of Jesus is no better proved than that of Osiris and Hercules, or that of Fot or Beddou, with whom, says M. de Guignes, the Chinese continually confound him, for they never call Jesus by any other name than Fot...[75]

It is evident that by Volney's time (late 18th century) the European intelligentsia had already so demolished the TF that it was "unanimously acknowledged" as a forgery. It should also be noted, once again, that Jesus was deemed "Beddou" or *Buddha*, called "Fot" in China.

Even if these passages were genuine, they would no more prove the existence of Jesus Christ than do writings about other gods prove *their* existence. In other words, by this same argument we could provide *many* "references" from ancient writers that the numerous Pagan gods also existed as "real people." In this case, Jesus would be merely a johnny-come-lately in a long line of "historical" godmen.

In the final analysis, there is no evidence that the biblical character called "Jesus Christ" ever existed. As Nicholas Carter concludes in *The Christ Myth*, "No sculptures, no drawings, no markings in stone, nothing written in his own hand; and no letters, no commentaries, indeed no authentic documents written by his Jewish and Gentile contemporaries, Justus of Tiberius, Philo, Josephus, Seneca, Petronius Arbiter, Pliny the Elder, *et al.*, to lend credence to his historicity."[76]

Thallus, Phlegon, Lentulus, et al.

One of the more ridiculous and desperate claims of modern apologists concerns the writings of the Roman astronomer of the 1st century, Thallus, as purportedly recorded by Christian historian Julius Africanus in the 3rd century. Thallus, it was supposedly asserted by Africanus, wrote about a "period of darkness," which Africanus *interpreted* as referring to the sun's darkening upon the crucifixion of Christ. Not only did Africanus *not* quote Thallus directly but all he did relate was merely the record of what sounds like an eclipse. No mention is made by Thallus of Jesus or his followers or any gospel event. Even the time when Thallus wrote is uncertain, and, as Jeff Lowder says, "the darkness itself is doubtful."[77] Obviously, Thallus serves as no testimony whatsoever of Christ or Christianity.

The same arguments are put forth regarding a writer named Phlegon, who, also according to Africanus, purportedly likewise reported an "eclipse." This statement, even if genuine, is worthless as "evidence" for the existence of Jesus. As Richard Carrier points out, such eclipses occurring at the deaths of kings constituted a common mythical element.[78] Moreover, the natural historian Pliny and the writer and statesman Seneca, whose works encompassed the very time of Christ's alleged advent, recorded "all the great phenomena of Nature, earthquakes, meteors, comets, and eclipses."[79] Yet, they absolutely failed to report Christ's crucifixion, with its attendant earth-shaking

events. Per renowned historian Gibbon (1737-1794), "The celebrated passage of Phlegon is now wisely abandoned."[80] Unfortunately, in today's climate of intellectual decay these "references" are unwisely brought forth. Moreover, these purported comments by Thallus and Phlegon were "preserved" only by inclusion in Africanus's works. It seems incredible that, had they really served as evidence of Christ's existence and spectacular death, these authors' works themselves would not have been preserved.[81]

And so on and so forth, through other specious "evidence," including the absurd letter by the publican Lentulus, and the forged and foolish correspondence between Jesus and King Abgar, etc. Regarding the letter allegedly from Lentulus describing a most beautiful Jesus, even so pious a Christian as Rev. Lundy cannot help but pronounce both Lentulus and the letter as fictions.[82] The Catholic Encyclopedia too admits that Lentulus is a "fictitious person" and says the letter is "certainly apocryphal,"[83] i.e., bogus.

Jewish Sources

Also brought to bear in the quest for the "historical" Jesus are purported references to Christ in Jewish literature, such as the Talmud (3rd to 6th centuries CE). Significantly, the "Jesus" (by several names and epithets) alleged by Christian apologists to be discussed in the Talmud is not present at all in the earlier Palestinian Talmud/Gemara (3rd-4th cents.) but only appears in the later Babylonian Talmud, which was not finished until around 600 CE,[84] long after Jesus's purported advent. Numerous scholars, Christian, Jewish and otherwise, have repeatedly demonstrated that these references are late and of no value in establishing the existence of such a person. As apologist Goguel says, "The Talmud contains nothing about Jesus which does not come from Christian tradition." Furthermore, Jewish scholar Solomon Schechter observes that Jewish texts composed during the time of Jesus's advent contain not "a single reference to the founder of Christianity." The Talmudic "Anti-Christiana," retorts Schechter, "collected by mediaeval fanatics, and freshened up again by modern ignoramuses, belong to the later centuries, when history and biography had given way to myth and speculation."[85]

Other Jewish scholars, such as Joseph Klausner, agree that the few references to Jesus in the Talmud are worthless historically but serve as polemics against the alleged founder of a "hated party." In other words, these Talmudic attacks are not against a supposed "Jesus of Nazareth" that Jewish scholars and rabbis knew to have existed at some point, but against the

purported founder of Christianity, as portrayed by Christians themselves, centuries after the alleged events. These very few references, then, are not "records" but reactions against Christian claims.

Drews likewise concurs that "no information about Jesus is to be found in the Talmud." He also points out that if Jesus had existed and behaved in the manner described, it is surprising that, instead of castigating him "in works intended solely for a Jewish public," the rabbis barely mention him, and only then in a context that has "not the least historical importance."[86] Drews also declares that the Talmud serves as "no independent tradition about Jesus" but is "merely an echo of Christian and pagan legends," not history.[87]

In the same manner, Drews counters another spurious apologist assertion regarding the Jews, which is that they never challenged the existence of Jesus. In his *Dialogue with Trypho the Jew*, Justin has Trypho state," You follow an empty rumour and make a Christ for yourselves." He also says, "If he was born and lived somewhere, he is entirely unknown." This writing appeared around the middle of the second century, making it clear that Christian claims *were* in fact challenged early on by Jews.[88] Indeed, the middle of the second century was a relatively short time after the Jesus fable began to be placed in history, and the Docetic view, which declared Christ a "phantom" and argued against his physical incarnation, became popular in the decades surrounding this time. There certainly were Jews among the Docetists as well.

As concerns the Dead Sea scrolls (c. 200 BCE-c. 100 CE), which are erroneously held up as evidence of Christ's existence, Professor of Bible and Hellenistic Literature at Hebrew Union College Samuel Sandmel remarks that the scrolls "turn out not to have added one jot to the previous knowledge about Jesus."[89] In fact, what the scrolls do show is a *blueprint* for the creation of Christ and Christianity, by Jews or Hebrews of an Israelite/Samaritan origin or inclination. Moreover, as Ellegard demonstrates, the "Church of God" or *ecclesia* revealed in the scrolls, as well as in the mature organization addressed by Paul and other writers, is most assuredly pre-Christian and *Jewish*. It is this *Church of God*, this *ecclesia*, a "close-knit brotherhood (and sisterhood) who kept somewhat aloof from both pagans and from other Jews,"[90] that eventually morphed into Christianity. Hence, what the scrolls do prove is that "Christianity" did not spring from the divinely inspired mind of an historical Jesus.

For an extensive exegesis and nullification of these purported Jewish references to Jesus, the reader is directed to Frank

Zindler's *The Jesus the Jews Never Knew.* As it turns out, there is no Jewish/Hebrew evidence of any worth to demonstrate Jesus's existence as an historical figure. In actuality, Jewish texts show the opposite: That "Jesus" is a composite, fictional character based on numerous figures, sayings and scriptural "prophecies."

In this regard, after listing the various Jesuses from both the "Old Testament" and Josephus's works, Leidner concludes: "The prior material indicates that the person of 'Jesus of Nazareth' could be constructed out of Judaic sources, without the need for an historical figure."[91] Indeed, Christian writers attempting to argue from "prophecy," in other words, illogically claiming that Jesus must not only have existed but also have been the Messiah because he was "prophesied" in the "Old Testament," have created long lists of scriptures "prophesying" him. One of these writers, Charles Weisman, lists in *Jesus Christ in The Old Testament* hundreds of so-called prophecies, such as from the books of Zechariah, Isaiah, Jeremiah, Psalms and Joshua. Oddly enough, as fervent and devout a Christian as he is, Weisman truthfully admits:

> It is...apparent that [the] messianic concept appears in the history of many ancient cultures. There are varied accounts and stories of a messiah in the histories of Egypt, Babylonia, Assyria, Persia, and other ancient civilizations.[92]

Weisman further acknowledges "the fact that Egyptian texts on this subject go back to 3000 B.C., long before the writings of Moses and the prophets..." Hence, these scriptures serve not as "prophecy" from God Himself but as well-known ideas found in numerous other cultures, long before the Christian era.

Knowing these so-called prophetic scriptures, and that the scriptural text used by the New Testament writers was the Greek Old Testament or Septuagint, it is easy to see how the forgers of the gospel and various other Christian texts simply used the Septuagint as a *blueprint*, cutting and pasting these "prophetic" scriptures until a fable and doctrine were created. There is abundant precedent for such behavior not only in the "Pagan" priesthood but also widely within the Hebraic priesthood itself.

Christian "Evidence"

Turning next to the Christian evidence for Christ, we begin with the earliest known Christian texts, the epistles contained in the New Testament canon. These canonical epistles have been shown by a number of scholars, including Edwin Johnson, Thomas Inman, Gerald Massey, Arthur Drews, Alvin Boyd Kuhn, Gordon Rylands, G.A. Wells, Earl Doherty, Freke and Gandy, and others, to be of little use in establishing an "historical Jesus."

First, as Drews states, "No theologian doubts that the Pauline Epistles have been greatly interpolated."[93] In addition, there is "no proof of the existence of Pauline Epistles before Justin, and it remains an open question whether Justin had any knowledge of such Epistles."[94] Moreover, the Pauline epistles relate no events from the gospel stories, contain no mention of such gospels and are essentially devoid of any "life of Jesus." Drews declares that, even if Jesus were "an historical personage," the Paulines "do not tell a single special fact about the life of Jesus." Concerning the "genuine epistles" of both Paul and Peter, apologist Sir Weigall remarks that Jesus's "life on earth is hardly mentioned at all, nor anything which really establishes Him as a historic personage."[95]

Nor do the epistles of John, James, Jude or that to the Hebrews discuss an historical Jesus of Nazareth. Other early Christian texts, such as the epistle to the Corinthians attributed to Clement, as well as the epistle of Barnabas, etc., reflect the same omission. In fact, there is not the slightest hint of the man Jesus to suggest that any of these writers ever knew him "in the flesh." Indeed, in none of the canonical epistles is there "a single reference to any of the wonderful events told in the gospels in any epistle written by those who 'companied with Jesus'—except the assertion that he had risen from the dead, to be found at 1 Corinthians 15 and elsewhere—whose value is problematical."[96] Regarding the claim that Paul is aware of an "historical" Jesus based on 1 Cor. 15, in which he says that Christ was buried and raised on the third day "in accordance with the scriptures," the word "scriptures" could refer *only* to the Old Testament, i.e., the Septuagint, specifically the verses at Isaiah 53, Jonah 1:17 (2:1 in the Hebrew) and Hosea 6:2. Hence, the reference is not to a certain "Jesus of Nazareth" who lived some decades earlier but to biblical stories well known to religious Jews, such as the myth of Jonah/Jonas, to whom Jesus is compared in the New Testament (Mt. 12:40; Lk. 11:30).[97]

1 Corinthians 11:23-32 also seems to point to knowledge (although not Paul's personally) of an "historical" Jesus. However, as Drews says, "here we have to do with what is clearly a later interpolation." Drews then gives reason for such an assertion, including that the passage is "obscure throughout" and violently interrupts the original text, "as is even acknowledged by many on the theological side."[98] Drews next cites a number of these theologians, such as Brandt and Schläger.

It is claimed that Paul's reference to a "veiled gospel" at 2 Cor. 4:3 serves as evidence of the existence of a canonical gospel; however, the word for "gospel" is ευαγελλιον—*evangelion*—which simply means "the glad tidings of salvation through Christ," as

defined by Strong's Concordance. The definition does not say "the narrative of the life of Jesus of Nazareth." Evangelion literally means "good angel," not a book. Concerning this "gospel" and the absence of Jesus's biography in the epistles, the Encyclopedia Britannica ("New Testament Literature") states:

> Thus, the "gospel" was an authoritative proclamation (as announced by a herald, *keryx*), or the kerygma (that which is proclaimed, *kerygma*). The earthly life of Jesus is hardly noted or missed, because something more glorious—the ascended Lord who sent the Spirit upon the Church—is what matters.

In other words, this mainstream resource acknowledges that the earliest connotation of "gospel" was *not* a narrative of Jesus Christ, and that his "earthly life" is in fact "hardly noted or missed" by Paul.

Even the story of Paul himself is questionable, as he is recorded nowhere in history, despite supposedly having "thrown the Jews into excitement over the whole earth," per Acts 24:5, "to have been persecuted by them with the direst hatred, and to have been dragged into court more than once, involving the highest Jewish and Roman authorities..."[99] In actuality, Paul seems to be a composite character whose "name" was used, like that of other figures, on a number of texts written by others.

Robert Eisenman finds the historical Paul or Saul in the "Saulus" of Josephus, who is a "mysterious Herodian" or relative of Herod Agrippa.[100] "Paul" never identifies himself as a Jew, except when he says that in order to win over Jews he became a Jew. Instead, he calls himself a "Hebrew," an "Israelite" and a "Benjamite." Bishop Epiphanius (3rd cent.) asserted that the Ebionites denied Paul's identity as a Jew, claiming that his parents were both Gentiles. After visiting Jerusalem, the legend holds, the Apostle to the Gentiles became motivated for his apparent conversion to Judaism, which included circumcision, by a desire to marry the daughter of a high priest.[101]

In addition, "Paul," i.e., the several writers of the "Pauline" epistles, used the Greek translation of the scriptures, not the Hebrew. Thus, although it is claimed that Paul was a "pupil" of Gamaliel, the renowned Jewish rabbi of the 1st century, and a zealot for the law, "the apostle" apparently did not know Hebrew. Also, despite the claims he was a Pharisee, Jewish authorities have long denied that Paul's interpretation of the Mosaic law is "rabbinical." In reality, Paul is "Greek in everything": "He thinks as a Greek, speaks as a Greek, uses Greek books."[102]

In conclusion, the "truth is that the Pauline epistles contain nothing which would force us to believe in an historical Jesus..."[103] Paul's Jesus is Isaiah's suffering servant, as well as

the "just man of Wisdom," rather than an historical character.[104] Hence, the earliest Christian texts depict a supernatural being, a typical dying and rising savior god, but know "nothing whatever about a merely human Jesus."[105] Indeed, the Pauline Jesus's resemblance to the pre-Christian savior gods is evident and has been evinced many times by a number of scholars, including Doherty, who thoroughly demonstrates that the earliest Christian writers, such as the canonical epistles authors, reveal no knowledge of an historical Jesus but deal with a spiritual savior common to the pre-Christian mystery cults. In his exhaustive treatment in *The Jesus Puzzle*, Doherty notes with some amazement the numerous opportunities missed by Paul and the other epistle writers to include some biographical material of Jesus, had they actually known of such an "historical person." In this enterprise, Doherty dissects the various early Christian texts, both canonical and noncanonical, to reveal odd omissions and admissions which clearly demonstrate that the earliest Christian preachers were speaking of a spiritual, disincarnate savior, not a real man called "Jesus of Nazareth." Like that of Drews, Doherty's detailed and thorough analysis need not be repeated here; suffice it to say that it shows that none of the biblical epistle writers was aware of any of the canonical gospels, and that the Jesus of the early Christians was not historical.

As it turns out, the savior of the epistles was little different from the various deities of the pagan salvation and mystery cults. What eventually differentiated Jesus, whose name basically means "salvation," was that he was turned into a "real person" by being imposed upon history and given historical dress. In other words, Jesus was not a human being turned into a god, but a god turned into a human being.

The Gospel Dates

The Pauline epistles do not reveal any historical Jesus; nor do they demonstrate any knowledge of the existence of the four canonical gospels, Matthew, Mark, Luke and John. As has been proved repeatedly, the gospels themselves cannot be viewed as "history" written by "eyewitnesses." Besides the fact that they date to much later than is supposed, the gospels frequently contradict each other, and, based on the numerous manuscripts composed over the centuries, have been determined (by German theologian Johann Griesbach, for one) to be a mass of some 150,000 "variant readings."[106] In this regard, *The Interpreter's Dictionary of the Bible*, a Christian book, contains an article written by M.M. Parvis (vol. 4, 594-595), who states:

> The New Testament is now known, in whole or in part, in nearly five thousand Greek manuscripts alone. Every one of these

handwritten copies differ from the other one... It has been estimated that these manuscripts and quotations differ among themselves between 150,000 and 250,000 times. The actual figure is, perhaps, much higher. A study of 150 Greek manuscripts of the Gospel of Luke has revealed more than 30,000 different readings... It is safe to say that there is not one sentence in the New Testament in which the manuscripts' tradition is wholly uniform.[107]

Some sources place the figure for the "variant readings" even higher, including *The Anchor Bible Dictionary On CD-ROM* ("Textual Criticism, NT"), which says, "Perhaps 300,000 differing readings is a fair figure for the 20th century (K.W. Clark 1962: 669)."[108] So much for "God's infallible Word" and his "inspired scribes." Apologists have come up with all sorts of excuses for this manmade mess; their excuses only demonstrate further that man's hand—and not that of the Almighty God—has been involved in the creation of Christianity and its texts at every step.

It would be impossible to date the appearance of the gospels based on the extant manuscripts, since the autographs or originals were destroyed long ago, an act that would appear to be the epitome of blasphemy, were these texts truly the precious testimonials by the Lord's very disciples themselves. Although a miniscule bit of papyrus (Rylands) dating to the middle of the second century has been identified speculatively as part of "John's Gospel" (18:31-33), the oldest fragments conclusively demonstrated as coming from the canonical gospels date to the 3rd century. The two verses of "John's Gospel," comprising only about 60 words, could easily be part of another, *non*-canonical gospel, of which there were numerous in the first centuries of the Christian era. That such texts contained verses paralleling those found in the canonical gospels is known from the writings of Justin Martyr, for example, who quotes from a number of them.

In reality, the four gospels selected for inclusion in the New Testament do not make any appearance in the literary and archaeological record until the last quarter of the 2nd century, between 170 and 180 CE, and even then they are not much mentioned for a couple of decades. In this regard, Church father and archbishop of Constantinople John Chrysostom (c. 347-407) stated that the names traditionally attached to the canonical gospels were first designated at the *end of the second century*.[109] The orthodox dating, of course, attempts to put the gospels a century earlier, between 70 and 110 CE. However, it should be kept in mind that the current mainstream dating was heretical when first propagated, over 150 years ago, causing apoplexy in the faithful, who believed the texts were composed shortly after Jesus's death. Over the centuries, because of increasingly

scientific scholarship, the date of the canonical gospels has been continually pushed to later decades, as it has long been accepted that there is absolutely no evidence, internal or external, for such an early date.

The early dating is mere wishful thinking on the part of those who truly believe that Jesus Christ existed and that his words, deed and life were faithfully recorded by eyewitnesses, i.e., his disciples. Such a scenario is not reality, however, and the most scholarship can offer in bending the dates to fit the alleged advent of Jesus Christ in the time of Herod is that the gospels were composed during the last decades of the first century. The internal evidence cited for this "late" a date is that the gospel writers were aware of the destruction of Jerusalem in 70 CE. Therefore, Mark, considered by most mainstream authorities to be the earliest of the gospels, could not have been written any earlier than 70 CE. The others followed, with John appearing perhaps as late as 110 CE. That is where mainstream scholarship ends. Nonetheless, the fact remains that the gospels are conspicuously absent from the writings of the Church fathers and apologists until the end of the *second* century.

As concerns the order in which the gospels were written, the priority of Mark was proposed as early as 1786 by Storr[110] and argued in detail by Christian Wilke in 1838.[111] According to proponents of the specious "outdated" argument, which claims that newer scholarship is better and more correct merely by virtue of its "modernity," the Markan-priority thesis is a *very* "outdated" premise and must therefore be wrong. By this same argument, "Q" scholarship—which proposes that an original "sayings" text was used in the creation of the gospels—is likewise "outdated," because it too began over a century and a half ago, with the research of Christian Weiss, also in 1838. It should be noted that even the existence of a Q document has been argued against by a number of scholars, including Farrer (1955), Farmer (1964) and Hobbs (1980).

Despite these facts, it is perceived that to go against the crowd is to commit scholarly heresy! In actuality, critics of the Mark-priority thesis *must* come afterwards, obviously, which makes their theories more "modern." G.R.S. Mead, for one, writing after the Markan-priority thesis was proposed, was insistent that the other synoptists, Matthew and Luke, did *not* use the canonical Mark as one of their source texts: "It is very evident that Mt. and Lk. do not use *our* Mk., though they use most of the material contained in our Mk."

This conclusion was also reached by Helmut Koester and others in the modern era. Indeed, scholars have hit upon an "Ur-

Markus" or source of Mark from which all three synoptics (Matthew, Mark and Luke) drew. Hence, it is asserted by Ur-Markus proponents that the other two synoptics did *not* use the canonical Mark. The Ur-Markus theory was developed by Weisse in the 1850s.[112] At the end of the 19th century, Hernle attempted to prove that Ur-Markus was the canonical Mark, and the debate was supposedly settled in the 1920s. Yet, modern mainstream scholars continue to debate the priority. As Burton Mack says, in *The Lost Gospel of Q*, "Even today there are scholars who continue...to favor Matthew as the earliest gospel."[113]

Following Griesbach (1783), the Tübingen School in the 1830s maintained not only the priority but also the *late* date of *130 CE* for Matthew, swimming firmly against the tide.[114] Scholars of the 20th century who have argued for the priority of Matthew include "Jameson, Chapman, Butler, and Wenham."

The fact is that scholars have gone back and forth on the order, as did the early Church fathers. As the Catholic Encyclopedia relates ("Synoptics"):

> The order: Matthew, Luke, Mark, was advanced by Griesbach and has been adopted by De Wette, Bleek, Maier, Langen, Grimm, Pasquier. The arrangement: Mark, Matthew, Luke, with various modifications as to their interdependence, is admitted by Ritschl, Reuss, Meyer, Wilke, Simons, Holtzmann, Weiss, Batiffol, Weizsäcker, etc. It is often designated under the name of the "Mark hypothesis", although in the eyes of most of its defenders, it is no longer a hypothesis, meaning thereby that it is an established fact. Besides these principal orders, others (Mark, Luke, Matthew; Luke, Matthew, Mark; Luke, Mark, Matthew) have been proposed, and more recent combinations (such as those advocated by Calmel, Zahn, Belser, and Bonaccorsi) have also been suggested.[115]

In *Therapeutae: St. John Never in Asia Minor*, George Reber evinces that the order the gospels were composed is the same as their placement in the canon: Matthew, Mark, Luke and John, as each one appears to correct the previous texts' mistakes, likely pointed out by critics along the way. Says Reber, "The blunders and mistakes of the first Gospel [Matthew] made it necessary that there should be a second."[116] Reber further states, "Mark copies Matthew, and Luke uses the words of both."[117] Concerning the gospel of Matthew, Reber also remarks that the book—"the source of all"—was "not written in Judea, or by one who knew anything of geography of the country, or the history of the Jews."[118] "Whoever the writer may have been," he continues, "it is evident that he received his education at the college at Alexandria, where Medicine and Divinity were taught, and regarded as inseparable."[119]

Despite claims to the contrary, little in New Testament scholarship is set in stone, including not only the priority of the gospels but also the dating. In reality, the majority of modern bible scholars have simply gone along with the dates of c. 70-110 CE, in spite of the fact that there is no evidence of the gospels' existence until a century later, as evinced by such notables as Bronson Keeler, author of *A Short History of the Bible*; the Christian Judge Charles Waite in *History of the Christian Religion to the Year Two Hundred*; and Walter Cassels in *Supernatural Religion*. Cassels's knowledge on the subject was so startlingly profound that, when his book was first released anonymously, other scholars—including Christian detractors—believed him to be a bishop. Regarding the orthodox dates (70-110), which were already established by his time at the end of the 19th century, Cassels states, "It is evident that the dates assigned by apologists are wholly arbitrary."[120]

In *Supernatural Religion*, Cassels painstakingly analyzes the bulk of the fathers' writings to find hints that they may have known the canonical gospels. Cassels's comprehensive analysis is synopsized thus:

> Before commencing our examination of the evidence as to the date, authorship, and character of the Gospels, it may be well to make a few preliminary remarks. We propose to examine all the writings of the early Church for traces of the Gospels. It is very important, however, that the silence of the early writers should receive as much attention as any supposed allusions to the Gospels. When such writers, quoting largely from the Old Testament and other sources, deal with subjects which would naturally be assisted by reference to our Gospels, and still more so by quoting such works as authoritative—and yet we find that not only they do not show any knowledge of those Gospels, but actually quote passages from unknown sources, or sayings of Jesus derived from tradition—the inference must be that our Gospels were either unknown or not recognized as works of any authority at the time.[121]

In his very scholarly, 1100-page book, Cassels comes up empty-handed, until the end of the *second* century.[122]

In proving many of his points throughout this large volume, Cassels uses extensive footnotes, frequently referring to dozens of mainly Christian authorities in a single citation, as well as providing numerous passages in the original languages, i.e., Greek and Latin. Again, Cassels's work is exhaustive, examining the "whole of the extant writings of the early Fathers," and "finding them a complete blank as regards the canonical Gospels..."[123] As examples of these early fathers who are oblivious to the existence of the gospels, Cassels cites Hegesippus, Papias,

and Dionysius, saying that they "do not furnish any evidence in favour of the Gospels."[124]

The author of *Christian Mythology Unveiled*, writing earlier than Cassels, likewise challenged Christian authorities to demonstrate conclusively that the New Testament, as it stands, existed at the end of the first century, as widely believed by the faithful. In his exegesis, CMU names several Christian authorities, such as Dodwell, who admits that the earlier Christian texts, such as the Shepherd of Hermas, cite no passage and make no mention of the New Testament. Nor do the apostolic Church fathers Clement of Rome, Barnabas, Hermas, Ignatius and Polycarp even mention the names of the four evangelists.[125]

Again, the important father and bishop of Antioch, Ignatius (c. 50-107), never refers to any of the evangelists or gospels, despite claims that his letters infer the existence of the gospels. However, these letters contain merely a "biography" consisting mainly of a rough outline of the Jesus myth, with little detail. Basically, the Ignatian texts insist simply that Jesus was "born and died," was "truly crucified by Pontius Pilate," and was born of the Virgin Mary. In his detailed analysis, Cassels shows that these epistles were forged towards the end of the 2nd century, so they still would not serve as evidence of the existence of the gospels before that date. Edwin Johnson's *Antiqua Mater* likewise casts doubt on the authenticity of the entire "Ignatius" corpus, as well as that of Polycarp (69? 159? CE), stating that there appears to be "little reason" for dating Polycarp's work to the "second century rather than the third or fourth."[126]

The Epistle of Barnabas (c. 130 CE) mentions neither the evangelists nor the gospels; nor, again, does the Shepherd of Hermas (c. 150 CE). At this point, Keeler observes:

> This comprises the whole of the extant Christian literature from the death of Jesus to the middle of the second century, and not one writer mentions the Four Gospels, or makes the slightest reference to them. They make quotations from tradition and from other Gospels, but not from our four.[127]

Regarding the purported existence of the "Gospel of Mark" in the time of Bishop Papias (fl. 150), Cassels remarks, "We shall, hereafter, in examining the testimony of Papias, see that the Gospel according to Mark, of which the Bishop of Hierapolis speaks was not our canonical Mark at all."[128] Per Eusebius, Papias claimed Mark wrote a gospel according to information received from Peter. This gospel would appear to be the Gospel of Peter, however, rather than the canonical gospel of Mark. The original Gospel of Peter apparently contained no mention of Pilate, which would be appropriate for a Roman gospel. That it is

not the canonical gospel of Mark is asserted by a number of authorities.[129]

Also, according to Eusebius, Papias also referred to a Hebrew gospel of Matthew, which contained "sayings of the Lord," about which the bishop wrote his multi-volume work, *Explanation of the Sayings of the Lord*. This "gospel of Matthew" was *not* the same as the canonical Matthew, however, so we are still without any hint of the existence of the latter.

Concerning these much-discussed "sayings" or *logia*, a number of scholars have attempted to find a "cynic sage" or "itinerant preacher" in the handful deemed by the "Jesus Seminar" to have been uttered by the "historical Jesus." Nevertheless, these sayings or logia were part of the mysteries for centuries and millennia prior to the Christian era, called *Logia Iesou* or "Sayings of the Savior," also known as the *Logia Kuriakou* or "Sayings of the Lord." The pre-Christian existence of these nearly verbatim "New Testament" sayings explains their appearance in texts discovered in Egypt, Syria and other places. Naturally, because of their resemblances to the gospel material, these texts and sayings are assumed to postdate the gospels. However, even if the actual texts themselves were not composed until after the common era, there were certainly such logia/sayings long prior to then.[130] That the New Testament Logia Iesou are not sayings of an "historical" Jesus is demonstrated by the fact that Paul is evidently completely unaware of any of them, relating not a single one verbatim.

Rather than serving as a "biography" of Jesus, according to Church tradition based on the writings of the fathers, these logia/sayings constituted "the primary nucleus of the canonical Gospels." One of these collections, the Hebrew Gospel of Matthew, is likely of Alexandrian origin, as "Matthew" is evidently a name from Egyptian mythology and the mysteries: To wit, Osiris's scribe was Mattiu, or Maatiu, "the word of truth." The 25th chapter of Matthew concerning the Last Judgment uses "the very phrases" found in the Egyptian *Bible*, the Book of the Dead.[131] In the Egyptian Last Judgment, *Maat* (Matt), or Truth, stands behind Osiris (Jesus), the Great Judge. It is evident that the Sayings of the Lord/Savior, the Logia, constituted part of the much earlier Egyptian religion. In addition, the Gospel of Thomas ("Oxyrhyncus Papyrus") virtually proves the existence of the Logia in separate sayings texts predating the canonical gospels. Like those of the canonical gospels, the Thomas sayings parallel scriptures from the Egyptian Bible or Book of the Dead.[132]

Many of these logia are also lifts or paraphrases from the Old Testament and other Jewish writings, such as the pre-Christian

Wisdom of Jesus ben Sirach (*Ecclesiasticus*), which represents the numerous wise sayings of a Jewish man named Jesus dating to almost two centuries prior to the common era. Depicted in certain Hellenistic Judaic and pre-Christian Gnostic texts as uttering various such "wisdom sayings," and later merged into the Logos/Christ, is the personified Wisdom, or Sophia, who existed in the Canaanite, Phoenician and Aramaic cultures as well, ages before the Christian era and in the area where Christianity was ostensibly conceived. As Rev. James elucidates, the god El attributed "wisdom (*hkmt*) to Baal together with eternal life and good fortune," and in the Aramaic sayings and proverbs of the 6th century BCE the personified Wisdom is declared "heaven-sent," i.e., divine. James continues, "If the conception of wisdom in the book of Proverbs (viii) is hardly mythological in the Ugaritic sense, it has every appearance of having a Canaanite origin both linguistically and in its affinity to the Logos-idea in its western Asian form."[133]

In addition to being a compilation of pre-Christian gods, Jesus is also a remake of the Wisdom figure, as is evident also from Proverbs 8:12, 22-36, in which "Wisdom" is made to say:

> The Lord created me at the beginning of his work...before the beginning of the earth.... When he established the heavens, I was there... Happy is the man who listens to me, watching daily at my gates... For he who finds me finds life.

In any case, the logia or sayings are "pre-historic," preceding Christianity by centuries or millennia; hence, they do not represent the "true utterances" or "personality" of an historical Jesus.

Nor do the writings of Papias, which inexplicably have been allowed to perish, have any value in establishing the existence of the gospels at his time. From an intensive study of his works that survived in the writings of others, Cassels was able to conclude that Papias was unaware of the existence of the canonical gospels.[134]

Christian authority Hegesippus (fl. 2nd cent.), a "born Jew," likewise does not use the canonical gospels but quotes from the lost Gospel of the Hebrews, as well as the Old Testament, the Proverbs of Solomon, and the various pre-Christian logia.[135] Famed German biblical scholar Tischendorf (1815-1875), who pored over the early Christian texts in a fervent search for "every trace, real or imaginary" of the existence of the New Testament and canonical gospels, made no claim concerning Hegesippus. Indeed, Tischendorf "does not pretend that Hegesippus made use of the Canonical Gospels, or knew of any other Holy Scriptures than those of the Old Testament..."[136]

Despite claims to the contrary, prolific Church father Justin Martyr (fl 150-160) likewise does not utilize or refer to the *canonical* gospels, as will be demonstrated in detail below.

Even as late as the time of Dionysius, Bishop of Corinth, there is no evidence of the gospels in Christian writings, including in the epistles attributed to him, written several years after 170.[137] It was not until the time of Bishop Irenaeus (fl. 200 CE) that the names of all four gospels were mentioned; in other words, the four evangelists were not identified as such until over a century and a half after Jesus's supposed death.

In the final analysis, there is no evidence for the existence of the canonical gospels prior to the last quarter of the second century. The dates of the gospels are thus given by both Keeler and Waite as follows:

> Irenaeus was the real founder of the New Testament canon. His date is from 180 to 200 A.D. Of our Gospels Luke was probably compiled or written about 170 A.D., Mark about 175 A.D., John about 178 A.D., and Matthew about 180 A.D. Irenaeus began to use them within a very short time after their origin, though it was probably not till the year 200 A.D. that he knew of them all.[138]

Kuhn confirms this late dating of the Gospel of Luke with the supposition that the friend to whom the gospel is addressed, Theophilus, was Bishop of Antioch from about 169 to 177 CE.[139] Significantly, Bishop Theophilus is the first writer to name the four evangelists as the authors of the gospels, in 180 CE: "He speaks of John's Gospel; but he says nothing of the writer having been an apostle, simply calling him an inspired man."[140]

Because this bishop of Antioch long postdates the era of the gospel story, it has been argued that the Theophilus of Luke is another individual, simply addressed as "God-lover," the meaning of "Theophilus." However, "Luke" could be the Docetist Leucius Charinus (fl. 180) or the Syrian satirist Lucian (c. 120-c. 180), as averred by Taylor. Hence, Luke's Theophilus would fit with the bishop of Antioch time-wise, as well as by virtue of the fact that Luke calls him κρατιστος ("kratistos"), which means:

> 1) mightiest, strongest, noblest, most illustrious, best, most excellent
> 1a) used in addressing men of prominent rank or office[141]

If there existed another Theophilus of "prominent rank or office," like the others he too is not found in the historical record.

Regarding the Gospel of John, both Irenaeus and Jerome stated that it was written to refute the writings of the Gnostic "heretic" Cerinthus, who "denied the incarnation of our Lord" and who apparently flourished around 150 CE, even though John was

said to have died around 100. In *Against Heresies* III, XI, 1),
referring to "St. John's Gospel," Irenaeus says:

> John, the disciple of the Lord, preaches this faith, and seeks, by
> the proclamation of the Gospel, to remove that error which by
> Cerinthus had been disseminated among men...[142]

In his "Preface to the Commentary on St. Matthew," Jerome
states:

> When [John] was in Asia, at the time when the seeds of heresy
> were springing up (I refer to Cerinthus, Ebion, and the rest who
> say that Christ has not come in the flesh, whom he in his own
> epistle calls Antichrists, and whom the Apostle Paul frequently
> assails), he was urged by almost all the bishops of Asia then
> living, and by deputations from many Churches, to write more
> profoundly concerning the divinity of the Saviour, and to break
> through all obstacles so as to attain to the very Word of God (if I
> may so speak) with a boldness as successful as it appears
> audacious. Ecclesiastical history relates that, when he was urged
> by the brethren to write, he replied that he would do so if a
> general fast were proclaimed and all would offer up prayer to
> God; and when the fast was over, the narrative goes on to say,
> being filled with revelation, he burst into the heaven-sent
> Preface: "In the beginning was the Word, and the Word was with
> God, and the Word was God: this was in the beginning with
> God."[143]

Adding to these fathers' assertions, the Catholic Encyclopedia
identifies Cerinthus as "Gnostic-Ebionite heretic, contemporary
with St. John; against whose errors on the divinity of Christ the
Apostle is said to have written the Fourth Gospel."[144]

The conclusion is that John's gospel could have existed no
earlier than the time of Cerinthus and that it was written for
Cerinthus's principal audience, the "heretical" Christians of Asia
Minor, "at the request of the bishops of Asia to combat that
heresy."[145] Cerinthus's "heresy" was that Christ had "not come in
the flesh," i.e., was not an historical personage. Jerome also
asserts that Cerinthus and his Docetic kind were those
"antichrists" addressed in the Johannine epistles. Hence, those
epistles were likely composed in the middle to late second century
as well, long after "John" had died.

Regarding the Gospel of John, Reber evinces that "John of
Ephesus" is a fiction and that his gospel was composed late in the
second century by Irenaeus himself, who created John and other
authorities, such as the nine bishops of Rome, including Clement,
in order to establish "apostolic succession." In this case, there
would be no *Christian* Roman church as such "until about the
reign of Antoninus Pius" (86-161).[146] Johnson also states that the
"history of the Church and its dogmas properly begins with the

period of the Antonines, 138-180 A.D." Reber's evidence that "John" did not exist before Irenaeus includes the vehemence with which the bishop defends John's gospel in his book *Against Heresies*: "That it was something new in the time of Irenaeus is evident from the fact that he is called upon and employed his genius to defend it."[147]

Concerning the date of John's gospel, Inman remarks that it is assumed by scholars to have been written over a century, and probably a century and a half, after Christ's death. He also states that the other gospels appear to have been written for non-inhabitants of, or those who knew little about, Jerusalem and Judea.[148] In his assertion regarding the scholars who dated John well into the second century, Inman names Bauer, who maintained that it was composed between 160 and 170 CE; Pleiderer, who put it at 140 CE; and Hilgenfeld, who dated it to between 130 and 140 CE.[149] Keeler agrees with the late date, recounting that John's gospel "was not heard of till about the year 180 A.D."[150] Leidner too concurs that there is reason to suspect that the canonical gospels did not exist until after Justin Martyr, i.e., the end of the second century. Even the famed Jesus scholar Ernest Renan had to concede that the canonical gospels did not achieve importance until around 180 CE. Interestingly, this period, between 170-180, was precisely when the Catholic Church began to be formed.

Alvar Ellegard is another modern author who concluded that the gospels did not exist until the second century. In his analysis, Ellegard examines word usage: To wit, the older texts use words that became archaic, while the newer texts employ innovations not found in the older ones. For example, earlier texts do not use the word "synagogue" very frequently, whereas the canonical gospels and Acts do.[151] Another word is "hagioi," or "saints," utilized in older texts—some of which are clearly pre-Christian—as well as by Paul, but not by later Christian writers.[152] In this manner, Ellegard has been able to trace a clear outline of the "Church of God" ("ecclesia," previously mentioned) with "saints" predating Christianity and with branches in the very places "Paul" visited. Again, this Church of God with its saints is detailed in the Dead Sea scrolls, which proves its pre-Christian existence. Ellegard's thesis is that the apostle James was the head of the Jerusalem Church of God, while Paul was one of its fervent missionaries. Ellegard also argues that not only is the pre-Christian church in Corinth "very firm and ancient" but also that the corresponding Roman church was likely in existence "even before the end of the first century BC.[153]

Serving as evidence of this pre-Christian church, in blatant anachronisms at Matthew 16:18 and 18:17 the word "church"

(ecclesia) is used, "and its papistical and infallible authority referred to as then existing, which is known not to have existed till ages after."[154] The use of the word "ecclesia" and "bishop," etc., are indications of the existence of the "Christian" organization, long before it was supposedly founded by "Jesus Christ." This Church of God apparently comprised various brotherhoods or sects, including the Zadokites, Nazarenes and the Egyptian Therapeuts. "From this [Therapeutan] society," says Reber, "were furnished all the monks which populated the deserts of Africa before the Christian era began."[155] Here, then, is the wellspring of Christianity, with no need for an "historical" founder.

The existence of the "Christian" organization, with churches, apostles, liturgy and a holy savior, decades if not centuries before the Christian era, is evident not only in the Dead Sea scrolls but also in the priesthoods of other cultures, such as the Greek, in which the holy men of the cult of Dionysus were called "Hosioi,"[156] the same term used to describe the "apostles" who became Christianized during the second century. These Hosioi were particularly in charge of the temple at Delphi, where it was said that Dionysus's dismembered remains were preserved.[157] It is evident that, after countless thousands of Jews had been initiated into the Dionysian mysteries at Alexandria, Corinth and elsewhere, they created their own church network with a similar structure and terminology, which eventually became Christianity.

As Drews points out, the historicization of the disincarnate savior could not have occurred until the generation alive during Jesus's alleged advent had passed away. In other words, the gospel tale must have been placed into history several decades after Jesus's purported death, into the second century.[158] By this time, there would be less of a challenge by Jewish opponents of these false representations, particularly after the destruction of Jerusalem and, later, Judea itself.

Regarding the era when Christianity truly burst upon the scene, Johnson remarks, "As the question at present stands, it cannot be too firmly stated, that the Christians as a distinct *religious* community, Christianity as a *religion* distinct from Judaism and from Paganism, stand out to the gaze of the world for the first time in the second decade of the second century."

The fact is that the gospels were not heard of until the end of the second century, an assertion thoroughly investigated and proved by the scholarship of the past 100 years or so. That the canonical gospels cannot be found in the writings of the Church fathers prior to the last quarter of the second century is true, and no amount of "new research" will change that fact. Again, the early dates are based on wishful thinking, rather than scientific analysis. It is important to understand these facts, so we can

proceed from this point to determine *who*, at the end of the *second* century, composed the canonical gospels.

Justin Martyr (c. 100-c. 165-167)

Although a number of writers and apologists have argued that Justin Martyr is the first Christian writer to be cognizant of the canonical gospels, in reality Martyr does *not* quote from the New Testament texts but apparently uses one or more of the same sources employed in the creation of the gospels, as well as other texts long lost. Furthermore, no other writer subsequent to Martyr shows any awareness of the existence of the gospels until around the year 180. It should also be noted that Martyr's works did not escape the centuries of mutilation and massive interpolation done to virtually every ancient author's works, which makes the disentanglement all that more difficult. Yet, even as it stands, Justin's writing still does not demonstrate knowledge of the canonical gospels.

In dozens of pages, Cassels provides a painstaking and thorough analysis of the Martyr material, using the original Greek text and revealing that Justin often repeats the same quotes, making it appear as if he is quoting "extensively," when, in fact, as the material is pared down, very little is left germane to the quest of whether or not the canonical gospels existed in his time. In the end, there is a mere handful of Martyr's sentences that Christian authorities have attempted to hold up as evidence for the gospels' existence: For example, biblical scholar Tischendorf "only cites two passages in support of his affirmation that Justin makes use of our first Gospel."[159]

A number of the passages in Justin that purportedly correspond to New Testament scriptures come from a text called "Memoirs of the Apostles," which, Cassels shows, is a book by that title, not a reference to several "memoirs" or apostolic gospels. The "Memoirs," in other words," constitutes a *single* text like the "Acts of the Apostles." Upon examination, the quotes Justin uses from the Memoirs "differ more or less widely" from parallel scriptures in the synoptics, Matthew, Mark and Luke. As confirmed by Tischendorf, only a couple of short exceptions are sufficiently similar to warrant comparison with the synoptic gospels. These various passages from the Memoirs or "Memorabilia" are repeated often enough that it is clear Justin is quoting them verbatim, rather than paraphrasing; yet, they are not identical to gospel scriptures, differing enough that they could not have come from those books. "There is almost invariably some difference," says Keeler "either in sense or construction, showing that Justin's book was different from our Gospels."[160] Also, several of the Memoirs scriptures do not appear in *any* form in

the canonical gospels. Moreover, Justin's version of the gospel tale and the Church history in its details is different from and contradictory to that found in the New Testament.[161]

Per the extant archaeological evidence and literary record, the gospel story itself does not even make its appearance in detail until the time of Justin around 140-150 CE. Even so, it is evident that Martyr did not refer to the four gospels. Nor did he address the apostles as we know them from the New Testament tales, which is peculiar considering that Justin opposed the Docetist Marcion, whose Gospel of the Lord was also "Paul's gospel" although not the "veiled gospel" of the Pauline epistles. Oddly enough, particularly since he does attack Marcion, who considered Paul the "truest apostle," *Justin never refers to Paul.* Also, despite his illusion to the Gospel of Peter, Martyr depicts virtually nothing of the chief apostle. Indeed, Reber remarks that Justin is "so oblivious of Peter that he seems to have been unconscious of his existence."[162] Concerning these important developments, Johnson remarks that the "Memorabilia do not coincide on their contents as a whole with any work that has come down to us; nor are 'the Apostles' identifiable with any known historical person." He then explains that the term "apostle" is Jewish and pre-Christian, referring to wandering Jews of the Diaspora (Jewish dispersion throughout the Roman Empire), and that the Memorabilia may simply be their "moral sayings."

In addition, rather than being sloppy in his citations, which is the accusation made to explain why his "Memoirs" differs so much from the gospels, Justin is surprisingly consistent and conscientious in his quotation. For example, Martyr quotes from the Old Testament 314 instances, 197 of which he names the particular book or author, equaling an impressive two-thirds of the total amount. Several of the other 117 instances may not have needed citation, "considering the nature of the passage." [163] Despite his remarkably fastidious record, when Justin is supposedly quoting the New Testament, he mentions none of the four gospels. Instead, he distinctly states that the quotes are from the "Memoirs." Since he is careful in his quotation of the Old Testament, it is reasonable to assume that he is accurately citing the "Memoirs" and that such a book is not the same as any of the texts found in the New Testament. There could be no reason why Martyr would not cite the gospel books by name, unless he was not using them. Since he never mentions the four gospels, it is logical to assert that he had never heard of them. Thus, the Memoirs text is not the same as the canonical gospels, and the mention of and quotation from this book does not serve as evidence of the existence of the gospels.

One absurd notion propounded as a result of the concession that Justin did *not* use the canonical gospels is that he did in fact possess the texts but never saw fit to refer to them or their authors, while willfully changing their words. This argument, were it true, would reflect intense "disregard and disrespect for the Gospels," especially since it is further argued that Justin altered them as he wished, discarding various parts and adding to the tale in other places.[164] Nor, if these precious gospels existed at his time, did Justin show any respect for their purported authors, as he never named them. Once he mentions "John," but it is evident that he does not associate any gospel with that name. Concluding that Justin "knows no authoritative writings except the Old Testament," Johnson adds that "he had neither our 'Gospels' nor our Pauline writings..."

In addition to the Memoirs, a single, non-canonical text apparently lost, Justin utilized other sources, including the mysterious Gospel of the Hebrews, which was widely read in Palestine during the second century and which in reality predates the canonical gospels. Per Cassels, the Gospel of the Hebrews was also called "the Gospel according to the Apostles," which suggests it was the same text as the Memoirs of the Apostles.[165] Other texts used by Justin include the Acts of Pilate (Gospel of Nicodemus), which he cited, and the Protevangelion and Gospel of the Infancy, as shown by Waite, among others. Justin also likely used the Gospel of Peter or "Memoirs of Peter," as he alludes to it, demonstrating that by "Memoirs" the Church father did indeed mean a *single* text. Another source for Justin's "narrative" is the Sibylline Oracles, which reflect essential points of the gospel tale. The Church father even proudly refers to the Greek prophetess, saying "the Sybil not only expressly and clearly foretells the future coming of our Savior Jesus Christ, but also all things that should be done by him." Justin's comments, of course, imply that by his time Jesus *still* had not come.

In actuality, the word "Gospels" appears *only once* in all of Justin's extant works, found in *The First Apology* (ch. LXVI), where the phrase occurs "which are called Gospels." This phrase is evidently an interpolation, of which, it must be recalled, there were many in the works of not only Justin Martyr but also practically every ancient author. The phrase is extraneous and gratuitous to the subject matter of the rest of the paragraph. To repeat, *it is also the only instance the term "Gospels" is found in Justin's entire works.* Martyr does use the word "Gospel" thrice in his *Dialogue*, but the term there refers not to the Memoirs or other texts but to *the* Gospel, i.e. the "Good News" of Jesus Christ. He also refers to *the* Gospel in one of the fragments of his

lost work on the Resurrection, but these few are the only times the word appears in Justin's known writings.

Concerning the early use of the word "Gospel," Ellegard evinces that it referred to the *"florilegia*, anthologies of Biblical passages, which were evidently popular reading among the Saints,"[166] i.e., the Jewish Messianic *Hagioi* who made up the elders of the pre-Christian churches of God found scattered throughout the empire. The Hagioi, Johnson avers, are tangential to the Hosioi, who likewise morphed into Christians.

Regarding the worth of Justin Martyr's works in establishing the existence of the canonical gospels in his day, Waite concludes:

> When it is considered that no one of the canonical gospels is expressly mentioned, nor [any] of the supposed writers, except John, and he under such circumstances as negative [sic] the presumption that Justin knew of him as the author of a gospel—that Justin refers by name to the writers of the Old Testament Scriptures nearly 200 times—that from a large number of quotations from written accounts of the sayings of Christ, only two or three agree literally with the canonical gospels—that in nearly all cases, parallel passages can only be obtained by patching together different passages, and sometimes from different gospels—that Justin quotes sayings of Christ not in the canonical gospels—that he refers to incidents in the life of Jesus, not found at all in those gospels, but which are in other known gospels—and finally that he cites two or three such by name, and one of them as authority for the miracles of Jesus; it cannot be denied that the evidence that the canonical gospels were unknown to Justin Martyr is very strong, and indeed, well nigh conclusive."[167]

Hence, with their absence in Justin's works, we remain with the dating of the gospels to the last quarter of the second century. Again, the clue to determining *who wrote the gospels* lies in this late dating—scholars have been wishfully looking in the wrong century.

The Memoirs of the Apostles reveals not the canonical gospels and their purported apostolic authors or scribes; rather, it is a text reflecting the efforts of religious Jews of the Diaspora who had established a pre-Christian "Church of God" with branches in various places, including the brotherhood sites addressed by "Paul." These anonymous Jews were eventually morphed into the New Testament apostles. Concerning this ecclesiastical organization revealed in Justin's works, Johnson concludes that here was a "class of Sectarians or Haeretics equally to be distinguished from orthodox Jews, as from the orthodox Christians." These could have been "Ebionites" or "Gnostics," but

their distinctive features included "the attitude in which they stood towards the ancestral traditions of the Fathers, Circumcision, the Sabbath, the fast-days, the Temple and the sacrificial rites." Renouncing these traditions, "they dream of a universal Jewish Church, into which the strangers shall have gathered, as the new branch is grafted into the noble stock of the ancient Vine." Johnson next avers that "Philo may well be called the first Father of such a Church."

In addition to these pre-existing Apostles are Messianic Saints, the Elect, and the Congregation/Church (*ecclesia*)—terms and concepts all found within texts such as the *Wisdom of Solomon*, the *Wisdom of Jesus* (*Ecclesiasticus*), the *Book of Tobit* and the *Book of Enoch*, as well as the *Didache*, *Epistle of Barnabas* and *Shepherd of Hermas*, all of which Johnson clearly shows to be pre-Christian texts later Christianized. These texts belong not to "Judeo-Christians" but to these "heretical" Messianic proto-Christians who already possessed an ecclesia/church, "comprising the Dispersed through the world." Said individuals thus broke "with the old observances of Judaism... The conception of a New People and a New Land published to all the world has dawned upon them." This "New People" were at some point in Egypt styled the "Therapeuts." Another such pre-Christian and probably Therapeutan text was *The Doctrine of the Twelve Apostles*, which "cites Christ's words, such as stand in the Gospels, but not as sayings of Jesus."[168] In other words, the text is one of the sources used by the gospel writers, originally not applicable to the "historical" Jesus but changed to revolve around him. It is likely that Justin Martyr, a Samaritan born at the sacred Israelite site of Shechem, whence came many of the ancestors of the Egypto-Hebrew monkish sect of the Therapeuts, was referring to a *Therapeutan* text called the "Memoirs of the Apostles."

The Proto-Christians

Egypto-Hebrew "spiritual physicians," the Therapeuts are an extraordinarily important group named as the original Christians by Eusebius in his Church history (2, 17). First referring to the discussion of the Therapeuts in Philo's *The Contemplative Life*, Eusebius pronounces them of "Hebrew stock and, therefore, in the Jewish manner, still [retaining] most of their ancient customs." The Church father further wonders if Philo "invented the designation" of "Therapeuts" or if "they were actually called this from the very start, because the title Christian was not yet in general use..."[169]

Eusebius next describes the Therapeuts' ascetic lifestyle, comparing it to that portrayed of the Christians in Acts, and

quotes Philo as concerns their location on Lake Mareotis near Alexandria. Concerning this proto-Christian sect, Philo also states:

> They read the sacred scriptures, and study their ancestral wisdom philosophically, allegorizing it, since they regard the literal sense as symbolic of a hidden reality revealed in figures. They possess also short works by early writers, the founders of their sect, who left many specimens of the allegorical method, which they take as their models, following the system on which their predecessors worked.[170]

In addition to asserting that the Therapeuts were Christian apostles, Eusebius then startles the reader by claiming that "it is very probable that what [Philo] calls [scriptural] short works by their early writers were the gospels, the apostolic writings, and in all probability passages interpreting the old prophets, such as are contained in the Epistle to the Hebrews and several others of Paul's epistles."[171]

At the time Philo wrote, the only "scriptures" to which he and others could possibly refer were the Jewish writings, many of which eventually became the so-called Old Testament, the Greek version (Septuagint) of which was used by the New Testament writers. According to the legend, the Septuagint had been translated by *Alexandrian* Jews, who were doubtlessly the predecessors of the Therapeuts, as the possession of such scriptures would very unlikely be in the hands of any other group. Eusebius is certainly correct in his assertions regarding the Therapeutan texts, as he is likewise correct that this Hebrew community was the wellspring from which Christianity emanated. It is clear from Philo that these early texts which eventually became the gospels and epistles were meant to be taken *allegorically* and not literally. In other words, the Savior contained in them was mystical, *not* historical. Regarding the Church historian's disclosures, Kuhn remarks, "Eusebius was merely testifying to what nearly all men of intelligence in his age knew to be the truth, that the Gospels, Epistles and Apocrypha were just portions of the mass of arcane esoteric wisdom transmitted, for centuries orally in the Mysteries, and later in written form, from remote antiquity to their age."[172]

By whatever moniker, the "Therapeutan" organization was in existence centuries before the common era and was well developed by the alleged time of the Christian founder, with a hierarchy including bishops, deacons, churches and monasteries, with sacred writings and commentaries read in churches, and rituals and festivals nearly identical to what later were called "Christian."[173]

Marcion of Pontus (c. 100-160 CE)

One important member of this Gnostic-Therapeutan-Christian brotherhood was the bishop Marcion of Pontus, who possessed and reworked a book called *The Gospel of the Lord.* According to Epiphanius, Marcion was the son of the bishop of Sinope in Pontus on the Black Sea. Marcion was thus a "Cappadocian"; however, as Herodotus (I, 72) says, the Greeks considered the Cappadocians to be Syrians. As a Syrian, or *Samaritan,* Marcion was well acquainted with the Jewish religion and scriptures, and he was not fond of either, rejecting the Old Testament god as a wicked demiurge.

A Docetic who did not believe in the literal incarnation of the savior god, Marcion was one of the powerful influences in the early church—a pre-existing organization that changed into "Christianity" only around Marcion's time. In other words, possibly the most powerful member of the brotherhood at Rome during the middle of the second century established Gnostic/ Docetic doctrine among his following, adamantly denying the "corporeal reality of the flesh of Christ." Marcion and the Docetists insisted that God could not incarnate, that the "Christ" they preached was a disincarnate figure, "not of human substance" and "not born of a human mother." Hence, the Savior's "divine nature was not degraded by contact with the flesh."[174] The Docetic viewpoint is simply a fancy way of stating that Gnostic Christians did not believe in an historical Jesus. In reality, some of these early Christians never knew there were claims of an historical Savior in the first place, as they died before he was placed into history.

A wealthy contributor to the Church at Rome, as well as a bishop himself—in its article "Marcionites" CE says, "it is obvious that Marcion was already a consecrated bishop" when he arrived at Rome—Marcion was one of the first to fight the efforts of the historicizing and Judaizing faction of Christianity. Although he was subsequently violently disparaged and his importance reduced, Marcion was one of the most influential early Christians, nearly attaining to the bishopric of the *Roman* Church. Concerning Marcion, German theologian Harnack stated that "no other religious personality in antiquity after Paul and before Augustine can rival him in significance." Marcionism, in fact, became one of the most popular forms of Christianity, with Marcionite churches springing up in "Italy, Egypt, Palestine, Arabia, Syria, Asia Minor and Persia." Again, Marcion's "heresy," which, according to Justin Martyr, "spread everywhere," included the rejection of the incarnation, or the denial of the Christ's "corporeality and humanity," i.e., he did not believe in an

historical Jesus. Eventually, he was excommunicated in 144 by Pope Pius I (d. 155).

Marcion was the first Christian to develop a "New Testament," publishing at Rome in Greek and Latin a "canon" or collection consisting of one gospel and 10 of the so-called Pauline epistles, excluding Hebrews and the Pastorals. It is evident that the three pastoral "Paulines," 1 Timothy, 2 Timothy and Titus, either did not exist at the time or were of little importance. The two Timothys, it appears, were written for an audience in Asia Minor, while Titus targeted Crete. Marcion's canon was non-Jewish, with the gospel containing little to identify its main hero as a "Jew," and with few or no Jewish references in the included Pauline epistles. Later writers claimed that Marcion had mutilated the original texts, removing from them anything Jewish (i.e., "Old Testament references and analogies"). However, it is not only possible but likely that Marcion's texts were closer to the originals and that they were, after Marcion's death in 160, Judaized with the pertinent material interpolated.

Thus, the Docetic Marcion's gospel, which was part of the first "New Testament" collection, was non-historicizing and non-Judaizing, in reality *predating* the canonical gospels and evidently used by the writers of the synoptics. The early Church fathers, anxious for an earlier date for the canonical gospels, pretended that Marcion had plagiarized his Gospel from Luke; yet, several scholars have discerned the opposite to be true. Among these are Cassels, Loffler, Corrodi, Eichhorn and Semler, the latter of whom "asserted that Marcion's Gospel was the genuine Luke, and our actual Gospel a later version of it..."[175] Waite likewise showed that Marcion was first and that Luke was created from it, along with 32 other texts. Johnson called the discussion of Marcion's "canon" an anachronism and remarked that Tertullian's comment regarding Marcion's gospel "means that Marcion's Evangelion was the substratum of 'our Luke.'"

The fact is that the existence of Marcion's gospel is attested to decades before the canonical gospels make their appearance in any of the early Christian writings. And, as Cassels says, even the internal evidence would "decidedly favour the priority of Marcion's Gospel."[176] Cassels argues that the gospels become increasingly more elaborate as they proceed, with "the introduction of elements from which the more crude primitive Gospels were free."[177] One such primitive gospel was Marcion's Gospel of the Lord: Usually, when there are two manuscripts of the same book—and, per the fathers, Marcion's was a shorter version identical to Luke's—"the shorter is generally the older."[178]

Cassels also points out that Justin, Marcion's ardent and contemporaneous opponent, never once even intimates that

Marcion had plagiarized his gospel from an existing canonical gospel, whether Luke or any other. If Marcion had committed this supreme literary crime, Justin surely would have assailed him at least somewhere in his writing; indeed, he likely would have made the alleged deed one of his major points of attack on this "heresiarch." The lack of such an attack and accusation by Justin against Marcion—to wit, that Marcion had plagiarized the Gospel of Luke—is a very important point: It reveals that Marcion did *not* plagiarize Luke's gospel and that the latter wasn't even in existence in Justin's time. Because Justin lived during the same time as Marcion, he was in a much better position to know the facts than Marcion's later Christian accusers, Irenaeus, Tertullian and Epiphanius. Rather than "plagiarizing" Luke's Gospel, it is evident that Marcion knew of none of the four canonical gospels.[179]

A major question concerning this debacle is how a hated "heretic" could not only possess but also publish what eventually became *the* New Testament, before the orthodox church did likewise. The answer is, of course, that the powerful, rich and connected Marcion *was* the orthodoxy before the Judaizers and historicizers moved in and took over his operation. In this manner, Marcion's Docetic, non-historical Jesus was turned into a Jewish man who allegedly "walked the earth" a century earlier.

It is apparent that Marcion's gospel preceded the canonical synoptics and that the author of Luke, at least, used it as a core text. It may be that Luke and Matthew used Marcion's Greek translation, while Mark used the Latin. An in-depth study would be desirable; however, because we do not possess the original of Marcion's gospel, which probably has some relationship to an "Ur-Markus," if it is not itself that source text, such a study would likely be inconclusive. The text of Marcion's gospel, nevertheless, was reconstructed by August Hahn and James Hamlyn Hill, reproduced by Waite, and is available online.

As concerns who created the Lukan version of Marcion's text, Dr. Carroll Bierbower, in "Was Jesus Virgin Born?" avers that it was Bishop of Antioch Theophilus himself who, about the year 160, edited and added to Marcion's gospel, "doubled its size and then named, it, 'The Gospel according to Luke.'"[180] Interestingly, per Epiphanius one of Marcion's more prominent followers was called "Lucanus" or "Lucianus," essentially the same as "Luke."[181]

The Muratorian Canon and The Diatessaron

Two other texts used by theologians and apologists to date the gospels are the Muratorian Canon and the Diatessaron. The Muratorian Canon, a list of New Testament books, was discovered in the 17th century and dated by the orthodoxy to the 2nd century

(180), by the reasoning that it was written as a move against the Gnostics. However, this latter date "is by no means firmly established," with several scholars placing the Canon in the fourth century.[182] In any event, even if it dated at the very earliest to the end of the second century, the exact period we are discussing, it could not serve as evidence of the existence of the gospels before then. The Muratori fragment lists the "Third Book of the Gospel according to Luke" and "...the fourth of the Gospels of John"; the beginning of the Muratori text is missing, such that it is presumed to have contained mention of Matthew and Mark's gospels as well. The date of 180 fits perfectly with the gospel composition dates of 170-180, and would reflect the work of Irenaeus. However, its discoverer, the Italian archaeologist, historian and priest Muratori (1672-1750), estimated that his copy was only 1,000 years old at the time.[183]

Concerning the nature of the Muratorian Canon, Cassels observes that it is an unofficial document that "merely conveys the private views and information of the anonymous writer, regarding whom nothing whatever is known."[184] Cassels concludes that the text "contains nothing involving an earlier date than the third century."[185] Again, the Canon cannot verify the existence of the gospels before the end of the second century.

The so-called "Diatessaron," ascribed to Justin's pupil Tatian (2nd cent.)—an attribution Cassels demonstrates to be sketchy—is said to be a "harmony" of the four gospels. Significantly, its purported writer never refers to the gospels or their contents in his only verified extant writing, "Oration to the Greeks."

The Diatessaron was widely used in Syria until the fifth century, when some 200 copies were destroyed by the Church custodian Theodoret, whose destruction was allegedly based on the fact that it "did not contain the genealogies and passages tracing the descent of Jesus through the race of David." In other words, this text, missing the genealogies, was less Judaized than the gospels; however, since John's gospel also did not contain such material, this excuse is untenable. It is more likely that "Tatian's Gospel" differed even more substantially from the four canonical and, like all the other non-canonical gospels, therefore had to be removed, hidden or destroyed.[186]

Differing from the gospels, rather than representing a "harmony" of them, the Diatessaron may have been the Gospel of the Hebrews or Memoirs used by Justin, as Tatian's text was called by Epiphanius the "Gospel of the Hebrews."[187] Naturally, it would be more than enlightening to have a copy of this important book; such a deplorable deficiency is the result of the censorship machine that has been in operation for centuries and millennia.

The Acts of the Apostles

It can be shown by the same thorough exegesis applied to the gospels that there is likewise no trace of the canonical Acts of the Apostles before the end of the second century. Acts has been attributed to "Luke," the purported companion of Paul; however, since the text was evidently not in existence until the end of the second century, it could not have been written by a contemporary of Paul. Moreover, the author of Acts, which was written in a "purer Greek" than any other canonical text, uses the Greek Old Testament rather than the Hebrew. This author was therefore not "Luke," as has been accepted as "gospel truth," but likely a Hellenized Jew of the Diaspora, as he possessed little knowledge of Palestine.

The speeches in Acts seem to have been professionally written from the mind of the author, rather than serving as a record of numerous speakers. The speeches for both Peter and Paul, for example, vary little in sentiment or style, revealing that they were constructed by the author and are not "eyewitness reports" of actual orations by these individuals.[188] These speeches are so unwieldy that it would have been nearly impossible to record them in those days with any degree of accuracy.[189] It should also be kept in mind that these speeches had to be *handwritten*, without benefit of printing presses, typewriters, computers or recording devices, which even today do not lead to infallible records. Hence, it is evident that the speeches in Acts represent fiction, as does most of the rest of the book.

Regarding the martyr Stephen in Acts, Cassels is not only skeptical as to the authenticity of the speech put into his mouth, but he also questions whether or not "there really was a martyr of the name of Stephen."[190] Eisenman regards Stephen's speech as "seemingly lifted almost bodily from Joshua's farewell address to the assembled tribes at Shechem in the Old Testament (Jos. 24:2-24)." A mistake in the speech concerning "the location of Abraham's burial site" provides proof of this assertion, as it also present at Joshua 24:32. Eisenman also finds it bizarre that Stephen, a Gentile, is depicted as "telling the *Jews* (now his tormentors) their *own* history."[191] Eisenman's conclusion is that the Stephen in Acts is a "fictitious stand-in, as are quite a few other characters we have already called attention to in Acts..."[192]

Drews sees intimations of an astrotheological motif in Stephen: To wit, Stephen's martyrdom occurs on December 26th, the day after Jesus's winter solstice birth, and has to do with the constellation of Corona ("crown"), which is "Stephanos" in Greek, and which "becomes visible at this time on the eastern horizon."[193] Taylor relates that Stephen is *Stephanos Arcticos*, the

"Northern Crown," which is the "First Martyr" at the vernal equinox.[194] Eisenman sees this "stephanos" or crown as referring to *"the unshorn locks of the Nazirite...which* tradition says was *worn by James,"* referring to James the Just, "the brother of the Jesus."[195] Eisenman furthers equates the stoning of Stephen with the stoning of the James described in Josephus.

In any event, Cassels finds the scene with Stephen to be overly dramatic, as if from a play:

> As the trial commences with a supernatural illumination of the face of Stephen, it ends with a supernatural vision, in which Stephen sees heaven opened, and the Son of Man standing at the right hand of God. Such a trial and such an execution present features which are undoubtedly not historical.[196]

Concerning Stephen's purported effect on Paul, which some (such as Bunsen) claim was so profound that the latter began to follow the former in a master-disciple relationship, Cassels denies that there is any evidence that Stephen made such an impact on Paul. Indeed, "the speech and martyrdom of Stephen made so little impression on Paul that, according to Acts, he continued a bitter persecutor of Christianity, 'making havoc of the Church.'"[197]

In reality, Paul's behavior in Acts and elsewhere belies the "historicity" of the tale. As Cassels remarks, it is unbelievable that the sudden and supernatural conversion of someone who previously had so openly persecuted the Church would have remained unknown to the Jerusalem community for three years, as depicted in Acts.[198] Knowing what we do about how modern apologists make much ado of the conversion of an "enemy," one could logically assume that such an earth-shattering victory would have spread through the community like wildfire. But, it did not, and the story is entirely implausible, if, as asserted at Acts 8:1-3, 22:4, 26:10 and Gal. 1:13, Paul were truly responsible for several Christian deaths. Surely, if this fable represented "history," someone would have noticed this mad mass-murderer and prosecuted him. Again, neither Paul nor his crimes against Christians appears in the historical record.

In any case, the problem with the speeches in Acts extends to that of James, regarding which Cassels says, "There are many reasons for which this speech also must be pronounced inauthentic."[199] Cassels then provides painstaking detail for these reasons, including that James is made to quote from the Septuagint and not the Hebrew Old Testament, which is highly improbable for someone as orthodox and Jewish as James. Furthermore, as is the case with so much of the Greek text, the Septuagint passage quoted (Amos 9:11-12) is different from the original Hebrew, a fact seemingly unknown to "James." Regarding

this situation, Cassels remarks that it is nearly inconceivable that "James, a bigoted leader of the Judaistic party and the head of the Church of Jerusalem, could have quoted the Septuagint version of the Holy Scriptures, differing from the Hebrew, to such an assembly."[200]

After much scrutiny, it becomes evident that the sentiments expressed in these speeches are not reflective of the known mentalities of the purported speakers. Cassels concludes that the speeches in Acts, although attributed to a variety of individuals, are "all cast in the same mould" and demonstrate that the originator was one person: Acts' author. Cassels also states that it becomes evident, when the "circumstances related" are tested against known events and "trustworthy documents," that Acts' narrative itself is "but a reproduction of legends or a development of tradition," as filtered through the mind and "pious views" of the writer. He then says, "The Acts of the Apostles, therefore, is not only an anonymous work, but upon due examination its claims to be considered sober and veracious history must be emphatically rejected."[201]

In other words, the Acts of the Apostles, evidently also dating to the last quarter of the second century, essentially represents fiction, not history. It is useless as testimony to an "historical" Jesus. After demonstrating that Acts is little but a corrupted rehash of Josephus, at one point Eisenman exclaims, "What malevolent fun the authors of Acts would appear to having, transmuting history into meaningless dross."[202]

Revelation/Apocalypse

The book of Revelation is likewise not an historical text and cannot be used in any way to demonstrate the historicity of Jesus. Contrary to popular belief, Revelation, or the Apocalypse, could not have been composed by the same person who wrote the epistles and gospel attributed to John. Indeed, Revelation was written in "harsh and Hebraistic Greek" and is mentioned earlier in the literary record than John's gospel, with its "polished elegance." Revelation was considered spurious by many Church authorities, a number of whom, oddly enough, attributed not only the Gospel of John but also Revelation to the Gnostic "heretic" Cerinthus (2nd cent.). One group who claimed Cerinthus wrote both Revelation and John's gospel were the so-called Alogi, "heretics" in Asia Minor around the end of the second century. The Christian father Dionysius also related that Revelation was ascribed by some to Cerinthus. One such person who attributed both Revelation and John's gospel to Cerinthus was the Roman churchman Gaius.[203]

The book of Revelation is composed in "the most Hebraistic Greek of the New Testament" and is the most "tinged with Judaism."[204] As evidence of its thorough Jewishness, the names of the 12 apostles are written on the heavenly Jerusalem's 12 foundation walls, upon whose 12 gates are inscribed the 12 tribes of Israel, who alone may pass through.[205] While the author of Revelation is thus Jewish, or Hebrew, the author of John's gospel is notorious for his anti-Judaic sentiment, and the two texts assuredly were written by different authors.

Concerning Revelation, Drews remarks that it is apparently an originally Jewish text worked over by Christians; he also avers that when the nucleus was written is undeterminable.[206] As demonstrated in *The Christ Conspiracy*, Revelation is an astrotheological text, the pre-Judaic core of which was likely composed centuries prior to the Christian era, with the Judeo-Christian façade added much later. The canonical text is but one of a genre of apocalypses; thus, it is not a unique revelation from the Almighty Himself.

Where are John the Baptist, Judas and Pilate?

Like the "historical Jesus," also absent from the earliest Christian texts are John the Baptist, Judas and Pilate. Concerning the Baptist in early Christian literature, Doherty remarks:

> And where is the Baptist? In Christian mythology there is hardly a more commanding figure short of Jesus himself. The forerunner, the herald in camelskin coat, the scourge of the unrepentant, the voice crying aloud in the wilderness. Until the Gospels appear, John is truly lost in the wilderness, for no Christian writer refers to him.[207]

The Baptist's presence in John's gospel (1:6-8 and 1:14) is obviously an interpolation into an older Gnostic text, as it breaks the Logos/Word discussion preceding and succeeding it. Additionally, John's speeches in the New Testament are direct lifts from the Old: "Nearly every detail of the words put in the mouth of the Baptist is found in the words of the prophet [Isaiah]..."[208] Indeed, "the whole story of the appearance of John and the baptism of Jesus is built on the prophet Isaiah."[209]

Like so many others in the Bible, John is not an original character, his precedent in Judaism being Elijah, with whom he is compared by Jesus (Mt. 11:14). "But Elijah, who passed among the Jews for a forerunner of the Messiah," says Drews, "is a form of Sun-God transferred to history." John is added to the story in order to "fulfill prophecy," with his role of messenger preparing the way for the "sun of righteousness" outlined in a number of places in the Old Testament, including at Malachi 3:1, directly

preceding the New. Hence, it is not "fulfillment of prophecy" but a reflection that the gospel writers used the Old Testament as a blueprint for the creation of their fictional story.

John is nowhere to be found outside the gospels, except for a passage in Josephus's *Antiquities* (XVIII, v, 2). Yet, this Josephan "John the Baptist" is never connected to Christianity, and his story is somewhat different from that which ended up in the later gospel account. Moreover, the chronology in Josephus does not match that of the eventual gospel tale, and the entire story is suspected as a forgery.[210]

It is Drews's conclusion that "the baptism in the Jordan" can only be understood in astrological terms, that John the Baptist, as portrayed in the gospels, "was not an historical personage" and that the Josephan Baptist material was forged "by some Christian hand."[211] Concurring with other scholars, Graetz calls the John passage in Josephus "a shameless interpolation." As "doubtful as that of the two references in Josephus to Jesus," the John passage also interrupts the narrative, indicating itself to be an interpolation.[212] Remsburg asks, "Is John the Baptist an historical character?" and comments that the language of the Josephus passage is suspicious and its position in the text "strongly suggests an interpolation."[213] Knowing that the TF and the James passage are forgeries, would it be surprising that this primitive Baptist passage is likewise bogus?

The Josephan Baptist material is likely based on ancient fables regarding the Babylonian god Oannes the Dipper, whose popularity at the beginning the common era was nearly at its peak. In this regard, Rev. Taylor comments that "Josephus himself evidently [derived] the story from the Chaldean Berossus, who describes an amphibious animal, under the very name of Oannes...[who] acquired the name of John the Dipper."[214] Drews concurs that John is the ancient "Babylonian Water-God, Oannes (Ea)," one of the 12 great gods of the Chaldean zodiac whose worship included baptism.[215] The name of this fish-god, Oannes— one of the Chaldean 12 "great gods"—is the same as "John" in Greek (Ιωαννες, or I-Oannes).

It is probable that at some point there were one or more officials named John within the baptist cult, since priests often took on the name of the god they were representing. The baptist cult, manifested in the Mandaeans (baptist Sabeans), appeared in the precise location where Oannes had been revered for centuries, if not millennia. It is interesting to note that the Mandaeans were known to be "mostly craftsmen, particularly metal-workers and *carpenters*..."[216] It is also intriguing that the priests of the Mandaeans were called "Nazoreans,"[217] i.e., Nazarenes or

Nazarites. Hence, the myth of Jesus as a carpenter and Nazarene makes him not only a member but also a priest of the Mandaean cult. Interestingly, like Marcion and other Gnostic-Christians, the anti-Judaic Mandaeans rejected the Pentateuch and its god Yahweh, whom they considered an evil being. Moreover, the Mandaean religion "contains much that is Indian," a believable contention, considering that the Mandaeans were situated in the area of Persian influence, "close to the Persian Gulf" and "easily reached by sea from India."[218] As Drews points out, "from ancient times Babylonian trade went down to India and Ceylon."

Like John, the disciple and betrayer Judas—so crucial to the gospel story—exists nowhere in the epistles or other early, noncanonical Christian writings, not to mention non-Christian sources. As Doherty points out, the epistle writers miss opportunities to curse his name when discussing the betrayal and death of "our Lord"—as if they had never heard of him. Scholars such as Volkmar and Guignebert declared fictitious the betrayal by Judas, while Loisy suggested it represented a personification of the "incredulous and false Judaism."[219] Robertson avers that "Judas" started out simply as "a Jew," or *Ioudaios* in the Greek.[220] Eisenman calls Judas a "largely mythological character."[221]

The term "Judas" stands for the entire tribe or nation of Judah or Judea, "Judas" (Ιουδας) being the Greek spelling of Judah. In other words, in the Greek bible, both Old and New Testaments, Judah and Judas are spelled exactly the same. The betrayal by Judas/Judah was thus designed to throw the onus of Jesus's death upon the Jews as a whole. Judas's story, Rylands determines, must have postdated that of Pilate in the Passion tale, and it is obvious that it was interpolated in a quest to garner Roman favor, as the church became increasingly Romanized and anti-Judaic.

The Roman governor Pilate himself does not factor into the Christ myth until the second century, with the appearance of the (forged) epistles of "Ignatius" and 1 Timothy, the latter of which contains the only non-gospel mention of Pilate in the New Testament. It is widely acknowledged that 1 Timothy was not written by Paul, and the epistle has been placed after 144 CE. Hence, Pilate becomes a later figure in the Christ myth, incorporated after the historicizers began to put the tale into history. Jesus's trial by Pilate has been shown by numerous writers, including Loisy, Schmiedel and Rylands, to have been fictitious.

Pilate was apparently chosen to be the villain in the gospel fable because he was hated both in Judea and Samaria, for a variety of offenses, including his initial blunder in moving his

headquarters from Caesarea to Jerusalem, which so incensed the Jews that he was forced to retreat. Eventually Pilate angered the Samaritans by massacring many of them during a pursuit for treasure at Gerizim, an act of violence that caused the prefect to be called before the emperor in Rome.

Nazareth, Cana, Bethany, etc.

The inaccuracy of the gospels as to dates and places has been demonstrated thoroughly by a number of scholars, including Cassels, Drews and Wells, whose arguments need not be repeated here. Such errors on the part of the gospel writers, of course, prove that these texts are not the "infallible Word of God." The whole of Matthew has a dreamy, play-like atmosphere about it, with no precise chronology, no concept of the length of Jesus's advent, and the ludicrous notion that Jesus, "the pious Jew," came to Jerusalem "for the first time at Passover." Matthew's idea of location is ridiculously vague: "a house, a mountain, a solitary place, and so on." The other synoptics, Mark and Luke, are essentially the same in regard to their vagueness of place and time, despite the fact that Luke presents himself as an "historian." In his dissection of the gospels' "accuracy," Drews notes how unhistorical are phrases such as "In those days," "At that time," "On a Sabbath day," "After eight days," "At the same hour," etc., which are commonly found in Luke, as well as the other gospels. Concerning Luke, Drews concludes that "we find him historically inaccurate in every case."[222]

Evidence in Christian literature of the sacred sites "where our Lord walked" is non-existent as well. After meticulously highlighting the omissions and ignorance of the Christian writers regarding any "life of Jesus," Doherty remarks that it is astonishing that none of the early Christian writers expresses any desire to visit these sacred sites, where Jesus was born, where he preached, the "upper room" in which the Last Supper occurred, where he was crucified, his tomb, etc. Doherty further expresses surprise that the numerous relics belonging to Jesus, such as his clothes, utensils and objects he handled, were not collected, "prized, clamored for, to be seen and touched by the faithful themselves." He asks, why wouldn't so devoted a Christian as Paul wish to possess such a memento? Why was there not shortly after Jesus's purported advent a fierce competition to provide such relics to the faithful? Doherty next observes:

> If the Gospel account had any basis, we would expect to find mention of all sorts of relics, genuine or otherwise: cups from the Last Supper, nails bearing Jesus' flesh, thorns from the bloody crown, the centurion's spear, pieces of cloth from the garments gambled over by the soldiers at the foot of the cross—indeed, just

as we find a host of relics all through the Middle Ages that were claimed to be these very things.[223]

In reality, such "sacred relics" were bogus, cranked out by the hundreds over a period of centuries.

The sacred sites that Paul and others should have been clamoring to see were non-existent, as were a number of the towns relevant to the gospel tale, including Nazareth, which was a fictional location used to cover up the fact that to be a "Nazarene" meant not to be a person from Nazareth but to be a member of a pre-Christian monkish order that was morphed into Christianity. As we have seen, the priests of the pre-Christian baptist cult the Mandaeans were called Nazarenes; per Epiphanius, the Nazarenes (Nazoreans) existed "*even before Christ*," as did the "so-called 'Essenes' at Qumran."[224] Church father Tertullian also clarified that "Nazarene" was derived from "Nazarite," a "class of Jewish ascetics," who existed long before the Christian era, as discussed in the Old Testament (Num. 6; Judges 13, 16), particularly in reference to the sun god Samson, their most famous "member." As Thayer's Lexicon notes, Nazarene and Nazarite are equivalent.

In the original New Testament Greek "Nazaraios" (*Nazarite*) occurs 15 times, and "Nazarenos" (*Nazarene*) four, but both are repeatedly mistranslated as "of Nazareth." At John 19:19, the term "Nazaraios" appears in the sign above his cross, which thus says, "Jesus the *Nazarite*," not "Jesus of Nazareth." It is obvious that the intent was to designate the Savior as a member of the sect of the Nazarenes or Nazarites. In Acts (2:22, 3:6, 4:10, 6:14, 22:8, 24:5, 26:9), Jesus and his followers are called *Nazarites*, referring specifically to a brotherhood, not a place. Concerning this issues, Eisenman states that the term Nazarene, Nazoraean or Nozrim "probably cannot derive from the word 'Nazareth,'" but that the reverse could be the case, which means "there could be a city in Galilee which derived its name from the expression *Nazoraean* in Hebrew, but not the other way around as the Gospels seem to prefer."[225]

The town of Nazareth was not a real place, a contention evinced many times, declared even by the Protestant authority the Encyclopedia Biblica to have not existed during Jesus's time. Nazareth is absent from the Old Testament, the Jewish "intertestamental" literature and the works of Josephus, even though the latter lived within miles of its supposed location. In reality, Nazareth does not appear as a town until the 4th century CE, "when pilgrim traffic began." At the spot where Nazareth was eventually located there are no building remains from the first century CE or earlier, and the site apparently was a necropolis. An

inscription found in 1962 at Caesarea purported to mention Nazareth dates from the late third to early fourth century and is thus too late to serve as evidence of the town's existence in the first century. In any case, it likely does not mention Nazareth after all.[226]

In addition, the famous Wedding at Cana likewise has no historical setting: "No place named Cana is mentioned in any document except the Fourth Gospel. The name may have been suggested by the Greek word *kaina* (*new things*)."[227] That the story of the wedding at Cana consists of ancient mythical elements has already been demonstrated with the water-to-wine miracle, which symbolizes the sun ripening the grape on the vine and fermenting the grape juice to wine. The tale representing history is further implausible in that the guests present must have already been inebriated from the wine before Jesus produced another *90 to 135 gallons*, which is the absurd amount recorded in the gospel account.[228]

The famed Bethany is also evidently mythical. At John 1:28, Bethany is cited as "beyond Jordan, where John was baptizing"; yet, there was no Bethany beyond the Jordan, an error noticed by Origen, who attempted to correct it by naming the place "Bethabara." There was a Bethany near Jerusalem, but "it is scarcely possible that there could have been a second village of the name; no trace of it existed in Origen's time, and it is utterly unknown."[229] In the Egyptian mythos, Bethany ("Beth-Anu") is the "house of god" and "abode of heaven" called "Annu," the equivalent of Jerusalem, the "fields of Aaru" in Egyptian.

The town of Bethesda, site of the famous pool, is also a mythical motif from the Egyptian religion. Such a pool in Judea was "unknown even to Josephus, or any other writer of that time." Naturally, "Gethsemane" is another biblical place-name that cannot be found in history; so too is Golgotha, the "place of skulls," also known as Calvary.[230] In addition, the town in Samaria named "Sychar" (Jn 4:5) is non-existent.[231] From these and other errors, it is clear that the writers were not natives of Palestine and, hence, not eyewitnesses of Jesus's purported advent. Concerning the bulk of the gospel place-names, Drews concludes, "The names of places in the gospels...afford no evidence whatever of the historicity of Jesus, since the whole topography of the life of Jesus is in its main lines borrowed from Isaiah and other prophets."[232] The reason these places are not found on Earth (until after the fable became historicized) is that the book is a reflection of Egyptian mythology, with its *allegorical* sacred sites, which were part of the mysteries.

Furthermore, as Leidner points out, the writers of the New Testament were so incompetent and removed from the alleged

events they were writing about that they made gross errors in the geography of what is essentially a tiny region, *because they used the outdated text of the Septuagint* as the basis for their historical fiction. A 90-mile span from Capernaum to Jerusalem comprises the entire area for the drama unfolded in the gospel fable. In this area, there was "a common language, Aramaic, and the customs and usages were known to all."[233] Nevertheless, the gospel authors are blatantly unfamiliar with the territory, and their descriptions are entirely anachronistic. For example, this small area had been urbanized for decades and centuries; yet, the gospel writers discuss shepherds and large areas set aside for sheep—sheep that had no place in first century Judea, Samaria and Galilee. In response to the gospel claim concerning the Baptist's "preaching in the wilderness," Taylor appropriately asks, "And what wilderness was that?"

Josephus's description of Galilee in his *Wars of the Jews* (III.III.1) names "204 villages and 15 fortified towns" and—while perhaps overstated ("the cities lie here very thick; and the very many villages there are here, are everywhere so full of people...")—makes it clear that the placement by the gospel writers of the Jesus myth in wild badlands is completely erroneous and fictitious. Another humorous, anachronistic error in "God's infallible word" occurs with the parable of the sower, the narrator of which is unfamiliar with the plow, while the parable itself is "told to 'great multitudes' who have taken time out from sheep-herding and stone age agriculture."[234]

Leidner also points out that while Josephus describes the Galileans as hardy people, the gospel writers have leper colonies and sickly people all about. In addition, the gospel writers use names from the Greek Old Testament for places that had been designated otherwise for centuries. Using the Septuagint for the fable's topography is equivalent to an American writer erroneously placing a modern tale in 12th century Europe.

As we can see, even various places in the gospel fable are mythical motifs and/or anachronistically named. The interweaving of Judaism and Jewish history and topography into the ancient mythos does not prove the historicity of Jesus; rather, it demonstrates that, in order to give the ancient celestial mythos and ritual an historical appearance, the gospel writers deliberately chose Judea and the Jewish people, using extant texts and information from the various religions, mystery schools, secret societies, etc., and interpolated Jewish "history," making the characters Jewish. This mythmaking process was not new to the gospel writers, as the mythology and astrotheology invoked was well known and had already been historicized many times in Old Testament stories.

Conclusion

It has been demonstrated that there is no evidence for the existence of Jesus Christ, Christians or Christianity in the literary or archaeological record of the first century. Nor do the earliest Christian texts provide evidence of an "historical" Jesus. In addition, the canonical gospels do not make their appearance until late in the second century. Moreover, a number of the main characters and places in the gospel tale cannot be verified by extrabiblical evidence. In the end, it is evident that "the traditional narrative of the Birth, Death, and Resurrection was constructed from data of the Old Testament, mystically interpreted."[235] In "How Jesus Got a Life," Frank Zindler concludes that "*'Jesus Christ' never existed as an historical figure*," that there "is no credible evidence indicating Jesus ever lived," and that the "Christ biography can be accounted for on purely literary, astrological, and comparative mythological grounds." Leidner concurs, remarking, "The gospel story is fictional in its entirety. There never was a Jesus of Nazareth and there never was a crucifixion story."

It is claimed that the reason Jesus is not found in any historian's works of the day is because, while a "real person," this "world savior" was an "itinerant Galilean preacher" and an "obscure rabbi." This obscure rabbi's "bio" was then enhanced by his followers, who, after his death, added a series of miracles and fairytales to his mundane life. After a thorough analysis of all the evidence, it is plain that the gospel tale is not a "biography" of an "itinerant Galilean preacher," who nobody had heard of but whose unknown and impoverished followers were so powerful that they could pull off one of the greatest coups in history. It simply did not happen. There was no "man" who so inspired his lowly disciples that—with greater supernatural power than Jesus ever possessed—they could convince Rome, with its crusty, cynical, old white male elite, to fall down on its knees to worship him. Particularly when he was of a "race" or ethnicity deemed peculiar and troublesome, if not despised, throughout the Roman Empire.

As to the Romans mindlessly adopting this non-entity from the backwater and turning him into a god, again, can anyone seriously imagine today the U.S. Senate entertaining for one moment the idea of deifying, say, a begging, dirty, scruffy, homeless, provincial preacher from an alien culture, whose fable was presented to them, decades or centuries after the alleged events, without a shred of evidence that it ever happened? And to adore and worship one whose close companions included poor and uneducated hayseeds? The all-powerful Romans suddenly overthrowing their entire established, entrenched and profitable

religious organizations and priesthoods, the secret societies to which practically all the elite belonged, closing down the mystery schools that had been in existence for ages, forgetting utterly about the numerous gods they adored for eons, and reducing their current leader, who himself was deified, to a mere servant of an obscure preacher from hicksville? Such a scenario is impossible to conceive, even with the gullibility and credulity of a small child. Such a view constitutes naivete of the highest order. Importantly, it represents a deleterious delusion.

When faced with the comparative mythology that reveals the gospel fable to be mythical, apologists clamor for "primary sources" or original texts to prove such assertions. In the first place, tremendous destruction of ancient cultures and such evidence followed Christianity wherever it went. Secondly, again, we would in turn request those "primary sources" that prove the validity of biblical claims. Where are the original gospels, written by the very hands of the blessed apostles and disciples themselves? Where are any artifacts that prove the gospel events happened? Or any of the other fabulous biblical tales? Where is the original Josephus that proves the Testimonium Flavianum is not a forgery? Where is an original text of an early Church father that clearly demonstrates the gospels were in existence before the end of the second century? And what to say of the first century?

Apologists often hold up the opinions of specialists in other fields who have nonetheless ventured the opinion that, beneath whatever aspects of the gospel tale may be fictional, there is still "some guy there." It is clear upon examination that these writers have not studied the subject in depth and have not "given any critical consideration to the question," accepting what they have been told generally since childhood, believing not based on "scientific grounds, but out of conventional feeling."[236]

In other words, when one studies the subject *in depth*, the conclusion is that there is no core to the Christian onion. Overall, it is evident that, like *Gulliver's Travels*, the gospel story is fiction, not history. Like Gulliver, Jesus is given a "real world" in which to play out his drama, with a few real figures out of history, but this tactic is no different than what was done with the numerous ancient gods, who in actuality never existed as "real people."

Both under scrutiny and to the untrained eye, it is obvious that the fable of Christ is essentially the same as that of various gods and godmen who were widely known and worshipped at the time of the Jewish godman's alleged advent. The reason for all the similarity, of course, is that these various gods were not "real people" with the same biographies but part of the ancient, ubiquitous astrotheology, with its celestial centerpieces, including the all-important God Sun.

1 Budge, *ETL*, 278.
2 www.infidels.org/library/historical/marshall_gauvin/
 did_jesus_really_live.html
3 Drews, *WHJ*, 57.
4 Rylands, 132.
5 www.ccel.org/fathers2/NPNF2-06/Npnf2-06-07.htm#P5779_1681529
6 www.newadvent.org/fathers/07014.htm
7 Bunsen, 339.
8 Bunsen, 341.
9 Drews, *WHJ*, 130.
10 Graves, K., 336.
11 Cassels, 366.
12 *CMU*, 84.
13 *CMU*, 69.
14 Kuhn, *WKG*, 157.
15 Kuhn, *WKG*, 257.
16 Drews, *WHJ*, 2.
17 Ellegard, 5.
18 Inman, *AFM*, 98.
19 www.infidels.org/library/modern/gordon_stein/jesus.html
20 Goguel, 26.
21 Josephus, 379.
22 pages.ca.inter.net/~oblio/supp10.htm
23 *CMU*, 47.
24 www.ccel.org/fathers2/ANF-04/anf04-55.htm (Emph. added.)
25 www.ccel.org/fathers2/ANF-10/anf10-46.htm#P7275_1473138
 (Emph. added.)
26 Drews, *WHJ*, 9.
27 Wells, *JM*, 202.
28 www.ccel.org/fathers2/NPNF2-06/Npnf2-06-03.htm
29 Wells, *JM*, 201.
30 www.positiveatheism.org/hist/rmsbrg02.htm
31 www.newadvent.org/cathen/08522a.htm
32 www.positiveatheism.org/hist/rmsbrg02.htm
33 Freke and Gandy, 137.
34 www.christianism.com/html/article1.html
35 Drews, *WHJ*, 32-32fn.
36 Graves, K., 323.
37 www.earlychristianwritings.com/testimonium.html
38 www.earlychristianwritings.com/testimonium.html
39 Wells, *JM*, 204.
40 Wells, *JL*, 49.
41 www.infidels.org/library/modern/scott_oser/hojfaq.html
42 www.infidels.org/library/modern/scott_oser/hojfaq.html
43 www.mystae.com/restricted/reflections/messiah/sources.html
44 Rylands, 266fn.
45 www.positiveatheism.org/hist/rmsbrg02.htm
46 Drews, *CM*, 230-231.
47 Rylands, 265.

48 Drews, *CM*, 172.
49 Eisenman, *JBJ*, 396.
50 mama.indstate.edu/users/nizrael/jesusrefutation.html
51 Taylor, *TD*, 401fn.
52 Taylor, *TD*, 403.
53 Taylor, *TD*, 407.
54 Drews, *WHJ*, 49-50.
55 Picknett and Prince, 282.
56 Drews, *WHJ*, 51-52.
57 Drews, *WHJ*, 53.
58 www.newadvent.org/fathers/07014.htm
59 Drews, *WHJ*, 54.
60 Kuhn, *WKG*, 164.
61 Taylor, *TD*, 403.
62 Taylor, *TD*, 404.
63 Drews, *WHJ*, 18-19fn.
64 Drews, *CM*, 228.
65 Drews, *CM*, 231.
66 Taylor, *TD*, 393.
67 Taylor, *TD*, 396.
68 Cutner, 116.
69 Cutner, 117.
70 Drews, *WHJ*, 27.
71 Drews, *WHJ*, 47.
72 Dupuis, 292-293.
73 Eisenman, *JBJ*, 624.
74 *ECD*, 211.
75 Volney, part 2, 41
76 www.christianism.com/articles/3.html
77 www.infidels.org/library/modern/jeff_lowder/jury/
 chap5.html#phlegon
78 www.infidels.org/library/modern/richard_carrier/thallus.html
79 www.ccel.org/g/gibbon/decline/volume1/chap15.htm
80 www.ccel.org/g/gibbon/decline/decline1.txt
81 www.infidels.org/library/magazines/tsr/1996/4/4front96.html
82 Lundy, 234.
83 www.newadvent.org/cathen/09154a.htm
84 www.humanists.net/jesuspuzzle/BkrvZindler.htm
85 www.christianism.com/html/add36d.html
86 Drews, *WHJ*, 11.
87 Drews, *WHJ*, 16.
88 Drews, *WHJ*, 16-17.
89 www.christianism.com/articles/21.html
90 Ellegard, 24.
91 Leidner, 26.
92 Weisman, 5.
93 Drews, *WHJ*, 90.
94 Drews, *WHJ*, 103.
95 Weigall, 26.

[96] Inman, *AFM*, 99.
[97] *vide* Drews, *WHJ*, 77.
[98] Drews, *CM*, 175.
[99] Drews, *WHJ*, 103.
[100] Eisenman, *JBJ*, 389.
[101] Cassels, 917.
[102] Drews, *WHJ*, 118.
[103] Drews, *CM*, 208.
[104] Drews, *WHJ*, 102.
[105] Drews, *WHJ*, 59.
[106] Mead, 39.
[107] www.pakistanlink.com/religion/religion-6-28-96.html
[108] www.islamic-awareness.org/Quran/Text/Qiraat/green.html
[109] Drews, *CM*, 215.
[110] www.mindspring.com/~scarlson/synopt/chron.htm
[111] Mack, 20.
[112] www.mindspring.com/~scarlson/synopt/chron.htm
[113] Mack, 20.
[114] www.mindspring.com/~scarlson/synopt/chron.htm
[115] www.newadvent.org/cathen/14389b.htm
[116] Reber, 66.
[117] Reber, 79.
[118] Reber, 81.
[119] Reber, 82.
[120] Cassels, 539.
[121] Cassels, 199.
[122] Cassels, 3.
[123] Cassels, 5.
[124] Cassels, 7.
[125] *CMU*, 144-145; Keeler, 17.
[126] www.radikalkritik.de/antiqua_mater.htm
[127] Keeler, 18.
[128] Cassels, 338.
[129] Keeler, 20.
[130] Kuhn, *WKG*, 151.
[131] Bonwick, *EBMT*, 419.
[132] Kuhn, *WKG*, 187.
[133] James, 314.
[134] Cassels, 383.
[135] Cassels, 350.
[136] Cassels, 355.
[137] Cassels, 491.
[138] Keeler, 84-85.
[139] Kuhn, *WKG*, 234.
[140] Keeler, 22-23.
[141] www.blueletterbible.org/tmp_dir/strongs/992943402.html
[142] www.ccel.org/fathers2/ANF-01/anf01-60.htm#P7297_1937859
[143] www.ccel.org/fathers2/NPNF2-06/Npnf2-06-23.htm#P8094_2629367
[144] www.newadvent.org/cathen/03539a.htm

145 www.dabar.org/NewTestament/Berkhof/john.html
146 Reber, 118.
147 Reber, 186.
148 Inman, *AFM*, 99.
149 www.dabar.org/NewTestament/Berkhof/john.html
150 Keeler, 15.
151 Ellegard, 32.
152 Ellegard, 33.
153 Ellegard, 42.
154 Taylor, *SECR*, 100.
155 Reber, 28.
156 Kerenyi, 49.
157 Kerenyi, 223.
158 Drews, *WHJ*, 229.
159 Cassels, 286.
160 Keeler, 21-22.
161 Cassels, 249.
162 Reber, 130.
163 Cassels, 257.
164 Cassels, 258.
165 Cassels, 344.
166 Ellegard, 54.
167 Waite, 315.
168 Drews, *CM*, 220fn.
169 Eusebius, 50-51.
170 Eusebius, 51-52.
171 Eusebius, 52.
172 Kuhn, *WKG*, 112.
173 Reber, 35.
174 Cassels, 454.
175 Cassels, 438.
176 Cassels, 473.
177 Cassels, 475.
178 Keeler, 82.
179 Cassels, 478.
180 www.geocities.com/Athens/Ithaca/3827/virginborn.html
181 www.newadvent.org/cathen/09645c.htm
182 Ellegard, 45.
183 Cassels, 540.
184 Cassels, 540.
185 Cassels, 546-547.
186 Cassels, 487.
187 Cassels, 631.
188 Cassels, 767.
189 Cassels, 757.
190 Cassels, 725.
191 Eisenman, *JBJ*, 440.
192 Eisenman, *JBJ*, 453.
193 Drews, *CM*, 211fn.

194 Taylor, *DP*, 218.
195 Eisenman, *JBJ*, 223.
196 Cassels, 808.
197 Cassels, 806.
198 Cassels, 849.
199 Cassels, 873.
200 Cassels, 875.
201 Cassels, 919-920.
202 Eisenman, *JBJ*, 494.
203 Eusebius, 369.
204 Cassels, 650.
205 Cassels, 793.
206 Drews, *WHJ*, 223.
207 Doherty, *JP*, 59.
208 Drews, *WHJ*, 187.
209 Drews, *WHJ*, 189.
210 Robertson, *CM*, 396.
211 Drews, *CM*, 121.
212 Drews, *WHJ*, 192.
213 www.positiveatheism.org/hist/rmsbrg05.htm
214 Taylor, *DP*, 53.
215 Drews, *CM*, 122.
216 Eisenman, *JBJ*, 330.
217 Eisenman, *JBJ*, 325, 836.
218 Drews, *CM*, 111.
219 Rylands, 192.
220 Robertson, *CM*, 354.
221 Eisenman, *JBJ*, 456.
222 Drews, *WHJ*, 157-158.
223 Doherty, *JP*, 75.
224 Eisenman, *JBJ*, 837.
225 Eisenman, *JBJ*, 250.
226 www.americanatheist.org/win96-7/T2/ozjesus.html
227 Rylands, 224.
228 www.blueletterbible.org/Comm/jfb/Jhn/Jhn002.html
229 Cassels, 661.
230 Evans, 67.
231 Cassels, 662.
232 Drews, *WHJ*, 205.
233 Leidner, 181.
234 Leidner, 182.
235 www.radikalkritik.de/antiqua_mater.htm
236 Drews, *WHJ*, 248.

Jesus Christ, Sun of God

The Gnostic sects, from which Christianity originated, knew at first only an astral Jesus, whose mythic "history" was composed of passages from the prophets, Isaiah, the twenty-second Psalm, and *Wisdom*. In this they were not far removed from the Pharisees, who, being "believers in fate," as we know from Josephus and the Talmud, also favoured astrological ideas. It was only after the destruction of Jerusalem, when the Pharisees abandoned these speculations and adhered strictly to the law—indeed, expressly combated the fancies of astral mythology—and when the new faith spread to wider circles which did not understand the astral meaning of the Jesus-myth and regarded the myth as a real history, that the knowledge of the astral features was gradually lost, and people began to seek standing-ground for the story of Jesus in the real course of events.

Arthur Drews, Witnesses to the Historicity of Jesus

The stars fought against Sisera; and surely the heavens will fight against the depravers of the human mind, and put them to flight, when it shall be known that Christ was but a personification of the Sun—and no more existed either as man or God, in divine or human shape, than Adonis, Atys, Bacchus, Osiris or any other heathen personifications of the Sun....

...Christ no more had a real existence than the Chrishna of India, the Adonis of Phoenicia, or the Hercules of Egypt and Greece. Chrishna, Adonis, Hercules, Mithra, and a score of others, were personifications of the Sun; and the character of Christ in all its essentials, is but a copy of these...

The Existence of Christ Disproved

The universal astrotheology never ceased to be the world's predominant religious ideology, as, unbeknownst to most, it continues to this day within the various religions currently popular. Three of the major religions—Christianity, Hinduism and Buddhism—are principally solar, while two—Judaism and Islam—are mainly lunar. In general, the bigger the religion, the more astrotheological it is. That Christianity represents a remake of the ancient, pervasive and powerful solar religion has been evident to a number of intelligent and erudite thinkers over the centuries, including the French scholar and abbé Charles Dupuis, who shook up 18th-century Europe with his profound understanding of solar mythology. Writing a multi-volume opus at the end of that century, Dupuis declared bluntly that Jesus Christ was the hero of "the solar fable" and that "eighteen centuries of imposture and ignorance will not destroy the striking likeness, which this fable has with the other sacred romances" about the sun.[1]

In reality, Dupuis and the many other mythicists who preceded and succeeded him were reinstating "lost" knowledge possessed by Pagans and Christians alike as early as the second century CE. It is plain that Pagan critics were aware that the central focus of Christianity was none other than that of the various non-Christian religions: To wit, the sun. From the beginning, early Church fathers such as Tertullian (fl. 190-220 CE) were compelled to combat this assertion by responding, to the effect: "You say we worship the sun. So do you."[2] In *Ad. Nationes*, Tertullian addressed and denied the contention that Christians were just another sect of sun worshippers:

> Chapter XIII.-The Charge of Worshipping the Sun Met by a Retort.
>
> Others...suppose that the sun is the god of the Christians, because it is a well-known fact that we pray towards the east, or because we make Sunday a day of festivity. What then? Do you do less than this? Do not many among you, with an affectation of sometimes worshipping the heavenly bodies likewise, move your lips in the direction of the sunrise? It is you, at all events, who have even admitted the sun into the calendar of the week; and you have selected its day...[3]

In *The Apology* (Ch. XVI), Tertullian provided the following comeback to the charge of sun worshipping:

> Others...believe that the sun is our god. We shall be counted Persians perhaps, though we do not worship the orb of day painted on a piece of linen cloth, having himself everywhere in his own disk. The idea no doubt has originated from our being known to turn to the east in prayer. But you, many of you, also under pretence sometimes of worshipping the heavenly bodies, move your lips in the direction of the sunrise. In the same way...we devote Sun-day to rejoicing, from a far different reason than Sun-worship...[4]

Tertullian also acknowledged that Christians prayed to the east; in fact, for centuries Christians bowed to the rising sun before entering churches. Despite his protestations, in *On the Resurrection of the Flesh* (XLIX), Tertullian referred to Paul's comments at 1 Cor. 15:21 and compared the "glory of the sun" to that of Christ:

> In like manner does he take examples from the heavenly bodies: "There is one glory of the sun" (that is, of Christ), "and another glory of the moon" (that is, of the Church), "and another glory of the stars" (in other words, of the seed of Abraham).[5]

Like so many of the ancient gods, Christ is principally a personification of the sun, representing light and immortality, demonstrated by the numerous correspondences between his

"life" and that of other solar heroes. This fact can also be established through iconography, as well as the scriptures themselves, in which we find the "foreshadowing" (blueprint) for the "sun of righteousness," as in the final chapter of the last Old Testament book, just preceding the New. In that book, Malachi ("my messenger") says:

> But unto you that fear my name shall the Sun of righteousness arise with healing in his wings...

This sun of righteousness is Jesus—and he is "Shamash," as the word appears in Malachi's original Hebrew. Shamash/Samas, the Babylonian sun god and winged sun of righteousness, is the same as the solar disc with wings found depicted in Assyria, Babylonia, Egypt and elsewhere.

Another clue can be found in Revelation, where Jesus is described as "the Amen":

JESUS IS THE SUN GOD

> This statement is proved by the Bible. In Revelation 3:14, Jesus is speaking, and refers to himself as "the Amen." Amen Ra is the name of an Egyptian Sun God... the life of Jesus duplicates the trajectory of the Sun in the sky....[6]

Commenting upon this identification of Christ as "the Amen," CMU observes:

> Thus the sun, as personified in Christ, says Rev. 1:18: "I am he that liveth, and was dead, and behold I am alive for evermore, Amen." Again, "I am the resurrection and the life; *the day star on high that redeemeth his people*: I come a light into the world." This word *Amen* is nothing else than the disguise in which the translators have thought it proper to put *Ammon*. The sun, in the sign of Aries, was personified in Jupiter Ammon, as well as in Christ. Ammon signifies the secret or concealed one, and *sacred* had originally no other meaning than *secret*. In Isaiah 65:16, is not the "God Ammon" mentioned in the original, and suppressed by English translators?[7]

Jesus's role as "the Amen" has already been discussed, including Amen's identification with Osiris, with whom the Christ character shares so many profound commonalities, including the most obvious that both are aspects of the God Sun.

In addition to the Pagans and "heretics," numerous of the early *orthodox* Christians for centuries called Christ "the true Sun," "our Sun" and "the Sun of Righteousness," etc. In his *Exhortation to the Heathen* (Ch. IX), Church father Clement of Alexandria (150?-215?) refers to Christ as the "Sun of the Resurrection":

> And the Lord, with ceaseless assiduity, exhorts, terrifies, urges, rouses, admonishes; *He awakes from the sleep of darkness*, and

raises up those who have wandered in error. "Awake," He says, "thou that sleepest, and arise from the dead, and Christ shall give thee light"—*Christ, the Sun of the Resurrection,* He *"who was born before the morning star,"* and *with His beams bestows life.*[8]

Regarding the "Sun of Righteousness," Clement further says (Ch. XI):

> But night fears the light, and hiding itself in terror, gives place to the day of the Lord. Sleepless light is now over all, and the west has given credence to the east. For this was the end of the new creation. For "the Sun of Righteousness," who drives His chariot over all, pervades equally all humanity, like "His Father, who makes His sun to rise on all men," and distils on them the dew of the truth. He hath changed sunset into sunrise, and through the cross brought death to life...[9]

The solar imagery could not be clearer: The sun of the resurrection, with his life-bestowing beams, rising or being born again each morning, awaking from the darkness, with the night fearing his light and ceding to his day. Furthermore, "sleepless light" or *daylight* pervades, and the west "gives credence to the east," as Jesus the Righteous Sun rises in his chariot, the same as Surya, Helios, Apollo, Mithra, Krishna, etc.

In his writing to "Autolycus" (II, XV), Antiochan Bishop Theophilus (d. 180), to whom "Luke" evidently addressed his gospel, describes the sun as a "type of God":

> ...For the sun is a type of God, and the moon of man. And as the sun far surpasses the moon in power and glory, so far does God surpass man. And as the sun remains ever full, never becoming less, so does God always abide perfect, being full of all power, and understanding, and wisdom, and immortality, and all good. But the moon wanes monthly, and in a manner dies, being a type of man; then it is born again, and is crescent, for a pattern of the future resurrection.[10]

While Christian historicizers actively worked to make some slight distinction between the visible Sun and the "true" Sun of Righteousness, Jesus Christ, their attempts were not successful, as the gospel fable remains the story of the sun, no matter how elegant the sophistry to prove otherwise. One of the alleged differences between Christ and the *other* "Suns of Righteousness" is that Christ purportedly walked the earth, emanating as the Word out of Judea. In *Contra Celsus* (VI, LXXIX), Origen attempts this distinction, while using solar imagery:

> And therefore there was no need that there should everywhere exist many bodies, and many spirits like Jesus, in order that the whole world of men might be enlightened by the Word of God. For the one Word was enough, having arisen as the "Sun of

righteousness," to send forth from Judea *His coming rays* into
the soul of all who were willing to receive Him.[11]

There would have been no need for such protestations and
claims if the mainstream "history" regarding Jesus were true. The
fact is that early Christians were desperate to explain why the
basic story of Jesus was widely found, centuries prior to the
purported advent of Christianity. They were, after all, being
charged with plagiarism and fraud. In reality, they were guilty of
it, no matter what excuse they came up with, and they simply
could not escape the fact that the gospel story revolved around
the *sun* and that they constituted a sun-worshipping cult. Why
these solar cultists have been so adamant in denying these facts,
and in maintaining their sun god as a "real person," is a question
that requires a great deal of attention. Furthermore, numerous
other sun gods of different ethnicities, i.e., Greek, Roman,
Egyptian, Indian, Assyrian, Babylonia, Scandinavian and
American, were also claimed to have "walked the earth," so this
distinction is in reality none at all.

Even with such denials of solar worship, however, Christians
continued to speak of their *"sun* of God." In *The Acts of the
Disputation with the Heresiarch Manes*, Church father Archelaus
(277 CE) related the comparison of the "glory of the sun" to that of
Christ, and referred to "the true Sun, who is our Saviour." The
Clementine Homilies, so-called heretical texts dating to no earlier
"than the first half of the third century," demonstrate "a clear
tendency to equate Jesus with the sun, and with the solar year."[12]
Also in the 3rd century, Christian father Anatolius, in establishing
the "Paschal festival," based his calculations on the positions of
the sun and moon during the vernal equinox.[13]

The need to time the Easter celebration—or *resurrection*—to
coincide with the vernal equinox demonstrates once again that
Christ is not an historical personage but the *sun*. This fact of
Easter being the resurrection of the Sun has been well known for
centuries, just as "the Savior's" birth at the winter solstice has
been recognized as another solar motif. Another obvious clue as
to Christ's nature is the fact that the "Lord's Day" is *Sun*day.

Concerning Easter, in his "Letter I. for 329" Bishop of
Alexandria Athanasius (c. 293-373) remarks, "Again, 'the Sun of
Righteousness,' causing His divine beams to rise upon us,
proclaims beforehand the time of the feast, in which, obeying
Him, we ought to celebrate it..."[14] Once more, Christ is the Sun of
Righteousness, with "divine beams."

The Easter calculations were recomputed in the seventh
century by the author(s) of the Paschal Chronicle or Alexandria
Chronicle, which determined the proper date for Easter as March

21st and the date of Christ's resurrection as March 25th (or, midnight, March 24, three days after the beginning of the equinox). In his various calculations, the Chronicle author discusses solar and lunar cycles, including the 19-year lunar cycle, by which he reckons the crucifixion and resurrection, concluding: "This is consistent with the prior determinations of reputable men in the calculation of the heavenly bodies."[15] To wit, Christ's death and resurrection are based on *astrotheology*.

The Chronicle author further confirms that Christianity is a continuation of the ancient "Pagan" astrotheological religion when he states that the "Annunciation of our Lady," i.e., the conception of Christ by the Virgin Mary, likewise occurred on March 25th, the vernal equinox, exactly nine months prior to the December 25th birthdate, the annual rebirth of the *sun*.[16]

Into the 4th century and well beyond, hymns addressed Christ *as the sun*, as in the following by the Catholic saint Ambrosius or Ambrose (c. 340-397):

> Verusque Sol, illabere,
> micans nitore perpeti,
> iubarque Sancti Spiritus
> infunde nostris sensibus!

One writer translates and comments on St. Ambrose's hymn thus:

> "O true Sun, go down,"—that is, fall as the afternoon sun does; it is evidently sung to the afternoon sun. "O thou true Sun, go down!, shining with perpetual light! Radiance of the Holy Spirit, infill our minds!" A beautiful thought. You see the sun here is called *true* sun, evidently marking a distinction between a true sun and lesser sun. "Shining with perpetual light; O glory of the Holy Spirit"—the sun is the glory or radiance of the Holy Spirit, or the third person of the Trinity—"infill our minds." It is an invocation, a prayer, and a hymn to the Sun, as typical an example of sun-worship as could be found in any one of the so-called sun worshiping religions... So we see that Jesus as late as the 6th and 7th centuries was spoken of as the true Sun and the glory of the Holy Spirit; and the Sun was looked upon as being the representative or prototype in the sky of what Jesus was among men.[17]

As we can see, the identification of Christ with or *as* the sun is not an isolated incident by non-Christian writers. Christian authorities knew what they were worshipping, despite their excessive protestations. By Augustine's time (354-c. 371), the din had become so great that the saint was forced to denounce the continual "heretical identification of Christ with Sol." Before becoming an orthodox Christian, however, Augustine was a Manichean, a member of a major "heretical" Christian sect that

was overt in the fact that its religion was sun worship. Not only did they, like other Christians, face the sun during their prayers, but they also stated that "Christ was the Sun, or that Christ resided in the Sun, where the Ancients had placed Apollo and Hercules," an assertion affirmed by Christian authorities "Theodoret, St. Cyril and St. Leon."[18]

The solar imagery and iconography identifying Christ with or as the sun was abundant for centuries, enduring to this day within both Catholicism and Protestantism. In "From Sabbath to Sunday," Samuele Bacchiocchi describes the solar imagery evident early on within Christianity and continuing:

> Christ-the-Sun. In numerous pagan pictorial representations... the Sun or Mithra is portrayed as a man with a disk at the back of his head. It is a known fact that this image of the Sun was used in early Christian art and literature to represent Christ, the true "Sun of righteousness." In the earliest known Christian mosaic (dated ca. A.D. 240) found in the Vatican necropolis below the altar of St. Peter (in the small mausoleum M. or the Iulii), Christ is portrayed as the Sun (Helios) ascending on the quadriga chariot with a flying cloak and a nimbus behind his head from which irradiate seven rays in the form of a T (allusion to the cross?). Thousands of hours have been devoted to drawing the sun-disk with the equal-armed cross behind the head of Christ and (from the fifth century) the heads of other important persons.
>
> The motif of the Sun was used not only by Christian artists to portray Christ but also by Christian teachers to proclaim Him to the pagan masses who were well acquainted with the rich Sun-symbology. Numerous Fathers abstracted and reinterpreted the pagan symbols and beliefs about the Sun and used them apologetically to teach the Christian message. Does not the fact that Christ was early associated in iconography and in literature (if not in actual worship) with the Sol invictus—Invincible Sun—suggest the possibility that even the day of the Sun could readily have been adopted for worshiping Christ, the Sol iustitiae—the Sun of Justice? It would require only a short step to worship Christ-the-Sun, on the day specifically dedicated to the Sun.[19]

As has been shown abundantly, the cross and numerous other "Christian" symbols and ritual are in reality rehashes of the paraphernalia of ancient astrotheological religion.

As late as the 15th century, when Marsilio Ficino authored *De Sole,* or *The Sun Book,* Christ continued to be compared to the sun. Of course, with the Catholic Church torturing and slaughtering "infidels" and "heretics" by the hundreds of thousands, it is evident why writers such as Ficino would not openly acknowledge Jesus *as* a sun god, a fact obviously known by the Christian hierarchy, who avidly read books such as *De*

Sole. These books, naturally, were not for the ignorant and illiterate masses, so the secret remained in the hands of the few. Nor did the masses, apparently, gather the true meaning behind the astrotheological imagery in these books and all around them while they sat in their churches.

In the 16th century, "German Humanist" Mutianus Rufus (Konrad Muth, 1471-1526) confided to a friend:

> There is but one god and goddess, but many are their powers and names: Jupiter, Sol, Apollo, Moses, Christ, Luna, Ceres, Proserpina, Tellus, Mary. But have a care in speaking these things. They should be hidden in silence as are the Eleusinian mysteries; sacred things must needs be wrapped in fable and enigma.[20]

Rufus further said: "You, since Jove, the best and greatest god, is propitious to you, may despise lesser gods in silence. When I say Jove, understand me to mean Christ and the true God." Thus, the better educated have been aware of Christ's real nature but have been sworn or intimidated into silence. Apparently, the priesthood, with its gross fictions, realized it could not control and manipulate the masses if such secrets were known.

With the relative safety of the 18th century and the "Age of Reason," Dupuis was able to break away from the pack and state the obvious. He was followed by Volney and a host of others who detailed the resemblances between the sun gods and Christ. So important and well presented was this information that respected Christian authorities were compelled to acknowledge the veracity of the research brought to light by Dupuis, Volney and the others.

In the 19th century, the learned Rev. Dr. Lundy, well aware of the numerous correspondences between the Christ figure and the gods of other cultures, spilled much ink in an attempt to distinguish his Savior from the rest, whom he acknowledged as sun gods. Lundy found it a "marvelous thing" that the Pagan avatars or incarnations of God had appeared on Earth, regardless of whether or not they were "types" or "prophecies" of Christ's later incarnation. Lundy also listed these avatars, such as "Bel of the Assyro-Babylonians, the Persian Mithra, the Hindu Agni, Egyptian Horus, Greco-Roman Apollo," declaring that all of them bore a "striking analogy to the Real Son of God, being all of them sun gods themselves." The good reverend then elucidated the classic interpretation of the sun as the "great creator and restorer in nature," adored as the "Creative, Preserving and Restoring Power of the universe by all these ancient peoples."

As is typical for an apologist, however, Lundy was compelled to denigrate Pagan intelligence by saying that, although they were

thus "seeking after God," the Pagans could never find him, because their "mistake" was in "identifying nature and God," rather than nature as simply a *symbol* of the Divine. He then proclaimed that this misinterpretation or inability to perceive clearly made their religion "unreal" and their gods "mere fictions—mere forces of nature deified—mere creatures of the imagination." Lundy next argued that there is a Supreme Being behind all this nature, and, of course, only Christianity possessed this Supreme Being. As abundantly demonstrated, such sophistic arguments are false, as the pre-Christians possessed virtually every concept found in the johnny-come-lately Christian religion, including the idea of a supreme being behind all of creation. After attempting thus to differentiate Christianity from Paganism, Lundy concluded that either a "real and not merely ideal Divine Personage had appeared among men, or Christianity is but a fiction like the rest."[21]

In *Who is this King of Glory?* Dr. Alvin Boyd Kuhn remarked upon Lundy's astonishing assertions:

> In Lundy's "Monumental Christianity" (p. 120) there is a paragraph of some length which it would be a crime of the deepest dye not to mention here. It stands as such a choice morsel of that combined arrogance and sad ignorance and misjudgment which the host of Christian writers has exhibited for centuries in their treatment of the religions of "paganism," that not to serve it up to the reader in this feast of clarification would be gross niggardliness....

> The passage deserves by way of comment and critique a whole extended essay instead of a few sentences. It is indeed an inviting piece de resistance. The main puzzle, however, is to tell duck from turkey. Indeed it is a fact that the more of such underhand blows of Christian writers at paganism one reads, the more impressed one becomes with the realization that most of the presumed stones of slander and reproach they hurl at paganism turn out to be bouquets of the highest praise. The diatribes of intended abuse more often than not resolve themselves through an unguarded utterance into the highest encomiums [glowing praise].[22]

As Kuhn points out, Lundy claimed it did not matter whether or not these other avatars and messiahs were "copies," "independent types" or "prophecies" of Christ, as Christianity is nonetheless superior. Kuhn continues:

> It being too confessedly humiliating to admit that the early Christians copied *their* unexampled true religion from the pagans, forsooth the copying had to be laid at the door of the pagans! But, horrors! The pagans were first, centuries ahead of them! A thing is not copied before it is in existence, but after. Later copies earlier, not vice versa.

Kuhn next recalls the "devil got there first" argument, to which Christian apologists have had to resort, knowing that these other avatars and messiahs *preceded* the Christ figure. Concerning the "prophecy" argument, whereby the misguided heathens somehow came up with the Christian mythos and doctrine centuries before Christ, Kuhn comments:

> ...If so, all that any sane mind could think of their accomplishment is that it was a feat of wondrous genius. If Christianity be the transcendently lofty pure revelation it is claimed to be, the pagans soared high to match its conceptions in advance. Yet a Christian writer must needs treat it with a slur.

> Then Lundy calmly admits that Bel, Mithra, Agni, Horus and Apollo all "bear a striking analogy to the Real Son of God," without the remotest suspicion that such an admission points with practical conclusiveness to the fact that Jesus was just another Sun-god figure with the others.[23]

Again, if there were no such correspondences between Paganism and Christianity, as less learned apologists have fervently opined, there would be no need for the charge that Paganism copied Christianity, rather than the other way around. The matter is settled as to the correspondences, as well as to their existence within Paganism, long before the Christian era.

In arguing against Dupuis's sun-god thesis Lundy further commented that the "sun-god of the Persians and Greeks was the type of Christ, the true Sun of Righteousness, and the Deliverer of man from all evil."[24] Orpheus also was a "type of Christ," according to Lundy, who noted the resemblances between the Greek demigod and the Jewish messiah: "Orpheus was a type of Christ, but it is doubtful whether such a person as Orpheus ever lived..."[25] Per Lundy, Old Testament characters too are included in the "foreshadowing" of Christ's advent: Jonah, for example, is a "type of Christ," as are Noah, Elijah, Daniel, etc. The minister also named Samson as a "type of Christ," his "carrying off the gates of Gaza" the same as Christ's "bursting open and carrying away the gates of Hades," while Samson's defeat of the Philistines "by his own death" is equivalent to Christ "conquering His and our enemies by His death and resurrection."[26]

Concerning the comparison of Christ and his 12 apostles to the sun and zodiacal signs, constituting another "Hercules and his 12 labors," Lundy argued a novel reason by simply proclaiming that things are not as they appear and that the story of the sun gods is *mythology*, while Christianity is a *religion!*[27] A proselytizing Christian minister for much of his life, Lundy used philosophical sleight-of-hand in his pronouncements. For the sake of integrity and honesty, he dared not deny the influence of

Paganism on Christianity; yet, he constantly attempted to show the latter's superiority, because "wise men" have promulgated the faith, which means it must be superior, a tautological and self-serving argument. Nevertheless, Lundy further maintained:

> The widely prevalent sun-myth has undoubtedly left some traces and survivals in the art, symbolism and ritual of early Christianity, as this volume shows; but it is also clear that Christianity has entirely passed beyond the inchoate mythological or chrysalis state, in being a complete, full-grown spiritual religion.[28]

Christianity, according to Lundy, while even in its earliest form copying the Pagan solar religion, is nonetheless superior, because superior minds have been working it over, and, it was Lundy's continual implication, the minds of other cultures and eras were inferior in their inability to take this "chrysalis" and metamorphose it into the beautiful butterfly it became in Christianity. The fact will remain, however, that the ancients of other cultures—even some of the most barbaric, cannibalistic savages, as Lundy himself showed—possessed the same "superior" concepts the reverend attempted to delineate in Christianity. In any case, Christianity itself is little more than the barbaric sacred-king/human-sacrifice ritual!

By the 20th century, the numerous "Pagan" mythical motifs and their biblical correlations had been studied and written about for well over 100 years, and were well known among the elite and erudite. Like Lundy, Christian apologist Arthur Weigall, coming on the heels of the work of the mythicists of the 18th and 19th centuries, was forced to address the numerous aspects of Christianity that were Pagan in origin. Indeed, Weigall acknowledged that the mythicist school was very powerful, and he did not attempt to deny what is undeniable, i.e., the many mythical motifs brought out quite thoroughly by these mythicists. Weigall's goal, however, was to "find the real Jesus" underneath all the Pagan mythological lacquer. He was an evemerist; yet, he believed that the "real Jesus" was in fact a divine being, truly "our Lord and Saviour." Weigall represented the Protestant perspective of the Church of England and, apparently sensing that the mythicist work had made the gospel story appear ridiculous as "history," attempted his best to rehabilitate the "body of Christ." Said he: "...the really important question today is one which is not local or factional, but is being asked all over the Christian world in all denominations, namely, whether or not the entire creed is obsolete."[29] Weigall continued:

> I believe that much of the generally accepted Christian doctrine is derived from pagan sources and not from Jesus Christ at all, a

great deal of ecclesiastical Christianity being, indeed, so definitely paganism re-dressed that one might almost speak of it as the last stronghold of the old heathen gods.[30]

Weigall attempted to demarcate the differences between this Christian Paganism and the "Jesus of History," highlighting the numerous mythical motifs discerned through centuries of biblical criticism and the study of ancient pre-Christian religion and mythology. His objective was as follows:

> *There is a widespread critical school which,* seeing only the old gods grouped about the Christian altar, *thinks that Jesus never existed at all,* but that His life is a myth invented during the First Century A.D.; and it is with this powerful school that I wish to do battle.[31]

Weigall was aware that the members of this *widespread and powerful school* were highly educated and intelligent, and he admitted that "*many of the most erudite critics are convinced that no such person ever lived.*"[32]

In 240+ pages, Weigall conceded just about every mythicist argument—except that the Christian founder himself was mythical. Like so many others previously who were honest critics of their own faith, Weigall was forced to acknowledge that there are "no contemporary or nearly contemporary references to Jesus in history."

Eventually, Weigall found his "historical" Jesus in a human sacrifice, the same as those numerous sacred-king sacrifices that preceded the gospel tale, except, apparently, the victim was the *real* God this time! The fact remains that when all the pre-Christian mythical motifs are removed from the story, and when it is realized that the sacred-king sacrifice was common globally, there is no one and nothing left to point to, except a sun god.

Christ's existence is real, insofar as he is the Sun, and there "cannot be any doubt...that anything is more real than the luminary, which 'lighteth every many that cometh into the World.'"[33] The sun has endured for billions of years, and human beings have been revering "him" (or her) for many thousands, turning him into a man who lived on Earth and had many adventures. As was done with Adonis, Dionysus, Hercules, Mithra and Osiris, so was the God Sun personified in Jesus.

The word "Jesus" itself is simply another name for Bacchus/ Dionysus, whose epithet was "IES," becoming Iesus or Jesus with the Latin terminus "us." When the hidden and arcane mythology is known, it becomes obvious that Jesus is simply a remake of the various sun gods, who themselves are rehashes of each other. After an etymological analysis of the name "Jesus" and its numerous variants, Kuhn pronounces that there are over 30

"Sun-god figures in the cults of the various nations of old." He also counts in the Bible 20 other "Sun-god characters under the very name of Jesus!" Kuhn next names some of them: "Isaac, Esau, Jesse, Jacob, Jeshu, Joachim, Joshua, Jonah and others"—all essentially the same name. Then there are the "Sun-god figures" of "Samson (whose name means 'solar'), David, Solomon, Saul (equals soul, or sol, the sun—Latin), Abraham, Moses, Gideon, Jephtha and the like. Their actions identify them as solar representatives."[34]

The story of the sun and its relation to the Christ myth can be found in detail in *The Christ Conspiracy*, which includes a thorough discussion of elements in the gospel fable original to Pagan astrotheology, many of which have already been highlighted herein. To recap, the story of the God Sun plays out as follows: The miraculously announced infant is born of a virgin (Virgo) in a cave or stable at the winter solstice ("Christmas"). His birth is attended by wise men (Three Kings in Orion's Belt) following a star in the East (Sirius) and bearing gifts. His life is threatened by a tyrant (Leo "the King"), who pursues him and slaughters many male newborns (stars). The solar babe escapes and grows up doing miracles, achieving manhood at the summer solstice, after which he heals the sick and raises the dead. He is baptized in the Jordan (Eridanus constellation) by Oannes the Dipper (Aquarius), and overcomes the "Prince of Darkness" (the night sky and winter). The sun god gathers around him 12 principle disciples or helpers (signs of the Zodiac), who preach the "good news." The solar hero is betrayed (Scorpio), killed, often by crucifixion ("crossified" at the equinoxes), side-wounded (Sagittarius) and buried in a cave (winter solstice). Three days later, the sun god rises again, leaving an empty tomb, and eventually ascends to heaven.

As stated in the Indian text the *Bhavisya Purana* and attested by early Church father Theodoret (5.38), the "Persian" Magi or Magas were *sun worshippers*, specifically of the sun god Mithra; hence, it was entirely appropriate for the "three wise men" to be the witnesses to the birth of Jesus, another sun god. Their gifts to the newborn *sun* of gold, frankincense and myrrh are likewise solar elements. These various solar elements found within the myths of several sun gods in one form or another also include Joseph, Mary and Jesus's flight into Egypt, a theme revolving also around the divine trio of Seb, Mari and Horus, who fled into the "peace of Egypt" to escape the wrath of Typhon/Set, i.e., Satan.[35]

In another astrotheological moment, Jesus tells a woman at a well that he is "the source of living water," while, in the Egyptian mythos, Osiris appears at the well to the woman "with the long

hair" (the goddess Nut) and represents the "water of life" and the "drink of life."[36] The Pool of Bethesda ("merciful") "by the Sheep Gate" mentioned in John's gospel is another Egyptian astrotheological motif, signifying the "pool of purification and healing" found in Amenti, the Egyptian paradise. The pool of purification represents a mystery rite followed by those who wished to be in the presence of Osiris, the "elect or chosen ones." In the gospel tale, the man who was rejected at the pool was one of the "non-elect."[37] The "Sheep Gate" may represent the sign of Aries.

Walking on water is another solar motif found in the myths of several cultures, present also in the tales of several of Buddha's disciples and in the Indian yogic tradition, which regularly claims its practitioners walk on water, reflecting their holy nature. It was said of the sun that it walked on water, describing its reflection on the surface.

The cursing of the fig tree is yet another theme in other myths, the fig serving as a "well-known Goddess symbol." [38] Sacred to the sun in India, the fig tree also figures into the Mithra myth.[39] Furthermore, the palm tree, together with two stones, was a "phallic emblem" of the Phoenician god Baal-Peor, "who was worshiped in the Jewish tabernacle until reforming priests of Yahweh killed his followers (Num. 25)."[40] The waving of palm branches was a ritual in the annual celebrations of a number of savior gods, including Osiris and Tammuz, as part of the sacred-king ritual.[41] In addition, in the ancient world the palm tree was said to be indestructible;[42] hence, it was a symbol of immortality, i.e., resurrection. After the resurrection, Jesus reveals himself to the "seven in the boat," as related in John's gospel. These seven fishers are part of the Egyptian mythos, representing "the planks in the boat for saving souls, and the Seven fishers of men in the *Ritual of the Dead*. The Seven are spirits or gods in the Egyptian gospel."[43] The sun god returning on the white horse is another motif found in several myths, including those of Krishna, Apollo and the Slavic Dazhbog, who daily was born, died and resurrected.

The Baptist

As stated, the "real" John the Baptist—as opposed to any priest in his name—was the Babylonian water-god Oannes, the sun in Aquarius, the Water-Carrier, Dipper or Baptizer, worshipped by the pre-Christian Mandaeans as their Christ. The fact that three centuries prior to the Christian era the Babylonian historian Berossus had popularized the ancient and established worship of Oannes in his works in Greek adds weight to this contention. Even the "early Christian syncretists in Egypt"

identified the Baptist with "the Chaldean god Oannes."[44] When Christianity was being forged, Oannes was subordinated to Jesus, when the latter was made the son of God over the divine forerunner, John the Baptist. That Oannes was a very important god in these pre-Christian and proto-Christian cults is obvious from the significance placed on John in the gospel fable. It was crucial for the Christian scheme to succeed that this important god be so prominently and thoroughly supplanted by the newly created Jewish godman. It would be reasonable to assume that this usurpation was so loudly and meticulously done to this particular god, Oannes/John, because he was a *Syrian* or *Samaritan* god, and was thus a competitor of the god of the Judeans and of other Samaritans of Hebrew/Israelite origin and Yahwistic bent.

The Baptist's role in the gospel myth is clearly astrotheological: To wit, John is born exactly six months earlier than Jesus, and he says concerning Jesus, "He must increase, but I must decrease." (Jn. 3:30) John represents the sun born at the summer solstice, making room for the sun born at the winter solstice, or Christmas. The Baptist's beheading is also astrotheological, as the day upon which it is observed, August 29th, represents the constellation of Leo (the "King" of the zodiac) separating the head from the body of the Water Man (Aquarius).[45]

In the Babylonian myth, the half-fish Oannes was said to rise every morning "from the waves of the Red Sea in order to instruct man as to his real spiritual nature." This motif represents the sun god in the constellation of the fishes, Pisces, which appeared to the Babylonians to "rise out of the Red Sea." It was said that at sunset Oannes "plunged back into the sea," appropriate for a sun god. Oannes was the god who "indicates the solstices and divides the year," also typical for a sun god.[46] Oannes is equivalent to Jonah, or Jonas, spelled Ιωνας in the Greek, which would explain that biblical story, as Jonah is likewise a sun god.

In *Occidental Mythology*, Joseph Campbell, while maintaining that there was an "historical" John the Baptist, discusses baptism as an "ancient rite" from the sacred Sumerian city of Eridu, whose water god, Ea, was later called Oannes. "Several scholars," says the eminent mythologist, "have suggested, therefore, that there was never either John or Jesus, but only a water-god and a sun-god."[47] Campbell's only concern in accepting this mythical thesis is the passage regarding John in Josephus, which is probably a garbled account of Oannes as an "historical personage."

While many people, including Berossus, have attempted to make Oannes into a "real person," whether a monster hybrid or,

as of late, an "alien," like the majority of important ancient gods, he is astrotheological. In fact, astrology was one of the numerous "civilizing sciences" Oannes is claimed to have brought to humankind so long ago. The theme of the teaching and civilizing god can be found in numerous cultures, including the Egyptian, with Osiris and Hermes, also a Greek teaching god, and in the Mesoamerican culture, with Quetzalcoatl. None of these gods was a "real person."

The Two Sisters, Mary and Martha

In the gospel tale appear two sisters, Mary and Martha, who lived with their brother Lazarus at Bethany and who "correspond perfectly to the two divine sisters, called at times the two dear sisters, Isis and Nephthys, with their brother Osiris, in the House of Annu."[48] As Osiris is anointed by Isis as Meri or Mari, the "lady with the long hair," so Lazarus is anointed by Mary, who wipes his feet with her long hair. Like Lazarus, Osiris—"El-Ausar-us"— is the mummy, raised from the dead. Isis and Nephthys, called Meri and Merti, lament for their dead brother, as do Mary and Martha.

The Crucifixion

The crucifixion is an old pre-Christian rite and motif reflecting, among other things, the sacred king-human sacrifice ritual that was carried out thousands of times in numerous parts of the world. This ritual/motif was not only physical but also *metaphysical*, "spiritual" or allegorical, as it represented an astrotheological concept as well.

In discussing the crucifixion of "our Lord," Sir Weigall was compelled to acknowledge that it resembled a pre-Christian human sacrifice rite:

> ...when we look closer we find that some of the main incidents in the Gospel account have their parallels in these rites of human sacrifice as practised by the ancients. In fact, one may say that if a cosmopolitan writer of that period had set himself to *invent* the story of the sacrificial death of an incarnate god who was thought to have died for the remission of sins, he might, out of his general knowledge, have produced a tale more or less like that in the Gospels.[49]

Despite the fact that the Passion and Crucifixion are found in older myths and rites, Weigall, as noted, found his "historic Jesus" here, as an actual human sacrifice, *expiatory* and not punitive in nature. In proving his thesis, Weigall recounted that Philo of Byblus reported the king of the Jews as customarily giving "his beloved son to die for the nation" in order to ensure good fortune, these royal victims being "sacrificed with mystic

rites." Another source is Porphyry, who related that "Phoenician history is full of such sacrifices." Likewise, the Canaanites sacrificed their kings and their children. When Abraham was commanded by God to commit such a sacrifice, he barely blinked an eye, reflecting that it was commonly done. In order to end a famine, King David sacrificed the sons of Saul—seven princes—by "hanging them up before the Lord."[50]

That the gospel tale is an archetypical human sacrifice is indicated by the Gospel of Peter, which, in its clearly fictional account of the Passion, makes it evident that the mocking by the people is part of the ancient ritualistic sacrifice of the sacred king. The sacred-king theme is also revealed in the pre-Christian text the *Wisdom of Solomon* (v. 2-5), in which the mocked sacrificial king and "son of God" puts on the scarlet robe, is spat upon and crucified. Unless this text is heavily Christianized, it serves as proof that the Christ myth is unoriginal and preceded the purported advent of "Jesus of Nazareth."

The human sacrifice depicted in the gospel story would have been done in secret, particularly in Israel during the centuries of foreign occupation. Rome had essentially banned human sacrifice, such that it would need to be carried out in the stealth of night, and without the audience as portrayed in the gospel fable. A number of individuals—high priests and their attendants—would be present, along with the victim. This rite constituted a major part of the mysteries, the divulgence of which brought about a swift death penalty.

In the gospel story a criminal, "Jesus Barabbas," is released by Pilate in accordance with the mob's wishes. Concerning this incident, Weigall concurred with Sir Frazer that the name is not that of a person but represents a title for the annual human sacrifice victim, meaning, "son of Father." As recorded by Philo around 40 CE, an Alexandrian mob "dressed up a crazy old man, putting a sham crown on his head, a sceptre in his hand, and a purple robe over his body, and hailing him as *Karabbas*, an obvious miswriting for *Barabbas*, and as *Maris*, the Syrian word for a royal personage."[51] It is probable that there *was* at least one "Jesus Barabbas" sacrificed in this manner during the decades that the gospel Jesus was said to have lived.

The pre-Christian Jesus ben Pandira was possibly also one of these sacrifices; yet, his tale seems to reflect that of the *god* in whose name a human victim was sacrificed, rather than a "biography" of a "real person." Again, it is possible that the sacrificial god Dionysus was called "Jesus ben Pandira," as he was styled "IES" and was the son of a panther. The same basic story was configured to many of the sacrificial "lambs," especially

evident when the victim was a substitute for the sacred king, such as a condemned criminal. Hence, we have not *one* "historical Jesus" but *many*, none of whom actually lived the "life" found within the standardized sacred-king mythos, i.e., the gospel story. Even if there were a dozen or more "historical Jesuses" who had been sacred-king sacrifices, it is not *their* "biography" being told in the gospel. The gospel tale represents a fictionalized, archetypical account of the ritual murder so commonly committed in the ancient world, from sea to shining sea.

In *Against Christianity*, Porphyry (233-c. 303) deftly criticized the multiple gospel accounts of Jesus's crucifixion, about which he remarked: "The evangelists were fiction writers—not observers or eyewitnesses to the life of Jesus. Each of the four contradicts the other in writing his account of the events of the suffering and crucifixion."[52] Porphyry continued his critique, listing each of the gospel accounts and emphasizing their differences, including variances in what the crucified savior supposedly uttered while dying. Porphyry's remarks show that even as early as the third century Pagan intellectuals were aware of the illogical nature of the gospels. In his attempt at refuting Porphyry, Christian teacher Magnes (end of 4th cent.) excused these contradictions by stating, "the truth is not to be sought by looking for facts in syllables and letters." Speculating on the mental state of the gospel writers, Magnes then claimed "that the eyewitnesses were drunk with fear, owing to 'the earthquake and the crash of rocks around them.'"[53] In his conclusion regarding these fables, Porphyry observed, "Anyone will recognize that the [gospels] are really fairytales if he takes time to read further into this nonsense of a story..."[54] He further stated: "This silliness in the gospels ought to be taught to old women and not to reasonable people. Anyone who should take the trouble to examine these facts more closely would find thousands of similar tales, none with an ounce of sense to them."[55]

This foolishness evident in the varying gospel accounts of the crucifixion is only explainable astrotheologically, not as "history." In the New Testament, there appears the crucifixion on Golgotha/ Calvary (Lk. 23:33), as well as that "allegorical" crucifixion in Egypt at Revelation 11:8, which "is a plain recognition of the astro-religion" and Egyptian sun worship. The Calvary crucifixion was likewise allegorical, representing the "sun's *passing over*, or *crossing* the equator in March," or Aries, the month of the Lamb of God, during the age when that sign rose heliacally at the vernal equinox.[56] The astrotheological explanation of Revelation extends

to the description of God/Jesus with his head and hair "as white as white wool," representing the fleece of the *lamb*.

Another crucifixion, found in John's gospel, was said to have taken place near a garden, where Jesus was then laid (Jn. 19:41-42). This crucifixion, CMU explains, "has allusion to the autumnal equinox, when the sun *crosses* the line of the equator, in September," a time when it is appropriate to be in a "fruit garden, or vineyard." In John's garden crucifixion, Jesus's mother stands near her son, an element omitted by the other evangelists. The explanation for this motif is that Mary, as the constellation of Virgo, can only appear at the autumnal equinox; she is nowhere to be found at the vernal equinox, or Calvary. The Virgin, as the genius of the month of August/September, "stands by" the autumnal equinox or crossification of the sun.

The Side Wounding

In the gospel tale, Jesus is pierced in the side with a spear while hanging on the cross or "fatal tree." The side wounding of the sacred-king victim is likewise a "widespread custom." As previously discussed, Roman historian and ethnographer Strabo reported that Albanians sacrificed victims to the moon goddess by side wounding with a spear. The Scandinavian salvation god Odin was hung on the fatal tree and stabbed with a spear, and "in the worship of Mithra, the bull, which was identical with Mithra himself, was stabbed in the side."[57] Another side-wounded sacrifice was the Aztec god Quetzalcoatl, per Lord Kingsborough, who said, "It is extremely singular that several Mexican paintings should represent Quecalcoatle with his side pierced with a spear, and the water flowing from the wound."[58] Kingsborough also cites the "lower compartment of the same page," which is the 10th page of the MS. of Bologna, upon which appears an image of the sun, Quetzalcoatl, "transfixed by a spear."[59]

In the sun god mythos, the side wounding represents the annual weakening of the sun, in the sign of Sagittarius, the Archer, at the approach of the winter solstice. Verifying this fact, in *The Survival of the Pagan Gods* Seznec describes a Christian map from the 14th century:

> On the site of Jerusalem a crucifix is reared; from the wound in Christ's side issues a straight line, *rivus sanguinis*, which crosses the picture diagonally. Another line, intersecting this one, emerges from the lance of Sagittarius.[60]

The rest of the drawing contains the zodiac, with an "immense" image of the Virgin in the center, along with the Patriarchs, planets, stars, months, etc. Obviously, the cartographer/artist

was privy to the astrotheological meaning of various Judeo-Christian themes.

Descent into Hell

The descent into hell is a late addition to Christianity and is found in the myths of Adonis, Baal, Balder, Dionysus, Hercules, Krishna, Orpheus, Persephone, Quetzalcoatl, Tammuz and others. Lundy attempts to explain this correlation with the "prophecy" and "prefiguring" argument:

> As the tree of life which grew in the midst of Eden finds its parallel in all mythologies from India to Scandinavia; and as Christ's descent into Hades is prefigured by Jonah and Zoroaster alike, who is said to have gone to heaven to receive the sacred fire and the Zend-Avesta from Ormuzd, and then descended into hell, rose and ascended on Mount Albordj, where he consecrated himself to meditation and piety; so our Lord's Ascension finds its prophetic parallels in Elijah and the mythological beings of all Oriental ancient nations.[61]

The Greek demigod Orpheus, for one, was identified with Jesus "in the minds of early Christians," evident by the fact that Orpheus frequently appears "in the paintings in the Catacombs."[62]

Part of the mysteries, the descent into hell by the solar hero symbolizes his nightly setting, from which he rises each morning. It also represents his annual death for three days at the winter solstice, as well as the monthly period around the new moon, when the light of the sun is extinguished. The descent into hell, present in Brahmanism, Buddhism, Christianity, Islam, Judaism and Zoroastrianism, also signifies the sun in the lower signs of the Zodiac, as well as "the sun below the equator, or the sun passing below from west to east."[63] Interestingly, considering its pacifist reputation, the Buddhist hell, like the Christian, is a horrible place of torment, with "burning, boiling, [and] frying, evidently of Egyptian origin..." Not content with just one, however, the Buddhists "speak of a hundred and thirty-six hells."[64]

The Resurrection

The pre-Christian sun gods are also often recognized as "fertility gods," whose deaths and resurrections occurred annually at the spring equinox, the very time of the death and resurrection of Jesus. It is interesting to note that early Christian iconography is devoid of resurrection imagery. As Lundy, an expert on early Christian monuments, observes, "It is a most singular fact that no actual representation of our Lord's resurrection has yet been discovered among the monuments of early Christianity."[65]

It is apparent that this motif was added later to the story, in a competitive move with other religions and against the wishes of some of the original Samaritan-Sadducean creators of Christianity. Traditional Sadducees, as is repeatedly stated, did not believe in the corporeal resurrection. Their presence in the Christ conspiracy is evidenced by the Gospel according to Mark, which was originally written without Jesus's resurrection at the end but which was later amended to include it. Nevertheless, the Sadducees' purported outright denial of various doctrines, including the resurrection and the existence of angels, is "problematic."[66] Hence, it would seem as if at least certain factions of the Sadducees were open to these concepts. In this regard, Eisenman distinguishes between the "Herodian" resurrection-denying Sadducees and the "anti-Herodian" Zadokites of the Dead Sea scrolls, who did in fact believe in the Resurrection.[67] This assertion is given weight by the appearance in the scrolls of the apparent end-times resurrection of the Teacher of Righteousness, an important character who in part was evidently later morphed into "Jesus of Nazareth."

These numerous aspects of the gospel story, as well as the many outlined elsewhere herein and in *The Christ Conspiracy*, represent archetypical, allegorical and astrotheological motifs. Other elements of Christianity, such as festivals, titles, rituals and sacred objects like the cross, are likewise found in numerous other cultures centuries to millennia before the Christian era and frequently have astrotheological meaning. Symbols such as relics and the rosary are likewise not "Christian" but predate the creation of Christianity by millennia. As examples of festivals that are pre-Christian, Lent and the 40 days' fast, are found in Egypt thousands of years BCE.[68] Ash Wednesday, when Catholics place ashes on their foreheads, is originally Pagan, appearing in Rome, where bathing in ashes was a New Year's sin-atoning festival. The Romans "in turn took it from Vedic India,"[69] where the ancient fire god Agni was believed to absolve sins through ashes, which symbolized the purifying effect of Shiva's blood as well. Another example is the observance of the Assumption of the Virgin, occurring in the fall, when the Virgin Mary was "assumed" or "taken up." The observance is not representative of an actual event that occurred to an historical character but symbolizes the constellation of Virgo at the autumnal equinox, when the Virgin is "rendered invisible by the solar rays."[70] Another Catholic ritual is the "Stations of the Cross," which were likewise not original with Christianity but constitute an ancient oriental meditation and initiation technique found in a variety of places. Ditto with rituals such as kissing the images of "saints." Even the monks' tonsure or "circle of baldness" at the top of their heads, evidently

proscribed at Leviticus 21:5, not only is thus pre-Christian, occurring in India, China, Persia, Chaldea and Greece, but also, per Herodotus, signifies sun worship.[71] Christian festivals and feasts, too, are representative of sun worship, "essentially connected with the principal epochs of the annual movement of the Star of Day." As Alan Watts said, "...because the sun itself in both its daily and annual course is seen as a type of Christ, the Sun of Justice, the Christian year is rather significantly integrated with the cycle of the sun."[72]

The Christos

The term "Christos," meaning "Anointed," was well known long before the Christian era, appearing in the Septuagint or Greek Old Testament some three dozen times. Some of the most important Old Testament scriptures had the term "Christos" in them. In other words, centuries before the "historical" Christ was ever conceived, Hebrews, Jews, Israelites and Samaritans were reading and reciting "sacred scriptures" about *Christ*. For example, "Christos" appears in the Old Testament at 1 Sam. 2:10, 2:35, 12:5 and 16:6. The scripture at 2 Samuel 22:51 says:

> [He is] the tower of salvation [yehoshua] for his king [melek]: and sheweth mercy to his anointed [ton christon], unto David, and to his seed for evermore.

As can be seen, the Hebrew for "salvation" is *yehoshua*, or *Joshua/Jesus*, while the word "anointed" in the Greek is *christos*: Hence, we have God, the "tower of salvation," or Yehoshua/Jesus, showing mercy to his Christ.

2 Samuel 23:1 states:

> Now these [be] the last words of David. David the son of Jesse said, and the man [who was] raised up on high, the anointed [christon, mashiach] of the God [elohim] of Jacob...

Thus, King David was called God's *Christ* centuries before the Christian era. So too was the Babylonian king Cyrus/Koresh at Isaiah 45:1.

Another example can be found at 1 Chronicles 16:22: "...Touch not mine anointed [χριστων], and do my prophets no harm." The word for "anointed" is the genitive of the plural *Christoi*, indicating multiple "anointeds" or Christs. As is evident, there have been many Christs, centuries and millennia before the Christian era. Indeed, CMU asks, "Did not Cicero, when he travelled in Greece, find inscriptions on monuments to many Christs?"[73]

The term was even used to designate the sun[74] and has its roots in Egypt: "Anointed" in the Book of the Dead (ch. XXX) is *mesu* [messiah].[75] Other sun gods were also called "anointed," in

the language of their own cultures. For instance, centuries before the common era the Vedic god Agni, who so resembles Jesus in a number of germane aspects, was called "akta" or *anointed.*[76]

The Son of God

The phrase "son of God" is commonly applied to numerous gods and men from around the world. In *The Truth About Jesus*, M.M. Mangasarian, a minister before discovering the mythical nature of Christ, states that the concept of "a Son of God" is "as old as the oldest cult." He further observes, "The sun is the son of heaven in all primitive faiths." Hence, the *sun* of God is the son of God.

In the Pyramid Text of Pepi I, dating to the 24th century BCE, the deceased king is eulogized as "the son of God."[77] In "The Legend of Ra and Isis," the sun god Ra is depicted as saying:

> Come unto me... I am a prince, the son of a prince, a sacred essence which hath proceeded from God. I am a great one, the son of a great one, and my father planned my name; I have multitudes of names and multitudes of forms, and my existence is in every god....
>
> ...I have made the heavens and the earth, I have ordered the mountains, I have created all that is above them, I have made the water...[78]

Even Satan is a pre-Christian "son of God," as at Job 1:6: "Now there was a day when the sons of God came to present themselves before the LORD, and Satan came also among them."

The son of God also makes an appearance in the writings of Seneca (4?-65 CE), whose works and philosophy display so much in common with Christian/Pauline ideology that in the fourth century Christian conspirators were compelled to forge bogus correspondence between Seneca and Paul, in order to show a relationship.[79] In reality, Christian authors "borrowed" many of their concepts from Seneca. For example, in the tragedy *Hercules on Oeta*, attributed to Seneca, the author described a hero/son of God who appeared on earth as the suffering servant, to die for mankind and be exalted to his father Zeus. In his suffering, he calls for water and is ignored. When he dies, the earth becomes dark, and the sky thunders, as he utters, "It is finished." After conquering death, he is "exalted to Heaven."[80] Thus, in this pre-Christian tragedy appear the Passion and Ascension, as applied to an archetypical Son and not an "historical" Jesus.

The "son of God" also is found in the Dead Sea collection, in "The Son of God" scroll 4Q246, which refers to the "coming kingly or Messianic figure" as the "son of God" or "son of Most High." In addition, "Images of this kind...abound in Old Testament

scripture, particularly in honouring great kings."⁸¹ For example, Psalms 2:7 says: "You are my son, today I have begotten you." Other instances appear at 2 Samuel 7:14 and Psalms 89:27.

For centuries and millennia before Christ's purported advent, millions of people globally believed in the Incarnation, Resurrection, Ascension and Atonement and Salvation of the son of God. This fact was especially so in regard to the Osirian religion. In other words, these concepts were *not* "prophecies" of the exalted Jewish godman to come but were already in existence in reference to the great *Egyptian* god, among many others. As Cassels relates:

> This idea of the redemption of men by the "son" of the most-high God is very ancient, and was widespread in early times. In the Babylonian religion the redeemer Marduk is sent upon the earth by his father Ea to save men from their spiritual maladies and moral perversity. The Greeks worshipped similar "sons" of God and benefactors of men in Heracles, Dionysos, and Jason or Jasios (the Greek name for Jesus), who likewise had a heavenly commission to redeem men, and were taken back into the circle of the blessed after a premature and impressive death. The idea flourished chiefly, however, in the religions of nearer Asia and North Africa, among the Phrygians, the Syrians, and the Egyptians, who worshipped in their Attis, Adonis, and Osiris (respectively) a god who suffered, died, and rose again for humanity, and expressed their belief in mysterious cults which are known as "mysteries."⁸²

Rather than an "historical" son of God, it is *the mysteries* being revealed in Christianity, in common worldwide long before Jesus's alleged existence.

The Twelve

As is the case with Jesus, there is no historical record of the 12 apostles or disciples, absent even from the Pauline epistles, save one late interpolation.⁸³ Eisenman has shown where a number of the apostles could have been modeled after certain *Jews* of the first century; however, as *Christians*, they are decidedly *not* historical. The 12 disciples/apostles were not "real people" but represent the 12 signs of the zodiac, and the teaching sun god or solar hero with the 12 "helpers" or "disciples" is another common astrotheological motif. In the solar myth, as the sun moves through the constellations it awakens and enlightens them. In addition to the myths already mentioned, the Twelve can be found in the stories of King Arthur and his 12 Knights; "Balder and his twelve judges; Odysseus and his Twelve Companions; Romulus and his Twelve Shepherds"; as well as Jacob and his 12 sons, et al.⁸⁴

It is evident that some if not all of the Christian Twelve symbolize ancient gods from a particular locale and ethnic group that the Christian creators wished either to disparage or to bring into the fold. For example, Andrew, one of the Baptist's disciples lost to Jesus, is a name of the crucified fertility god of Patras, Greece. It seems that his name was used to incorporate Jews who either lived there or who had been otherwise Hellenized.

The "apostle" Peter ("rock") is associated with Jesus ("salvation") long before the Christian era, in Old Testament scriptures that address either the divine "Rock of Salvation" or God as both "my rock" and "my salvation," such as at Deut. 32:15; 2 Sam. 22:3, 22:7; Psa. 18:22, 18:46, 62:2, 62:6, 62:7, 89:26, 95:1; and Isaiah 17:10. Hence, the apostle Peter, as demonstrated in *The Christ Conspiracy* and elsewhere, is the old "rock" (*petra*) found within Judaism and Paganism alike, especially prevalent in Mithraism. Petra is also the "doorkeeper" to heaven and to the mysteries in the Egyptian mythos. It is clear from his characteristics that Peter is styled after the Roman god Janus, as has been noted and demonstrated elsewhere. Petra was thus a popular god epithet at Rome, which is why Peter is a *Roman* representative; in other words, Peter was invented to incorporate that major faction of the brotherhood.

According to Pausanias, the inhabitants of Orchomenos in Greece worshipped "Petras," or rocks, "which were supposed to have fallen from heaven."[85] Regarding this scenario, Christian scholar Bryant comments that "every oracular temple" possessed "some legend about a stone...some reference to the word Petra." He further remarks that "when the worship of the Sun was almost universal," Petor or Petros was "one name of that Deity even among the Greeks."[86]

The Peter or rock is also found within the Eleusinian mysteries, as Bell relates:

> The holy mysteries...were read...out of a book called Πετρωμα
> [Petroma], a derivative from πετρα [petra], a *stone*, because the
> book was composed of two stones fitly cemented.[87]

"Petra" is an old mythical motif, an aspect of the God Sun incorporated into the Christ myth as Peter, whose role as second banana is a reflection of how ubiquitous and important was the pre-Christian Peter cult.

Regarding Simon, by which name Peter was called as well, it has already been established that there was a Syro-Samaritan god named Semon or Saman (Hebrew "Shamash" or "Samas"), apparently also styled "rock" or Petra. Considering that "Jesus" is basically the *Samaritan* savior and Ephraimite sun god Joshua, it

is not surprising that his "close companion" was the Samaritan god Simon/Saman, the head of the Buddhist Samaneans.

In Mark's gospel, Matthew the tax-collector is called Levi, son of Alphaeus. Eisenman notes that Josephus's father was named "Matthias," or Matthew, and suggests that the father "might have been the prototype for the renowned 'Matthew,' to whom the traditions incorporated in the First Gospel are attributed."[88] Zindler examines Matthew's other names, Levi, which represents the priestly tribe of the Levites, and Alphaeus, which has "astrological significance." He links Alphaeus to the Babylonian *alpu*, meaning "bull," an epithet of Marduk and the zodiacal sign of Taurus. Says Zindler, "It would appear that the purpose of this disciple story is to reduce the priesthood, the erstwhile leaders of the Israelite religion, to the rank of simple students at the feet of the new teacher."[89]

This usurpation of "Levi Alphaeus" by Jesus evidently represents a displacement of the priesthood that reigned during the Age of Taurus, which would be residual in the Judean priesthood that slaughtered bulls, the most spectacular of the animal sacrifices. Although the Ram of Aries was supposed to supplant this sacrifice among the orthodoxy, it appears that the Judean priesthood received a renewed impetus in bull sacrifice during its sojourn in Babylon, where it came across Mithraism. In addition, Matthew's occupation as "tax-collector" would also be an appropriate designation for the Levitical priesthood, since the latter required constant tithes for practically every aspect of Jewish life, including the sacrifice of food animals centralized at Jerusalem through the destruction of the natives' "high places."

As previously noted, "Matthew" plays an important role in Egyptian mythology as well. In the Egyptian Book of the Dead, one destination of the souls of the deceased are the "Fields of Peace" ("Yaru"[90]) or "Aaru-salaam." In order to arrive in the heavenly realm, the deceased had to pass through the Hall of Maati, to be cleansed of sins, which journey allows him to see "God, the Lord of mankind."[91] Thoth or Tehuti is the scribe of the gods, as well as "the god of right and truth," i.e., Maat, who is depicted as his "wife."[92] The two together would be "Maat-Tehuti," which may explain how the "Matthaios" of the New Testament Greek became "Matthew."

In addition to gods, it is possible that leaders of proto-Christian cults were also targeted for usurpation, which would account for the variety of "Jameses," as Zindler suggests. It is also likely that "James," or "Iakobos" (*Jacob*) in the original Greek, represents *Israel*, as a nation and a spiritual entity. Delving into the etymology of "James" and "Jacob," Taylor equates the latter with *Iacchus*, an alternate for Dionysus/Bacchus, and the former

with *Iamus*, "I AM" being "the universal and most ancient name of the God Apollo." That Apollo and Dionysus are two epithets for the same entity, i.e., the sun, answers the puzzling question as to why "James" and "Jacob" are considered the same name.[93] In Greek mythology the child prophet *Iamos* is Apollo's son with Evadne, who places the newborn "in the rushes..."[94] Also, one of the four "sons" and "brothers" of Horus was *Amset*, who was the "genius at the Cardinal Point in the East."[95]

Regarding Thomas, again, Christian mythology claims that the odd, Thomas-worshipping cult at Malabar in India was established by the "historical Thomas." However, it is evident that this cult was that of *Tammuz*, Tamus or Tamas, worshipped in Syria and, apparently, India thousands of years prior to the Christian era and having nothing to do with any gospel fable, except as a source of it. In fact, the Brahmans in the Malabar area "hold the place in detestation," because they consider the Indian "Thomas" to be a "form of Buddha." As we have seen, "Buddha," like Tammuz, is a sun god. The sun by the name of "Thomas," which means "twin," would have been worshipped during the Age of Gemini (the Twins), some 5,000 or 6,000 years before the common era.

As demonstrated in *The Christ Conspiracy*, Judas is likewise an old Pagan motif, the adversary or enemy of the good god ("Chrestos") who, in the Egyptian mythos is the "serpent" Set, i.e., Satan, the "Prince of Darkness" who opposes the God Sun. His Hebraic name, which is the same as "Judah," is obviously designed to place the onus of Jesus's death on the Judeans. This suspicion is further evidenced by the fact that much of the Christian mythos and ritual was fabricated by Samaritans or northern kingdom people, who denigrated the Judean hero Judah. In the celestial mythos, Judas is the "backbiter," or Scorpio, representing the time of year when the sun becomes weakened. In the Egyptian version, Horus is stung by the scorpion, "that is, the heat of the sun is rendered weak by the cold of winter."[96] Judas or *Judah* as "Iscariot," i.e., the Issachar of Genesis 49, is the "strong ass, crouching down between two burdens," which is to say the Ass stars in the constellation of Cancer, when the sun's strength begins to weaken. Judas is, in another words, the "jackass" of the gospel fable.[97]

The mythical Twelve is a formula also used in Jewish religious structure, found in the proto-Christian text *The Teaching of the Twelve Apostles*, which was later Christianized.[98] This body appears to be have been established during the early part of the Jewish Diaspora, such that "the Twelve" are depicted as moving throughout the known world, preaching "Scripture," i.e., the

Mosaic Law. It is evident this group of men, along with the Dionysian proselytizers, the Therapeuts and assorted others, were all rolled into a fictional group constituting the "early Christians," i.e. those who supposedly existed but are found nowhere in the historical, literary or archaeological record.

Word of God/Logos

The Logos or Word is a prehistoric concept widely found as representing the manner by which God created the cosmos. It "had long been known that Plato, Aristotle and others before the Christian era" revered the Divine Word, the development of which was "most astonishing" in ancient Egypt, where it was believed that creation was spoken into existence by the "highest god." This Egyptian Word is Thoth, who is "not separable from Ptah," the great father god.[99] Indeed, "Ptah, worshipped as the architect of the universe 2,000 years before Genesis was written, also created the world through the word..."[100] The Word is also present in texts such as the "Book of knowing the evolutions of Ra," in which the sun god Ra is depicted as creating the heaven and earth thus: "I brought into my own mouth my name as a word of power, and I straightaway came into being."[101] The Logos is therefore the creative power of the God Sun, reflecting the "mind of the great Being or of the great God-universe," called in Christianity "the Redeemer."[102]

The Logos is "the heavenly incorruptible food of the soul," the "bread...from heaven."[103] (Exod. 16:4-5) Hence, the Divine Word is the "manna from heaven," and the "biblical" concept of the "bread from heaven" associated with the Word of God is straight out of the Egyptian religion, ages before the Bible was composed. This idea is discussed, for example, in the pyramid text recording the afterlife transition of the king Pepi I of the 6th Dynasty, during the 24th century before the common era:

> He thirsts not, nor hungers, nor is sad; he eats the bread of Ra and drinks what he drinks daily, and his bread also is that which is spoken by Seb, and that which comes forth from the mouth of the gods.[104]

The "bread of life" is also that bread "spoken by Seb," the earth god, i.e., the harvest. Seb becomes "Io-Seph" or Joseph in the Christian version of the mythos.

The mysterious Logos was known or developed by not only the Egyptians but also the Chaldeans, [105] as part of their priestcraft. Another example of the pre-Christian Logos was Marduk, the Assyro-Babylonian/Chaldean god, who was well known to Jews in Babylon, as reflected in the Talmud.[106] The Logos concept was acknowledged by Heraclitus in the 6th century BCE, who also

spoke of the unity of the "Father and Son," centuries prior to the Christian era.[107] The pre-Christian Dead Sea scrolls also contain the "Logos of Righteousness" in "A Genesis Florilegium" (4Q252).[108] The thousands of newly released scrolls and fragments likely contain more intimations of this sort and others. In the Orphic tract *Diathecae*, related by Justin Martyr in "Justin on the Sole Government of God" (Ch. II), "Orpheus" speaks of the "Word Divine," the "One and Universal King, One, Self-Begotten, and the Only One," and the "Great King."[109] Justin also describes Orpheus as introducing "the three hundred and sixty gods," who represent the days of the year and indicate the antiquity of this tract.

Josephus affirms the Logos's solar identification in his discussion of the menorah, or seven-branched candlestick, representing the sun in the middle surrounded by the moon and five planets, the central sun of which, the historian reiterates, was recognized by Philo as the Word of God.[110] In Revelation/ Apocalypse, Christ is depicted as the solar Logos in the middle of the "seven candlesticks or lamps," i.e., the menorah. As Bunsen says in *The Angel-Messiah*, "the Hebrews knew traditions according to which the Memra or Word of God, the Messiah, was symbolised first by fire...and later the Hebrews symbolised the Word by the sun."[111]

Philo also considered this solar Logos of God the "Archangelic Word" and "Second God," or crucified Word, concepts refined and Judaized by the Jewish philosopher. Humanity was created not in the likeness of the "most high God" but "in that of the 'Second God who is his Word.'" Nevertheless, the Word is itself "the image of God, at once the most ancient of all conceivable things." The Word is also "the Governor (of all things) and his creative and kingly power." He is likewise the "Ambassador sent by the Governor (of the universe) to his subject (man)."[112] To Philo, God is a Shepherd and King who appoints "his true Logos, his first-begotten, to have the care of this sacred flock..."[113] Philo's "Eternal Logos," then, is the "manifestation of God in every way." The seeker striving towards the Divine Word, the "fountain of Wisdom," will attain "eternal life" and will be guided to "the Father, God." *The proto-Christian imagery in Philo's writing is evident.* He further calls the Logos "the Light," and "quoting in a peculiar form Ps. 26:1: 'For the Lord is my light...and my Saviour,' he goes on to say that, as the sun divides day and night, so, Moses says, 'God divides light and darkness'..."[114] Even the *incarnation* of the Logos is found in Philo's writings, a concept likewise not original to Judaism or Christianity. Philo's incarnated Word is called "mediator," "son of God," "light of the

world," who "descends from his heavenly sphere and enters the world of sense, to give strength to the good, and save men from sin, and lead them to their true home, the kingdom of heaven, and their heavenly father."[115]

Philo identified as the Logos the angel/messenger who accompanied the Jews during the Exodus out of Egypt (Ex. 23:20), and later Church fathers confirmed the identity of this angel/Logos as *Joshua/Jesus, the Old Testament and northern kingdom hero.* Hence, we have Jesus the Logos within Judaism long before the creation of the Christian godman.

As stated, Philo developed the Logos concept as it applied to Judaism, using the Septuagint or Greek scriptures, which, varying widely from the original Hebrew, had been translated in a manner as *to create the Jewish version of the Logos.* In fact, "in the Septuagint translation of the Bible we are fortunately able to track the progress of the theory which culminated in the Christian doctrine of the Logos."[116]

Considering that Philo was alive at exactly the time Jesus was purported to have lived, it is impossible to believe the scenario depicted in mainstream "history": Philo was exactly describing *Jesus*, when this Logos just happened along, yet Philo was completely oblivious to the miraculous manifestation of his very own belief system? In his very part of the world? And exact era? Clearly, Jesus Christ is a mythical character, Judaized as the Logos of the Septuagint and Philo, and historicized during the second century. It is thus reasonable to suggest that Philo, an apparent Therapeut, worked with others whose goal was to synthesize Paganism and Judaism, the result of which, in the *second* century, became Christianity. Indeed, Philo's ideas form the core of the Gospel according to John and appear in the works of other Christian writers, including Justin Martyr. In the end, Cassels says, "there is not a representation in the fourth Gospel which has not close parallels in the works of Philo."[117]

It is obvious that the creators of Christianity used the works of Philo, as well as those of Plato, Socrates and Aristotle, in order to create their godman and tenets. As demonstrated, the push to usurp the Logos concept of the Greek philosophers can be found in the Septuagint, and from the Septuagint with its Logos named Jesus to the utter historicization of the Word in the New Testament is not much of a leap. In the Septuagint it is also Wisdom, or Sophia, who is the intermediary between God and man, and Jesus is subsequently put in her place as well. These concepts are traceable through the works of the Gnostics, and the transition between Plato, the Septuagint, Philo, the Gnostics and the New Testament becomes practically seamless. With the

addition to these sources of the apocryphal Jewish, Samaritan and Therapeutan texts, the transition is smoothed even more.

Joshua, Son of Nun

Frequently written about and equated with the Word by a number of sources from the Septuagint to Philo and the Church fathers is the Old Testament "hero" Joshua, whose Logos role would subsequently become famous in Christianity. The name "Joshua" (Hebrew "Yehoshua") appears over 200 times in the Old Testament, and readers of the Greek bible, used by the creators of the New Testament, would see this oft-used word as Ιησους, or *Jesus*. Therefore, a reader or hearer of the Septuagint scriptures would have been quite familiar with the name Jesus, in reference to a prominent "Jewish" figure, long before the creation of the gospel story. Indeed, the scripture Joshua 6:27 says, "So the LORD was with Joshua; and his fame was in all the land"—a passage translated centuries before Christ's purported advent as stating that the Lord was with *Jesus,* who was renowned throughout the land, exactly as was later repeated in the New Testament. Per Philo and the Church fathers, Joshua was the "angel" at Exodus 23:20 who, accompanying the people out of Egypt, led Israel into the Promised Land; at 1 Corinthians 10:1-4, Paul claimed this "supernatural Rock" that followed the Hebrews out of Egypt was *Christ*. Also, the New Testament Jesus was baptized at the same spot where Joshua was said to have passed over the Jordan River. Concerning Joshua's leading of the tribes over the Jordan, in *The Books of Joshua and Judges* Christian scholar Ignatius Hunt remarks, "There is no doubt about the high importance of this event in the Old Testament's salvation-history, for it brings the Chosen People into Canaan, thus fulfilling a centuries-old promise."[118] Indeed, as Pelikan says in *Jesus Through the Ages*, the conquering of Jericho by "the first Joshua...foreshadows the redemption accomplished by the second Joshua, Jesus."[119] Moreover, the pre-Christian apocryphal and intertestamental "Jewish" (Sadducean) text *The Wisdom of Jesus* (c. 180 BCE), a.k.a. *Ben Sirach* and *Ecclesiasticus*; calls Joshua "the great savior of God's chosen ones" (46:1-8).

The relationship between the OT Joshua and the NT Jesus is also indicated at Acts 3:20-23, in which Peter is made to say that God appointed a Christ—*Jesus*—after which the apostle discusses the prophet addressed by Moses at Deuteronomy 18:15, i.e., *Joshua*. The canonical Epistle to the Hebrews and the non-canonical epistle of Barnabas both display this connection between Joshua and Jesus; in fact, translators of these epistles have been hard-pressed to distinguish between the two. Furthermore, a number of the Church fathers maintained that

Joshua and Jesus were essentially the same. For example, in his *Dialogue with Trypho the Jew* (CXIII), Justin says:

JOSHUA WAS A FIGURE OF CHRIST.

"What I mean is this. Jesus (Joshua), as I have now frequently remarked, who was called Oshea, when he was sent to spy out the land of Canaan, was named by Moses Jesus (Joshua)...."

The Catholic Encyclopedia ("Josue/Joshua") notes that "in the name Jesus Nave [Joshua son of Nun] many of the Fathers see the type of Jesus" and that to "the Fathers Josue is an historical person and a type of the Messias." The comment that Joshua is an "historical person" is made in response to prominent scholarship that showed him to be mythical. Even the Protestant Encyclopedia Biblica is "very skeptical about Joshua" and "is disposed to agree on 'a solar mythical origin' for the Jewish leader."[120] In his *Christianity and Mythology*, Robertson declares: "That Joshua is a purely mythical personage was long ago decided by the historical criticism of the school of Colenso and Kuenen; that he was originally a solar deity can be established at least as satisfactorily as the solar character of Moses, if not as that of Samson."[121] Robertson further calls Moses and Joshua "obviously solar personages" and "old Saviour-Gods" turned into miracle-making leaders.[122] So strong was this scholarship that the Biblical Commission of February 15, 1909 was compelled to decree that it would "not tolerate that a Catholic deny the historicity of Josue."[123] That the story of Joshua and the walls of Jericho falling down is fiction, however, as are the fables of Joshua's conquest of other Canaanite cities, has since been proved by archaeology, which has revealed, among many other things, that the Canaanite cities were not walled, as related in the Bible.[124]

The modern Christian publication *The Books of Joshua and Judges* asks the reader to explain "why Joshua may be regarded as a figure of Christ,"[125] verifying that the association between Joshua and Jesus continues to this day. The identification of Joshua as "the type of Jesus" and "a type of Messiah" has prompted a number of writers, including W.B. Smith, Robertson, Couchoud, Dujardin, Bolland, Drews, Weigall and Rylands, to evince a pre-Christian Jesus cult. For example, Bolland calls Jesus Christ "merely an allegorical rehabilitation of the Old Testament Joshua."[126] Robertson reiterates that the "quite certainly unhistorical" Joshua, a sun god "like Samson and Moses," was an "ancient deity reduced to human status."[127] Drews likewise asserts that Joshua/Jesus was the sun god of the Ephraimites, one of the main tribes of the northern kingdom of Israel, later called Samaria. The Ephraimites eventually came to

be known as Samaritans, although, according to the Judean biblical "history," the Samaritans were Assyrian mongrels who had replaced the original Israelites. Nevertheless, the Samaritans themselves have maintained otherwise, that they are true "sons of Joseph," a claim that is accurate to the degree that, while thousands of Israelites were removed or killed, many thousands more remained in the northern kingdom, with only a "very small percentage...exiled, to judge from [the Assyrian conqueror] Sargon's own account." Nor could there have been a large a number of foreigners transported into Samaria, as claimed by biblical writers.

Per the biblical tale, Joshua was an Ephraimite (Num. 3:18), rather than a Judean, revered as the redeemer and messiah of the northern kingdom people in particular, as Friedman states:

> ...Joshua was a northern hero. He is identified as coming from the tribe of Ephraim, Jeroboam's tribe; Joshua's tomb is in the territory of Ephraim, and, according to the last chapter of the book of Joshua, Joshua's work culminates in a covenant ceremony at Shechem.[128]

According to the Samaritan text the Asatir (10:45), Samaritan tradition designates Joshua as the "scepter" mentioned at Genesis 49:10 as belonging to "Shiloh" or the messiah, which at Numbers 24:17 is equated with the messiah himself. This same scepter at Hebrews 1:8 refers to the New Testament Jesus. In the Jewish text 2 Esdras, at 7:28-29 (4 Ezra 7:27), the Messiah is blatantly called "Jesus":

> For my son Jesus shall be revealed with those that be with him, and they that remain shall rejoice within four hundred years. After these years shall my son Christ die, and all men that have life.[129]

This remarkable passage could be a Christian interpolation; however, in "Was there a 'Messiah-Joshua' Tradition at the Turn of the Era?" Robert Kraft argues otherwise. After presenting some insights as to the passage's possible genuineness, Kraft asks:

> Could it be, then, that the identification of the dying Messiah with a ΙΗΣΟΥΣ [Iesous] figure is indeed original and reflects a detail of Messianic speculation which originated in pre-Christian Judaism?[130]

Regarding the Joshua-as-Messiah theology, Kraft further comments:

> As to its origins, if indeed it had any *one* place of origin, the Northern Kingdom and particularly Samaria is the most likely candidate with its reverence for Joseph-Ephraim and its antipathy to any suggestions of a Davidic Messiah. From Samaria, and perhaps by means of diaspora Samaritan

communities such as we encounter in Alexandria, the rudimentary Joshua messianology came to influence Greek as well as Semitic Judaism.

Kraft also states that the "this [Samaritan] messianological thought...perhaps filtered into hellenistic Judaism by means of the sizeable Samaritan element at Alexandria."

While the Judeans were expecting a "son of David" messiah, the Israelites/Samaritans awaited a "son of Joseph" messiah, who in "Talmudic allusion" was often called "Messiah ben Joseph," or "Christ, son of Joseph."[131] This distinction between the two messiahs is made at Sukkah 52a, which claims that "Messiah the son of Joseph" will be or has been slain, as the "pierced" one referred to at Zechariah 12:10. At Sukkah 52b, Messiah the son of Joseph is one of "four craftsmen," which include "Messiah the son of David," Elijah and the "Righteous Priest" (Melchizedek). Per Zechariah 2, these "craftsmen" are to measure Jerusalem, which sounds like a possible activity for the priestly carpenter guild of the Nazarites/Nazarenes. In any event, in the "prophecy" or blueprint established for the northern kingdom messiah is the pre-Christian tale of a slain "son of Joseph" who is a "craftsman."

The Samaritan role in the creation of the gospel myth is evident and significant. The scripture in Acts identifying Jesus with Joshua, "coupled with the fact that Joshua was especially honored in Samaria, throws light upon the taunting assertion of the Jews (Jn. viii, 48) that Jesus was a Samaritan."[132] Moreover, the "Redeemer figure of the Samaritans, called 'the *Taheb*,' also seems to have been a Joshua-like figure or a 'Joshua *redivivus*' or a 'Joshua-come-back-to-life.'"[133] Joshua's importance was demonstrated abundantly during the time of Pontius Pilate, when a messianic figure caused an uprising in Samaria that was brutally quelled, with a number of individuals crucified on Mt. Gerizim. The temple at Gerizim was used for "sacrifice for Adam, Melchizedek, Jacob and Joshua" by the Samaritan priesthood, largely composed of Zadokites/Sadducees, the inheritors of the centuries-old "Jewish" priesthood who were "expelled from Jerusalem." When Pilate destroyed and desecrated the Gerizim temple, it was as if he had "crucified Joshua," a notion that reveals why the Roman prefect was chosen as the villain in the gospel fable, in which he allegedly "crucified Jesus."

This Old Testament messiah, redeemer, Logos and angel who "led the Israelites out of Egypt and went before them as a pillar of flame" (Num.20:16; Exod. 13:21) also wrestled Jacob (Gen. 32:24) and "fought against [the Israelites'] enemies [and] drove the Canaanites from their homes" (Exod. 33:14; 2 Sam. 23), etc.[134] This divine intermediary is the "King" (Molech), as well as

Yahweh's "anointed" and "begotten son," as in Psalms 2. This entity is in Jewish mysticism "Metatron," who is "related to the Logos," and is the "Lord of lords" and "King of kings," etc. Again, this northern kingdom messiah is the "son of Joseph," the "mythical Joseph," as Drews says. In this regard, Eisenman declares that "the biblical 'Joshua,' the individual upon whom Jesus is typed...really *was* a true 'son of Joseph.'"[135] Moreover, Arabic tradition holds that Joshua's mother is "Mirzam,"[136] the same as the Miriam of Exodus, sister of Moses and Aaron, likewise held in Persian tradition to be the mother of Joshua.[137] Both names are equivalent to Mariam or *Mary*. As Strong's Concordance (3137) relates: "Mary or Miriam='their rebellion.'"
Hence, in Joshua is a pre-Christian Jesus who is the Messiah, Anointed, Savior, Redeemer, Deliverer, Logos and Son of God, also the son of Joseph and Mary who is a pierced and slain "craftsman" persecuted by Pontius Pilate!

That Joshua was not just revered but worshipped, in rites held over from when he was apparently a Canaanite/Israelite god, is suggested by numerous factors, including his veneration in the Samaritan temple at Gerizim. Drews identifies this "cult deity" Joshua with not only Jesus but also the "old Greek divine healer-hero, Jason,"[138] who was worshipped widely, particularly as an epithet of Asclepius. Indeed, "Jason [is] the Greek counterpart of *the biblical Joshua, whose solar nature is beyond question.*"[139] The Jason cult proves the existence of pre-Christian Jesus worship among Pagans, while the Joshua cult does likewise among the Israelites. The pre-Christian Jewish Jesus and his relationship to the gospel Jesus, as well as to Jason, is described by Weigall:

> There is evidence, it is suggested, of the cult of a sun-god called Joshua or Jesus in primitive times, whose twelve disciples were the twelve signs of the Zodiac; and just as Jesus Christ with His twelve apostles came to Jerusalem to eat the Paschal lamb, so Joshua crossed the Jordan with his twelve helpers and offered that lamb on the other side, and so the Greek Jason—an identical name—with his twelve retainers went in search of the golden fleece of the lamb.[140]

It is thus apparent that there were pre-Christian Christ and Jesus cults involving a number of savior gods and a widespread area. Other indications of the Joshua/Jesus cult can be found not only in the Greek but also in the Hebrew Old Testament. As is discussed in detail in *The Christ Conspiracy*, the religion of the Israelites and Hebrews was polytheistic, not monotheistic, essentially the same as that of their Canaanite neighbors, with Egyptian and Mesopotamian influence. As such, the Israelites worshipped a variety of gods, or Baalim, Adonai and Elohim, the singular of the latter being "El." This polytheism was hidden,

particularly after the "Babylonian Exile," when the Jewish priests, influenced by Zoroastrianism, made Judaism a monotheistic religion. As did Pagans, however, Jews frequently personified and deified concepts such as Wisdom or the Word, and it is clear that, like these others, "Salvation" was also personified as the "Salvation God." In this regard, "Joshua" is revealed to be an ancient Canaanite god, Baal Yehoshua, the Lord of Salvation. As a baal, he is also an aspect of the great God Sun.

Suggestions of the worship of Baal or El Yehoshua, Yeshua or Yeshuah, the Lord of Salvation, can be uncovered in a number of Hebrew scriptures. For example, the original Hebrew at Exodus 15:2 indicates "El Yeshua," the God of Salvation:

> The LORD [is] my strength and song, and he is become my salvation (y@shuw'ah): he [is] my God ('el), and I will prepare him an habitation; my father's God ('elohiym), and I will exalt him.

"The Lord" in this passage is Yah, or Jah, and this scripture could be interpreted: "Jah...is become my Yesha/Joshua/Jesus... my El...my father's Elohim and I will exalt him." The Hebrew word Yah/Jah is used 50 times in the OT, but rarely transliterated as such. In the Webster's translation, only one verse, Psalms 68:4, is left transliterated as Jah: "Sing unto God, sing praises to his name: extol him that rideth upon the heavens by his name JAH, and rejoice before him." As shown, the Judean tribal god Yahweh is a sun, fire and volcano god; here, "Yah/Jah" is the typical sun god, riding through the heavens. The Septuagint does not match this verse but is a jumble. In fact, the Septuagint translation repeatedly does not correspond with the Hebrew: "In many places the differences are slight, amounting to a verse here and there. In the Psalms, the differences are greater, and greater still in Jeremiah, where a variant Hebrew source text may have been used by the original LXX [Septuagint] scholars."[141] The biblical texts found at the Dead Sea, many of which differ from the "received" Hebrew (Masoretic) text, may prove that the Septuagint was not "mistranslated" from the "original" Hebrew but that its translators used Hebrew texts different from the Masoretic. In either case, it is evident that the Bible is not the "divinely inspired, infallible Word of God" but a very fallible, manmade text.

Already cited as an example of the Jewish salvation cult is 2 Samuel 22:51, which calls God the "tower of salvation," i.e., Yehoshua/Joshua/Jesus. Another instance of the personified Salvation may be found at Deuteronomy 32:15:

> ...then he forsook God (el-o'-ah) who made him, and scoffed at the Rock of his salvation (y@shuw'ah).

"Eloah" is the same as El, while "salvation" is Yeshuah. An important scriptural concept, the "rock" in Greek is "petra";

hence, again, we have Peter and Jesus together already, centuries before the Christian era. At Psalms 95:1 is another reference to the "rock of salvation":

O come, let us sing to the LORD: let us make a joyful noise to the rock of our salvation (yesha').

The Vulgate of this verse (94:1 in this Latin version) is:

venite laudemus Dominum iubilemus petrae Iesu nostro

Here "salvation" is *Iesu*, i.e., Iesus, or Jesus: "Come, we shall praise the Lord, we shall rejoice in the Peter of our Jesus."

In another instance of the Salvation God, Psalms 68:19 says:

Blessed [be] the Lord ('Adonay) [who] daily loadeth us [with benefits, even] the God ('el) of our salvation (y@shuw'ah).

A simple translation of this verse could be: "Blessed be the Lord(s)...El Yeshua (Jesus)." In this scripture the Lord is El Yeshua or the God Jesus.

Still another intimation appears at Psalms 74:12:

For God ('elohiym) [is] my King (melek) of old, working salvation (y@shuw'ah)...

In this scripture appear together "Elohim," "Molech" and "Yeshua," all aspects of the Most High God Sun.

The God Salvation appears boldly at Isaiah 12:2:

Behold, God ('el) [is] my salvation (y@shuw'ah)

Simply, this scripture says: "Behold, El Yeshua."

Habakkuk 3:13 speaks of the salvation of the anointed:

Thou wentest forth for the salvation of thy people, for the salvation of thy anointed....

Here "salvation" in the Hebrew is *yesha*, while anointed is *maschiach*. Hence, we have Yesha and Messiah, equal to "Jesus" and "Christ," in the same sentence. The Greek for "anointed" is τους χριστους, or tous christous, the plural of christos. Thus, the translation should be "anointed ones," reflecting that there was more than one messiah/christ.

The salvation cult is also represented in the Dead Sea scrolls, one of which is titled by Eisenman and Wise, "The Children of Salvation (Yesha) and the Mystery of Existence." The word for "salvation" being "Yesha" intrigued these authors, who remarked, "The use of the noun '*Yesha*' or the verbal noun '*Yeshuato*' ('His Salvation') is fairly widespread at Qumran and much underrated."[142] A number of these pre-Christian Zadokite writings discuss "salvation," or *yesha*, as in "You reveal Your salvation to me" or "Sing for joy in the tents of salvation."[143] Singing for joy in

the tents of *Jesus*, of course, is a major occupation of evangelical Christians.

The deliverer Joshua is overtly the subject of commentaries found at the Dead Sea, and, together with the obsession with Salvation, or Yesha, it is evident the scrolls' Zadokite authors were focused on the pre-Christian Jesus. Moreover, as Eisenman evinces, these Zadokites were closely related to the "Jerusalem Church," i.e., the faction in Judea that became Christian, ostensibly headed by "James the Just." Both these endeavors were integrated into the widespread and encompassing Gnostic movement, which was also "concerned mainly with *salvation*," or "Jesus," and syncretizing efforts of which produced Christianity. As demonstrated in *The Christ Conspiracy*, there are many connections between the Zadokites and the Christians. Another correspondence exists in the curious fact that in the 2nd century the Bishop of Sardis, Melito, in a list of the books of the Old Testament, omitted Esther, the only Old Testament text not found at the Dead Sea.

The truth is that there were several sects and at least one brotherhood network, including what became the Jerusalem Church, who were fervent followers of either or both of the ancient heroes Moses and Joshua. Another "underrated" fact is that the Jewish agitation during the Roman occupation incorporated "reenactments" of major biblical events involving these two figures, "with faith that this reenactment would bring salvation."[144] Expanding on this concept of various messianic agitators of the first centuries around the Christian era attempting to reproduce events from the Old Testament, especially those of the lives of Moses and Joshua, Price writes:

> A few scholars have noted the odd "coincidence" that both Theudas and the Egyptian sought to repeat the ancient feats of Joshua leading his people into the promised land. If they were trying to substantiate their messianic claims by aping Joshua, wouldn't this mean there was some currently available category like a "Joshua Messiah," a "Jesus Christ?"... It seems there was. Samaritans made a great deal of the Deut. 18:18-22 prophecy of the eventual advent of a "Prophet like Moses," and some Samaritan sectarians believed that the Samaritan mage Dositheus...was the Messiah. Other Samaritans claimed that the future prophetic Messiah was Moses' immediate successor, Joshua.[145]

After spending much time examining the overlooked "resurrection" of and importance placed upon these characters, Leidner deduces that there was a Joshua sect widespread in Judea. He cites the Dead Sea Scrolls as evidence of this cult of both Moses and his successor/lieutenant, Joshua. In addition,

the apocryphal text called *The Testament* or *Assumption of Moses*, referred to in the canonical epistle of Jude (9), "describes the transfer of authority from Moses to the first Jesus." The implication is apparent:

> From the foregoing...we can conclude that if but a fraction of the aura and greatness of Moses were transferred to the successor, we would have a supernatural being named Jesus who would mediate between God and man, and who would make intercession to God for the removal of sin. And this would be arrived at without the need for the "historical Jesus of Nazareth."[146]

The Joshua sect included proselytizing members or missionaries, such as "Paul" and the others with whom he competes—"a bible belt so crowded with rival missionaries, so swamped and crisscrossed with speakers that he is hard put to get a speaking engagement." Thus, Paul is not a divinely inspired instigator of a novel faith but "one of many in a well-established movement."[147] The main tool of this pre-Christian missionary work was the Septuagint, which was *the* version of Jewish scriptures used in *all* synagogues in the Diaspora, i.e., outside of Israel. It should be recalled that the Diaspora was composed of the vast majority of Jews, up to 7 million, and that the Septuagint was the source for numerous scriptures and concepts found in the New Testament.

In further proving the existence of this established, organized, pre-Christian Jesus/Joshua sect, with its churches and missionaries, Leidner examines the epistles of Jude, James and Hebrews, and concludes:

> These epistles point to late speculative Judaism, also to the theology of Paul and the Jerusalem church. There is no awareness of "Jesus of Nazareth." However there are clear linkages to Joshua and Moses, with confirmation for the premise that Joshua was the prototype for the gospel Jesus.[148]

Leidner continues his examination of the Joshua/Jesus connection by exploring Muslim traditions, including the Koran, which places "Jesus" and "Mary" in the same era as Moses.[149] In other words, the Arabs believed that Jesus was Joshua, the "prophet," and that Mary was Mirzam/Miriam, his mother.

Still another Joshua/Jesus of the Old Testament, the high priest in the biblical book of Zechariah, lent his role to the New Testament Jesus as well. Like the more famous one, this Joshua/Jesus was supposed to lead his people into Israel, the main Messianic task within Judaism. Like the NT Jesus, Zechariah's Joshua/Jesus is depicted as fighting with Satan. These two Joshuas, one Moses's successor and the other a high

priest, "blend into one person," as Drews says. Hence, "the name 'Jesus' received a Messianic significance, and came to be used for the 'branch' of the prophet Isaiah."[150] The pertinent prophecy at Isaiah 11:1 says, "There shall come forth a shoot from the stump of Jesse, and a branch shall grow out of his roots." The branch in Hebrew is *netser*, from the root *natsar*, meaning "to guard." The "Nazarites," then, were the branches of Jesse, i.e., the Jesseans, the name "Jesse" being another variant of "Jesus." Out of this Jessean or Jesuist cult the messiah would come—or be created, as was the case.

In addition to representing a number of pre-Christian saviors, the use of the name Jesus as a secret word to heal and cast out demons is a pre-Christian practice, exemplified in the epithet of "Jason" or "Iasios" applied to the healing god Asclepius and others. Intimations of this assertion are found at Mark 9:38 and Luke 9:49, which depict the complaints of the disciples that there are others casting out demons in the name of Jesus. Moreover, Justin Martyr related that Joshua became able to perform miracles only after Moses changed his name from Hosea to Yeshua.[151] The conclusion is that it was the *name* Yeshua/Jesus itself, rather than the "person," that possessed the power to cast out demons.

An example of this secret, sacred and healing non-Christian name of Jesus exists in an ancient magic papyrus (PGM IV), evidently dating to the fourth century CE, which contains an invocation as follows:

> I adjure thee by the God of the Hebrews, Jesus...

It has been suggested that a "confused Pagan" wrote this invocation; yet, it is probable that the spell accurately depicts something said esoterically by initiated Jews and Hebrews for centuries. In other words, the Jews/Hebrews/Israelites did in fact call their God—whose name "Yahweh" was ineffable and not to be spoken—by the epithet of "Jesus" or "savior/healer," as the Lord of Salvation or Salvation God. Adding to the scriptural evidence already provided for this assertion, in ch. 75 of *Dialogue with Trypho* entitled, "IT IS PROVED THAT JESUS WAS THE NAME OF GOD IN THE BOOK OF EXODUS," Justin argued that the conversation between Moses and Yahweh at Exodus 23:20-21—in which the Lord sends an "angel" (or *messenger*) to Moses to guard him on his way, stating that his (the Lord's) name is "on" the angel—refers to Joshua/Jesus and means that the Lord's name itself is Jesus.[152]

Thousands of magical texts were destroyed over the centuries, no doubt many of them containing some variant of the name "Jesus," i.e., IES, Iesios, Iasios, Iaso, Iason, or Jason. It is clear

that a number of magicians and "physicians"—or *Therapeuts*—were running about conjuring and healing in the name of "Jesus," long before any "historical" Jewish godman of that name was conceived. It is further obvious that this god Jesus was eventually falsely imposed upon history.

As is also evidenced by the PGM IV magical papyrus, the most likely candidates for this "Jewish" Jesus cult are not Judeans but "Hebrews," i.e., members of the other tribes, including and especially those of Ephraim and Manasseh/Samaria, whose priests determined that Joshua/Jesus was the fulfillment of several OT "prophecies" later used in creating the Christian Jesus. When all the evidence is weighed, it is clear that Israelite followers of Joshua/Jesus created the Christian godman as a "fulfillment" of this promise. In this regard, in *Asiatic Researches* Wilford remarks:

> In this manner, many of the *Samaritans*, in order to elude the prophecies concerning CHRIST, insisted that they were fulfilled in the person of JOSHUA, whose name is the same with Jesus, and who, according to the *Hebrew* text, was contemporary with CRISHNA; and they have also a book of the wars of JOSHUA with SCAUBEC, which may be called their MAHA-BHARAT.[153]

To repeat, Joshua was the "national hero" of the Samaritans, who received only the Pentateuch and the Book of Joshua as scripture. In their later texts, as Joshua cultists the Samaritans created numerous other tales about their great hero, one of which was discovered and published by Moses Gaster as "The Samaritan Hebrew Sources of the Arabic Book of Joshua." This text is traceable to circa 200 BCE and serves as a bridge between the ancient Joshua sect and the Christian Jesus cult. Upon inspection, it is certain that this text was one of the many used by the gospel writers in creating their fictional accounts. This text is also reminiscent of the "War Scroll" found at the Dead Sea; hence, once again our attention is turned to the pre-Christian and proto-Christian Zadokite and Samaritan churches of God as cornerstones of the Christian edifice.

Another "prophetic" source of "the messiah," i.e., Christ, was the Sibylline Oracles, many of which have been heavily Christianized if not forged outright. One of these purported oracles "predicted" that "a certain excellent man shall come again from Heaven, who spread forth his hands upon the very fruitful tree, the best of the Hebrews, who once made the sun stand still."[154] This "oracle," written by a Jew or Hebrew possibly around 130 CE, proves that "Jews" expected *Joshua*, who "once made the sun stand still," to return to earth from heaven. The "fruitful tree" has been interpreted to mean a cross; the passage does not

represent the gospel story of an "historical" Jesus but may depict the recurrent sacrificial ritual of hanging a god on a tree. The word "fruitful" in Hebrew is "Ephraim," again demonstrating a northern kingdom connection. Importantly, according to this "oracle" Jesus had not come yet by 130 CE, fitting with the contention that the "historical" Jesus had not been invented by then. It is likely that the push to historicize Joshua/Jesus occurred after the destruction of Judea and Samaria in 135 CE.

It was not the beloved Moses who led "the chosen" into the Promised Land but Joshua, who, like Moses, was the "Servant of God" (Judges 2:8). Joshua was also often called the "minister of Moses" (Exod. 24:13; 33:11) and, as depicted biblically and in the apocryphal text *The Assumption of Moses*, was given the Book of the Law to preserve. The lingering importance of Joshua to Israel, especially in the northern kingdom, cannot be underestimated. As Ignatius Hunt states:

> The book of Joshua is a religious epic, telling the story of the conquest, division, and initial settlement of Canaan (Palestine), i.e., the Promised Land and the Holy Land. No story could be more sacred or more treasured in the eyes of the Israelites; for it was Yahweh Himself who had promised this land to the patriarchs, and the entire conquest was carried out as a promise-fulfillment by Yahweh through the agency of His faithful warrior and inspired leader, Joshua.[155]

Again, Samaritans and other Jews/Israelites during the few centuries preceding the common era were religiously reading a Greek Bible in which the major hero, who led them into the "Promised Land," as ordained by God Himself, was named *Jesus*. This Jesus was a "son of Joseph," a "craftsman," and the "son of Miriam/Mary," as well as the Word, Scepter, Branch, Messiah, High Priest, etc. During the tumultuous times under the Alexandrian and Roman Empires, fanatical pre-Christian salvation cultists fervently awaited Joshua's return to save them once again. When he did not come, and after his followers' lands were seized and their temples destroyed, this mythical Joshua/Jesus messiah so long expected was created as an "historical" personage.

Shiloh, Shechem and Samaria

The Samaritan-Jewish religion of northern Palestine retained numerous archaic Egypto-Canaanite elements later proscribed by the fanatical Yahwist/Judean priesthood of the southern kingdom, who rewrote biblical texts and changed tribal history in order to create an appearance of monotheism. As Schonfield states in *The Passover Plot*, "There has been emerging ever clearer evidence that in the Galilean region an ancient Israelitish type of

religion persisted in the time of Jesus, defying Judean efforts to obliterate it."[156]

In the northern kingdom were important Israelite sites that predated Judean dominance, such as Shiloh, the very place "where the Lord first made his name known" and where Joshua set up the tabernacle or "tent of meeting," as well as where the ark of the covenant was located. Another northern sacred site, in Manasseh, was Shechem, where the Lord first appeared to Abram, as El Elyon (Helios), the Most High God. El Elyon blessed Abram by saying his descendants would be "like the stars," a phrase that could be translated as "Ephraim," meaning "fruitful," with the "phra," or "phre" meaning "star" or "sun" in Egyptian and Hebrew.[157] Shechem was an extremely important site, as it was where El-berith or Baal-berith, the "god of the covenant," was worshipped (Judges 9:4, 9:46). Moreover, Ephraim and Manasseh's father, Joseph, was said to be buried at Shechem, where also Joshua "wrote these words in the book of the law of God; and he took a large stone and set it up there under the oak that was by the sanctuary of the LORD." (Jos. 24:26) Interestingly, the place where Joshua exhorted the Israelites "regarding their life in the Holy Land" (Jos. 23:1-16) is Shechem in the Hebrew text but Shiloh in the Septuagint, which casts doubt on the incident's historicity but suggests a competition between priesthoods. In any event, Shiloh and Shechem are highly relevant to the Joshua cult.

It is noteworthy that there was an ancient Egyptian site by the name of "Sekhem," sacred to Heru-ur or "Horus the Elder," and "one of the most important religious centers in Egypt."[158] Osiris, too, was hallowed at Sekhem, which was not only a place on Earth but also one in "heaven": "I am the lord to whom homage is paid in Sekhem."[159] In Hebrew the letter *shin* is often pronounced not as "sh" but as "s"; hence, Shechem could be pronounced "Sekhem." It is likely that "Joshua," said to have come as an "angel" with the Hebrews "out of Egypt," was an Egyptian god worshipped at Sekhem, with both the god and town transplanted from Egypt to Canaan. It is further interesting that Horus was called "Iusa" and was closely associated with the god "Shu"—the air god and life force who was also a *logos* from Ra, the Most High. Joshua, or Yehoshua, likewise the Logos, could be "Iao-Shu," an Egyptian hybrid god. Significantly, Sekhem was a seat of Egyptian mysteries.[160] One of the Egyptian rituals includes the following proclamation: "I enter in and I come forth from the tank of flame (or lake of fire) on the day when the adversaries are annihilated in Sekhem."[161] The Joshua-Shu connection becomes even stronger when it is recognized that Shu was "the warrior-god

who fought for Horus as leader of the war against the rebel powers of darkness and of drought."[162]

Yet another significant connection between Canaan/Samaria and Christianity occurs in the identification by Bishop Epiphanius (4th century) of the pre-Christian and proto-Christian monkish order of the Essenes as the descendants of Samaritans. The Samaritans and Sadducees also have some intriguing links, as many Sadducees/Zadokites were Samaritan priests. Indeed, the Sadducees are "frequently identified" with the Samaritans by several Church fathers, including Hippolytus and Epiphanius, who further claimed that the Sadducees "were descended from the Samaritans, as well as from a priest named Zadok..."[163] Also, the Samaritan Messiah, Dositheus, was associated with the Sadducees and pronounced their leader. Per Epiphanius, the Dositheans followed "the same customs as the Samaritans," including circumcision and the Sabbath, as well as using the Pentateuch as their main religious text. However, unlike traditional Samaritans and Sadducees, the Dositheans believed in "the resurrection of the dead."

The Sadducees/Zadokites of the Dead Sea scrolls possessed numerous Samaritan qualities, as evinced by two of the major experts regarding the scrolls, Moses Gaster and his son, Theodore. One such correspondence appears in the style of writing in both the scrolls and the Samaritan Bible. The scrolls writers' connection to the northern kingdom is further evidenced by the fact that in their "Reworking of Exodus," these particular Zadokites used not the Hebrew Bible but the *Samaritan Pentateuch.*[164] It also appears that these Zadokites, or Sadducees, whose ancestors had ruled as priests in both Judea and Samaria, were connected to the Hebraic Therapeuts of Egypt, who were educated at the famed University of Alexandria. In addition to various proofs adduced in *The Christ Conspiracy*, the pottery vessels that contained the Dead Sea scrolls were of an Egyptian design, revealing a link to that nation. Interestingly, some of these scrolls, which include writings on "astrology, magic, and apocalyptic dreams of worldwide Jewish domination,"[165] purportedly use a code, called the Atbash Cipher, also employed a millennium later by the Knights Templar, long before the discovery of the scrolls.[166]

The northern kingdom people, i.e., Israelites and Samaritans, esteemed Joseph, Moses and Joshua but disdained Aaron, Judah and David. In his studies of the thousands of Genizah scrolls found at Cairo, some of which were later discovered at the Dead Sea as well, Talmudist and founder of Conservative Judaism, Solomon Schechter (1847-1915), wondered why various of the scroll writers disparaged David, et al. The probable reason is that

these writers were northern kingdom people, which is further evidenced by the fact that the Genizah manuscripts were found in a *Karaite* synagogue.[167] The Karaites are descendants of the Samaritans, also identified as "Sadducees" in the Talmud (Megilah 24b; Chagigah 17a). In the Talmud, the Sadducees and Samaritans, as well as the "Judeo-Christians," are lumped together as "Minim" (Shabbath 116a). The Jewish Encyclopedia ("Sadducees") relates that the Sadducees "disappear from history, though their views are partly maintained and echoed by the Samaritans, with whom they are frequently identified."[168] The JE further states that the Sadducees are also substituted in the Talmud for Christian Gnostics.

One of the better known and more widely studied Genizah manuscripts, the "Damascus Document," known as the "Zadokite Document" as well, was also found at the Dead Sea and nowhere else, indicating that the Samaritans/Karaites were the heirs of the Dead Sea Zadokites. The Zadokite-Samaritan connection also appears in the famed "copper scroll," which records treasure buried around Palestine, including at Gerizim, the main Samaritan temple site. The pre-Christian *Wisdom of Jesus*, with its reverence for Joshua and numerous "Christian" concepts is, according to Abraham Geiger, a *Sadducean* text, found not only at the Dead Sea but also by Schecter, presumably in the same Karaite/Samaritan cache from Cairo. Hence, again the Sadducees are intimately connected with the Samaritans, as are the Dead Sea scrolls and Egypt, where much of the Christian myth was formulated.

Although both claimed descent from Abraham, the Jews and Israelites/Samaritans were bitter enemies, even after their joint deportation to Egypt during the rule of Antiochus IV Epiphanes (215-164 BCE), at which time their respective holy sites were Paganized with Gentile gods. In 129 BCE, Jewish high priest and tyrant John Hyrcanus destroyed the Samaritan temple at Gerizim. Despite their longstanding differences, however, Samaritans joined with Jews against the emperor Vespasian (9-79 CE). During Hadrian's reign (117-138), Samaritans and Jews were treated essentially as one people, and they behaved as one, as together in the Diaspora they built synagogues over much of the Roman Empire, likely with greater Samaritan influence, since Judea was "economically backward,"[169] while the Samaritan priesthood was the richer. At this time, too, their priesthoods together were actively creating the story of Jesus Christ, a synthesis of the Judean and Samaritan messiahs. This synthesis took place largely at Alexandria, where there were huge numbers of both Jews and Samaritans. The reason for such a sizeable population at Alexandria is that "Jews" were given their own section as a

reward for assisting Alexander the Great in conquering Egypt. In fact, Hebrews, Israelites, Jews and Samaritans may have made up 50 percent of the all-important city's original population.[170]

The Samaritan and Galilean origin of the Christian myth and ritual explains the antinomian ("anti-Law") doctrines and the antipathy towards strictly "Jewish" or Judean ideology and ritual. Concerning the Samaritans, or "Cutheans/Cuthim," as they are derogatorily termed in the Talmud, Johnson remarks that "what particularly arrests attention is the statement that in rabbinic writings the term *Cuthim* has often been substituted for Sadducees or haeretics, *i.e.*, *Christians.*" He further states that the Samaritans "are said to have idolised Joshua as an Ephraimite and as connected with Shechem" and "to have expected the Messiah as Prophet, who would convert all nations to their religion." In this regard, Johnson continues, "Some hold that the idea of the Messiah as son of Joseph was of Samaritan origin," a "new" faith that began to arise among "heathens and Jews" and spread throughout Samaria and Galilee. In addition to Alexandria, this faith was largely orchestrated out of the large and wealthy northern city of Antioch, once the capital of Syria and where, per Acts, the Christians were first so called. This significant point concerning Samaria and Antioch—one of the four largest cities of the Roman Empire—explains many of the peculiar and dichotomous features within the gospels, including, again, their antipathy towards Jews and Judea. Moreover, three of the major deities worshipped in Antioch were Dionysus, Isis and Mithra, all of whom were contributing factors to the Christ myth. Regarding the origins of Christianity, Johnson concludes, "Further study of Samaritan, Syrophoenician, Persian, and Babylonian worship may lead to a clearer apprehension of the truth on this subject."

Jesus Christ, The Lord Sun

When the origins of Christianity are investigated, and knowledge of comparative mythology is factored in, it becomes evident that Christianity is Paganism Judaized, historicized, rehashed and repackaged. Its main god or godman is the same as that of the many religions of the Roman Empire and beyond, with a new name. Even then, there is not so much of a change, as "Jesus" was a pre-Christian title shared by a number of gods. By any name, whether Osiris, Dionysus, Adonis, Asclepius, Krishna, Buddha, Mithra or Jesus, the archetypical "son of God," as depicted in the gospel tale and elsewhere, is in reality an aspect or personification of the God Sun. In the Jewish or Hebrew world, Jesus is Joshua redivivus, with his 12 tribal leaders or followers, etc. The god's mother, immaculately fecundated and perpetually

inviolable, is the same mythical entity found in numerous cultures, with a change of dress dependent on the era and ethnicity of her human creators. The demigods and legendary heroes of other cultures are demoted to "patriarchs" and "saints," while Pagan temples become churches and Pagan rituals are usurped. The sayings of the god are unoriginal but have been floating about as platitudes known to the vulgar masses or "wisdom sayings" shared among mystery school initiates. In the end, practically nothing is original to Christianity.

The Pagan origins of Christianity have been pointed out since the beginning of the Christian era, so much so that the early Church fathers were forced to address the similarities between their pretended godman and the gods of earlier cultures. These apologists developed the spurious "devil-got-there-first" argument, or that "fallen angels had counterfeited the true gospel after they heard it preached by the true prophets of God," excuses that have satisfied the simple mind both then and today.

Concerning the origins of Christianity and its evident plagiarism of astrotheological Pagan rites and myths, Count Volney concludes:

> "Ye priests! who murmur at this relation, you wear his emblems all over your bodies; your tonsure is the disk of the sun; your stole is his zodiac; your rosaries are symbols of the stars and planets. Ye pontiffs and prelates! your mitre, your crozier, your mantle are those of Osiris; and that cross whose mystery you extol without comprehending it, is the cross of Serapis, traced by the hands of Egyptian priests on the plan of the figurative world; which, passing through the equinoxes and the tropics, became the emblem of the future life and of the resurrection, because it touched the gates of ivory and of horn, through which the soul passed to heaven."

Adding to this astute analysis, CMU remarks:

> When all the circumstances are duly weighed in the mind that dares to look truth in the face, the conviction flashes upon instantly, that all our gospels, and every thing else that is said about Jesus Christ in the New Testament, has no reference whatever to any event that ever did in reality take place upon this globe; or to any personages that ever in truth existed: that the whole is an astronomical allegory, or parable, having invariably a primary and sacred allusion to the sun, and his passage through the signs of the zodiac; or a verbal representation of the phenomena of the solar year and seasons. A belief in the literal or ostensible meaning of these parables shows the sottish credulity into which man sinks, after his reason has been mortgaged in youth to the priest, who keeps him in the ignorance that is suitable for mental slavery.[171]

The basic story of "Jesus Christ" goes back thousands of years and is found in a number of cultures around the globe, several of whom were isolated until fairly recently. The tale is not that of an historical supernatural savior but that of the sun. So evident was this fact that, where Christianity conquered, the subject peoples substituted Christ for their native sun gods: "In the wake of the Spanish Conquest and the assault on indigenous religion, Maya beliefs and practices took new forms. Early in the twentieth century, the sun was often identified with Jesus Christ, son of the Virgin Mary, who in turn was identified with the moon."[172] This ancient narrative and the various wisdom sayings were encapsulated in stone and in texts both sacred and secret, mostly orally transmitted, until the first centuries around the so-called Christian era, when it was decided by factions of the "sons of the Sun" to make the mysteries known. Representing salvation cultists, i.e., followers of IE, IES, YES, JES, Jesus and Joshua, these international brethren had been exchanging information for centuries and millennia, eventually amalgamating their multitudinous ideologies into one great mishmash called Christianity.

[1] Dupuis, 97-98.

[2] www.newadvent.org/cathen/14520c.htm

[3] www.ccel.org/fathers2/ANF-03/anf03-15.htm#P1457_561810

[4] www.ccel.org/fathers2/ANF-03/anf03-05.htm#P321_123623

[5] www.ccel.org/fathers2/ANF-03/anf03-41.htm#P9676_2650295

[6] www.hiddenmeanings.com/supernova.html

[7] *CMU*, 59.

[8] www.newadvent.org/fathers/0208.htm (Emph. added)

[9] www.newadvent.org/fathers/0208.htm

[10] www.newadvent.org/fathers/02042.htm

[11] www.ccel.org/fathers2/ANF-04/anf04-61.htm#P10823_2891900
 (Emph. added)

[12] www.christianism.com/articles/13.html

[13] www.ccel.org/fathers2/ANF-06/anf06-57.htm

[14] www.ccel.org/fathers2/NPNF2-04/Npnf2-04-72.htm

[15] *CP*, 163.

[16] *CP*, 166.

[17] www.theosophy-nw.org/theosnw/ctg/chj-chz.htm

[18] Dupuis, 265-267.

[19] www2.andrews.edu/~samuele/books/sabbath_to_sunday/8.html

[20] Seznec, 99fn.

[21] Lundy, 120.

[22] Kuhn, *WKG*, 469-470.

[23] Kuhn, *WKG*, 471.

[24] Lundy, 186.

[25] Lundy, 260.

[26] Lundy, 269.

[27] Lundy, xix.
[28] Lundy, xix.
[29] Weigall, 14.
[30] Weigall, 16.
[31] Weigall, 21. (Emph. added)
[32] Weigall, 22. (Emph. added)
[33] Dupuis, 286-289.
[34] tridaho.com/kuhn/abksungods.htm
[35] *vide* Robertson, *CM*, 187.
[36] Massey, *HJMC*, 68.
[37] Massey, *EBD*, 100.
[38] Walker, *WEMS*, 307.
[39] Higgins, II, 188.
[40] Walker, *WDSSO*, 469.
[41] Walker, *WEMS*, 469.
[42] Higgins, II, 231.
[43] Massey, *EBD*.
[44] Graves, R., 92.
[45] Taylor, *DP*, 61.
[46] Drews, *WHJ*, 190-191.
[47] Campbell, *OM*, 349-350.
[48] Massey, *HJMC*, 136.
[49] Weigall, 67-68.
[50] Weigall, 69-70.
[51] Weigall, 74.
[52] Hoffmann, 32.
[53] Hoffmann, 33fn.
[54] Hoffmann, 35.
[55] Hoffmann, 36.
[56] *CMU*, 113.
[57] Weigall, 85.
[58] Kingsborough, VIII, 17.
[59] Kingsborough, VIII, 21-22.
[60] Seznec, 125.
[61] Lundy, 286.
[62] Weigall, 114.
[63] Bonwick, *EBMT*, 62.
[64] Bonwick, *EBMT*, 64.
[65] Lundy, 268.
[66] Wise, et al., 18.
[67] Eisenman, *JBJ*, 830.
[68] Bonwick, *EBMT*, 370.
[69] Walker, *WEMS*, 66.
[70] Higgins, II, 6.
[71] Bonwick, *EBMT*, 358.
[72] Watts, 87.
[73] *CMU*, 148.
[74] *CMU*, 46.
[75] Budge, *EBD*, 15.

76 Drews, *CM*, 131fn.
77 Budge, *EBD*, lxxxiv.
78 Budge, *EBD*, xc.
79 Halliday, 4.
80 Rylands, 176-177.
81 Eisenman and Wise, 69.
82 Drews, *WHJ*, 68.
83 Robertson, *CM*, 341.
84 Graves, R., 201.
85 Bryant, I, 289.
86 Bryant, I, 290.
87 Bell, I, 282.
88 Eisenman, *JBJ*, 798.
89 www.atheists.org/church/twelve.html
90 *Funk & Wagnalls Encyclopedia*, "Egyptian Mythology."
91 Budge, *EBD*, xli
92 Budge, *EBD*, cxvii-cxix.
93 Taylor, *DP*, 207.
94 Robertson, *CM*, 183.
95 Churchward, J., *SSM*, 181.
96 Spence, *AEML*, 83.
97 Taylor, *DP*, 172.
98 Robertson, *CM*, 345.
99 Rylands, 51.
100 Baring, 421.
101 Budge, *EBD*, c.
102 Dupuis, 279-280.
103 Cassels, 558.
104 Budge, *EBD*, lxxv.
105 Bonwick, *EBMT*, 402.
106 Bonwick, *EBMT*, 404-405.
107 Freke and Gandy, 83.
108 Eisenman and Wise, 85.
109 www.ccel.org/fathers2/ANF-01/anf01-50.htm#P5648_1299382.
110 Bunsen, 193.
111 Bunsen, 105-106.
112 Cassels, 566
113 Cassels, 565.
114 Cassels, 634.
115 Drews, *WHJ*, 67.
116 Cassels, 569.
117 Cassels, 559.
118 Hunt, 21.
119 Pelikan, 41.
120 Cutner, 202.
121 Robertson, *CM*, 99.
122 Robertson, *CM*, 107.
123 www.newadvent.org/cathen/08524a.htm
124 Finkelstein, 77, 81.

[125] Hunt, 123.
[126] www.didjesusexist.com/case/ch2.html
[127] Robertson, *PC*, 40.
[128] Friedman, 66.
[129] *MBB*, 96.
[130] ccat.sas.upenn.edu/gopher/other/journals/kraftpub/Christianity/Joshua
[131] Eisenman, *JBJ*, 843.
[132] Rylands, 154.
[133] Eisenman, *JBJ*, 495.
[134] Drews, *CM*, 56.
[135] Eisenman, *JBJ*, 841.
[136] Drews, *CM*, 83.
[137] Robertson, *CM*, 297.
[138] Kuhn, *WKG*, 272.
[139] Drews, *WHJ*, 165. (Emph. added)
[140] Weigall, 25.
[141] www.blueletterbible.org/info_septuagint.html
[142] Eisenman and Wise, 243.
[143] Wise, et al., 97, 113.
[144] Leidner, 30.
[145] Price, 247.
[146] Leidner, 34.
[147] Leidner, 63.
[148] Leidner, 69.
[149] Leidner, 199.
[150] Drews, *WHJ*, 200.
[151] Drews, *WHJ*, 219.
[152] www.newadvent.org/fathers/0128.htm
[153] Jones, *AR*, X, 34.
[154] Rylands, 156.
[155] Hunt, 3.
[156] Schonfeld, 45.
[157] Higgins, I, 688.
[158] Budge, *EBD*, cxxxvi, 21.
[159] Budge, *EBD*, 337.
[160] Churchward, *OER*, 181.
[161] Churchward, *OER*, 183.
[162] Churchward, *OER*, 188.
[163] essenes.crosswinds.net/panarion.htm
[164] Wise, et al., 201.
[165] Wise, et al., 13.
[166] Picknett and Prince, 109.
[167] Eisenman, *JBJ*, 748.
[168] www.jewishencyclopedia.com
[169] Hengel, 35.
[170] Freke and Gandy, 179.
[171] *CMU*, 151.
[172] Singh, 361.

"Cristo Sole"—Christ as the sun god Helios in quadriga chariot, c. 240, found under the altar in St. Peter's Basilica, Vatican

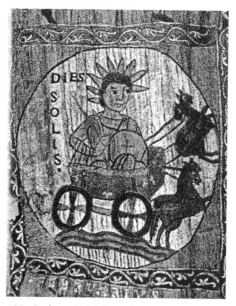

Christian God Sun in horse-drawn chariot, 11th century. (Singh)

Christ's Transfiguration per Matt. 17:2: "His face shone like the sun," 12th century (Singh)

Bulgarian Christ as a beardless youth with solar halo or nimbus, 13th century (Singh)

Nefer-tem, "the solar god of the dawn, whose
attribute, the lotus opening in the morning,
symbolizes resurrection." 8th century BCE.
(Bonwick, *EBMT*)

"Horus, with his Cross, Raising the Dead."
(Lundy)

Pharaoh Amenhetep worshipping
Aton the sun. (Budge, *ETL*)

"Irish monks raising hands in ancient Egyptian
manner of paying homage to the sun," St. Peter's
Basilica, Vatican City. (Singh)

"He is risen indeed! Alleluia!"
www.sonriseministries.com

The Mysterious Brotherhood

Secret associations have existed from the most remote times. The Egyptian priesthood was certainly in full force before the date of the pyramids, and it was a band of secret-keepers. The presence of symbols in the ruins of Memphis, Thebes, Babylon, Nineveh, Persepolis, Troy, and Mexico, indicates a hidden meaning confided to one set of men. All mythologies are founded upon secrets. Ancient buildings, as pyramids, temples, etc., have their specific value to the student in the secrets they manifestly masonify.

James Bonwick, *Egyptian Belief and Modern Thought*

In this electrifying journey into the mists of the past, we have explored religious and mythological concepts of the ages and found them to be cosmological and astrotheological. We have also discovered that many of the ancient gods not only symbolized various planetary bodies but also were specifically solar, with "lives" and "personalities" that in reality represent the movements and qualities of the most visible orb, the sun. The fact that the information regarding these "suns of God" is not widely known constitutes evidence of the "Christ conspiracy," as priesthoods in a variety of places and eras have contrived to keep this vital information hidden, for the benefit of themselves and to the detriment of the lay public. So powerful has the arcane priestly knowledge been deemed that the mythos and ritual of the sun god was turned into a central part of the famous "mysteries," the esoteric, secret traditions of many religions. As a result, traditions and legends exist globally regarding secret societies called "Sons of the Sun" or other such moniker. Even Buddhism, which is commonly regarded as open and egalitarian, has its esoteric religion of initiates, evident from its clerical hierarchy and brotherhood: Hence, Buddhism possesses "two doctrines, the one public and ostensible, the other interior and secret, precisely like the Egyptian priesthood."

These two religious traditions, the esoteric and exoteric, have been developed, it is claimed, because there are two major segments of society: the better-educated, more intellectual elite and the less erudite masses. In some cases, there has been a good reason for secrecy: For example, even in ancient Greece, where philosophical exploration was encouraged and practiced, to question the veracity of widely held myths could bring down the wrath of those in power. Therefore, many original thinkers have been driven "underground," where they have developed methods of expressing themselves that would not be understood by others not "initiated." One of the arcane doctrines these mysteries-makers developed was monotheism, which was "as early as 1500

B.C. a Babylonian esoteric priestly doctrine." Contrary to popular opinion that the Judeo-Christian tradition is the originator of "monotheism," the "unity of God" is the basis of Orphism and the Greek mysteries, attested by the Church fathers Eusebius, Augustine, Lactantius, Justin, Athenagoras and "a great many other" apologists.[1] This fact of monotheism being a mystery also explains why Egypt was monotheistic as well as polytheistic.[2]

Over the millennia, not a few individuals have taken advantage of this situation of secrecy, and have malevolently exploited the unsuspecting public, as they continue to do today. There is also a reason pastors (pastoral, pasture) are "shepherds" with "flocks" of "sheep," as the attitude of the priesthood/brotherhood towards the *sheeple* has been consistently derogatory. For example, Bishop Synesius (d. 414?) blatantly remarked that the people "are desirous of being deceived [and] we cannot act otherwise respecting them." Church doctor Gregory Nazianzen (325-389) commented to Jerome (Hieron. ad. Nep.) that "a little jargon is all that is necessary to impose on the people. The less they comprehend, the more they admire." He then related that the Church fathers and other priestly predecessors "have often said not what they thought but what circumstances and necessity dictated to them." Even the famed Babylonian priest Sanchoniathon (fl. 13th cent. BCE) declared that the priestly role was "to excite admiration by means of the marvelous."[3] Comments Volney, "It is useless to point out the whole depravity of such a doctrine."

Fortunately, Count Volney was not afraid to speak his mind, such that he did not just crank out some dry dissertation that ultimately would be read by a handful and forgotten. His book *The Ruins of Empires* was widely circulated among the French and English, albeit mostly among the elite, since they were often the only people wealthy enough to be literate, multilingual and able to afford books. Volney's work was studied even by Napoleon I, who once remarked to the Count that the question of whether or not Jesus existed was a "great one."[4] In any event, over the centuries it has been easy to control information—and to distribute propaganda and disinformation. Indeed, included in the "mysteries" or "occult" has been much misinformation or disinformation, a deceptive "art" widely practiced in a variety of fields and subjects, for the purpose of maintaining secrets. One fundamental way to keep the esoteric traditions hidden has been to impose exile and/or death on the initiate who divulged the mysteries. Mysteries candidates have hazarded such severe punishment because initiation promised, as do exoteric religions of today, a

better and happier life, not only in this world but also in the next.[5]

Incorporated in the priestly repertoire have been many magic tricks and much voodoo, performed within both the esoteric and exoteric religious traditions. This "voodoo"—a term applicable to all "religious" ritual, including those superstitious mumblings and gestures of today's popular religions—is meant to empower its performer, to make his or her life better, to bring relief from suffering and to gain materially. The sum has been designed to empower the priesthood, naturally, who have professed to have a direct link to God or any number of gods. One of the priestly magical arts is astrology, which has formed an enormous part of the priestcraft, including not only the cosmic astrotheology but also judicial astrology and the casting of horoscopes. Priests have also claimed to be able to influence weather and drive off pests, which has given them hold over agricultural societies. Furthermore, many priests have been master craftsmen, possessing knowledge of geometry, smith-craft, carpentry and masonry. They also have worn vivid clothing believed to invoke the power of gods and demons, including robes with zodiacs on them or of a particular color, and hats such as the cone-shaped miter, "which was an emblem of the sun."[6]

The esoteric or suppressed information presented in this book and in *The Christ Conspiracy* has frequently come from religionists or brotherhood members who have been privy to knowledge not readily available to the masses. The average person—no matter how educated—could not learn the esoterica of any religion unless initiated and processed through the ranks of its mystery school. Some researchers, such as Higgins, were Masons, and could go to India, give Master Mason signals and be accepted into the inner circle, where they could compare notes.

These missionaries and researchers were part of a long line of the same activity: For centuries and millennia, priests, magi, monks, therapeuts or "spiritual physicians"-cum-drug peddlers, astrologers, carpenters, smiths, masons and other brotherhood/guild members traveled the "Silk Road" and beyond, from England to China, exchanging bits and pieces of their ritual and mythos, "borrowing" a better innovation, in constant competition to improve their stories. In other words, they have enjoyed swapping mythical "recipes," as it were, as well as playing "can you top this?" This exchange is precisely how religions have been created. These travelers also traded whole texts, which they procured because they had the proper insider's credentials. Such is one way books were collected for the library of Alexandria, for

example. Of course, force has also been used abundantly in order to gain knowledge.

In this manner, insiders have learned the secrets of their foreign brethren, which is why so many sources of the forbidden information are priests, such as Jesuits. Much of the (suppressed) knowledge concerning Buddha and Krishna comes from Jesuits and other missionaries who traveled to India beginning several centuries ago. The Jesuits were trying to convert the "heathen" Indians, and engaged in debates with learned Brahmans, whom the Christians were unable to beat, because, it is maintained, virtually the entire story and moral sayings of Christ were already in India, revolving largely around Krishna. These similarities between Christ and Krishna distressed the early Christian missionaries, who had convinced themselves of the veracity of the Christ fable, not suspecting it was based on Paganism. Brahman priests asserted that the Krishna story preceded Christianity by at least six centuries and that "the New Testament was built out of the Hindu epics." Western religionists swiftly pointed the finger in the direction of the Brahmans. For instance, Christian apologist Benjamin George Wilkinson said that when the Brahmans "invented the Krishna story" there were no opposition in India powerful "enough to prevent them from creating the fraud." In his accusation, Wilkinson confirmed that there were fascinating similarities between the Krishna and Christ myths.

The cultural interchange between East and West going back centuries and millennia has included an exchange of mysteries, confirmed by Ptolemy (2nd cent. CE), who related that he had learned from Indians at Alexandria, and by Lucian, who wrote that "pilgrims from India resorted to Hierapolis in Syria."[7] Based on literary and other evidence, it seems that the Indian mysteries followed a similar format as the Egyptian, including, per *The Book of The Dead* or *Papyrus of Ani* (i, cxxv), one of the mysteries referred to as occurring at Saqqara: The all-important "birth and death" of the sun god, where the initiate entered into *Rest-au*, the domain of Amon, the "Hidden One."[8] Again, the mysteries were mainly based on astrotheological concepts, emphasizing the solar orb, as well as rituals such as the death and resurrection of the god. It is apparent that the Indian priesthood knew about the heliocentricity of the solar system, as well as the roundness of the earth, and that these facts constituted part of the mysteries, likewise not to be divulged to the uninitiated and the *mlecchas*, or foreign barbarians. In this regard, a significant amount of chicanery has been committed during the past couple of centuries regarding Krishna and various elements of his myth, including the evidently esoteric tradition of the crucified god. Moreover, the

Christian invasion, particularly of the Portuguese, destroyed much of the evidence, including *thousands* of temples and other artifacts. The British occupation also served to silence the ancient mythos containing much found in the later Christianity.

The antiquity of "the mysteries" is attested by their mention in the works of Homer (8th cent. BCE) and Hesiod (9th cent. BCE). However, as we have seen, commencing in prehistory "priests" or "shamans" used caves in which to conduct the mysteries, which frequently revolved around the celestial bodies. The purported birthplaces and burial locations of gods found globally, which themselves were often in caves, also served in the mysteries as sacred sites for initiations. Beginning millennia ago and also frequently taking place in caves, the Indian mysteries provide an example of a typical initiation, including eerie and scary transcendental experiences designed to reveal other worlds and realities, as well as profound, universal truths. Such mysteries were held in caves such as at Elephanta, the island near Bombay, which contained "dark winding avenues," plunging the "terrified aspirant" into a series of "horrors," described by Western initiates Apuleius (c. 124-c.170 CE) and Dion Chrysostom (40-112 CE).[9] Within these caves was evidently performed "the whole stupendous drama of the Indian theology," with "grand machinery...while kings were the actors, and holy Brahmins the admiring spectators!" The presence of circumstances of Krishna's life in these mystifying caves suggests that those elements likewise constituted part of the mysteries, which may be why the various esoterica concerning the avatar discussed herein are not widely known. These esoterica were certainly part of the mysteries in other nations, such as Persia and Upper Egypt.[10]

Dating back thousands of years, mystery schools, secret societies and brotherhoods have not been confined to "sophisticated" cultures but have existed in the most primitive cultures on Earth. For example, secret societies are commonly found all over Africa, serving as initiatory orders: "In Cabende and Loango there are secret associations of the Fetishmen or mediums." These societies comprise fraternities and orders, "whose secrets are only known to the initiated, and whose mysterious faculties are the terrors of the uninitiated."[11] To prepare for initiation, members were put on a 10-year probation, during which time they fasted, drank, did drugs and gave evidence of being "ecstatics or mediums, by becoming frantic in sacred dances and by seeing in the state of trance!" Considering their antiquity, it is not surprising that secrets have existed and have been passed along through the ages, in a more or less organized fashion, even in primitive eras and places. Interestingly, Mason Albert Churchward revealed that the 3rd degree in modern

Freemasonry was based on initiatory practices of the "Nilotic Negro," although in the 3rd degree the "ceremony has been much perverted from the true," being "more faithfully portrayed in part of the 18°."

In *The Golden Bough*, Sir Frazer discussed the secret societies and mystery rites of a number of cultures, including the American "secret society called Olala."[12] This society practiced a mystical rite in which the initiate was decapitated in effigy, whereupon he disappeared for a year, at the end of which he was "resurrected." Another example of the pre-Christian rebirth ritual appears in the aboriginal secret society the Australian Arunta, who possessed a "mystery of the resurrection," among other rituals through which "every native has to pass," beginning around the age of 10 or 12 and continuing possibly until 25 or 30.[13] This ritual is paralleled in the gospel story of Jesus teaching in the temple at 12, thus beginning his "training," after which he disappears, until the age of 28 or 30. Furthermore, in the "region of the Lower Congo a simulation of death and resurrection is, or rather used to be, practised by the members of a guild or secret society called *ndembo*."[14] Frazer's use of the term "guild" is interesting, in that many of the secret societies, mystery schools and cults were built around not only a particular god but also a specific craft, such as carpentry, smith-craft or masonry, long before the common era.

The resurrection is also present among the mysterious Dogon tribe of Africa, who claimed that beings called "Nommos" descended from the heavens in the remote past. One of these Nommos was sacrificed upon a tree by a "wicked priest." The son of Amma (cf. *Ammon*), the god of the universe, this Nommo's body was shared in an eucharistic ceremony, and after his death he was resurrected. The Nommo's death served as a sin-atonement for all mankind, and he was to return to Earth again at some future date.[15] Despite this tale's remarkable correspondence to the gospel myth, there is no evidence that the Dogon were influenced by Christianity; in actuality, their traditions predate the introduction of Christianity in their isolated area and therefore represent an unrelated and independent development not based on any "historical" Jesus.

The death and resurrection of the god symbolized those of the initiate and constituted one of the ways to achieve union with the god and to gain his immortality. Performed even by primitive cultures ages before the Christian era, the symbolic death and resurrection is possibly the highest mystery. The mysteries of the mourned dying god, whose resurrection is afterwards fêted, include those of Adonis, Attis and Osiris, whose rituals were virtually the same as those of the later Catholic Church. Even the

phrases at the resurrection ceremony were the same: "Be of good cheer, ye initiates, for the god is saved. For he shall be to you a Salvation from ills."[16] The initiate into such a mystery cult expected to emulate the god in his death and rebirth: With his symbolic death so went his sins, while his rebirth brought righteousness.[17]

Concerning the mysteries, the Catholic Encyclopedia ("Paganism") comments:

...[T]he Mysteries had already fostered, though not created, the conviction of immortality.... These mysteries usually began with the selection of [initiates], their preliminary "baptism," fasting, and (Samothrace) confession. After many sacrifices, the Mysteries proper were celebrated, including nearly always a mimetic dance, or "tableaux," showing heaven, hell, purgatory; the soul's destiny; the gods... There was often seen the "passion" of the god (Osiris)...

The salvific death and resurrection at Easter of the god, the initiation as remover of sin, and the notion of becoming "born again," are all ages-old Pagan motifs or mysteries rehashed in the later Christianity. The all-important death-and-resurrection motif is exemplified in the "Parisian magical papyrus," a *Pagan* text ostensibly unaffected by Christianity:

"Lord, being born again I perish in that I am being exalted, and having been exalted I die; from a life-giving birth being born into death I was thus freed and go the way which Thou has founded, as Thou hast ordained and hast made the mystery."[18]

As in Christianity, the death of the savior god was accompanied by a cannibalistic eucharist or "sacred meal," which had it roots in "the prehistoric cannibalistic meal at which the flesh of the theanthropic sacrificial victim was eaten."[19]

The "main purpose of these secret cults was to obtain a happier lot beyond the grave."[20] One way in which the initiate could attain to this "happier lot" in the afterlife, it was claimed, was to serve as a sacrifice. Hence, one of the major factors in not a few mystery cults was the practice of human sacrifice, as well as ritualistic cannibalism and fertilization of fields using human bodies, with the sprinkling or baptism of the faithful using the blood—all of these grotesque rites constituting "the mysteries." In *Divine Institutes*, Church father Lactantius (240-c. 320) described in detail the perverse addiction to human sacrifice, which served as the "sacred rites" of numerous cultures. On Cyprus, for example, humans were sacrificed to Jupiter, while the "people of Tauris, a fierce and inhuman nation," sacrificed humans to the goddess Diana. As civilized as they were, the Greeks practiced the bloody rite in a number of areas. The

Romans too appeased Jupiter Latialis and Saturn with human blood. Other cultures that practiced human sacrifice include the Gauls (Celts), who sacrificed to Hesus and Teutas. Lactantius further depicted human sacrifice conducted by some of the better-known members of the mysterious brotherhood, the Curetes or Corybantes, committed on "lofty Ida," in northwest Turkey. While the sacrificed infant boy cried, the Curetes struck "their shields with stakes" or "beat their empty helmets," in order to cover up the sound.[21] As shown earlier, human sacrifice was also practiced in India and Israel, as well as the Americas. That this abominable practice existed into the common era is evidenced by the fact that the emperor Hadrian was compelled to abolish it. Even so, it continued in some places, in secret, and is apparently practiced to this day in remote areas, among not just sinister brotherhood members or primitive heathens. In *The Highest Altar: The Story of Human Sacrifice* (1989), Patrick Tierney writes that he found "an area around Lake Titicaca" where human sacrifice "remains an almost casual, seasonal occurrence." Tierney further states:

> But the worst was yet to come—the discovery of an ultrafundamentalist Christian sect in the Andes that performed a human sacrifice on August 18, 1986. This weirdest of events sparked my interest in Biblical human sacrifice. Eventually, my mountain climbing took me to Israel, the home of all our sacrificial hopes.[22]

The sacrifice in the majority of places became most frenzied in times of war, famine or other disaster, which is pitifully ironic considering that these horrendous catastrophes were already decimating the population. These sacrifices, complained Lactantius, included the savage slaughter of the people's own children, and he argued that the gods they were propitiating could do no worse to them than what they themselves were doing with these homicidal rites. Of course, Lactantius's Christian god demanded the bloody sacrifice of *his* own son, for the exact same reason.

Among the authors of Christianity there may have been those with the intent of putting an end to this widespread and atrocious practice of human sacrifice by composing and imposing upon history the archetypical human sacrifice of the gospel myth as a once-and-for-all atonement. However, this desire to end human sacrifice has led to the sacrifice of millions of humans worldwide, as well as the enslavement of the soul to a cruel and dreary deception, as Christianity has been forced upon the populace at the point of a sword. In reality, another of the mysteries revealed to the initiate as he climbed the ranks was that the worshipped godman (e.g., Jesus Christ) was not a "real person" and had not "walked the earth."

Another primitive and barbaric mystery or initiatory rite carried over into Christianity is circumcision, which is found anciently in a number of places. Herodotus (II, 36) mentions that it was practiced in Egypt, but not elsewhere, except by "those who have learnt from Egypt."[23] Other mysteries likewise destroyed the sex drive, rendering men impotent, such as hemlock drinking or castration. Lactantius also criticized such sadistic "religious" customs as castration and other self-mutilation, gruesome rituals also performed by Christians. Like Lactantius, Augustine too addressed one of the more abhorrent "mysteries," the castration of the priests of Cybele, called the "Galli," such men he considered "miserably and vilely enervated and corrupted."[24]

Frequently included in the mysteries was the use of psychedelic or entheogenic drugs of one type or another. As demonstrated by ethnomycologist James Arthur in *Mushrooms and Mankind*, plant-drugs were used as sacraments in the sacred meal, eucharist, communion or "last supper," which is likewise an important part of the mysteries. Another "drug" was the orgies or "love feasts" called "agapae." All of these rites were purportedly designed to allow the participant to transcend himself and his dull, boring daily life in some way, whether "spiritually" or hedonistically.

In his *Exhortation to the Heathen*, Church father Clement of Alexandria discussed the orgiastic bacchanals of the Greeks, which comprised rowdy and violent "celebrations" dedicated to Dionysus, including consuming raw flesh, wearing snakes and "shrieking out the name of that Eva by whom error came into the world." The Eleusinian mysteries, Clement related, represented the "wanderings, and seizure, and grief" of Demeter and Proserpine, or Persephone. In condemning a variety of mysteries, and their publicizers, Clement remarked upon the mythical founder of Troy, Dardanus, "who taught the mysteries of the mother of the gods, or Eetion, who instituted the orgies and mysteries of the Samothracians, or that Phrygian Midas who, having learned the cunning imposture from Odrysus, communicated it to his subjects." Another of these mysteries-expositors was "Cyprian Islander Cinyras, who dared to bring forth from night to the light of day the lewd orgies of Aphrodite in his eagerness to deify a strumpet of his own country." Clement also named "Melampus the son of Amythaon [who] imported the festivals of Ceres from Egypt into Greece, celebrating her grief in song." Finally, the Alexandrian father called the mysteries "the prime authors of evil," and "the parents of impious fables and of deadly superstition, who sowed in human life that seed of evil and ruin..."[25] Obviously, Clement took a dim view of "the mysteries"; however, Christianity itself possessed mysteries, which were the

same as their Pagan predecessors. Clement's mention of "Eetion" or "Aetion" indicates this fact, as "Eetion," the founder of the Samothracian mysteries is another name for Jason, i.e., Jesus. Hence, Eetion/Jason is a pre-Christian Jesus who instituted some of the most famous mysteries, which in actuality differ little from the later Christian mythos and ritual.

While many of them were grisly and deranged, the mysteries in general were supposed to create union with the Godhead, "the ultimate goal of the mystery religion."[26] Such a union is a state of bliss and ecstasy that purportedly reflects "heaven," but also allegedly imparts "secret knowledge" or *gnosis*. As explicated by the ancient authority on the mysteries, Iamblichus, the initiate was supposed to experience the Oneness of the cosmos, as well as its numerous divine and awesome manifestations. The mysteries were reputed to develop the soul, allowing it to progress both in this world and in the "eternal world" to come. Part of the mysteries included terrifying the initiate, which would take him out of himself, creating a "cosmic experience." Some initiation ceremonies, such as at Athens, required the neophyte to be stripped naked. Early images of Jesus's baptism portray him naked; apparently, this nudeness is part of early Christian baptismal practices, i.e., *mysteries*. Again, the intention of these various practices, including the use of drugs, was to place the initiate into a hypnotic, meditative or transcendental state, whereby he would experience divine revelation. The initiation created tension and disassociation from the "real word," provoking emotions ranging from terror to ecstasy, hysteria and joy. At some point, the initiate might see a blinding light, which is purported to be God, particularly in solar cults. This bright light was produced artificially by the mysteries-keepers in order to insure the initiate's experience. An out-of-body experience often accompanied this ordeal. Such an initiation experience is what is portrayed in the New Testament at 1 Corinthians 15, and not an appearance of an "historical" Jesus.

Within these astrotheological and nature-worshipping mysteries, the initiates "took the name of constellations, and assumed the figures of animals," such as the lion, raven and ram. Masks of such animals were used during "the first representation of the drama..." Volney relates that in the "mysteries of Ceres," i.e., those of Eleusis, there was a "chief" representing "the creator," while the torchbearer was the sun. Another person, "nearest to the altar," stood for the moon, and "the herald or deacon, Mercury." In Mithraism existed a ceremony involving a celestial ladder, by which the person's soul was said to pass through seven steps, representing the planetary spheres. This ladder is the same as that found in the biblical story of Jacob; it

is also present within the Indian mysteries.[27] In reality, the tale of Jacob, the "supplanter," and the ladder is a lift from the Egyptian myth of Set, the *supplanter*, who in one story, "acting as a friend of the dead," helps Osiris reach heaven "by means of a ladder."[28] Models of this celestial ladder, also called the "ladder of Horus," were frequently found in the tombs of the dead so that the deceased could attain to heaven, to reach the "sun door." For the same reason, copies of *The Book of the Dead* containing pictures of these magical ladders were also placed in tombs. The Book of the Dead itself represents the ritual of a "secret brotherhood" and the "ceremonial of an older prehistoric mystery."[29] Another of the solar mysteries was the all-important sun door, to which the celestial ladder led and through which all souls must pass in order to gain salvation and immortality. This sun door is represented in thousands of artifacts and structures the world over dating to several millennia ago.

The invocations within the mysteries were designed to conjure God or the gods, as well as the daemons, or good spirits, personal genii, etc. In this regard, another of the mysteries was the solar Logos or Divine Word that created the cosmos, a religious concept understood in numerous cultures for thousands of years before the Christian era. Indeed, language itself was highly important in the mysteries, which included the pronouncement of "unintelligible terms," a practice found today within mystery schools and secret societies, as well as Charismatic Christian churches. These terms included "Men, Thren, Mor, Phor, Teux, Za, Zon, The, Lou, Khri, Gr, Ze, On," which purportedly fixed the sun in the sky. Other words include "Iax, Azuph, Zuon, Threux, Ban, Khok," which, along with the "famous Ephesian 'spells,'" may "belong to an archaic language" used by priests, as with Sanskrit, Hebrew and Latin. It was related by Diodorus Siculus in the first century BCE that "a barbarous or foreign dialect" was utilized in the Samothracian mysteries. The Eleusinian expression "Konx om pax" is apparently Akkadian in origin, a "profession of the Supreme Truth of existence."[30] This "language of the priests" is deemed by ancient writers "the speech of the gods." One of these "holy languages" was Chaldean, a corrupted form of which is Hebrew. All mysteries had their sacred language, as well as their secret names for their god or gods. In many instances these secret words or sacred language thus used in a variety of cultures have proved to be the same or similar, demonstrating a common origin.

The universality of the mysteries and their uniting presence within brotherhoods is evidenced by the fact that many priesthoods and brotherhoods have overlapped and been "confused" with each other. For example, one of the gods who

unite the mysterious brotherhood is Hermes, who not only is Egyptian, Indian and Greek but also is "linked indirectly with the Druids" and is found among the "early Israelites."[31] The god "Hermes" was present in the British Isles in pre-Christian times. Since "Hermes" is "Budh," "Bodh" or "Budha" in Sanskrit, of which ancient Irish is a close relative, it is not surprising to find "Buddha" or "Fo" in Ireland. In addition, as stated, it was common for individuals to be initiated into a number of mystery schools. It was claimed that the "great master" Pythagoras was initiated into "all the religious mysteries of all countries."[32] Hence, the mysteries again served to unify different cultures through brotherhoods that preserved them and passed them down over the ages.

Samothracian Mysteries

The mysteries can be found within most if not all cultures and religions of any antiquity. Some of the most famous and exalted mysteries of old were those held on the Greek island of Samothrace, predating the common era by ages. The Samothracian mysteries are evidently very ancient, purportedly founded by the pre-Greek inhabitants of Greece, the Pelasgians, and traceable to Egypt.[33] Although they are not often discussed in modern literature, these mysteries were so important that they formed much of the nucleus of the official state religion of Rome. In reality, Samothrace was an enormously popular sacred site open to non-initiates as well; hence, it played a significant role in pre-Christian religious life in general around the Mediterranean. A number of famous and influential individuals were counted among the initiates into the Samothracian mysteries, including the "heroes of the Trojan war" and Phillip, Alexander the Great's father, among others who visited "the celebrated temple of the Cabiri." As in the Indian mysteries, the Samothracian initiates were provided experiences designed to frighten, enlighten and expand their minds, "given an inner experience of the spiritual potentialities woven into the earthly material world, the inner fire in matter."[34] Only bits and pieces of these mysteries have come down to us, as ancient writers were loathe to reveal anything about them, likely because initiates were under a blood oath and non-initiates probably risked their lives as well.

The most popular Samothracian gods were the "seven Kabiri," or Cabiri, originally not Greek but Pelasgian. The Greek gods Hades, Demeter, Persephone and Hermes were also worshipped, and the Samothracians identified Attis with Adonis, Osiris and Adam, all titles of the God Sun. The word "Adonis" or "Adon," meaning "Lord," is essentially the same as Adam, the mythical "patriarch," who, as Massey says, is "the first and chief," being

also Atum, the Egyptian "first cause" and divine solar principle. The Kabiri, Kabeiroi, Cabiri or Cabeiri represent gods known to protect against "dangers and accidents, and more especially storms,"[35] and were thus beseeched by the heroic element of the populace. The "Kabirian mysteries" of Samothrace are "almost certainly connected with those of the Ionic Dodona,"[36] an originally Pelasgian site of Zeus worship on the northwest side of the Greek mainland, the "most ancient Greek shrine" and home to a famous oracle consulted by a variety of rulers, including Croesus of Lydia. The mysteries of the Cabiri, according to Herodotus (II, 51), constituted "rites which the men of the island of Samothrace learned from the Pelasgians," who originally inhabited Samothrace before moving to Attica, where they taught the Athenians the mysteries.[37]

In the later ages of the mysteries, three gods, "Axieros, Axiocersa, and Axiocersus," a.k.a. Casmillus, were worshipped on Samothrace, whereas earlier the "trinity" consisted of the "Cabirian Nymphs," the three daughters of "Sydic by Hephaistos, who, as the smith-God of the Greeks, was especially connected with these mysteries."[38] The fact that Hephaistos, a sun god and a "smith-god," was venerated at Samothrace indicates that the Samothracians were a smith-craft cult. The smith-craft cult likewise connects Samothrace to the Levant, where "Yahu" was the Kenite smith god, and to Egypt, where the creator god Ptah, an aspect of the God Sun identified by the Greeks with Hephaistos, was a "great worker in metals" who fashioned the "great metal plate" that serves as heaven's floor and the sky's ceiling.[39] Ptah was also "a master architect, and framer of everything in the universe," as well as the "demiurge" and the "architect of the universe." In fact, Ptah is one of the "Seven Wise Ones,"[40] who correspond to the seven Cabiri, the mysteries of whom "are supposed to be of Egyptian origin."[41] The Egyptian sun god Horus too was associated with the smith cult, with his followers "armed with weapons of metal" and "called in the Egyptian text Mesniu, or Mesnitu, which in all probability signifies 'workers in metal,' or 'blacksmiths.'"[42] Moreover, Horus of Behudet was given the epithet of "Lord of the Forge-city," or Edfu, the city where the god himself supposedly worked as a smith. As Spence relates, it was at Edfu where the "great golden disk of the sun itself had been forged." The smith-craft cult's importance thus lies in the great heavenly vault, as well as in weaponry. It is noteworthy that the word "Mesniu" contains "mes," which in Egyptian means "to give birth,"[43] while the Egyptian *mesu* means "anointed,"[44] the same as "messiah."

The term Kabiri has a possible Semitic connection in "Kabirim," the plural of *kabir*, which means "almighty."

Apparently equating the Cabiri with the "Kibeiri," Wallace-Murphy and Hopkins claim the latter were an "ancient Egyptian-Hebrew sect...the precursors of the Therapeutae and the Essenes."[45] While the Cabiri are traditionally not considered "Hebrew," the assertion is intriguing, in light of the evidence that the Hebraic wandering physicians the Therapeuts were proto-Christians, and that there are a number of significant connections between the Samothracian and Christian religions. Moreover, the "father of the Kibeiri" was said to be Jupiter, who is equated with Melchizedek,[46] the "spiritual father of the Kibeiri, the sons of Zadok, the Essenes and the Druids,"[47] another interesting assertion, considering that the "sons of Zadok" or Zadokites, whose El or god was Melchizedek, laid out in the Dead Sea scrolls a blueprint for the creation of much of Christianity. The connection to the Druids is also interesting, since the Cabiri, as gods, were evidently found in Ireland as well, invoked by the Corybantes or "sacrificing priests."[48] Although it is a title of the gods themselves, "Cabiri" also designates the Samothracian priesthood, which was likewise originally Pelasgian in ethnicity.[49] Per Bell, "'Cabiri,' as well as Corybantes or Galli, was the name of the priests of Cybele, who were 'generally eunuchs.'"[50]

In the island legend, the "mistress of Samothrace," Electra, mates with Zeus and gives birth to Iasion, or Jason. Iasion is called by the Roman poet Virgil (70-9 BCE) "Iasius," which is equivalent to *Iesous*, as *Jesus* is spelled in the New Testament Greek. Hence, Iasius/Jesus, the son of God, is the "healer and patron of physicians in the Greek mysteries,"[51] as well as the bringer of divine revelation. The god/hero Iasius/Iasios makes his entrance into Greek myth, and thus the Pagan world, by at least as early as Homer and Hesiod, both of whom mention him eight to nine centuries before the common era. Eventually, Iasios became known as the "founder of the Samothracian mysteries," having been appointed thus by "God" (Zeus). As Robertson says, "Jason...actually served as a Greek form of the name Joshua or Jesous; and Jasion...in one story is the founder of the famous Samothrakian mysteries..."[52] According to Diodorus (V, 49), Iasios/Jasius is the father of "Korybas," for whom are named the Corybantes. It is suggested that Jasius's mother was a "virgin"; in any case, he was miraculously conceived. Also, Jasius was sacrificed by God, his Father; yet, he was immortal and lived again.

As recounted by Apollonius of Rhodes (fl. 3rd cent. BCE), Orpheus, the legendary proselytizer of both the Samothracian mysteries and the god Dionysus, another Argonaut, induces Argonaut leader Jason to stop at Samothrace. According to Diodorus, the Samothracian gods saved the Argo from destruction

in a storm. Jason was also considered responsible for bringing the Egyptian mysteries to Greece, through Danaus, who escaped from Egypt to Greece via the Argo with his 50 daughters, the latter of whom "taught the Egyptian mysteries to the Greeks."[53] Since the name Iasios and Dionysus's epithet "Iacchus" are interchangeable, it is likely that Jason and Dionysus were considered one, with Orpheus their proselytizer. As in the Dionysian mysteries, the Samothracian initiate was plied with wine, to provoke an ecstatic, "out-of-body" experience. Wine was thus the communion drink in both the Samothracian and Christian religions.

According to Greek historian Pausanias (2nd cent. CE), Iasius or Jasius, along with Heracles/Hercules, is one of the "Dactyls" ("fingers") or "fathers of the Cabeiroi." These Dactyls, whose disciple was Orpheus, were originally located in either Phrygia or on Crete. "They are also associated with the mysteries of smith-craft, and Diodorus identifies them with the Curetes, tutors of the infant Zeus and founders of Cnossos" on Crete. Once more appear the "mysteries of smith-craft," representing a specific brotherhood and craft, associated with religion, millennia ago.

The Samothracian religion is connected to Christianity also via the cult called "Naaseni" or "Naasenes," a group of Syrian "Serpent Gnostics" prominent in the second century CE. In his *Refutation of All Heresies* (Bk. V, ch. II), Church father Hippolytus (c. 170-c. 235 CE) describes the foundation of the Naasenes, who claimed their system originated with "James the Lord's Brother" and who, according to Hippolytus, were "really traceable to the ancient mysteries." Eisenman ventures that "Naasene" is "a corruption" of Nazarene/Nazorean;[54] keepers of the mysteries, these "Naasenes" would thus be early Christians. The mysteries Hippolytus refers to are the Phrygian, Egyptian and Isiac, which were "allegorized by the Naaseni," who incorporated a "primal Adam" in their ideology. In Chapter III, Hippolytus further relates that in the Samothracian temple there were "two images of naked men, having both hands stretched aloft towards heaven, and their pudenda erecta,"[55] and that these statues represented Adam, the primal man. Next, Hippolytus relates words "spoken by the Savior: 'If ye do not drink my blood, and eat my flesh, ye will not enter into the kingdom of heaven; but even though...ye drink of the cup which I drink of, whither I go, ye cannot enter there.'" These remarks are reflective of the ancient human sacrifice ritual involving theophagy and cannibalism. By using the term "us" in his description, Hippolytus implies that he himself is an initiate in the "great and ineffable mystery." He certainly was an initiate of the *Christian* mysteries, and, like others before him such as

Irenaeus, he may have been a member of one or more Gnostic sects as well.

To reiterate, it was not, and is not today, uncommon to be initiated into several secret societies and mystery schools. In fact, it was de rigueur for the truly ambitious to be indoctrinated into as many such sects as possible. This ambition is why ancient sages such as Pythagoras and Apollonius of Tyana were depicted as traveling from country to country, visiting esoteric groups and mystery schools. To increase his authority among the flocks, the apostle Paul is portrayed in the same manner, visiting many areas where mystery schools flourished, proselytizing the same spiritual "Jesus" of the mysteries.

In the Samothracian mysteries appears a miraculously conceived, sacrificed and resurrected pre-Christian healing god named Jesus, worshipped by a sect or sects that eventually became Christian. With thousands of Hebrews, Samaritans and Jews initiated into the mysteries, it is not surprising that there subsequently emerged the Christian religion, more or less identical to these mysteries. There is much more to this subject, and a fuller investigation would require another volume, which would include an examination of the similarities between the Cabiri/Samothracian deities and those found in Indian texts.[56]

Eleusinian Mysteries

Like those of Samothrace, the mysteries of the Greek city of Eleusis were famed throughout the "known world." By the time of Ptolemy, the Eleusinian mysteries had apparently taken center stage from the Samothracian, and their yearly celebrations were noted by a significant portion of the Greek world. In fact, annually at this time messengers were sent out to wherever fellow Athenians resided, announcing a "Sacred Truce."[57] The antiquity of the Eleusinian Mysteries is given weight by the fact that the site in Eleusis is built upon Mycenaean remains, leading Rev. James to declare, "The Mysteries of Eleusis were undoubtedly of Mycenaean origin,"[58] referring to the Bronze Age culture whose mythical exploits were related in Homer's *The Iliad*. It appears that the Eleusinian and other mysteries originated in Egypt and were brought elsewhere "by men who had been partially initiated there."[59] Since these are in large part mysteries of Dionysus/ Bacchus, it could be said that they, like the god himself, were "imitations of the Egyptian." Spence likewise traces them to Egypt, noting that, because the Eleusinians were concerned with not only the underworld and dead but also rebirth, through the cornstalk and the myth of Demeter and Persephone/Kore, the "whole mystery...resolved itself into symbolism of the growth of the crops." Spence further states, "The blackfellows of Australia

and certain North American Indian tribes possess societies and celebrations almost identical with that of Eleusis..."[60] Concerning the Greek mysteries, an extension of the Egyptian, Spence also states, "These mystical associations would appear to be all of Neolithic origin, and to possess an agricultural basis for the most part."[61]

Much has already been written about these Greek mysteries; yet, they remain enigmatic. Like the others, the divulgence of these most solemn rites was thought to bring about the wrath and judgment of the deities. In the 5th century BCE, the Athenian general, politician and friend of Socrates, Alcibiades, was accused of "insulting these religious rites," of which he may not have been guilty. Nevertheless, he was persecuted and eventually murdered, despite his status as "the most popular man of his age."[62] The Eleusinian mysteries were held in high regard also by the Romans, including renowned writers such as Horace, Virgil and Cicero. Like the Greeks, the Romans brooked no insult concerning these rites and assailed transgressors with ferocity.

These Greco-Egyptian mysteries and others can be reconstructed to a degree; however, without the personal mystical experience involved, whether it be through fasting, drugs, sex or other agency, such as sheer fright, one cannot make a definitive pronouncement upon them. Some of the more mundane aspects of the Eleusinian mysteries include the following, from Porphyry: "In the mysteries at Eleusis the hierophant is dressed up to represent the demiurge, and the torch-bearer the sun, the priest at the altar the moon, and the sacred herald Hermes."[63] Thus, the concept of the "demiurge" originated long prior to the organized Gnostic movement, as part of the Greek mysteries, representing "Helios, the Sun."[64] The Demiurge was considered not only the architect and creator of the cosmos but also the smith and the *carpenter*, as well as the *mason*.

Once the demiurge's high priest or hierophant had finished his questioning, the initiate into the Eleusinian mysteries could expect a professional show, as "strange and amazing objects presented themselves; sometimes the place they were in seemed to shake all over, sometimes it appeared resplendent with light, and radiant fire; then clouded with horror and darkness; sometimes thunder and lightning, sometimes frightful noises and bellowings, sometimes terrific apparitions astonished the trembling spectators."[65] Once more, this bright light common to the mysteries is what is depicted in the tale of Paul's epiphany.

In addition, per early Christian authorities Theodoret, Arnobius and Clement of Alexandria, one emblem "worshipped" in the Eleusinian mysteries was the yoni, or female genitalia, representing the Goddess. The yonic symbol was likewise "openly

carried in procession at Athens."[66] As noted, the goddess involved was Ceres/Demeter, and the Eleusinian mysteries were called "the rites of Bona Dea" ("Good Goddess"). Thus, these earthy mysteries are Neolithic in origin, dating back many thousands of years, into primitive, prehistoric times.

"Eleusis," Robert Graves says, means "advent," and the term "was adopted in the Christian mysteries to signify the arrival of the Divine Child." Its usage "comprises Christmas and the four preceding weeks."[67] Hence, in the Eleusinian Mysteries are significant connections to Christianity, including also the bread-and-water communion and the yoni symbol, or *vesica piscis*, which in Medieval times was used to frame images of Christian divines, such as Christ and the Virgin.[68]

Jewish Mysteries

Like their neighbors, Jews and Israelites participated in "holy mysteries," as is clear from the story in Ezekiel, in which the Temple elders engage in secret rituals behind closed doors. These mysteries were evidently astrotheological in nature, resembling those of many other cultures, including the Egyptian, which heavily influenced the Jewish. In addition to these mysteries were many other secrets, to be shared with Jewish initiates and kept from all others. An intimation of the existence of Jewish secrets and mysteries can be fond in the apocryphal text 2 Esdras (14:26): "Write. And when thou hast done, some things shalt thou publish openly, and some things shalt thou deliver in secret to the wise." Another concept apparently kept secret to some degree was the idea of the Messiah itself, a "secret doctrine" as found in Isaiah and elsewhere. The "chief representatives" of these Jewish mysteries evidently acted apart from the "official Jewish religion."[69]

Along with "unintelligible terms," the mysteries included the names and numbers of gods. In Jewish magic and mysticism, the tetragrammaton YHWH was considered a very efficacious spell name, such that it was not to be pronounced, lest the Jews' enemies used it against them. Other "secret names" revered by the Jews included Adonai and Sabaoth, prominent names in the Gnostic literature, in which are referred to the "mysteries of Adonai." Concerning the concept of the "unspeakable name," Legge remarks that the idea of the ineffable divine name was as old as Egypt, "especially in the Osirian religion, where it forms the base of the story of Ra and Isis." Like YHWH, various of Osiris's names and epithets were also claimed to be ineffable, as was the case with the Babylonian god Marduk. YHWH's ineffability was assumed in the period "directly after Alexander." "In every case, the magical idea that the god might be compelled by utterance of

his secret name seems to be at the root of the practice."[70] This practice of "names of power" was part of not only the Egyptian magical arts or mysteries but also primitive, aboriginal cultures, with their shamans and witches.[71] In Egypt, it was believed that the person who knew the "most great name of God" could "kill the living, raise the dead, and perform marvellous miracles."[72] The Jewish YHWH was one such name, as was "Yahweh saves," i.e., Yahoshua, or *Jesus*, long before the Christian era.

Because Jews were highly secretive and xenophobic, they were considered furtive and untrustworthy by "the nations," i.e., non-Jews. The typical attitude towards Jews during the first century CE was expressed repeatedly by the Roman philosopher and statesman Seneca (4 BCE?-65 CE), who "among the other superstitions of civil theology, also found fault with the sacred things of the Jews, and especially the sabbath..." The sabbath, in Seneca's opinion, was an excuse for "idleness," which costs them a seventh of their lives, as well as leaving undone things that "demand immediate attention." Seneca also complained that Jews—"that most accursed nation"—had spread their customs everywhere, being received "in all lands," in which "the conquered have given laws to the conquerors."[73] Seneca, it should be noted, was the "only voice consistently raised" against the bloody and barbaric gladiatorial shows,[74] and it is evident that he was a genteel and principled individual. He was also emulated largely by "Paul" and other epistle writers.

In commenting on Seneca's remarks, Augustine calls the Jews "the people of God, to whom the mystery of eternal life was revealed..." In his assertions as to what Emperor Nero's tutor said, Augustine makes a point of addressing what he did *not* say: To wit, Seneca never mentioned Christianity, Christians or their purported leader and founder. With his speculation as to why Seneca did not mention Christians, Augustine was trying to justify the perplexing omission, which in reality existed because *in Seneca's time there were no "Christians" and Christ had not been created yet.* The "mystery of eternal life" referred to by Augustine is the death and resurrection of Jesus, a mystery purportedly revealed to and by Jews. In actuality, eternal life was one of the focuses of numerous mysteries of other cultures and nations, long before "the Jews" came into being.

The Jews were always expecting the Most High God to favor them above all others, sending the messiah or messiahs in order to provide them with dominion over the rest of the world. Calling the Jews a "small and comparatively insignificant people," the erudite author of *Supernatural Religion*, Cassels, was astonished at "an arrogance that would have been ridiculous if, in the influence which they have actually exerted over the world, it had

not been almost sublime."[75] In order to procure this divine favor, the Jewish priesthood instituted all sorts of bizarre rules and rituals, including many "borrowed" from a number of other cultures, which they then disparaged and attempted to subjugate. One of the principal concepts taken by Judaism from other cultures was the "religious science" of astrology, or astrotheology. As a religious development, astrotheology, or the reverence of celestial bodies, was preceded by magical rites and elemental worship. Nevertheless, astrotheology or "sidereal religion" existed in Mesopotamia before the invention of writing, as is evidenced by the "earliest symbol of a deity," which is that of a star.[76] Among the archaic magic rites was the propitiation of idols, and in the Egyptian the "magic figure or mummy" or idol was associated with the word "Ter," while in Hebrew the word for idol is "tera."[77]According to Arabian tradition, Abraham, "son of *Terah*," was a "maker of idols or teraphim," which are the same as the "gods" of Jacob's uncle Laban that his daughter Rachel stole (Gen. 31:19).

Another of the "magic rites" was the sacrifice of children, which occurred in Mesopotamia before the era of Abraham, who, like his predecessors, attempted to propitiate God with the sacrifice of his own son. The blood offering for atonement of sins is a very ancient concept, found in numerous cultures. Although their texts had condemned it, the Jewish priesthood still practiced human sacrifice into the Roman era, when it began to reject the savage rite. Animal sacrifice remained a large part of Judaism, until the era of the synagogue. This bloody sacrifice was principally found in a comparable magnitude in Persia, which is likely the origin of the Jewish version. Progressing backwards in time, the various "Jewish" mysteries, such as the claim to be the "sole proprietors of the key of knowledge," as moral authorities over "ceremonial observances and bloody sacrifices," are "provably of Indian origin."

Accounting for these ancient Indo-Persian connections, Bunsen divided "the Jews" into two parties: the "Iranian Kenites," who were Yahweh followers; and the "Indian Hebrews," who worshipped the Elohim or Canaanite gods. Bunsen considered the Sadducees to be of the latter, and said, regarding the former, "This Highpriestly order of non-Hebrews in Israel, of Rechabites and Essenes, we now venture to connect with the order of Melchisedec."[78] One of the more important secret societies is the Order of Melchizedek ("Righteous Molech"), which is considered "Jewish" but which likely originated in the Molech cult of Canaan. Regarding Melchizedek, Villanueva writes:

...some heretics, by reason of its being common to all men to receive their vital heat from the sun and heaven, and their grosser matter from the terraqueous globe, over which, and more particularly over its watery component, the moon exercises dominion, have specially attributed this to Melchisedec, whose father they state to be Heracles, or the sun, and his mother Astharte, that is the moon or Tellus.[79]

Hence, Melchizedek, purportedly a "real person," is alleged to be the son of the sun and the moon, the same as Horus and other sun gods, making him likewise a personification of the sun, i.e., Molech. Indeed, not only is Molech a god but so too is Zedek: In discussing Melchizedek and Adonizedek, the king of Jerusalem (Jos. 10:1) whose name means "Zedek is my lord," Hunt comments, "Zedek was a local god." The place where Melchizedek was supposedly from, Salem or "Salim," itself is the name of a local god.[80] That Melchizedek is actually the ancient Phoenician god Molech, as well as Yahweh, is also asserted by Drews, who says in reference to Melchizedek: "He is Jahwe, the King of Jeru-Salem itself...and corresponds to the Phoenician Moloch (Melech) Sidyk, who offered his only born son, Jehud, to the people as an expiation."[81] As is well known, the Molech cult was marked by human sacrifice, especially that of children, immolated while the priests banged drums to cover their cries.

As can be seen in the Old Testament, as well as in the apocryphal texts, Jews eventually openly took the moral high ground against such "vices and crimes" within the mysteries, both Jewish and Gentile. For example, in the pre-Christian apocryphal Jewish text *The Wisdom of Solomon* (14:23-26), the author rails against "secret ceremonies" and "strange rites":

> For whilst they slew their children in sacrifices, or used secret ceremonies, or made revellings of strange rites; they kept neither lives nor marriages undefiled: but either one slew another traitorously, or grieved him by adultery. So that there reigned in all men, without exception, blood, manslaughter, theft, and dissimulation, corruption, unfaithfulness, tumults, perjury, disquieting of good men, forgetfulness of good turns, defiling of souls, changing of kind, disorder in marriages, adultery, and shameless uncleanness.[82]

In these proscriptions and exhortations against secrets and mysterious rites is the acknowledgement that they existed, widely enough to be deemed a cultural phenomenon, rather than aberrant behavior by a handful of misfits.

As stated, Jews, Hebrews and Israelites joined "Pagan" mystery schools in droves, particularly at Alexandria where millions of them resided, as well in many other parts of the Roman Empire. The "Jewish" mysteries included not only the

Pagan influences dating back to Egyptian, Mesopotamian and Canaanite times but also "the systems of the Essenes, the Therapeuts, and doubtless of other Jewish sects [that] may be so characterized."[83] Another of these sects was that of the Zadokites/Sadducees, whose texts were found at the Dead Sea and "who had perpetuated many of the Hellenistic (Greek) reforms..."[84] There were, however, "many Sadducean Priests during this period who continued to be pious, maintaining the ancient traditions of the Temple in Jerusalem." The Dead Sea Zadokite/Sadducean brotherhood, whose focus on "salvation" placed them into the category of salvation cultists and predecessors of the Christians, constituted one of the many other sects scheming for not only the overthrow of the Jerusalem priesthood but also the creation of a new one, which they eventually attained in Christianity.

The Dead Sea Zadokites repeatedly referred to "secrets" and "God's mysteries." As Michael Wise says: "Particularly striking is the notion of hidden teaching, called the 'mystery.' Early Christianity and rabbinic Judaism also embraced similar but distinct notions of 'continuing revelation' not known to outsiders."[85] That the scrolls writers possessed secrets available only to initiates is clear from the punishment prescribed for "the man who murmurs against the secret teaching of the *Yahad*," who is to be "banished, never to return."[86] (The Yahad is the "unity" or Zadokite organization outlined and expressed in the scrolls.) The astrology of the Jews, which was one of their "mysteries," as it was of the Pagans, is evident also in the Dead Sea scrolls, which contained a number of astrological texts, including a "horoscope written in code" that incorporated the "royal science" and "true predictor of destiny" astrology, as well as the "ancient 'science'" of physiognomy.[87] The Jewish astrological mysteries continued for centuries into the Christian era, as is evidenced by the zodiacal imagery in ancient synagogues.

Christian Mysteries

Unbeknownst to the masses, and in spite the fervent objections by early Church fathers, Christianity possesses its own mysteries. In fact, "Christianity began as a mystery religion, replete with initiations, secrets and multiple levels of indoctrination."[88] Many of Christianity's most germane features were part of the Pagan mysteries, which the Christians turned inside out by making them public. Indeed, Christianity was "in its origin a secret society," and there were mysteries "in every established Church," forming also "the rock of the Catholic Church." As the Catholic Encyclopedia itself says concerning the word "mystery":

> In the language of the early Christians the mysteries were those religious teachings that were carefully guarded from the knowledge of the profane....
>
> In the New Testament the word mystery is applied ordinarily to the sublime revelation of the Gospel (Matt., xiii, 11; Col., ii, 2; I Tim., iii, 9; I Cor., xv, 51), and to the Incarnation and life of the Saviour and His manifestation by the preaching of the Apostles (Rom., xvi, 25; Eph., iii, 4; vi, 19; Col., i, 26; iv, 3).[89]

In reality, the Vatican Council made it anathema for anyone to declare that there are no Christian mysteries. The Greek word "mystery" (μυστηριον) appears 27 times in the New Testament, referring in almost all cases to the mystery cult. Christian mystery language appears in several other verses, such as 2 Cor. 12:2-4, Ephes. 6:12; and 2 Pet. 2:1, 4.

In these verses, there is much talk about the "mysteries of the kingdom of God," the "wisdom of God in a mystery," the "mysteries of God," the "mystery of Christ," the "mystery of the gospel," the "mystery of iniquity," the "mystery of faith," the "mystery of godliness," etc. In addition to this list is 1 Corinthians 2:1, which contains the word "testimony" in some versions; however, the Revised Standard Version of the Bible notes, "Other ancient authorities read *mystery* (or *secret*)."

The first two definitions in Strong's Concordance for the Greek words for mystery or mysteries are: "1) hidden thing, secret, mystery"; and, "1a) generally mysteries, religious secrets, confided only to the initiated and not to ordinary mortals."[90] To reiterate, nearly all these New Testament usages of "mystery" are indistinguishable in meaning from the concepts promulgated by the Pagan mystery schools. This fact is particularly evident in the writings attributed to Paul, which are Gnostic in many aspects. Indeed, Paul "frequently employs for his purposes the imagery and technical vocabulary of the Hellenistic mystery religions."[91] While denying that Christianity has anything to do with Paganism, and protesting that the religion is unique in practically everything and "ruthlessly exclusive," the Catholic Encyclopedia subsequently admits, "That the terminology of the mysteries was largely transported into Christian use (Paul, Ignatius, Origen, Clement etc.), is certain; that liturgy (especially of baptism), organization (of the catechumenate), disciplina arcani were affected by them, is highly probable."[92]

In actuality, "Paul" considers himself a "steward" or "dispenser" of God's mysteries, as he states at 1 Corinthians 4:1: "This is how one should regard us, as servants of Christ and stewards of the mysteries of God." 2 Corinthians 12:2-4 discusses a man "caught up to the third heaven," and Paul's gnostic,

mysteries language is likewise apparent in his descriptions of this heavenly hierarchy. As Wilder relates:

> Scutellius enumerates nine classes of spiritual beings, namely: 1. Invisible Gods; 2. Visible Gods of the Sky; 3. Archangels; 4. Angels; 5. Demons; 6. Leaders; 7. Princes; 8. Heroes or Demigods; 9. Souls. Paul in his epistle to the Ephesians enumerates the following: 1. Princes; 2. Authorities; 3. Kosmokrators or princes of the Cosmos; 4. Spiritual essences in the supercelestial spheres.... These, the Kosmokrators, are supposed by Thomas Taylor to be the rulers of the planets. The Assyrians and Chaldaeans enumerated nine distinct orders—three Triads of three classes each.[93]

At Ephesians 6:12, the Gnostic Christian writer addresses "world rulers," i.e., demons. At Romans 16:25-26, Paul refers to "my gospel" and the "preaching of Jesus Christ," as well as "the mystery which was kept secret for long ages but is now disclosed and through the prophetic writings is made known to all nations..." These remarks clearly constitute an acknowledgement that Christianity is an exoteric revelation of the mysteries, which had been passed along in secret for centuries, if not millennia, but which were now being blurted out by "Christian" initiates, against their oaths. The Christian interpretation has been that "the mystery" was Jewish, found in the Jewish scriptures, rather than in the Pagan mysteries. As has been demonstrated abundantly, however, such "Jewish" scriptures, rituals and magic rites themselves have their predecessors and counterparts in other cultures, and Jews were heavily involved in the Pagan mysteries. In the end, Christianity has been falsely presented as "divine revelation," instituted by a "new" incarnation of God, and teeming with new concepts hot off God's presses.

It is obvious that "Paul" and other Christian writers were members and initiates of a number of secret societies, mystery schools and salvation cults. Indeed, their language reveals esoteric membership knowledge at practically every turn. In addition to the abundant mysteries imagery and language in the so-called Pauline epistles are hints in other canonical texts, such as 2 Peter 1:4, which refers to "partakers of the divine nature." The use of parables by Jesus and the blatant acknowledgement of the masses' incomprehensibility at Acts 28:26 likewise reveal an initiatory model.

The enigmatic biblical book of Revelation also demonstrates the mysteries, in a manner that has mystified millions of readers over the centuries. As established in *The Christ Conspiracy*, Revelation is an astronomical and astrological text, recounting the basic mythos of the "Great Year," or precession of the equinoxes, specifically during the Age of Aries, the Ram or Lamb.

Revelation's frightening images are classic mysteries concepts, imposed upon the neophyte during initiation, designed to "strike terror into the heart of all those who should not remain faithful to the laws of the Initiation."[94] In other words, the "priests wanted to rule the World by fear."

In addition to these canonical texts are the writings of the Church fathers, who refer many times to "the mysteries," both Pagan and Christian. As demonstrated, these fathers' writings reveal a great deal of knowledge about the so-called Pagan mysteries,[95] which is to be expected, since the Christian mysteries were merely a rehash and continuation of their Pagan counterparts. Also, the less orthodox writing "becomes intelligible only in its context in pagan literary history." In other words, "Christian Gnosticism can only be understood in reference to Hellenistic mystery cults and the magical papyri."[96]

The Christian mysteries are discussed by Clement Alexandrinus in *The Stromata* (X), in which he also uses the term "the perfect" in its mysteries context.[97] This chapter is entitled, "THE OPINION OF THE APOSTLES ON VEILING THE MYSTERIES OF THE FAITH," in which Clement calls Paul the "divine apostle."

In his *Origen de Principiis* (II), Origen discusses the "wisdom of the princes of this world," which is to say, "the secret and occult philosophy" of the Egyptians, as well as "the astrology of the Chaldeans and Indians," who profess to know "high things," along with the Greeks, who claim to understand "divine things."[98]

In *Contra Celsus* (III), Origen discusses the mysteries and "those who are 'perfect' in Christianity," and speaks of inviting "them to our mysteries, for we speak wisdom among the perfect." "The perfect" refers to those initiates who are *perfected* in the mysteries. In fact, the word "perfect" (*teleios* in Greek, which also means "man," as in adulthood) as used in the gospel of Matthew and the *canonical* epistles is the very term utilized to designate the higher level of initiation in the Pagan mystery schools. One Christian brotherhood that appears to have continued this tradition is that of the Cathars, who called their highest adepts "parfaits," French for "perfect."[99] The Cathars seem to be the continuation, more or less interrupted, of a Gnostic Docetic group that spread throughout much of Europe and was most renowned during the 12th century, when the Catholic Church slaughtered thousands of its members in an effort to eradicate its "heresy." Part of this "heresy" was the insistence that Christ never took incarnation, i.e., did not have a physical body, as the Cathars taught that matter was "evil" and that "Christ who did not really undergo human birth or death."[100] In other words, according to these *Christians*, Jesus was *not* an "historical" figure.

In another of his works, *The Commentary on the Gospel of John*, Origen again speaks of the Christian mysteries, stating that the "saints before the bodily advent of Jesus" were at an advantage in understanding "the mysteries of divinity," because "the Word of God was their teacher before He became flesh."[101] Origen further addresses "the sacred mysteries of religion," as well as "the mysteries of Christ's deity" and "the heavenly mysteries," among other references.

In the *Divine Liturgy of St. James*, Lactantius repeatedly discusses "the divine and pure mysteries," "the divine mysteries," "His pure mysteries," "heavenly mysteries," "holy mysteries" and "Thy pure mysteries."[102] The Christian mysteries are also addressed by St. Ambrose (340-397 CE), in his treatise *On the Mysteries*, which included baptism, confirmation and the eucharist, the latter of which Ambrose insists is traceable to the "high priest" Melchizedek.[103]

The mystery and mysteries in both the New Testament and the writings of the Church fathers represent spiritual concepts that can be known only by the initiated: In other words, Christianity is a mystery cult. In reality, the Christ myth began to be formulated when Jews and Israelites were initiated into the Pagan mysteries. Having no consideration for keeping the secrets of the Gentiles, they then ran about divulging them, such loose-lipped individuals becoming known as Christians. These Christians were then persecuted for exposing the secrets of the Pagan mysteries. Because the populace at large did not know these mysteries, these early Christians pretended that they originated them.

At the same time as they were exposing the Pagan mysteries and claiming them as their own, however, Christians were, as typically "Jewish," very cultish and secretive, to the point where they were suspected of sedition. They were repeatedly accused by critics such as Celsus "of teaching their doctrines secretly and against the law, which seeks them out and punishes them with death, and this indicates a period of persecution."[104]

Although religions of all sorts were generally tolerated, secret societies were closely watched and outlawed in the Roman Empire:

> About the beginning of the reign of Trajan, A.D. 98, a special law was published against *Hetaeriae,* or fraternities, what we now call secret clubs or brotherhoods, which were established up and down the Roman empire. Their pretext was social feasting, and the better dispatch of business, friendship, and good fellowship. But they were suspected by the government to be hotbeds of sedition, plots, and conspiracies.[105]

The situation with the ancient secret societies and mystery cults is much the same as it is with today's fraternities and societies, such as the Masons. Naturally, representatives of "the government" are often also members of these groups, which means that the suspicion concerning them is held by the people themselves, rather than governments.

As concerns the source of the "Christian" mysteries, in addition to those already explored, such as the Samothracian and Eleusinian, is prominently featured the Egyptian religion. Albert Churchward, a Mason and expert on Egyptian mysteries, described the Christian miracles as literalizations of the "Kamite Mysteries." Miracles such as healing the blind, deaf, dumb and lame, and raising the dead are part of the "Mysteries of Amenti." The conferment by "Jesus" of such powers upon his disciples is likewise part of the mysteries rites: "So the followers, called the children of Horus, had the power given them previously by their Lord 'to raise the dead.'"[106]

As abundantly demonstrated, Christianity took many of its elements from Egypt. A number of the Church fathers were educated as "doctors" and "spiritual physicians," i.e., Therapeuts, in Alexandria and elsewhere in Egypt. These Alexandrian graduates included Clement, Origen and Theognostus, all of whom headed the Alexandrian school. Other prominent Egyptian Christian figures include Dionysius, bishop of Alexandria, and Gregory of Nazianzus. At Alexandria, these architects of Christianity had at their disposal an enormous library with books from around the known world—books that discussed the mysteries in some form or another. It can be stated with a high degree of certainty that virtually every concept in Christianity could be found in some or many of those books—and we would wager that enough of them survived and are hidden, in the massive Vatican archives, for us to prove our point thoroughly. There we would also find an abundance of our "primary sources," although we need them not absolutely, because there is enough material left behind by the censoring destroyers to prove our case.

In any event, that "Paul" and the others were revealing the pre-Christian mysteries is also clear from Colossians 1:26, which says, "[Even] the mystery which hath been hid from ages and from generations, but now is made manifest to the saints." What mystery is this that has been hidden for ages and is now revealed in Christianity? It is the celestial and solar mythos and ritual, i.e., astrotheology. This esoteric or mysteries language is apparent also at Hebrews 8:5, in reference to the "true tent" or tabernacle, of which the earthly tabernacle is only "a copy and shadow of the heavenly sanctuary." At 9:23, the author refers to "heavenly

things" and the true heavenly sanctuary into which Christ has entered. CMU comments that these references mean "unquestionably, astronomical truths concealed from the millions, under the veil of allegory." The mysteries term "to veil" ("kalupto") itself is used at 2 Corinthians 4:3, referring to "our gospel" as "veiled to those who are perishing." Moreover, when Jesus is made to refer to the "mysteries of the kingdom of heaven" at Matthew 13:11, he speaks to the initiated regarding "the symbolical worship of the sun, and other celestial bodies."

The core of these mysteries, now being revealed to the masses in Christianity, was the coming of the redeeming savior, who would rescue the world from cold and darkness. As we have seen, this central savior is the sun, called by various names, including Joshua, Jasius or *Jesus*, long before the Christian era. The revealers of this doctrine did not state anything so obviously, leaving the uninitiated masses to believe that the solar symbolism, mythos and ritual were "literal" tales involving an "historical" godman. Yet, the solar symbolism is inescapable. For example, at Philippians 3:20, the author says, "But our commonwealth [conversation, citizenship] is in heaven, and from it we await a Savior, the Lord Jesus Christ, who will change our lowly body to be like his glorious body..." This language is peculiar for someone who believes in an "historical" Jesus but it is perfectly fitting for an initiate into the mysteries, in which the sun is not only the symbol of deity but also of immortality.

Concerning the astrotheology of the New Testament, CMU concludes:

> Thus it is an astronomical key that lays open the secret arcanum of all that Paul, or any other of the New Testament writers say about "Christ and heavenly things"; for these, when the veil of allegory is withdrawn, stand confessed in the Sun, (the Mithras, or Mediator) moon, stars, the elements and seasons, the deification of which formed the occult astro-theology which was the basis of all the religions of the east; and from which christianism is only a distorted emanation.[107]

The astrotheological nature of the Christian mysteries, like that of the mysteries upon which they were founded, is evident, as the great "God of Light" (Sun) is worshipped in the form of "the Lamb" (Aries). "The mysteries of Christ are therefore merely the mysteries of the God Sun in its equinoctial triumph, when it assumes the forms of the first sign, or those of the celestial Lamb; consequently, the figure of the Lamb was the emblem or the seal with which in those times the Neophytes of this sect were marked."[108] The change of the equinox from the Bull to the Ram and then to the Fish, with the attendant ushering in of the new gods, was the reason for the creation of Christianity.

Long into the Christian era (e.g., the 14th century), the "Christians or their Doctors" maintained their "secret doctrine," holding it above the heads of the vulgar masses. Indeed, the higher initiates continue to hold close the knowledge of Christ as the sun, as well as, of course, that Christianity is simply Paganism synthesized with Judaism. Despite the chicanery, it is evident that the "names and significations" of Pagan symbols used in the mysteries "passed into the newly-born Christianity."[109] In other words, the brotherhood has suppressed the fact that the majority of important Christian motifs are found in ancient pre-Christian cultures. In the end, there is "not a vestige—not an iota of Christianity, whether Catholic or Protestant, that did not belong to Paganism, thousands of years before the reign of Tiberius..."[110]

Despite all the secrecy the fact is that in numerous cultures, long before the Christian era, the central figure of the mysteries was the *sun*. The mystery language refers constantly to "light," to the dispelling of darkness, etc. The goal of the mysteries was purification of the soul—by *Sol*, who was "the purifier." The mysteries surrounding this grandiose God Sun included rites and myths commonly found in the Pagan world and held as central tenets within the Christian faith, such as baptism, communion, the eucharist, immortality through resurrection, etc.

Like their Pagan predecessors, in particular the Dionysians, Christians also participated in secret "midnight rites," the "agapae" or "love feasts," as at Jude 1:12, which were "close imitations of the bacchanal orgies."[111] Moreover, the secretive Christians were accused of the standard vices of alien cults: Atheism, orgies, infant-sacrifice and cannibalism, etc. The eating of their god certainly *was* one of the Christian mysteries, as was his sacrifice or expiatory death: "Jesus Christ, the son of a king, is offered by God to himself, to avert his own vengeance, and this is repeatedly called the *mystery of the Gospel*..."[112] In *Among the Cannibal Christians*, Earl Lee seeks to establish that the ancient practice of theophagy, or the eating of the "god's body and blood," i.e., the cannibalism of a human proxy, did not end with the allegorization of the eucharist but continued in secret in numerous places globally, including in the Christian world.

Another part of the mysteries were the wisdom sayings or logia, which had been passed down for ages orally and through initiation, and which are not an indication of an "historical" Jesus. Rather, these wisdom sayings/logia were "pre-extant, pre-historic, and pre-Christian."[113] As one example, the phrase "Come unto me," repeated several times by Jesus is only comprehensible as a mysteries formula. These sayings are "the *mythoi* in Greek,"

i.e., "mythical sayings assigned to Sayers, who were also mythical..." Not only did these sayings/logia/mythoi exist before writing, they were also "not allowed to be written afterwards."

The world at the time of the formation of Christianity was teeming with religions, sects, cults, mystery schools, secret societies and other brotherhoods (collectively, *collegia*). One of the reasons these "colleges" were so popular and appealing was because they were "universal" in including the individual, despite rank, race or other status symbol. Pertinent examples of these colleges included the "Orphic brotherhoods in Greece," as well as the fraternities of the "oriental cults which, in increasing numbers, swept over the Graeco-Roman world."[114] Many of these colleges were either local or very loosely associated with others, but that of Dionysus was more organized, with cells in a variety of places, including mystery-school locations addressed in the New Testament epistles, such as Ephesus and Corinth. Concerning the guild of roving Dionysiac artists, Halliday states, "This society developed a single organisation with affiliated branches throughout the Empire, its headquarters being in Rome."[115]

These Dionysian "artists" were members of a mystery school, probably Samothracian but certainly Orphic, and brought with them as they traveled mystery plays that taught spiritual and ethical concepts: In other words, they spread religion. It is evident that this pre-Christian "church" with its wandering actors/preachers served as an archetypical organization upon which the Christian structure was founded, particularly, again, in consideration of the fact that countless thousands of Jews were initiated into the Dionysian mysteries with the promise of Alexandrian citizenship—a point that can scarcely be emphasized enough. As this group spread about, it picked up concepts from its various ports of call; hence, it served to amalgamate religious concepts, exactly as did Christianity.

To repeat, the atmosphere into which Christianity was born was one of mystery schools, secret societies, apocalyptic sects and salvation cults, replete with spiritual concepts and deities of all sorts, including many that were used in the formation of the Christ character. The world at the time was not as small and unpopulated as commonly believed: It was in many places a sophisticated network of towns and cities. Apostles of all types of religions, cults and sects moved freely from England to India and beyond. Egypt was a bustle with religiosity, possessing practically every notion found in the later Christianity, whose doctors and doctrinal authorities were frequently educated at Alexandria, where existed the world's most famous university and library, and where devotees from near and far flocked to become educated. Also, Rome itself was a hotbed of practically every sect, cult and

religion in the "known world." Ideas were widely exchanged, and initiates of one mystery school or secret society were often members of others. Priests and monks of all stripes traveled to monasteries, temple sites and other brotherhood strongholds in order to learn each others' priestcraft. Priestcraft, in fact, was highly developed, with new gods being created, along with requisite rituals and relics. It is preposterous, therefore, for Christianity to be presented as a "new revelation," utterly uninfluenced and unaffected by, as well as unrelated to, pre-Christian cultures and religions.

The Chaldean Brotherhood

One of the most influential pre-Christian priesthoods was that of the Chaldeans, members not of an ethnicity but of a brotherhood or fraternity. The Chaldeans, whose roots go back at least three thousand years, were also called "Urchani," or "Ur-Chan": i.e., "priests of the sun." The designation "Hyrcani" was a popular name for people, "cities and regions," such as Hyrcania, the term apparently referring to fire, the name being a "compound of Ur-chane, the God of that element...worshipped particularly at Ur in Chaldea."[116]

An additional class of Chaldean priest-astronomers were the "Conah," who had their own colleges.[117] The word Cohen, Cahen or Konah (Gen. 14:19), the Hebrew term for priest, lord or prince, is apparently the same as Can, Con or Kona, by which the Egyptian Hercules was called. "Kun" is also a title of the "ancient priests of Apollo." The language of Hebrew, as stated, is a degraded version of Chaldean, which was "set apart for the gods alone" and was so sacred that, according to Iamblichus, it could never be used to utter a threat.[118]

The Chaldean or Chaldee language was in early modern scholarship deemed the earliest tongue, having purportedly originated in Ayoudia (Judea), India, and serving as the root of both Sanskrit and Tamil, as well as Pushto, Hebrew, Ethiopian, Syriac, et al. In the late biblical book of Daniel, the Chaldeans and the Persian Magi are deemed the same. As seen, the Indians and the Persians were united 3,000 years ago; hence, there is sound reason to claim a Chaldean-Indian relationship. Indeed, a "Chaldaean record on physic or divination was found in India in 1765,"[119] indicating that long-asserted connection. The language of Welsh also purportedly has a strong connection to Chaldee or "Hebrew": Higgins claimed that in his book *Celtic Druids* he "*completely proves*" that "Welsh is Hebrew." Welsh is also "both Sanskrit and Latin." Even Chinese has some connection to Chaldean. This development evidently occurred as Chaldean-speaking priests traveled widely, which might also explain the

presence of the "Hebrew" language in Central America. What this proliferation means is not that "the Jews" are the progenitors of all races, as fallaciously maintained, but that because of their isolation and xenophobia they have preserved one derivative of Chaldee. Moreover, this preservation continued into the Christian era, as, oddly enough, Church fathers called themselves "Chaldeans": "Chaildee was the pious but appropriate epithet by which those patriarchs of Christianity thought fit to distinguish themselves. The word means *associate of God.*"[120]

The Druids

Another famed brotherhood that influenced the ancient world was that of the Druids, the white-clad fraternity famously of the British Isles but also situated in Belgium, France, Germany, Holland and Scandinavia.[121] This fraternity had much in common with a number of others, including its antiquity, which is believed to rival that of the Persian Magi, the Indian Brahmans and the Assyro-Babylonian Chaldeans. So similar were these brotherhoods in their rites and tenets that not a few scholars have sought to find a common origin. Christian writer Bell, for example, averred that "there seems to have been such conformity as plainly evinces them to have all sprung from the same common root, the religion of Noah and the Antediluvians."[122] The connection between the Druids, who were "magistrates of the ancient Britons and Gauls," and these other famed priesthoods was remarked upon in antiquity, some writers even declaring the Druids to be the originators of the sacred rites: "We have the authority of Pliny for stating that these had transmitted the science of the Magi, or the art of Magic, to the Chaldeans and Persians."[123]

While a number of sources place the emergence of the Druids within a short period preceding the common era, others have traced them to much earlier times, based on a variety of factors, including language and religion. For example, "the *Four Masters* relate that as early as 927 BCE, there existed Mur Ollavan, the *City of the Learned*, or Druidic seminary."[124] The compiler of an Irish glossary, Cormac MacCullinan, names Druids among the Tuatha, Firbolgs and the Milesians, early inhabitants of Ireland.

Although they are depicted as peaceful monks, Druids were known to practice human sacrifice and capital punishment for "blasphemy." These violent customs, however, have been asserted to be late intrusions based on alien influence. As O'Brien notes:

> The Druidical religion was at first extremely simple; but such is the corruption of human nature, that it was soon debased by abominable rites and ceremonies, in the same manner as was practised by the Canaanites, the Carthagenians, and by all the heathens in the other parts of the world.[125]

Bell maintains that the Druid religion "continued pure and uncontaminated by any foreign customs" until their cultural exchange with the Phoenicians, after which they "lost their original simplicity, adored a variety of gods, adopted the barbarous custom of offering human victims, and even improved on the cruelty of other nations." Conversely, Stewart claims that the Celtic headhunting, with the subsequent power-mongering display of skulls, existed in the earliest Celtic cultures.[126] The Druidic sacrifice included piercing "with darts," crucifixion, and "being laid on a pile of straw...consumed by fire."[127] Even Bonwick, somewhat of an Irish apologist, acknowledges the Druid sacrifice, as well as that of the Druids' descendants, the Culdees: "One would fancy...that the Culdees performed sacred rites, and indulged, like their Druidical fathers, in human sacrifice...to propitiate the Powers, and secure good fortune."[128] That these human victims were crucified, in a sacred or expiatory ritual, i.e., in the name of a god, lends credence to the assertions by O'Brien and others that there were images of crucified gods in ancient, pre-Christian Ireland, and verifies once again the contention that the gospel story is pre-Christian and non-historical.

Furthermore, the Druidical religion was like that of many other places, a "polytheistic monotheism" wherein there was recognized both the One and Its multiple parts. One of the names of their god was "Esus" or "Hesus," the woodcutter, which is essentially the same as Jesus the carpenter: The Druids "worshipped the Supreme Being under the name of *Esus,* or *Hesus.*"[129] As Lactantius asserted, the Gauls sacrificed humans to Hesus, and the name was placed on crosses used for the victims. Thus, in pre-Christian times were committed expiatory human sacrifices, by crucifixion, in the name of Hesus. So close was the connection that the British and Irish poets recognized in "Jesus" the same sacred king of their own religious rites: "They saw Jesus as the latest theophany of the same suffering sacred king whom they had worshipped under various names from time immemorial."[130] Furthermore, Hesus's name in Irish is *Aesar,* evidently related to the Egyptian Ausar (Osiris), as well as the Etruscan Aesar, the Indian Iswara, the Persian Aser and the Scandinavian Aesir.[131]

Another Druidic name for the Supreme Being was "Be'il" or "Be'al," contracted to "Bel," as in Bel-Samhain and Beltane, the principal Druidic festivals. Samhain or Samhan is itself a term for the sun god,[132] the same as the Semitic Samson and Saman, while Bel is essentially Baal. As noted, the British Isles were colonized or at least visited by Phoenicians, i.e., Semites from the Levant, who brought with them their sacrificial rites. It is apparent that British and Irish culture had some relationship to

the Phoenicians and, evidently, the "Hebrews," among others: "The beliefs, rituals and practices of the Druids have a great deal in common with those of the early Hebrew prophets and certain esoteric groups in biblical Israel."[133] The "most sacred name of God" among the Welsh was "Ya'u, or Yahu," the same as the Kenite smith god, as well as the Jewish Yahweh.

Moreover, the pre-Christian inhabitants of the British Isles possessed a number of important concepts found in Christianity, including the Trinity and the "Logos," in the form of a divine "oracular stone" styled *Logh-oun*.[134] Also, the Druids revered the "Virgin Pariturae," or the "virgin about to bring forth," centuries before Christianity arrived in the British Isles.[135] In addition, the most prominent god in "early Irish missionary records," Crom, Cromm, etc., was "certainly the Sun-God, for his image was surrounded by the fixed representations of twelve lesser divinities."[136] Other Irish gods include "Neit," identified with the Indian *Naat* and the Egyptian *Neith*, and *Chreeshna*, which in Irish means "sun."[137]

The Druids were the keepers of the mysteries, which, like much of the rest of their culture, were very similar in nature to those of Egypt, India, Persia, Greece, Rome and elsewhere. The reason for all of these similarities, in Albert Churchward's opinion, is that the mysteries of these various nations were all emanations of the Egyptian: "These old Egyptian Mysteries are the originals of all other Mysteries—Gnostic, Kabalistic, Eleusinian, Pythagorean, Zoroastrian, Hindu, Druidic and Jewish..."[138] Churchward also remarked that (due to Ireland's isolated location) the Irish mysteries-keepers perpetuated a purer form than all the rest, "possibly because we know that direct communication was maintained from Egypt to Ireland by the Her-Seshta to comparatively late periods..."[139]

This purity has led to another conclusion about the mysteries' origins, and that of the common culture in general, which is that the "Druids" or their Irish forebears were natives whose great learning and culture extended to the rest of the world. "From the mountains of Britain proceeded the light which produced the wisdom of Egypt, Babylonia, Persia, India, Phoenicia, Judea, and Greece," says Bonwick.[140] Another writer, Myfyr, proclaimed, "That the Druids of Britain were Brahmins is beyond the least shadow of a doubt."[141] Again, the ancient Irish language is closely related to Sanskrit, and the religious rites of the Irish are closely related to those of the sun-worshipping Indians. One of the most respected authorities on ancient Island, Colonel Vallancey, held that "Druidism was not the established religion of the Pagan Irish, but Buddhism."[142] By whatever name, "The Druidical religion...

prevailed not only in Britain, but likewise all over the East." Also, there "existed very anciently in Ireland a particular worship which, by the nature of its doctrines, by the character of its symbols, by the names even of its gods lies near to that religion of the Cabirs of Samothrace, emanated probably from Phoenicia."[143] It thus appears that much traffic passed through the British and Irish isles, as well as many migrations of a variety of peoples. These peoples, it appears, include the famed Chaldeans, as "many terms of divination used [in Ireland] are like those employed in Chaldaic." Indeed, the Tuatha de Danaan, "so associated with Irish deities, have been thought to be wandering Chaldees."[144]

The Druids were known as the most stubborn resistors of the Roman Empire, which pursued them with an unusual ferocity, likely based in large part on the Irish priesthood's control of local goldmines.[145] Yet, at the same time it is asserted that, in order to "retain their influence in the tribe," the Druids were "among the first and most influential of converts"[146] to the Roman and Christian religions.

The Mandaeans and Nazoreans

Styled by the Catholic Encyclopedia "pagan Gnostics," the important brotherhood of the Mandaeans comprised the Nasoraeans/Nazoreans and Sabeans, and its members were also called "Christians of St. John," i.e., the Baptist. Despite this moniker, the Mandaeans are not "Christians" and do not believe in Jesus Christ as the Messiah; in reality, while revering "John the Baptist," they perceived Christ as an oppressor, sorcerer and liar. Also, the modern Mandaeans "claim to have existed long before the time of the Baptist,"[147] i.e., the first century, and they honor the supposedly historical "John" as a great leader, "but nothing more." In the Aramaic language of the Mandaeans, "John" is "Yohanna," essentially the same as I-Oannes, the Babylonian dipper/water-god, and it is evident that this sect constituted pre-Christian Oannes-worshippers. As stated, the Mandaean religions appears to have been heavily influenced by the Indian, which makes sense since this sect was located on the Persian Gulf, "easily reached by sea from India."

The only surviving Gnostic sect, the Mandaeans' name comes from the Babylonian-Aramaic word "mndaya," which means "those who know" or "gnostics."[148] Concerning the Mandaeans, Picknett and Prince state:

> The name Mandaean literally means *Gnostic* (from *manda*, gnosis) and properly refers to the laity only, although it is often applied to the community as a whole. Their priests are called

Nasoreans. The Arabs refer to them as *Subbas,* and they appear in the Koran under the name of *Sabians.*[149]

The Sabeans, considered pre-Christian Arabs and equated with the Chaldeans, are named for their baptism, as "sbya" in Syriac and Aramaic means "baptist." Like the Mandaeans, the Sabeans of "Central Asia" were said to have been worshippers of "John the Baptist," which is likely reflective of their esteem for Oannes, an aspect of the God Sun: "In Persia, the first idolaters were called Sabians, who adored the rising sun with the profoundest veneration."[150] O'Brien theorized that the Round Towers of Ireland were constructed by Sabeans, who were Buddhistic and who built the towers as astronomical observatories and sacred grounds. In constructing the Round Towers, these "Sabeans" certainly displayed masterful masonry skills, as well as religious knowledge; hence, they could be considered an ancient *Masonic* order.

As evinced by Schonfield and Eisenman, et al., the Nasoraeans/Nazoreans were the same as the Nazarenes, proto-Christians who were the priests of the Mandaeans as well as a carpenter sect. Purportedly referring to a "pagan Gnostic" sect, the term "Nasoraean" is an Arabic word (Nasara) designating "Christians." Nevertheless, this sect was contemptuous of Christianity, while its members possessed an "extraordinary veneration for St. John the Baptist, who figures largely in their mythology."[151] Contradicting itself, CE first states that there is little similarity between the Nazoreans and Christians, and then that early Christian missionaries found these groups to be similar. It also claims that the "St. John Christians" followed "myths," which implies, of course, that Catholics did not. If the Nazoreans were "pagan Gnostics," evidently preceding the Christian era, their high regard for "John the Baptist" is inexplicable, if he had been a "real person." Continuing its discussion of the Nazoreans, CE reiterates the existence of Christian mysteries and validates the Babylonian influence and origin of much of the Mandaean/Nazarene religion, describing its worship of the "Light-King" as "one of singular beauty and elevation."[152] The worship of the "Light-King" who became the Baptist is surely that of Oannes, revered in Syria, Mesopotamia and Babylonia for millennia prior to the establishment of "John the Baptist" as an "historical personage."

Moreover, the Mandaeans possessed an Apocalypse that discusses "Enoch Uthra," whose "life" is basically the same as that depicted in the gospel story: The Mandaean King of Light "enters into Jerusalem...walks in bodily form... He comes in the years of Paltus [Pilate]." He is also depicted as a great healer of

the sick, blind, mute, lame and leprous, as well as a raiser of the dead. With such miracles, he makes Jewish converts: "Three hundred sixty prophets go out from Jerusalem," testifying in the name of the Lord. Later, Enoch ascends, and "Jerusalem shall be laid waste," with the Jews dispersed into exile.[153]

The "Christ" of the Mandaeans/Nazoreans is "Manda de Hayye," a "god of order" who battles with the "aeons of chaos." The Mandaean/Nazorean cosmology is largely Babylonian, featuring Marduk, Ea and the female monster Tiamat, who serves as the "Holy Ghost" or "Ruha" (Hebrew *Ruach*) and who, along with "Ur" (Ur/Or=sun), begets the "seven planets, twelve signs of the Zodiac, and the five elements." As CE relates:

> The seven planets...and the twelve signs of the Zodiac constitute an evil influence in the world, which is continually being overcome by the Manda de Hayye... This Manda de Hayye becomes incarnate in Jibil the Glorious or Hibil Ziva... Kessler pointedly remarks that if Manda is the Christ, then Hibil is the Jesus Christ of Nasoraeanism. Hibil's descents into Hades plays a great role in their theology.[154]

If Christ is "Manda," yet the Mandaeans/Nazoreans worshipped I-Oannes, then Christ and Oannes are the same: To wit, the sun. Also, CE acknowledges that "Christ" is a disincarnate entity, while "Jesus Christ" is the incarnation, a concept mirrored in the Indian system, with Vishnu and Krishna. Although Manda the Christ is depicted as overcoming the "evil 12," in the mythos globally the sun generally is not hostile to the 12 signs, one other notable exception being the Hercules story, in which the god gains victory over the 12 constellations.

Regarding the Mandaean cosmology, CE further states: "Frequent mention is made of heavenly Jordans, being streams of living waters from the transcendental realm of light. Hibil Ziva was baptized in 360,000 of them before his descent to the nether world." This motif confirms the assertion that the "River Jordan" was originally an allegorical "sun river," the Iarutana or Eridanus, appearing symbolically in the heavens as a constellation, after which many mundane rivers were named. The sun god Helios, for one, was said to have been "drowned," i.e., dunked or "baptized," in the River Eridanus.[155] This allegorical River Jordan, along with the Baptist mythology, is probably the source of the rumor that the Nazoreans lived at one point near the Jordan River. The number "360,000" indicates that the myth is old, preceding the development of the 365-day solar calendar. It also implies a 1,000-year reign by the Mandaean Christ.

Displaying further correspondences to Christianity, in addition to the baptism, which occurred on Sundays, the Mandaeans/Nazoreans celebrated communion. Moreover, the

Mandaean priesthood and Nazorean hierarchy was similar to the later Christian: a highly venerated priesthood, a patriarch/pope ("Rash Amma"), bishops and deacons, as well as the ranks of "Treasurer, Disciple, and Messenger," a triune hierarchy which resembles that found in the organization depicted in Dead Sea scrolls. It is intriguing that the "chief patriarch" of the Nazoreans is named "Amma," while the "son of God" in Dogon mythology is likewise called "Amma," particularly since both groups possess a tradition of a water or fish god.

The Nazoreans maintained that they were descendants of the Egyptian solders who chased the Hebrews during the "Exodus." Holding a "bitter hatred of all that is Jewish or Christian," they called Moses a "false prophet," while Jesus was the "Great Deceiver." Paradoxically, per CE, the Nazoreans' "extensive use of Biblical names," along with their Indo-Babylonian theology, "would leave one to believe that...they were once historically connected with Jewish Christians."[156] It is most noteworthy that the Catholic Encyclopedia admits *Indian* influence in the precise area where Christianity sprouted, and in a sect that has been considered the earliest of the Christians, particularly since CE goes to such lengths to deny any Indian influence on Christianity!

Importantly, the Catholic Encyclopedia admits that modern scholarship has shown Gnosticism and Mandaeism to be older than Christianity, as Gnosticism is related to the Babylonian religion that existed after Cyrus's time. CE further states: "This Mandaean religion is so unmistakably a form of Gnosticism that it seems beyond doubt that Gnosticism existed independent of, and anterior to, Christianity."[157] CE also asserts that the Mandaean religion, "unmistakably a form of Gnosticism," is *oriental* in origin. The term "oriental," CE states, includes India, Hinduism and Sanskrit: "the study of Sanskrit, together with the classic lore of the ancient Hindus, which has cast so much light on our knowledge of the European languages and peoples, forms another great division of Oriental research."[158] Despite all the protestation to the contrary, it is thus further evident that Christianity developed out of these Indian-influenced systems, using pre-existing motifs, sayings and rituals.

The "Egyptian" descent, as well as the "bitter hatred of all that is Jewish," may be reflective of a Canaanite, Israelite and Samaritan origin, especially since the Nazoreans are also considered Semitic. In *The Passover Plot*, Schonfield highlights various Nazorean characteristics in common with the Samaritans, including their mutual claim to be "'maintainers' or 'preservers' of the true faith of Israel" and their opposition to the Judeans.[159] In addition, a Syrian theologian has traced their lineage to the Dositheans, the followers of the Samaritan messiah Dositheus.[160]

Interestingly, the Nazoreans are also connected to the proto-Christian Zadokites of the Dead Sea, by way of the term the Zadokites used to describe themselves: "Guardians/Keepers of the Law." This term in Aramaic is "'Natsarraya,' whence the Greek 'Nazaraioi' is a very close transliteration." As Sid Green says, "This allows us to see how the community which sheltered the Zadokite bloodline became known as the 'Nazoraioi' or 'Nazoreans'..." The Mandaeans' involvement in the proto-Christian brotherhood is evident from the "direct link" discovered by Schonfield between the Mandaeans' *Book of John the Baptist* and the Dead Sea Zadokites' *Genesis Apocryphon*. [161] Also, some of the Dead Sea scrolls contains with parallels with the Mandaean religion. [162] Schonfield also remarks upon the "several features of the Pauline doctrine (the Heavenly Messiah and Second Adam) which are still reflected in the literature of the Mandaean-Nazoreans," as well as the similarities between Pauline scriptures and passages in the Dead Sea scrolls. [163] With the destruction of Judea in 70 CE, "we would expect," says Schonfield, "that a number of Nazoreans reached Alexandria to swell the community there." [164] Indeed, we would expect that it was at this point that Nazarenes fervently threw their hat into the ring of Jews and Samaritans in the process of creating Christianity.

Modern scholarship has determined as true the Mandaeans' claim of having no kinship with "the Jews." It appears that this sect migrated from Egypt, through Palestine, and eventually became fused with Indo-Babylonian Oannes-worshippers, demoting the local water god under their own "demiurge," *Ptahil* (Ptah). Moreover, according to CE, the Nazorean "Second Life" or "World-constituting Aeon," is also the "Architect of the Universe," evidently the Gnostic demiourgos, as well as a Masonic term used to describe God. As demonstrated, the demiourgos himself was deemed a smith, a carpenter or a mason. In *The History of Secret Societies*, Daraul includes mention of Mandaeism, the remnants of which exist in Iraq, as resembling Freemasonry in its initiation and rituals. [165]

The Therapeuts and Essenes

As is obvious from the constant internecine battling, there were a number of "Jewish" brotherhoods, several of whom believed that they were "God's elect" and that salvation would come through them. Their principle agent of salvation (*yesha*) was the Messiah (*christos*), and in the Jewish communities influenced by the Greek culture ("Hellenized") this messiah was depicted not as a warrior but as a spiritual and mystical entity. In this way, not only would the Romans and Greeks themselves be overthrown but so too would be their gods, replaced by the Jewish tribal god

Yahweh and his heavenly host. These various Jewish sects were intent on creating a philosophy or religion that would manipulate the Gentiles into the "monotheism" of Judaism and away from "idolatry," or polytheism, with the awareness that those who held the keys to a monotheistic god would dominate in religion and culture in general.

In 63 BCE when the Roman General Pompey captured Jerusalem, the city's inhabitants were demoralized, but they bounced back philosophically, furiously producing numerous texts to establish their dominance as "God's chosen." Their future reign would include a "Kingdom of God," a concept that eventually motivated some of them to create Christianity and its alleged founder. Hellenized Jews were not as sectarian as others and included in their interpretation of the kingdom any man considered "righteous," whether Jew or Gentile. Within this Hellenized Jewish community were those who practiced mysticism and who maintained that direct communion with God was possible, irrespective of the Mosaic Law. This belief, too, was a fundamental principle of Christianity. Such a concept, in fact, had the effect of making the Law somewhat worthless, producing antinomian ("anti-law") movements such as the Pauline. One of the principal means by which one could "know God" was through "Wisdom" or the Logos/Word, pre-Christian concepts that became fundamental in Christianity. The Wisdom literature of the centuries preceding Christianity was abundant, with its principal character personified as "Sophia," who eventually became intertwined with the Logos. In the Gnostic Christian doctrine, Sophia, who was also the Holy Spirit, became the "mother of the Logos" (Christ). These concepts were allegorical before being literalized in Christianity. The transition from Jewish mysticism to Gnosticism can be demonstrated by the fact that the Hellenized Jews did not interpret the Bible literally but sought its allegorical meaning.

One group of these "Jews by birth" who "differed from other Jews" was that of the Alexandrian Therapeuts or "Physicians," members of the Egyptian "Church of God" who were described by Philo as an ascetic sect who cherished Wisdom/Sophia. The Therapeuts, while Hebrews "after a fashion," were not necessarily "Jews," i.e., members of the Judean tribe; they appear to have been largely northern kingdom peoples, or Israelites and Samaritans, who occupied much of Alexandria and who possessed great wealth, more so than the Jews. Despite their supposed snobbery per Philo, the Therapeuts were "universalists," as opposed to the sectarian Essenes, who excluded "non-Jews" or *goyim*. It is noteworthy that, when referring to the Essenes, Philo uses the

Greek term, *hosioi*, the "holy ones," the same word employed to describe the elect of Dionysus. The word *hosioi* is also found copiously in other Jewish texts written in Greek, whenever the "holy ones" are referred to. Also interesting is that while Philo used the Septuagint, he limited his use almost exclusively to the Pentateuch or "Five Books of Moses"; as stated, the Samaritans also utilized only the Pentateuch and the Book of Joshua.

As Hellenized "Jews," the Therapeuts were known for their allegorical interpretation of the scriptures, upon which they expounded at communal meals. In these allegorical expositions were "secrets" to be revealed, i.e., mysteries, one of which can be found in the story of the Exodus, the purported Jewish deliverance from Egypt. The Therapeutan interpretation of this mythical motif stated that it meant "the delivery of the soul from the bonds of sense and the passage to the kingdom of the pure spirit."[166] Another of these mysteries was undoubtedly the sacred meal itself, per Philo's description, which would be equivalent to the Passover. Still another "Therapeutan" mystery is the symbolic death and resurrection of the initiate, ancient themes found in a wide variety of fraternities and mystery cults.

According to Philo, the Therapeuts of his era (1st century CE) possessed not only the "Jewish" scriptures but also the commentaries and writings of their sect's founders, who "left many monuments of their doctrine in allegorical representations, which they use as certain models, imitating the manner of the original institution."[167] The scriptures used by the Therapeuts constituted the Septuagint, which their Alexandrian predecessors had translated. It is apparent that this same Alexandrian brotherhood became known as the Therapeuts, who in turn created Christianity, using these Greek scriptures. Indeed, in a moment of extraordinary clarity and honesty Church historian Eusebius declared that the Therapeutan scriptures became the Christian bible, and that the Therapeuts represented the apostolic tradition, i.e., were early Christians. One of the more important biblical and Therapeutan texts was *The Wisdom of Solomon*, a pre-Christian pseudepigraphical writing by an Alexandrian Jew included in the Greek Bible that "exerted powerful influence upon the thought of Hellenistic Jews." Also called *The Book of Wisdom, Solomon* is related to the Epistle to the Hebrews, which itself was evidently written specifically to the Hebrews *at Alexandria* and which possesses concepts found in both Philo and the Dead Sea scrolls. The author of Hebrews, Bunsen submits, was Apollos (Acts 18:24), an Alexandrian Jew (Therapeut) highly esteemed by Paul. Also Therapeutan were Aquila and Priscilla, reputed in Acts to have taught a "more

perfect knowledge" or gnosis of the scriptures to Apollos, which is to say that they were initiates into the mysteries. Bunsen notes that only the Therapeuts would have allowed a woman, such as Priscilla, into their ranks.[168]

Philo himself was apparently a Therapeut, based on a number of factors, not the least of which is that he was knowledgeable about the mythos and ritual of the Alexandrian mystery school, which indicates that he was initiated into it. Also, Philo's likely involvement with the Therapeutan Church of God is reflected in the fact that later "Christian" writings "borrowed" heavily from the Jewish philosopher, upon whose pages practically every concept within Christianity may be found. For example, in addition to the Logos or Divine Word abundantly discussed, when Philo addresses circumcision—a tremendously important issue to the early Christians in their efforts at proselytizing—he talks about "circumcision of the heart," another significant "Christian" concept.

Bunsen contends that other Therapeuts included the Stephen of Acts and his "disciple" Paul, as the same author avers their relationship to have been. The assertion of Epiphanius that Paul was a converted "Jew," or Israelite, born of Gentile parents, would lend weight to the idea that he was a Therapeut, his initiation serving as the means of his conversion. Bunsen also claims the reason Paul was hated by the Judean priesthood was because he was a "universalist," as opposed to a bigoted sectarian who wished to exclude all Gentiles from the holy mysteries. As noted, the Hellenized Therapeuts were also universalists, and their allegorical interpretation of the scriptures placed them in the same category as the Gnostics, of which "Paul" certainly was one. In reality, the two groups at Alexandria were, or became, virtually inseparable, and it can likewise be asserted that the Antiochan Gnostics were also Therapeutan. As stated, with such a nonliteral or liberal view of the scriptures, the Alexandrian Jews were less concerned with keeping Mosaic Law to the letter, and it is evident that they considered the Law oppressive, as did Paul.

Furthermore, Barnabas, to whom is attributed the highly Hebraistic epistle, was purported in the "Clementines" to have taught in Rome and Alexandria, prior to Jesus's alleged crucifixion.[169] It is likely that Barnabas was a pre-Christian Therapeut and that his epistle was one of those Therapeutan texts later Christianized, per Eusebius. In fact, the epistle shows just such a development, with its salvation hero, *Joshua*, turned into *Jesus*. There is also a Dead Sea connection to Barnabas, as an identical quotation is found in both the epistle and one of the scrolls. There are a number of such germane connections between the Therapeuts and the Dead Sea Zadokites.

Another apparently Therapeutan text is *The Book of Enoch,* which contains much of the later Christ myth. Several copies of Enoch, a highly *astrological* text, were found at the Dead Sea, demonstrating its importance to the pious Zadokites who deposited the scrolls there. Bunsen states that Enoch was composed in Galilee between 130-100 BCE, possibly with interpolations after the creation of Christianity. He further says, "The Essenic and especially Therapeutic contents of the book are uncontestable."[170] In Enoch, the Messiah is depicted as coming to earth as a "white bull with large horns," an interesting notion in consideration of Buddha's overshadowing of Maya in the form of a white elephant, and of Mithra the Mediator represented by the bull.

The Therapeuts, and their "secret society" Palestinian counterparts, the Essenes, may be deemed keepers of "Jewish mysteries." Not a few researchers have wondered why the gospels and Acts make no mention of these two important "secret societies," whose members likely included the "'saints' found by Peter at Lydda and the 'disciples' discovered by Paul in various places."[171] The fact that these pre-Christian and proto-Christian brotherhoods do not appear in the New Testament is evidence that it was their members who created Christianity, omitting their existence in order to make it appear as if the "new" religion were a divine revelation. The Therapeuts and Essenes are not precisely the same brotherhood, for a variety of reasons, including their different locations; nevertheless, they possessed relevant aspects in common, including a reverence for the sun, which is appropriate for mystery and salvation cultists. As we have seen, the Essenes have been called, or associated with, "Jesseans," after "Jesse," who is a solar hero and another variant of "Jesus." Concerning these brotherhoods, Drews says that "the Essaeans or Essenians...like the Therapeuts of Egypt, cultivated a mystic esoteric doctrine, and cured disease and expelled devils by the magic of names." He then relates that Isaiah's "servant of God" was "also a physician of the soul, a healer, and an expeller of demons." As recounted by Epiphanius, "the name Jesus means in Hebrew *curator* or *therapeutes* (healer or physician)," and, says Drews, "it is not at all improbable that the Essaeans worshipped their god under the name of Jesus or Joshua."[172] As we have seen, the name Joshua (Jesus) was equivalent to "Jason," the Greek healing and savior god whose cult was "widely spread not only in Asia Minor but also in the West."[173] The Essene reverence of Joshua/Jesus predated the common era and the purported advent of "Jesus of Nazareth."

The Therapeuts' and Essenes' "superstition" was composed of "a mixture of the Egyptian and Persian mysteries," essentially

representing sun worship,[174] appropriate since Jesus is the sun. The Therapeuts, many of whom lived around Lake Mareotis near Alexandria, were syncretists who, although "Jewish," subscribed to such "Pagan" ideas as paradise and, like the Druids, believed "in the return of pure souls to the Sun, whose rising they invoked every day."[175] Living so closely to Alexandria, the great center of learning, the Therapeuts possessed tremendous clout and significant wealth as well. These circumstances, says Schonfield, "were conducive to the production in Alexandria rather than in Antioch in Syria...of a Gospel like that of Matthew, and would explain the characteristics of this Gospel, at once Judaic and universalistic."[176] Although they were thus headquartered in Egypt, the Therapeutan community, Philo relates, "is to be found in many parts of the world..."[177] This sect is obviously an important part of the brotherhood network that extended from Britain and India to beyond, existing in a number of places significant to Christianity, including the communities addressed in the Pauline and other epistles. On the face of it, it is remarkable, as Ellegard points out, in consideration of the enormous amount of Jews, Israelites and Samaritans in Alexandria (up to a million by Philo's account), that the communities addressed by Paul do not include any in Egypt.[178] It is as if Egypt and Alexandria were deliberately avoided because any discussion might clue the reader as to whence Christianity truly emanated.

From a variety of evidence, including "Paul's" remarks concerning "bishops" and other entities and concepts that reveal longevity, it is apparent that the churches addressed by the apostle were already in existence long before he supposedly founded them. While tracing this proto-Christian organization to the Therapeuts, Reber takes a different perspective, attempting to show that the fledgling Pauline institutions were taken over by the well-established Therapeuts, who imposed their government on them, with the "fullness of being" recorded in Paul's epistles constituting interpolations. Reber further asserts the large numbers of Alexandria Jews (Therapeuts) transported the doctrines of Philo into the church. As proof of this assertion, Reber relates the story in Acts and the Epistles of Apollos the Alexandrian Jew (Therapeut), who "brought with him to Ephesus the Logos idea of Philo..."[179] Nevertheless, Philo was the bridge between Hellenic Judaism and Christianity, and it is clear that the Therapeuts occupied the middle ground, instigating Christianity, rather than taking it over. In this regard, in Ephesus, the site where Paul addressed the Ephesians, there existed a "great Gnostic college, where Buddhism, Zoroastrianism, and the Chaldean system were taught side by side with

the Platonic philosophy." The other places where Paul supposedly lived and traveled also possess powerful branches of the universal, mysterious brotherhood that eventually created Christianity.

Enter the Masons

Over the ages, there have existed numerous brotherhoods that have possessed gods, rituals, rites, myths and mysteries quite similar to those of Christianity, but that preceded the Christian era by centuries and millennia. Many of these brotherhoods have much in common with each other, demonstrated by numerous authorities beginning in antiquity to be related in one fashion or another. The similarities that connect specific fraternities are not limited to gods, rituals, myths, etc., but also include physical artifacts such as symbols and architecture, i.e., *masonry*. Originating in ancient times, a number of brotherhoods have been both craft guilds and religious organizations. The religious tradition of the Irish, for instance, included "the divine smith" who was likewise "a great builder, or a resourceful master mason."[180] The giant smith or forger was an important and popular image in ancient British culture, as it was in Near Eastern, Greek and Roman. In Egypt, the smith-craft cult revered the god Ptah-Hephaistos, while doctors worshiped the famed and "very ancient" Iemhetep, the "god of physicians and those who dealt in medical magic."[181] In the same manner, carpenters worshiped a carpenter god and masons revered a masonic or stonecutter god. Indeed, it is apparent that in antiquity there existed masonic guilds or "collegia" that also served as mystery schools, secret societies and religious sects. As related by the historian Plutarch (46?-c. 120 CE), many of these collegia or colleges, which included the spectrum of trades and crafts, were legendarily established in 719 BCE by the Roman king Numa Pompilius and possessed the detailed organization as well as the community support found in later Masonic "lodges."

As related by the Catholic Encyclopedia, the many "fantastic theories" regarding the history of formal "Masonry" as an organization include that it was founded by God, "the Great Architect," and that "Adam, the Patriarchs, the kings and philosophers of old" were its "patrons." Indeed, Jesus Christ himself is "included in the list as Grand Master of the Christian Church." Over the centuries, Masons have laid claim to "Noah's Ark, the Tower of Babel, the Pyramids, and Solomon's Temple." The mysteries, whether Dionysian, Druidic, Egyptian, Eleusinian or Mithraic, are at the heart of Masonry, as are "sects and schools such as the Pythagoreans, Essenes, Culdees, Zoroastrians, and Gnostics." Masonry's origin has been traced to "the Evangelical

societies that preceded the Reformation," as well as to the Knights Templar or St. John's Knights. Masonic origins have been asserted of practically every secret society, including "the alchemists, Rosicrucians, and Cabbalists," and so on, from Britain to Arabia to China. "It is claimed also that Pythagoras founded the Druidic institution and hence that Masonry probably existed in England 500 years before the Christian Era."[182] In *Inside The Brotherhood*, Martin Short writes: "In terms of ritual, modern Masons may owe more to Ancient Egyptians than to England's cathedral-builders, something they can scarcely admit today."[183] Short, however, considers the contentions of antiquity based on connections to Druids, etc., to be part of Masonry's "broad lunatic fringe."

Current Masonic lore states that "Freemasonry" only began in England in 1717, an assertion readily disproved by the existence of Rosslyn Chapel in Scotland, constructed between 1440 and 1490, and displaying not only extraordinary masonry itself but also many of the well-known symbols and rituals of the Masonic brotherhood. As Masonic authors Knight and Lomas state concerning Rosslyn Chapel, "the structure is covered in...a combination of Celtic and Templar motifs with elements that are instantly recognisable to modern Freemasons."[184] This fact places Masonry as an arcane organization in the 15th century; however, CE relates that the word "Freemasonry" is found in a manuscript from the 13th century. Also averred by Knight and Lomas is that the "history" proposed by the historians of modern Freemasonry is designed to establish supremacy, i.e., for the lodges of the British Isles.

Regardless of the presumed modern history of Masonry as an organized brotherhood, various important aspects of the society are quite ancient. Indeed, the modern Masonic mysteries are "hopelessly garbled and watered-down versions of genuine mysteries of earlier times."[185] In *The Brotherhood*, Stephen Knight submits that claims to antiquity are incautious; yet, he acknowledges that "the philosophic, religious and ritualistic concoction" that is "speculative Freemasonry" is "drawn from many sources—some of them, like the Isis-Osiris myth, dating back to the dawn of history."[186] As stated, for millennia God himself has been deemed the "Great Architect of the Universe," evidenced by the fact that the Egyptian creator god Ptah was considered the "inspiration" for the "mystery of building."[187] The popular Egyptian sun and fertility god Osiris too was the "god of fortifications," equated with Nimrod, the alleged builder of the biblical Tower of Babel, believed in modern Masonry to be the first mason.[188]

Egypt's role in Masonry is significant: For example, the Great Pyramid has been deemed the "greatest Masonic temple that has ever been built."[189] Indeed, the pyramid's masonry is astonishing—the result of an obviously sophisticated and organized culture with profound mathematical and astronomical knowledge. In other words, the architects and builders represented a school or society of skilled and knowledgeable professors and acolytes. Did this ancient *masonic* group possess initiations and secrets? Was it a secret society? The answer to both questions is yes. Hence, Masonry as a secret society has existed for thousands of years. In the Near East, Masonry as an organized brotherhood may be traceable to at least the 18th century BCE, based on Akkadian writings among the some 24,000 texts found at the ancient site of Mari. As Brian Desborough says in "Who Were the Israelites?": "Of masonic interest is the textual discovery that some 2000 of the nation's craftspeople were members of guilds." Another ancient advanced culture of "master builders" was that of the enormous Harrapan civilization in the Indus Valley, dating back at least 4,500 years. In the final analysis, says Bonwick, "No one can doubt that Free-masonry, *Phré* or Sun masonry, existed B.C. 4000, if not much earlier..."[190]

Part of the difficulty in accepting such antiquity for the Masonic order stems from the very fact that its mysteries were *secret* and that they were passed down orally for millennia, so that they would not be destroyed by rival cultists.[191] Despite the inculcated disbelief, like the carpenter and smith cults, the masonic cult, with its "symbolic teachings," predates not only Christianity but also Judaism.[192] The evidence indicates an "unbroken chain" of masonic knowledge, passing from Egypt to Israel, via "sacred geometry," an engineering and architectural "art form," as well as other skills. Purportedly, however, this knowledge was "lost until the Knights Templar discovered documentation about it during their excavations under the Temple Mount in the twelfth century."[193] Whether or not there were gaps of a century or a millennium, and whether or not Masonic endeavors were made by organizations or by a few individuals, it is clear that, along with the actual physical and scientific elements of building and stonecutting, i.e., masonry, many of the concepts and rituals found in organized Masonry are ancient and have been passed along over a significant period of time.

Although masonic religious guilds long predate Judaism and Christianity, in its current form "Freemasonry" has been highly Judaized. In *Chapter Masonry* (1901), Christian writer Ronayne, a high initiate and Worshipful Master of the "Keystone Lodge" in

Chicago before renouncing Freemasonry, described modern
Masonry as loaded with biblical references and thoroughly
connected to early biblical lore, tracing its origins to "Solomon's
Temple" and its purported architect, "Hiram Abiff." Modern
Freemasonry includes ancient Judaic Masonic concepts such as
the Jachin and Boaz, the two pillars at the entrance of the
Temple. Concerning this ancient Jewish masonry, in *James the
Brother of Jesus* Eisenman discusses the Zealot High Priest of the
first century, Phineas, who was a "simple Stone-Cutter," and
comments: "Though we remarked the 'Stone-Cutter' theme above,
we did not connect it at that point to the 'Rechabites' being
'craftsmen' in all traditions, not to mention its latterday spin-off
in the ideology of being 'Masons.'"[194] As was the case with priests
in earlier times and cultures, the Jewish Zealot high priest of the
first century was a *mason*. The Old Testament Rechabite sect,
Eisenman states, was composed of "Potters" and distinguished by
its emphasis on artisans or craftsmen; according to Eisler, these
craftsmen included carpenters and smiths.[195] To reiterate, that
there were organizations of craftsmen, potters, carpenters *and
masons*, thousands of years ago, is a fact, as is their existence
within a religious context, i.e., as a sect or cult.

The knowledge of ancient Jewish masonry and its religious
significance increased in 1999, when archaeologists found the
"largest stone factory ever discovered in Israel," built some 2,000
years ago. The factory consists of caverns covering a quarter of an
acre 15 feet beneath East Jerusalem, where were unearthed
"carved stone mugs, dishes and wine jugs for priests serving in
the nearby Jewish Temple." In creating the factory, "Masons cut
stone blocks from the walls and ceilings, to be used as raw
material while carving out a new workroom."[196] These stone
vessels were used ritually, thus connecting masonic products
with religion.

Masonic imagery is given importance in a number of the Dead
Sea scrolls, such as "A Firm Foundation" (4Q541), which makes
"the usual allusions to 'Wisdom,' [and] 'Mysteries,'" and contains
masonic terms, as in its title. In the "Qumran Hymns" appears
other imagery of this type, such as "the Cornerstone," "the
Tower," "pillars," "wall" and "Fortress."[197] In reality, the scrolls are
full of architectural metaphors, including the term "Shoddy-Wall-
Builders."[198] Moreover, the scrolls' Zadokite authors reveal their
own masonic-like brotherhood, replete with rules, rituals, levels
of initiations and harsh punishments. Concerning the scrolls
writers, Knight and Lomas remark, "Everything we found out
about the Qumran Community added to our conviction that they
were the spiritual descendants of the Egyptian kings and the

antecedents of the Templars and Freemasonry."[199] The scrolls are not the product of a "Qumran community," however, but of a more widespread brotherhood. As Wise says regarding the so-called "Community Rule" found at the Dead Sea, "the work itself refers to various groups or chapters scattered throughout Palestine."[200] Concerning this document, Wise further relates that "virtually every structural element of this ancient Jewish writing has analogs in the charters of guilds and religious associations from Egypt, Greece, and Asia Minor." In other words, it reflects a guild or religious brotherhood, which, it turns out, is immersed in masonic symbolism and thought.

One of the more prominent masonic terms used in the scrolls is "cornerstone," also employed in the gospels to describe Jesus. Says Eisenman, "The imagery of 'Stone' and 'Cornerstone' is part and parcel of that applied to the Disciples in early Christianity and omnipresent in the Dead Sea Scrolls..."[201] "Stone" imagery, of course, includes the Rock, or Disciple Peter, as well. The scrolls' authors, the Zadokites, used ciphers or secret writing to encode some of their texts, claimed to be the "Atbash Cipher," later employed by the Knights Templar, who likewise used a peculiar "highly sophisticated secret alphabet,"[202] much as other secret societies have done. A mysterious and powerful secret society "behind the formation of builders' guilds, including that of the stonemasons,"[203] the Templars represent a brotherhood that preserved much of the ancient knowledge, including not only masonry but also astrology, which would make them a continuation of the mysteries.

Another pre-Christian religious brotherhood that strongly resembled a Masonic organization was Mithraism, as noted by a number of authorities, including the Catholic Encyclopedia and the French scholar Renan.[204] As Robertson says, "Mithraism was always a sort of freemasonry, never a public organization."[205] Halliday comments that "the general character of the initiatory rites was that which the world at large associates with Freemasonry, and which, indeed, is common to all similar kinds of religious ceremony in all stages of culture down to the puberty ceremonies of savages."[206] Regarding the Mithraic mysteries, O'Brien remarks, "The mysteries celebrated within the recesses of those caverns are precisely of that character which are called *Free-masonic* or *Cabiric.*"[207] It is apparent that, beginning in pre-historic times, caves have served in the performance of mysterious rites. Also, while the Cabirian or Samothracian mysteries are designated as representing smith-craft, they apparently also were "masonic."

In its entry under "Mithraism," the Catholic Encyclopedia states:

> The small Mithraic congregations were like masonic lodges for a few and for men only and even those mostly of one class, the military; a religion that excludes the half of the human race bears no comparison to the religion of Christ. Mithraism was all comprehensive and tolerant of every other cult, the Pater Patrum himself was an adept in a number of other religions; Christianity was essential exclusive, condemning every other religion in the world, alone and unique in its majesty.[208]

As thoroughly demonstrated, Mithraism possesses numerous correspondences to Christianity, correlations that predate the latter religion by centuries if not millennia. These similarities include the Masonic-like structure of Mithraism, especially within the mysteries, the Mithraic revolving around the slain Bull, representing the older age of Taurus, while the Christian had its sacrificed Lamb, or Aries, with an initiation "like the private sign of free-masons."[209]

A number of important correspondences between Christianity and Masonry are outlined in *The Christ Conspiracy*, which evinces that a Masonic brotherhood transcending religious sectarianism was responsible for creating Christianity. Concerning Masonic imagery within Christianity, Massey remarks that the key to deciphering it lies in the "Gnostic clue to the Hidden Wisdom." He further says, "Wherever we meet [the Gnostics] they give us the Masonic grip; and by the same sign we know that Paul was a Gnostic." That major players in the creation of Christianity were members of a brotherhood or brotherhoods is a fact, as is the Masonic structure and terminology used in Christianity. Masonry plays an important role in biblical metaphors, which is sensible since the Bible's creators surely knew that stone foundations and buildings last the longest. Also, as is the case today, the people who erected stone edifices in ancient times were often quite wealthy and powerful, capable of creating a religion such as Christianity.

One pertinent example of Masonic terminology within Christianity appears in the phrase describing Jesus as "the cornerstone that the builders rejected" (Mt. 21:42; Mk. 12:10; Lk. 20:17), a well-known Masonic term with mystical connotations beyond merely representing a physical stone. In other words, the phrase belongs to a mystery school and secret society, in this case relating to stonecutting or *masonry*. This phrase regarding the "rejected cornerstone" comes from the Old Testament (Psalms 118:22), demonstrating the Masonic influence in Judaism as well. This Psalm is supposedly "prophetic"; however, Christian authority Matthew Henry submits that it may originally have referred to David, who was rejected by Saul. In any event, this Old Testament passage is immediately preceded by "I shall give

thanks to You, for You have answered me, And You have become my salvation." The word for "salvation" in this scripture is *Yeshua* or *Jesus*. Thus, a pre-Christian reader of the Old Testament would see: "...You have become my Jesus. The stone which the builders rejected has become the chief cornerstone." This messianic passage is not *prophecy* but a *blueprint* for the creation of the Christ character.

The phrase for "cornerstone" in the gospels, as well as at Acts 4:11 and 1 Peter 2:7, is "kephalen gonias" or "head of the corner." It is translated as "chief cornerstone" in the New King James Version, the HNV and NASB; as "head of the corner" in RSV, Webster's, ASV and YLT; and as "corner-stone" in Darby's.[210] The Bible Gateway translates the phrase as "capstone," which is defined as a "coping stone," the "high point" and "crowning achievement." The copingstone is that which tops the corner of a sloping wall; hence, the "capstone" is the peak of a pyramid, representing the Masonic hierarchy. Building upon Isaiah 28:16, 1 Peter 2:6 discusses the laying in Zion of a foundation stone, "a tested stone, a precious cornerstone of a sure foundation." The phrase for "cornerstone" is "akrogoniaios lithos" in the Greek, defined by Strong's as "placed at an extreme corner, the corner foundation stone." This same Greek phrase is used at Ephesians 2:20, in reference to Christ himself. Furthermore, while the canonical gospels discuss the "rejected cornerstone," the apocryphal Gospel of Thomas portrays Jesus as asking to see "the stone which the builders have rejected," evidently "an exact parallel of the ritual of the Masonic Mark Masonry degree."[211]

In addition to the "cornerstone" imagery in the New Testament is the masonic terminology used by the "wise master-builder" Paul, who spoke "wisdom amongst the Perfected"[212] and referred to "brethren," i.e., members of a brotherhood or fraternity. Paul's labeling himself a "Master Builder" (1 Cor. 3:10) signifies that "he was also initiated into the Eleusinian Mysteries, where the *epoptae* [initiates] were known by that title." Also in the first epistle to the Corinthians (3:9-14), which likewise uses Isaiah 28:16, Paul discusses "God's building," as well as the importance of a good foundation, which is Jesus Christ. The word for "master builder" is αρχιτεκτων ("architekton"), which comes from "arche," meaning "beginning" or "origin," and "tekton," or "carpenter." Tekton, the word used to describe Joseph and Jesus as "carpenters" (Mt. 13:55; Mk. 6:3), also means "builder," "any craftsman, or workman," a poet, songwriter, author and "planner, contriver, plotter." Interestingly, in modern Greek the word for "carpenter" is "marangos," not tekton. In fact, "tekton" in modern Greek means *freemason*, while the word for "stonemason"

is κτιστης ("ktistes").²¹³ "Freemasonry" in modern Greek is τεκτωνισμος or "tektonism." Hence, the term tekton, used to describe Jesus, was passed along over the centuries as a reference to a member of a *Masonic brotherhood*, rather than a carpenter or a simple stone-cutting workman.

As can be seen, there is scriptural reason to associate Jesus with Masonry. In addition to the examples already provided, at Hebrews 11:10 the author states, "For he looked forward to the city which has foundations, whose builder and maker is God." The original Greek word for "builder" is τεχνιτης ("tekhnites" or "technites") which means "builder," "artificer" or "craftsmen," and which is also used at Acts 19:24 and 19:38, as well as Revelation 18:22. In Hebrews, "technites" refers to a *masonic* craftsman, as opposed to a carpenter or smith. The word in this scripture for "maker" is *demiourgos*, i.e., demiurge, defined by Strong's as "the author of any work, an artisan, framer, builder," signifying carpenter and *mason*. Moreover, it has been asserted that Revelation 2:17 is a Masonic initiation, with its discussion of "hidden manna" and a "white stone" with a "new name" on it, known only to an initiate.

The contention that Jesus himself is a "master builder" is logical, considering that both God—styled by John Damascene among others to be the "Master-Craftsman—and Paul were also deemed as such, and that Jesus is called the "capstone" of an obviously Masonic organization. Following in the tradition of making "Jesus Christ" all things to all people, the Masonic authors of *The Hiram Key* attempt to make him a Freemason, reflected in the chapter entitled, "Jesus Christ: Man, God, Myth or Freemason?" However, these writers are not the first to suggest that Jesus Christ was the *"Mason* of God" or that Christianity is Masonic.

In *The Devil's Pulpit*, a series of lectures for which he was imprisoned on "blasphemy" charges in 1827, English minister Robert Taylor endeavored to "prove Free Masonry to be the combined result of the Egyptian, Jewish, and Christian superstitions, and absolutely identical with the celebrated Eleusinian Mysteries of Greece, the Dionysian Mysteries, or orgies of Bacchus and the Christian Mysteries of the Sacrament of the Body and Blood of Christ..."²¹⁴ Taylor further stated that "the terms *Christians, Jews, Israelites* and *Hebrews* are not names of communities that ever existed in a national or political character, but are designations of the different degrees, or grades of initiation in the mysteries of masonry."²¹⁵ In other words, these terms were titles given to initiates, with the canonical Epistle to the Hebrews representing instructions to the higher initiates into

the mysteries. It is evident that the epistle is not written for a national group but for a mystical sect and religious fraternity. Taylor also asserted that only by one's initiation into a particular "Masonic" mystery sect could one be involved in building temples and theaters within that religion. In other words, only those knowledgeable in the Dionysian mysteries could be involved in building Dionysian religious sites, etc. Hence, again, Masonry and religion have been intertwined for a long time.

Like the Gnostic-Christian demiurge, a number of other gods have been "master craftsmen" of some sort or another, such as Agni, the Vedic fire and sun god, and Agni's father, Tvashtar, who was a "modeler," "divine artist," "carpenter," etc. The god as a "master builder" or stonemason is a pre-Christian motif, as demonstrated by the concept of "God," whether as Ptah, Osiris or other, as the "Grand Architect of the Universe." Verifying this association, in his diatribe *Against the Heathen Gods* Christian writer Commodianus (fl. c. 240) remarks:

> Ye make Neptune a god descended from Saturn; and he wields a trident that he may spear the fishes. It is plain by his being thus provided that he is a sea-god. Did not he himself with Apollo raise up walls for the Trojans? How did that poor stone-mason become a god?[216]

Not only is Neptune, or Poseidon, a mason god, but Apollo, a sun god, is also a mason who helped build the walls of Troy, confirming the connection between the sun and masonry, long before the Christian era. Furthermore, as noted, in one of his lives the "sun of God" Buddha was a mason as well.

The solar origin and meaning behind Masonic myth and ritual were explained succinctly by Thomas Paine in his erudite essay, "Origin of Freemasonry," in which he stated that Christianity and Masonry "have one and the same common origin: Both are derived from the worship of the Sun." The term "Masonry" itself supposedly comes from a Greek word meaning "I am in the midst of heaven," a reference to the sun. In discussing the term "Tith-On," Bryant says that in Greek it means "μασος ηλιου": *the mount of the Sun.*[217] The word here for "mount" is "masos," which in the accusative would be "mason." As such, "mason" represents an ancient word, found in Greek and possessing a lithic meaning and solar association. The solar iconography and ritual of Masonry are elucidated in *Stellar Theology* by Robert Brown, Jr., who declared that "Masonic tradition" was "one of the numerous allegories" of the sun's yearly passage through the zodiac and its 12 constellations. This "system of astronomical symbols and emblems" was used to "teach the great truths about the

omnipotent God and immortality." Moreover, Masonry's "all-seeing eye is distinctly solar in its character."[218]

Further outlining a number of salient correspondences between Masonry and sun worship, Col. Olcott remarks: "The Sun, overwhelmed by the three autumn months, returns to life at the vernal equinox, and is exalted at the summer solstice. In this drama the candidate was required to represent the Sun, and a solar significance characterizes the whole ritual."[219] In addition, the orientation of the Masonic lodges is based on the sun's positions, aligned east and west, as is typical for sacred structures such as temples and churches. A number of Masonic terms are astrotheological, such as E.A.M., M.M. and O.G.M.H.A., which signify the sun, and F.C.M., which represents the moon. The Masons also celebrate the solstices, or specifically June 24th and December 27th, dates with "purely astronomical significance." The two "St. John's Days" are pre-Christian and very important within Masonry, representing ancient sun worship.[220]

One of the "modern" Masonic "mantras"—the name of the Great Architect—is "Jahbulon" or "Jahbelon," which breaks down into Jah, Bel and On,[221] three ancient names of the God Sun. The "Excellent High Priest" of Masonic ritual explains that these words are the "Masonic god in Syriac, Chaldeic and Egyptian."[222] Ronayne states that the name for the Lord in Masonry, "GAOTU," an acronym for "Great Architect of the Universe," is "the old pagan title of Baal or the sun god."[223] Interestingly, according to Bryant the word "Cabal" means the "place of Baal." Ronayne further relates that the Greater Mysteries in Freemasonry introduce to the initiate "the alleged conflict, death, burial, and raising of Hiram, constituting, as they do, the Egyptian legend of Osiris, or Baal, without even a single change."[224] He then says that Osiris and the "Tyrian architect" Hiram Abiff "are one and the same, not a mortal individual, but an immortal principle." Ronayne next comments, "Hence, then, we are driven to the inevitable conclusion that the Masonic system is a horrible mixture of paganism and Judaism..."[225]

"Masonry" by whatever name has been an essentially organized fraternity in numerous places for centuries to millennia, reflected in ancient stone buildings and archaic priestly rituals that go hand in hand. This assertion does not insist that a single fraternity has held the keys of power throughout history; on the contrary, various factions, more or less loosely connected, have vied fervently for the top spot. In modern times, Masonic organizations have had a tremendous impact on culture, particular in the Western world: "It is no secret that Masonry was a moving force behind the American Revolution

and the founding of the Republic of the United States of America."[226] American Founding Fathers who allegedly were Masons include: "George Washington...Benjamin Franklin, Ethan Allen, John Hancock, John Paul Jones, Paul Revere, Robert Livingston, and 35 other lesser known men who were signers of the Declaration of Independence and/or the Constitution." The contention that Thomas Jefferson was a Mason is questionable, since the historical record reports the extent of his "involvement" as limited to one visit to a Masonic lodge in South Carolina. In any case, at least 17 American presidents have been Masons, including Ford and Reagan.[227]

Since Masonry played such an important role in an event as momentous as the founding and governing of the USA, as well as numerous other nations and/or governments, it is not difficult to believe that it also was instrumental in the creation of various religions. This contention is especially true since it is *masons* and their benefactors who build the temples, synagogues, churches and cathedrals. It is thus apparent that masons have seen themselves as builders of religions. As David Gallop shows in *In God's Name*, Masonic organizations continue to create mayhem upon this planet, specifically in the name of the *Catholic religion*. Magistrate and Mason Godfrey Higgins declared that the Pope, "who holds many secret things," is the "Grand Master of the Masons," the "Grand Master-Mason of the world."[228] Naturally, in its play for global domination the Church has placed itself in competition with "Masonry," or, rather, various factions of it. As Massey states, the "war of the Papacy against Masonry" has occurred because the latter is the heir to the pre-Christian mysteries, which prove that Christianity is unoriginal.[229] Masonic rituals are also carried out within the higher levels of the religion of Mormonism; yet, few acknowledge this fact or criticize the Mormon hierarchy for its Masonic origins, similar to those of the Jehovah's Witnesses. The denial of these facts concerning Masonry and its role in world events and institutions, including and especially religion, may occur out of obstinacy, naivete or ignorance, or the denier may be part of the fraternity, bound by oaths of secrecy. Many germane facts concerning Masonry are not widely known because of the various blood oaths taken by Masons, including one in which the penalty is "having my skull smote off and my brains exposed to the scorching rays of the noonday sun..."[230]

Knowing that there were countless fraternities and secret societies "up and down the Roman Empire," a number of which represented craft guilds or cults such as that of the smith and carpenter, it is illogical and irresponsible to insist that there were

no such organized *masonic* religious orders, particularly in view of how important were stone-working and stone edifices to secular and religious leaders alike, between whom the distinction has often been slight to non-existent. The rulers of the ages were well aware of the significance of stone in producing "immortality," i.e., impregnability and indestructibility, so they have desired their monuments, buildings, temples, treasuries, fortifications and tombs be made out of it. Included in the grand buildings of most parts of the world—*especially* the religious edifices—are numerous astrological motifs and symbols. It is a *fact* that religion, astrology and masonry are intertwined. In the end, Masonry as a politico-religious brotherhood goes back much further than is maintained and has been very active in the creation of many cultures and religions, including Christianity and its savior, Jesus Christ, Mason of God.

Brotherhood Mythmaking

Although the seed was planted decades or centuries earlier, Christianity did not begin to grow until after the destruction in 135 CE of the Jewish state. It was at that point that large numbers of Hebrew, Israelite, Jewish and Samaritan refugees dove into the various mystery schools in the towns to which they had fled. Many Jews and Israelites had previously occupied these areas and involved themselves in the "Pagan" mystery schools, so there was precedent and opportunity for entrance. In creating the Christ myth, brotherhood members drew upon the tremendous reserves of the libraries at Alexandria and elsewhere, including in their writings both Jewish and Pagan sayings, myths and rituals. The creators of Christianity took an ancient, archetypical sun god and healing savior and turned him into a "real person," placing him fallaciously into history, in order to usurp the reigning deities.

Countless individuals over the centuries—clergy, scholars and lay people alike—have demonstrated that virtually everything of the Christian religion existed well in advance of the Christian era, around the world. How, then, can we not suppose that there has been a widespread conspiracy to keep this astoundingly significant information suppressed and away from the masses, conveniently overlooked in schools, textbooks and sermons? How is it that scholars of various disciplines and eras have not cried foul loudly enough at this deception and disservice to pre-Christian cultures, which have been depicted in the meanest and most beggarly manner over the centuries? Those who *have* spoken up have faced tremendous persecution, which, if many had their way, would continue in full to this day. Unfortunately, those who make their livelihoods from religious delusion and

fraud, including priests and politicians, have been more powerful than those who have seen through the hoax and conspiracy. This conspiratorial mechanism is the only way to explain how facts known by numerous people from the beginning of the Christian era, roughly 19 centuries ago, ranging from Christian authorities, heretical and orthodox alike, to secret society members, including Leonardo da Vinci and Thomas Paine, as well as many lesser known but brilliant scholars of the last couple of centuries, have been kept out of sight and hidden far away from daylight.

[1] Dupuis, 269.
[2] Rylands, 254.
[3] Volney, ch. XXIII.
[4] Goguel, 15n.
[5] Bell, I, 281.
[6] Volney, ch. XXII.VI.
[7] Jones, *AR*, 3, 297.
[8] Spence, *AEML*, 57.
[9] Maurice, I, 111.
[10] Maurice, I, 119.
[11] Massey, *GML*, 204.
[12] Frazer, 811.
[13] Churchward, A., 110.
[14] Frazer, 808.
[15] Temple, 32.
[16] Halliday, 240-241.
[17] Halliday, 242.
[18] Halliday, 244-245.
[19] Rylands, 195.
[20] James, 198.
[21] www.newadvent.org/fathers/07011.htm
[22] Tierney, 13.
[23] Herodotus, 99.
[24] www.ccel.org/fathers2/NPNF1-02/npnf1-02-12.htm
[25] www.newadvent.org/fathers/0208.htm
[26] Halliday, 217.
[27] Volney, ch. XXII.VI.
[28] Spence, *AEML*, 99.
[29] Spence, *AEML*, 121, 122.
[30] Iamblichos, 243.
[31] Wallace-Murphy and Hopkins, 150.
[32] Halliday, 247fn.
[33] Spence, *AEML*, 176.
[34] McLean, 107.
[35] Villanueva, 300-301.
[36] Bunsen, 73.
[37] Herodotus, 105.
[38] McLean, 107.
[39] Spence, *AEML*, 144.

40 Spence, *AEML*, 147.
41 Spence, *AEML*, 122.
42 Spence, *AEML*, 93.
43 Budge, *EBD*, 144.
44 Budge, *EBD*, 15.
45 Wallace-Murphy and Hopkins, 181.
46 Wallace-Murphy and Hopkins, 191.
47 Wallace-Murphy and Hopkins, 194.
48 Villanueva/O'Brien, 295.
49 Graves, R., 239.
50 Bell, I, 205.
51 Drews, *WHJ*, 225.
52 Robertson, *CM*, 298.
53 Temple, 66, 167.
54 Eisenman, 836.
55 www.newadvent.org/fathers/050105.htm
56 Wilford, *AR*, V, 297, et seq.
57 Legge, I, 38.
58 James, 133.
59 Churchward, A., 174.
60 Spence, *AEML*, 58.
61 Spence, *AEML*, 59.
62 O'Brien, 349.
63 www.cosmopolis.com/texts/porphyry-on-images.html
64 Graves, R., 249.
65 Bell, I, 282.
66 Cox, II, 127.
67 Graves, R., 157.
68 Walker, *WDSSO*, 11, 16.
69 Drews, *WHJ*, 217.
70 Legge, II, 37.
71 Spence, *AEML*, 258-259.
72 Spence, *AEML*, 261.
73 www.ccel.org/fathers2/NPNF1-02/npnf1-02-12.htm
74 Halliday, 107.
75 Cassels, 799.
76 Bunsen, 6.
77 Bunsen, 7.
78 Bunsen, 253.
79 Villanueva, 268-269.
80 Hunt, 41, 42.
81 Drews, *CM*, 134fn.
82 *MBB*, 224.
83 Rylands, 205.
84 www.billwilliams.org/Scrolls/scrolls.html
85 Wise, et al., 125.
86 Wise, et al., 137.
87 Wise, et al., 243.
88 www.atheists.org/church/jesuslife.html

89 www.newadvent.org/cathen/10662a.htm

90 www.blueletterbible.org/

91 Halliday, 4, 144.

92 www.newadvent.org/cathen/11388a.htm

93 Iamblichos, 81-82.

94 Dupuis, 425.

95 Freke and Gandy, 85.

96 Halliday, 6.

97 www.newadvent.org/fathers/02105.htm

98 www.ccel.org/fathers2/ANF-04/anf04-47.htm#P6761_1418989

99 Baigent, et al., 59.

100 Webster's Dictionary, "Cathar."

101 www.newadvent.org/fathers/101506.htm

102 www.newadvent.org/fathers/0717.htm

103 www.newadvent.org/fathers/3405.htm

104 Cassels, 539.

105 Lundy, 55.

106 Churchward, A., 391-2.

107 *CMU*, 150.

108 Dupuis, 252.

109 Lundy, 26.

110 *CMU*, viii.

111 *CMU*, 153fn.

112 Taylor, *TD*, 168.

113 Massey, *GML*, 54.

114 Halliday, 21.

115 Halliday, 58.

116 Bryant, I, 209-210.

117 Bryant, I, 42.

118 Iamblichos, 235.

119 Bonwick, *IDOIR*, 128.

120 O'Brien, 44.

121 Bonwick, *IDOIR*, 1.

122 Bell, I, 265.

123 Villanueva, 250-251.

124 Bonwick, *IDOIR*, 14.

125 Villanueva, 253fn.

126 Stewart, 41.

127 Bell, I, 267.

128 Bonwick, *IDOIR*, 285.

129 Bell, I, 266.

130 Graves, R., 143.

131 Bonwick, *IDOIR*, 123.

132 Bonwick, *IDOIR*, 126.

133 Wallace-Murphy and Hopkins, 43.

134 Bonwick, *IDOIR*, 36.

135 Wallace-Murphy and Hopkins, 88.

136 Bonwick, *IDOIR*, 121.

137 Bonwick, *IDOIR*, 129.

138 Churchward, A., 193.
139 Churchward, A., 195.
140 Bonwick, *IDOIR*, 4.
141 Bonwick, *IDOIR*, 8.
142 Bonwick, *IDOIR*, 33.
143 Bonwick, *IDOIR*, 35.
144 Bonwick, *IDOIR*, 128.
145 *vide* Desborough.
146 Bonwick, *IDOIR*, 25.
147 Picknett and Prince, 327.
148 Picknett and Prince, 325.
149 Picknett and Prince, 325.
150 Villanueva, 111fn.
151 www.newadvent.org/cathen/10705a.htm
152 www.newadvent.org/cathen/10705a.htm
153 Goguel, 68.
154 www.newadvent.org/cathen/10705a.htm
155 Spence, *THA*, 27.
156 www.newadvent.org/cathen/10705a.htm
157 www.newadvent.org/cathen/06592a.htm
158 www.newadvent.org/cathen/11302c.htm
159 Schonfield, 234-235.
160 Picknett and Prince, 332.
161 Schonfield, 236.
162 Picknett and Prince, 330.
163 Schonfield, 240.
164 Schonfield, 283.
165 Daraul, 86.
166 Drews, *WHJ*, 226.
167 Bunsen, 131.
168 Bunsen, 243.
169 Bunsen, 185.
170 Bunsen, 298.
171 Rylands, 120.
172 Drews, *WHJ*, 218.
173 Rylands, 162.
174 *CMU*, 153.
175 Graves, R., 149.
176 Schonfield, 283.
177 Eusebius, 51.
178 Ellegard, 26.
179 Reber, 43.
180 Stewart, 119.
181 Spence, *AEML*, 151.
182 www.newadvent.org/cathen/09771a.htm
183 Short, 71.
184 Knight and Lomas, *SM*, 24.
185 Temple, 74.
186 Knight, S., 15-16.

187 Knight and Lomas, *HK*, 100.
188 Hislop, 43.
189 Churchward, A., 117.
190 Bonwick, *EBMT*, 198.
191 Tucker, 78.
192 Tucker, 135.
193 Wallace-Murphy and Hopkins, 113-114.
194 Eisenman, *JBJ*, 406.
195 Schonfield, 238.
196 www.biblicalheritage.org/Archaeology/factory.htm
197 Eisenman and Wise, 142.
198 Wise, et al., 55.
199 Knight and Lomas, *HK*, 202.
200 Wise, et al., 123.
201 Eisenman, 476.
202 Wallace-Murphy and Hopkins, 102.
203 Picknett and Prince, 110.
204 Legge, II, 263-264.
205 Robertson, *PC*, 130.
206 Halliday, 304.
207 O'Brien, 354.
208 www.newadvent.org/cathen/10402a.htm
209 Higgins, II, 111.
210 www.blueletterbible.org/
211 Knight and Lomas, *HK*, 41.
212 Massey, *GML*, 33.
213 *Collins Contemporary Greek Dictionary*, 168, 311; *Oxford Dictionary of Modern Greek*, 189.
214 Taylor, *DP*, 245.
215 Taylor, *DP*, 253.
216 www.ccel.org/fathers2/ANF-04/anf04-38.htm
217 Bryant, I, 418.
218 Olcott, 305-306.
219 Olcott, 304-305.
220 Knight and Lomas, *SM*, 67
221 Ronayne, 272.
222 Ronayne, 282.
223 Ronayne, 101.
224 Ronayne, 125.
225 Ronayne, 125.
226 Knight and Lomas, *HK*, 354.
227 Knight, S., 34.
228 Higgins, I, 823fn.
229 Massey, *GML*, 58.
230 Ronayne, 221.

Dionysian initiation of a man.
(Kerenyi)

SYMBOLS.

The above symbol is an abbreviation of the Greek name for Jesus (IHSOUS). The New Testament was written throughout in Greek capital letters, and it was the custom to abbreviate familiar words. When the name Jesus occurred, it was abbreviated, and the scribes used only the first two and last letters. The Greek custom of contraction is to put in first and last letters and indicate omissions by a line over

the word—So IHsouS by omitting "sou" became I H S. It was easy to draw a line down through this bar and so

we get and so finally

Ancient "abbreviation of the Greek
name for Jesus." (Ward)

Conclusion

One universal mythos, or fable wearing the garb of history, has been the basis of all religions, ancient and modern. This mythos is rooted in, and has secret allusions to, the zodiac and the solar system, in which the sun and the rest of the "Host of Heaven," were turned into imaginary personages, under peculiar nomenclatures in each country; and fanciful narratives concerning them were invented by the astronomizing priest, in order to stultify and subject the minds of the ignorant populace. This deception continues to the present day, *for the solar mythos was the true Christianity.* "When the French, under Napoleon, possessed Italy, they examined the chair of St. Peter, *and found upon it the signs of the zodiac.*"

Christian Mythology Unveiled

The parallels between the myths of our traditions and those of vastly different cultures offer parallel myths of the Fall, virgin births, resurrections, and so on—often strikingly similar to our own cherished sacred stories. This may lead one to wonder whether our tradition is merely one of many valid choices on a cosmic menu of the transcendent.

J.F. Bierlein, *Parallel Myths*

By inspecting the origins of religion, which influences billions around the globe, we can recognize that, although portrayed otherwise, a multiplicity of cultures have much in common with each other. The majority of religions possess at their nucleus not a god, messiah, prophet or other anthropomorphic concept but one genderless, raceless and formless source viewed by the ancient religion-builders as a "divine science." This science or knowledge began to be formulated many thousands of years ago, largely based on human perception of the environment, the sun, moon, stars, planets and nature in general. In creating a view of the cosmos in this manner, mankind added qualities of his own and designed a mystical, mythical and colorful pantheon of deities and demons to populate his world and worlds unseen. So numerous are these religious, spiritual, metaphysical and mystical concepts developed over the millennia of observation and practice of ritual and rite that it would be difficult to produce anything new. As the saying goes, there is nothing new under the sun, and when various important ideologies are examined, they resolve themselves into an initial and profound awe of creation, the world, the cosmos and whoever may be responsible for all of it. The investigation of religion and mythology reveals that, while on the surface human religions and creeds appear to be disparate and divisive, the majority of them have the same roots in nature and astral worship. In actuality, most of the world's religions have

been stellar, lunar, soli-lunar and solar, reflecting astrotheology, or the worship of the heavens and planetary bodies.

Instead of understanding the commonalities underlying it, the proponents of religion have underscored its shallow rigidity and meanness, causing division and grief worldwide, even as they maintain some semblance of civilization. Beneath the surface of the reasonable is too often the fanatic, ready with viperous mouth or vicious weapon to do away with anyone who criticizes the precious faith, which in reality may merely be a creed of derangement, hatred and murderous intent. Stupendous destruction and wanton slaughter have been generated in the name of religion, of this god or that, the most dominant of whom resemble each other in their cruelty and brutality. Man's "holy texts" are filled with horrible tales of torture and butchery, frequently done by the "chosen," "saved" or some other such designation attached to those who blindly believe in inferior and rude ideologies. Human sacrifice in the name of any number of gods and their religions has been so awfully common that huge swaths of earth worldwide are "killing fields," beginning in ancient times and continuing into the present.

In this religiously slavish conditioning, we are told that we must mindlessly follow so-called sacred scriptures, such as the "Good Book," while such writings are often nothing of the kind, filled with countless examples of the most vile and despicable behavior. As CMU remarks:

> As sanctioning precedents for the commission of almost every crime may be conveniently found in the Jew books, in like manner they hold forth examples of the coarsest obscenities, though false translation has hidden many of them. Where shall we find vices so lewd and unnatural as those which were practised, and seem to have been of ordinary occurrence, amongst the chosen people? Would the law relating to asses and he-goats have been made if the unnatural crime which it was intended to prevent had not been in practice? See in Judges, c. 19th, the infamous doings of the men of Gibeah and Benjamin, the descendants of the chosen son of Jacob. Would any man of ordinary decency read to the females of his household passages so outrageously—nay, so matchlessly obscene, as those we frequently meet with in the Bible? For instance, the 4th c., v. 12th of Ezekiel, and nearly the whole of the chapters 19th and 23rd of the same book. See also Hosea, c. 1, verses 2 and 3, and c. 3rd to the end. The Song of Solomon is evidently the lascivious effusion of some devoted debauchee; yet such is the transcendent impudence of our priests, that these superlatively lecherous imaginings have been, by *forged headings*, called "Christ's love to the church." The instances above cited are trivial when

compared with the number which might be adduced of obscenities altogether unequalled in any other book...

In addition, exalted and revered religious figures, fraudulently depicted as historical characters and prophets of the one true God, turn out to be mass-murdering criminals:

...That a person so profligate, wicked, and cruel, as the whole life of David shows him to have been, should acquire the...title ["a man after God's own heart "], has no doubt astonished many people; but the exposition shows clearly *that the priests bestowed it upon him, for his pre-eminence in the commission of every great crime that promoted their interest and power.* Many others of these "worthies" appear to have been the peculiar favourites of Jehovah, from possessing similar qualities (saints in subsequent times were always made out of the same sort of material), whilst the good and virtuous few he was generally at enmity. This appears in contrasting the bloody and revengeful character of the priest Samuel, with that of the plain, honest and brave soldier, Saul; that of the cunning and deceitful Jacob, with his generous and amiable brother, Esau. Amongst the numerous atrocious murders of David, do we not find that of Mephiboseth, the lame son, or brother of his peculiar friend and generous protector, Jonathan? The wholesale murders ordered by Moses, Joshua, David, and some others, are, if true, the most horrid imaginable. Blood was the order of the day among the Jews, so it flowed on all occasions. Exod. 13:2 shows that by their laws the first-born children were dedicated as sacrifices to the Jewish Moloch, as well as the first-born of other animals; but it is probable that the horror which this shocking barbarity excited in surrounding countries, at last induced the priests to accept of a lamb, or other victim that was equally good to eat, in redemption of the devoted child... That the Jews offered such human sacrifices is proved in Solomon's having built a temple to Moloch, which he would not have done with the intention of observing any other rites than those of the Ammonitish god. The Jew books have also furnished Christianity with examples of private assassination, which are nowhere else matched in cool atrocity: to give two instances only, see the base cowardly treachery by which those of Sisera, and of Eglon, king of Moab, were perpetrated.[1]

A common rite among not only "Pagans" but also the Israelites, the bizarre and grisly ritual of human sacrifice is overtly at the foundation of one of the world's major religions, Christianity, which has been demonstrated to be little more than a rehash of the numerous systems that preceded it.

As they are currently proselytized, devoid of the mythological knowledge underlying them, the various popular religions are difficult to respect or take seriously, as many of their core tenets assault the credulity and insult the intelligence. For example, the

God of the cosmos is portrayed as all-powerful yet so incompetent and bizarre that, in order to fix a creature he made badly in the first place, he must take birth as his own son and be executed on a cross! This fable is weird and nonsensical; yet, as the priestly wag said, "Give me a child before the age of seven, and he's mine for life." Thus, grown adults, whose minds have been finely honed in science, art, literature and other fields, nevertheless babble like insensate robots when it comes to religion. The "religious" part of the brain is attacked early on and endlessly conditioned to the point where critical thinking is turned off and zombieism rules. The same scriptures are parroted over and over again, the same objections to criticism, the same citations of "proofs"—endlessly repeated until the mind shuts down, and, with blank, staring eyes, the victim of the brainwashing succumbs.

One must also ask what good have these belief systems begotten, after all these thousands of years, with the last two millennia, it is claimed by adherents, supposed to usher in the end of sin, as brought to us by the latest of the great godmen? If Jesus died for our sins, why has there been unending horror and sinfulness on the planet since then, much of it committed by the most pious Christians themselves?

In the early days of Christianity, its advocates procured enough power to impress their interests upon a variety of people, finding little resistance in the religion-tolerant Roman Empire. After much grousing about "persecution," fanatic Christian proponents *became* the persecutors themselves and went on a rampage, destroying culture and life worldwide. This atrocious behavior had been committed by thousands of sects, cults and religions, long before the Christian era; nevertheless, during the past nearly two thousand years Christianity has held the top position in regard to murder and mayhem. The religion of the "Prince of Peace" has been one of the first *global* propaganda and war machines in history. Says Dr. Inman: "From the moment that Christianity became a political power, its history resembled that of any tyrant or other ruler, and it is filled with misrepresentations, lying, fraud, the records of fighting and slaughter, of brutal passions, frightful laws, and horrible punishments... In fact, the more loud the proclamation of a pure Christianity, the more devilish is the practice of its heralds."[2] Such voices as Inman's who have abhorred and objected to this turn of history have been silenced countless times over the centuries; others have "sailed around" this perilous subject, "as if charting the coastline of a forbidden island."[3]

Summarizing the history of Christianity, CMU remarks:

To the shame of the credulous and priest-degraded mankind, the present superstition of Europe hath been established, as it were, in defiance of the light of Nature, reason, common sense, and all experience; and what is still more strange and revolting, by those very means and agencies which men ought to hold most in contempt and detestation; viz., fraud, forgery, pretended miracles and prophecies, hypocrisy, avarice, tyranny, cruelty, massacres, and wars which have deluged the earth with blood, and sacrificed hundreds of millions of human beings to its frenzied demon.[4]

Contrary to popular belief, Christianity was not created in an atmosphere of love and peace; rather, it was formed at the ends of swords pointed at members of the clergy and laity alike. Bloody battles were fought over doctrine at every turn, each tiny and ultimately meaningless detail wrestled over tooth and nail. Bishops and their hooligans appeared at synods and slaughtered those who disagreed with them, a shameful behavior that occurred in numerous places where Christianity spread. For example, the all-important Council of Nicea (326 CE), during which so much Christian dogma was established, was a congregation of lunatics who, Episcopius says, "were led on by fury, faction, and madness."[5]

The list of religious atrocities committed in the sacrosanct name of Christ is long and varied:

In proof of this, witness the gibbets, the wheels, the massacres, and the horrible burnings at the stake of nearly a hundred thousand human beings in a single province—the massacres and devastations of nine mad crusades of Christians against unoffending Turks, during nearly two hundred years; in which many millions of human beings perished—the massacre of the Anabaptists—the massacres of the Lutherans and Papists, from the Rhine to the extremities of the north—the massacres in Ireland, England, and Scotland, in the time of Charles the First, who was himself massacred—the massacres ordered by Henry the Eighth and his daughter Mary—the massacres of St. Bartholomew in France; and forty years more of other massacres between the time of Francis the First, and the entry of Henry the Fourth into Paris—the massacres of the Inquisition, which are more execrable still, as being judicially committed—to say nothing of the innumerable schisms, and twenty wars of popes against popes—bishops against bishops—the poisoning assassinations—the cruel rapines of more than a dozen of popes, who far exceeded a Nero or Caligula in every species of crime and wickedness—the massacre of twelve millions of the inhabitants of the new world, executed CRUCIFIX IN HAND; and all for the honour and glory of the Jewish deity and his son!! This is

without reckoning all the massacres committed in the same names, precedently to any of the above.[6]

Not only did this new superstition cost millions of lives but it also sucked the hard-earned property from those same individuals, as well as from those who managed to survive its invasion. From the early Christian era "till about the close of the sixteenth century, when the science of Nature began to check the mischievous demon of theology...millions upon millions of men, women, and children were tortured and murdered in religious persecutions and wars; whilst a sum not less than £400,000,000,000 in money, besides other property, was wrung from the laboring man, not to instruct him in a particle of useful knowledge, but to keep him in a state of abject ignorance which alone fits him for slavery."[7]

Despite its boasts and claims, Christianity is not unique, as practically all of its dogma, tenets, beliefs, myths and fables can be found in the numerous cultures that preceded it in a wide area of the world. Christian apologist Sir Weigall recaps the absorption of Paganism by Christianity, while clinging to the religion of his youth and naivete:

> From Pagan mythology Christianity had unconsciously taken over many a wonderful story and had incorporated it into the life of Jesus: from Mithraism the tale of the birth in the cave and the adoration of the shepherds; from Adonis-worship the tale of the Star in the East; from Dionysos-worship the tale of the turning water into wine; and so forth....

> Meanwhile many of the old heathen gods had been taken into the Church as saints. Castor and Pollux became St. Cosmo and St. Damien; Dionysos, many of whose attributes were attached to St. John the Baptist, still holds his place as St. Denis of Paris; Diana Illythia is now St. Yllis of Dôle; the Dia Victore is worshipped in the Basses Alpes as St. Victoire; and so forth. All over Christendom, pagan sacred places were perpetuated by the erection of Christian chapels or churches on the same sites; and there are hundreds of shrines dedicated to the Madonna on ground once sacred to nymphs or goddesses, while the holy wells or springs of heathendom are now the holy wells of the Church. The statutes of Jupiter and Apollo became those of St. Peter and St. Paul; and the figures of Isis were turned into those of the Virgin Mary...

> ... Christianity is very largely a pagan faith; yet behind its pomp and vanities, beneath its preposterous complexities, there is still to be found the Jesus of history, and in His teaching and example is the world's salvation. If only we can get back to Him....[8]

Having virtually every aspect of the Christian fable peeled away as Pagan mythology, the apologist is desperate to find any strings to grasp for dear life as he hangs over the precipice of truth. The arguments against Christ as a myth by modern apologists are not original but the same as the rants of the early Church fathers, which have been dealt with repeatedly for centuries. In every age are found individuals who ridicule and otherwise "counter" with sophistry and circular argumentation common-sense assertions by astute writers firmly pointing to the emperor's transparent nakedness. Such fanatics waste much time and energy on a fruitless and megalomaniacal endeavor to play spokesperson for the Almighty, pointlessly attempting to prove the unprovable and undesirable. Were Jesus Christ a "real," "historical" entity, he surely would not need the likes of the modern apologist to defend him. And if he did, he could not possibly be considered the great, omnipotent, omniscient, omnipresent being he is pretended to be.

In the final analysis, Christ is as mythical as his predecessors, who were believed by countless millions to be "real people" but who are deemed fictional by today's mainstream scholarship. That the "life of Jesus" is a virtual smorgasbord of qualities assigned to these numerous mythical gods, godmen and heroes is evidence of his fictional nature as well. Along with the unoriginally of its professed founder comes the commonness of its tenets, as Christianity is little different from other popular creeds. Regarding the similarities between religions, Dr. Inman comments:

> Within certain limits, we may...say, that the Brahminic, the Jewish, the Buddhist, and the Christian religions are essentially alike, differing only upon minor points, such as the absolute value of morality, of ceremonial, of doctrine, of asceticism, the nature of a hypothetical antecedent, and an equally uncertain future existence, and the best means of escaping the penalties attached, in the second state, to impropriety of conduct in the first. If we deride the Brahmin and the Buddhist for the faith which they entertain, our laugh must necessarily recoil on ourselves, for we have no more unequivocal grounds for our belief than they have for theirs. We point in vain to what we call "Revelation," for they can do the same, and if priority in such matters is good for anything, the Brahminic must take precedence of the Jewish, and the Buddhist of the Christian code. Nor can we call miracles to our exclusive aid, for the religious books of the Hindoos are as full of them, as are those of the Jew and Christian, and the stories told in the one can be readily paralleled in impossibility, incapacity, frivolity, and absurdity by the others.[9]

Many of the resemblances between cultures "are so striking as to suggest that at an early date in the world's history there was some means of communication between, or link that joined, the eastern and western continents."[10] Indeed, in several cases the detailed evidence startlingly points to a common cultural heritage, so much so that an intense and voluminous study is required to determine its origin, if a single one there be. This "central country," as it were, has been located all over the world, in places now both inaccessible and commonly visited. While a tremendous effort has been extended in locating one source of human culture, and while much of it has been meaningful, the truth regarding human origins remains elusive.

One of the major reasons for the pervasive cultural commonality is that religious and mythological systems have been astrotheological, especially revealed in the reverence and worship of the most visible orb, the sun, deemed as the savior and life-giver, the proxy or representative of the Divine, as well as the Deity itself. At last, it matters not what rancid reasoning apologists proffer, as the one, true, universal Lord and Savior has been and will continue to be the Sun, by whatever name, whether Apollo, Odin, Osiris, Krishna, Buddha or Christ.

Instead of emphasizing cultural commonality and leading the world into peace and prosperity, the priesthoods have focused on differences and division, soliciting their flocks with promises of superiority over other systems. In many religions, it is the duty of the priests not to educate but to mystify, and such priestcraft has been perfected over a period of millennia, with the element of terror strongly emphasized to keep the sheep in line. As CMU comments:

> By such chimerical apparatus, the priest can reduce the mental faculties of man almost to annihilation; and hence it is that the great herd of human beings have hitherto been mere congregated masses of variously compounded folly, knavery, and credulity; where ignorance is prized and cherished as the sole medium through which clerical and secular oppressors can ride over the necks of the multitude; while the spider's web of superstition confines their intellects as it were within the bounds of a nut-shell. In this way are whole nations of human beings educated under traditional and legendary lies and fables; yet so firmly does the false impressions instilled in childhood rivet them upon the mind, that myriads have died for them, as the highest service to their "God!"[11]

Religions also strike at the very heart of human nature, repressing sexuality in a manner that causes tremendous psychological, emotional and physical harm. "What is it that has poisoned love amongst the human species," CMU asks, "and

rendered the simple union of the sexes an unnatural bond of tyranny and slavery, which, in nine cases in every ten, entails life-lasting misery upon the victims of the indissoluble marriages of Christian superstition?"[12] This unnatural suppression has created priesthoods whose members must turn to each other: "We learn from 'Burnet's Exposition' that the practice of unnatural lusts had been so common among the dignitaries of the church that St. Bernard, in a sermon preached to the clergy of France, affirmed sodomy to be so common in his time, *that bishops with bishops lived in it.*"[13]

Fortunately, in many places today the torture related to religious conversion is no longer physical; yet it continues, in the form of psychological attacks, ad hominems, and the voodoo called "prayer," used by fanatics to "smite their enemies" or otherwise entrap their psyches in a morass of superstition and oppressive dogma. Popular imagery and films such as "The Passion of the Christ," which depicts Jesus's scourging and crucifixion in gory, gruesome detail, represent mass mind-control and psychological abuse.

The oppression within religion is neither Western nor Eastern but global, in cultures ancient and modern alike. Concerning such religious oppression, Dr. Inman remarks:

> Both in India and Italy, men, women, and children alike are, or were, taught to regard themselves as servants, and even slaves of the hierarchy, and their money is, or was, alienated from wives and children to swell the coffers of spiritual tyrants. Perpetual terrors of hell are sounded, until those hearers, whose hearts are impressionable, are habitually haunted by imaginary horrors, each one of which has to be bought off by a sort of hush-money paid to the priest, who has invented, adopted, or described them....
>
> So long as men are debased by their guides, and allow themselves, with the docility of a well-trained dog, to be ruled, and so long as tyrannical flamens [priests] can wring an ever increasing tax from the people, there is probably nothing more in the breast of each than a vague feeling of dislike, or regret, at the existence of such things, which rarely receives utterance for fear of punishment.[14]

To blindly believe in one or more religious doctrines is to remain ignorant and unrighteous, while to acquire the knowledge of what religion truly represents, good and bad, is to become wise and sensible.

Concerning the apprehension of the truth behind religion, Drews writes:

> When the actual prejudice against astral mythology disappears, when a closer knowledge of the starry heavens than we now have

places the student in a position to test these relations in detail, when it is generally recognised that astronomy and a knowledge of astrological language are at least as necessary for a correct understanding of the ancient east as philology is for critical theology, the time will have come for the last supports of the present purely historical conception of the gospels to break down, for the symbolical-mythical method to triumph completely over the present historical method, and for the "twilight of the gods" of critical thinking.[15]

We have entered a new era, based on the astronomical precession of the equinoxes as well as the Western dating method. In doing so, we must also move into a new age of perception. The only constant is change, and change we will and must, albeit many will go kicking and screaming into the night, delaying our collective entrance into the dawn of the new day. Such stubbornness and rigidity are unfortunate, as well as responsible for the atrocious state of the planet at present. As we have seen, the earth has been under the dominion for many centuries of a diversity of societies and brotherhoods—and the planet's condition reflects this fact, as the world increasingly resembles a trashed frat house.

In divesting ourselves of the old, genocidal gods and religions, we need not be afraid of divine retribution. When the ancients stopped believing in Hercules as a "real person" and recognized him as the mythical "*sun* of God," he did not strike back in fury and destroy them. In educating ourselves to the myths behind our most cherished religious concepts, we are not risking the wrath of an omniscient and omnipotent God. Instead, we are risking the wrath of the crazed masses who will insist on "feeling Jesus in their hearts," etc., rather than becoming educated. Scratch their imaginary friends, their gods, and they will turn into bullies and terrorists, slandering with the vilest of epithets and cursing with the darkest of wishes.

Furthermore, the typical religious constructs of "God" and the role of "his" worshippers reveal themselves as parochial, narrow and simpleminded in light of our knowledge of the enormity—if not infinitude—of the cosmos. There are billions of galaxies containing billions of solar systems, a vast number of which could maintain life of some sort. The puerile and naïve perception of the God of the cosmos coming to Earth, so fascinated by the submicroscopic life forms that earthlings represent in the cosmic scheme, is not only outdated but just plain wrong. We humans simply must stop fighting and bickering, sweating the small stuff and causing horror on a grand scale. We must transcend ourselves, our miniscule worldview and our stultifying ideologies called religion. In the end, man's religions are for the most part

meaningless, childish and grotesque distractions from living life in the here and now.

It is time for us human beings to recognize our *own* divinity and that of the rest of the cosmos, to understand our own glorious nature and that of all creation, in order to develop the ultimate respect for ourselves and love for life. We must find ourselves, know ourselves and love ourselves. The way to attain this state is through education and the production of health in the body, mind and spirit. This process should be started in childhood but it can be done at any point. Nevertheless, our precious children—our destiny and future—must be raised in a kind, loving environment that does not mutilate their bodies with heinous "rituals" or their minds with deleterious notions of the universe. These steps are needed for us to finally have peace within our souls and upon our planet.

1 *CMU*, 204-207.
2 Inman, *AFM*, 13.
3 Graves, R., 242.
4 *CMU*, 187fn.
5 *CMU*, 79.
6 *CMU*, 160-163.
7 *CMU*, 176-179.
8 Weigall, 204-208.
9 Inman, *AFM*, 87.
10 Olcott, 201-202.
11 *CMU*. 209-210.
12 *CMU*, 74.
13 *CMU*, 77fn.
14 Inman, *AFM*, 104.
15 Drews, 194.

Bibliography

"Ancient Factory Discovered Under Jerusalem,"
www.biblicalheritage.org/Archaeology/factory.htm

"Ancient India—Deities,"
www.crystalinks.com/indiadieties.html

"Budha," www.hindunet.org/god/planet_deities/budha/

"Christ-Krishna Connection,"
hinduism.about.com/library/weekly/aa122200a.htm

"Early Church Fathers," www.ccel.org/fathers2/

"Happy Birthday, Krishna!"
hinduism.about.com/religion/hinduism/library/weekly/a
a082000a.htm

"Iasion, the Pre-Homeric pagan Jesus,"
members.iinet.net.au/~quentinj/Christianity/iasion.html

"Indian calendar," webexhibits.org/calendars/calendar-
indian.html

"Indo-European Languages,"
www1.cord.edu/faculty/sprunger/e315/i-e.htm

"Jesus Outside the New Testament,"
www.mystae.com/restricted/reflections/messiah/sources.
html

"Konarak: Temple of the Sungod,"
www.vnn.org/editorials/ET9905/ET28-3969.html

"Makarasankranthi,"
www.webonautics.com/ethnicindia/festivals/makarasank
ranthi.html

"Oldest Astronomical Megalith Alignment Discovered In Egypt
By Science Team,"
www.sciencedaily.com/releases/1998/04/980403081524.
htm

"Origins of the Christmas Festival,"
www.skeptictank.org/xmaspage.htm

"Porphyry On Cult Images,"
www.cosmopolis.com/texts/porphyry-on-images.html

"Religion of Mankind," www.vedicbooks.com/magazine.htm

"Sources for Cult of St. Mercurius,"
www.ucc.ie/milmart/mercsrcs.html

"Temple of Recumbent Buddha,"
www.travelchinaguide.com/attraction/beijing/wofo.htm

"The Hamoukar Expedition," The University of Chicago
Oriental Institute,
www.oi.uchicago.edu/OI/PROJ/HAM/Hamoukar.html

"The Mathematical Impossibility of the Christian God,"
www.angelfire.com/band/kissed/stolen.html

"The Weaver's Place in History,"
 www.himalayanacademy.com/books/weaver/i_three.htm
"Varro on Pagan Religion," www.sentex.net/~tcc/fvarro.html
Aletheia, M.D., *The Rationalist's Manual* (1897),
 www.infidels.org/library/historical/m_d_aletheia/rationali
 sts_manual.html
Anonymous, *The Christian Mythology Unveiled*, Printed
 privately, 1842?
Arthur, James, *Mushrooms and Mankind*, Book Tree, CA,
 2000.
Bacchiocchi, Samuele, "Sun-Worship and the Origin of
 Sunday,"
 www2.andrews.edu/~samuele/books/sabbath_to_sunday
 /8.html
Baigent, Michael, Leigh, Richard and Lincoln, Henry, *Holy
 Blood, Holy Grail*, Dell, NY, 1983.
Baring, Anne and Cashford, Jules, *The Myth of the Goddess:
 Evolution of an Image*, Arkana/Penguin, London, 1993.
Bell, John, *Bell's New Pantheon* (1790), Garland Publishing,
 NY, 1979.
ben Yehoshua, Hayyim, *The Myth of the Historical Jesus*,
 www.jdstone.org/truth/files/j_myth.html,
 mama.indstate.edu/users/nizrael/jesusrefutation.html
Berry, Gerald, *Religions of the World*, Barnes & Noble, NY,
 1955.
Biblical Archaeology Review (5-6/00), www.bib-arg.org
Bierbower, Carroll, "Was Jesus Virgin Born?"
 www.geocities.com/Athens/Ithaca/3827/virginborn.html
Bierlein, J.F., *Parallel Myths*, Ballantine, NY, 1994.
Blavatsky, Helena, *Isis Unveiled*, Theosophical Society, CA,
 1988.
Blavatsky, Helena, *Secret Doctrine*, II, Theosophical Society,
 CA, 1988.
Blueletter Bible, www.blueletterbible.org
Bonwick, James, *Egyptian Belief and Modern Thought*,
 Falcon's Wing, CO, 1956.
Bonwick, James, *Irish Druids and Old Irish Religions* (1894),
 Ayer, NH, 1984.
Bradley, Michael and Lauriol, Joelle,
 www.michaelbradley.bigstep.com/articles/messiah.html
Brennan, Herbie, *The Secret History of Ancient Egypt*, Berkley,
 NY, 2000.
Bryant, Jacob, *A New System, or An Analysis of Ancient
 Mythology*, I (1774), Garland, NY/London, 1979.

Budge, E.A. Wallis, *Egyptian Tales and Legends: Pagan, Christian, Muslim*, Dover, 2002.

Budge, E.A. Wallis, *The Egyptian Book of the Dead*, Dover, NY, 1967.

Bunsen, Ernest de, *The Angel-Messiah of the Buddhists, Essenes and Christians*, Longmans, Green & Co., London, 1880.

Burstein, Stanley, *The Babyloniaca of Berossus*, Undena Publications, Malibu, California, 1980.

Campbell, Joseph, *Occidental Mythology*, Arkana/Penguin, NY, 1991.

Campbell, Joseph, *The Hero with a Thousand Faces*, Princeton University Press, NJ, 1973.

Capt, E. Raymond, *Missing Links Discovered in Assyrian Tablets*, Artisan, CA, 1985.

Carlson, Stephen, "Chronology of the Synoptic Problem," www.mindspring.com/~scarlson/synopt/chron.htm

Carpenter, Edward, *Pagan and Christian Creeds* (1921), Health Research, 1975.

Carrier, Richard, "Thallus: An Analysis (1999)," www.infidels.org/library/modern/richard_carrier/thallus.html

Case, Shirley Jackson, *The Historicity of Jesus* (1912), www.didjesusexist.com/case.html

Cassels, Walter Richard, *Supernatural Religion*, D.M. Bennett, 1879.

Catholic Encyclopedia, www.newadvent.org

Catholic First, www.catholicfirst.com

Charlesworth, James H., *Jesus Within Judaism*, Doubleday, 1988.

Choudhury, Paramesh, *The Aryan Hoax (That Dupes the Indians)*, Calcutta, 1995.

Christianism.com

Chronicon Paschale: 284-628 AD, trs. Michael and Mary Whitby, Liverpool University Press, Liverpool, 1989.

Churchward, Albert, *The Origin and Evolution of Freemasonry* (1921), The Book Tree, CA, 2000.

Churchward, Albert, *The Origin and Evolution of Religion* (1924), Kessinger, 1992.

Churchward, James, *The Sacred Symbols of Mu* (1933), Be Books, Albuquerque, 1995.

Collins Contemporary Greek Dictionary, Wm. Collins Sons & Co., Glasgow, 1978.

Cologne Digital Sanskrit Dictionary, www.uni-koeln.de/phil-fak/indologie/tamil/mwd_search.html

Cox, George W., *The Mythology of the Aryan Nations*, Longmans, Green & Co., London, 1870.

Cutner, Herbert, *Jesus: God, Man or Myth?* (1950), The Book Tree, CA, 2000.

Daraul, Arkon, *A History of Secret Societies*, Citadel, NY, 1990.

Davies, Stevan, "Mark's Use of the Gospel of Thomas," www.miseri.edu/users/davies/thomas/tomark1.htm

DeMeo, James, *Saharasia*, OBRL, OR, 1998.

Desborough, Brian, "Who Were the Israelites?" www.davidicke.net/emagazine/vol7/desbr.html

Doane, *Bible Myths and Their Parallels in Other Religions* (1882), Health Research, WA, 1985.

Doherty, Earl, "Josephus Unbound," pages.ca.inter.net/~oblio/supp10.htm

Doherty, Earl, "Review of *The Jesus the Jews Never Knew* by Frank Zindler," www.humanists.net/jesuspuzzle/BkrvZindler.htm

Doherty, Earl, *The Jesus Puzzle: Did Christianity begin with a mythical Christ?*, Canadian Humanist Publications, Ottawa, 1999.

Doresse, Jean, *The Secret Books of The Egyptian Gnostics*, Inner Traditions, VT, 1986.

Dravidian Encyclopedia, The International School of Dravidian Linguistics, Thiruvananthapuram, India, 1990.

Drews, Arthur, *The Christ Myth*, Prometheus, Amherst, NY, 1998.

Drews, Arthur, *Witnesses to the Historicity of Jesus*, tr. Joseph McCabe, Watts, London, 1912.

Dujardin, Edouard, *Ancient History of the God Jesus*, Watts, London, 1938.

Dupuis, Charles Francois, *The Origin of All Religious Worship*, Garland, New York/London, 1984.

Eisenman, Robert and Wise, Michael, *Dead Sea Scrolls Uncovered*, Penguin, NY, 1992.

Eisenman, Robert, *James, the Brother of Jesus*, Penguin, NY, 1997.

Ellegård, Alvar, *Jesus: One Hundred Years Before Christ*, The Overlook Press, NY, 1999.

Ellis, Peter, "Our Druid Cousins," hinduismtoday.com/archives/2000/2/2000-2-16.shtml.

Encyclopedia Britannica, www.britannica.com

Epiphanius, *Panarion*, esscnes.net/panarion.htm

Eusebius, *The History of the Church from Christ to Constantine*, tr. G.A. Williamson, Penguin Books, London, 1989.

Evans, Elizabeth, *The Christ Myth*, Book Tree, CA, 2000.

Every, George, *Christian Mythology*, Hamlyn, London, 1970.

Ficino, Marsilio, *De Sole (The Sun Book)*, users.globalnet.co.uk/~alfar2/ficino.htm

Finkelstein, Israel and Silberman, Neil, *The Bible Unearthed*, Simon & Schuster, NY 2001.

Frawley, David, "The Wisdom Tradition of the Ancient World," *The Quest*, Winter 1992.

Frazer, James George, *The Golden Bough*, Collier, NY, 1963.

Freke, Timothy and Gandy, Peter, *The Jesus Mysteries*, Three Rivers Press/Random House, NY, 1999.

Freud, Sigmund, *Moses and Monotheism*, Vintage, NY, 1939.

Friedman, Richard E., *Who Wrote the Bible?*, Harper, San Francisco, 1997.

Gadon, Elinor W., *The Once and Future Goddess*, Harper & Row, San Francisco, 1989.

Gauvin, Marshall, "Did Jesus Christ Really Live?" www.infidels.org/library/historical/marshall_gauvin/did_j esus_really_live.html

Giri, Swami Satyeswarananda, *Kriya: Finding the True Path*, Sanskrit Classics, San Diego, 1991.

Goguel, Maurice, *Jesus the Nazarene: Myth or History* (1926), didjesusexist.com/goguel/preface.html

Goodspeed, Edgar, *The Apocrypha*, Vintage Books, NY, 1989.

Graves, Kersey, *The World's Sixteen Crucified Saviors*, University Books, NY, 1971.

Graves, Robert, *The White Goddess*, Farrar, Straus and Giroux, NY, 1966.

Green, Sid, "Sons of Zadok," didjesusexist.com/zadok.html

Guignebert, Charles, *The Early History of Christianity*, Twayne, NY, 1927.

Gunkel, Hermann *The Legends of Genesis*, Schocken, NY, 1964.

Hackwood, Fredk. Wm., *Christ Lore: Being the Legends, Traditions, Myths, Symbols, Customs & Superstitions of the Christian Church*, London, 1902.

Halliday, W.R., *The Pagan Background of Early Christianity*, University of Liverpool, 1925.

Hancock, Graham and Faiia, Santha, *Heaven's Mirror: Quest for the Lost Civilization*, Three Rivers, NY, 1998.

Hancock, Graham, www.grahamhancock.com/underworld4.php

Hardy, R. Spence, *A Manual of Budhism*, Chowkhamba Sanskrit Series, India 1967.

Harwood, William, *Mythology's Last Gods: Yahweh and Jesus*, Prometheus, Buffalo, 1992.

Hassnain, Fida, *A Search for the Historical Jesus: From Apocryphal, Buddhist, Islamic and Sanskrit Sources*, Gateway Books, Bath, 1994.

Hengel, Martin, *Judaism and Hellenism*, tr. John Bowden, Fortress, Philadelphia, 1981.

Herodotus, *The Histories*, tr. Aubrey de Selincourt, Penguin, 1996.

Higgins, Godfrey, *Anacalypsis* (1836), A&B Books, NY, 1992.

Hinduism Today, 2/00, www.hinduism-today.com/2000/2/2000-2-16.html

Hislop, Alexander, *The Two Babylons*, Loizeaux, NJ, 1959.

Historical Atlas of the World, Barnes & Noble, NY, 1972.

Hoffmann, R. Joseph, *Porphyry's Against the Christians: The Literary Remains*, Prometheus, NY, 1994.

Hofmann, R. Joseph, *Celsus On the Truth Doctrine: A Discourse Against the Christians*, Oxford, NY, 1987.

Hopkins, Edward, *The Religions of India*, Ginn & Co., Boston, 1895.

Huc, M. L'Abbé, *Christianity in China, Tartary, and Thibet*, London, Longman & Co., 1857.

Hunt, Ignatius, *The Books of Joshua and Judges*, The Liturgical Press, MN, 1965.

Iamblichos, *Theurgia or On the Mysteries of Egypt*, www.esotericarchives.com/oracle/iambl_th.htm

Iamblichos, *Theurgia or The Egyptian Mysteries*, tr. Alexander Wilder, The Metaphysical Publishing Co., NY, 1911.

Inman, Thomas, *Ancient Faiths and Modern*, J.W. Bouton, NY, 1875.

Inman, Thomas, *Ancient Pagan and Modern Christian Symbolism* (1869), Book Tree, CA, 2002.

Jackson, John G., *Christianity Before Christ*, American Atheist Press, Texas, 1985.

Jackson, John G., *Ethiopia and the Origin of Civilization* (1939), www.nbufront.org/html/MastersMuseums/JGJackson/EthiopiaOriginOfCivilization.html

Jackson, John G., *Pagan Origins of the Christ Myth* (1941), www.nbufront.org/html/MastersMuseums/JGJackson/ChristMyth/ChristMythPart1.html

Jacolliot, Louis, *The Bible in India: Hindoo Origin of Hebrew and Christian Revelation* (1876), Sun Books, Santa Fe, 1992.

James, E.O., *The Ancient Gods*, Putnam, NY, 1960.

Johnson, Edwin, *Antiqua Mater*, Trubner & Co., London, 1887; www.radikalkritik.de/antiqua_mater.htm

Jones, Sir William, "Third Anniversary Discourse," www.eliohs.unifi.it/digilib/eliohs.testi/700/jones/Jones_Discourse_3.html

Jones, Sir William, ed., *Asiatic Researches* (1788-1839), Cosmo Publications, New Delhi, India, 1979.

Josephus, The Complete Works of, tr. Wm. Whitson, Kregel, MI 1951.

Keeler, Bronson, *A Short History of the Bible* (1881), Health Research, CA, 1965.

Kerenyi, Carl, *Dionysos: Archetypal Image of Indestructible Life*, Princeton, NJ, 1976.

Kingsborough, Lord, *Antiquities of Mexico*, 7 vols., Robert Havell, London, 1831.

Kirby, Peter, "Testimonium Flavianum," www.earlychristianwritings.com/testimonium.html

Knight, Christopher and Lomas, Robert, *The Hiram Key: Pharaohs, Freemasons and the Discovery of the Secret Scrolls of Jesus*, Element, Boston, 1998.

Knight, Christopher and Lomas, Robert, *The Second Messiah*, Barnes and Noble, NY, 2000.

Knight, Stephen, *The Brotherhood*, Dorset, NY, 1986.

Koul, M.L., "Sun Worship in Kashmir," kashmirsentinel.com/maya1999/4.6.html

Kraft, Robert, "Was There A 'Messiah-Joshua' Tradition At The Turn Of The Era?," International Melbourne Congress, July 1992; ccat.sas.upenn.edu/gopher/other/journals/kraftpub/Christianity/Joshua

Kroepel, Robert, "The Assyrian and Babylonian Bel Myth Parallels to the Christian Jesus Myth," www.bobkwebsite.com/belmythvjesusmyth.html

Krupp, Dr. E.C., *In Search of Ancient Astronomies*, Doubleday, NY, 1978.

Kuhn, Alvin Boyd, "The Great Myth of the Sun-Gods," tridaho.com/kuhn/abksungods.htm

Kuhn, Alvin Boyd, *Who is this King of Glory?*, Academy Press, NJ, 1944.

Lee, Earl, *Among the Cannibal Christians*, See Sharp Press, Tucson, AZ, 1999.

Legge, Francis, *Forerunners and Rivals of Christianity: From 330 B.C. To 330 A.D.*, University Books, NY, 1964.

Leidner, Harold, *The Fabrication of the Christ Myth*, Survey Books, FL, 1999.

Lowder, Jeffrey, "Josh McDowell's 'Evidence' for Jesus," www.infidels.org/library/modern/jeff_lowder/jury/chap5.html#phlegon

Lucian, *De Dea Syria*, eds. Harold Attridge and Robert Oden, Scholars Press, Montana, 1976.

Lundy, John P., *Monumental Christianity: The Art and Symbolism of the Primitive Church*, Swan Sonnenschein & Co., London, 1889.

Mack, Burton, *The Lost Gospel of Q*, Harper, CA, 1993.

Macrobius, *The Saturnalia*, tr. Percival Vaughan Davies, Columbia University Press, NY, 1969.

Maharaj, D. Parsuram, "Christmas' Hindu Roots," www.swordoftruth.com/swordoftruth/archives/readersvoice/chr.html

Malik, Tariq, "Ancient Tombs and Shrines Faced Sun and Stars," www.space.com/scienceastronomy/ancient_tombs_040405.html

Mangasarian, M.M., "The Truth About Jesus," www.infidels.org/library/historical/m_m_mangasarian/truth_about_jesus.html

Massey, Gerald, *Gerald Massey's Lectures*, A&B Publishers, NY, 1992.

Massey, Gerald, *The Egyptian Book of the Dead*, Health Research, WA.

Massey, Gerald, *The Historical Jesus and the Mythical Christ*, Health Research, WA.

Maunder, E. Walter, *The Astronomy of the Bible*, T. Sealey Clark & Co., London, 1908.

McCabe, Joseph, *The Story of Religious Controversy*, XIV, www.infidels.org/library/historical/joseph_mccabe/religious_controversy

McLean, Adam, *The Triple Goddess: An Exploration of the Archetypal Feminine*, Phanes Press, 1989.

Mead, GRS, *The Gospel and the gospels*, Health Research, WA, 1972.

Moor, Edward, *The Hindu Pantheon* (1810), Asian Educational Services, New Delhi/Madras, India, 1999.

Moor, Edward, *The Hindu Pantheon*, ed. W.O. Simpson, Indological Book House, India, 1968.

Muir, J., *Original Sanskrit Texts*, V, Trubner & Co., London, 1870.

Müller, F. Max, "On False Analogies in Comparative Theology," *Lectures on the Science of Religion*, Charles Scribner's Sons, NY, 1873.

Müller, F. Max, *Lectures on the Origin and Growth of Religion*, New York, Charles Scribner's Sons, NY, 1879.

New Larousse Encyclopedia of Mythology, Hamlyn, London, 1983.

New Schaff-Herzog Encyclopedia of Religious Knowledge, www.ccel.org/s/schaff/encyc/; www.christianism.com/articles/13.html

O'Brien, Henry, *The Round Towers of Ireland or The Mysteries of Freemasonry, of Sabaism, and of Budhism*, Whittaker and Co., London, 1834

Olcott, William Tyler, *Sun Lore of All Ages* (1914), The Book Tree, Escondido, CA 1999

Online Sanskrit Dictionary, sanskrit.gde.to/dict/

Oser, Scott, "Historicity Of Jesus FAQ," www.infidels.org/library/modern/scott_oser/hojfaq.html

Palmer, A. Smythe, *Babylonian Influence on the Bible and Popular Beliefs* (1897), The Book Tree, CA, 2000.

Pandey, Lalta Prasad, *Sun-Worship in Ancient India*, Motilal Banardisdass, Delhi, 1971.

Past Worlds: Atlas of Archaeology, HarperCollins, London, 1996.

Pelikan, Jaroslav, *Jesus Through the Ages*, Harper & Row, NY, 1985.

Perry, W.J., *The Children of the Sun* (1923), AUP, Illinois, 2004.

Picknett, Lynn and Prince, Clive, *The Templar Revolution*, Touchstone, NY, 1997.

Prabhupada, Swami, *The Bhagavad-Gita as It Is*, Bhaktivedanta, LA, 1988.

Prajnanananda, Swami, *Christ the Saviour and Christ Myth*, Ramakrishna Vedanta Math, Calcutta, India 1984.

Prasad, Ganga, *The Fountainhead of Religion*, The Book Tree, CA, 2000.

Price, Robert, *Deconstructing Jesus*, Prometheus, NY, 2000.

Rath, Sanjay, "Poverty-Destroying Mantra," sanjayrath.tripod.com/Hindu/surya.htm

Reade, W. Winwood, *The Veil of Isis; Or, Mysteries of the Druids* (1861), cercledusanglier.free.fr/veil.pdf

Reber, George, *Therapeutae: St. John Never in Asia Minor* (1872), Kessinger, 2003.

Reik, Theodor, *Pagan Rites in Judaism*, Noonday, NY, 1964.

Remsburg, John E., *The Christ: a critical review and analysis of the evidences of his existence*, www.positiveatheism.org/hist/rmsbrg.htm

Rig Veda, The, tr. Wendy D. O'Flaherty, Penguin, London, 1981.

Rinat, Zafrir, "6th Century B.C.E. artifacts unearthed near Ein Gedi," www.haaretzdaily.com

Robertson, J.M., *Christianity and Mythology,* Watts & Co., London, 1910.

Robertson, J.M., *Pagan Christs,* Dorset, NY, 1966.

Ronayne, E., *Chapter Masonry,* Ezra A. Cook, Chicago, 1956.

Ross, W.J., *Tacitus and Bracciolini,*
 www.gutenberg.net/browse/BIBREC/BR9098.HTM,
 www.knowledgerush.com/paginated_txt/etext05/
 7tcbr10/7tcbr10_txttoc.html

Roussin, Lucille, "Helios in the Synagogue: Did Some Jews Worship the Sun God?" *Biblical Archaeology Review,* March/April 2001.

Roy, S.B., *Prehistoric Lunar Astronomy,* Institute of Chronology, New Delhi, 1976.

Rylands, L. Gordon, *The Beginnings of Gnostic Christianity,* Watts & Co., London, 1940.

Santillana, Giorgio de & Dechend, Hertha von, *Hamlet's Mill,* David R. Godine, Boston, 1977.

Schonfield, Hugh, *The Passover Plot,* Element, MA, 1996.

Seneca, Lucius Annaeus, *Thyestes,* tr. Caryl Churchill, sunnyokanagan.com/joshua/seneca.html

Seznec, Jean, *The Survival of the Pagan Gods,* Harper & Row, NY, 1961.

Short Description of Gods, Goddesses and Ritual Objects of Buddhism and Hinduism In Nepal, Handicraft Association of Nepal, Kathmandu, 2000.

Short, Martin, *Inside The Brotherhood,* Dorset, NY, 1989.

Siculus, Diodorus, *The Antiquities of Egypt,* tr. Edwin Murphy, Transaction Publishers, 1990.

Silberman, Neil, "The World of Paul," *Biblical Archaeology Review,* November/December, 1996.

Singh, Madanjeet, *The Sun: Symbol of Power and Life,* Harry N. Abrams, NY, 1993.

Spence, Lewis, *Ancient Egyptian Myths and Legends* (1915), Dover, NY, 1990.

Spence, Lewis, *The History of Atlantis* (1926), Adventures Unlimited, IL, 1996.

Spence, Lewis, *The Myths of Mexico and Peru* (1913), Dover, NY, 1994.

Srivastava, V.C., *Sun-Worship in Ancient India,* Indological Publications, Allahabad, 1972.

Stein, Gordon, "The Jesus of History,"
www.infidels.org/library/modern/gordon_stein/jesus.html

Stewart, R.J., *Celtic Gods, Celtic Goddesses*, Cassel & Co.,
London, 1990.

Still, James, www.mystae.com/restricted/reflections/
messiah/sources.html

Stone, Merlin, *When God was a Woman*, Dorset, NY, 1976.

Taylor, Robert, *Syntagma of the Evidences of the Christian
Religion*, Kessinger, 1997.

Taylor, Robert, *The Devil's Pulpit*, Kessinger, 1997.

Taylor, Robert, *The Diegesis* (1894), Health Research, CA,
1977.

Temple, Robert, *The Sirius Mystery*, Destiny, Vermont, 1987.

The Bhagavad Gita, tr. Barbara Stoler Miller, Bantam, NY,
1986.

The Existence of Christ Disproved by Irresistible Evidence, "A
German Jew," 1840?

The Free Dictionary, encyclopedia.thefreedictionary.com

The Jewish Encyclopedia, www.jewishencyclopedia.com

The Missing Books of the Bible, Halo, Baltimore, 1996.

The Oxford Dictionary of Modern Greek, Clarendon, Oxford,
1975.

The Talmud, Soncino Ed., Davka Corp. CD.

Thomas, Maurice, *Indian Antiquities*, I, W. Richardson,
London, 1794.

Tierney, Patrick, *The Highest Altar: The Story of Human
Sacrifice*, Viking, NY, 1989.

Till, Farrell, "Did Marco Polo Lie?"
www.infidels.org/library/magazines/tsr/1996/
4/4front96.html

Titcomb, Sarah Elizabeth, *Aryan Sun Myths: The Origin of
Religions* (1899), The Book Tree, CA 1999.

Tucker, Prentiss, *The Lost Key: An Explanation of Masonic
Symbols* (1927), The Book Tree, CA, 1999.

Ulansey, David, "Mithraic Mysteries," *Biblical Archaeology
Review*, September/October, 1994.

Ulansey, David, "Mithraism: The Cosmic Mysteries of
Mithras," www.well.com/user/davidu/mithras.html

Vermes, Geza, *The Dead Sea Scrolls in English*, Penguin,
London/NY, 1987.

Villanueva, Joachimo, *Phoenician Ireland*, tr. Henry O'Brien,
Longman & Co., London, 1833.

Virgil, *Eclogues*, classics.mit.edu/Virgil/eclogue.html

Volney, Constantin Francois de, *The Ruins, Or, Meditation on the Revolutions of Empires: And The Law of Nature* (1789), onlinebooks.library.upenn.edu/webbin/gutbook/lookup? num=1397

Waddell, L.A., *Egyptian Civilization and Its Sumerian Origin* (1930), CPA, OR.

Walker, Barbara, *The Woman's Dictionary of Sacred Symbols and Objects*, Harper, San Francisco, 1988.

Walker, Barbara, *The Woman's Encyclopedia of Myths and Secrets*, Harper, San Francisco, 1983.

Wallace-Murphy, Tim and Hopkins, Marilyn, *Rosslyn: Guardian of the Secrets of the Holy Grail*, Barnes & Noble, NY, 2000.

Ward, Henry David, *History of the Cross: The Pagan Origin and Idolatrous Adoption and Worship of the Image* (1871), The Book Tree, CA, 1999.

Watts, Alan, *Myth and Ritual in Christianity*, Thames & Hudson, London, 1954.

Webster's Dictionary, "Infopedia" CD.

Weigall, Arthur, *The Paganism in Our Christianity*, Hutchinson & Co., London, 1928.

Weil, Simone, *Intimations of Christianity Among the Ancient Greeks*, ARK, London, 1987.

Weisman, Charles, *Jesus Christ in the Old Testament*, Weisman Publications, MN, 1993.

Weiss, Zeev, "The Sepphoris Synagogue Mosaic," *Biblical Archaeology Review*, September/October, 2000.

Wells, G.A., *The Jesus Legend*, Open Court, Chicago, 1996.

Wells, G.A., *The Jesus Myth*, Open Court, Chicago, 1999.

Williams, Sandra, "The Sadducean Origins of the Dead Sea Scrolls," www.billwilliams.org/Scrolls/scrolls.html

Wise, Michael, Abegg, Martin and Cook, Edward, *The Dead Sea Scrolls*, Harper, San Francisco, 1996.

Wooley, C. Leonard, *The Sumerians*, Clarendon Press, Oxford, 1929.

Wooley, C. Leonard, *Ur 'of the Chaldees'*, Cornell University Press, NY, 1982.

Yallop, David, *In God's Name*, Bantam, NY, 1988.

Philo, The Works of, tr. C.D. Yonge, Hendrickson, 1993.

Zeitlin, Solomon, "The Christ Passage in Josephus," didjesusexist.com/zeitlin.html

Zindler, Frank, "The Twelve: Further Fictions from the New Testament," www.atheists.org/church/twelve.html

Zindler, Frank, "Where Jesus Never Walked," www.americanatheist.org/win96-7/T2/ozjesus.html

Index